MW00862191

CALATRAVA

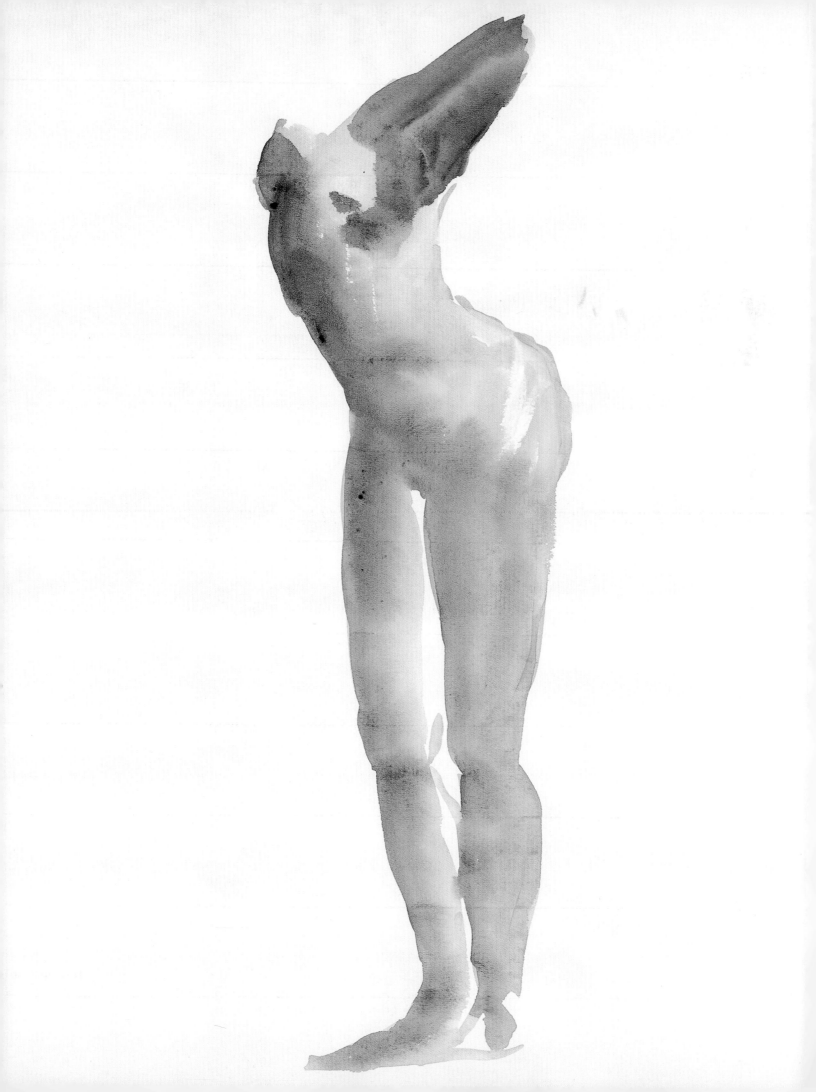

Philip Jodidio

Calatrava

Santiago Calatrava
Complete Works 1979–today

TASCHEN

CONTENTS

THE SECRET OF PHILANTHROPY

"I started out wanting to go to art school," recalls Santiago Calatrava. "Then one day, I went to buy some things in a stationery store in Valencia, and I saw a little book with beautiful colors. It had yellow and orange ellipses on a blue background, and I bought it immediately. It turned out to be about Le Corbusier, whose work was a discovery for me. I saw images of the concrete stairways in the Unité d'Habitation, and I said to myself, what an extraordinary sense of form. The point of the book was to show the artistic aspects of the architect's work. As a result of buying it, I transferred to architecture school."[1]

Born near Valencia in 1951, Calatrava went to primary and secondary school there. Beginning in 1959, he also attended the Arts and Crafts School, where he started formal learning in drawing and painting. When he was 13, his family took advantage of the recent opening of the borders of Franco's Spain, and sent him to France as an exchange student. After graduating from high school in Valencia, he went to Paris to attend the École des Beaux-Arts, but he arrived in 1968, in the midst of the student uprising. He returned to Valencia and, seduced by a small colorful book, enrolled in the Escuela Técnica Superior de Arquitectura, where he got a degree in architecture and did postgraduate work in urbanism.

Where others might have ended their studies, Calatrava decided to continue. Attracted by the mathematical rigor that he perceived in certain works of historic architecture, and feeling that his training in Valencia had given him no clear direction, he decided to begin postgraduate studies in civil engineering and enrolled in 1975 at the ETH (Federal Institute of Technology) in Zurich. He received his Ph.D. in 1981. This decision certainly changed his life in many ways. It was during this period that he met and married his wife, Robertina Marangoni, who was a law student in Zurich. Professionally speaking, the keys to Santiago Calatrava's current activity are also to be found in Zurich. As he says, "The desire to start over from zero was extremely strong for me. I was determined to set aside all of what I worked with in architecture school and to learn to draw like an engineer and to think like one too. I was fascinated by the concept of gravity and resolute in feeling that it was necessary to work with simple forms. I could say that my taste for simplicity in engineering comes in part from my observation of the work of the Swiss engineer Robert Maillart. With simple forms he showed that it is possible to create a strong content and to elicit an emotional response. With the proper combination of force and mass, you can create emotion."

ENGINEER, ARCHITECT, ARTIST

Calatrava's early interest in art, and the aesthetic sense that drew him to the small book on Corbusier would remain another constant factor in his work, and one of the things that sets him apart in the world of contemporary architecture. Referring to a 2005 exhibition of his art and architecture held at New York's Metropolitan Museum of Art, Calatrava says, "I think that the curator in charge, Gary Tinterow, understood my way of working, because he titled the show 'Sculpture into Architecture' rather than the reverse. Architecture critics haven't gotten over being perplexed by my work." Indeed, while noting that the last time the Metropolitan showed the work of a living architect was in 1973, Nicolai Ouroussoff, when reviewing this show, wrote in *The New York Times*, "No one would argue that Mr. Calatrava's sculptures would make it into the Met on their own merits; as art, they are mostly derivative of the works of dead masters like Brancusi," going on to a rather brutal conclusion, "One wishes he had left the sculpture back in his studio."[2] This comment above all seems to show a lack of understanding of Calatrava's sculpture. "In sculpture," he says, "I have used spheres, and cubes, simple forms often related to my knowledge of engineering. It is a sculpture that gave rise to the Turning Torso (Malmö, Sweden, 1999–2004). I must admit that I greatly admire the

liberty of a Frank Gehry, or Frank Stella as a sculptor. There is a joy and a liberty in Stella's work that is not present in my sculpture, which is always based in the rough business of mathematics."[3] Calatrava is quite clear about saying that he has always disliked the art gallery circuit, almost never showing his sculpture. He also underlines the fact that "the reaction I receive from artists is very positive. Art is much freer than architecture, because, as Picasso said, some artists work with marble and others with shit." This is not to say that Santiago Calatrava is at all naive about the difficulty of his task. In 1997, he wrote, "Architecture and sculpture are two rivers in which the same water flows. Imagine that sculpture is unfettered plasticity, while architecture is plasticity that must submit to function, and to the obvious notion of human scale (through function). Where sculpture ignores function, unbowed by mundane questions of use, it is superior to architecture as pure expression. But through its rapport with human scale and the environment, through its penetrability and interiority, architecture dominates sculpture in these specific areas."[4]

Calatrava goes so far as to suggest that art must be considered to be a source of ideas for architecture. "Why do I make drawings of the human figure? The artist or the architect can send his message across time by the very force of form and shadow. Rodin wrote, 'Harmony in living bodies is the result of the counterbalancing of masses that move; the Cathedral is built on the example of the living body.'[5] Let me give you an example of the importance of art for 20th-century architecture. When Le Corbusier wrote 'Architecture is the masterly, correct, and magnificent play of masses brought together in light' in 1923,[6] how many people knew that he was borrowing from the thought of the sculptor Auguste Rodin? In 1914, in his book *Les Cathédrales de France*, Rodin wrote, 'The sculptor only attains great expression when he gives all his attention to the harmonic play of light and shadow, just as the architect does.'[7] The fact that one of the most famous phrases of modern architecture was inspired not by an architect but by a sculptor underlines the significance of art."

Aside from his consistent interest in art, Santiago Calatrava has also brought a related passion to his own very personal definition of architecture—that of movement: implied but also real, that is to say, physical motion. From the early folding doors of his Ernsting's Warehouse (Coesfeld-Lette, Germany, 1983–85) to the more recent 115-ton Burke Brise Soleil (Milwaukee Art Museum, Milwaukee, Wisconsin, 1994–2001), he has come back again and again, in his sculpture and his architecture, to the unusual concept of repetitive, physical movement. Why? "There is a cinematic element in 20th-century art," replies Calatrava. "Artists like Alexander Calder, Naum Gabo or Moholy-Nagy created sculptures that move. I love their work and it gives me a great emotion. My doctoral thesis 'On the Foldability of Frames' had to do with the fact that a geometric figure can be reduced from three dimensions to two and ultimately to just one. Take a polyhedron and collapse it, making it into a planar surface. Another transformation reduces it to a single line, a single dimension. You can view this as a problem of mathematics or topology. All the mystery of the omnipresent Platonic solids is summed up in the polyhedron. After thinking about these questions, I looked at ancient sculpture in a different light. Works such as the *Discobolus* by Myron create a tension based on an instant of movement, and that is how I became interested in the problem of time, time as a variable. Einstein said 'God does not play dice with the Universe,' and so it became apparent to me that everything is related to mathematics and the unique dimension of time. Then I thought about statics (the branch of physics concerned with physical systems in static equilibrium) and realized that there is nothing static about them. Everything is potential movement. Newton's second law of motion states that the acceleration of an object is dependent upon two variables: the net force acting upon the object and the mass of the object. Mass and acceleration are related, and thus there is time in force. I realized that architecture is full of things that move, from doors to furniture. Architecture itself moves and with a little luck becomes a beautiful ruin. Everything changes, everything dies, and there is an exis-

tential meaning in cyclical movements. I wanted to make a door of my own, one that would have a poetic meaning and transform itself into a figure in space, and that is how the Ernsting's project came about."

THE ESSENCE OF ARCHITECTURE

The fact that some are uncomfortable with the multiple forms of expression chosen by Santiago Calatrava is probably the best indication that he is on to something important. Today, he is carrying forward one of the most complex and politically sensitive projects imaginable in the United States, the World Trade Center Transportation Hub in the midst of the desolation that New Yorkers have come to call Ground Zero. "We think he is the da Vinci of our time," said Joseph Seymour, the former executive director of the Port Authority of New York and New Jersey, which is building the station. "He combines light and air and structural elegance with strength." Nor is such praise rare, even in the closed world of architecture. In 2005, Santiago Calatrava became the second Spaniard (after Josep Lluís Sert in 1981) to win the prestigious American Institute of Architects' Gold Medal. The AIA Committee on Design declared, "Santiago Calatrava's work seeks out the essence of architecture. His architecture expands the vision and expresses the energy of the human spirit, captivating the imagination and delighting us in the wonders of what sculptural form and dynamic structure can accomplish. Santiago Ca-latrava defines the reason for the Gold Medal. His vision elevates the human spirit through the creation of environments in which we live, play, and work."

Santiago Calatrava does not seem to be perturbed by the coexistence of art, architecture, and engineering in his own thought. And yet, with his combined interests, Calatrava is indeed close to the heart of one of the most intense debates in the recent history of construction and design. As Sigfried Giedion wrote in his seminal book *Space, Time and Architecture*, "The advent of the structural engineer with speedier, industrialized form-giving components broke up the artistic bombast and shattered the privileged position of the architect and provided the basis for present-day developments. The 19th-century engineer unconsciously assumed the role of guardian of the new elements he was continually delivering to the architects. He was developing forms that were both anonymous and universal." Gideon retraces the debate about the role of engineering by citing a number of essential dates and events. Among them, "1877: In this year the question entered the Académie, when a prize was offered for the best paper discussing 'the union or the separation of engineer and architect.' Davioud, one of the architects of the Trocadéro, won the prize with this answer: 'The accord will never become real, complete, and fruitful until the day that the engineer, the artist, and the scientist are fused together in the same person. We have for a long time lived under the foolish persuasion that art is a kind of activity distinct from all other forms of human intelligence, having its sole source and origin in the personality of the artist himself and in his capricious fancy.'"[8] Though neither Giedion's insistence on the "anonymity" of the work of the engineer, nor Davioud's reference to the "capricious fancy" of the artist seem to fit well with Calatrava's powerful originality, he does appear to meet the Frenchman's requirements for an accord between art, engineering, and architecture. Then too, Joseph Seymour's reference to the "da Vinci of our time" also comes to mind.

The catalogue of Santiago Calatrava's 1993 exhibition at the Museum of Modern Art in New York underlines the close relationship of his work to that of other groundbreaking engineers: "Calatrava is part of the distinguished heritage of 20th-century engineering. Like those of the preceding generations—Robert Maillart, Pier Luigi Nervi, Eduardo Torroja, and Félix Candela—Calatrava goes beyond an approach that merely solves technical problems. Structure, for these engineers, is

a balance between the scientific criterion of efficiency and the innovation of new forms. Calatrava considers engineering 'the art of the possible,' and seeks a new vocabulary of form that is based on technical know-how, yet is not an anthem to techniques."[9] The first figure cited, Robert Maillart (1872–1940), graduated from the ETH in Zurich in 1894 and went on to create some of the most spectacular modern bridges, and to make innovative use of concrete. His Giesshübel Warehouse in Zurich (1910) employed a concrete slab "mushroom ceiling" for the first time, permitting Maillart to do away with the use of beams. As Matilda McQuaid writes, "Maillart was one of the first engineers of this century to break completely from masonry construction and apply a technically appropriate and elegant solution to reinforced concrete construction. Although the technical idea in Calatrava's work is neither the primary motivation, as with Maillart, nor understated, it informs the overall expression of the structure. His work becomes an intertwinement of plastic expression and structural revelation, producing results that possibly can be best described as a synthesis of aesthetics and structural physics."[10]

Although he naturally admires the work of Maillart, Santiago Calatrava is quick to point out that his bridges are very different from those of his predecessor, if only because of their sites. "Maillart's bridges," says Calatrava, "are often set in beautiful mountain scenery. His achievement was to successfully introduce an artificial element into such magnificent locations. Today," he continues, "I believe that one of the most important tasks is to reconsider the periphery of cities. Most often public works in such areas are purely functional, and yet even near railroad tracks, or spanning polluted rivers, bridges can have a remarkably positive effect. By creating an appropriate environment they can have a symbolic impact whose ramifications go far beyond their immediate location."[11]

Calatrava's work has undoubtedly been influenced by that of Félix Candela, who was born in Madrid in 1910, and emigrated to Mexico in 1939, where he created a number of remarkable thin-shelled concrete structures such as the Iglesia de la Virgen Milagrosa (Narvarte, Mexico, 1955), a design entirely based on hyperbolic paraboloids. Another Spaniard, the Madrid engineer Eduardo Torroja (1899–1961) was fascinated by the use of organic or vegetal forms whose undeniable sculptural presence may well spring from the influence of Gaudí. Many of Santiago Calatrava's references are to Spanish, and more specifically Catalan, architects or artists. "What fascinates me in the personality of Goya, for example," says Calatrava, "is that he is one of the first artists to renounce the idea, as Rembrandt had before him, of serving any one master. What I admire in Miró's work," he continues, "is its remarkable silence, as well as his radical rejection of everything conventional." Although Gaudí provides him with an example like that of Maillart, Calatrava seems more at ease speaking about the sculptor Julio González. "The father and grandfather of González were metalworkers for Gaudí on projects like the Park Güell. Then they went to Paris, and that is where the work of Julio González with metal comes from. With all due modesty," concludes Calatrava, "one might say that what we do is a natural continuation of the work of Gaudí and of González, a work of artisans moving toward abstract art."[12]

The kind of art that Santiago Calatrava is referring to is apparent in his most successful bridges and buildings, and yet it remains difficult to describe in words. Another of the essential figures of 20th-century engineering, the Italian Pier Luigi Nervi, attempted such a definition in a series of lectures he delivered at Harvard in 1961: "It is very difficult to explain the reason for our immediate approval of forms which come to us from a physical world with which we, seemingly, have no direct tie whatsoever. Why do these forms satisfy and move us in the same manner as natural things such as flowers, plants, and landscapes to which we have become accustomed through numberless generations? It can also be noted that these achievements have in common a structural essence, a necessary absence of all decoration, a purity of line and shape more than sufficient to define an authentic style, a style I have termed the *truthful style*. I realize how difficult it is to find the

right words to express this concept. When I make these remarks to friends, I am often told that this view of the near future is terribly sad, that perhaps it would be better to renounce voluntarily the further tightening of the bonds between our creations and the physical laws, if indeed these ties must lead us to a fatal monotony. I do not find this pessimism justified. Binding as technical demands may be, there always remains a margin of freedom sufficient to show the personality of the creator of a work and, if he be an artist, to allow that his creation, even in its strict technical obedience, become a real and true work of art."[13]

ALONG THE STEEL RAILS

The reason for Calatrava's long presence in Zurich is one of circumstances. Having completed his own studies, he stayed on there because his wife, Robertina, had not yet completed hers. Then, as luck would have it, he won a 1982 open competition to design the new Stadelhofen Railway Station (1982–90). To say that this unusual building is centrally located would almost be an understatement. Set into a green hill near Bellevueplatz and off Theaterstrasse close to the lake, it is tightly integrated into a largely traditional urban environment. "In order to understand the Stadelhofen Railway Station," says Santiago Calatrava, "you have to view it as an extremely urban project, one which entailed the repair of the urban fabric. There is a clear contrast between the radical nature of the technical and architectural solutions chosen, and the attitude towards the city that is extremely gentle. Any number of links have been created—not only bridges and access points, but also connections with the streets which didn't exist before. Small park areas such as the veil of greenery hanging over the upper level were created." Indeed, when approaching the station from the city, the visitor first encounters a very traditional pavilion that originally housed the station before entering or descending into the areas designed specifically by Calatrava. "It was obvious from the outset," continues the architect, "that the respect given to buildings over 100 years old in Switzerland, precluded any attempt to demolish or substantially modify the old station house. I did not find that aspect illogical however, because it fits into a reading of the city which remains intact."[14] Once the traveler has gone past the old pavilion, however, he enters a very different world that seems closer to the imagination of Gaudí than to that of the stolid burghers of Zurich. Although Calatrava points out that Zurich does have something of a tradition of radical architecture with houses by figures such as Marcel Breuer, it is clear that with the Stadelhofen Station he indulged for the first time in his career on a large scale in the kind of innovative design for which he has become famous.

The curved 40 x 240-meter site required construction during the continued operation of the commuter train line, and was modified to include a large shopping area below ground. The whole has an organic unity that the circumstances could not have simplified. Like an extravagant flying dinosaur that has come to nest against this hillside, the structure is articulated by a pattern of repeating elements, with enormous anthropomorphic gates leading to the underground shopping mall where one quickly gets the impression of being in the concrete belly of the beast. There is a continuity in the dark metal above ground and the riblike concrete below which establishes a clear hierarchy of spaces and forms; all of this while placing an obvious emphasis on the legibility and functional clarity of the station.

Though it may be that the whole of Stadelhofen Railway Station gives the impression of being conceived around a kind of dinosaur metaphor, the substance of Calatrava's design is more complex, or perhaps different. "In reality, what I have attempted, is what I would call a dialectic of transgression, which is based on the vocabulary of structural forces. In Stadelhofen, for example, there are a series of inclined columns. Though this appears to be an aesthetic decision, it is in fact related to the necessity of holding up the structure. Naturally there were

various solutions for this type of support. They could have been simple cylinders for example, but I chose to articulate them in the shape of a hand. This is where the question of metaphors becomes interesting. How better to express the function of the columns than to invest them with the sense of the physical gesture of carrying?"[15]

Though Santiago Calatrava's name is often cited with reference to bridges, he is also a recognized specialist of railroad stations, including the Oriente Station in Lisbon or the new Liège-Guillemins facility. One of the buildings that contributed most to his reputation, however, was the Lyon-Saint Exupéry TGV Terminal (1989–94). This 5600-square-meter station located at the Satolas airport is one of a new generation of rail facilities designed to serve France's growing network of high-speed trains (TGV). The juxtaposition of rail, air, and local transport facilities at a single location makes for a particularly efficient system. The 120-meter-long, 100-meter-wide, and 40-meter-high passenger terminal, which opened on July 7, 1994, is based on a central steel element weighing 1300 tons. Calatrava's station seems to echo Eero Saarinen's TWA Terminal at Kennedy Airport (1957–62) in its suggestion of a bird in flight, but it is more exuberant than its American ancestor. The plan of the complex, with its link to the airport, also resembles a manta ray. A total of six train lines run below the main building and stop at a 500-meter-long covered platform also designed by Calatrava. The middle tracks, intended for through trains moving at over 300 kilometers per hour, are enclosed in a concrete shell, a system which required careful calculation of the "shock waves" surrounding the TGV. Shared by the French national rail company (SNCF), the Rhône-Alpes region and the Rhône Department, the total cost of this facility exceeded 600 million francs.

When asked about the image of a prehistoric bird, Calatrava responds in a typically oblique, yet informative manner: "I am merely an architect," he says, "not an artist or someone who is seeking to foment a revolution. It might be interesting to note that Victor Hugo in his novel *Notre-Dame de Paris* compares the cathedral to a prehistoric monster. Despite the fact that he may have had an excellent knowledge of architecture, and that he was a very conscientious writer, he did not hesitate to use such an unexpected metaphor in describing Notre-Dame Cathedral. I honestly am not looking for metaphors. I never thought of a bird, but more of the research which I am sometimes pretentious enough to call sculpture."[16] Indeed, both the drawings and the sculpture by Calatrava that are most closely related to Satolas seem to find their origin not in the metaphor of a bird, but in a study of the eye and the eyelid, a recurring theme in his work. "The eye," says Calatrava, "is the real tool of the architect, and that is an idea that goes back to the Babylonians."

The swooping front of the Saint Exupéry Station that runs right into the earth has been compared to the beak of a bird, but Calatrava once again seems to have had an entirely different idea in mind. "The 'beak' was formed as the result of complex calculations of the forces playing on the structure. It also happens to be the assembly point for the water run-off pipes. Naturally, I did my best to minimize the mass of that point, without any thought of an anthropomorphic design," he says. Admitting that the use of his own sculptures as a starting point for the design represents as much of an aesthetic choice as would a consciously anthropomorphic concept, Calatrava says, "Call it irrational if you will, but I would say that there is no path to follow. I want to be like a boat in the sea. Behind it there is a trail, but in front there is no path."[17]

TREES ON THE HILL

Calatrava's work on the spectacular Oriente Station in Lisbon is a significant example of his method and explains a good deal of his recent success. Following the catastrophic earthquake of 1755, Lisbon oriented itself toward the

"IN REALITY, WHAT I HAVE ATTEMPTED, IS WHAT I WOULD CALL A DIALECTIC OF TRANSGRESSION, WHICH IS BASED ON THE VOCABULARY OF STRUCTURAL FORCES."

interior, turning its back almost literally on the broad vistas of the Tagus estuary. This tendency was amplified in more recent times, as poor landfill on the river's edge became the site for industrial facilities. The 340 hectares that comprised the so-called Redevelopment Area, with Expo '98 and the Oriente Station at its heart, were occupied until the 1990s by fuel depots, container warehouses, the city's slaughterhouse, and sewer or waste treatment facilities. Although much of Lisbon's glorious past remains inscribed in its streets and squares, its intimate relation to the Tagus, formerly the source of wealth beyond imagination, was almost lost in the mists of time.

It is in this context that the Association of Portuguese Architects launched an "Ideas Contest for the Riverside Zone" in 1988. The construction of the Belém Cultural Center (1988–92) near the river's edge represents a first significant step toward the rehabilitation of Lisbon's historic ties to the Tagus. An even more important political and cultural decision began to take form in November 1993 when Parque Expo '98 SA confided a first "Urbanization Plan for the Redevelopment Area" to the architect Luis Vassalo Rosa. From the outset, the intention of the developers of this tract was to create something more than the typically ephemeral architecture of a World Fair. Situated at the eastern extremity of the city, with five kilometers of waterfront on the Tagus, the Redevelopment Area is close to the Vasco da Gama Bridge. Inaugurated on March 29, 1998, this impressive structure spans the 12-kilometer width of the Tagus, rising as high as 45 meters. Symbolically, the completion of a bridge named after the great explorer, and the placement of Expo '98 could not have sent a clearer signal. Lisbon, and indeed Portugal, were intent on reclaiming their historic heritage, and once again to open out onto the Tagus and the world beyond.

Santiago Calatrava was chosen to build the Oriente Station following a limited competition in which Terry Farrell, Nicholas Grimshaw, Rem Koolhaas, and Ricardo Bofill also participated. The Oriente Station is, together with Álvaro Siza's Portuguese Pavilion, undeniably the most architecturally significant structure to emerge from Expo '98. The station, with its 200 000 visitors per day, was clearly the centerpiece of the plan to revive the waterfront in the east of the city. The most spectacular aspect of the project is undoubtedly the 78 x 238-meter covering over the eight raised railway tracks whose typology recalls that of a stand of trees. Rather than emphasizing the break between the city and the river implied by the station, Calatrava has sought, here as elsewhere, to open passageways and reestablish links. This will is made manifest by the fact that the architect has cut into the elevated mound on which the railway tracks run, in order to effectively build the station below them. The complex includes two large glass and steel awnings over the entrances, one measuring no less than 112 meters in length and 11 meters in width. There is a bus station and car park, a metro station below (not designed by Calatrava), and a longitudinal gallery including commercial spaces that were included in the architect's brief. Ticketing and service facilities are located five meters below the tracks, with an atrium marking the longitudinal gallery five meters lower, and the opening on the river side intended as a main access point.

Seen from a distance, or for that matter from within, the most visible aspect of the Oriente Station is indeed its treelike design. At least two other projects by Santiago Calatrava have also called on the structural typology of the tree or forest; his unbuilt design for the Cathedral of St. John the Divine in New York (1991) and the BCE Place, Galleria and Heritage Square in Toronto (1987–92). St. John the Divine, one of New York's best-known churches, was originally built in a neo-Romanesque style by Heins & La Farge in 1892 and "gothicized" by Cram & Ferguson in 1911. Calatrava's project would have added a new south transept and a "bio-shelter" perched 55 meters above ground level. Obviously related in its symbolism to the Garden of Eden, the bio-shelter would have been completed with structural elements below derived from the form of trees. Placed in the existing attic of the nave, this garden would not have changed the profile of the building, but

would have brought natural light into the church. Philip Johnson, a jury member, pointed out the relationship of Calatrava's design to the decor of the church, and, indeed, the tree typology does bring to mind the origins of Gothic architecture. The image of the tree is also at the heart of the Bell Canada Enterprises Place, Galleria and Heritage Square. Here, Calatrava worked with the New York office of Skidmore, Owings & Merrill to create a six-story 115-meter-long white-painted steel and glass passageway connecting two towers. As The New York Times wrote, "This gallery is nothing if not Gaudí-esque." It also recalls a forest path in a metaphorical sense. The use of white steel and glass is also premonitory of the tree-related designs for the platforms of the Oriente Station.

Whether it be in Toronto or in New York, Santiago Calatrava called on the tree metaphor for different reasons—related in the first instance to a large urban space set between high towers, and in the second to the neo-Gothic design of St. John the Divine. The fact that the tree is one of the most obvious models for the column or early church nave forms only reinforces its undeniable biological presence. In each instance, the words of Nervi—"our immediate approval of forms, which come to us from a physical world"—come to mind. In the case of the Oriente Station, Calatrava explains that very specific circumstances related to his own understanding of Lisbon led him to the unusual canopy design. He says, "I went to Lisbon at least five times during the competition for the Oriente Station, if only to take in the mood of the city. It may be obvious to say so, but Lisbon is a very beautiful city. Like Rome, it is built on hills, which means that there are often remarkable views. You are in the city and yet able to look at it at the same time. There is also the monumentality of the Tagus, which is at this point the widest river in Europe. The Sea of Straw is incredibly vast. The urban history of Lisbon is very ancient, and yet it retains a clarity in its composition."[18]

When Calatrava speaks of the platform design of the Oriente Station, he refers to "trees on a hill." The "hill" in this instance is the high mound on which the railway tracks run. To explain the tree metaphor, he again refers to his visits to Lisbon during the competition. "There are numerous parks in the city with trees," he says. "I immediately felt that the elevated tracks called for a wooded hillside. This was a very explicit idea in my mind. For the competition, I cited a melancholic poem by Fernando Pessoa, which evokes the idea of going to the 'arvoredo,' the woods. I wanted to accentuate the transparency of the station. In an urban environment, which will undoubtedly become even more dense, the Oriente Station will resemble an oasis. It will be a place where people will come to rest!" When asked why in this instance he has preferred a vegetal metaphor to the anthropomorphic designs he seems more at ease with, Calatrava replies, "Imagine that you create an elevated square. This is obviously not an introverted type of architecture. I am on a hillside in Lisbon and I look around me. What is lacking? Some protection from the sun and the rain."[19]

A more recent design by Calatrava, for the Liège TGV Station shows some changes in his thinking and illustrates reasons for the differences between the pared-down simplicity of his bridges and the more complex feeling of his larger buildings. "Bridges, by their very nature necessitate a strict economy of means. You have the bridge surface, the arc that supports it, and the foundations, with each representing about one third of the cost. Given the simplicity of the function of a bridge, there is only limited margin for intervention. On the other hand, in a railway station, there are at least 16 types of decisions which can have an aesthetic impact, from the choice of metal window frames to the lighting design and so on. It is up to the skills of the designer to obtain the result he has imagined within the economic constraints of such a project." Despite this fundamentally different situation, it can readily be seen that Calatrava's taste for "transgression" or innovation pushes him equally to design unusual bridges and unexpected stations. "Take the case of the new TGV Station in Liège," he continues. "We reinvented the façade completely. Or rather there is no façade. That, in my opinion is a fundamental trans-

"EVERYTHING IS BASED ON MAN, BUT IN MAN'S COMPLEXITY, THE SACRED EXISTS, OR THERE WOULDN'T BE SO MANY PEOPLE CROWDING INTO THE PANTHEON IN ROME TO SEE THE ROUND HOLE IN THE DOME."

gression. In the place of a traditional façade, there will only be large openings signaled by metal awnings overhanging the square in front of the station." As Calatrava points out, this design decision has important consequences on the functional layout of the station. In a more symbolic vein it might be asked how a station with no façade can be identified as such. "The setting is an urban one, and it seemed to me that the first vision that travelers or visitors would have of the station would be important," explains Calatrava. "My solution was two-fold. As it is located on a hill, and is approached from above, there is a view of the city and of the layout of the station. The plan thus becomes the real façade. In order to improve the rapport between the city and the station, we proposed to create a square in front of it."[20] It would seem that this strategy of absence or of a kind of minimalism brings the Liège Station closer to the bridges in its concept than some of Santiago Calatrava's earlier buildings. As for his taste for "transgression," it becomes apparent that Calatrava's careful methods imply a respect for the economic and functional conditions of a project, and seek out a specific reasoning within the gamut of available technical possibilities. His ideas work and engage public interest because they spring from the fertile imagination of the architect-engineer, but also because they respect, from the outset, the fundamental forces at play.

WINGS AND A PRAYER

Calatrava's sensitivity to urban design is undoubtedly what won him the competition in Lisbon, but also in Liège, or more recently in Manhattan for the symbolically charged World Trade Center Transportation Hub. He seems to genuinely feel that the architect can elevate a place such as a railway station and give it a sense of the sacred. When asked if his idea is to make spaces that are comfortable and humane or rather to reach for something more, his answer reveals much about his creative process. "Everything is based on man," he says, "but in man's complexity, the sacred exists, or there wouldn't be so many people crowding into the Pantheon in Rome to see the round hole in the dome. What about railway stations? If you take the example of the modern stations in Switzerland—in Zurich or Basel for example—you get the feeling that you are in a shopping mall. Grand Central Terminal in New York seems to come from a different planet. By exalting abstract values, architecture is capable of being a catalyst for enormous events. But if you go at it with a purely functionalist attitude, you don't catalyze anything. You wind up with a mediocre shopping mall. The feeling that I get in the Central Hall of Grand Central Terminal is the product of great intelligence. It gives a particular sense, even a sacred aspect to commerce. While sacrificing nothing of its utility, the station becomes an act of celebration. Look at all that has sprung up around the void at the heart of Grand Central—the Seagram Building and Park Avenue itself. In America, no building resembles the Pantheon so closely in these terms. Look at what the architects have placed in the center of the great hall—a clock and a small stand intended to give away timetables—two elements intended to give, rather than to take, from travelers. We need beauty and beauty can generate great things."[21]

When describing his plans for the new World Trade Center Transportation Hub, Calatrava lists his materials as "glass, steel, concrete, stone, and light." Calatrava has understood that light must shine into the very heart of one of the darkest events in recent American history, and in that he has touched the sensitivity of New Yorkers even before the wings of his new station rise up out of the ground. Although suggestive of motifs from many traditions (the Byzantine mandorla, the wings of cherubim above the Ark of the Covenant, the sheltering wings on Egyptian canopic urns), the form of his glass roof is summed up, according to Santiago Calatrava, by the image of a bird released from a child's hands. Whatever its symbolism, the complex will also address the overly intricate layering of lower Manhattan's transport system, born of a century of progressive exten-

sions, enlargements, and changes of direction. Working with skilled specialists as he has in other rail facilities, Calatrava has found elegant solutions to extremely complex technical problems. The generosity that the architect evokes in the design of Grand Central Terminal is at the heart of his WTC project, and it is expressed largely through space and light. As the formal description goes, "The part of the building visible at street level is an arched oval of glass and steel, approximately 107 meters long, 35 meters across at its widest point, and 29 meters at its apex. The steel ribs that support this structure extend upward into a pair of canopies, which resemble outspread wings and rise to a maximum height of 51 meters. On the main concourse—approximately 10 meters at street level, and 40 meters below the apex of the glass roof—visitors will be able to look up at a column-free, clear span." Echoing Santiago Calatrava's own feelings about the importance of an uplifting design, Michael Bloomberg, the former Mayor of New York declared, "Today we unveil the design of downtown's new PATH station and we imagine that future generations will look at this building as a true record of our lives today as we rebuild our city. What will they see in Santiago Calatrava's thrilling work? They'll see creativity in design, and strength in construction. They'll see confidence in our investment in a stunning gateway to what will always be the 'Financial Capital of the World.' They'll see a seamless connection to the PATH train, city subways, and, ultimately, to our regional airports. And they'll see optimism—a building appearing to take flight—just like the neighborhood it serves."

ACROSS THE RIVER AND THROUGH THE TREES

As Santiago Calatrava says himself, designing a bridge involves a very specific set of issues, not the least of them symbolic. "If you look back over the history of 19th- and 20th-century bridges," says Calatrava, "many are very special and significant structures. They were given stone cladding, sculpted lions or railings, even angels holding lamps as is the case on the Alexander III Bridge in Paris. This attitude disappeared as a result of World War II," he continues. "Hundreds of bridges all over Europe had to be rebuilt quickly. It was out of necessity that a school of purely functionalist bridge design sprang up. A good bridge was a simple one, and above all a cheap one." Calatrava obviously feels that this functionalist school of bridge design has far outlived its postwar usefulness. "Today, we have to rediscover the potential of bridges," he declares. He cites the examples of European cities like Florence, Venice, or Paris to highlight the fact that through their usefulness, but also their permanence, bridges of the past have had a key role in forming impressions of the cities themselves. To make his point Santiago Calatrava goes so far as to say that building a bridge can be a more potent cultural gesture than creating a new museum. "The bridge is more efficient," he says, "because it is available to everyone. Even an illiterate person can enjoy a bridge. A single gesture transforms nature and gives it order. You can't get any more efficient than that," he concludes.[22]

The success of Calatrava's own efforts to give a new meaning to bridges might best be summed up by the example of the Alamillo Bridge and the La Cartuja Viaduct, (Seville, 1987–92). Standing out at one of the entries to Expo '92, the spectacular 142-meter-high pylon is inclined at a 58-degree angle (the same as that of the Great Pyramid of Cheops near Cairo), making it visible from much of the old city of Seville. Supported by 13 pairs of cables, the Alamillo Bridge has a 200-meter span, and runs over the Meandro de San Jerónimo, an all but stagnant branch of the Guadalquivir River. It is supported by 13 pairs of stay cables, but, above all, the "weight of the concrete filled pylon is sufficient to counterbalance the deck, therefore backstays are not required."[23] Although Calatrava had originally imagined a second bridge, inclined in the opposite direction, like a mirror

image of the first one, to cross the nearby Gaudalquivir, budgetary considerations made the client, the regional government of Andalusia, opt for only one span together with the 500-meter-long La Cartuja Viaduct.

Aside from his own copiously illustrated notebooks which make clear the thinking that went into creating the innovative form of the Alamillo pylon, Calatrava here called quite directly on the inspiration provided by *Running Torso*, a sculpture he created in 1986, in which inclined stacked marble cubes are balanced by a tensioned wire. Indeed, many of the drawings which Calatrava hangs on the walls of his Zurich home depict figures in motion. *Running Torso* is clearly inspired, as its title implies, by the tension and forces of a body moving forward. Although the specific use that Calatrava makes of this analysis is very personal, the result does retain something of the "truthful style" evoked by Nervi.

Despite the ease with which the uninformed person can indeed appreciate the beauty of a bridge, the method which leads to these forms is quite complex. "It is an intuitive process, which is to say a system which relies on the synthesis of a number of factors," he says. His description of bridge design deserves to be quoted at length: "I believe that first and foremost, the location of a bridge must be considered. On certain sites, for example, you could not employ an arc because it is not feasible to transfer the loads to the shore in an appropriate manner. Then, too, waterborne traffic must be considered. The height of a bridge can be determined by the type of boats which must past beneath it. The choice of materials is also essential—wood, steel or concrete might be used according to the local circumstances—and cost factors. These elements and others lead, by a process of elimination, toward certain possible structural solutions. It is then that not only the type of bridge itself, but also its impact on its environment begin to give it form. And then, too, the engineer must make the calculations necessary to be certain that the design he imagines is indeed viable. I create a model which links mathematical science to nature, permitting an understanding of the behavior of nature. We are always confronted with the forces of nature," he concludes.[24]

Another of Santiago Calatrava's bridges, the Campo Volantín Footbridge (Bilbao, Spain, 1990–97) is exemplary in terms of his thoughts on peripheral or industrial urban spaces, as well as a proficient exercise in engineering resulting in an unexpected form. Crossing the Bilbao River in a location intended to link the city center with the rundown commercial area called Uribitarte, it calls on the principle of the inclined arch which Calatrava first used in an unbuilt 1988 project for a new bridge on the Seine, between the 12th and the 13th arrondisements, linking the Gare de Lyon and the Gare d'Austerlitz. Here, an inclined parabolic arch spanning 71 meters supports a curved walkway that makes for a visually arresting design. Yet, that curve is more than artistic license. As Sergio Polano explains, "The torsion created at the points of suspension of the uprights by the eccentricity of the weight is balanced by the counter-curve of the walkway, thus transferring the load to the concrete foundations," the whole suggesting "a pendulum in suspended motion."[25] Where actual physical motion is not part of the design, Santiago Calatrava's work often brings to mind the sort of tension he evokes in a sculpture like the *Discobolus*.

Recent bridges by Calatrava confront radically different locations with the language of simplicity and efficiency that has come to characterize his river or canal crossings. His Three Bridges over the Hoofdvaart (Hoofddorp, the Netherlands, 2004) are located in a rapidly expanding semiurban area near Schiphol Airport. All three address the essentially flat environment, becoming "vertical landmarks" thanks to their bold steel spindle pylons. The varying angles of the pylons can be read as a sequence or a progression, which inspired the musical names given to them—the Lyre (*Citer*), the Harp (*Harp*) and the Lute (*Luit*). Much more delicate in terms of the historical setting involved, Calatrava's new bridge in Venice, the aptly named Fourth Bridge on the Canal Grande (1999–2008) is only the fourth crossing to be built over the famous canal since the 16th century. Connecting

the railway station and Piazzale Roma, the 94-meter bridge has a central arch with a very large radius and a transparent glass deck. Again, elegance and a deft capacity to deal with local pride and political complexities have allowed Santiago Calatrava to build where others have tried and failed in the past.

THE VERTICAL CHALLENGE

From the largely horizontal world of bridges, Calatrava has ventured boldly into the verticality of towers on numerous occasions in his career, though he now seems to be concentrating even more on such design. The best known of his earlier towers is the Montjuic Communications Tower (Barcelona, 1989–92) which was built at the time of the Olympic Games. Some 130 meters high, with an inclined stem, the tower has been compared to a javelin being thrown, yet Calatrava's own approach, as usual, seems to be quite unexpected. His drawings make clear that the inclined design is inspired by the shape of a kneeling human figure making an offering. Similarly, the plan of the tower would seem at first sight to be inspired by Masonic symbols such as the compass. Santiago Calatrava insists that this particular impression is incorrect, and that it is once again the human eye which inspired him. Naturally the eye is also one of the Masonic symbols, but the reasoning and content of the Montjuic Tower are clearly multifaceted, just as its engineering creates a surprisingly dynamic shape. As the catalogue of the 1993 exhibition at MoMA explains, "Symbolically, the tower refers to the ritual events of the Olympic Games. Its singular form does not contradict the laws of statics, because the center of gravity at the base coincides with the resulting vertical of its dead load. The inclination of the stem coincides with the angle of the summer solstice in Barcelona and acts as a sundial as the sun travels across the circular platform at the base of the stairs. These characteristics heighten the existence of the two major avenues in Barcelona, La Meridiana and El Paralelo, denoting the avant-garde vocation of this city and referring to the technical advances of the period."[26]

More recently, Calatrava has designed three very different towers, the Turning Torso (Malmö, Sweden, 1999–2004), based on his drawings of a male torso; the 80 South Street Tower in New York, made of 12 cantilevered, glazed cubes inspired by a series of sculptures he made up to 20 years earlier; and, most surprisingly, the Chicago Spire (Chicago, 2005), a 150-story, 610-meter tower that will become the tallest building in the United States. In each instance, the architect shows that he in no way feels that towers are outdated as symbols, or as functional, efficient forms of design. Both the Turning Torso and the 80 South Street Tower embody his idea of using the science of statics to evoke the actual movement inherent in the concept of mass. Based on mathematical calculations these works escape the realm of dry science to evoke the body or the uplifting sentiment that only a great building can inspire.

The New York Times evoked Brancusi in describing Calatrava's sculptures, in itself not a disparaging comparison, and yet it may be true that the architect-engineer seems to call on examples from the early part of the 20th century more readily than recent thought and art. Calatrava quotes Einstein, who famously said, "God does not play dice with the Universe." But at the time, the master of modern physics was reacting to the advances of Quantum Theory, and in particular Werner Heisenberg's *Uncertainty Principle*, which stated, with reference to subatomic particles, that, "The more precisely the position is determined, the less precisely the momentum is known in this instant, and vice versa." Where many artists and architects since then (1927) have embodied the reasoning of uncertain times in their work, why is it that Calatrava seems so firmly anchored in another era—one where Platonic solids might have ruled rather than the complexity described by the theories of Benoît Mandelbrot for example. "In the 1980s," says Calatrava, "there was indeed experimentation in architecture that had to do with the Chaos Theory

and the sort of mathematics used to predict the movement of a stock exchange or the weather. But there is a programmatic element in Einstein's famous sentence that I would like to underline. Order exists, and I am tempted to say that we have already gone beyond the Chaos Theory and begun to think of the order of design. Personally, I have never wanted to render anything explicit in architecture other than order. I have indeed always referred to pure geometry and to controlled movement. The only place chance may enter into my work is when I make a sketch. Where current architecture is concerned, I note that those who choose models based on uncertainty, in the form of disorder or deconstruction if you will, must refer strongly to engineering when they seek to give some maturity to their work. People like Daniel Libeskind proudly refer to their past experience with mathematics, and it is obvious that the science of engineers is essential to their architecture. I might be so bold as to say that I have always played the game from the center. Even the roof of the Bodegas Ysios (Laguardia, Álava, Spain, 1998–2001) is based on a sinusoid curve. In my sculpture I have obviously used simple forms, and 20 years later, a sculpture, allied with the idea of the human body was the basis for the Turning Torso."[27]

A COLLECTION OF PEARLS

As Santiago Calatrava enters the mature phase of his career, his recent works testify that he has no intention of becoming duller as time goes by. The ongoing work in his native city of Valencia has recently seen the inauguration of a final phase of the cultural complex he started in 1991, the Opera House (1996–2006). The Tenerife Auditorium (Santa Cruz de Tenerife, Canary Islands, Spain, 1991–2003) similarly confirms the boldness of his designs and brings forth the recurring theme of the eye, the instrument of his passion. Working against the clock and on an enormous scale, Santiago Calatrava also completed the Athens Olympic Sports Complex (OAKA, Athens, Greece, 2001–04) including no less than 199 000 square meters of plazas; 94 000 square meters of pathways; 61 000 square meters of green areas; 29 000 square meters of water elements; 130 000 square meters of service facilities; and 178 000 square meters of parking lots and roads. It is easy to see where Calatrava has been, but not as obvious to tell where he will go in the future. This very point may well be a key to understanding his thought. "Imagine that you don't know where you are going," he says. "The baggage you bring with you is what you carry inside. For me this is almost a situation of paranoia, or of schizophrenia. I have a sense of forms born of 14 years of university studies—I have encountered mathematics and I love them. When I look at the work of Picasso, Cézanne or Matisse, all of which moves me, I must notice that they never engaged in the abstraction, except in limited details of their works. They worked to create an emotion and I am also born of their universe. I have long been inspired by a simple phrase of Michelangelo, '*l'architettura dipende dalle membra dell'uomo.*' To use the human body as a means of expression is and will remain important."

No matter how significant mathematics and the science of engineering are in the work of Santiago Calatrava, it is art and emotion that drive him to create works that far surpass the mundane calculation of forces. "Life is like a collection of pearls," says Calatrava. "You find one here and another there on your road. What is the sense of function in architecture? It is love, the love that one gives others, the generosity of the architect. There is a great secret in architecture and that is its philanthropic nature, and that philanthropy can be understood in the terms of function. A building functions well out of love for men. The secret of philanthropy in architecture is in its function. Beauty is given through intelligence or intuition. In architecture it is necessary to draw every detail. Each act, except the emotion that sets you on your way, is an act of intelligence. Architecture is what makes beautiful ruins; it is the most abstract of all the arts."[28]

1 Interview with Santiago Calatrava, Zurich, February 22, 2006.

2 Nicolai Ouroussoff, "Buildings Shown as Art and Art as Buildings," *The New York Times*, October 25, 2005.

3 Interview with Santiago Calatrava, Zurich, February 22, 2006.

4 *Julio González, Dessiner dans l'espace,* Skira, Kunstmuseum Bern, 1997. "L'architecture et la sculpture sont deux fleuves dans lesquels coule une même eau. Imaginons que la sculpture est plastique pure et que l'architecture est plastique soumise à la fonction et avec une évidente notion de l'échelle humaine (à travers la fonctionnalité). Tandis que la sculpture ignore le cadre de la fonctionnalité –, – elle est étrangère à la servitude dérivée des questions d'utilisation et donc elle est, pour ainsi dire, supérieure à l'architecture en tant qu'expression purement plastique. L'architecture au contraire soumet son expression plastique et à ces exigences. Par contre, celle-ci, de par son rapport à l'échelle humaine, à l'échelle de l'environnement de par don intériorité et sa pénétrabilité, elle l'emporte dans ces domaines spécifiques sur la sculpture."

5 Auguste Rodin, *Les Cathédrales de France*, Armand Colin, Paris, 1914. "L'harmonie, dans les corps vivants, resulte du contre-balancement des masses qui se déplacent: la Cathédrale est construite à l'exemple des corps vivants."

6 Le Corbusier, *Vers une architecture*, 1923. "L'architecture est le jeu savant, correct et magnifique des volumes assemblés sous la lumière. Nos yeux sont faits pour voir les formes sous la lumière; les ombres et les clairs révèlent les formes; les cubes, les cônes, les sphères, les cylindres ou les pyramides sont les grandes formes primaires que la lumière révèle bien; l'image nous en est nette et tangible, sans ambiguïté. C'est pour cela que ce sont de belles formes, les plus belles formes. Tout le monde est d'accord en cela, l'enfant, le sauvage et le métaphysicien. C'est la condition même des arts plastiques."

7 Auguste Rodin, *Les Cathédrales* op cit. "Il n'atteint à la grande expression qu'en donnant toute son etude aux jeux harmoniques de la lumière et de l'ombre, exactement comme fait l'architecte."

8 Sigfried Giedion, *Space, Time and Architecture*, Harvard University Press, Cambridge, Massachusetts, 5th edition, 1976.

9 Matilda McQuaid, *Santiago Calatrava, Structure and Expression*, The Museum of Modern Art, New York, 1993.

10 Ibid.

11 Interview with Santiago Calatrava, Zurich, June 1997.

12 Ibid.

13 Pier Luigi Nervi, *Aesthetics and Technology in Building, The Charles Eliot Norton Lectures, 1961–1962,* Harvard University Press, Cambridge, Massachusetts, 1965.

14 Interview with Santiago Calatrava, Zurich, June 1997.

15 Ibid.

16 Ibid.

17 Ibid.

18 Interview with Santiago Calatrava, Paris, September 1998.

19 Ibid.

20 Interview with Santiago Calatrava, Zurich, June 1997.

21 Interview with Santiago Calatrava, Zurich, February 22, 2006.

22 Interview with Santiago Calatrava, Zurich, June 1997.

23 Dennis Sharp (ed.), *Santiago Calatrava*, Architectural Monographs, no. 46, Academy Editions, London, 1996.

24 Interview with Santiago Calatrava, Zurich, June 1997.

25 Sergio Polano, *Santiago Calatrava, Complete Works*, Gingko, Electa, Milan, 1996.

26 "Santiago Calatrava, Structure and Expression," MoMA, New York, March–May 1993.

27 Interview with Santiago Calatrava, Zurich, February 22, 2006.

28 Ibid.

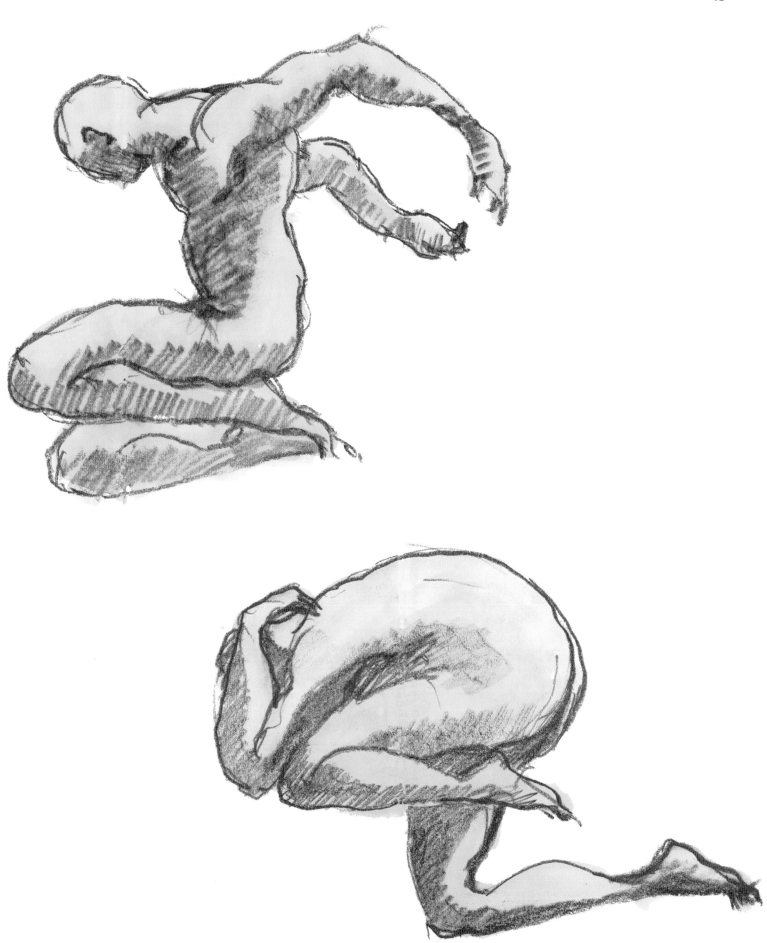

DAS GEHEIMNIS
DER PHILANTHROPIE

„Anfangs wollte ich eine Kunstakademie besuchen", erinnert sich Santiago Calatrava. „Dann ging ich eines Tages los, um etwas in einem Schreibwarenladen in Valencia zu kaufen und sah ein kleines Buch mit wunderbaren Farben. Es hatte gelbe und orangefarbene Ellipsen auf blauem Untergrund, und ich kaufte es auf der Stelle. Es handelte von Le Corbusier, dessen Werk für mich eine Offenbarung war. Ich sah Bilder von den Treppenhäusern aus Beton in der Unité d'Habitation, und ich dachte bei mir, was für ein außerordentliches Formgefühl! Das Buch sollte die künstlerischen Aspekte im Werk des Architekten veranschaulichen. Die Folge dieses Kaufs war, dass ich an die Architekturfakultät wechselte."[1]

Calatrava wurde 1951 in der Nähe von Valencia geboren und besuchte dort die Grund- und Oberschule. Ab 1959 war er außerdem an der Escola d'Art i superior de disseny de Valencia eingeschrieben, wo er mit methodischem Unterricht in Zeichnen und Malen begann. Als er 13 Jahre alt war, schickte seine Familie ihn als Austauschschüler nach Frankreich, da die spanischen Grenzen kurz zuvor von Franco geöffnet worden waren. Nach Abschluss der Oberschule in Valencia ging er nach Paris, um dort die École des Beaux-Arts zu besuchen, geriet jedoch 1968 mitten in die Studentenunruhen jener Zeit. Er kehrte nach Valencia zurück und schrieb sich unter dem Eindruck eines kleinen, farbenprächtigen Büchleins an der Escuela Técnica Superior de Arquitectura ein. Nach Abschluss des Architekturstudiums belegte er weiterführende Kurse in Städtebau.

Angezogen von der mathematischen Strenge, die er in bestimmten Werken historischer Architektur erkannte, und mit dem Gefühl, dass die Ausbildung in Valencia ihm keine klare Richtung vorgegeben hatte, entschied er sich für weiterführende Studien im Fach Bautechnik und schrieb sich 1975 an der ETH (Eidgenössische Technische Hochschule) in Zürich ein. 1981 wurde er dort promoviert. Diese Entscheidung sollte sein Leben in vieler Hinsicht verändern. So lernte er während dieser Züricher Zeit die Jurastudentin Robertina Marangoni kennen und heiratete sie. Auch in beruflicher Hinsicht sind die Schlüssel zu Calatravas gegenwärtigem Tun in Zürich zu finden. Laut eigener Einschätzung verspürte er „das starke Bedürfnis, wieder ganz von vorne anzufangen. Ich war entschlossen, alles, womit ich in der Ausbildung gearbeitet hatte, zur Seite zu legen und zu lernen, wie ein Ingenieur zu zeichnen und auch wie einer zu denken. Ich war fasziniert von der Vorstellung der Schwerkraft und spürte deutlich, dass es notwendig war, mit einfachen Formen zu arbeiten. Ich kann sagen, dass mein Hang zu technischer Einfachheit zum Teil auf mein Studium der Arbeit des Schweizer Ingenieurs Robert Maillart zurückzuführen ist. Mit einfachen Formen zeigte er, dass es möglich ist, starke Aussagen zu machen und gefühlsmäßige Reaktionen hervorzurufen. Mit der richtigen Kombination von Kraft und Masse lässt sich Emotion erzeugen."

INGENIEUR, ARCHITEKT, KÜNSTLER

Auch Calatravas frühes Interesse an Kunst und sein ästhetisches Gespür, das ihn das Büchlein über Corbusier erstehen ließ, sollten Konstanten in seinem Werk bleiben und ihn darüber hinaus in der Welt der zeitgenössischen Architektur zu einer herausgehobenen Erscheinung machen. In Bezug auf eine Ausstellung über seine Kunst und Architektur, die 2005 im Metropolitan Museum of Art in New York stattfand, sagte Calatrava: „Ich glaube, der zuständige Kurator Gary Tinterow verstand meine Art zu arbeiten, weil er der Schau den Titel ‚Sculpture into Architecture' gab und nicht umgekehrt. Architekturkritiker reagieren auf meine Arbeiten nach wie vor eher mit Verwirrung." Und in der Tat registrierte Nicolai Ourousoff in der New York Times zwar, dass man im Metropolitan zuletzt 1973 das Werk eines lebenden Architekten ausgestellt hatte, fuhr dann aber fort: „Niemand würde behaupten, Calatravas Skulpturen gehörten an und für sich betrachtet in das Met; in künstlerischer Hinsicht sind sie überwiegend vom Werk toter Meister wie

Brancusi inspiriert", um alsbald mit der recht harschen Ansicht zu schließen: „Er hätte die Skulpturen besser in seinem Atelier gelassen."[2] Diese Bemerkung scheint vor allem einen Mangel an Verständnis für Calatravas bildhauerisches Werk zu offenbaren. „Bei den Skulpturen", sagte er, „verwende ich Kugeln und Kuben, einfache Formen, die häufig mit meinen Kenntnissen als Ingenieur zu tun haben. Es war die Bildhauerei, die mich zum ‚Drehenden Torso' (Wohnhochhaus in Malmö, 1999–2004) anregte. Ich muss gestehen, dass ich die Freiheit eines Frank Gehry oder eines Frank Stella als Bildhauer sehr bewundere. Stellas Werke sind von solcher Freude und Freiheit erfüllt, die in meinen Skulpturen, die stets auf den festen Regeln der Mathematik fußen, nicht präsent sind."[3] Calatrava ließ keinen Zweifel daran, dass ihm der Galerienzirkus stets zuwider war und er folglich seine Skulpturen nahezu nie ausstellte. Auch betonte er die Tatsache, dass „die Reaktionen, die ich von Künstlern erhalte, sehr positiv sind. Kunst ist viel freier als Architektur, weil, wie Picasso sagte, einige Künstler mit Marmor und andere mit Scheiße arbeiten." Dies soll jedoch keineswegs heißen, dass sich Calatrava über die Schwierigkeit seiner Aufgabe irgendwelche Illusionen macht. 1997 schrieb er: „Architektur und Skulptur sind zwei Flüsse, in denen dasselbe Wasser fließt. Man kann sich Skulptur als ungehinderte Plastizität vorstellen, während Architektur Plastizität ist, die sich einer Funktion und der offenkundigen Vorstellung menschlicher Maßstäblichkeit (durch Funktion) unterwerfen muss. Wo die Skulptur Funktion außer Acht lässt, ungebrochen ist von profanen Fragen der Verwendung, ist sie als reiner Ausdruck der Architektur überlegen. Durch ihre enge Beziehung zum menschlichen Maß und zur Umgebung sowie durch den Umstand, dass man in sie eindringen und sie betreten kann, herrscht die Architektur in diesen spezifischen Bereichen allerdings über die Skulptur."[4]

Calatrava schlug sogar vor, die Kunst als Ideenpool für Architektur zu betrachten. „Weshalb fertige ich Zeichnungen von der menschlichen Figur an? Künstler und Architekt können ihre Botschaft unabhängig von der Zeit durch die schiere Macht von Form und Schatten senden. Rodin schrieb: ‚Harmonie bei lebenden Körpern ist das Ergebnis des Ausgleichs sich bewegender Massen. Die Kathedrale wurde nach dem Beispiel des lebenden Körpers erbaut.'[5] Ich möchte ein Beispiel anführen für die Bedeutung der Kunst für die Architektur des 20. Jahrhunderts. Als Le Corbusier 1923 schrieb: ‚Architektur ist das kunstvolle, korrekte und großartige Spiel der unter dem Licht versammelten Baukörper'[6], wie vielen war da bewusst, dass er Anleihen bei dem Bildhauer Auguste Rodin machte? 1914 schrieb Rodin in seinem Buch Les cathédrales de France: ‚Der Bildhauer erreicht nur dann großen Ausdruck, wenn er seine ganze Aufmerksamkeit dem harmonischen Zusammenspiel von Licht und Schatten widmet, so wie es der Architekt tut.'[7] Die Tatsache, dass einer der berühmtesten Sätze der modernen Architektur nicht von einem Architekten, sondern von einem Bildhauer inspiriert wurde, unterstreicht die Bedeutung von Kunst."

Neben seinem anhaltenden Interesse für Kunst fügte Calatrava seiner sehr persönlichen Definition von Architektur eine weitere verwandte Leidenschaft hinzu: Bewegung, und zwar in implizierter wie realer Ausprägung, das heißt, als naturgesetzliche Bewegung. Von den frühen Falttüren des Lagerhauses der Firma Ernsting's (Coesfeld-Lette, 1983–85) bis zu dem neueren, 115 t schweren Sonnensegel des Kunstmuseums in Milwaukee (1994–2001) kommt er mit seinen Skulpturen und seiner Architektur immer wieder auf das ungewöhnliche Element der sich wiederholenden, realen Bewegung zurück. Weshalb? „In der Kunst des 20. Jahrhunderts spielt Kinetik eine Rolle", erwiderte Calatrava. „Künstler wie Alexander Calder, Naum Gabo oder Moholy-Nagy schufen Skulpturen, die sich bewegen. Ich liebe ihre Arbeit und sie berührt mich emotional sehr stark. Meine Doktorarbeit ‚Über die Faltbarkeit von Tragwerken' beschäftigte sich mit der Tatsache, dass man eine dreidimensionale, geometrische Figur auf zwei und schließlich auf eine Dimension reduzieren kann. Nehmen Sie ein Polyeder und klappen sie es flächig zusammen. Eine weitere Wandlung reduziert es auf eine Linie und damit auf eine

Dimension. Sie können das als eine mathematische oder topologische Frage betrachten. Sämtliche Mysterien der allgegenwärtigen platonischen Körper sind im Polyeder versammelt. Nachdem ich über diese Fragen nachgedacht hatte, sah ich antike Skulpturen in einem anderen Licht. Werke wie der Diskobol des Myron erzeugen eine Spannung, die von einer Augenblicksbewegung abhängt. So begann ich, mich für das Problem der Zeit zu interessieren, Zeit als Variable. Einstein sagte: ‚Gott würfelt nicht mit dem Universum‘, und so wurde mir klar, dass alles mit Mathematik und der einzigartigen Dimension der Zeit zu tun hat. Dann dachte ich über Statik nach (den Zweig der Physik, der sich mit physikalischen Systemen in statischem Gleichgewicht beschäftigt) und erkannte, dass daran nichts statisch ist. Alles ist potenzielle Bewegung. Im zweiten Newton'schen Axiom heißt es, dass die Beschleunigung eines Objekts von zwei Variablen abhängt – die auf das Objekt einwirkende reine Kraft und die Masse des Objekts. Masse und Beschleunigung stehen in Verbindung und somit gibt es Zeit in der Kraft. Ich begriff, dass Architektur voller beweglicher Dinge ist, von den Türen bis zum Mobiliar. Architektur selbst bewegt sich auch und wird mit etwas Glück zu einer schönen Ruine. Alles verändert sich, alles stirbt, und zyklische Bewegungen bergen eine existenzielle Bedeutung. Ich wollte eine eigene Tür schaffen, eine die poetische Bedeutung haben sollte und sich in eine Figur im Raum verwandeln konnte, und so entstand das Ernsting-Projekt.“

DAS WESEN DER ARCHITEKTUR

Die Tatsache, dass es manchen Menschen angesichts der von Calatrava gewählten vielfältigen Ausdrucksformen unbehaglich wird, ist vermutlich der beste Indikator dafür, dass er etwas Bedeutsames erkannt hat. Derzeit führt er mit seinem Verkehrsknotenpunkt am World Trade Center, inmitten der von New Yorkern als „Ground Zero“ bezeichneten Trostlosigkeit, eines der komplexesten und politisch denkbar heikelsten Projekte weiter. „Wir halten ihn für den da Vinci unserer Tage“, sagte Joseph Seymour, der frühere leitende Direktor der Port Authority von New York und New Jersey, in deren Auftrag dieser Bahnhof entsteht. „Er vereint Licht und Luft und konstruktive Eleganz mit Stärke.“ Selbst in der geschlossenen Welt der Architektur ist solches Lob nicht selten. 2005 war Santiago Calatrava nach Josep Lluís Sert im Jahr 1981 der zweite Spanier, der mit der renommierten Goldmedaille des American Institute of Architects (AIA) ausgezeichnet wurde. Das Committee on Design des AIA erklärte: „Santiago Calatravas Schaffen spürt das Wesen der Architektur auf. Seine Architektur erweitert den Horizont und bringt die Energie des menschlichen Geistes zum Ausdruck, sie bezaubert die Fantasie und erfreut uns mit den Wundern, die plastische Form und dynamische Konstruktion hervorbringen können. Santiago Calatrava verkörpert den Anlass für diese Goldmedaille. Seine Vision erhebt den menschlichen Geist, indem er Umgebungen schafft, in denen wir leben, spielen und arbeiten.“

Das Nebeneinander von Kunst, Architektur und Technik in seinem eigenen Denken scheint Santiago Calatrava nicht zu verwirren. Und er befindet sich mit diesen Interessen eng beim Kernpunkt einer der leidenschaftlichsten Debatten in der jüngeren Geschichte von Konstruktion und Design. Sigfried Giedion schrieb in seinem zukunftsweisenden Buch *Raum, Zeit und Architektur*: „Das Eindringen des Ingenieurkonstrukteurs bedeutete zugleich das Eindringen rascherer, industrieller Gestaltungsmittel, die erst die Möglichkeit gaben, Grundlagen für das heutige Leben zu schaffen. Unbewusst übernahm der Konstrukteur im 19. Jahrhundert eine Wächterrolle. Durch die neuen Mittel, die er immer wieder dem Architekten in die Hand drückte, zwang er diesen, sich nicht völlig im luftleeren Raum zu verlieren. Der Konstrukteur drängte zu einer Gestaltung, die zugleich anonym und kollektiv war.“ Giedion verfolgte die Debatte über die Rolle des Ingenieurs zurück, indem er

eine Reihe wichtiger Daten und Ereignisse anführte, darunter „1877: Die Akademie stellt eine Preisfrage über ‚L'union ou la separation des ingénieurs et des architectes'. Davioud, der Architekt des Trocadéro, erhält den Preis für die Antwort: ‚Die Union zwischen Architekt und Ingenieur muss untrennbar sein. Die Lösung wird erst dann wirklich, vollständig und fruchtbar sein, wenn Architekt und Ingenieur, Künstler und Wissenschaftler in einer Person vereint sind ... Wir leben seit langem in der einfältigen Überzeugung, dass die Kunst eine Wesenheit sei, die sich von allen anderen Formen der menschlichen Intelligenz unterscheide, durchaus unabhängig habe sie ihre Quellen und ihre einzige Geburtsstätte in der kapriziösen Fantasie der Künstlerpersönlichkeit.'“[8] Da weder Giedions Beharren auf der „Anonymität“ der Arbeit des Ingenieurs noch Daviouds Verweis auf die „kapriziöse Fantasie“ der Künstler zu Calatravas machtvoller Originalität zu passen scheinen, erfüllt er wohl die Forderung Daviouds nach dem Einklang zwischen Kunst, Technik und Architektur. In diesem Zusammenhang kommt einem auch Joseph Seymours Bemerkung von Calatrava als dem „da Vinci unserer Tage“ in den Sinn.

Der Katalog von Santiago Calatravas Ausstellung im Museum of Modern Art in New York von 1993 unterstreicht die enge Beziehung seiner Arbeit zu der anderer wegweisender Ingenieure: „Calatrava ist Teil des ruhmreichen Vermächtnisses der Ingenieure des 20. Jahrhunderts. Wie die Vertreter vorhergehender Generationen – Robert Maillart, Pier Luigi Nervi, Eduardo Torroja und Felix Candela – sucht Calatrava mit seiner Arbeitsweise mehr als nur die Lösung technischer Probleme. Konstruktion bedeutete für diese Ingenieure das Abwägen zwischen dem wissenschaftlichen Kriterium der Effizienz und der Einführung neuer Formen. Calatrava betrachtet die Arbeit von Ingenieuren als ‚die Kunst des Möglichen‘ und sucht nach einer neuen Formensprache, die auf technischem Wissen basiert und doch keine Hymne an die Technik ist.“[9] Der zuerst genannte Robert Maillart (1872–1940) schloss 1894 sein Studium an der ETH in Zürich ab und schuf in der Folgezeit einige der spektakulärsten modernen Brücken, darüber hinaus verwendete er Beton auf innovative Weise. Bei seinem Lagerhaus Giesshübel in Zürich (1910) machte er zum ersten Mal Gebrauch von einer „Pilzdecke“ aus Betonplatten, die es ihm ermöglichte, ohne Balken auszukommen. Matilda McQuaid führte aus: „Maillart war einer der ersten Ingenieure dieses Jahrhunderts, der vollständig vom Mauerwerkbau abkam und für das Bauen mit armiertem Beton eine technisch geeignete, elegante Lösung anwendete. Obgleich bei Calatravas Arbeit die technische Idee weder wie bei Maillart die primäre Motivation, noch völlig untergeordnet ist, bestimmt sie den Gesamteindruck des Bauwerks. Sein Werk wird zu einer Verflechtung plastischen Ausdrucks und konstruktiver Offenbarung und zeigt Ergebnisse, die man am ehesten als Synthese von Ästhetik und konstruktiver Physik beschreiben kann.“[10]

Auch wenn Calatrava die Bauten Maillarts bewundert, stellt er doch schnell klar, dass sich seine Brücken stark von denen seines Vorgängers unterscheiden, und sei es nur aufgrund ihrer Standorte. „Maillarts Brücken“, sagte Calatrava, „stehen oft in herrlicher Berglandschaft. Seine Leistung bestand darin, ein künstliches Element in solch großartige Standorte einzupassen, ohne sie zu stören ... Heutzutage halte ich die erneute Beschäftigung mit der Peripherie von Städten für eine der wichtigsten Aufgaben. Die meisten öffentlichen Bauten in solchen Bereichen sind rein funktional, aber selbst in der Nähe von Eisenbahngleisen oder über verschmutzten Flüssen können Brücken eine bemerkenswert positive Wirkung haben. Indem sie ein passendes Umfeld schaffen, können sie eine symbolische Wirkung entwickeln, deren indirekte Folgen weit über ihren unmittelbaren Standort hinausreichen.“[11]

Calatravas Arbeit wurde zweifellos von der Felix Candelas beeinflusst. Der 1910 in Madrid gebürtige Candela emigrierte 1939 nach Mexiko, wo er eine Reihe bemerkenswerter dünnschaliger Betonbauten schuf, wie die Iglesia de la Virgen Milagrosa (Navarte, Mexiko, 1955), deren Formgebung zur Gänze auf hyperbolischen Paraboloiden basiert. Ein weiterer Spanier, der Madrider Ingenieur

„IN WIRKLICHKEIT HABE ICH ETWAS VERSUCHT, DAS ICH ALS DIALEKTISCHE TRANSGRESSION BEZEICHNEN WÜRDE, DIE AUF DER FORMENSPRACHE KONSTRUKTIVER KRÄFTE BASIERT."

Eduardo Torroja (1899–1961), war fasziniert von der Verwendung organischer oder vegetabiler Formen, deren skulpturale Präsenz sehr wohl vom Vorbild Gaudís herrühren mag. Calatrava bezieht viele seiner Anregungen von spanischen, genauer gesagt von katalanischen Architekten oder Künstlern. „Was mich beispielsweise an der Person Goyas fasziniert", sagte Calatrava, „ist die Tatsache, dass er, wie Rembrandt vor ihm, zu den ersten Künstlern gehört, die sich von der Vorstellung lossagen, irgendeinem Meister zu dienen. An Mirós Werk bewundere ich dessen außerordentliche Stille, ebenso wie seine radikale Absage an jegliche Konvention." Obgleich Gaudí, ähnlich wie Maillart, für ihn ein Vorbild war, scheint Calatrava lieber über den Bildhauer Julio González zu reden. „Vater und Großvater von González waren als Schmiede für Gaudí an Projekten wie dem Parque Güell tätig. Dann gingen sie nach Paris, und hier findet sich die Quelle für Julio González' Arbeit mit Metall. Bei aller gebotenen Bescheidenheit", schließt Calatrava, „könnte man sagen, dass unsere Arbeit die natürliche Fortführung des Wirkens von Gaudí und González darstellt, die Arbeit von Kunsthandwerkern auf dem Weg zur abstrakten Kunst."[12]

Die Art von Kunst, die Calatrava meint, sieht man in seinen gelungensten Brücken und Gebäuden, und doch ist sie schwer in Worte zu fassen. Ein anderer wegweisender Ingenieur des 20. Jahrhunderts, der Italiener Pier Luigi Nervi, versuchte eine solche Definition in einer Reihe von Vorlesungen, die er 1961 in Harvard hielt: „Es ist äußerst schwierig zu erklären, warum wir bestimmte Formen unmittelbar akzeptieren, die aus einer physischen Welt zu uns kommen, zu der wir scheinbar keinerlei direkte Verbindungen unterhalten. Weshalb befriedigen und bewegen uns diese Formen in der gleichen Weise wie natürliche Dinge wie Blumen, Pflanzen und Landschaften, an die wir uns seit zahllosen Generationen gewöhnt haben? Außerdem kann man festhalten, dass diesen Errungenschaften ein konstruktiver Kern gemein ist, ein notwendiges Fehlen jeglicher Verzierung, eine Reinheit von Linienführung und Form, völlig ausreichend zur Beschreibung eines authentischen Stils, den ich den *wahren Stil* nenne. Ich bin mir darüber im Klaren, wie schwierig es ist, die richtigen Worte zur Erklärung dieser Gedanken zu finden. Wenn ich Freunden gegenüber diese Bemerkungen mache, höre ich häufig, diese Auffassung von der nahen Zukunft sei schrecklich traurig, und es wäre vielleicht besser, freiwillig auf das weitere Festigen der Bande zwischen unseren Werken und den physikalischen Gesetzen zu verzichten, falls uns diese Bande zu einer tödlichen Monotonie führen müssen. Ich finde diesen Pessimismus nicht angebracht. Wie bindend technische Anforderungen auch sein mögen, es bleibt immer genügend Freiraum, um die Persönlichkeit des jeweiligen Urhebers erkennen zu lassen, und wenn es sich um einen Künstler handelt, zu gewährleisten, dass seine Schöpfung, ungeachtet ihrer strikten technischen Verpflichtung, zu einem wahrhaften Kunstwerk wird."[13]

ENTLANG DER STÄHLERNEN GLEISE

Calatravas langer Aufenthalt in Zürich hat eine Reihe von Gründen. Nach Abschluss seines eigenen Studiums blieb er zunächst dort, weil seine Frau Robertina das ihre noch nicht beendet hatte. Wie es der Zufall wollte, gewann er 1982 einen offenen Wettbewerb für den neuen Bahnhof Stadelhofen (1982–90). Behauptet man, dieses ungewöhnliche Gebäude befände sich in zentraler Lage, kommt dies fast einer Untertreibung gleich.

Hineingebaut in einen begrünten Hang nahe dem Bellevueplatz an der Theaterstrasse, unweit des Zürichsees, ist es in ein größtenteils traditionelles Stadtgefüge integriert. „Um den Bahnhof Stadelhofen zu verstehen", sagte Calatrava, „muss man ihn als urbanes Projekt ansehen, eines, bei dem es um die Reparatur des urbanen Gefüges ging. Es besteht ein eindeutiger Gegensatz zwischen der radikalen Natur der gewählten technischen und architektonischen Lösungen

und der äußerst freundlichen Haltung zur Stadt hin. Es wurden unzählige Verbindungen geschaffen – nicht nur Brücken und Zugänge, sondern auch Verbindungen zu umliegenden Straßen, die es vorher nicht gab. Es entstanden kleine Parks, wie die Grünanlage auf der oberen Ebene." Ehe der Besucher, der sich dem Bahnhof von der Stadt her nähert, die von Calatrava konzipierten Bereiche betritt bzw. zu ihnen hinuntergeht, trifft er zuvor auf einen sehr traditionellen Pavillon, in dem der Bahnhof früher untergebracht war. „Es war von Anfang an klar", so der Architekt, „dass der Respekt, den in der Schweiz Bauten genießen, die 100 Jahre oder älter sind, jeden Versuch ausschloss, das alte Bahnhofsgebäude abzureißen oder wesentlich zu verändern. Ich fand diesen Standpunkt allerdings nicht unlogisch, weil er zu einer intakten Stadt passt."[14] Hat der Reisende allerdings dann den alten Pavillon durchschritten, betritt er eine ganz andere Welt, die anscheinend eher mit der Fantasie Gaudís zu tun hat als mit dem Phlegma Zürischer Bürger. Während Calatrava darauf verweist, dass Zürich mit Häusern von Leuten wie Marcel Breuer eine gewisse Tradition radikaler Architektur aufweist, ist es offensichtlich, dass er mit dem Bahnhof Stadelhofen zum ersten Mal in seiner Laufbahn in großem Maßstab die Art innovativer Gestaltung ausführte, die ihn berühmt gemacht hat.

Auf dem geschwungenen, 40 x 240 m großen Gelände musste bei laufendem Betrieb der Pendlerzüge gebaut werden; außerdem war eine großflächige, unterirdische Einkaufszone hinzugekommen. Das Ganze zeichnet sich durch eine organische Einheit aus, die wegen der Begleitumstände nicht hätte einfacher sein können. Wie ein fantastischer Flugsaurier, der sich an diesem Abhang niedergelassen hat, wird der Bau durch ein Muster sich wiederholender Elemente gegliedert; riesige zoomorphe Tore führen zu der unterirdischen Einkaufszone, in der man schnell den Eindruck gewinnt, sich im steinernen Bauch der Bestie zu befinden. Es besteht eine Kontinuität zwischen dem oberirdischen dunklen Metall und dem rippengleichen Beton unten, die eine klare Hierarchie von Räumen und Formen festlegt, während gleichzeitig die Lesbarkeit und funktionelle Klarheit des Bahnhofs größte Bedeutung haben.

Obwohl der Bahnhof Stadelhofen insgesamt den Eindruck erweckt, er sei um eine Art Dinosauriermetapher herum konzipiert, ist die Substanz von Calatravas Gestaltung komplexer oder andersartig. „In Wirklichkeit habe ich etwas versucht, das ich als dialektische Transgression bezeichnen würde, die auf der Formensprache konstruktiver Kräfte basiert. In Stadelhofen gibt es beispielsweise eine Reihe geneigter Pfeiler. Diese anscheinend ästhetische Entscheidung hat in Wahrheit mit der Notwendigkeit zu tun, den Bau zu stützen. Natürlich gab es verschiedene Lösungen für dieses Problem. Ich hätte zum Beispiel schlichte Zylinder wählen können, aber ich entschied mich, sie in Form einer Hand zu gestalten. Hier wird die Frage der Metaphern interessant. Wie lässt sich die Funktion von Pfeilern besser zum Ausdruck bringen, als sie mit der Empfindung der physischen Geste des Tragens auszustatten?"[15]

Obgleich Calatravas Name häufig im Zusammenhang mit Brücken genannt wird, ist er auch ein anerkannter Spezialist für Bahnhöfe, wie der Bahnhof Oriente in Lissabon oder der neue Komplex in Liège-Guillemins belegen. Einer der Bauten, die am meisten zu seinem Renommee beitrugen, war allerdings der TGV-Bahnhof in Lyon-Saint Exupéry (1989–94). Dieser 5600 m² große Bahnhof am Flughafen Satolas gehört zu einer neuen Generation von Bahnhöfen, die eigens für das wachsende Netz von Hochgeschwindigkeitszügen (TGV) in Frankreich errichtet wurden. Das Nebeneinander von Bahn-, Luft- und Lokalverkehr am selben Ort gewährleistet ein besonders leistungsfähiges System. Das 120 m lange, 100 m breite und 40 m hohe Passagierterminal, das am 7. Juli 1994 eröffnet wurde, hat ein 1300 t schweres Dach aus Stahl. Mit seiner Anmutung eines fliegenden Vogels scheint Calatravas Bahnhof auf Eero Saarinens TWA-Terminal am Kennedy-Airport (1957–62) zurückzugreifen, aber er ist extravaganter als sein amerikanischer Vorfahr. Der Grundriss der Anlage erinnert dank seiner Verbindung zum Flughafen auch an einen Mantarochen. Unter dem Hauptgebäude verkehren insgesamt sechs Bahnlinien

und halten an einem ebenfalls von Calatrava entworfenen 500 m langen, überdachten Bahnsteig an. Die mittleren Gleise, die Zügen mit einer Geschwindigkeit von über 300 km/h vorbehalten sind, sind in einem Betongehäuse eingeschlossen. Bei dessen Errichtung galt es, die den TGV umgebenden Druckwellen sorgfältig zu berechnen. Die Gesamtkosten dieser Einrichtung, die von der französischen Bahn (SNCF), der Region Rhône-Alpes und dem Département Rhône gemeinsam aufgebracht wurden, betrugen umgerechnet mehr als 91,5 Millionen Euro.

Wenn man ihn nach dem Bild des prähistorischen Vogels fragt, antwortet Calatrava in gewohnt indirekter, gleichwohl informativer Art: „Ich bin bloß ein Architekt, kein Künstler oder einer, der eine Revolution anfachen will. Interessanterweise hat Victor Hugo in seinem Roman *Notre-Dame de Paris* die Kathedrale mit einem urzeitlichen Monster verglichen. Obwohl er über gute Kenntnisse von Architektur verfügt haben mag und ein äußerst gewissenhafter Autor war, zögerte er nicht, zur Beschreibung von Notre-Dame eine derart unvermutete Metapher zu verwenden. Ich bin ehrlich gesagt nicht auf der Suche nach Metaphern. Ich hatte nie einen Vogel im Sinn, sondern eher die Vorstudien, die ich bisweilen etwas anmaßend als Skulpturen bezeichne.“[16] Tatsächlich rekurrieren die Zeichnungen und die Skulptur Calatravas, die sich am deutlichsten auf Satolas beziehen, anscheinend nicht auf die Vogel-Metapher, sondern auf eine Studie des Auges und des Augenlides, ein in seinem Werk immer wiederkehrendes Motiv. „Das Auge“, so Calatrava, „ist das wahre Werkzeug des Architekten, und das ist eine Vorstellung, die sich bis auf die Babylonier zurückverfolgen lässt.“

Die gebogene Vorderseite des Bahnhofs Saint Exupéry, die in die Erde hineinzustoßen scheint, wurde mit dem Schnabel eines Vogels verglichen, aber wiederum scheint Calatrava an etwas gänzlich anderes gedacht zu haben. „Der ‚Schnabel‘ entstand als Ergebnis komplizierter Berechnungen der auf den Bau einwirkenden Kräfte. Außerdem laufen hier sämtliche Wasserabflüsse zusammen. Natürlich habe ich mich bemüht, die Masse dieses Punktes so gering wie möglich zu halten, ohne allerdings an irgendwelche zoomorphen Bezüge zu denken“, erklärte Calatrava. „Nennen sie es irrational, aber ich würde sagen, dass es keinen Pfad gibt, dem ich folge. Ich möchte sein wie ein Schiff auf See. Es hinterlässt eine Spur, aber davor gibt es keinen Pfad.“[17]

BÄUME AUF DEM HÜGEL

Calatravas Arbeit an dem Aufsehen erregenden Bahnhof Oriente in Lissabon ist ein vielsagendes Exempel für seine Vorgehensweise und erklärt einen Gutteil seines derzeitigen Erfolgs. In der Folge des verheerenden Erdbebens von 1755 orientierte sich Lissabon stärker zum Land hin und kehrte, nahezu im Wortsinn, der Tejomündung mit ihren weiten Ausblicken den Rücken zu. Diese Tendenz verstärkte sich in der Zeit danach, weil sich auf Aufschüttungen am Flussufer Industrieanlagen ansiedelten. Das 340 ha umfassende Sanierungsgebiet, in dessen Zentrum das Gelände der Expo '98 und der Bahnhof Oriente liegen, hatte man bis in die 1990er-Jahre für Brennstofftanks, Containerlager, den städtischen Schlachthof sowie für Kläranlagen und Einrichtungen zur Abfallverwertung genutzt. Obgleich viel von Lissabons glorreicher Vergangenheit in seinen Straßen und Plätzen erkennbar bleibt, ging sein inniges Verhältnis zum Tejo, einstmals die Quelle unvorstellbaren Reichtums, in den Zeitläufen beinahe verloren.

Vor diesem Hintergrund führte der portugiesische Architektenbund 1988 einen Ideenwettbewerb zur Gestaltung der Uferzone durch. Der Bau des Kulturzentrums von Belém (1988–92) in Ufernähe war der erste wichtige Schritt hin zu Wiederbelebung der historischen Bindungen Lissabons an den Tejo. Eine noch bedeutsamere politische und kulturelle Entscheidung begann im November 1993 Gestalt anzunehmen, als die Parque Expo '98 SA den Architekten Luis Vassalo Rosa mit einer ersten „Planung zur Urbanisierung des Sanierungsgebiets“ betraute. Von

Anfang an beabsichtigten die Bauträger, hier etwas entstehen zu lassen, das über die typisch kurzlebige Architektur einer Weltausstellung hinausging. Das am Ostrand der Stadt gelegene Gebiet, das 5 km Flussufer des Tejo umfasst, befindet sich in der Nähe der Vasco-da-Gama-Brücke. Die am 29. März 1998 eröffnete, 45 m hohe, imposante Brücke überspannt den hier 12 km breiten Tejo. Die Fertigstellung der nach dem berühmten Entdecker benannten Brücke und die Vergabe der Expo '98 hätten nicht symbolträchtiger sein können: Lissabon und mit ihm ganz Portugal waren entschlossen, ihr historisches Erbe wieder geltend zu machen und sich erneut dem Tejo und darüber hinaus der Welt zu öffnen.

Nach einem geschlossenen Wettbewerb, an dem sich auch Terry Farrell, Nicholas Grimshaw, Rem Koolhaas und Ricardo Bofill beteiligten, erhielt Santiago Calatrava den Auftrag zum Bau des Bahnhofs Oriente. Neben Álvaro Sizas portugiesischem Pavillon ist dieser Bahnhof zweifellos der architektonisch bedeutsamste Bau der Expo '98. Mit seinen 200 000 Besuchern pro Tag stand er eindeutig im Zentrum der Planung zur Wiederbelebung der Uferzone im Osten der Stadt. Das eindrucksvollste Element des Projekts ist dabei sicherlich die 78 x 238 m große Überdachung der acht erhöhten Bahngleise, die an ein lichtes Gehölz denken lässt. Anstatt die vom Bahnhof vorgegebene Zäsur zwischen Stadt und Fluss zu betonen, war Calatrava hier wie andernorts bestrebt, Durchgänge zu öffnen und Verbindungen wieder herzustellen. Deshalb schnitt der Architekt in den erhöhten Erdwall, auf dem die Gleise verlaufen, ein, um den Bahnhof unter die Erde zu verlegen. Über den Eingängen befinden sich zwei großflächige Schutzdächer aus Stahl und Glas, von denen das eine in der Länge nicht weniger als 112 m und in der Breite 11 m misst. Es gibt einen Busbahnhof und einen Parkplatz, darunter eine nicht von Calatrava konzipierte U-Bahnstation sowie eine längs verlaufende Ladengalerie, die Bestandteil der Ausschreibung war. Die Fahrkarten- und Serviceschalter befinden sich 5 m unterhalb der Gleise, während unter der Galerie ein Atrium entstand, das die als Hauptzugang gedachte Öffnung zum Fluss hin markiert.

Aus der Entfernung oder auch von innen betrachtet ist der augenfälligste Aspekt des Bahnhofs Oriente die an Bäume erinnernde Gestaltung. Mindestens zwei weitere Projekte Calatravas machten mit ihrer konstruktiven Typologie Anleihen bei Bäumen oder Wäldchen; sein nicht realisierter Entwurf für die Kathedrale St. John the Divine in New York (1991) und das Projekt BCE Place, Galleria und Heritage Square in Toronto (1987–92). St. John the Divine, eine der bekanntesten Kirchen New Yorks, war 1892 von Heins & La Farge im Stil der Neoromanik erbaut und 1911 von Cram & Ferguson „gotisiert“ worden. Calatravas Entwurf zufolge wären ein neues, südliches Querschiff und ein „Bio-Shelter“ in 55 m Höhe ergänzt worden. Das offenkundig sinnbildlich mit dem Paradies verwandte „Bio-Shelter“ hätte von konstruktiven Elementen gestützt werden sollen, deren Gestaltung von Bäumen inspiriert war. Dieser im vorhandenen Dachgeschoss des Langhauses untergebrachte Garten hätte zwar den Umriss des Bauwerks nicht verändert, aber Tageslicht in die Kirche einfallen lassen. Philip Johnson, der der Jury angehörte, wies auf den Zusammenhang von Calatravas Entwurf mit dem Stil der Kirche hin, und in der Tat ruft das Bild des Baums die Ursprünge der Gotik in Erinnerung. Auch dem Projekt BCE Place, Galleria und Heritage Square liegt das Bild des Baums zugrunde. Hier arbeitete Calatrava mit dem New Yorker Büro von Skidmore, Owings & Merrill zusammen beim Bau eines sechsgeschossigen, 115 m langen Durchgangs aus weißlackiertem Stahl und Glas, der zwei Türme miteinander verbindet. Der Kommentar der *New York Times* dazu lautete: „Diese Galerie erinnert stark an Gaudí“. Sie erinnert außerdem an einen metaphorischen Waldweg. Der Gebrauch von weißgestrichenem Stahl und Glas nimmt darüber hinaus die baumartige Gestaltung der Bahnsteige im Bahnhof Oriente vorweg.

Ob nun in Toronto oder in New York, Santiago Calatrava griff aus verschiedenen Gründen auf die Baummetapher zurück – im ersten Fall in Verbindung mit einem großflächigen, städtischen Raum inmitten von Hochhäusern, im zweiten mit Bezug auf den neogotischen Stil von St. John the Divine. Die Tatsache, dass der

Baum eine der offenkundigsten Vorlagen für Säulen oder die Formen früher Kirchenschiffe ist, bekräftigt nur seine starke biologische Präsenz. Dazu fallen einem die Worte Nervis ein, dass „wir bestimmte Formen unmittelbar akzeptieren, die aus einer physischen Welt zu uns kommen." Im Fall des Bahnhofs Oriente erläuterte Calatrava, dass mit seinem eigenen Verständnis von Lissabon in Zusammenhang stehende, besondere Umstände zu dem ungewöhnlichen Entwurf der Überdachung führten. „Während des Wettbewerbs für den Bahnhof Oriente fuhr ich mindestens fünfmal nach Lissabon, und wenn es nur war, um die Atmosphäre der Stadt in mich aufzunehmen. Es mag unnötig sein, das zu sagen, aber Lissabon ist eine sehr schöne Stadt. Wie Rom ist sie auf Hügeln erbaut, so dass sich häufig denkwürdige Aussichten ergeben. Man befindet sich in der Stadt und kann sie doch gleichzeitig betrachten. Dazu kommt der majestätische Tejo, der an diesem Punkt der breiteste Fluss Europas ist. Das so genannte Mar da Palha (Strohmeer) ist unglaublich riesig. Die Stadtgeschichte Lissabons reicht weit in die Antike zurück, und doch zeichnet sich ihre Anlage durch große Klarheit aus."[18]

Wenn Calatrava von der Gestaltung der Bahnsteige des Bahnhofs Oriente redet, spricht er von „Bäumen auf einem Hügel". Mit „Hügel" ist der hohe Damm gemeint, auf dem die Gleise verlaufen. Zur Erklärung der Baummetapher verweist er wiederum auf seine Besuche in Lissabon während des Wettbewerbs. „In der Stadt gibt es zahlreiche Parkanlagen mit Bäumen", sagt er. „Ich spürte sofort, dass die erhöhten Gleise einen bewaldeten Hang brauchten. Ich hatte da eine sehr deutliche Vorstellung im Kopf. Für den Wettbewerb zitierte ich ein sehr düsteres Gedicht von Fernando Pessoa, das die Vorstellung heraufbeschwört, in den ‚arvoredo', den Wald, zu gehen. Ich wollte die Transparenz des Bahnhofs betonen. In einem urbanen Kontext, der sich zweifellos noch stärker verdichten wird, soll der Bahnhof Oriente einer Oase gleichen. Die Leute werden diesen Ort aufsuchen, um Ruhe zu finden!" Als er gefragt wurde, weshalb er in diesem Fall eine Pflanzenmetapher statt der vom ihm ansonsten geschätzten zoomorphen Gestaltungen bevorzugte, antwortete er: „Stellen Sie sich vor, Sie gestalten einen erhöhten Platz. Das ist offensichtlich keine introvertierte Art von Architektur. Ich stehe auf einem Hügel in Lissabon und schaue mich um. Was fehlt? Schutz vor der Sonne und dem Regen."[19]

Der neuere Entwurf Calatravas für den TGV-Bahnhof in Liège offenbart einige Änderungen in seiner Denkweise und veranschaulicht Gründe für die Unterschiede zwischen der schmucklosen Schlichtheit seiner Brücken und der komplexern Anmutung seiner größeren Gebäude. „Brücken erfordern gerade aufgrund ihres Charakters eine strikte Sparsamkeit der Mittel. Man hat die Brückentafel, den sie tragenden Bogen und den Unterbau, die jeweils etwa ein Drittel der Kosten ausmachen. Angesichts der funktionalen Eindimensionalität einer Brücke gibt es nur begrenzten Raum für Abweichungen. Andererseits gibt es bei einem Bahnhof wenigstens 16 Arten von Entscheidungen, die sich ästhetisch auswirken können, angefangen bei der Wahl der Metallfensterrahmen bis hin zur Gestaltung der Beleuchtung und so weiter. Es hängt vom Geschick des Designers ab, innerhalb der wirtschaftlichen Zwänge eines solchen Projekts das von ihm intendierte Ergebnis zu erzielen." Ungeachtet dieser grundlegend anderen Situation ist leicht zu erkennen, dass Calatravas Neigung zu „Transgression" oder Innovation ihn gleichermaßen dazu bringt, ungewöhnliche Brücken und überraschende Bahnhöfe zu entwerfen. „Nehmen Sie den Fall des neuen TGV-Bahnhofs in Liège", so Calatrava, „wir erfanden die Fassade vollständig neu. Beziehungsweise, es gibt keine Fassade. Das ist meiner Ansicht nach eine grundlegende Transgression. Anstelle einer herkömmlichen Fassade wird es nur große Öffnungen geben, durch Markisen aus Metall markiert, die den Bahnhofsvorplatz überdachen." Wie Calatrava aufzeigte, hat diese Designentscheidung wichtige Folgen für die funktionale Anlage des Bahnhofs. Bildlicher gesprochen könnte man fragen, wie man einen Bahnhof ohne Fassade als einen solchen erkennen kann. „Der Kontext ist urban und es schien mir, als sei der erste Eindruck, den Reisende oder Besucher vom Bahnhof bekä-

men, wichtig", erklärte Calatrava. „Meine Lösung war eine zweifache. Da er auf einem Hügel liegt und man sich von oben nähert, hat man einen Blick auf die Stadt und auf die Bahnhofsanlage. Somit wird der Grundriss zur eigentlichen Fassade. Um das Verhältnis zwischen Stadt und Bahnhof zu verbessern, befürworteten wir eine Platzanlage vor dem Bahnhof."[20] Es scheint, dass der Bahnhof von Liège mit dieser Strategie des Fehlens oder besser einer Art von Minimalismus in seinem Konzept den Brücken näher steht als einige von Calatravas früheren Bauten. Was seinen Hang zur „Transgression" betrifft, wird ersichtlich, dass Calatravas sorgfältige Methoden Rücksicht auf die ökonomischen und funktionalen Bedingungen eines Projekts nehmen und aus der Skala verfügbarer technischer Möglichkeiten eine spezifische Schlussfolgerung ziehen. Seine Ideen funktionieren und fesseln das öffentliche Interesse, weil die fruchtbare Vorstellungskraft des Entwurfsingenieurs sie hervorbringt, aber auch, weil sie von Anfang an die beteiligten grundlegenden Kräfte berücksichtigen.

FLÜGEL UND EIN GEBET

Zweifellos war Calatravas Gespür für Stadtplanung ausschlaggebend für seine erfolgreiche Teilnahme an den Wettbewerben in Lissabon, wie auch in Liège oder in jüngerer Zeit in Manhattan, wo es um den symbolisch bedeutsamen Verkehrsknoten am World Trade Center ging. Er ist anscheinend zutiefst davon überzeugt, dass der Architekt einen Ort wie einen Bahnhof überhöhen und mit einer sakralen Anmutung ausstatten kann. Gefragt, ob es ihm eher darum gehe, dem Menschen angemessene Räume zu bauen oder ob er etwas anstrebe, was darüber hinaus reiche, offenbart seine Antwort viel über sein kreatives Vorgehen. „Alles fußt auf dem Menschen, aber die Vielschichtigkeit des Menschen beinhaltet auch das Sakrale, sonst gäbe es nicht so viele Leute, die sich in Rom ins Pantheon drängen, um die runde Öffnung in der Kuppel zu sehen. Wie sieht es mit Bahnhöfen aus? Wenn man beispielsweise die modernen Bahnhöfe in Zürich oder Basel betrachtet, hat man den Eindruck, man befände sich in einem Einkaufszentrum. Das Grand Central Terminal in New York scheint von einem anderen Planeten zu stammen. Indem sie abstrakte Werte sublimiert, kann die Architektur als Katalysator für gewaltige Ereignisse fungieren. Wenn man sie allerdings in rein funktionalistischer Absicht in Angriff nimmt, katalysiert man gar nichts, sondern landet in einem mittelprächtigen Einkaufszentrum. Das Gefühl, das sich bei mir in der zentralen Halle des Grand Central Terminals einstellt, sagt mir, dass ich es mit einem Werk großer Einsicht zu tun habe. Es verleiht dem Kommerz ein spezielles Empfinden, ja sogar eine sakrale Anmutung. Während an der Funktionalität des Bahnhofs keine Abstriche nötig sind, wird er zu einem Festakt. Schauen Sie sich an, was darum herum alles entstanden ist – das Seagram Building und die Park Avenue selbst. In dieser Hinsicht gleicht in Amerika kein Gebäude so sehr dem Pantheon. Schauen Sie, was die Architekten ins Zentrum der großen Halle gestellt haben – eine Uhr und einen kleinen Stand, an dem man Fahrpläne bekommt – zwei Elemente, die den Reisenden nichts nehmen, sondern ihnen etwas geben. Wir brauchen Schönheit, und Schönheit kann große Dinge in Gang setzen."[21]

Wenn Calatrava seine Pläne für den neuen Verkehrsknotenpunkt am World Trade Center beschreibt, führt er die Materialien „Glas, Stahl, Beton, Stein und Licht" auf. Calatrava hat begriffen, dass genau in den Brennpunkt eines der dunkelsten Geschehnisse der jüngeren amerikanischen Geschichte Licht fallen muss. Damit erreichte er das Empfinden der New Yorker, noch ehe sich die Flügel der neuen Station aus dem Boden erheben. Wenngleich die Form des Glasdachs Motive aus vielen Kulturen andeutet (byzantinische Mandorla, Engelsflügel über der Bundeslade, Schutzgötter auf ägyptischen Kanopen), lässt sie sich Calatrava zufolge in dem Bild eines Vogels zusammenfassen, der befreit aus der Hand eines Kindes aufsteigt. Unabhängig von der Symbolik, wird sich der Komplex auch der allzu kom-

„ALLES FUSST AUF DEM MENSCHEN, ABER DIE VIELSCHICHTIGKEIT DES MENSCHEN BEINHALTET AUCH DAS SAKRALE, SONST GÄBE ES NICHT SO VIELE LEUTE, DIE SICH IN ROM INS PANTHEON DRÄNGEN, UM DIE RUNDE ÖFFNUNG IN DER KUPPEL ZU SEHEN."

plizierten Schichtung der Nahverkehrssysteme in Lower Manhattan annehmen, Folge eines Jahrhunderts beständiger Erweiterungen, Vergrößerungen und Richtungswechsel. Da Calatrava auch hier, wie schon bei anderen Einrichtungen der Bahn, mit erfahrenen Spezialisten zusammenarbeitete, gelangen ihm elegante Lösungen für hochkomplexe technische Probleme. Die von Calatrava bei der Gestaltung des Grand Central Terminals beschworene Großzügigkeit liegt auch seinem WTC-Projekt zugrunde, und sie findet in erster Linie Ausdruck durch Raum und Licht. In der offiziellen Beschreibung heißt es: „Der auf Straßenhöhe sichtbare Teil der Anlage besteht aus einem gewölbten Oval aus Glas und Stahl, das etwa 107 m lang, an seinem breitesten Punkt 35 m tief und an der höchsten Stelle 29 m hoch ist. Die Stahlrippen,die diesen Bau stützen, verlängern sich nach oben zu zwei Kragdächern, die ausgebreiteten Flügeln ähneln und eine Höhe von 51 m erreichen. Von dem etwa 10 m unter dem Straßenniveau und 40 m unter der Spitze des Glasdachs gelegenen Hauptbahnsteig aus können Besucher zu einem stützenfreien, durchsichtigen Dach aufschauen." Der damalige Bürgermeister von New York, Michael Bloomberg, griff bei der Präsentation Calatravas Gedanken über die Bedeutung einer erhebenden Gestaltung auf, wenn er sagt: „Heute zeigen wir den Entwurf für die neue zentrale PATH-Station, und wir stellen uns vor, dass künftige Generationen dieses Bauwerk als wahres Zeugnis unseres heutigen Lebens betrachten werden, da wir dabei sind, unsere Stadt wieder aufzubauen. Was werden sie in Calatravas sensationellem Bauwerk erkennen? Sie werden kreative Gestaltung und tragfähige Bauweise erkennen. Sie erkennen Zutrauen zu unserer Investition in ein fantastisches Tor zu dem, was immer die ‚Finanzkapitale der Welt' sein wird. Sie erkennen eine nahtlose Verbindung zu den Pendlerzügen von PATH, den städtischen Untergrundbahnen und schließlich zu unseren Regionalflughäfen. Und sie erkennen Optimismus – ein Gebäude im Begriff abzuheben – genau wie das umliegende Stadtviertel."

ÜBER DEN FLUSS UND DURCH DIE BÄUME

Wie Calatrava selbst erläutert, bringt das Entwerfen einer Brücke eine Reihe sehr spezifischer Fragestellungen mit sich, nicht zuletzt solche der Symbolik. „Wenn man sich die Geschichte der Brücken im 19. und 20. Jahrhundert anschaut", sagt Calatrava, „so finden sich darunter ganz besondere, bemerkenswerte Konstruktionen. Man hat sie mit Stein verkleidet, stattete sie mit Löwenskulpturen und plastisch gestalteten Brüstungen aus, sogar, wie im Fall des Pont Alexandre III in Paris, mit Lampen tragenden Putti. Als Folge des Zweiten Weltkriegs verflüchtigte sich diese Einstellung zum Brückenbau. Hunderte von Brücken in ganz Europa mussten schnell wieder aufgebaut werden, und aus purer Notwendigkeit entstanden rein funktionalistische Brückenentwürfe. Eine gute Brücke war eine schlichte und vor allem kostengünstige Brücke." Calatrava ist der Meinung, diese funktionalistische Schule der Brückengestaltung habe schon lange ausgedient. „Heute gilt es, das Potenzial von Brücken wieder zu entdecken", versichert er. Er führt das Beispiel europäischer Städte wie Florenz, Venedig oder Paris an, um zu veranschaulichen, welche Schlüsselrolle historische Brücken dank ihrer Nützlichkeit und Dauerhaftigkeit bei der Prägung von Stadtbildern spielten. Um seine Meinung zu untermauern, geht Calatrava so weit zu sagen, eine Brücke könne eine überzeugendere kulturelle Aussage darstellen als ein Museumsneubau. „Eine Brücke ist effizienter", sagte er, „weil sie jedem dient. Auch ein ungebildeter Mensch kann Freude an einer Brücke haben. Eine einzige Maßnahme verwandelt die Natur und gibt ihr Ordnung. Etwas Effizienteres gibt es nicht."[22]

Calatravas erfolgreiches Bemühen, Brücken eine neue Bedeutung zu verschaffen, lässt sich am besten anhand der Alamillo-Brücke und des La Cartuja-Viaduktes (Sevilla, 1987–92) darstellen. Der am Eingang zur Expo '92 stehende imposante, 142 m hohe Pylon ist in einem Winkel von 58 Grad (dem gleichen wie

der der Cheopspyramide) geneigt und ist von einem Großteil der Altstadt von Sevilla aus zu sehen. Die von 13 Seilpaaren getragene Alamillo-Brücke überspannt mit 200 m den Meandro San Jeronimo, einen nahezu stehenden Nebenarm des Guadalquivir. Neben den 13 doppelten Spannseilen reicht „vor allem der mit Beton gefüllte Pylon als Gegengewicht für die Brückentafel aus und macht weitere Verstrebungen entbehrlich."[23] Zwar hatte Calatrava ursprünglich eine in die Gegenrichtung geneigte, zweite Brücke vorgesehen, die wie ein Spiegelbild der ersten den nahen Guadalquivir überqueren sollte, wegen der Knappheit des Budgets entschied sich jedoch der Auftraggeber, die Junta de Andalucia, für nur eine Brücke und den mehr als 500 m langen La Cartuja-Viadukt.

Abgesehen von den reich bebilderten Aufzeichnungen, die den Denkprozess bei der Entwicklung der innovativen Form des Alamillo-Pylons verdeutlichen, griff Calatrava hier ganz direkt auf das Vorbild des „Rennenden Torsos" zurück, einer 1986 von ihm geschaffenen Skulptur, bei der schräg gestapelte Marmorkuben von einem Spanndraht gehalten werden. Tatsächlich zeigen viele der Zeichnungen, die an den Wänden von Calatravas Züricher Wohnung hängen, Figuren in Bewegung. Wie der Titel sagt, ist auch „Rennender Torso" von der Spannung und den Kräften eines sich nach vorne bewegenden Körpers inspiriert. Wenngleich die Art, wie Calatrava diese Analyse umsetzt, sehr persönlich ist, ist dem Ergebnis doch etwas von dem von Nervi beschworenen „wahren Stil" eigen.

Obwohl es auch einem Laien nicht schwer fällt, die Schönheit einer Brücke zu würdigen, sind die Verfahren, die zu diesen Formen führen, durchaus komplex. Calatrava zufolge ist es „ein intuitiver Prozess, soll heißen, ein System, das auf der Synthese einer Reihe von Faktoren beruht". Seine Beschreibung des Entwurfsverfahrens verdient, ausführlich zitiert zu werden: „Ich glaube, dass an allererster Stelle der künftige Standort einer Brücke bedacht werden muss. So kann man beispielsweise an bestimmten Orten keine Bögen bauen, weil sich die Lasten nicht in angemessener Weise auf das Ufer ableiten lassen. Außerdem muss der Schiffsverkehr berücksichtigt werden. Die Höhe einer Brücke kann von der Art der Schiffe abhängen, die sie passieren müssen. Darüber hinaus ist auch die Wahl des Materials wichtig – Holz, Stahl oder Beton können entsprechend der lokalen Gegebenheiten und der Kostenplanung verwendet werden. Diese Faktoren führen neben anderen durch ein Ausschlussverfahren zu bestimmten konstruktiven Lösungsmöglichkeiten. An diesem Punkt beginnt nicht nur der Brückentyp selbst, sondern auch seine Wirkung auf die Umgebung die Form vorzugeben. Schließlich muss der Ingenieur die nötigen Berechnungen anstellen, um sicherzugehen, dass die ihm vorschwebende Gestaltung tatsächlich realisierbar ist. Ich fertige ein Modell an, das mathematische Gesetze mit der Natur verbindet und mit dessen Hilfe es möglich ist, das Verhalten der Natur zu begreifen. Wir sind beständig mit den Kräften der Natur konfrontiert", fügte er abschließend hinzu.[24]

Eine weitere Brücke Calatravas, die Campo-Volantín-Fußgängerbrücke in Bilbao (1990–97), ist beispielhaft für die Einbeziehung peripherer oder industrieller Stadtareale sowie ein technisches Glanzstück, das zu einer überraschenden Formgebung führte. Die Brücke überquert die Ría de Bilbao und verbindet das Stadtzentrum mit einem Uribitarte genannten, heruntergekommenen Geschäftsviertel. Calatrava hatte diesen Brückentyp mit einem geneigten Bogen zum ersten Mal 1988 bei einem nicht realisierten Projekt einer neuen Seine-Brücke zwischen dem 12. und 13. Arrondissement vorgeschlagen, die den Gare de Lyon mit dem Gare d'Austerlitz verbinden sollte. Der insgesamt 71 m überspannende, geneigte Parabelbogen trägt einen geschwungenen Fußweg, ein optisch reizvolles Bild. Diese Biegung geht jedoch über reine künstlerische Freiheit hinaus. Sergio Polano erläuterte: „Die Torsion, die an den Aufhängungspunkten der Stützen durch die exzentrische Lage des Gewichts entsteht, wird durch die gegenläufige Kurve des Fußwegs ausgeglichen, die Last somit auf die Betongründung übertragen." Das Ganze erinnert an „ein im Schwung angehaltenes Pendel".[25] Wo tatsächliche physische Bewegung nicht Teil des Entwurfs ist, erinnert Calatravas

Schaffen häufig an die Art von Spannung, die man von Skulpturen wie dem Diskobol des Myron kennt.

Neuere Brücken Calatravas konfrontieren extrem unterschiedliche Standorte mit der schlichten Formensprache und Effizienz, die für seine Flussoder Kanalüberführungen typisch geworden sind. Seine Drei Brücken über den Hoofdvaart (Hoofddorp, Niederlande 2004) befinden sich in einer rasch expandierenden, semi-urbanen Gegend nahe dem Flughafen Schiphol. Alle drei reagieren auf die im Wesentlichen flache Umgebung, indem sie dank ihrer kühnen spindelförmigen Stahlpylone zu „vertikalen Merkzeichen" werden. Die unterschiedlichen Neigungswinkel der Pylone können als eine Sequenz oder Abfolge verstanden werden, die zu den musikalischen Bezeichnungen Zither, Harfe und Laute anregte. Viel heikler im Hinblick auf den historischen Rahmen verhält es sich in Venedig, wo Calatrava die passend benannte Fourth Bridge on the Canal Grande (1999–2008) baut, tatsächlich erst die vierte Überquerung des berühmten Kanals seit dem 16. Jahrhundert. Die 94 m lange Brücke, die den Bahnhof mit der Piazzale Roma verbindet, zeichnet sich durch einen sehr hohen zentralen Bogen und eine transparente gläserne Brückentafel aus. Wiederum haben Eleganz und Geschick im Umgang mit Lokalstolz und politischen Verflechtungen es Calatrava ermöglicht zu bauen, wo in der Vergangenheit andere scheiterten.

DIE VERTIKALE HERAUSFORDERUNG

Aus der überwiegend horizontalen Welt der Brücken wagte sich Calatrava in seiner Tätigkeit bei zahlreichen Gelegenheiten in die Vertikalität von Türmen vor; gegenwärtig scheint er sich noch stärker auf Projekte dieser Art zu konzentrieren. Der bekannteste seiner frühen Türme ist der Fernmeldeturm auf dem Montjuïc in Barcelona (1989–92), der im Vorfeld der Olympischen Spiele errichtet wurde. Mit seinen mehr als 130 m Höhe und dem geneigten Schaft wurde der Turm mit einem Speer im Flug verglichen, aber wie gewöhnlich scheint Calatravas eigener Gedankengang gänzlich überraschend. Aus seinen Zeichnungen geht hervor, dass die geneigte Form von einer knienden menschlichen Figur inspiriert ist, die ein Opfer darbringt. In ähnlicher Weise scheint der Grundriss des Turms auf den ersten Blick von freimaurerischen Symbolen wie dem Kompass inspiriert. Calatrava beteuert hingegen, dieser Eindruck treffe nicht zu, sondern ihn habe wiederum das menschliche Auge angeregt. Natürlich gehört auch das Auge zu den Symbolen der Freimaurer, aber Logik und Substanz des Montjuïc-Turms sind offensichtlich mehrdimensional, ebenso wie seine Konstruktionsweise eine überraschend dynamische Form ergab. Im Katalog der 1993 gezeigten Ausstellung im MoMA heißt es dazu: „Der Turm verweist sinnbildhaft auf die Rituale der Olympischen Spiele. Seine eigentümliche Form widerspricht nicht den Gesetzen der Statik, weil der Massenschwerpunkt an der Basis mit der sich ergebenden Senkrechten seiner Eigenlast übereinstimmt. Der Neigungswinkel des Schafts fällt zusammen mit dem Einfallswinkel der Sommersonnenwende in Barcelona. So fungiert der Turm als Sonnenuhr, wenn die Sonne über die kreisrunde Plattform am Sockel der Treppe wandert. Diese Eigenschaften heben die Existenz der beiden Prachtstraßen Barcelonas, La Meridiana und El Paralelo, hervor, unterstreichen die avantgardistische Ausrichtung dieser Stadt und verweisen auf die technischen Fortschritte der Zeit."[26]

In jüngerer Zeit entwarf Calatrava drei sehr unterschiedliche „Türme" oder besser gesagt Hochhäuser: den auf seinen Zeichnungen eines männlichen Torsos basierenden „Drehenden Torso" (Malmö, Schweden 1999–2004), den 80 South Street Tower in New York, der aus zwölf auskragenden, verglasten Kuben besteht und von bis zu 20 Jahre früher entstandenen Skulpturen des Architekten inspiriert ist, und als Höhepunkt den geplanten Chicago Spire (Chicago, 2005), ein 150-geschossiges Hochhaus, das mit 610 m das höchste Gebäude in den Vereinig-

ten Staaten wäre. Mit jedem dieser Projekte beweist der Architekt, dass er Hochhäuser als Symbole oder funktional taugliche Entwurfsformen keineswegs als überholt ansieht. Sowohl der „Drehende Torso" als auch der 80 South Street Tower verkörpern sein Konzept, die Gesetze der Statik zu nutzen, um die dem Begriff der Masse tatsächlich inhärente Bewegung zu evozieren. Die auf mathematischen Berechnungen basierenden Bauten brechen aus der Sphäre der trockenen Wissenschaft aus und rufen erhebende Gefühle hervor, wie sie nur ein großartiges Bauwerk auslösen kann.

Bei der Beschreibung von Calatravas Skulpturen berief sich die *New York Times* auf Brancusi, an sich kein abschätziger Vergleich, und es ist vielleicht zutreffend, dass der Bauingenieur eher auf Gedanken und Kunst aus dem frühen 20. Jahrhundert als auf solche aus neuerer Zeit zurückgreift. Calatrava zitiert Einsteins berühmten Satz, in dem er sagt, Gott würfele nicht mit dem Universum. Damals reagierte der Vater der modernen Physik auf den Vormarsch der Quantentheorie und im Besonderen auf die Heisenberg'sche Unschärferelation, in der es in Bezug auf sub-atomare Teilchen heißt, dass die Kenntnis des Orts eines Teilchens sich komplementär zu seiner Geschwindigkeit verhält und umgekehrt. Wenn so viele Künstler und Architekten seither (1927) der Denkweise unsicherer Zeiten in ihrer Arbeit Form gaben, wie kommt es, dass Calatrava anscheinend fest in einer anderen Ära verankert ist – einer, in der platonische Körper bestimmend sind anstatt der beispielsweise von den Theorien Benoît Mandelbrots beschriebenen Komplexität. „In den 1980er-Jahren", sagte Calatrava, „wurde in der Architektur tatsächlich mit der Chaostheorie und der Sorte Mathematik experimentiert, mit der man die Bewegungen am Aktienmarkt oder das Wetter voraussagen kann. Aber in Einsteins berühmtem Satz ist ein programmatisches Element enthalten, das ich gerne unterstreichen möchte. Ordnung existiert, und ich bin versucht zu sagen, dass wir die Chaostheorie bereits hinter uns gelassen und damit begonnen haben, an die Ordnung des Entwurfs zu denken. Ich persönlich wollte mit Architektur nie etwas anderes als Ordnung wiedergeben. Tatsächlich habe ich mich immer auf reine Geometrie und beherrschte Bewegung bezogen. Die einzige Gelegenheit, bei der in meiner Arbeit der Zufall eine Rolle spielen könnte, ergibt sich, wenn ich Skizzen anfertige. Wo es um aktuelle Architektur geht, stelle ich fest, dass diejenigen, deren Entwürfe auf Ungewissheit in Form von Unordnung oder Dekonstruktion fußen, sehr stark auf Bautechnik angewiesen sind, wenn sie für ihr Schaffen eine gewisse Ausgereiftheit anstreben. Leute wie Daniel Libeskind verweisen stolz auf ihre Erfahrung mit Mathematik, und es ist offenkundig, dass die Ingenieurwissenschaften für ihre Architektur unentbehrlich sind. Ich möchte so weit gehen zu behaupten, dass ich immer aus dem Zentrum heraus begonnen habe. Sogar das Dach der Bodegas Ysios (Laguardia, Álava, Spanien 1998–2001) basiert auf einer Sinuskurve. Bei meinen Skulpturen habe ich offensichtlich einfache Formen verwendet, und 20 Jahre später lieferte eine mit der Vorstellung des menschlichen Körpers verwandte Skulptur die Grundlage für den ‚Drehenden Torso'."[27]

EINE PERLENSAMMLUNG

Für Calatrava hat inzwischen die Reifephase seiner Laufbahn begonnen, aber seine jüngsten Projekte künden davon, dass er keineswegs beabsichtigt, als Tribut an die Zeit weniger Spannungsreiches zu planen. Bei dem laufenden Projekt in seiner Heimatstadt Valencia wurde vor kurzem mit dem Opernhaus von Valencia (Palau de les Arts, 1996–2006) die Schlussphase des 1991 begonnenen Kulturkomplexes in Angriff genommen. Das Auditorio de Tenerife (Santa Cruz de Tenerife, Kanarische Inseln, 1991–2003) bestätigt in ähnlicher Weise die Kühnheit seiner Entwürfe und greift außerdem das immer wiederkehrende Leitmotiv des menschlichen Auges auf. Unter enormem Zeitdruck und in riesigen Dimensionen stellte Calatrava außerdem die Sportanlagen der Olympischen Spiele in Athen

(OAKA, Athen, 2001–04) fertig, darunter 199 000 m² Platzanlagen, ein Wegenetz von 94 000 m², 61 000 m² Grünflächen, 29 000 m² Wasserflächen, 130 000 m² Serviceeinrichtungen sowie 178 000 m² Parkplätze und Straßen. Es ist leicht zu sehen, wo Calatrava war, aber es ist nicht ganz so einfach zu sagen, wohin er sich künftig wenden wird. Genau dies könnte der Schlüssel zum Verständnis seiner Gedankengänge sein. „Stellen Sie sich vor, Sie wissen nicht, wohin Sie gehen", sagt er, „das mitgeführte Gepäck ist das, was man im Inneren mit sich trägt. Für mich bedeutet das beinahe eine paranoide oder schizophrene Situation. Ich habe ein Formgefühl, das in 14 Jahren Universitätsstudium entstanden ist – ich habe Mathematik kennengelernt, und ich liebe sie. Wenn ich das Werk von Picasso, Cézanne oder Matisse betrachte, das mich tief bewegt, muss ich feststellen, dass sie sich, abgesehen von begrenzten Details in ihren Werken, nie auf die Abstraktion einließen. Sie wollten Emotion erzeugen, und ich gehöre auch in ihr Universum. Mich hat lange Zeit ein einfacher Satz Michelangelos inspiriert, ‚l'architettura dipende dalle membra dell'uomo'. Den menschlichen Körper als Ausdrucksmittel zu nutzen, ist und bleibt wichtig."

Ganz gleich, welch maßgebliche Rolle Mathematik und Ingenieurwissenschaften in Calatravas Werk spielen, es sind Kunst und Emotion, die ihn Werke schaffen lassen, die weit über die nüchterne Berechnung von Kräften hinausgehen. „Das Leben ist wie eine Sammlung Perlen", so Calatrava, „du findest hier und da eine auf deinem Weg. Was ist der Sinn von Funktion in der Architektur? Es ist Liebe, die Liebe, die man anderen schenkt, die Freigiebigkeit des Architekten. In der Architektur gibt es ein großes Geheimnis, und das ist ihre philanthropische Natur, und diese Philanthropie kann man im Sinne von Funktion verstehen. Ein Gebäude funktioniert gut aus Liebe zu den Menschen. Das Geheimnis der Philanthropie in der Architektur ist in ihrer Funktion zu finden. Schönheit entsteht durch Intelligenz oder Intuition. In der Architektur muss man jedes Detail zeichnen. Jede Tat, außer der dich antreibenden Emotion, ist eine rationale Tat. Architektur ergibt schöne Ruinen; sie ist die abstrakteste der Künste."[28]

1 Interview mit Santiago Calatrava, Zürich, 22. Februar 2006.

2 Nicolai Ourousoff, „Buildings Shown as Art and Art as Buildings", *The New York Times*, 25. Oktober 2005.

3 Interview mit Santiago Calatrava, Zürich, 22. Februar 2006.

4 „L'architecture et la sculpture sont deux fleuves dans lesquels coule une même eau. Imaginons que la sculpture est plastique pure et que l'architecture et plastique soumise à la fonction et avec une évidente fonctionnalité, elle es étrangère à la servitude dérivée des questions d'utilisation et donc elle est, pour ainsi dire, supérieur à l'architecture en tant qu'expression purement plastique. L'architecture au contraire soumet son expression plastique et à ces exigence. Par contre, celle-ci, et de par son rapport à l'échelle humaine, à l'échelle de l'environnement de par son intériorité et sa pénétrabilité, elle l'emporte dans ces domains spécifique sur la sculpture." In: *Julio González, Zeichnen im Raum. Dessiner dans l'espace.* Mailand: 1997.

5 „L'harmonie, dans les corps vivants, resulte du contrebalancement des masses qui se déplacent: la Cathédrale est construite à l'example des corps vivants." In: Auguste Rodin, *Les cathédrales de France*, Paris: 1914.

6 „L'architecture est le jeu savant, correct et magnifique des volumes assemblés sous la lumière. Nos yeux sont faits pour voir les formes sous la lumière; les ombres et les clairs révélont les formes; les cubes, les cônes, les sphères, les cylindres ou les pyramides sont les grandes formes primaires que la lumière révèle bien; l'image nous en est nette et tangible, sans ambiguité. C'est pour cela que ce sont de belles formes, les plus belles formes. Tout le monde est d'accord en cela, l'enfang, le sauvage et le métaphysicien. C'est la condition même des arts plastiques." In: Le Corbusier, *Vers une architecture*, 1923. [dt. *Ausblick auf eine Architektur*, Braunschweig: 1982. S. 38].

7 „Il n'atteint à la grande expression qu'en donnant toute son étude aux jeux harmoniques de la lumière et de l'ombre, exactement comme fait l'architecte." In: Auguste Rodin, 1914.

8 Sigfried Giedion, *Raum, Zeit und Architektur: Die Entstehung einer neuen Tradition*, Zürich: 1992. S. 139 f. und 158 f.

9 Matilda McQuaid, *Santiago Calatrava, Structure and Expression*, The Museum of Modern Art, New York: 1993.

10 Ebd.

11 Interview mit Santiago Calatrava, Zürich, Juni 1997.

12 Ebd.

13 Pier Luigi Nervi, *Aesthetics and Technology in Building, The Charles Eliot Norton Lectures, 1961–1962*, Cambridge: Mass. 1965.

14 Interview mit Santiago Calatrava, Zürich, Juni 1997.

15 Ebd.

16 Ebd.

17 Ebd.

18 Interview mit Santiago Calatrava, Paris, September 1998.

19 Ebd.

20 Interview mit Santiago Calatrava, Zürich, Juni 1997.

21 Interview mit Santiago Calatrava, Zürich, 22. Februar 2006.

22 Interview mit Santiago Calatrava, Zürich, Juni 1997.

23 Dennis Sharp (Hrsg.), *Santiago Calatrava*, London: 1996.

24 Interview mit Santiago Calatrava, Zürich, Juni 1997.

25 Sergio Polano, *Santiago Calatrava, Complete Works*, Mailand; 1996.

26 *Santiago Calatrava, 1983–93*, Catálogo de la exposición antologica en la Lonja de Valencia del 31 de Mayo al 30 de Junio de 1993, Madrid: 1993.

27 Interview mit Santiago Calatrava, Zürich, 22. Februar 2006.

28 Ebd.

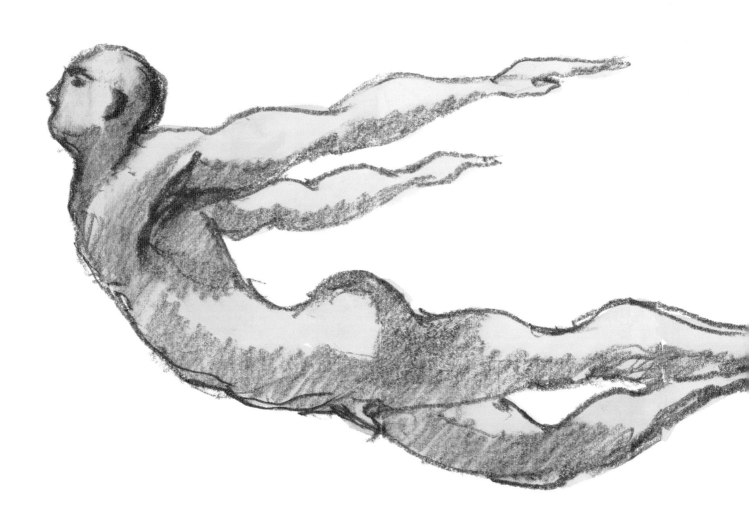

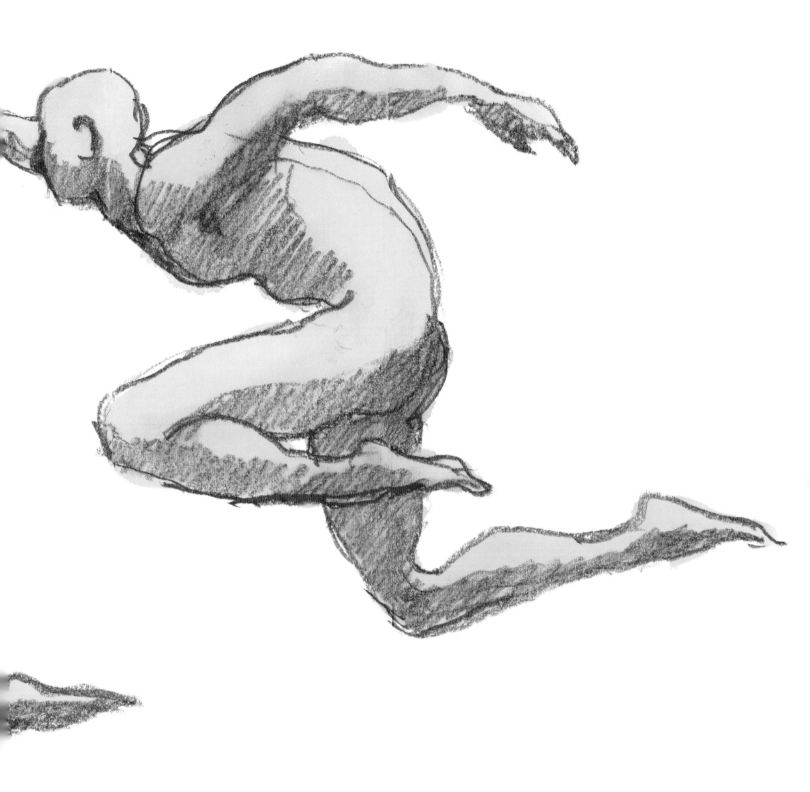

LE SECRET DE
LA PHILANTHROPIE

« J'ai commencé par vouloir étudier dans une école d'art », se souvient Santiago Calatrava. « Puis un beau jour, dans une papeterie de Valence, j'ai aperçu un petit livre aux superbes couleurs. On y voyait des ellipses jaunes et orange sur fond bleu et je l'ai acheté immédiatement. C'était un ouvrage sur Le Corbusier, dont l'œuvre m'était inconnue. J'y ai découvert des images des escaliers en béton de l'*Unité d'habitation* et j'ai été émerveillé par cet extraordinaire sens de la forme. L'objet du livre était de montrer les aspects artistiques du travail de l'architecte. Après l'avoir acheté et étudié, j'ai choisi de m'inscrire à l'école d'architecture. »[1]

Né en 1951 près de Valence, Calatrava y a fait ses études primaires et secondaires et, dès 1959, a commencé à suivre des cours de dessin et de peinture à l'école des Arts appliqués. Lorsqu'il eut 13 ans, sa famille profita de l'ouverture récente des frontières de l'Espagne franquiste pour l'envoyer en France dans le cadre d'un échange. À la fin de ses études secondaires, il partit pour Paris et l'École nationale supérieure des beaux-arts, mais arriva en 1968 au beau milieu des événements étudiants. Il rentra donc à Valence et, séduit par un opuscule plein de couleurs, s'inscrivit à l'Escuela Técnica Superior de Arquitectura, où il passa son diplôme d'architecte puis fit des études supérieures d'urbanisme.

Quand d'autres auraient pu décider de s'en tenir là, il décida de poursuivre sa formation. Attiré par la rigueur mathématique qu'il percevait dans certaines réalisations historiques et sentant que ses études à Valence ne lui offraient aucun débouché précis, il décida d'entamer des études supérieures de génie civil et, en 1975, intégra l'ETH (Institut fédéral de technologie) de Zurich, d'où il sortit docteur en 1981. Cette décision modifia le cours de sa vie à maints égards. C'est au cours de cette période qu'il rencontra et épousa Robertina Marangoni, étudiante en droit à Zurich également. Sur le plan professionnel, la clé des activités actuelles de Santiago Calatrava se trouve aussi en Suisse. Comme il l'explique : « Le désir de recommencer à zéro était très fort chez moi. J'étais déterminé à mettre de côté tout ce que j'avais fait à l'école d'Architecture pour apprendre à dessiner et à penser comme un ingénieur. J'étais fasciné par le concept de la pesanteur et persuadé qu'il fallait travailler à partir de formes simples. Je peux dire que mon goût pour la simplicité en ingénierie vient en partie de mon observation du travail de l'ingénieur suisse Robert Maillart. À l'aide de formes simples, il montrait qu'il était possible de créer un contenu puissant et de susciter une réponse émotionnelle. Avec une combinaison adéquate de force et de masse, vous pouvez créer l'émotion. »

INGÉNIEUR, ARCHITECTE, ARTISTE

L'attrait précoce de Calatrava pour l'art et l'esthétique qui le poussa vers le petit livre sur Corbusier allait rester un facteur permanent dans son œuvre, et l'un des éléments qui font de lui une figure à part dans le monde de l'architecture contemporaine. Évoquant une exposition organisée en 2005 par le Metropolitan Museum of Art de New York sur son travail architectural et artistique, il explique : « Je pense que Gary Tinterow, conservateur et commissaire de l'exposition, avait compris ma façon de travailler car il intitula la manifestation *Sculpture en architecture* plutôt que l'inverse. Les critiques d'architecture n'ont pas encore dépassé le stade de la perplexité devant mon travail. » En effet, tout en notant que la dernière fois que le Metropolitan avait présenté l'œuvre d'un architecte vivant remontait à 1973, Nicolai Ourousoff écrivit dans le *New York Times* : « Personne ne contestera que les sculptures de M. Calatrava pourraient être présentées au Met pour leurs mérites propres. En tant qu'objets d'art, elles dérivent essentiellement des œuvres de maîtres disparus comme Brancusi. » Mais il concluait sur un mode moins agréable : « On aurait préféré qu'il laissât ses sculptures dans son atelier ».[2] Ce commentaire montre avant tout une incompréhension de la sculpture de l'archi-

tecte. « En sculpture », dit celui-ci, « j'ai utilisé des sphères, des cubes et des formes simples souvent liées à ma connaissance de l'ingénierie. C'est une sculpture qui a donné naissance à la *Turning Torso* (Malmö, Suède, 1999–2004). Je dois admettre que j'admire énormément la liberté d'un Frank Gehry ou celle de Frank Stella en tant que sculpteurs. On trouve une joie et une liberté dans l'œuvre de Stella qui sont absentes de mes sculptures qui, elles, partent toujours de la matière brute des mathématiques. »[3] Il explique par ailleurs qu'il n'a jamais apprécié le milieu des galeries d'art et n'a presque jamais présenté ses sculptures. Et il souligne : « La réaction que je reçois des artistes est très positive. L'art est beaucoup plus libre que l'architecture car, comme le disait Picasso, certains artistes travaillent avec le marbre et d'autres avec la merde. » Ceci ne veut pas dire qu'il est naïf devant la difficulté de sa tâche. En 1997, il écrivait : « L'architecture et la sculpture sont deux fleuves dans lesquels coule une même eau. Pensons la sculpture comme une plastique pure et l'architecture comme une plastique soumise à la fonction, avec la prise en considération nécessaire de l'échelle humaine (à travers la fonctionnalité). La sculpture, elle, ignore le cadre de la fonctionnalité, elle est étrangère à la servitude issue de l'utilisation, ce qui la rend donc, d'une certaine façon, supérieure à l'architecture en tant qu'expression purement plastique. L'architecture au contraire soumet son expression plastique à ces exigences. Par son rapport avec l'échelle humaine et son environnement, par sa pénétrabilité et son intériorité, elle l'emporte sur la sculpture dans ces domaines spécifiques. »[4]

Calatrava va jusqu'à suggérer que l'art doit être considéré comme une source d'idées pour l'architecture. « Pourquoi fais-je des dessins du corps humain ? L'artiste, ou l'architecte, peut transmettre son message dans le temps par la seule force de la forme et de l'ombre. Rodin a écrit : ‹ L'harmonie dans les corps vivants est le résultat de l'équilibrage des masses qui se déplacent ; la cathédrale est construite à l'exemple des corps vivants ›[5]. Laissez-moi vous donner un exemple de l'importance de l'art pour le XXe siècle architectural. Lorsque Le Corbusier écrivait, en 1923, ‹ L'architecture est le jeu savant, correct et magnifique des volumes assemblés sous la lumière ›[6], combien savaient qu'il l'empruntait à la pensée du sculpteur Auguste Rodin ? En 1914, dans son livre *Les Cathédrales de France,* ce dernier écrivait en effet : ‹ Le sculpteur n'atteint à la grande expression qu'en concentrant son attention sur les jeux harmoniques de la lumière et de l'ombre, exactement comme le fait l'architecte ›.[7] Le fait que l'une des plus célèbres citations de l'architecture moderne ait été inspirée non pas par un architecte mais par un sculpteur me semble souligner l'importance de la signification de l'art. »

En dehors de cet intérêt permanent pour l'art, Santiago Calatrava apporte également une vraie passion à sa définition personnelle de l'architecture, soit le mouvement, implicite mais également bien réel, autrement dit le déplacement physique. Des premières portes articulées de son entrepôt Ernsting's (Coesfeld-Lette, Allemagne, 1983–85) au plus récent « Burke Brise Soleil » de cent quinze tonnes du Milwaukee Art Museum (Milwaukee, Wisconsin, 1994–2001), il revient sans cesse dans sa sculpture comme dans son architecture sur le concept original de mouvement physique répétitif. Pourquoi ? « Il existe un élément cinétique dans l'art du XXe siècle », réplique-t-il, « des artistes comme Alexander Calder, Naum Gabo ou Moholy-Nagy ont créé des sculptures qui bougent. J'aime leur travail et il déclenche en moi une grande émotion. Ma thèse de doctorat sur ‹ La flexibilité des structures tridimensionnelles › étudie le fait qu'une figure géométrique peut passer de trois à deux dimensions et terminer en une seule. Prenez un polyèdre et pliez-le pour en faire une surface plane. Une autre manipulation le réduit à une simple ligne, donc à une seule dimension. Vous pouvez considérer ceci comme un problème de mathématique ou de topologie. Tout le mystère des solides platoniciens se résume dans le polyèdre. Après avoir réfléchi à ces questions, j'ai regardé la sculpture ancienne sous un jour différent. Des œuvres comme le *Discobole* de Myron créent une tension qui repose sur un instant de mouvement et c'est ainsi que j'en suis venu à m'intéresser au problème du temps, du temps en

tant que variable. Einstein disait : ‹ Dieu ne joue pas aux dés avec l'univers ›. Et il m'est apparu que tout est lié aux mathématiques et à la dimension unique du temps. Puis, j'ai réfléchi à la statique (la branche de la physique qui traite des systèmes physiques en équilibre statique) et j'ai compris qu'il n'y a rien de statique. Tout est en mouvement potentiel. La seconde loi du mouvement de Newton dit que l'accélération d'un objet dépend de deux variables, la force nette qui agit sur l'objet et la masse de cet objet. La masse et l'accélération sont liées et ainsi le temps est présent dans la force. J'ai réalisé que l'architecture est pleine d'éléments mobiles, des portes aux meubles. L'architecture elle-même bouge, et, avec un peu de chance, devient une ruine magnifique. Tout change, tout meurt et les mouvements cycliques possèdent une signification existentielle. Je voulais faire une porte qui serait mienne, qui aurait un sens poétique et se transformerait en figure dans l'espace, et c'est ainsi qu'est né le projet Ernsting. »

L'ESSENCE DE L'ARCHITECTURE

Le fait qu'un certain nombre de gens ne se sentent pas à l'aise avec les diverses formes d'expression choisies par Santiago Calatrava est probablement la meilleure preuve qu'il touche à quelque chose d'important. Aujourd'hui, il travaille à l'un des projets les plus complexes et les plus politiquement sensibles que l'on puisse imaginer, puisqu'il s'agit de la gare de transit du World Trade Center, à New York, au milieu de ce champ de ruines que les New-Yorkais ont appelé *Ground Zero*. « Nous pensons qu'il est le Vinci de notre époque », a dit Joseph Seymour, ancien directeur exécutif de la Port Authority de New York et du New Jersey, commanditaire de cette gare. « Il associe lumière, air, élégance structurelle et puissance. » Ce type de louange n'est pas rare, même dans le cercle restreint de l'architecture. En 2005, Santiago Calatrava est devenu le second Espagnol (après Josep Lluís Sert en 1981) à remporter la prestigieuse médaille d'or de l'American Institute of Architects. Le comité de l'AIA a déclaré à cette occasion : « L'œuvre de Santiago Calatrava exprime l'essence de l'architecture. Elle enrichit la vision de l'esprit humain et exprime son énergie, captivant l'imagination et nous émerveillant devant ce qu'une forme sculpturale et une structure dynamique peuvent accomplir. Santiago Calatrava justifie et définit à la fois la raison d'être de cette médaille d'or. Sa vision élève l'esprit humain par la création d'environnements dans lesquels nous vivons, nous nous divertissons et nous travaillons. »

Calatrava ne semble pas perturbé par cette coexistence dans sa pensée de l'art, de l'architecture et de l'ingénierie, qui le plonge au cœur d'un des débats les plus intenses de l'histoire récente de la construction et du design. Comme l'écrivait Sigfried Giedion dans son œuvre fondamentale *Espace, temps et architecture* : « L'arrivée de l'ingénieur structurel et de composants industriels à mise en œuvre rapide et générateurs de formes a brisé le pathos artistique, bousculé la position privilégiée de l'architecte et jeté les bases des développements actuels. L'ingénieur du XIXᵉ siècle assumait inconsciemment le rôle de garant des éléments nouveaux qu'il fournissait aux architectes. Il développait des formes qui étaient à la fois anonymes et universelles. » Giedion retrace le débat sur le rôle de l'ingénierie en citant un certain nombre de dates et d'événements essentiels, dont : « 1877 : cette année-là, la question fit son entrée à l'Académie lorsqu'un prix fut offert pour la meilleure communication sur ‹ L'union ou le divorce entre l'ingénieur et l'architecte ›. Davioud, l'un des architectes du Trocadéro, remporta le prix avec cette réponse : ‹ L'accord ne sera jamais réel, complet et fructueux tant que l'ingénieur, l'artiste et le savant n'auront pas fusionné dans la même personne. Nous avons longtemps vécu avec la folle conviction que l'art est un type d'activité distinct de toutes les autres formes d'intelligence humaine, qui prendrait sa source et son origine dans la personnalité de l'artiste et les caprices de son imagination ›. »[8]

Même si l'insistance de Giedion) sur « l'anonymat » du travail de l'ingénieur ou la référence de Davioud aux « caprices de l'imagination » de l'artiste ne semblent pas correspondre à la puissante originalité de Calatrava, ce dernier pourrait bien incarner ce désir de l'architecte français d'un accord entre l'art, l'ingénierie et l'architecture. Et l'on ne peut s'empêcher de penser à la référence faite par Joseph Seymour au « Vinci de notre époque ».

Le catalogue de l'exposition de Santiago Calatrava au Museum of Modern Art de New York en 1993 souligne l'étroite relation entre son œuvre et celle d'autres grands ingénieurs : « Calatrava appartient au remarquable patrimoine de l'ingénierie du XXᵉ siècle. Comme ses prédécesseurs – Robert Maillart, Pier Luigi Nervi, Eduardo Torroja et Felix Candela –, il va au-delà d'une approche qui se contenterait de résoudre des problèmes techniques. Pour ces ingénieurs, la structure résulte d'un équilibre entre le critère scientifique d'efficacité et l'innovation dans la recherche formelle. Calatrava considère l'ingénierie comme ‹ l'art du possible › et cherche un nouveau vocabulaire formel, reposant sur un savoir-faire technologique qui ne soit pas pour autant un hymne à la technique. »[9] Le premier personnage cité, Robert Maillart (1872–1940), diplômé de l'ETH de Zurich en 1894, a créé quelques-uns des ponts modernes les plus spectaculaires et fait un usage novateur du béton. Son entrepôt de Giesshübel à Zurich (1910) faisait appel pour la première fois à un « plancher-champignon » en dalles de béton, permettant de se passer de poutres. Comme l'écrit Matilda McQuaid : « Maillart fut l'un des premiers ingénieurs de ce siècle à rompre complètement avec la construction en maçonnerie et à appliquer une solution élégante et techniquement appropriée à la construction en béton armé. Bien que, comme pour Maillart, la trouvaille technique chez Calatrava ne soit ni sa première motivation ni la dernière, elle nourrit l'expression générale de la structure. Son œuvre devient une imbrication d'expression plastique et de mise en valeur structurelle, aboutissant à des résultats qui peuvent parfaitement se décrire comme une synthèse de l'esthétique et de la physique structurelle. »[10]

Bien qu'il admire, naturellement, l'œuvre de Maillart, Santiago Calatrava s'empresse de faire remarquer que ses propres ponts sont très différents de ceux de ses prédécesseurs, ne serait-ce que par leurs sites. « Les ponts de Maillart », dit-il, « sont souvent implantés dans de magnifiques paysages de montagne. Sa réussite est d'avoir su introduire un élément artificiel dans des lieux aussi splendides. Aujourd'hui, je crois que l'une de nos tâches les plus importantes est de reconsidérer la périphérie des villes. La plupart du temps, les réalisations publiques dans ces zones sont purement fonctionnelles alors que les ponts, même près de voies ferrées ou au-dessus de rivières polluées, peuvent exercer un effet formidablement positif. En créant un environnement approprié, ils peuvent avoir un impact symbolique dont les ramifications vont bien au-delà du site immédiat. »[11]

L'œuvre de Calatrava a sans nul doute été influencée par celle de Felix Candela qui, né à Madrid en 1910, avait émigré au Mexique en 1939 où il conçut un certain nombre de remarquables structures en voiles minces de béton, comme l'église de la Vierge miraculeuse (Navarte, Mexico, 1955), projet reposant entièrement sur des paraboloïdes hyperboliques. Un autre Espagnol, l'ingénieur madrilène Eduardo Torroja (1899–1961), était fasciné par les formes organiques ou végétales dont la présence sculpturale indéniable vient sans doute de l'influence de Gaudí. Nombre des références de Santiago Calatrava sont espagnoles et plus spécifiquement liées à des architectes ou des artistes catalans. « Ce qui me fascine dans la personnalité de Goya, par exemple », dit-il, « c'est qu'il a été l'un des premiers artistes, comme Rembrandt avant lui, à renoncer à l'idée de servir un maître. Ce que j'admire dans l'œuvre de Miró », poursuit-il, « c'est son remarquable silence et son rejet radical de tout ce qui est conventionnel. » Bien que Gaudí lui offre un exemple voisin de celui de Maillart, il semble plus à l'aise lorsqu'il évoque le sculpteur Julio González. « Le père et le grand-père de González étaient ferronniers pour Gaudí et ils ont travaillé sur des projets comme le parc Güell. Puis ils s'installèrent

« EN RÉALITÉ, CE QUE J'AI TENTÉ EST CE QUE J'APPELLERAIS UNE DIALECTIQUE DE TRANSGRESSION, QUI REPOSE SUR LE VOCABULAIRE DES FORCES STRUCTURALES. »

à Paris et c'est de là que vient le goût du travail du métal chez Julio González. Avec toute la modestie qui s'impose, on pourrait dire que ce que nous faisons est la continuation naturelle du travail de Gaudí et de González, un travail d'artisans s'orientant vers l'art abstrait. »[12]

Si le type d'art auquel Calatrava se réfère est bien apparent dans ses ponts et ses bâtiments les plus réussis, il reste cependant difficile à décrire avec des mots. Une autre des figures essentielles de l'ingénierie du XXe siècle, l'Italien Pier Luigi Nervi, en a tenté une définition dans une série de conférences données à Harvard en 1961 :

« Il est très difficile d'expliquer pourquoi nous approuvons instantanément des formes qui nous viennent d'un monde physique avec lequel nous n'avons apparemment pas le moindre lien direct. Par quel biais ces formes nous satisfont-elles, pourquoi nous touchent-elles de la même façon que des choses naturelles comme les fleurs, les plantes et les paysages auxquels nous sommes accoutumés depuis d'innombrables générations ? On doit aussi noter que ces réussites possèdent en commun une essence structurelle, la nécessaire absence de toute décoration, une pureté de lignes et de formes plus que suffisante pour définir un style authentique, un style que j'ai baptisé le *style véridique*. Je comprends à quel point il est difficile de trouver les mots justes pour exprimer ce concept. Lorsque je fais ces remarques à des amis, ils me disent souvent que cette vue d'un futur proche est terriblement triste, qu'il serait peut-être préférable de renoncer volontairement à resserrer plus encore les liens entre nos créations et les lois de la physique, si en effet ces liens doivent nous mener à une monotonie fatale. Mais je ne pense pas que ce pessimisme soit justifié. Aussi contraignantes que soient les exigences techniques, il reste toujours une marge de liberté suffisante pour permettre à la personnalité du créateur d'une œuvre de s'exprimer et, s'il est un artiste, pour faire en sorte que sa création, même dans sa stricte orthodoxie technique, devienne une œuvre d'art véritable et authentique. »[13]

LE LONG DES RAILS D'ACIER

La raison de la présence prolongée de Calatrava à Zurich tient beaucoup aux circonstances. Après y avoir achevé ses études, il y demeura d'abord parce que son épouse, Robertina, n'avait pas encore fini les siennes puis – signe du destin – il remporta le concours pour la conception de la nouvelle gare de Stadelhofen (1982–90). Dire que ce curieux bâtiment est « central » serait un euphémisme. Implanté sur le flanc d'une colline boisée près de Bellevueplatz et de la Theaterstrasse, non loin du lac, il est étroitement intégré à un environnement urbain essentiellement traditionnel. « Pour comprendre la gare de Stadelhofen », explique Calatrava, « il faut la voir comme un projet extrêmement urbain, qui a entraîné une intervention sur le tissu de la ville. Il existe un contraste clair entre la nature radicale des solutions architecturales et techniques choisies et l'attitude envers la ville, qui est extrêmement respectueuse. Un certain nombre de liens ont été créés, pas seulement des passerelles et des accès, mais également des connexions avec des rues, qui n'existaient pas auparavant. De petits espaces verts, comme le voile de verdure surmontant le niveau supérieur, ont été créés. » En effet, lorsque, venant de la ville, le visiteur approche de la gare, il tombe d'abord sur un pavillon très traditionnel – la gare d'origine – avant de pénétrer ou de descendre dans les espaces imaginés par Calatrava. « Il était évident dès le départ », poursuit l'architecte, « que le respect accordé à tout bâtiment vieux de plus de cent ans en Suisse interdisait toute tentative de démolition ou de modification substantielle de l'ancienne gare. Néanmoins, je n'ai pas trouvé cet aspect illogique, car il s'intégrait à une lecture de la ville qui reste intacte. »[14] Après avoir traversé l'ancien pavillon, le voyageur entre dans un univers très différent, qui semble plus proche de l'imagination de Gaudí que de celle des tranquilles bourgeois zurichois. Même si Calatrava fait remarquer

que Zurich possède une tradition d'architecture radicale avec des maisons réalisées par des figures comme Marcel Breuer, il est clair que la gare de Stadelhofen lui a permis pour la première fois de sa carrière de se livrer, à grande échelle, au type de conception novatrice qui allait le rendre célèbre.

Le terrain en légère courbe de 40 mètres de large par 240 mètres de long fut aménagé pour permettre l'implantation d'une vaste surface commerciale en sous-sol. Par ailleurs, les travaux ne devaient pas interrompre le passage des trains de banlieue. L'ensemble présente une unité organique que le contexte ne favorisait pas particulièrement. Tel un ptérodactyle qui serait venu faire son nid au flanc de cette colline, la structure s'articule dans un système d'éléments répétés et d'énormes portes anthropomorphiques qui mènent au centre commercial souterrain où l'on a rapidement l'impression de se trouver dans les entrailles de la bête. On note une continuité entre la structure en métal sombre à l'air libre et les nervures en béton du sous-sol, qui crée une hiérarchie claire de volumes et de formes tout en renforçant la lisibilité et la clarté fonctionnelle de l'ensemble.

Si cette gare donne l'impression d'être conçue autour d'une métaphore de dinosaure, la substance de la conception de Calatrava est plus complexe, ou peut-être différente. « En réalité, ce que j'ai tenté est ce que j'appellerais une dialectique de transgression, qui repose sur le vocabulaire des forces structurales. À Stadelhofen, par exemple, se trouve une série de colonnes inclinées. On peut imaginer qu'il s'agit d'une décision esthétique, mais elle vient en fait de la nécessité de soutenir la structure. Il existait bien sûr plusieurs solutions pour ce type de support. On aurait pu n'avoir que de simples cylindres, par exemple, mais j'ai choisi de les articuler comme une main. C'est là que la question des métaphores devient intéressante. Comment mieux exprimer la fonction des colonnes qu'en les investissant du sens du geste physique de porter quelque chose ? »[15]

Si Santiago Calatrava est souvent cité dès qu'il est question de ponts, il est également un spécialiste reconnu des gares et l'auteur, notamment, de la gare de l'Orient à Lisbonne et de la nouvelle gare de Liège-Guillemins. L'une des réalisations qui ont le plus contribué à sa réputation reste cependant la gare du TGV de l'aéroport de Lyon-Saint Exupéry (1989–94). Cette gare de 5600 mètres carrés est intégrée au réseau français des trains à grande vitesse (TGV). Elle assure une correspondance efficace entre le TGV, les transports locaux et le terminal aérien. Inauguré le 7 juillet 1994, le hall central de 120 mètres de long, 100 mètres de large et 40 mètres de haut s'articule autour d'un élément central pesant 1300 tonnes. La gare de Calatrava rappelle un peu le terminal TWA conçu par Eero Saarinen pour l'aéroport Kennedy (New York, 1957–62) par sa ressemblance avec un oiseau en vol, tout en étant plus exubérante que son ancêtre américain. Le plan du complexe et de sa liaison avec le terminal de l'aéroport évoque, lui, une raie manta. Le bâtiment principal, prévu pour six voies, possède des quais couverts de 500 mètres de long également conçus par Calatrava. Les voies centrales sont prises dans une coque de béton pour permettre aux trains qui ne s'y arrêtent pas de traverser la gare à 300 km/h. Ce système a nécessité des calculs approfondis de l'onde de choc générée par le TGV. Le budget de cette réalisation financée par la SNCF, la Région Rhône-Alpes et le Département du Rhône a atteint cent millions d'euros.

Interrogé sur la référence à un oiseau préhistorique, Calatrava répond à sa façon, assez détournée mais néanmoins informative : « Je suis avant tout un architecte, pas un artiste ni quelqu'un qui essaye de fomenter une révolution. Il est intéressant de noter que Victor Hugo, dans *Notre-Dame de Paris*, compare la cathédrale à un monstre préhistorique. Bien qu'il possédât sans doute une bonne connaissance de l'architecture et fût un écrivain très consciencieux, il n'a pas hésité à user d'une métaphore aussi inattendue que celle-ci pour décrire cet édifice. Honnêtement, je ne cherche pas la métaphore. Je n'ai jamais pensé à un oiseau, mais plutôt à une recherche que j'ai parfois la prétention d'appeler sculpture. »[16] En fait, les dessins et la sculpture de Calatrava qui se rapprochent le plus du projet

de Lyon-Saint Exupéry semblent trouver leur origine non pas dans l'image d'un oiseau mais dans une étude de l'œil et de la paupière, thème récurrent dans son œuvre. « L'œil », dit-il, « est le vrai outil de l'architecte, et cette idée remonte aux Babyloniens. »

L'avancée en plongée vers le sol de la gare de Saint Exupéry a été comparée au bec d'un oiseau mais l'architecte, une fois encore, avait en tête une idée fort différente. « Ce ‹ bec › est le résultat d'un calcul complexe des forces jouant sur la structure. C'est également le point où se regroupent les écoulements des eaux pluviales. Naturellement, j'ai fait de mon mieux pour minimiser la masse en ce point, mais sans aucune intention zoomorphique. » Admettant que l'utilisation de ses propres sculptures comme point de départ du projet représente autant un choix esthétique qu'un concept métaphorique voulu, il ajoute : « Vous pouvez juger cela irrationnel, mais je dirais qu'il n'y a là aucune piste à suivre. Je veux être comme un navire en mer : derrière, il y a bien le sillage, mais devant, rien qui indique la voie. »[17]

DES ARBRES SUR LA COLLINE

Le travail de Calatrava sur la spectaculaire gare de l'Orient à Lisbonne est un exemple significatif de sa méthode et explique en grande partie ses récents succès. À la suite du catastrophique tremblement de terre de 1755, Lisbonne se réorienta vers l'intérieur des terres, tournant pratiquement le dos à l'estuaire du Tage. Ce mouvement s'amplifia à une époque plus récente, lorsque des installations industrielles prirent possession de remblais en bordure du fleuve. Les 340 hectares de la « Zone de redéveloppement » centrés autour d'Expo '98 et de la gare de l'Orient étaient occupés jusque dans les années 1990 par des dépôts d'essence et des entrepôts de conteneurs, les abattoirs municipaux et des installations de traitement des eaux usées. Si le glorieux passé de la capitale reste inscrit dans ses rues et ses places, sa relation intime avec le Tage, source de sa richesse, s'était presque perdue dans les brumes du temps.

C'est dans ce contexte que l'Association des architectes portugais lança, en 1988, un « concours d'idées pour la zone du fleuve ». La construction du Centre culturel de Belém (1988–92) sur la rive du fleuve représentait une première grande étape vers la réhabilitation des liens historiques de la ville avec le Tage. Une décision politique et culturelle encore plus importante fut prise en novembre 1993 lorsque Parque Expo '98 SA confia un premier « plan d'urbanisation de la zone de redéveloppement » à l'architecte Luis Vassalo Rosa. Dès le départ, l'intention des promoteurs était de créer quelque chose qui apporte davantage à la capitale que l'architecture éphémère typique des expositions universelles. Située à l'extrémité est de la ville, avec cinq kilomètres de quais sur le Tage, la zone de redéveloppement jouxte le pont Vasco de Gama. Inaugurée le 29 mars 1998, cette structure impressionnante enjambe le fleuve sur douze kilomètres et atteint jusqu'à 45 mètres de hauteur. Symboliquement, l'achèvement de ce pont qui porte le nom du grand explorateur et l'implantation d'Expo '98 n'auraient pu représenter un signal plus clair. Lisbonne et le Portugal manifestaient leur intention de reprendre en main leur héritage historique et de s'ouvrir de nouveau sur le Tage et sur le monde.

Santiago Calatrava a été choisi pour le projet de la gare de l'Orient à l'issue d'un concours sur invitation organisé entre lui, Terry Farrell, Nicholas Grimshaw, Rem Koolhaas et Ricardo Bofill. Ce projet, avec celui du Pavillon portugais d'Álvaro Siza, fait incontestablement partie des constructions les plus significatives suscitées par Expo '98. La gare et ses 200 000 voyageurs quotidiens était le point central du programme de réaménagement des quartiers est. L'aspect le plus spectaculaire est constitué par la couverture (238 x 78 m) des huit quais surélevés dont la typologie évoque une forêt. Plutôt que de faire ressortir la rupture entre la ville et le fleuve qu'impliquait la gare, Calatrava a cherché, ici comme ailleurs, à

ouvrir des passages et à rétablir des liens. Cette volonté se manifeste dans sa décision de couper dans le tertre sur lequel passent les voies pour construire la gare proprement dite en dessous. Le complexe comprend, au-dessus des entrées, deux vastes auvents en verre et acier mesurant chacun 112 mètres de long par onze de large. On trouve également une gare routière, un parking, une station de métro (non conçue par Calatrava) et une longue galerie qui comprend des espaces commerciaux prévus dans le cahier des charges. Les services et le hall de vente des billets sont situés à cinq mètres sous les voies et un atrium signale la galerie tout en longueur cinq mètres plus bas. L'accès côté fleuve constitue l'entrée principale.

De loin comme de l'intérieur, l'aspect le plus visible de la gare est son évocation d'une forêt. Au moins deux autres projets de Calatrava se sont appuyés sur la typologie structurelle de l'arbre ou de la forêt : le projet, non réalisé, pour la cathédrale Saint John the Divine à New York (1991) et celui de Gallery and Heritage Square pour BCE Place à Toronto (1987–92). Saint John the Divine, construite à l'origine en style néo-roman par Heins & La Farge en 1892 et « gothicisée » en 1911 par Cram & Ferguson, est l'une des plus célèbres églises new-yorkaises. Le projet de Calatrava consistait à lui ajouter un nouveau transept sud et un « bio-abri » perché à 55 mètres du sol. Lié au symbolisme du jardin d'Eden, ce dernier aurait été complété par des éléments structurels dérivés de la forme des arbres. Implanté dans l'attique au-dessus de la nef, ce jardin n'aurait pas modifié la silhouette du bâtiment mais permis de faire entrer plus de lumière naturelle dans l'église. Philip Johnson, l'un des membres du jury, fit remarquer la relation entre le projet de Calatrava, le décor de l'église et la typologie de l'arbre qui rappelle les origines de l'architecture gothique. L'image de l'arbre est également au centre de la Bell Canada Entreprises (BCE) Place, à Toronto. Calatrava a travaillé ici avec l'agence new-yorkaise de Skidmore, Owings & Merrill, pour créer, entre deux tours de bureaux, un passage de six étages de haut et 115 mètres de long à structure en acier laqué blanc et verre. Comme le *New York Times* l'écrit alors, « Cette galerie est pour le moins gaudiesque ». Elle évoque aussi, métaphoriquement, un cheminement en forêt. L'utilisation de l'acier peint en blanc et du verre annonce également les projets arboricoles des quais de la gare de l'Orient.

À Toronto comme à New York, Santiago Calatrava a fait appel à la métaphore de l'arbre pour différentes raisons, liées dans le premier cas à un vaste espace urbain pris entre deux tours de grande hauteur et dans le second au style néo-gothique de Saint John the Divine. Que l'arbre soit l'un des modèles évidents de la colonne et des nefs des premières églises ne fait que confirmer son indéniable présence biologique. Mais dans un cas comme dans l'autre, les mots de Nervi – « ... notre approbation instantanée des formes qui nous viennent du monde physique » – remontent jusqu'à nous. Concernant la gare de l'Orient, Calatrava explique que ce sont des circonstances très spécifiques tenant à sa vision personnelle de Lisbonne qui l'ont conduit à proposer cet auvent de forme si curieuse : « Je suis allé à Lisbonne au moins cinq fois pendant la préparation du concours pour la gare, ne serait-ce que pour ressentir l'atmosphère de la ville. Il est évident que c'est une très belle ville. Comme Rome, elle est construite sur des collines, ce qui offre des perspectives remarquables. Vous êtes dans la ville tout en vous trouvant en position de la regarder. Il y aussi la monumentalité du Tage, qui est à cet endroit le fleuve le plus large d'Europe. Cette ‹ mer de Paille › est incroyablement vaste. L'histoire urbaine de Lisbonne est très ancienne et a pourtant conservé sa clarté de composition. »[18]

Lorsque Calatrava parle de la conception des quais de la gare, il fait référence à « des arbres sur une colline ». Ici, la ‹ colline ›, c'est le petit tertre sur lequel passent les voies. Il repense à ses visites à Lisbonne : « Il y a dans cette ville de nombreux parcs boisés », dit-il, « et j'ai senti immédiatement que ces voies surélevées appelaient un flanc de colline planté d'arbres. C'était très clair dans mon esprit. Pour le concours, j'ai cité un poème plein de mélancolie de Fernando Pessoa

qui évoque l'idée d'aller à l'*arvoredo*, aux bois. Je voulais accentuer la transparence de la gare. Dans un environnement urbain, qui deviendra très certainement de plus en plus dense, la gare de l'Orient ressemblera à une oasis. Ce sera un lieu où les gens viendront se reposer ! » Si on lui demande pourquoi il a préféré, dans ce cas précis, une métaphore végétale plutôt qu'anthropomorphique (avec laquelle il semble plus à l'aise), il réplique : « Imaginez que vous créez une place surélevée. Ce n'est, à l'évidence, pas un type d'architecture introvertie. Je suis sur une colline de Lisbonne et je regarde autour de moi. Que manque-t-il ? De quoi se protéger du soleil et de la pluie. »[19]

Un projet plus récent, pour la gare TGV de Liège cette fois, illustre certaines évolutions dans sa pensée et les raisons des différences entre la simplicité épurée de ses ponts et l'impression d'une plus grande complexité que donnent ses grands bâtiments. « Les ponts, par leur nature même, nécessitent une stricte économie de moyens. Vous avez le tablier, l'arche qui le soutient et les fondations, chaque élément représentant environ un tiers du coût. Étant donné la simplicité de la fonction d'un pont, la marge d'intervention est limitée. D'un autre côté, dans une gare, au moins seize types de décisions peuvent exercer un impact esthétique, depuis le choix des huisseries métalliques jusqu'au mode d'éclairage. Obtenir le résultat voulu tout en respectant les contraintes économiques d'un tel projet met à l'épreuve le savoir-faire du concepteur. » Même si les deux situations sont fondamentalement différentes, on constate que le goût de l'architecte pour la « transgression » ou l'innovation le pousse néanmoins à dessiner des ponts inhabituels et des gares qui le sont tout autant. « Prenez le cas de la nouvelle gare TGV de Liège », poursuit-il. « Nous avons totalement réinventé la façade. Ou plutôt, il n'y a plus de façade. C'est, à mon avis, une transgression fondamentale. Au lieu d'une façade traditionnelle, il n'y aura que de grandes ouvertures signalées par des auvents métalliques au-dessus de la place devant la gare. » Comme il le fait remarquer, cette décision entraîne des conséquences importantes sur le plan fonctionnel. Au niveau du symbole, on peut se demander comment une gare sans façade peut être identifiée comme telle. « L'environnement est urbain et il m'a semblé que la première vision que les voyageurs ou les visiteurs auraient de la gare était importante », explique-t-il. « Ma solution est en deux volets. Comme le bâtiment est situé sur une colline et qu'on en approche par le haut, on a une vue sur la ville et sur le plan de la gare. Le plan devient ainsi la vraie façade. Pour améliorer le rapport avec la ville, nous avons proposé de créer une place juste devant. »[20] Il peut sembler que cette stratégie d'absence ou d'un certain minimalisme rapproche davantage, dans son concept, la gare de Liège des ponts que de certains bâtiments réalisés auparavant par l'architecte. Pour ce qui est de son goût pour la « transgression », il est clair que ses méthodes prudentes impliquent un vrai respect du contexte fonctionnel et économique d'un projet et la recherche d'un raisonnement spécifique parmi la gamme des possibilités techniques disponibles. Ses idées fonctionnent et suscitent l'intérêt du public parce qu'elles sortent de l'imagination fertile de l'architecte-ingénieur, mais aussi parce qu'elles respectent, dès l'origine, les forces fondamentales qui sont en jeu.

DES AILES ET UNE PRIÈRE

La sensibilité de Calatrava à l'urbanisme est certainement ce qui lui a valu de remporter le concours de Lisbonne mais aussi celui de Liège et plus récemment celui de Manhattan pour le *hub* du World Trade Center. Il est sincèrement convaincu qu'un architecte peut donner un sens du sacré à un lieu tel qu'une gare. À la question de savoir si son but est de réaliser des espaces confortables et humains ou bien d'atteindre à quelque chose de supérieur, il répond : « Tout repose sur l'homme mais, dans la complexité de l'homme, le sacré existe, ou bien il n'y aurait pas tant de gens pour venir voir, au Panthéon de Rome, l'oculus de sa cou-

pole. Et les gares ? Si vous prenez l'exemple des gares suisses modernes, à Bâle ou à Zurich par exemple, vous avez l'impression de vous retrouver dans un centre commercial. Celle de Grand Central, à New York, semble appartenir à une autre planète. En exaltant les valeurs abstraites, l'architecture est capable de catalyser d'immenses événements. Mais si vous l'abordez avec une attitude purement fonctionnaliste, vous ne catalysez rien du tout. Vous vous retrouvez avec un centre commercial médiocre. Le sentiment que j'éprouve dans le hall principal de Grand Central est le produit d'une grande intelligence. Le lieu donne au commerce un sens particulier, presque sacré. Tout en ne sacrifiant rien de sa fonction, la gare devient un acte de célébration. Regardez tout ce qui a surgi autour du vide au cœur de Grand Central, le Seagram Building et Park Avenue… De ce point de vue, en Amérique, rien ne ressemble autant au Panthéon. Voyez ce que ses architectes ont placé au centre du grand hall – une horloge et un petit tourniquet pour donner les horaires –, deux éléments qui sont là pour offrir quelque chose aux voyageurs et non pour leur prendre. Nous avons besoin de la beauté et la beauté peut générer de grandes choses. »[21]

Lorsqu'il décrit ses plans pour le nouveau *hub* du World Trade Center, Calatrava énumère ses matériaux : « le verre, l'acier, le béton, la pierre et la lumière ». Il a compris que la lumière doit briller au cœur même de ce qui rappellera toujours l'un des plus sombres événements de l'histoire récente des États-Unis et en cela il a su toucher la sensibilité des New-Yorkais avant même que les ailes de sa nouvelle gare ne surgissent du sol. Bien qu'empruntant à l'iconographie de civilisations variées (la mandorle byzantine, les ailes du chérubin au-dessus de l'arche de l'Alliance, les ailes protectrices sur les urnes canopes égyptiennes), la forme de son toit de verre représente plutôt, selon lui, un oiseau s'échappant des mains d'un enfant. Mais au-delà de ce symbolisme, ce projet résoudra également les problèmes que pose l'accumulation des strates de systèmes de transport de Manhattan, aboutissement d'un siècle d'extensions, d'agrandissements et de changements de direction. Calatrava, en collaborant avec des spécialistes comme pour ses autres projets ferroviaires, a su trouver des solutions élégantes à des problèmes techniques d'une extrême complexité. La générosité dont parle l'architecte à propos de la conception de la gare de Grand Central est au centre de son projet pour le WTC et s'exprime avec ampleur dans l'espace et la lumière : « La partie du bâtiment visible au niveau de la rue est un arc ovale de verre et d'acier, d'environ 107 mètres de long, 35 de large à son maximum et 29 de haut à son apex. Les nervures d'acier qui soutiennent la structure se prolongent en un couple d'auvents qui ressemble à des ailes déployées et s'élève jusqu'à 51 mètres. Dans le hall principal, à quelque dix mètres sous le niveau de la rue et à 40 mètres du sommet de la couverture de verre, les visiteurs pourront regarder vers le haut, vers une immense aile sans pilier. » Faisant écho au sentiment de Calatrava sur l'importance d'une conception qui élève l'âme, Michael Bloomberg, l'ancien maire de New York, a déclaré : « Aujourd'hui, nous dévoilons le projet de la nouvelle gare PATH (Port Authority Trans-Hudson) du centre ville et nous pouvons penser que les générations futures regarderont ce bâtiment comme un authentique témoignage de notre vie au moment où nous reconstruisons notre ville. Que verront-elles dans l'œuvre enthousiasmante de Santiago Calatrava ? Elles y verront la créativité de la conception et la force de la construction. Elles y verront la confiance dans notre investissement pour cette étonnante ‹ porte › de ce qui restera toujours la ‹ capitale financière du monde ›. Elles y verront une connexion parfaite entre les trains, le métro et, enfin, nos aéroports régionaux. Et elles y verront un signal d'optimisme – un bâtiment qui semble prendre son envol – comme tout le quartier du WTC qu'elle dessert. »

DE L'AUTRE CÔTÉ DE LA RIVIÈRE, À TRAVERS LES ARBRES

Comme le dit Santiago Calatrava lui-même, concevoir un pont entraîne un ensemble de défis très spécifiques dont les moindres ne sont pas ceux qui concernent les symboles. « Si vous considérez l'histoire des ponts des XIXᵉ et XXᵉ siècles, beaucoup sont des structures très spéciales et chargées de sens. Ils ont reçu des habillages de pierre, des lions sculptés ou même des anges soutenant les lampadaires, comme sur le pont Alexandre III à Paris. Cette attitude a disparu après la Seconde Guerre mondiale », poursuit-il, « des centaines de ponts devaient alors être reconstruits rapidement dans toute l'Europe et c'est de la nécessité qu'est née cette école de conception de ponts purement fonctionnels. Un bon pont était un pont simple et, surtout, peu coûteux à construire. » Calatrava pense que cette école fonctionnaliste a perdu de son utilité après-guerre. « Aujourd'hui, nous devons redécouvrir le potentiel des ponts », ajoute-t-il, citant les exemples de villes européennes comme Florence, Venise ou Paris pour souligner qu'à travers leur fonction, mais aussi leur permanence, les ponts du passé ont joué un rôle clé dans la formation de l'image des villes. Il va jusqu'à dire que la construction d'un pont peut être un geste culturel plus fort que l'édification d'un nouveau musée. « Le pont est plus efficace », affirme-t-il, « parce qu'il est accessible à tous. Même une personne analphabète peut apprécier un pont. Un simple geste transforme la nature et l'ordonne. Il n'y a rien de plus efficace. »[22]

Le succès de ses efforts pour donner un sens nouveau aux ponts est brillamment illustré par l'exemple du pont Alamillo et du viaduc de La Cartuja à Séville (1987–92). À l'une des entrées de l'Expo '92, le spectaculaire pylône de 142 mètres de haut incliné à 58° (le même angle que celui de la pyramide de Khéops près du Caire) de l'Alamillo le rend visible d'une grande partie du vieux Séville. Soutenu par treize paires de haubans, ce pont de 200 mètres de portée franchit le Meandro San Jeronimo, un bras vigoureux du Guadalquivir. « Le poids du pylône rempli de béton suffit à équilibrer celui du tablier et évite de recourir à des haubans arrière. »[23] Bien que l'architecte ait à l'origine pensé à un second pont incliné dans le sens opposé – telle une image en miroir du premier – pour franchir le Guadalquivir tout proche, des considérations budgétaires ont poussé les autorités andalouses à ne retenir qu'un seul franchissement et le viaduc de 500 mètres de long de La Cartuja.

Parallèlement à ses propres carnets de notes, abondamment illustrés, qui éclairent sa réflexion sur la forme novatrice du pylône sévillan, Calatrava s'est appuyé ici assez directement sur *Running Torso*, une sculpture qu'il créa en 1986, composée d'un empilement de cubes de marbre inclinés maintenus en équilibre par un câble en tension. De fait, nombre des dessins accrochés aux murs de sa maison de Zurich représentent des figures en mouvement. *Running Torso* est clairement inspiré, comme son titre l'indique, par la tension et les forces d'un corps se déplaçant vers l'avant. Malgré l'utilisation spécifique et très personnelle que l'architecte fait de cette analyse, le résultat conserve quelque chose du « style véridique » évoqué par Nervi.

Bien qu'une personne non informée puisse apprécier aisément la beauté d'un pont, la méthode qui conduit à ces formes est assez complexe. « C'est un processus intuitif, c'est-à-dire un système qui s'appuie sur la synthèse d'un certain nombre de facteurs », affirme Calatrava. Son explication mérite d'être citée *in extenso* : « Je pense qu'avant tout, la localisation du pont doit être prise en considération. Sur certains sites par exemple, vous ne pouvez pas utiliser d'arche parce qu'il est impossible de transférer les charges aux rives de façon adéquate. Ensuite, il faut tenir compte du trafic fluvial. La hauteur d'un pont peut être déterminée par le type de bateaux qui vont passer dessous. Le choix des matériaux est tout aussi essentiel : le bois, l'acier

ou le béton peuvent être utilisés en fonction du contexte local et du cadre budgétaire. Ces éléments, et d'autres encore, mènent par un processus d'élimination à un certain nombre de solutions structurelles. C'est ainsi que le type de pont, mais aussi son impact sur l'environnement, commencent à prendre forme. Dès lors, l'ingénieur doit faire les calculs nécessaires pour être sûr que son projet est totalement viable. Je crée une maquette qui fait le lien entre les études mathématiques et la nature, pour permettre de mieux comprendre le comportement de celle-ci. Nous sommes toujours confrontés aux forces de la nature »[24], conclut-il.

Un autre pont, la passerelle de Campo Volantin (Bilbao, Espagne, 1990–97), est tout aussi exemplaire de sa réflexion sur les espace urbains périphériques ou industriels et d'un exercice approfondi de l'ingénierie permettant d'aboutir à une forme inattendue. Franchissant le fleuve de Bilbao pour relier le centre ville à un quartier commercial en déshérence appelé Uribitarte, il fait appel au principe de l'arche inclinée que Calatrava avait utilisé une première fois en 1988 pour le projet (non réalisé), à Paris, d'un pont sur la Seine entre les gares de Lyon et d'Austerlitz. À Bilbao, une arche parabolique inclinée de 71 mètres de haut soutient la passerelle en courbe, dessinant une silhouette étonnante. Mais cette courbe est bien plus qu'un caprice esthétique. Comme l'explique Sergio Polano, « La torsion créée aux points de suspension des montants par la position excentrée du poids est équilibrée par la contre-courbe de la passerelle, transférant ainsi la charge vers les fondations en béton », l'ensemble suggérant « un pendule arrêté dans son mouvement ».[25] Même lorsque le mouvement physique ne fait pas partie du propos, les projets de Calatrava font souvent penser à la tension évoquée dans une sculpture comme celle du *Discobole*.

Les ponts récents de l'architecte confrontent des sites radicalement différents avec le langage de la simplicité et de l'efficacité qui caractérise tous ses ouvrages d'art. Ses Trois ponts sur le Hoofdvaart (Haarlemmermeer, Pays-Bas, 2004) sont situés dans une zone semi-urbaine en plein développement près de l'aéroport de Schipol. Tous trois répondent à un environnement essentiellement plat et deviennent en quelque sorte des « monuments verticaux » grâce à leurs audacieux pylônes fuselés en acier. Leurs degrés d'inclinaison différents peuvent se lire comme une séquence ou une progression, qui d'ailleurs inspiré leurs noms d'origine musicale : La Lyre (*Citer*), La Harpe (*Harp*) et Le Luth (*Luit*). Beaucoup plus délicat quant à son cadre historique, le nouveau pont construit par Calatrava à Venise, le bien nommé Quarto Ponte sul Canal Grande (1999–2008), n'est que le quatrième pont construit sur le fameux canal depuis le XVIᵉ siècle. Reliant la gare à la Piazzale Roma, cet ouvrage de 94 mètres de long possède une arche centrale de très grand rayon et un tablier en verre transparent. Là encore, l'élégance et la capacité à se plier à la fierté et aux complexités politiques locales ont permis à Santiago Calatrava de réussir à construire là où d'autres l'avaient tenté en vain dans le passé.

LE DÉFI VERTICAL

À maintes occasions au cours de sa carrière, Calatrava est audacieusement passé de l'univers des ponts, essentiellement horizontal, à la verticalité de celui des tours, et il semble aujourd'hui se concentrer sur ce type de projet. La plus connue de ses premières réalisations dans ce domaine est la Tour de communications de Montjuic (Barcelone, 1989–92), édifiée à l'occasion des Jeux olympiques. Avec ses quelque 130 mètres de haut, son fût incliné l'a fait comparer à un javelot lancé, bien qu'une fois encore, l'approche de l'architecte soit déroutante. Ses dessins montrent qu'il s'est inspiré d'une figure agenouillée en position d'offrande. À première vue, le plan de la tour pourrait aussi paraître inspiré de symboles maçonniques comme le compas, mais Calatrava réfute cette remarque et avoue qu'une fois de plus, son inspiration vient en fait de l'œil humain. Certes, l'œil

est également l'un des emblèmes maçonniques, mais la conception comme le contenu de la tour de Montjuic ont de multiples significations et sa technique de construction crée une forme étonnamment dynamique. Comme l'explique le catalogue de l'exposition du MoMA (1993) : « Symboliquement, la tour se réfère à l'événement rituel des Jeux olympiques. Sa forme singulière ne contredit pas les lois de la statique, car son centre de gravité coïncide à la base avec la verticale de son poids mort. Son fût a une inclinaison qui correspond à l'angle du solstice d'été à Barcelone et il agit comme un cadran solaire lorsque le soleil se déplace à travers la plate-forme circulaire au pied de ses escaliers. Ces caractéristiques rappellent la présence des deux grandes avenues de Barcelone, la Meridiana et El Paralelo, qui expriment la vocation d'avant-garde de cette ville et se réfèrent aux progrès techniques de l'époque. »[26]

Plus récemment, Calatrava a conçu trois tours très différentes, la *Turning Torso* (Malmö, Suède, 1999–2004), d'après ses dessins d'un torse masculin ; la 80 South Street Tower à New York, faite de douze cubes de verre en porte-à-faux inspirés d'une série de sculptures qu'il réalisa vingt ans plus tôt et, plus surprenante encore, la Chicago Spire (Chicago, 2005), une tour de 150 étages et 610 mètres de haut qui devrait être l'immeuble le plus haut des États-Unis. Dans chaque cas, l'architecte montre qu'il ne pense évidemment pas que les tours sont des symboles dépassés ni de pures formes efficaces qui seraient démodées. La *Turning Torso* et la tour de 80 South Street incarnent son idée d'utiliser la statique pour évoquer le mouvement inhérent au concept de masse. Reposant sur des calculs mathématiques poussés, ces projets échappent au domaine de la science pure pour évoquer le corps ou la spiritualité que seule une grande œuvre architecturale peut susciter.

Le *New York Times* citait le nom de Brancusi pour décrire les sculptures de Calatrava, ce qui en soi n'est pas une comparaison désavantageuse, mais de fait, il est vrai que l'architecte-ingénieur se réfère plus volontiers à l'art de la première moitié du XXᵉ siècle qu'aux développements plus récents de l'art et de la pensée. Il cite Einstein, pour lequel « Dieu ne joue pas aux dés avec l'univers ». Mais en même temps, le maître de la physique moderne réagissait aux progrès de la Théorie des quanta et en particulier au *Principe d'incertitude* de Werner Heisenberg qui, faisant référence aux particules infra-atomiques, écrivait que « Plus la position est déterminée avec précision, moins la mesure du moment de mouvement est précise, et vice-versa ». Alors que beaucoup d'artistes et d'architectes depuis lors (1927) ont exprimé dans leurs œuvres l'incertitude du moment, pourquoi Calatrava semble-t-il si fermement ancré dans l'époque du règne des solides platoniciens plutôt que dans la complexité décrite par les théories de Benoît Mandelbrot par exemple ? « Dans les années 1980 », dit-il, « il existait en effet des expérimentations architecturales en rapport avec la théorie du chaos et les mathématiques servant à prédire les mouvements de la bourse ou de la météo. Mais il existe dans la célèbre phrase d'Einstein un élément programmatique que j'aimerais souligner. L'ordre existe, et je suis tenté de dire que nous avons déjà dépassé la Théorie du chaos et commencé à penser à l'ordre de la conception. Personnellement, je n'ai jamais souhaité rendre explicite, dans mon architecture, autre chose que l'ordre. Je me suis toujours référé à la géométrie pure et au mouvement contrôlé. Le seul moment où le hasard peut apparaître dans mon travail est l'instant du croquis. Pour ce qui est de l'architecture actuelle, je note que ceux qui choisissent des modèles basés sur l'incertitude, en forme de désordre ou de déconstruction si vous préférez, doivent se rapprocher de l'ingénierie lorsqu'ils cherchent à donner quelque maturité à leur travail. Des architectes comme Daniel Libeskind, par exemple, font état avec fierté de leur expérience des mathématiques et il est évident que la science des ingénieurs est indispensable à leur architecture. Je pourrais aussi me vanter et dire que j'ai toujours joué au centre du terrain. Même le toit du chai des Bodegas Ysios (Laguardia, Álava, Espagne, 1998–2001) part d'une courbe sinusoïdale. Dans ma sculpture, j'ai toujours utilisé des formes simples et vingt ans plus tard une sculpture sur l'idée de corps humain a été la base de la tour *Turning Torso*. »[27]

UNE COLLECTION DE PERLES

Alors que Santiago Calatrava aborde une phase de maturité en termes de carrière, ses réalisations témoignent d'une vitalité créative qu'il n'a aucune intention d'assagir avec le temps. Sa ville natale, Valence, a récemment inauguré avec son Opéra (Palau de les Arts, 1996–2006) la phase finale de son énorme complexe culturel commencé en 1991. L'Auditorium de Tenerife (Santa Cruz de Tenerife, îles Canaries, Espagne, 1991–2003) confirme également l'audace de ses projets et reprend le thème récurrent de l'œil, objet de sa passion. Travaillant contre la montre et à une échelle énorme, il a également achevé le Complexe sportif olympique d'Athènes (OAKA, Athènes, Grèce, 2001–04) qui ne comprend pas moins de 199 000 mètres carrés de places, 94 000 mètres carrés d'allées, 61 000 mètres carrés d'espaces verts, 29 000 mètres carrés d'installations aquatiques, 130 000 mètres carrés d'équipements de service et 178 000 mètres carrés de voies d'accès et de parkings. S'il est facile de voir d'où vient l'architecte, il est moins aisé de prédire où il sera demain. « Imaginez que vous ne savez pas où vous allez », dit-il, « votre bagage, c'est ce que vous portez en vous. Pour moi, c'est presque une situation de paranoïa, ou de schizophrénie. Je possède un sens des formes issu de quatorze ans d'études universitaires, j'ai fait la rencontre des mathématiques et je les aime. Lorsque je regarde l'œuvre de Picasso, de Cézanne ou de Matisse, artistes qui m'émeuvent, je suis obligé de remarquer qu'ils ne se sont jamais engagés dans l'abstraction, à quelques détails près. Ils ont travaillé pour créer une émotion et c'est de cet univers-là que je viens. J'ai longtemps été inspiré par une petite phrase de Michel-Ange : « *L'architettura dipende dalle membra dell'uomo*« (L'architecture dépend des membres de l'homme). Utiliser le corps humain comme moyen d'expression est et restera important pour moi. »

Quelle que soit l'importance des mathématiques et des sciences de l'ingénierie dans l'œuvre de Santiago Calatrava, c'est l'art et l'émotion qui le poussent à créer des œuvres qui dépassent, et de loin, le prosaïque calcul des forces. « La vie est comme une collection de perles », dit-il. « Vous en trouvez une ici, une autre là, sur votre chemin. Quel est le sens de la fonction en architecture ? C'est l'amour, l'amour que l'on donne aux autres, la générosité de l'architecte. Il existe un grand secret en architecture, c'est sa nature philanthropique, qui doit être comprise en termes de fonction. Un bâtiment fonctionne bien grâce à l'amour des hommes. Le secret de la philanthropie en architecture est dans sa fonction. La beauté est perçue par le biais de l'intelligence ou de l'intuition. En architecture, il est nécessaire de dessiner chaque détail. Chaque acte, à part l'émotion qui guide votre vie, est un acte d'intelligence. L'architecture est ce qui fait que les ruines sont magnifiques, c'est le plus abstrait de tous les arts. »[28]

« TOUT REPOSE SUR L'HOMME MAIS, DANS LA COMPLEXITÉ DE L'HOMME, LE SACRÉ EXISTE, OU BIEN IL N'Y AURAIT PAS TANT DE GENS POUR VENIR VOIR, AU PANTHÉON DE ROME, L'OCULUS DE SA COUPOLE. »

1 Entretien de l'auteur avec Santiago Calatrava, Zurich, 22 février 2006.

2 Nicolai Ourousoff, « Buildings Shown as Art and Art as Buildings », *The New York Times*, 25 octobre 2005.

3 Entretien avec Santiago Calatrava, Zurich, 22 février 2006.

4 *Julio González, Dessiner dans l'espace*, Skira, Kunstmuseum, Berne, 1997.

5 Auguste Rodin, *Les Cathédrales de France*, Armand Colin, Paris, 1914.

6 Le Corbusier, *Vers une architecture*, 1923. « L'architecture est le jeu savant, correct et magnifique des volumes assemblés sous la lumière. Nos yeux sont faits pour voir les formes sous la lumière ; les ombres et la clarté révèlent les formes ; les cubes, les cônes, les sphères, les cylindres ou les pyramides sont les grandes formes primaires que la lumière révèle bien ; l'image nous en est nette et tangible, sans ambiguïté. C'est pour cela que ce sont de belles formes, les plus belles formes. Tout le monde est d'accord en cela, l'enfant, le sauvage et le métaphysicien. C'est la condition même des arts plastiques. »

7 Auguste Rodin, op. cit.

8 Sigfried Giedion, *Space, Times and Architecture*, Harvard University Press, Cambridge, Massachusetts, 5e édition, 1976.

9 Matilda McQuaid, *Santiago Calatrava, Structure and Expression*, The Museum of Modern Art, New York, 1993.

10 *Ibid.*

11 Entretien avec Santiago Calatrava, Zurich, juin 1997.

12 *Ibid.*

13 Pier Luigi Nervi, *Aesthetics and Technology in Building, The Charles Eliot Norton Lectures, 1961–1962*, Harvard University Press, Cambridge, Massachusetts, 1965.

14 Entretien avec Santiago Calatrava, Zurich, juin 1997.

15 *Ibid.*

16 *Ibid.*

17 *Ibid.*

18 Entretien avec Santiago Calatrava, Paris, septembre 1998.

19 *Ibid.*

20 Entretien avec Santiago Calatrava, Zurich, juin 1997.

21 Entretien avec Santiago Calatrava, Zurich, 22 février 2006.

22 Entretien avec Santiago Calatrava, Zurich, juin 1997.

23 Dennis Sharp (dir.), *Santiago Calatrava*, Architectural Monographs n° 46, Academy Editions, Londres, 1996.

24 Entretien avec Santiago Calatrava, Zurich, juin 1997.

25 Sergio Polano, *Santiago Calatrava, Complete Works*, Gingko, Electa, Milan, 1996.

26 *Santiago Calatrava, 1983–1993*, Catalogo de la exposicion antologica en la Lonja de Valencia del 31 de Mayo al 30 de Junio de 1993, El Croquis Editorial, Madrid, 1993.

27 Entretien avec Santiago Calatrava, Zurich, 22 février 2006.

28 *Ibid.*

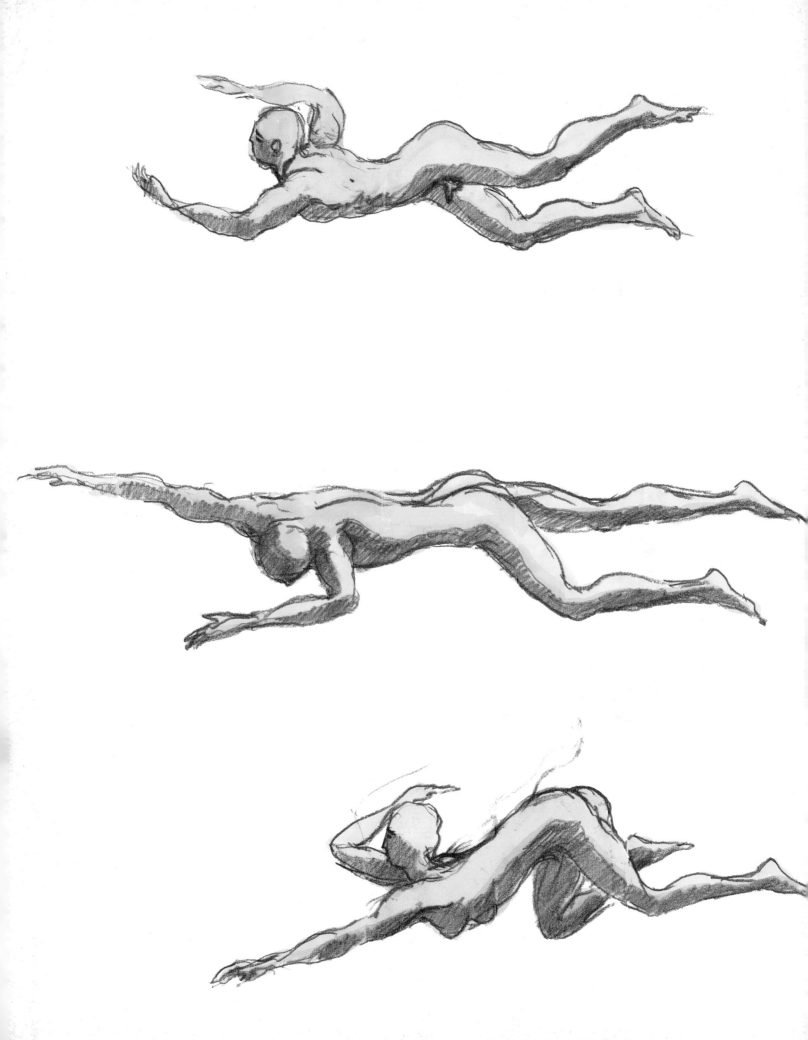

ALPINE
BRIDGES

Switzerland. 1973–1979.

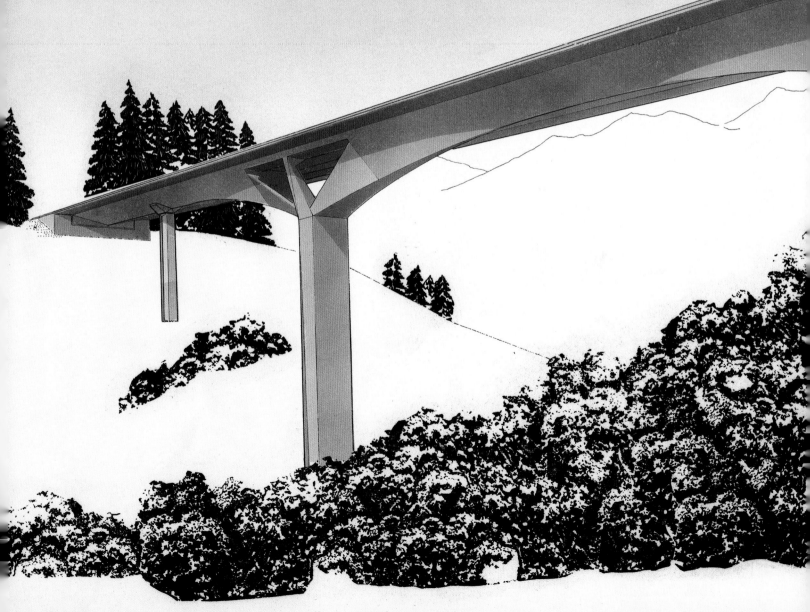

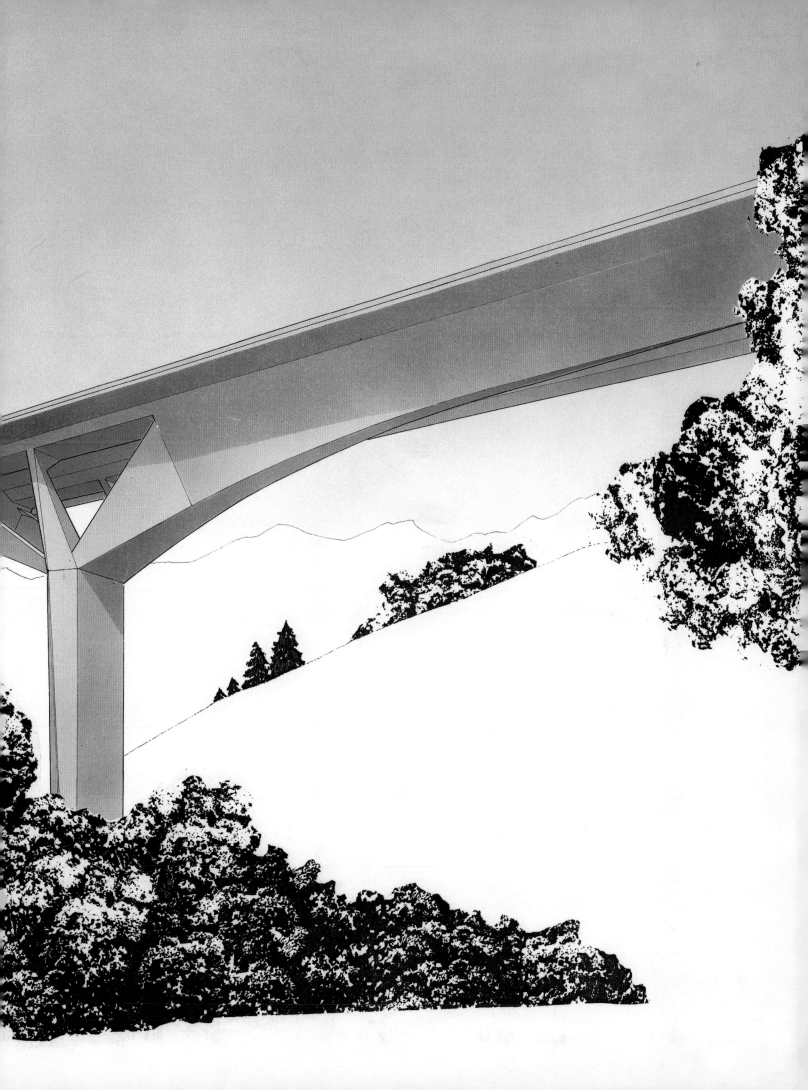

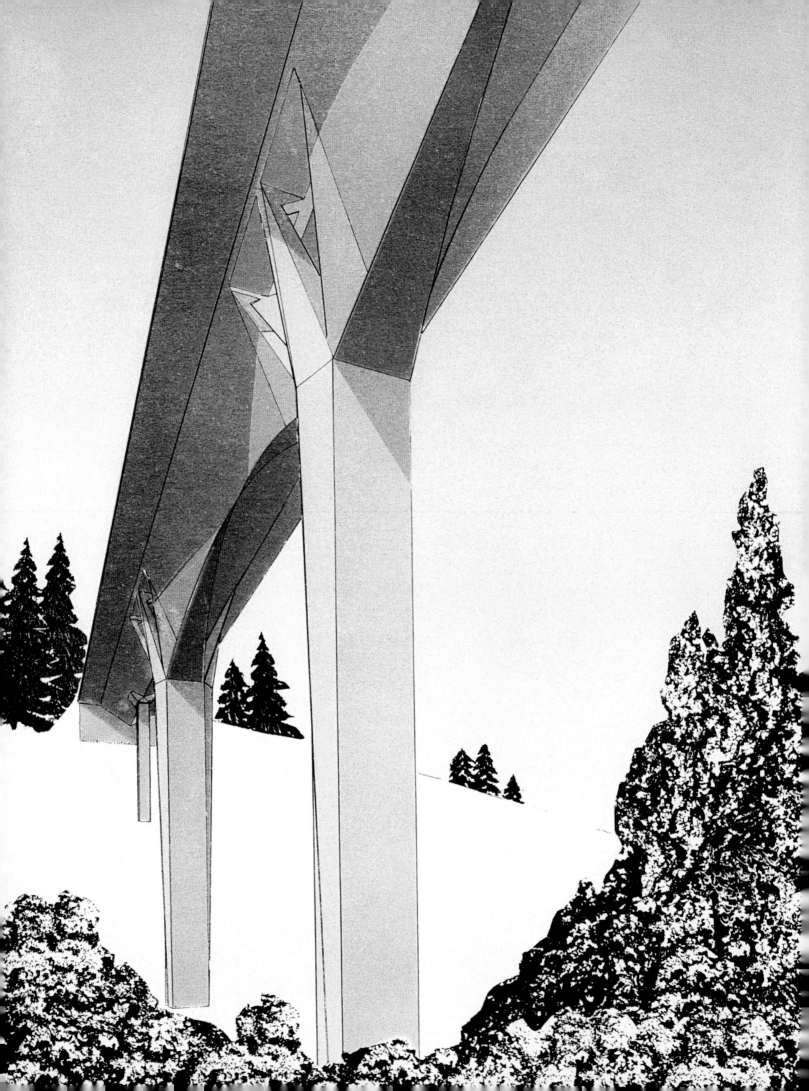

Project
ALPINE BRIDGES
Location
SWITZERLAND

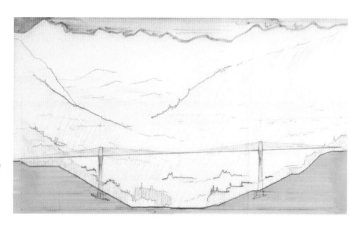

Calatrava was well aware of the engineering tradition of the ETH in Zurich and it is significant that one of his first published works is this series of bridges that in many ways take up where the famous Swiss engineer Robert Maillart left off.

Calatrava war sich der Ingenieurtradition der ETH in Zürich wohl bewusst, und es ist bezeichnend, dass eine seiner ersten publizierten Arbeiten in der Reihe von Brücken da weitermacht, wo der berühmte Schweizer Ingenieur Robert Maillart aufhörte.

Calatrava était très au fait des traditions d'ingénierie de l'ETH de Zurich et il est significatif que l'un de ses premiers travaux publiés ait été cette série de ponts qui, à de nombreux égards, reprend le problème là où l'ingénieur suisse Robert Maillart l'avait laissé.

Between 1973 and 1979, Santiago Calatrava designed a series of bridges that mark the beginnings of his career. Inspired by the Swiss mountains and the work of Robert Maillart (1872–1940), one of the most famous graduates of Zurich's ETH, he evolved toward progressively more daring and spectacular concepts. He describes this work in his own terms as follows: "After passing my architectural exams in Valencia, Spain, I enrolled at the Federal Institute of Technology (ETH) in Zurich, Switzerland, in 1973 to study civil engineering. I had spent many holidays visiting various regions of Switzerland and was fascinated by its beautiful mountain landscape. I had also developed an interest in the concrete bridges of Robert Maillart, whose work I had studied as an architecture student and which was primarily located in Switzerland."

WALENSEE BRIDGE
"During my third year of study, the 'Brückenbau' course (bridge construction) provided my first opportunity to design a bridge. The site, near Walensee, faced the beautiful Churfirsten Mountains. The exercise was to design a bridge spanning from a mountain tunnel across a ravine. My design proposed continuing the shape of the concrete tunnel shell, while permitting the sun to illuminate the roadway. I achieved this by cutting and modifying the shape of the tubular section to the structural requirements of the span. The tensile forces were carried over the pylon supports by the upper portion of the elliptical shell, while the compressive forces were taken along the road deck."

ACLETA BRIDGE
"In the spring of 1979 I commenced my thesis work at the ETH with a bridge design in Disentis, Switzerland. The location is a splendid Alpine area of the Vorderrhein valley on the way from Reichenau towards the Oberalppass. The road to Disentis crosses two impressive bridges. One designed by Robert Maillart in 1905 over the Rhine in Tavanasa; the other, the Lavina Tobel Bridge in Tamins, was designed by Max Bill in 1966. I initially produced two series of bridge designs. The first series was based on the classical concrete arch bridge designs of Maillart and variations on those principles. The second series followed my earlier explorations in 'free cantilever' bridges. This series of four variations to the 'free cantilever' model was primarily concerned with controlling the interacting forces contained at the pylon and deck connection, and allowing these forces to become the formal expression of the bridge. The third design variation looked to increase the structural efficiency of the method explored in the second variation. In order to produce longer free spans, I increased the static height of the pylon to deck connection by extend-

ing the lateral arms of the support pylon above the road deck. The tensile forces would therefore be transferred through cables embedded in the concrete pylon walls in a similar manner as that previously described for the Walensee Bridge. The fourth design variation, in contrast to the shell structure of the Walensee Bridge, proposed a reduction in the thickness of the pylon's lateral walls containing the embedded tension cables in an effort to create a prestressed concrete shell structure. This development proved to be a short step from removing the concrete shell in which the cables were embedded and leaving them exposed. I would explore this variation shortly."

BIASCINA VIADUCT
"After completing my thesis, and becoming a licensed Civil Engineer at the end of spring 1979, I worked as an assistant in the Architecture Department at the ETH. In order to study for her law exams, my wife and our son moved to her parents' house near Locarno, in southern Switzerland. I spent every weekend traveling by train from Zurich to Locarno and back. After passing through the Gotthard, the trains' spiral descent through the mountain tunnels to the valley below provided several stunning views of the Biascina Bridge, which was being built at the time for the transalpine Gotthard Highway. During these trips I began to sketch my own ideas for the design of this bridge. I applied the principles developed during my thesis explorations in 'free cantilever' design and realized a clear span of 300 meters by liberating the embedded tension cables from the prestressed concrete shells of the pylon supports."

SKETCHES FOR THE
IABSE SYMPOSIUM IN ZURICH
"During the fall semester of 1979, while I was working as an assistant in the Architecture Department at the ETH and writing my Ph. D. thesis, the International Association for Bridge and Structural Engineering (IABSE) decided to hold its 50th anniversary symposium in Zurich the following year. A professor in the Civil Engineering Department at the ETH, Mr. Christian Menn, was invited to speak on 'Modern Bridge Design and Construction.' He asked me to design a bridge that might be presented during his lecture. I presented him with several design variations for very tall pylon bridges that would make it possible to cross deep Alpine valleys, one of which was presented at the symposium. In these variations I explored the effects of different pylon cross sections, such as 'cross,' 'double T,' rhomboid, hexagonal, and whole box, as well as diverse methods of connecting the cables to the top of the pylon."

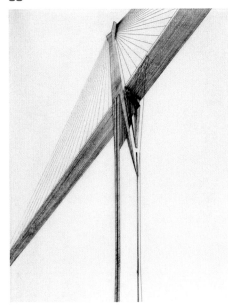 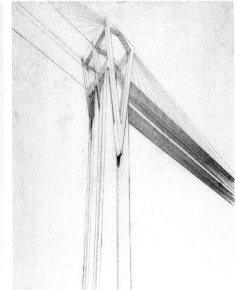 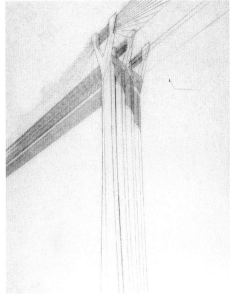

As Calatrava explains, his mastery of the requirements of engineering allows him to explore the gamut of shapes that can resist the forces applicable to such bridges. With his knowledge of fundamentals, he is left free to invent sculptural solutions to given problems.

Wie Calatrava erklärt, kann er dank seiner umfassenden technischen Kenntnisse die Skala der Formen ausschöpfen, die den auf solche Brücken einwirkenden Kräften standhalten können. Dies ermöglicht es ihm, plastische Lösungen zu erdenken.

Comme l'explique Calatrava, sa maîtrise des contraintes techniques lui permet d'explorer toute la gamme des formes susceptibles de résister aux forces engendrées par ce type de ponts. Sa connaissance le rend libre d'inventer des solutions sculpturales.

Die Anfänge von Santiago Calatravas Laufbahn als Architekt standen im Zeichen einer Reihe von Brückenentwürfen zwischen 1973 und 1979. Beflügelt von der schweizerischen Bergwelt und dem Werk Robert Maillarts (1872–1940), einem der berühmtesten Absolventen der ETH in Zürich, gerieten seine Konzepte zunehmend spektakulär. Er selbst beschreibt diese Arbeiten wie folgt: „Nachdem ich meine Architekturexamina in Valencia bestanden hatte, schrieb ich mich 1973 an der Eidgenössischen Technischen Hochschule in Zürich für Bauingenieurwesen ein. In vielen Ferien hatte ich die Schweiz bereist und war von der wunderbaren Bergwelt fasziniert. Außerdem interessierten mich die Betonbrücken Robert Maillarts, dessen überwiegend in der Schweiz befindliches Werk ich als Architekturstudent kennen gelernt hatte."

WALENSEE-BRÜCKE

„Während meines dritten Studienjahres gab mir der Kurs ‚Brückenbau' die erste Gelegenheit, eine Brücke zu entwerfen. Dem Baugelände in der Nähe des Walensees liegen die markanten Gipfel der Churfirsten gegenüber. Ich musste eine Brücke konzipieren, die sich von einem Bergtunnel über eine Schlucht spannte. Mein Entwurf sah vor, die Form des Tunnelgehäuses aus Beton fortzusetzen; außerdem sollte das Sonnenlicht auf die Straße fallen. Ich erreichte dies, indem ich die Form des Röhrenquerschnitts modifizierte, um sie den konstruktiven Erfordernissen der Öffnung anzupassen. Die Zugkräfte wurden durch den oberen Teil des elliptischen Gehäuses über die Stützpfeiler aufgenommen, während die Druckkräfte entlang der Straßendecke geführt wurden."

ACLETA-BRÜCKE

„Im Frühjahr 1979 begann ich meine Abschlussarbeit an der ETH mit einem Brückenentwurf in Disentis/Schweiz. Die Stelle liegt in einer großartigen, alpinen Region des Vorderrheintales auf dem Weg von Reichenau zum Oberalppass. Die Straße nach Disentis überquert zwei imposante Brücken. Die eine, 1905 von Robert Maillart entworfen, überspannt den Rhein bei Tavanasa, während die Lavina-Tobel-Brücke in Tamins 1966 von Max Bill geplant wurde. Zu Anfang konzipierte ich zwei Serien von Brückenentwürfen: Die erste Serie fußte auf der klassischen Betonbogenbrücke Maillarts und Abwandlungen dieser Grundregeln. Für die zweite Serie mit vier Variationen zog ich meine früheren Versuche mit freitragenden Auslegerbrücken heran. Dabei ging es in erster Linie darum, die in der Pfeiler- und Tafelverbindung enthaltenen, interagierenden Kräfte, die der Brücke ihr Gesicht geben, zu beherrschen. Die dritte Entwurfsvariante sollte nach Möglichkeit die konstruktive Effizienz der zuvor ausgeloteten Methode steigern. Um größere Spannweiten zu

erreichen, steigerte ich die statische Höhe der Pfeiler-Tafelverbindung, indem ich die Seitenarme des Stützpfeilers über der Straßentafel verlängerte. Ähnlich wie zuvor bei der Walensee-Brücke beschrieben, würden die Zugkräfte daher durch in die Betonwände des Pfeilers eingebettete Seile übertragen. Im Gegensatz zur Gehäusekonstruktion der Walensee-Brücke sah die vierte Entwurfsvariante vor, die Stärke der Seitenwände des Stützpfeilers mit den eingebetteten Seilen zu reduzieren, um eine Spannbetonschalenkonstruktion zu schaffen. Von dieser Entwicklung war es nicht mehr weit bis zur Entfernung der Betonumhüllung der Seile, die dann frei sichtbar wären. Ich sollte diese Variante kurze Zeit später erproben."

BIASCINA-VIADUKT

„Nachdem ich im Frühjahr 1979 meine Abschlussarbeit beendet und die Prüfung zum Bauingenieur abgelegt hatte, war ich als Assistent an der Architekturabteilung der ETH tätig. Meine Frau musste sich damals auf ihre juristischen Examina vorbereiten und zog deshalb mit unserem Sohn ins Haus ihrer Eltern bei Locarno im Süden der Schweiz. Ich fuhr in dieser Zeit an jedem Wochenende mit dem Zug von Zürich nach Locarno und zurück. Nach dem Passieren des Gotthard eröffneten sich auf der kurvenreichen Talfahrt durch zahllose Tunnel einige fantastische Ausblicke auf die Biascina-Brücke, die damals für die transalpine Gotthardstraße gebaut wurde. Auf diesen Reisen begann ich, meine eigenen Ideen für die Gestaltung dieser Brücke zu skizzieren. Ich wendete die für meine Abschlussarbeit entwickelten Prinzipien für freitragende Auslegerkonstruktionen an und realisierte eine freie Spannweite von 300 m, indem ich die ummantelten Spannseile von den Spannbetonhülsen der Pylonenstützen befreite."

ENTWÜRFE FÜR DAS IABSE-SYMPOSIUM IN ZÜRICH

„Im Lauf des Herbstsemesters 1979, während ich als Assistent am Fachbereich Architektur der ETH an meiner Doktorarbeit schrieb, entschied die International Association for Bridge and Structural Engineering (IABSE), das Symposium zur Feier ihres 50-jährigen Bestehens im folgenden Jahr in Zürich zu veranstalten. Man hatte Christian Menn, Professor im Fachbereich Bauingenieurwesen der ETH, eingeladen, über das Thema ‚Modern Bridge Design and Construction' zu sprechen. Er bat mich, eine Brücke zu entwerfen, die er während seines Vortrags vorstellen könnte. Ich legte ihm mehrere Entwürfe für sehr hohe Pylonenbrücken über tiefe Alpentäler vor. Einer davon wurde bei dem Symposium gezeigt. Mit diesen Varianten erforschte ich die Auswirkungen verschiedener Pylonen-Querschnitte, wie Kreuz, Doppel-T, Raute, Hexagon und Viereck, sowie verschiedene Methoden, die Seile mit der Spitze des Pylons zu verbinden."

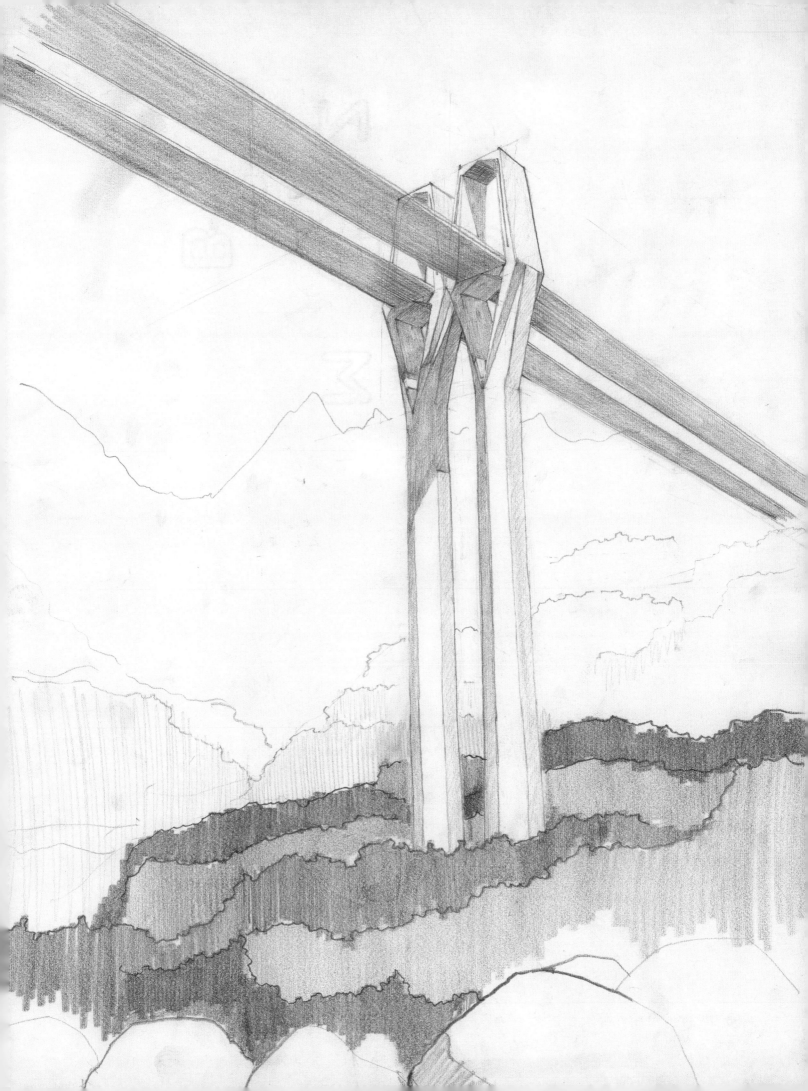

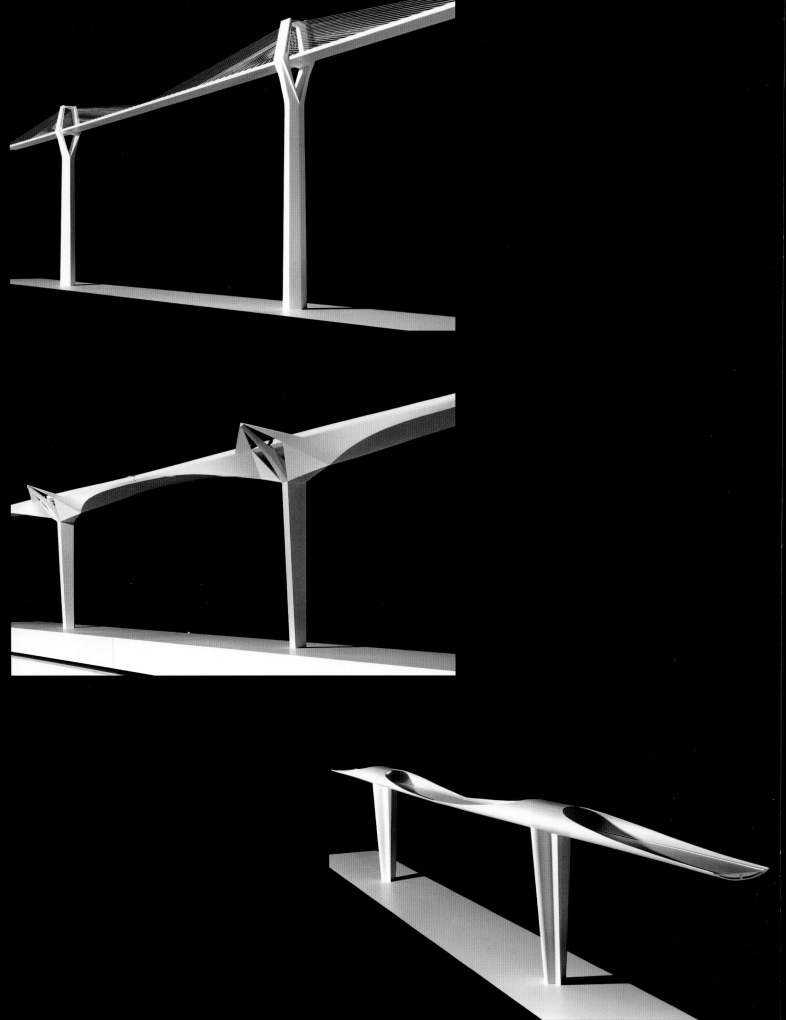

Although it would appear that Calatrava's earlier sketches had a more summary character than his more recent work, the idea of the lightness and broad span of the bridge seen to the right is clearly in his mind—an indication of his future design goals.
Collection Tom F. Peters

Obwohl Calatravas frühere Skizzen summarischer erscheinen mögen als seine jüngeren Arbeiten, ist die Idee der Leichtigkeit und einer großen Spannweite der Brücke (rechts) offensichtlich Thema – ein Hinweis auf seine späteren Entwurfsziele.
Collection Tom F. Peters

Bien qu'il semble que les croquis anciens de Calatrava possèdent un caractère plus sommaire que ceux réalisés pour ses œuvres plus récentes, il avait déjà en tête l'idée de légèreté et de grande portée comme le montre le pont illustré à droite – indication sur ses futurs objectifs conceptuels.
Collection Tom F. Peters

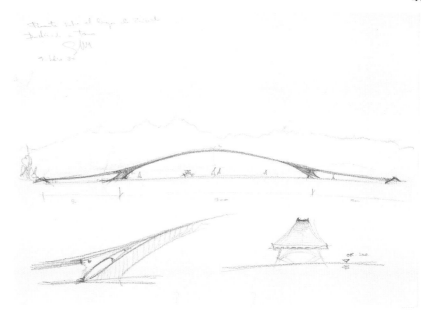

De 1973 à 1979, Calatrava conçut une série de ponts qui marquent les débuts de sa carrière. Inspiré par les montagnes suisses et l'œuvre de Robert Maillart (1872–1940) l'un des plus fameux diplômés de l'ETH de Zurich, il évolua peu à peu vers des concepts de plus en plus audacieux et spectaculaires. Il décrit ainsi ces ouvrages : « Après avoir obtenu mon diplôme d'architecte à Valence (Espagne), je me suis inscrit à l'Institut fédéral de technologie de Zurich (ETH), en 1973, pour étudier le génie civil. J'avais déjà passé plusieurs fois des vacances en Suisse et visité diverses régions. J'étais fasciné par la beauté des paysages alpins. Je m'étais également intéressé aux ponts en béton de Robert Maillart (pour la plupart en Suisse), dont j'avais étudié l'œuvre quand j'étais étudiant. »

PONT DU WALENSEE

« Au cours de ma troisième année d'études, le cours de construction de ponts (*Brückenbau*) m'offrit l'opportunité d'en dessiner un pour la première fois. Le site, près du Walensee, faisait face au superbe massif des Churfisten. L'exercice consistait à imaginer un ouvrage franchissant un ravin au sortir d'un tunnel. Mon projet proposait de prolonger la forme de la coque en béton du tunnel, tout en laissant le soleil éclairer la route. J'y suis parvenu en coupant et modifiant la section tubulaire en fonction des contraintes structurelles imposées par la portée. Les forces de traction étaient transférées aux supports du pylône par la partie supérieure de la coque elliptique, et les forces de compression réparties le long du tablier. »

PONT D'ACLETA

« J'ai commencé ma préparation de thèse à l'ETH au printemps 1979 par un projet de pont à Disentis, en Suisse. Il s'agissait d'une magnifique région de la vallée du Haut-Rhin, entre Reichenau et l'Oberalppass. La route pour Disentis franchit deux ponts impressionnants, l'un dessiné par Robert Maillart en 1905 pour franchir le Rhin à Tavanasa, l'autre, le pont de Lavina Tobel à Tamins, conçu par Max Bill en 1966. Au départ, je proposai deux séries de projets. La première s'appuyait sur les principes de ponts à arche classiques en béton de Maillart et quelques variations sur ce concept. La seconde était dans la ligne de mes explorations antérieures de ponts en ‹ porte-à-faux libre ›. Cette série de quatre variantes consistait d'abord dans le contrôle des forces interactives qui œuvraient à la connexion entre le pylône et le tablier pour leur permettre de se transformer en expression formelle du pont. La troisième proposition visait à accroître l'efficacité structurelle de la méthode explorée dans la seconde. Pour obtenir des portées plus longues, j'augmen-

tai la hauteur statique de la connexion pylône-tablier en étendant les bras latéraux du pylône de soutien par-dessus le tablier. Les forces de traction seraient alors transférées par des câbles noyés dans les parois en béton du pylône de manière similaire à celle décrite pour le pont du Walensee. La quatrième variante, par contraste avec la structure en coque du pont du Walensee, proposait de réduire l'épaisseur des parois latérales du pylône contenant les câbles en tension pour créer une structure en coque de béton précontraint. Ce développement n'était pas loin de supprimer la coque de béton dans laquelle les câbles étaient insérés et de les rendre apparents, ce que j'allais bientôt étudier. »

VIADUC DE BIASCINA

« Après avoir soutenu ma thèse et être devenu ingénieur civil diplômé à la fin du printemps 1979, j'ai travaillé comme assistant au département d'architecture de l'ETH. Pour se préparer à ses examens de droit, ma femme emménagea avec notre fils dans la maison de ses parents près de Locarno, en Suisse méridionale. Chaque week-end, je faisais l'aller-retour en train entre Zurich et Locarno. Après avoir franchi le Gothard, la descente en zigzag vers la vallée à travers une série de tunnels offrait des vues stupéfiantes sur le pont de Biascina que l'on construisait en même temps que l'autoroute transalpine du Gothard. Au cours de ces voyages, j'ai commencé à tracer des croquis à partir de mes idées personnelles sur cet ouvrage. J'ai appliqué les principes mis au point lors des recherches exploratoires pour ma thèse sur les ‹ porte-à-faux libres ›, et réalisé une portée sans soutien de 300 mètres en dégageant les câbles des coques en béton précontraint des pylônes. »

CROQUIS POUR LE SYMPOSIUM DE L'IABSE À ZURICH

« À l'automne 1979, alors que je travaillais comme assistant à l'ETH et rédigeais ma thèse de doctorat, l'International Association for Bridge and Structural Engineering (IABSE) décida de tenir le symposium de son cinquantième anniversaire à Zurich l'année suivante. Un professeur du département de génie civil de l'ETH, Christian Menn, m'invita à y parler de « La conception et la construction de ponts modernes ». Il me demanda de concevoir un exemple qui pourrait être présenté à l'occasion de cette conférence. Je lui soumis plusieurs variantes d'un projet d'ouvrage à très hauts pylônes qui permettrait de franchir les vallées alpines. L'une fut présentée au symposium. J'y explorais les effets de différentes sections de pylônes comme la croix, le ‹ double-T ›, l'ovale, l'hexagone et la boîte, ainsi que diverses méthodes pour connecter les câbles au sommet du pylône. »

A concern for great simplicity and elegance is seen in these two sketches, one dealing with the problem of curvature and the other with great height in the support pylons. As always, Calatrava takes into account the fundamental engineering required to attain such a reduced form of expression.
Collection Tom F. Peters

In diesen beiden Skizzen sieht man, welche Rolle Einfachheit und Eleganz spielen, die eine zeigt das Problem der Krümmung, die andere die enorme Höhe der Stützpylone. Wie immer berücksichtigt Calatrava die grundlegende Technik, die erforderlich ist, um solch klaren Ausdruck zu erzielen.
Collection Tom F. Peters

Le souci de grande simplicité et d'élégance se remarque dans ces deux croquis, l'un traitant du problème d'une courbe et l'autre de la hauteur des pylônes. Comme toujours, Calatrava prend en compte les principes fondamentaux de l'ingénierie pour atteindre à une forme d'expression aussi concentrée que possible.
Collection Tom F. Peters

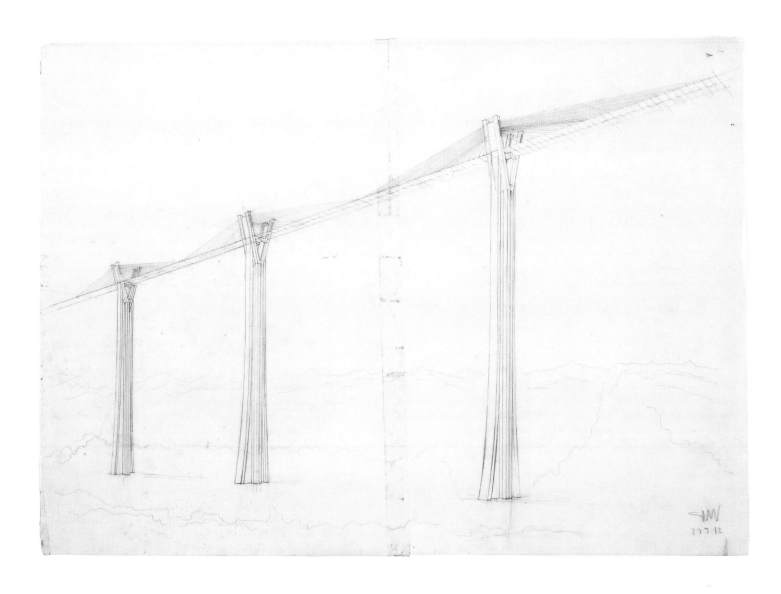

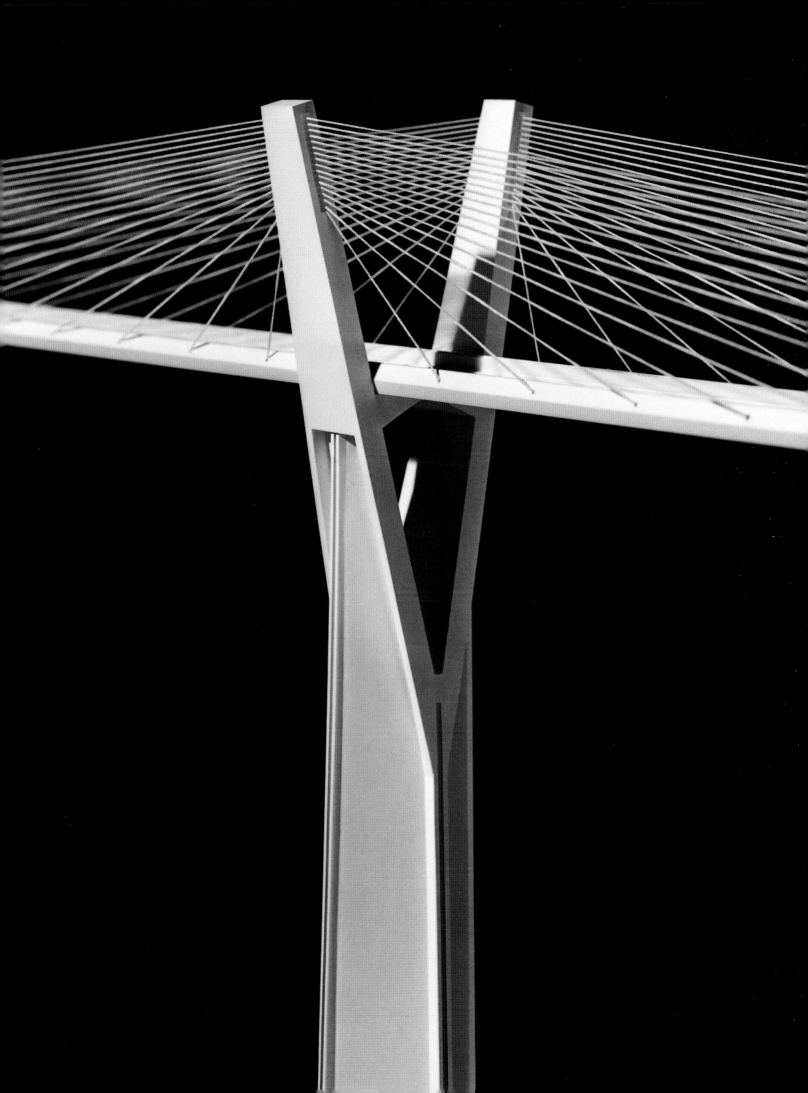

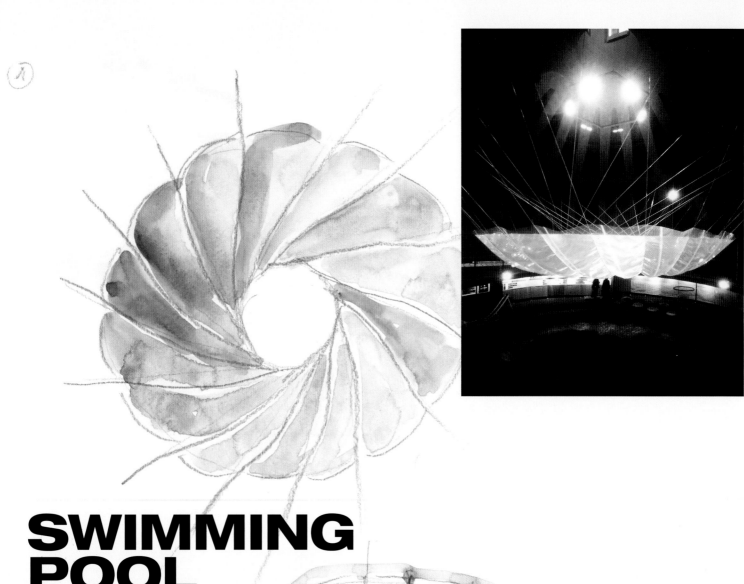

SWIMMING POOL

Zurich, Switzerland. 1980.

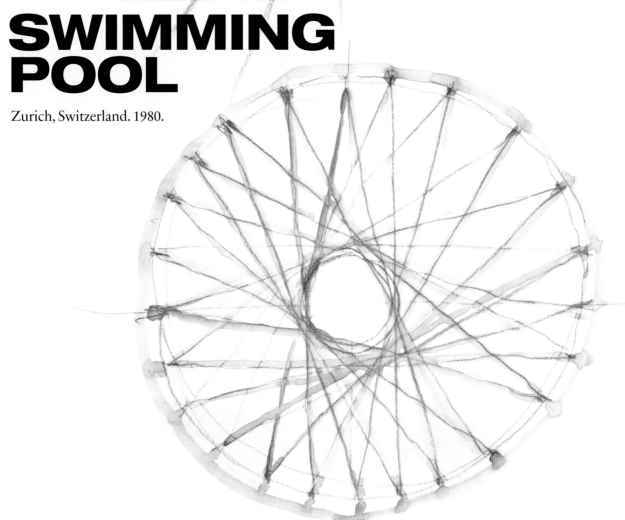

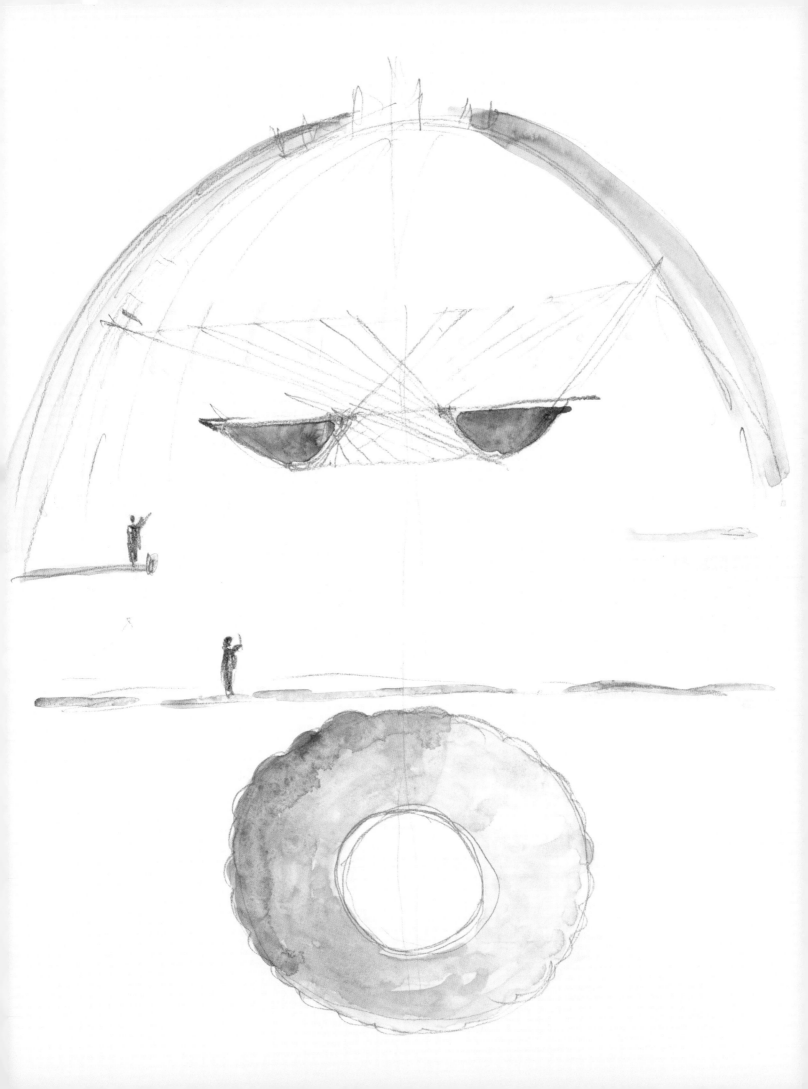

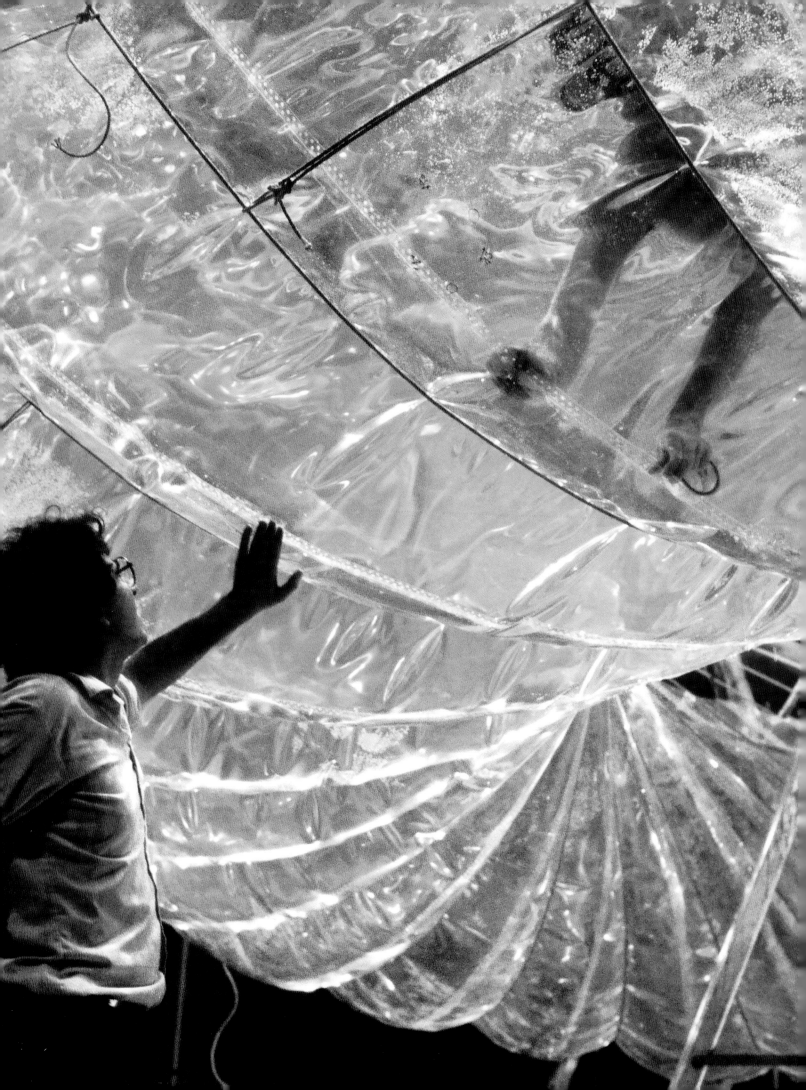

Project
SWIMMING POOL
Location
ETH ZURICH, SWITZERLAND

The very idea of creating an ephemeral swimming pool made of plastic that hangs in the air was a radical one indeed, an indication that Santiago Calatrava would not follow an ordinary path in the world of architecture.

Schon die Idee, ein in der Luft hängendes, temporäres Schwimmbecken aus Plastik zu gestalten, war in der Tat radikal, Hinweis darauf, dass Santiago Calatrava in der Welt der Architektur keinen ausgetretenen Pfad zu beschreiten gedachte.

L'idée même d'une piscine éphémère en plastique suspendue dans les airs laissait présager, par son radicalisme, que Calatrava ne suivrait pas une voie toute tracée dans le monde de l'architecture.

Santiago Calatrava's own description of this project may be the best, recorded during an interview in Zurich in February 2006. "A group of students came to me when I was teaching at the ETH, and asked for my help with a project that had to do with the use of plastics. We decided to create a swimming pool that could be suspended from the 24 rings around the cupola of the professors' lounge at the ETH. We worked with models made by pouring liquid plaster into molds, and at first this gave a form much like a sausage, but we wanted a more precisely mathematical shape, so we started over and over again. By using mathematical calculations, I deduced a form very similar to that which evolved from the physical experiments. At the time we had only a very rudimentary computer, but we used it to calculate the form of the necessary plastic sheets. We found a company willing to give us polycarbonate sheets for a reasonable price, and I went to the Federal Institute that does research on materials. There I conducted a number of experiments that lead us to use a form of ultrasonic welding for the plastic. When we filled the welded sheets with water, there were leaks all over. The idea was to be able to take a swim, suspended above the lounge, and since there were book and magazine stacks below, leaks were potentially a major problem. So too was the solidity of the shell—bathers certainly would not be able to stand up, concentrating too much weight on any given point. Despite the use of mathematics and experimentation, there was a strong element of transgression in this project. We decided that anyone who wanted to swim would have to do so naked, adding an unexpected element of Eros to the equations. The concept was purely abstract and gratuitous—to take a bath naked in space. Curiously, when you create an object like this, it takes on a life of its own, with the reflections, shadows, and light. Architecture will never cease to amaze me."

Santiago Calatravas eigene Beschreibung dieses Projekts ist vermutlich die beste, festgehalten während eines Interviews im Februar 2006 in Zürich. „Als ich an der ETH unterrichtete, kamen einige Studenten zu mir und baten um meine Hilfe bei einem Projekt, das mit der Nutzung von Kunststoff zu tun hatte. Wir beschlossen, ein Schwimmbecken zu gestalten, das an den 24 Ringen um die Kuppel des Aufenthaltsraums der Professoren aufgehängt werden konnte. Wir arbeiteten mit Modellen, die wir anfertigten, indem wir flüssigen Gips in Formen gossen. Anfangs entstanden dabei wurstähnliche Gebilde, aber wir wollten eine mathematisch präzisere Form, also fingen wir immer wieder von vorne an. Mithilfe mathematischer Berechnungen kam ich zu einer Form, die der experimentell geschaffenen sehr ähnlich war. Damals verfügten wir nur über einen sehr unzureichenden Computer, aber wir berechneten mit ihm die Form der benötigten Plastikplanen. Wir fanden eine Firma, die willens war, uns Polycarbonatfolien zu einem moderaten Preis zu überlassen, und ich ging zu dem für Materialforschung zuständigen staatlichen Institut. Dort führte ich einige Experimente durch, die uns dazu veranlassten, den Kunststoff mit einer Art Ultraschall-Schweißgerät zu verbinden. Als wir die verschweißten Folien mit Wasser füllten, entstanden überall undichte Stellen. Die Idee war, über dem Aufenthaltsraum schwebend schwimmen zu können, und da unten Bücher- und Zeitschriftenregale standen, wären Leckagen problematisch gewesen. Ebenso verhielt es sich mit der Festigkeit der Kuppelschale – die Schwimmer hätten sich ganz sicher nicht hinstellen können, da sich dadurch zuviel Gewicht auf einem Punkt konzentriert hätte. Ungeachtet des Einsatzes mathematischer und experimenteller Methoden, gab es bei diesem Projekt ein starkes Element von Transgression. Wir entschieden, dass man nur nackt schwimmen können sollte und erweiterten die Gleichung damit um ein unerwartetes erotisches Element. Der Gedanke war rein abstrakt und überflüssig – nackt im Raum ein Bad zu nehmen. Komischerweise entwickelt ein solches Objekt ein Eigenleben, mit Reflexionen, Schatten und Licht. Architektur wird nie aufhören, mich zu verblüffen."

La description de ce projet donnée par Santiago Calatrava lors d'un entretien à Zurich en février 2006 est particulièrement instructive : « Un groupe d'étudiants vint me voir alors que j'enseignais à l'ETH et me demanda de l'aider pour un projet sur l'utilisation des plastiques. Nous avons décidé de créer une piscine suspendue par vingt-quatre anneaux à la coupole de la salle des professeurs de l'ETH. Nous avons travaillé sur des maquettes fabriquées en versant du plâtre liquide dans des moules, ce qui donna au début une forme de saucisse, mais nous souhaitions une forme plus précisément mathématique et avons recommencé plusieurs fois. Par des calculs mathématiques, je suis arrivé à une forme très similaire à celle obtenue avec ces expériences physiques. Nous ne disposions alors que d'un ordinateur très rudimentaire, mais qui nous a permis de calculer la découpe des feuilles de plastique nécessaires. Nous avons trouvé une entreprise disposée à nous céder des feuilles de polycarbonate pour un prix raisonnable et je suis allé à l'Institut fédéral qui pratique des recherches sur les matériaux. J'ai réalisé un certain nombre d'expériences qui nous ont amenés à choisir la soudure du plastique par ultrasons. Lorsque nous avons rempli d'eau les feuilles soudées ensemble, il y avait des fuites de tous les côtés. L'idée était de pouvoir se baigner dans un bassin suspendu au-dessus de la salle et comme il y avait des livres et des magazines juste au-dessous, ces fuites représentaient un sérieux problème. La solidité de la coque en était un autre, les baigneurs ne pouvant pas se tenir debout sur le fond afin de ne pas concentrer trop de poids en un seul point. Malgré le recours aux mathématiques et à l'expérimentation, ce projet ne manquait pas d'aspects transgressifs. Nous avons décidé que les nageurs devraient être nus, ajoutant ainsi un élément érotique inattendu à l'équation. Le concept était purement abstrait et gratuit : prendre un bain nu dans l'espace. Curieusement, la création d'un objet de ce genre a pris peu à peu une existence en soi, avec ses reflets, ses ombres et ses lumières. L'architecture ne cessera jamais de m'étonner. »

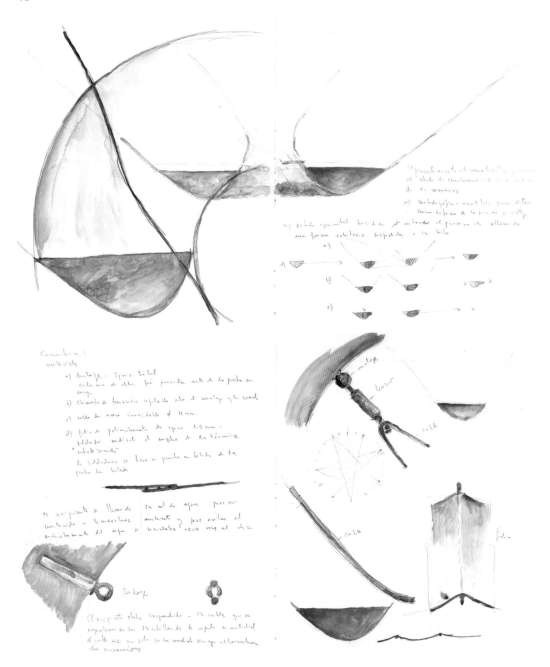

Calatrava's sketches deal in an apparently aesthetic way with the idea of a suspended swimming pool, yet a closer examination reveals that he is in fact dealing with the technical problems posed by the project.

Calatravas Skizzen setzen sich in augenscheinlich ästhetischer Weise mit der Idee eines hängenden Schwimmbeckens auseinander, wohingegen eine nähere Betrachtung ergibt, dass er sich in Wirklichkeit mit den technischen Problemen des Projekts beschäftigt.

Ces croquis de la piscine suspendue relèvent apparemment de l'esthétique, mais un examen plus minutieux nous apprend que Calatrava y étudie, en fait, les problèmes techniques posés par le projet.

Hanging at the limits of lightness in the seeming incongruity of a transparent, pliable swimming pool floating in space, volunteers took their swim without bathing suits.

In den Grenzregionen der Unbeschwertheit, der scheinbaren Widersinnigkeit eines transparenten, flexiblen, im Raum schwebenden Schwimmbeckens treibend, nehmen Freiwillige ein hüllenloses Bad.

Défiant les limites de la pesanteur et ne redoutant pas l'apparente absurdité de leur situation, des volontaires se sont baignés sans maillot dans une piscine transparente et pliable suspendue dans l'espace.

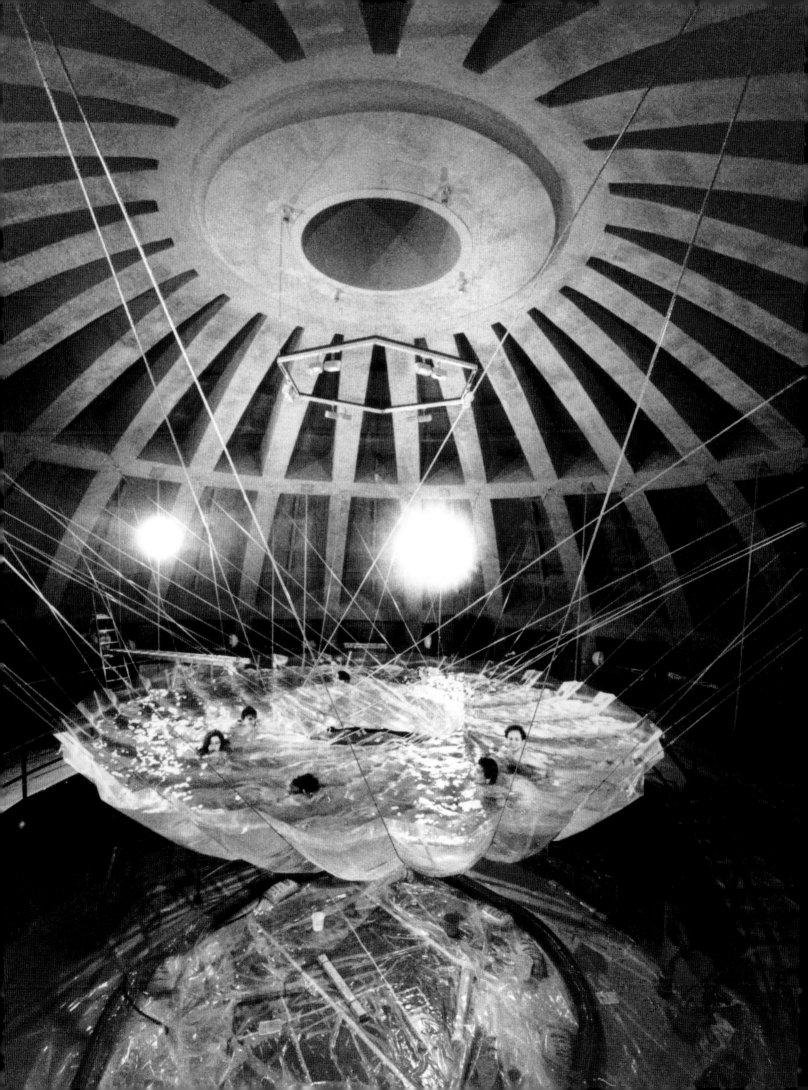

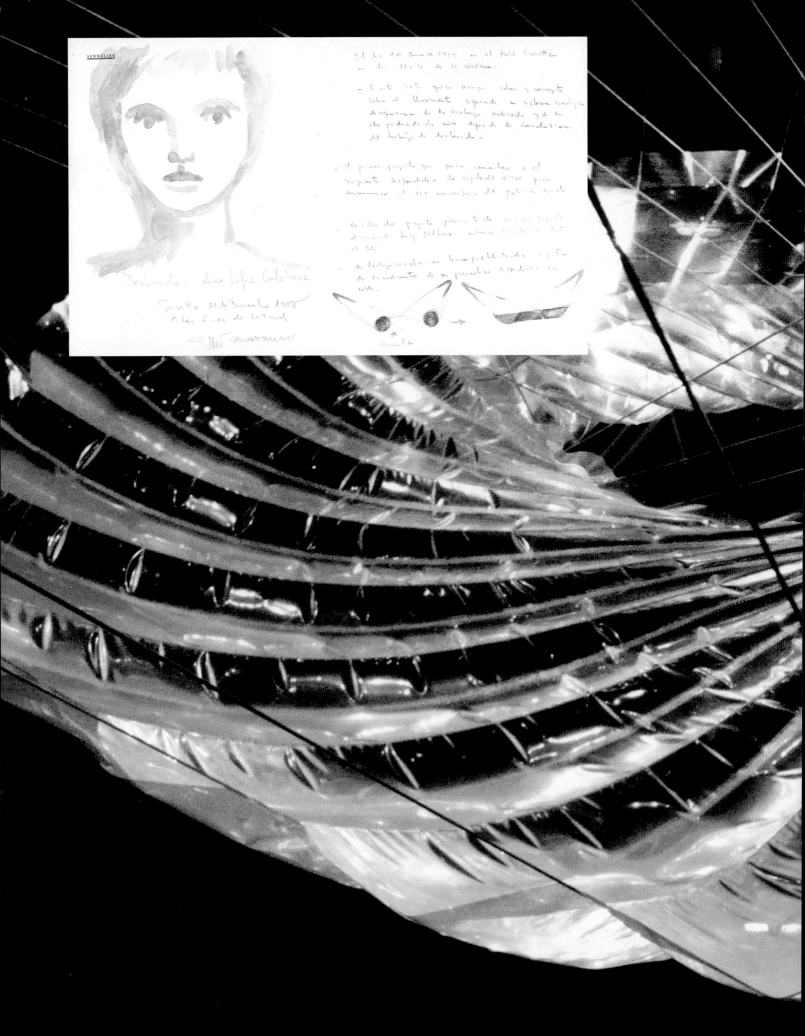

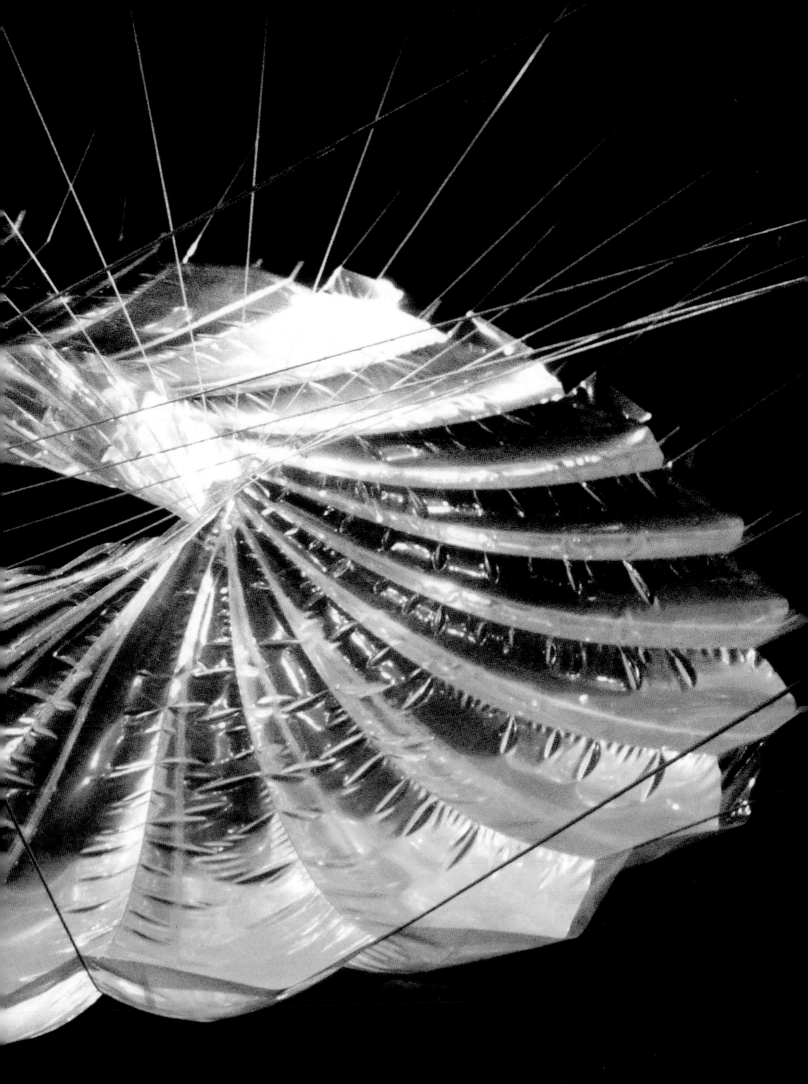

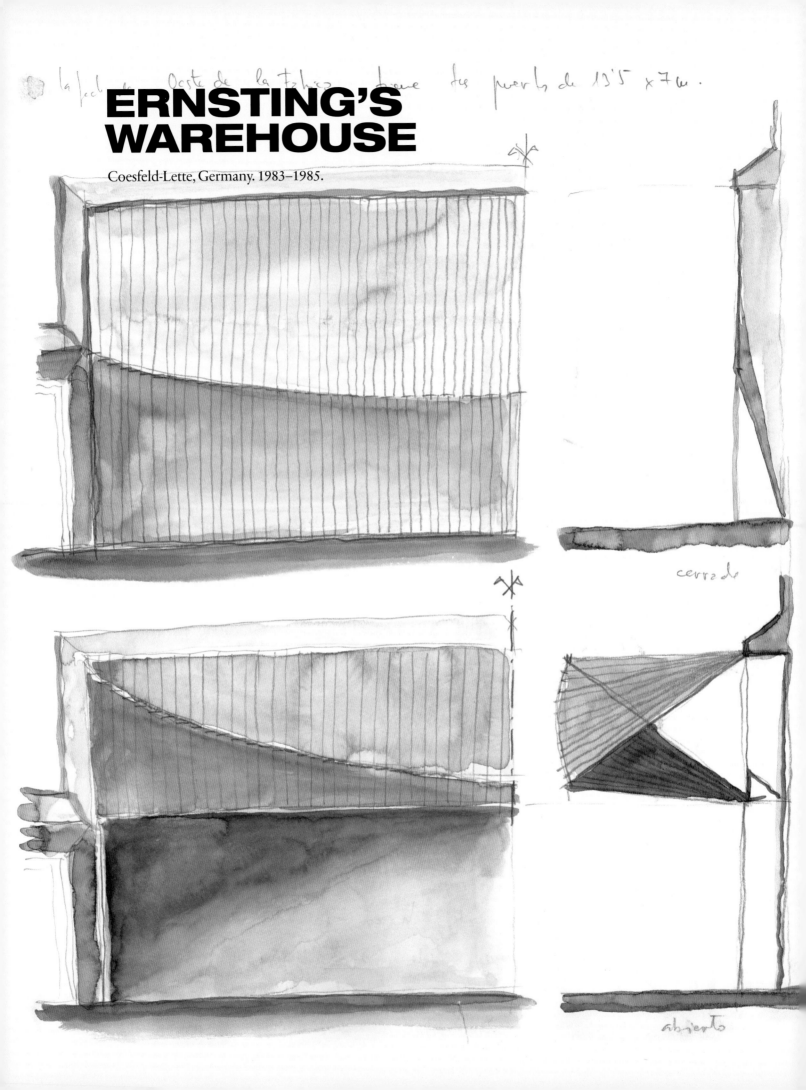

ERNSTING'S WAREHOUSE

Coesfeld-Lette, Germany. 1983–1985.

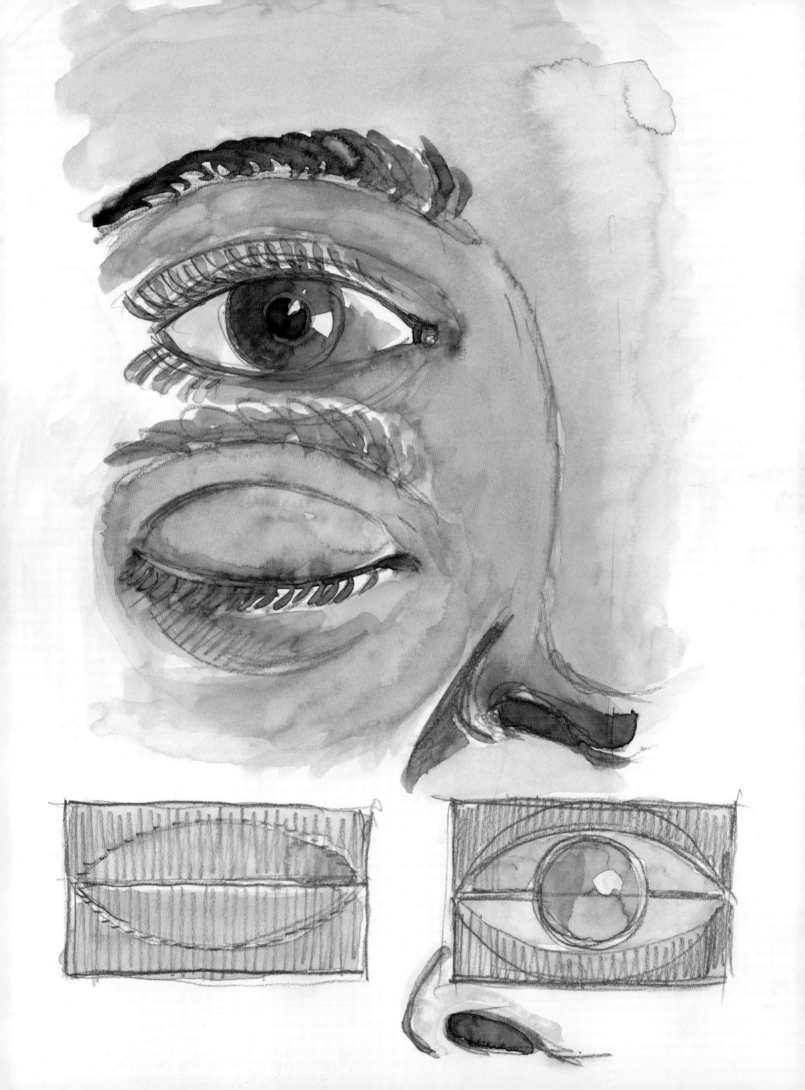

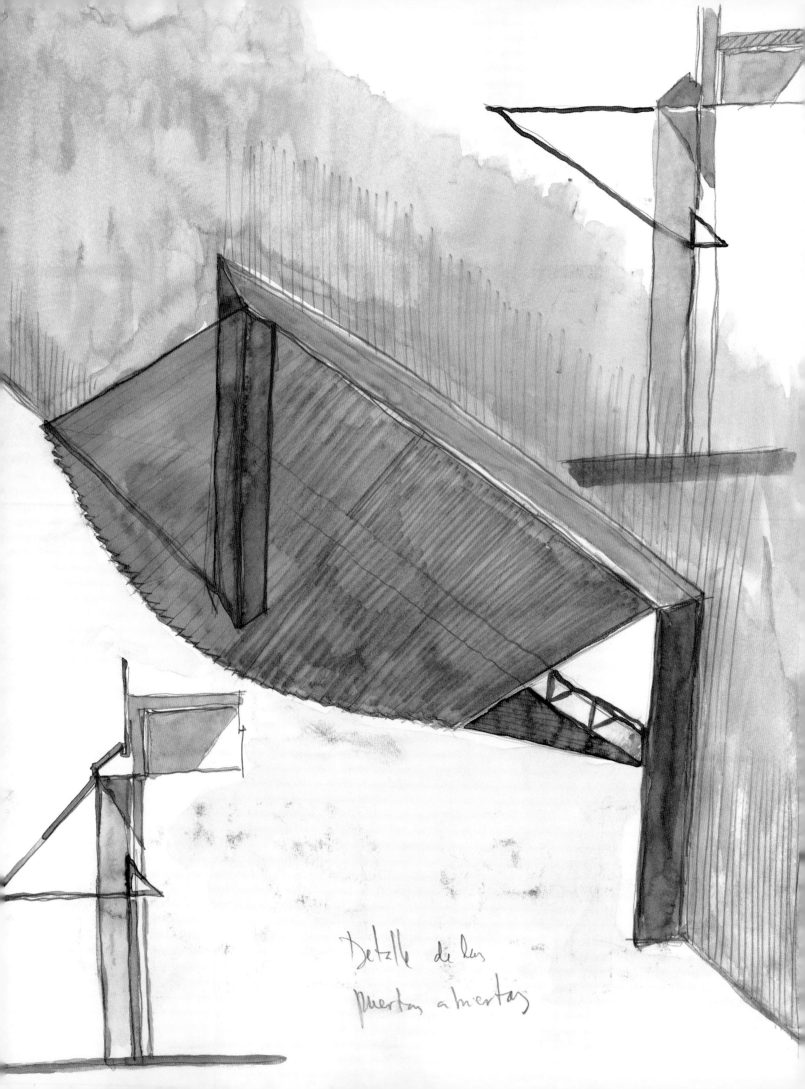

Detalle de las
puertas abiertas

Project
ERNSTING'S WAREHOUSE
Location
COESFELD-LETTE, GERMANY
Client
ERNSTING'S COMPANY

One fact that sets Santiago Calatrava apart from other architects and engineers is that even relatively technical drawings such as this sketch for the Ernsting's cargo door become works of art, giving an attractive appearance to a detail that would usually be expressed in a much drier form.

Ein Umstand, der Calatrava von anderen Architekten und Ingenieuren unterscheidet, ist, dass selbst eher technische Zeichnungen, wie seine Skizze des Ladetores der Firma Ernsting's zu Kunstwerken werden, die einem Detail, das üblicherweise staubtrocken dargestellt wird, ein reizvolles Erscheinungsbild verleihen.

L'un des points qui distinguent Calatrava des autres architectes et ingénieurs est que, même des dessins relativement techniques comme ce croquis des portes de l'entrepôt Ernsting's, deviennent des œuvres d'art et confèrent un aspect séduisant à des détails généralement exprimés de façon beaucoup plus sèche.

Santiago Calatrava's fascination with human or natural form and function is clearly part of his design process. This interest has led him to create bridges that have been described in terms of "frozen movement," but has also inspired him to actually introduce movement into some of his buildings. Then, too, his drawings and sculptures participate actively in the search for innovative solutions. All of these elements are present in the Ernsting's Warehouse, which he was commissioned to complete after an invited competition involving Fabio Reinhardt and Bruno Reichlin. Ernsting's is a well-known German clothing manufacturer with a reputation for seeking quality in its working environments. In the case of the Coesfeld-Lette campus, the warehouse that Calatrava worked on in the 1980s is now located opposite a more recent structure by David Chipperfield, the Service Center (1998–2001), an elegant minimalist design surrounded by a garden conceived by the noted Belgian landscape architects Jacques and Peter Wirtz. Calatrava worked with an initial warehouse form proposed by Gerzi, a specialist in facilities for the textile industry. He decided to cover the Gerzi structure with untreated aluminum, a typical industrial material, seeking to make each façade different while maintaining the overall unity imposed by the cladding. The aluminum is treated according to light patterns, corrugated on the south where it "responds to sunlight as if it were a giant sculpture," or with a specially formed S-profile on the north where the façade receives only midday sun. The most surprising feature suggested by Calatrava is to be found in the form of the three large loading bay doors, measuring 13 x 5 meters. The hinged aluminum ribs rise to form a concave arch as they open, creating canopies. A sculpture by Calatrava with a "form based on the human eye" was part of the design process. "Here," says the architect, "the form became an experiment in kinetics, used to investigate the mechanical transformation of planes in a building."

Die Faszination, die menschliche oder naturgegebene Formen und Funktionen auf Santiago Calatrava ausüben, ist eindeutig Teil seiner Entwurfsarbeit. Dieses Interesse führte dazu, dass er Brücken konzipierte, die als „gefrorene Bewegung" beschrieben wurden, inspirierte ihn aber auch, Bewegung tatsächlich in einige seiner Bauten zu integrieren. Darüber hinaus sind seine Zeichnungen und Skulpturen Teil seiner Suche nach innovativen Lösungen. Alle diese Elemente sind im Lagerhaus der Firma Ernsting's präsent, mit dessen Fertigstellung er im Anschluss an einen geschlossenen Wettbewerb mit Beteiligung von Fabio Reinhardt und Bruno Reichlin beauftragt wurde. Bei der Firma Ernsting's handelt es sich um einen namhaften Hersteller von Bekleidung, der auf die Qualität seiner Arbeitsplätze Wert legt. Dem Lagerhaus in Coesfeld-Lette, an dem Calatrava in den 1980er-Jahren arbeitete, steht jetzt ein neuerer Bau von David Chipperfield gegenüber. Bei diesem Servicezentrum (1998–2001) handelt es sich um ein elegantes, minimalistisches Gebäude, umgeben von einer Gartenanlage, die von den bekannten belgischen Landschaftsarchitekten Jacques und Peter Wirtz gestaltet wurde. Calatrava musste mit einer vorgegebenen Lagerhausform von Gerzi arbeiten, einem Spezialisten für Bauten der Textilindustrie. Er entschied, den Gerzi-Bau mit unbehandeltem Aluminium, einem typischen Industriematerial, zu ummanteln. Dabei war er bemüht, jede Fassade anders zu gestalten und dabei doch die von der Verkleidung vorgegebene Einheitlichkeit zu wahren. Das Aluminium ist dem Lichteinfall entsprechend behandelt, gewellt auf der Südseite, wo es „auf Sonnenlicht wie eine riesige Skulptur reagiert", und mit einem speziell geformten S-Profil auf der Nordseite, wo die Fassade nur zur Mittagszeit Licht erhält. Das überraschendste von Calatrava entworfene Detail betrifft die Form der drei breiten, 13 x 5 m großen Tore der Laderampen. Die schwenkbaren Aluminiumrippen erheben sich beim Öffnen zu einem konkaven Bogen und bilden Vordächer. Eine Skulptur Calatravas mit einer „auf dem menschlichen Auge basierenden Form" beeinflusste seinen Entwurfsprozess. „Hier", sagt der Architekt, „wurde die Form zu einem kinetischen Experiment, das genutzt wurde, um die mechanische Transformation von Flächen in einem Gebäude zu erkunden."

La fascination de Calatrava pour les formes et les fonctions humaines ou naturelles appartient de toute évidence à son processus de conception. Cet intérêt l'a conduit à créer des ponts au sujet desquels on a pu parler de « mouvement figé », mais aussi à introduire vraiment le mouvement dans certains de ses projets de bâtiments. Ses dessins et ses sculptures participent activement à sa recherche de solutions innovantes. Tous ces éléments sont présents dans l'entrepôt Ernsting's dont il reçut commande à l'issue d'un concours restreint auquel participèrent Fabio Reinhardt et Bruno Reichlin. Ernsting's est un fabricant de vêtements allemand très réputé, connu pour rechercher une certaine qualité dans ses lieux de travail. L'entrepôt de la zone d'activités de Coesfeld-Lette, conçu par Calatrava dans les années 1980, se trouve aujourd'hui en face d'une structure plus récente, le Centre de services (1998–2001) signé David Chipperfield, élégante réalisation minimaliste entourée d'un jardin conçu par les célèbres paysagistes belges Jacques et Peter Wirtz. Calatrava a travaillé sur un bâtiment initial de Gerzi, un spécialiste des installations pour l'industrie textile. Il décida d'habiller cette structure d'aluminium brut, matériau typiquement industriel, et chercha à différencier chaque façade tout en maintenant l'unité d'habillage de l'ensemble. L'aluminium est traité en fonction du type de lumière : ondulé au sud, où il « réagit à la lumière du soleil comme un sculpture géante », ou profilé en « S » et spécialement mis au point pour la façade nord touchée par le soleil uniquement à la mi-journée. L'élément le plus étonnant reste cependant la forme des portes des trois grands sas de chargement de 13 x 5 mètres. Leurs deux parties articulées en aluminium s'élèvent pour former un arc concave qui se transforme en auvent. Une sculpture de Calatrava, « dont la forme est inspirée de celle de l'œil humain », a joué un rôle dans cette conception. « Ici », dit l'architecte, « la forme est devenue une expérimentation cinétique utilisée pour étudier la transformation mécanique des plans d'un bâtiment. »

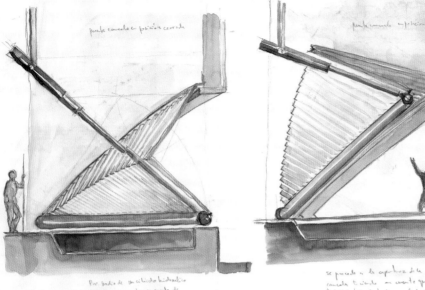

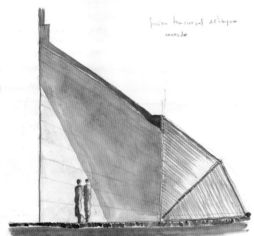

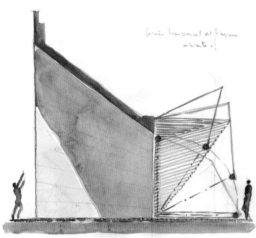

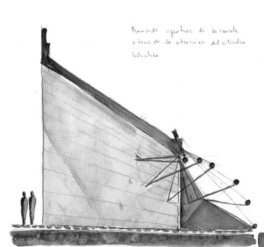

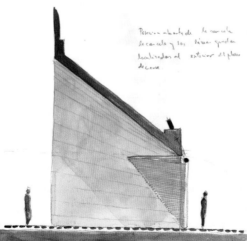

Calatrava's sketches reveal the mechanisms of his folding doors, inspired by such natural forms as the human eye and adapted to the requirements of the materials employed.

Calatravas Skizzen zeigen die Funktionsweise seiner Falttüren, die von naturgegebenen Formen wie dem menschlichen Auge inspiriert und den Bedingungen der verwendeten Materialien angepasst sind.

Les croquis de Calatrava expliquent le mécanisme de ces portes repliables, inspirées de formes naturelles comme celle de l'œil humain et adaptées aux contraintes des matériaux employés.

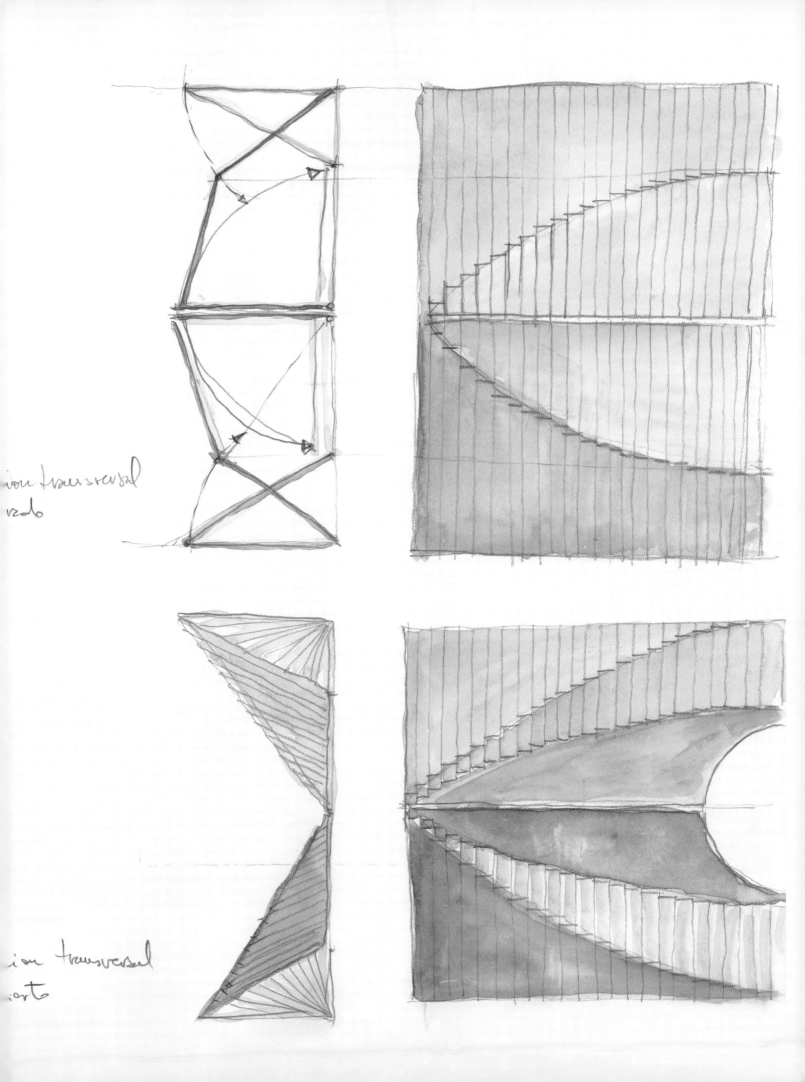

ion transversal
vado

ion transversal
erto

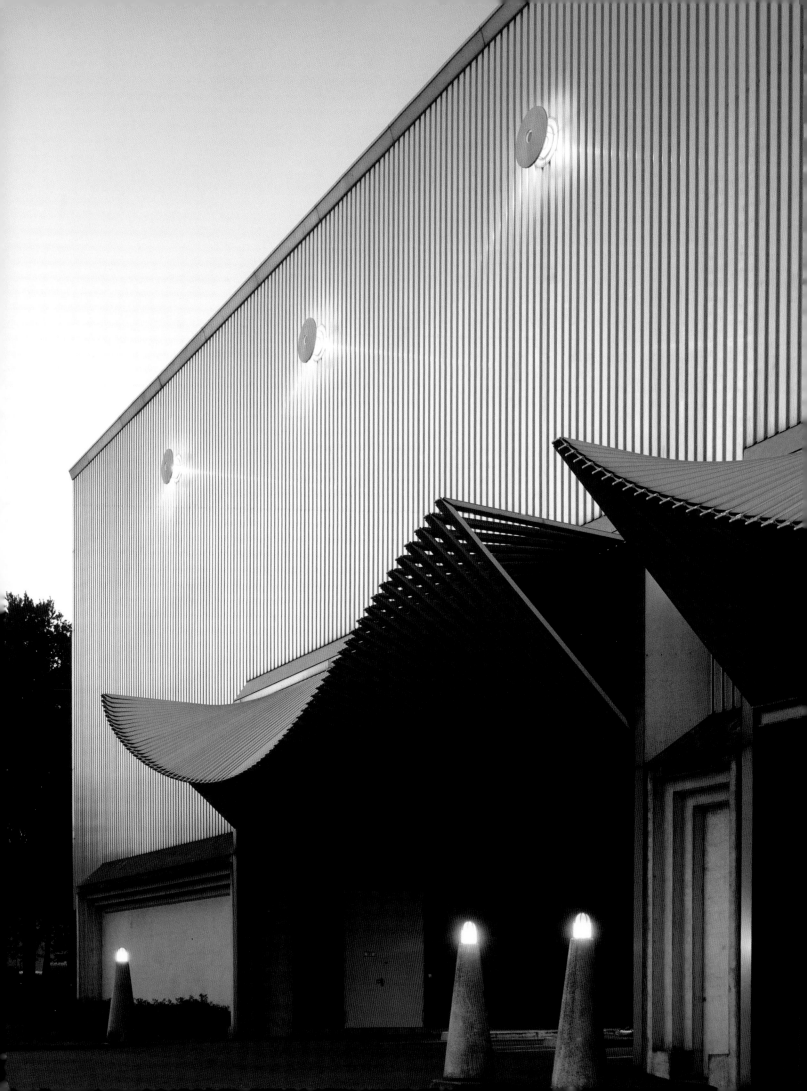

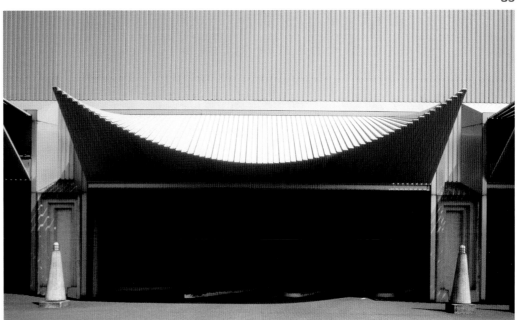

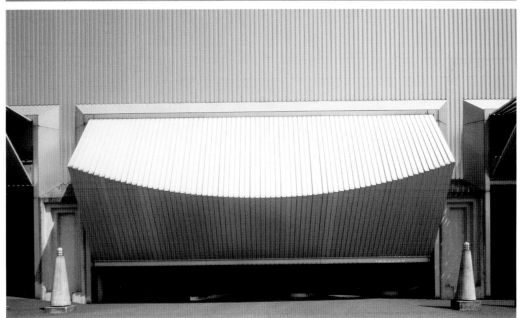

Simplicity and elegance are the hallmarks of the Ernsting's doors. Although warehouse architecture has often given rise to innovative and economically viable solutions, Calatrava brings a new level of sophistication to this project.

Schlichtheit und Eleganz kennzeichnen die Tore der Firma Ernsting's. Wenngleich die Architektur von Lagerhäusern schon häufig zu innovativen und wirtschaftlich vertretbaren Lösungen führte, bringt Calatrava einen neuen Grad von Raffinement in dieses Projekt ein.

La simplicité et l'élégance sont le signe distinctif des portes Ernsting's. Bien que l'architecture d'entrepôts ait souvent suscité des solutions innovantes et économiques, Calatrava lui apporte un degré supplémentaire de sophistication.

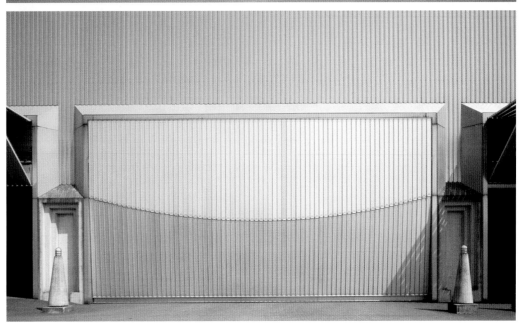

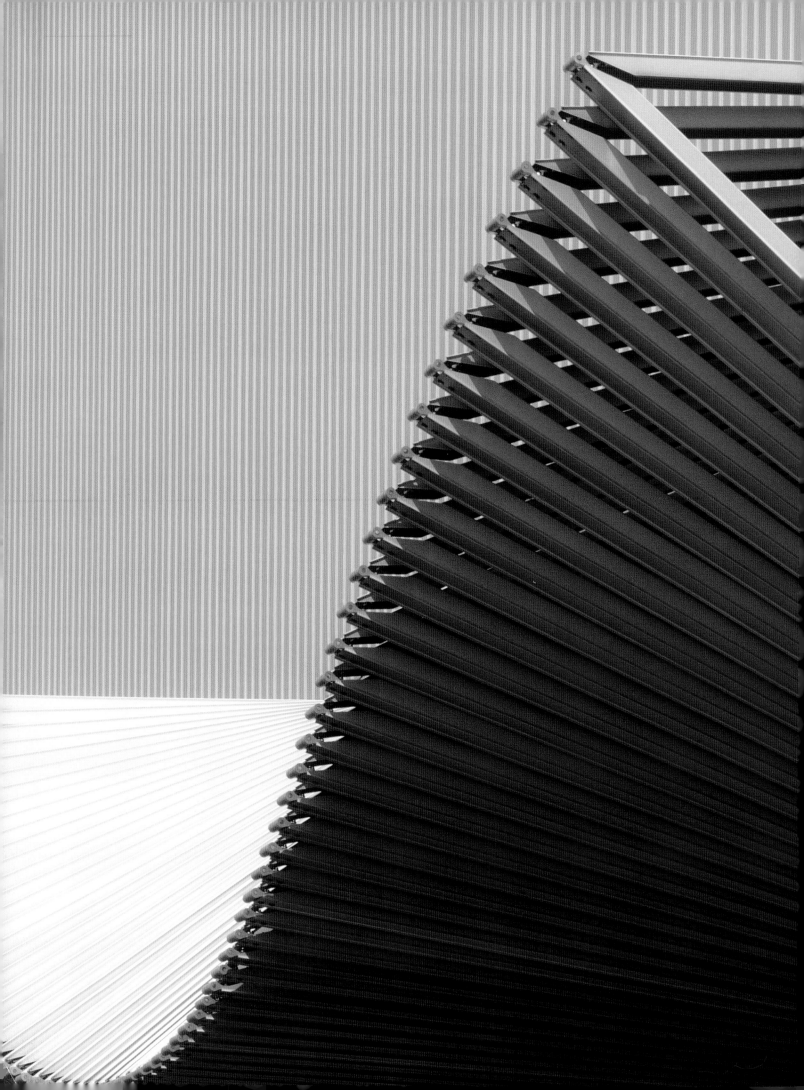

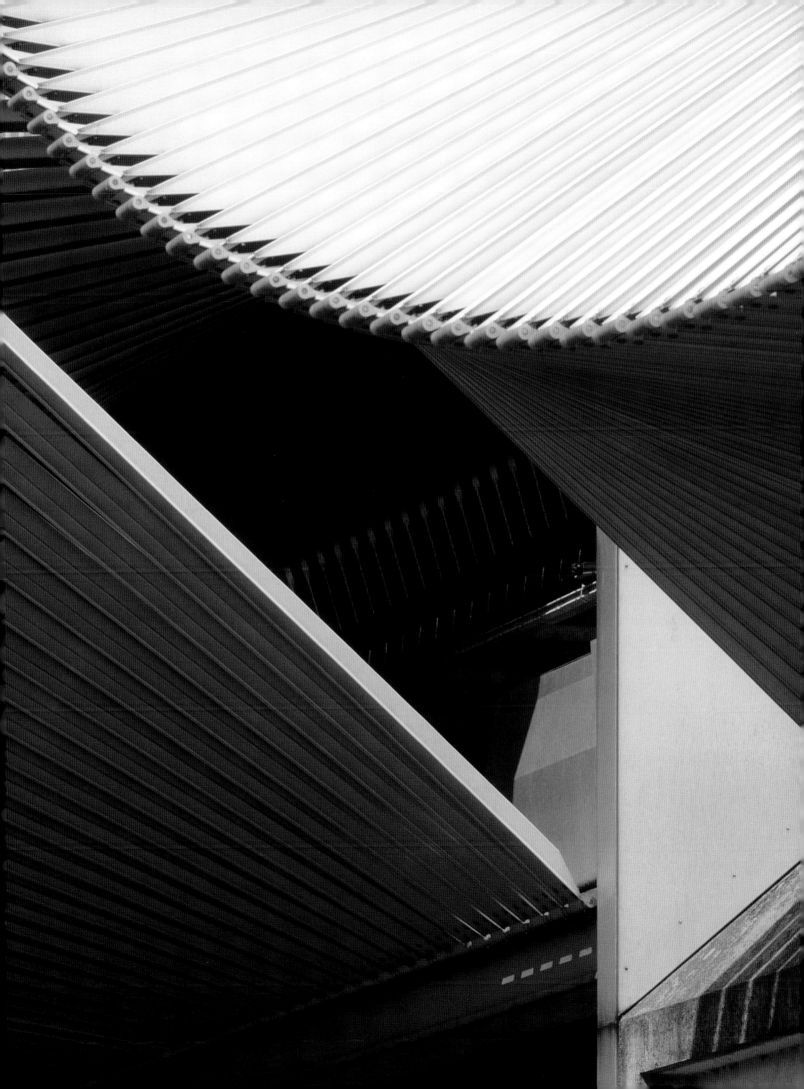

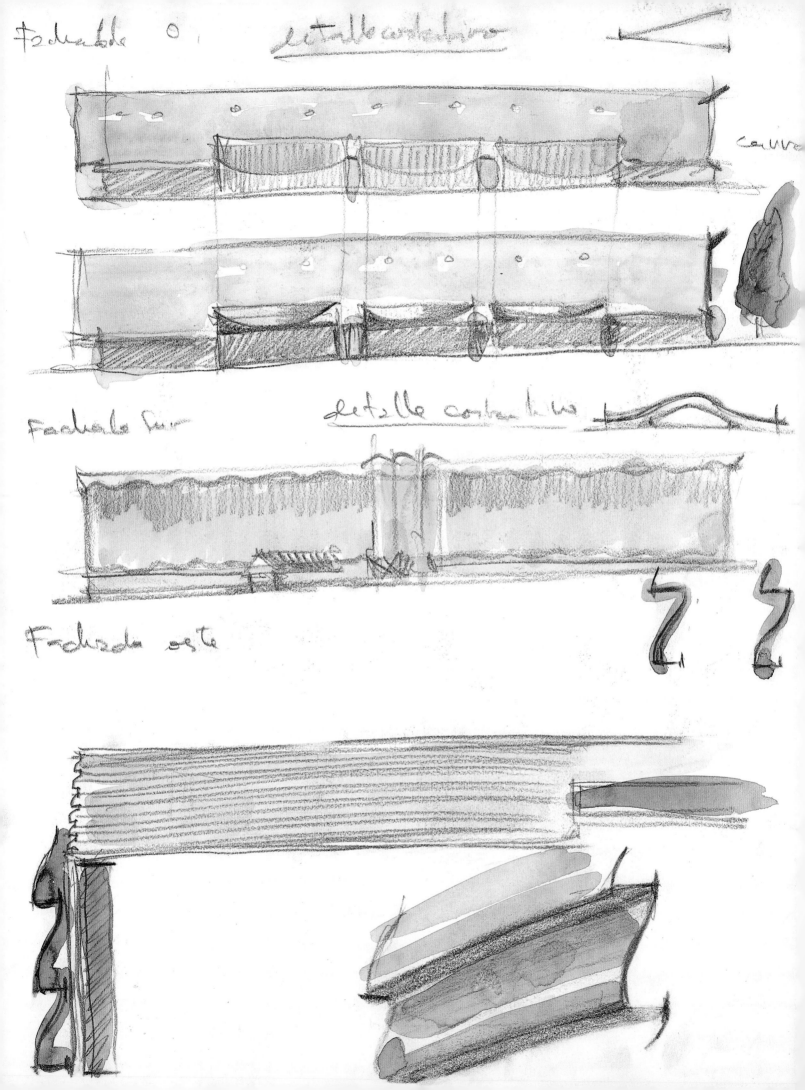

Fachada O. detalle constructivo

Louver

Fachada Sur detalle constructivo

Fachada este

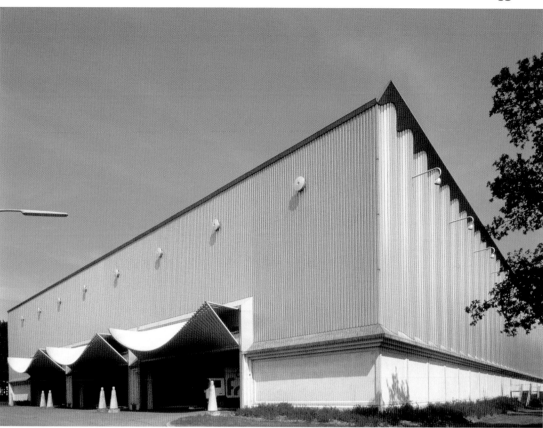

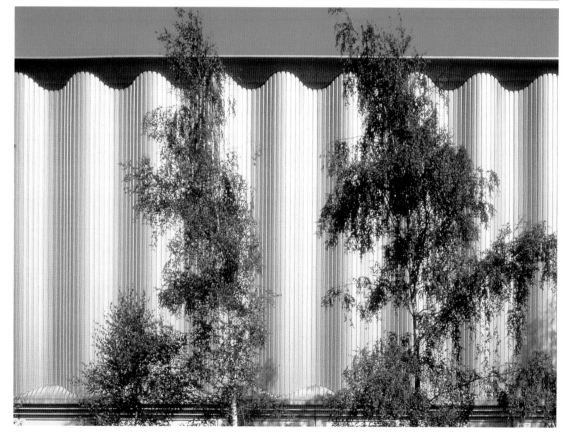

The undulating metal surface of the warehouse brings something of the regularity that one might expect in such circumstances, and yet the curtain-like walls are also harmonious with the more inventive doors of the cargo bays.

Die gewellte Aluminiumverkleidung des Lagerhauses schafft etwas von der unter diesen Umständen zu erwartenden Regelmäßigkeit, und doch harmonieren auch vorhangartige Wände mit den innovativeren Toren der Laderampen.

L'enveloppe en métal ondulé de l'entrepôt offre la régularité attendue pour ce type de construction, tandis que les murs-rideaux sont en harmonie avec les portes, plus originales, des quais de chargement.

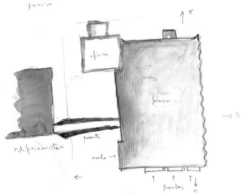

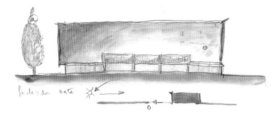

Calatrava's examination of the site leads him to complete a series of drawings (above) that place his own design in its future context, next to other structures. The surprising sketch of a whale to the right plays on the sort of zoomorphic inspiration that runs throughout the architect's work.

Calatravas Besichtigung des Baugeländes hatte zur Folge, dass er eine Reihe von Zeichnungen (oben) anfertigte, die seinen Entwurf in seinen künftigen Kontext neben andere Gebäude stellen. Die verblüffende Skizze eines Walfischs (rechts) macht sich die Art von zoomorpher Inspiration zunutze, die das Schaffen des Architekten durchzieht.

Étudiant le site, Calatrava a réalisé une série de dessins (ci-dessus) qui place le projet dans son futur contexte, à côté d'autres constructions. La surprenante présence d'une baleine, à droite, est un clin d'œil à l'inspiration zoomorphique qui court dans toute l'œuvre de l'architecte.

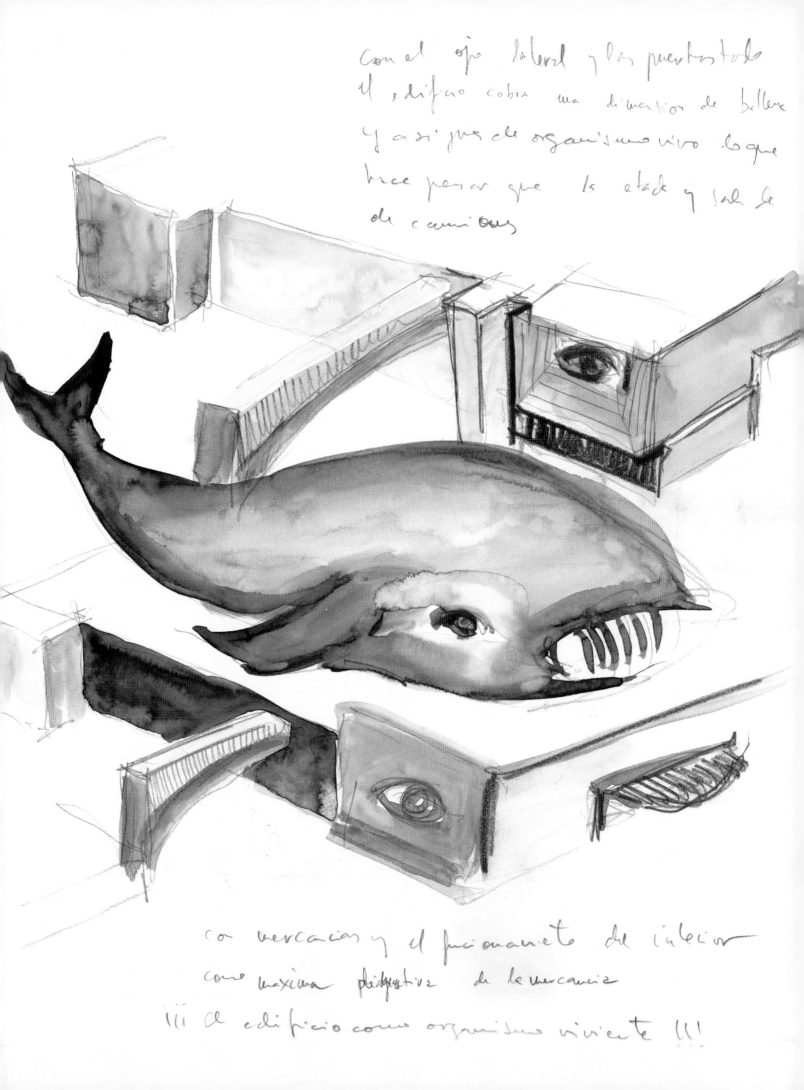

El ojo mecanico

El elemento primario en la composicion
global sel ojo mecanico para ser construi
do en el nicho lateral.

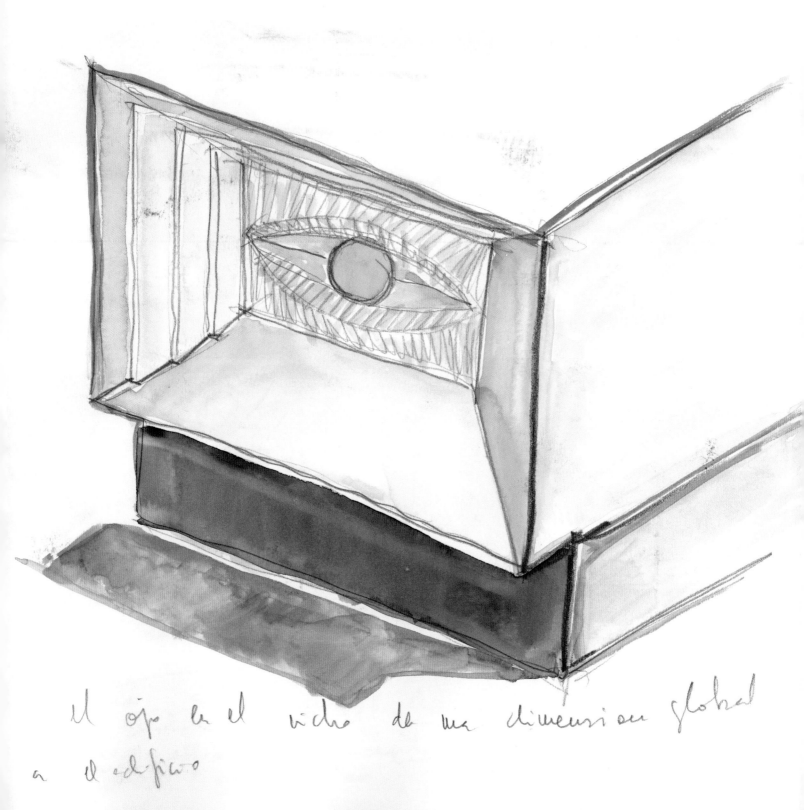

El ojo mecanico nicho de una dimension global
a el edificio

The architect's real tool is neither a computer nor a pencil, but his eye. The eye is at the center of a creativity that extends to a wide and diverse range of forms, inspired by the human body, but also by the animal world.

Das wahre Werkzeug des Architekten ist weder ein Computer noch ein Bleistift, sondern sein Auge. Es steht im Zentrum einer Kreativität, die ein breites, variantenreiches, vom menschlichen Körper und der Tierwelt inspiriertes Formenspektrum umfasst.

L'outil essentiel de l'architecte n'est ni l'ordinateur ni le crayon mais son œil. L'œil est au centre d'une créativité qui couvre une grande variété de formes inspirées par le corps humain, mais aussi par le monde animal.

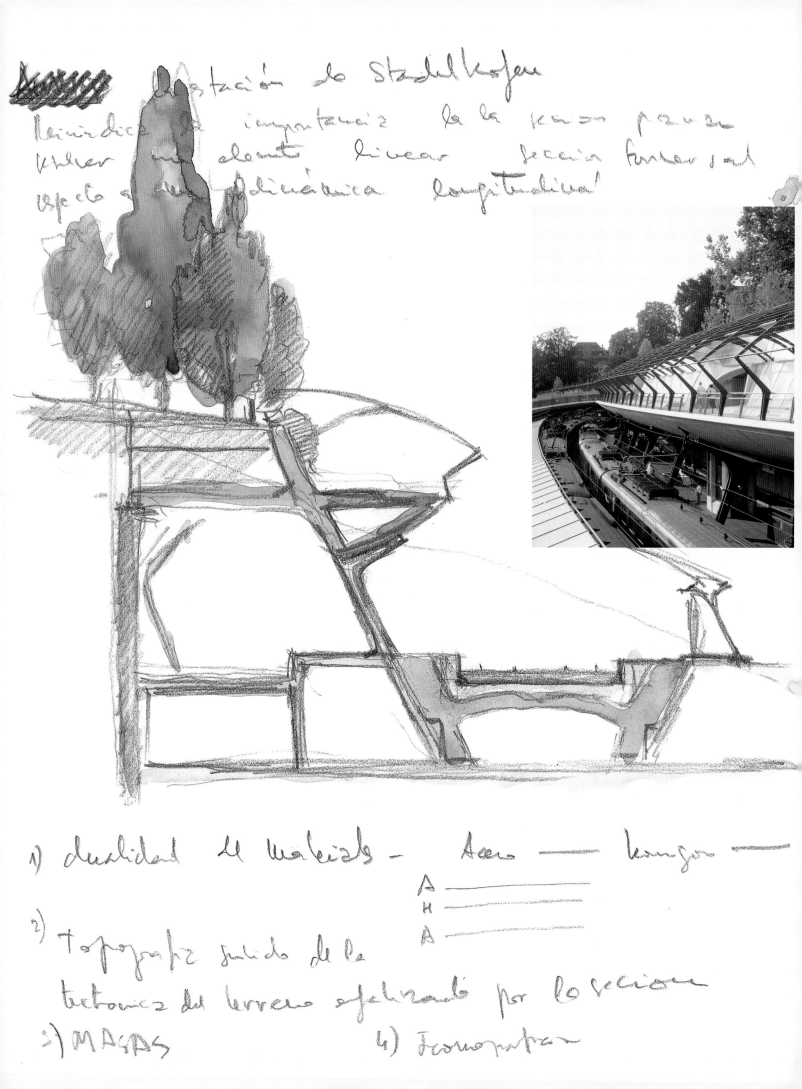

estación de Stadelhofen

reivindicar la importancia de la razón para crear un elemento lineal sección transversal respecto a su dinámica longitudinal

1) dualidad de materiales — Acero — hormigón —

ㅅ ———
H ———
ㅅ ———

2) Topografía salida de la tectónica del terreno enfatizada por la sección

3) MASAS 4) Isomorfismo

STADELHOFEN STATION

Zurich, Switzerland. 1983–1990.

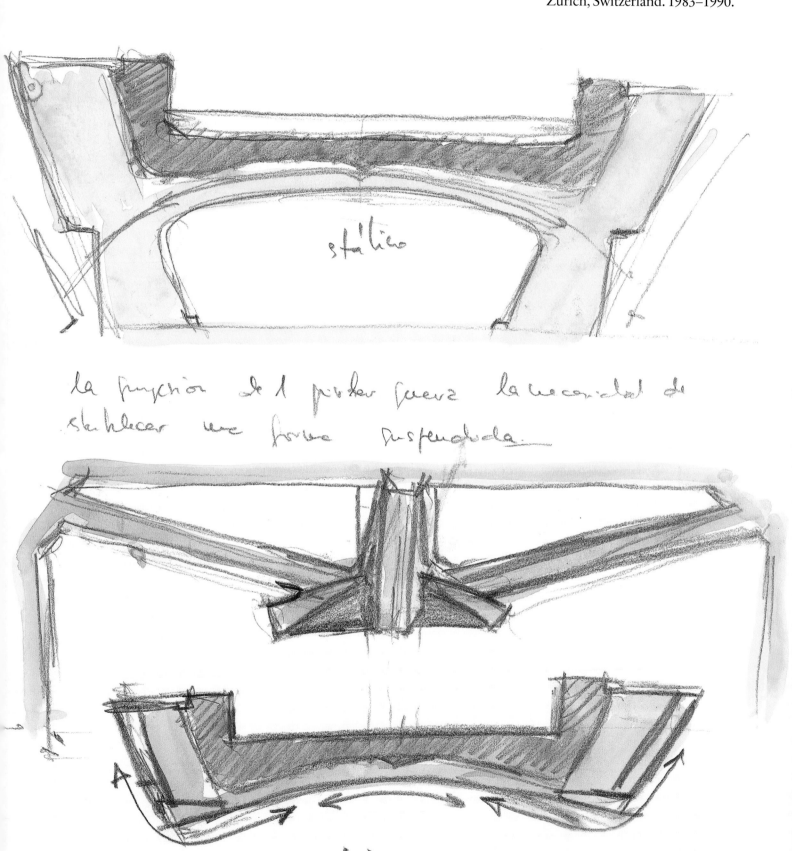

stilico

la funcion de 1 pilar fuera la necesidad de
stablecer una forma suspendida.

dinamic

Petite secaion du le staior de ferrocarrro.

Project
STADELHOFEN STATION
Location
STADELHOFEN SQUARE, ZURICH, SWITZERLAND
Client
SWISS FEDERAL RAILWAYS, BERNE
Length
270 METERS

It might be difficult to identify the sketch to the left were it not part of the architect's material for the Stadelhofen Station. Calatrava imagines people in specific areas of the finished space well before the first concrete is poured.

Es fiele möglicherweise schwer, die Skizze links zu identifizieren, wäre sie nicht Teil des Materials zum Stadion Stadelhofen. Calatrava stellt sich Menschen an bestimmten Bereichen des fertigen Bauwerks vor, ehe noch der erste Beton gegossen ist.

Il pourrait être difficile d'identifier le croquis à gauche s'il ne faisait partie du projet de la gare de Stadelhofen. L'architecte imagine les usagers dans des zones précises de l'œuvre achevée, bien avant que le premier béton ne soit coulé.

For this expansion and redefinition of an existing station, intended as an inner-city node for a rapid transit system, Santiago Calatrava participated in the competition with the architect Arnold Amlser and the landscape architect Werner Rüeger. As a 1981 graduate of Zurich's highly reputed ETH school, Calatrava was familiar with the city, but the establishment of his offices there was due in part to his victory in this competition. Located against a curved, green embankment near the Bellevueplatz and not far from the Theaterstrasse, the Stadelhofen Railway Station is close to the city center, and to the Zurich-See. Although the station stretches 270 meters (with a width of 40 meters), it reveals its structure only as the traveler reaches the train tracks. A transparent glass canopy covers the entire length of the platform giving it a great deal of natural light in spite of the fairly enclosed site. By proposing to undercut and redefine the existing hillside while maintaining its slope, the architects obviated the need for a tunnel, a solution readily accepted by the client, who put a premium on the rapidity of the work to be done. Approached through a series of pedestrian streets, the first visible sign of the station is a 19th-century building, preserved because of its value in terms of the local context. A cable trellis creates a "transparent green canopy that softens the station's intrusion into its environment." Below ground, a parallel shopping area, whose ribbed concrete design may appear to be anthropomorphic, follows the curve of the tracks themselves. Mouthlike hatches or doorways intended to permit the evening closure of the facility lead downwards toward this commercial zone. Santiago Calatrava's drawings typically reveal such practical inspiration as the form of the human hand that he adopted for the inclined columns.

Mit dem Architekten Arnold Amsler und dem Landschaftsarchitekten Werner Rüeger beteiligte sich Santiago Calatrava am Wettbewerb um die Erweiterung und Neustrukturierung eines vorhandenen Bahnhofs, der als innerstädtischer Knotenpunkt in einem Schnellnahverkehrssystem vorgesehen war. Als Absolvent der renommierten Zürcher ETH war Calatrava mit der Stadt vertraut, aber die Eröffnung seines Büros dort ist größtenteils seiner erfolgreichen Teilnahme an diesem Wettbewerb zu verdanken. Der Bahnhof Stadelhofen liegt in der Nähe des Stadtzentrums und des Zürichsees an einer begrünten, bogenförmigen Böschung nahe dem Bellevueplatz und unweit der Theaterstrasse. Obgleich sich der 40 m tiefe Bahnhof über eine Länge von 270 m erstreckt, kann der Reisende seine Bauart erst erfassen, wenn er die Bahngleise erreicht. Ein transparentes Vordach aus Glas überdeckt die gesamte Länge des Bahnsteigs und sorgt trotz des recht eng bebauten Geländes für sehr viel Tageslicht. Der Vorschlag der Architekten, bei Erhaltung des Gefälles den unteren Teil des vorhandenen Abhangs abzutragen und umzugestalten, machte einen Tunnel überflüssig, eine Lösung, die der Auftraggeber begrüßte, da es ihm auf einen schnelle Durchführung der anstehenden Arbeiten ankam. Wenn man sich dem Bahnhof durch eine Reihe von Fußgängerstraßen nähert, ist der erste Teil, den man sieht, ein Bau aus dem 19. Jahrhundert, der wegen seiner Bedeutung für das unmittelbare Umfeld denkmalgeschützt ist. Ein Gitter aus gespannten Seilen erzeugt ein „transparentes, grünes Vordach, das den Bahnhof in seinem Kontext weniger als Fremdkörper erscheinen lässt". Unterirdisch folgt eine parallel angelegte Ladengalerie, deren Gestaltung mit wie Rippen wirkenden Betonunterzügen zoomorph erscheinen mag, dem Bogen der Gleise. An Münder gemahnende Öffnungen, die sich abends verschließen lassen, führen nach unten zu den Geschäften. Santiago Calatravas Zeichnungen zeigen, dass er sich bei den geneigten Stützen von der Form der menschlichen Hand inspirieren ließ.

À l'occasion du concours organisé pour la restructuration et l'extension d'une gare existante destinée à devenir la plate-forme d'échanges du système de transports locaux, Santiago Calatrava a collaboré avec l'architecte Arnold Amsler et l'architecte paysagiste Werner Rüeger. Diplômé en 1981 de la prestigieuse ETH, Calatrava connaissait très bien la ville, mais la décision d'y implanter son agence est due en partie à cette commande. Située le long d'un talus incurvé et boisé près de la Bellevueplatz et non loin de la Theaterstrasse, la gare de Stadelhofen est proche du centre-ville et du lac. Bien qu'elle s'étende sur 270 mètres (pour 40 mètres de large), elle ne révèle au voyageur l'importance de sa structure qu'au moment où il atteint les quais. Un auvent en verre transparent couvre la totalité de ceux-ci et leur assure un éclairage généreux malgré le relatif encaissement du site. En proposant de remodeler et de découper le flanc de la colline tout en conservant sa pente, les architectes ont évité de creuser un tunnel, solution appréciée par le client pour lequel la courte durée du chantier était un élément essentiel. Le premier signe visible de cette gare, que l'on atteint au débouché de rues piétonnes, est un bâtiment du XIXe siècle conservé pour sa valeur historique locale. Un treillis de câbles crée un « auvent vert transparent qui adoucit l'effet de l'insertion de la gare dans son environnement ». En sous-sol, un espace commercial, dont la structure en béton aux impressionnantes nervures peut sembler d'inspiration anthropomorphique, épouse la courbe des voies. Des demi-portes en forme de bouches qui permettent de fermer les installations le soir donnent accès à cette partie commerciale. Le dessin de Calatrava montre à sa manière caractéristique une inspiration formelle tirée du corps humain comme, par exemple, dans le profil de mains des colonnes inclinées.

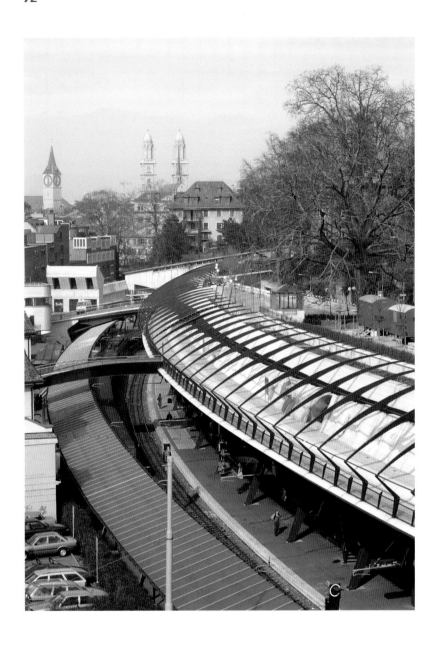

In this early work, Santiago Calatrava has inserted a repetitive, yet wholly unexpected, structural system into the tight, curved site. Working within the constraints imposed by the location, the requirements of the railway, and passenger access and comfort, he nonetheless succeeds in going far beyond a standardized solution.

Bei diesem Frühwerk setzte Santiago Calatrava ein sich wiederholendes, aber gänzlich unerwartetes konstruktives System in das enge, gebogene Baugelände ein. Trotz der Beschränkungen durch Standort, Auflagen der Eisenbahn, Erreichbarkeit und Komfort gelang es ihm, weit mehr als eine Standardlösung anzubieten.

Dans cette réalisation de ses débuts, Calatrava a inséré un système structurel répétitif mais totalement inattendu dans un site aussi étroit et incurvé. Tout en respectant les contraintes du lieu, des voies de chemin de fer, et les impératifs d'accès et de confort des voyageurs, il réussit à établir des propositions bien au-delà des solutions standard.

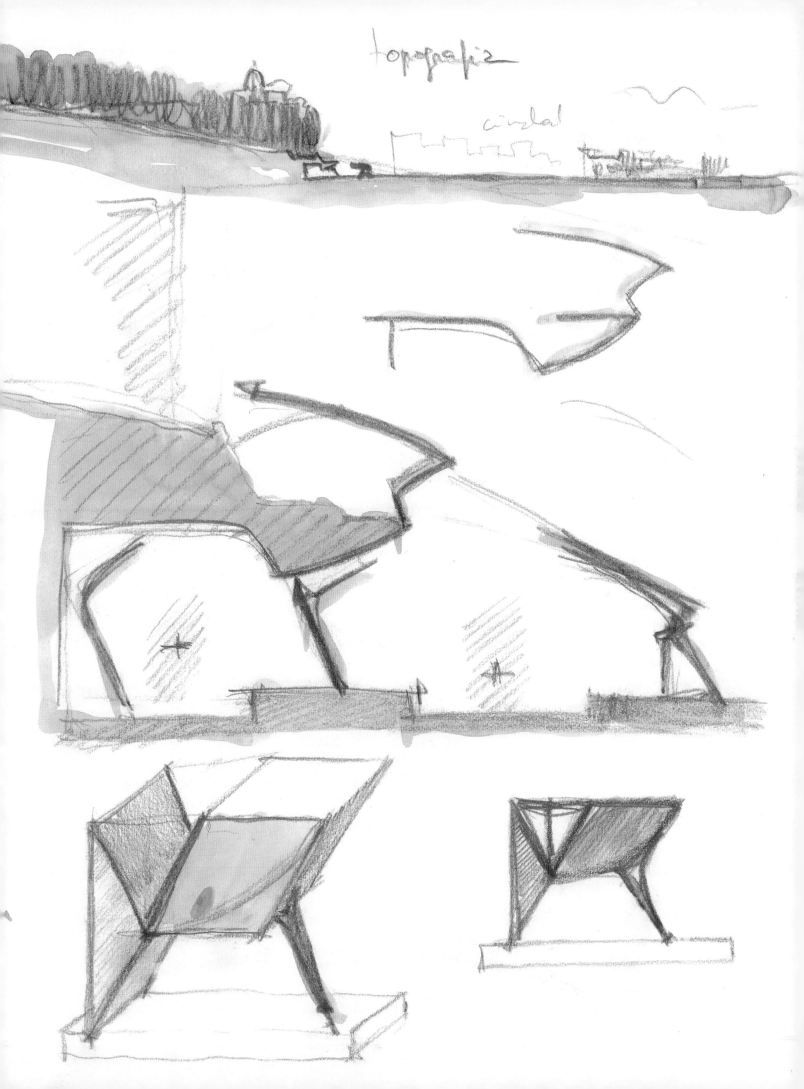

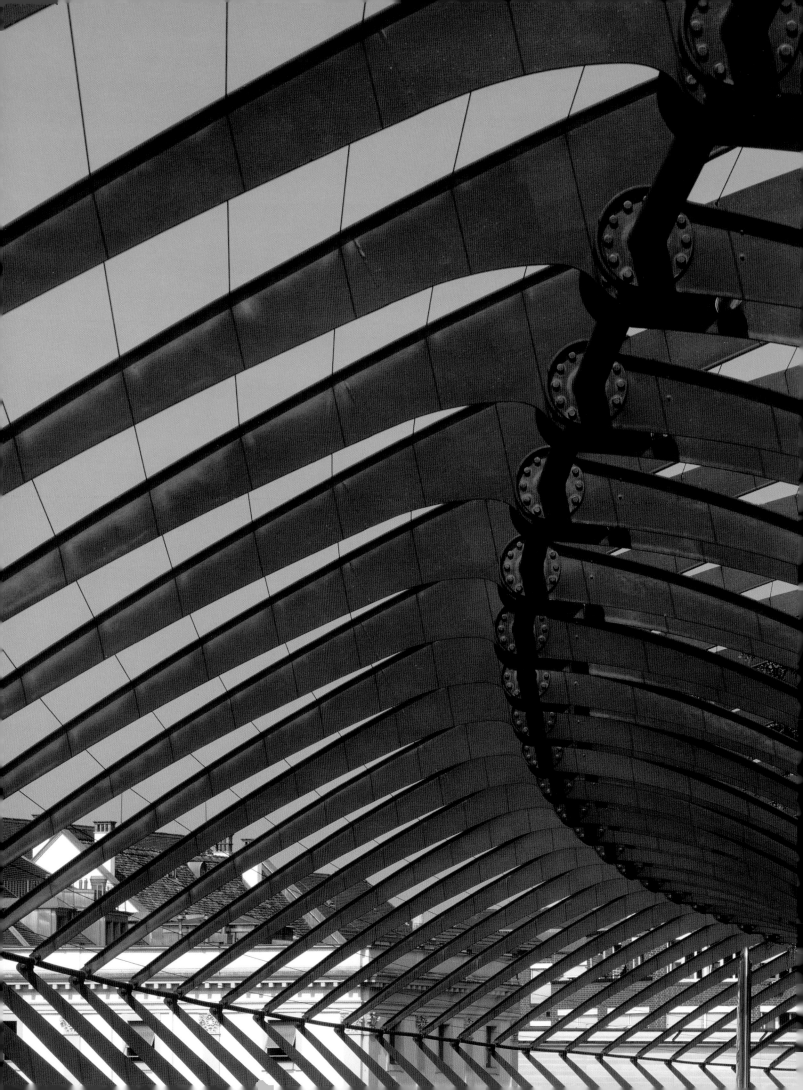

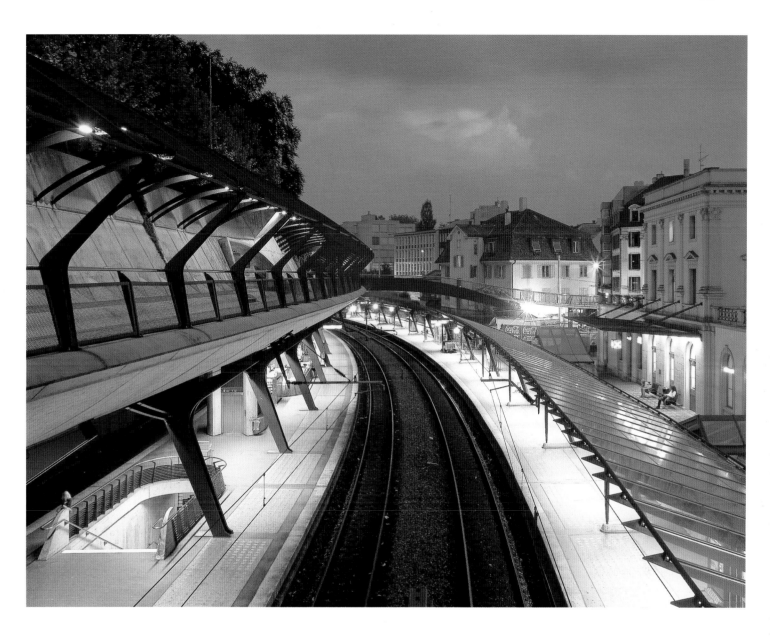

The angled supports of the platform canopies and the detailing of the connecting elements give a curious, almost archaic appearance to the station. Against the expectations of some, the user feels fundamentally comfortable in these spaces, and that is a direct result of Calatrava's use of forms born of his observation of the natural world.

Die schrägen Stützen der Bahnsteigüberdachungen und die Gestaltung der verbindenden Elemente verleihen dem Bahnhof ein seltsames, fast archaisches Aussehen. Entgegen mancher Erwartungen fühlen sich die Nutzer wohl in diesen Räumen – unmittelbar bedingt durch Calatravas Verwendung von Formen, die sich aus seiner Naturbeobachtung ergaben.

Les piliers inclinés de l'auvent du quai et le détail des pièces de connexion confèrent à la gare un aspect curieux, presque archaïque. Si, contrairement aux attentes de certains, les voyageurs se sentent parfaitement à l'aise dans ces volumes, c'est parce que Calatrava utilise des formes nées de son observation de la nature.

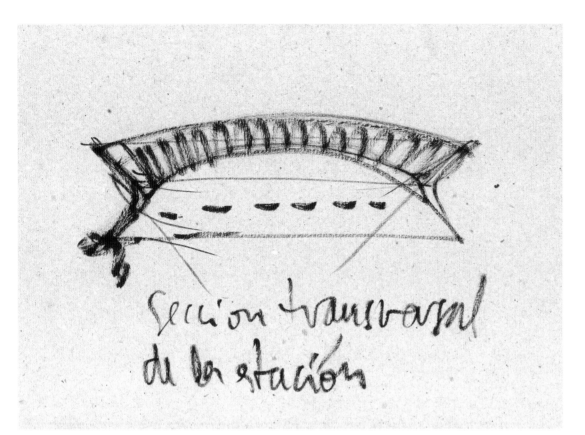

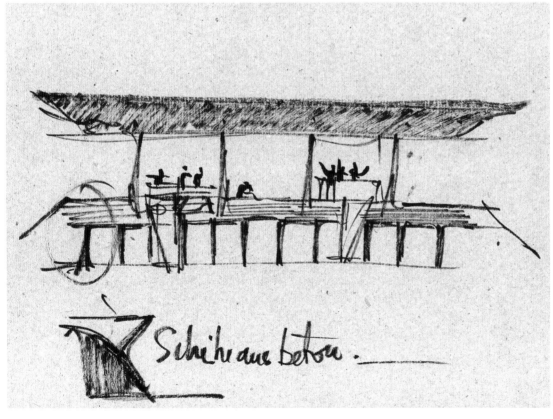

The ribbed concrete designs of the areas below the station platforms might evoke a dinosaur skeleton, but they are certainly an original and effective solution to the space requirements of the facility.

Zwar mögen die gerippten Betonunterzüge der Bereiche unterhalb der Bahnsteige an ein Dinosaurierskelett erinnern, aber sie stellen mit Sicherheit eine neuartige, wirkungsvolle Lösung der räumlichen Anforderungen des Gebäudes dar.

Les nervures en béton des zones situées sous les quais de la gare évoquent certes un squelette de dinosaure, mais sont avant tout une réponse originale et efficace aux exigences du programme en termes d'espace.

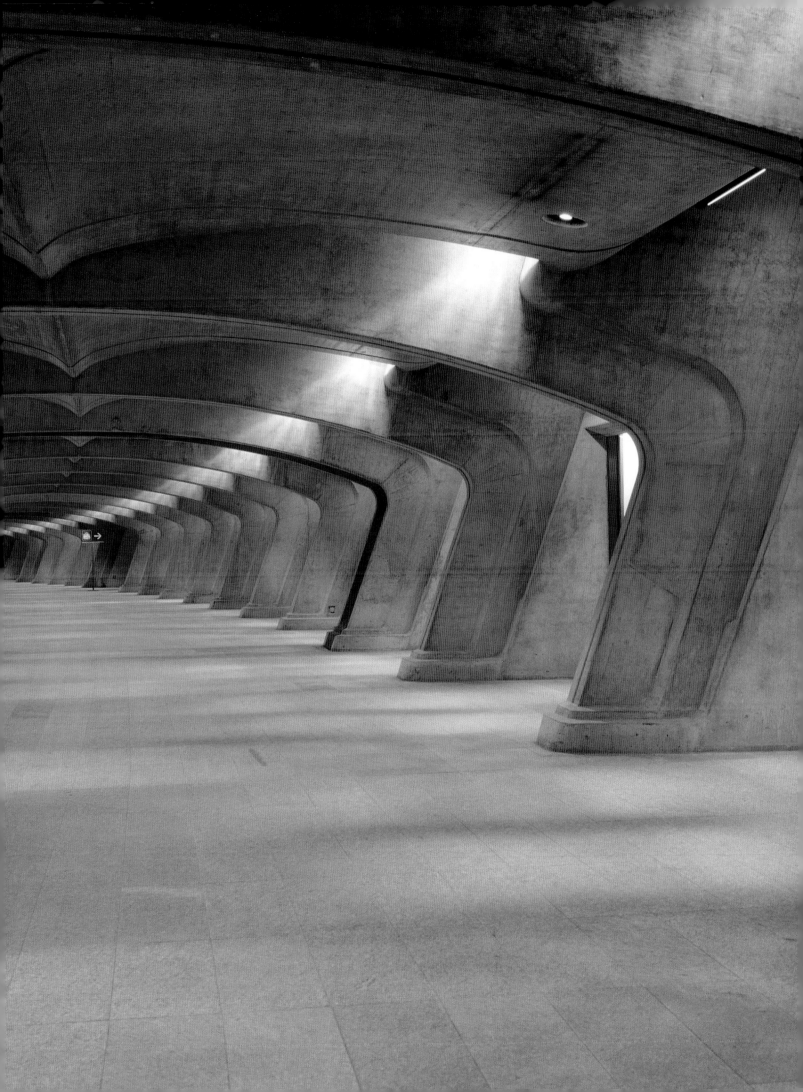

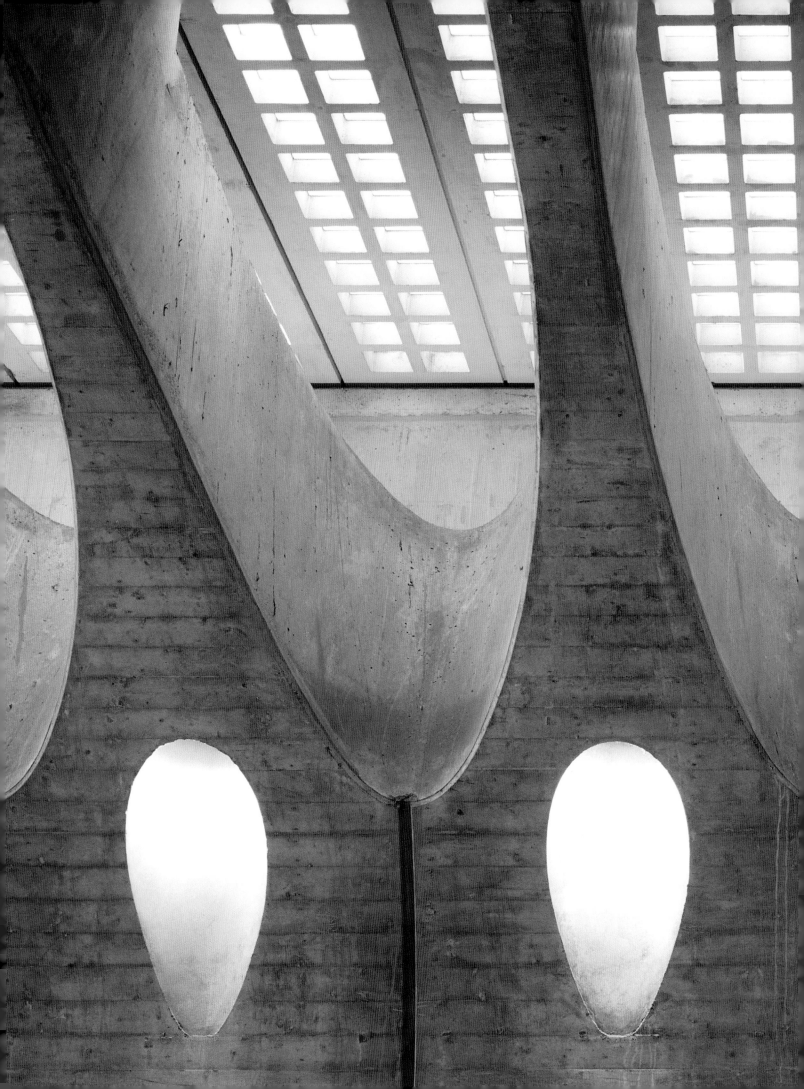

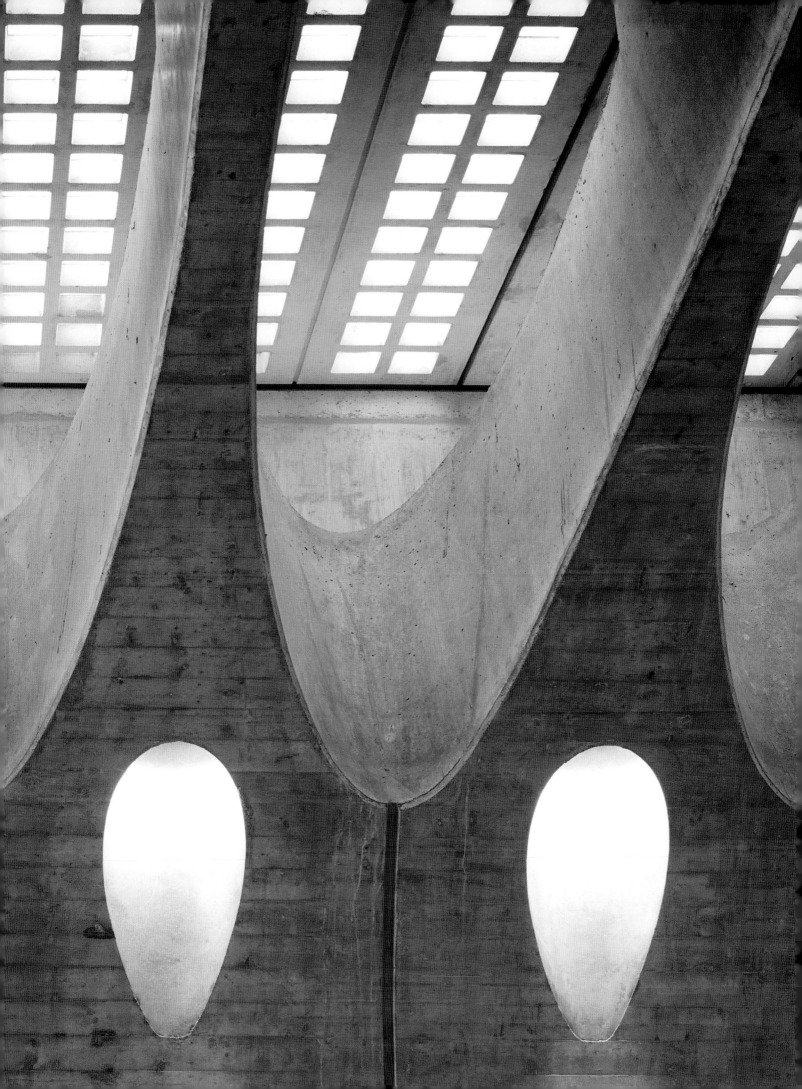

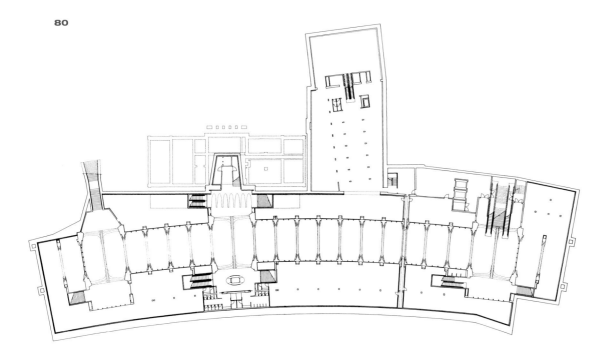

Where architects are often obliged to conceive just the outer shell of their buildings, Calatrava has succeeded here in carrying through his aesthetic and functional ideas throughout the interiors, giving a coherent and consistent appearance and feeling to the whole.

Wo Architekten häufig gezwungen sind, nur die äußere Hülle ihrer Bauten zu gestalten, gelang es Calatrava hier, seine ästhetischen und funktionalen Ideen auch im Inneren umzusetzen und so dem Gesamtprojekt ein kohärentes, stimmiges Erscheinungsbild zu geben.

Alors que les architectes doivent souvent se cantonner à l'extérieur des bâtiments, Calatrava a réussi à développer ses conceptions esthétiques et fonctionnelles à l'intérieur, pour donner une vraie cohérence à l'ensemble.

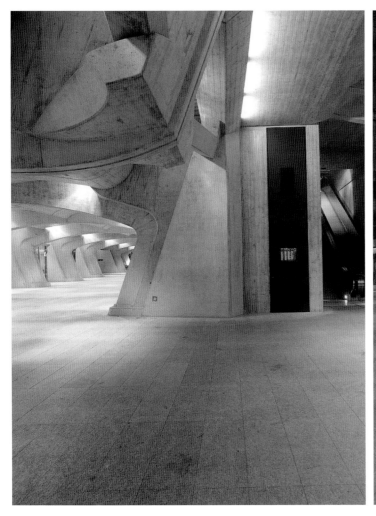

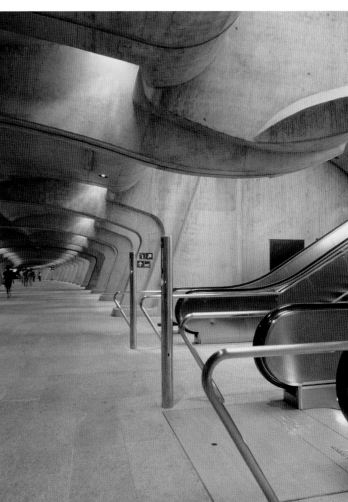

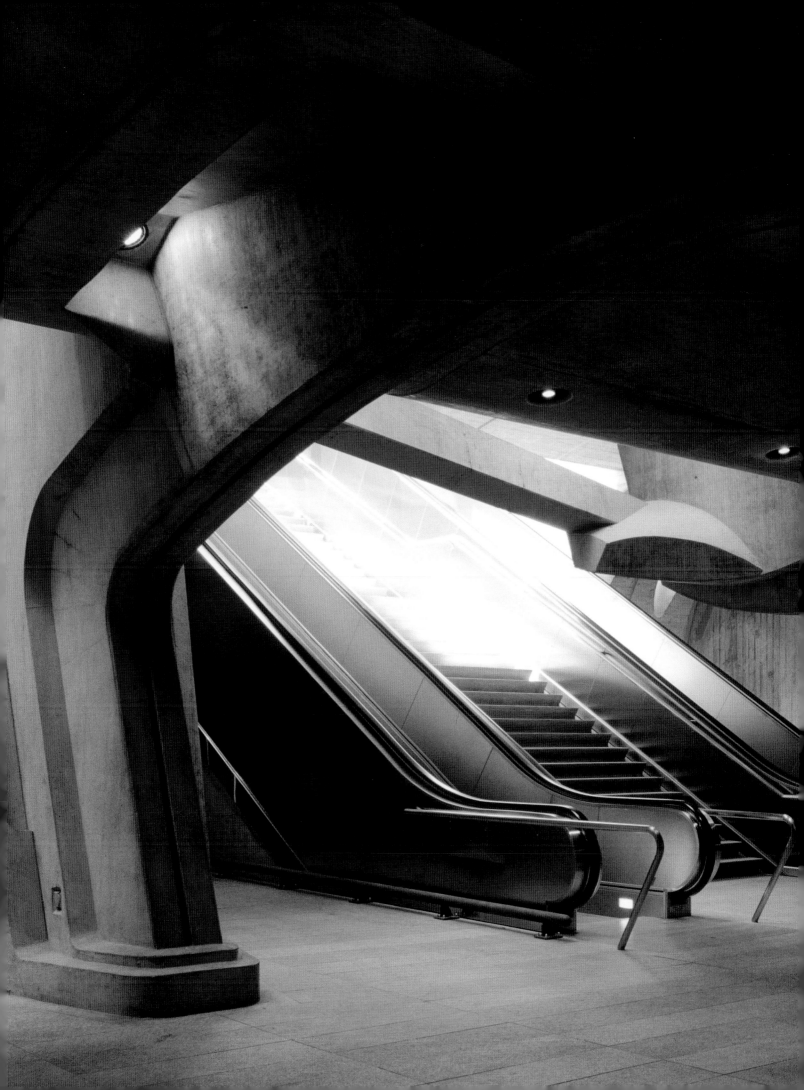

BACH DE RODA-
FELIPE II BRIDGE

Barcelona, Spain. 1984–1987.

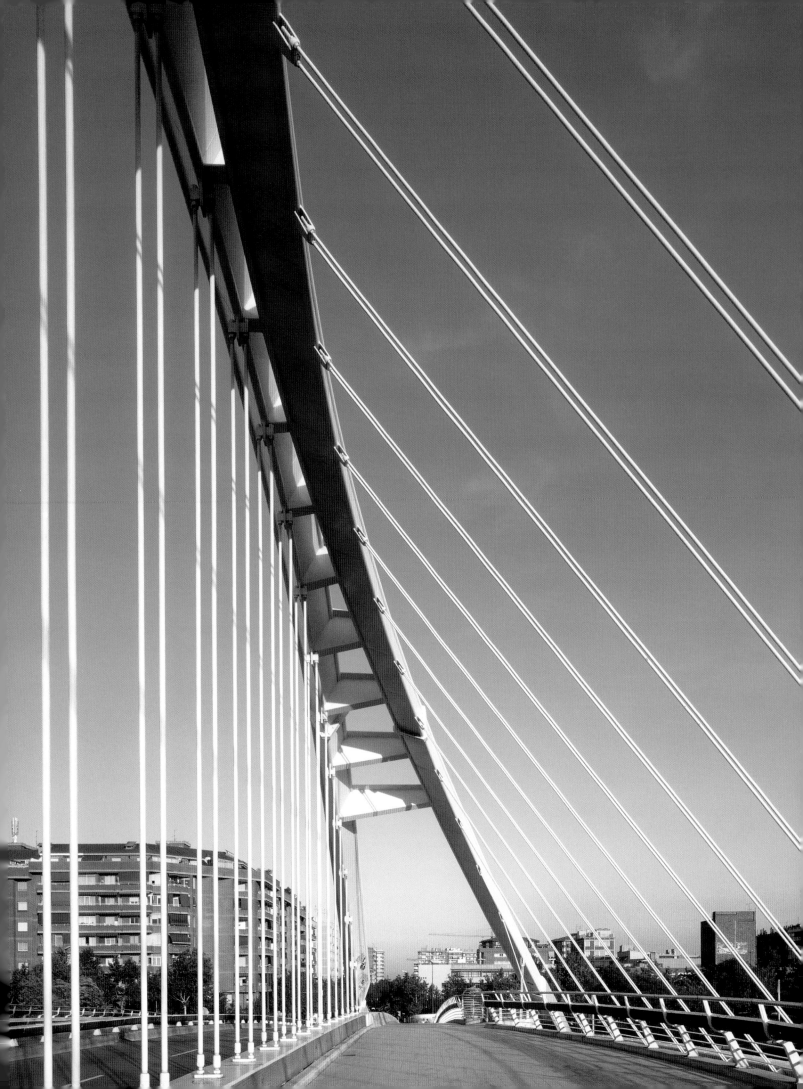

Project
BACH DE RODA-FELIPE II BRIDGE

Location
BARCELONA, SPAIN

Length
128 METERS

Calatrava's education as an engineer, and the specific nature of bridge design lead him to reduce his formal expression to the strict minimum that is necessary. The real measure of his talent is that he finds new ways to solve age-old problems.

Calatravas Ausbildung als Ingenieur und der spezifische Charakter seiner Brückenentwürfe brachten ihn dazu, seinen formalen Ausdruck auf das absolut notwendige Minimum zu reduzieren. Seine wirkliche Begabung ist, dass er neue Wege zur Lösung uralter Probleme findet.

La formation d'ingénieur de Calatrava et la nature spécifique des problèmes de la conception de ponts l'ont conduit à réduire l'expression formelle au strict nécessaire. Son vrai talent consiste à apporter des solutions révolutionnaires à des problèmes très anciens.

With its overall length of 128 meters and its twin inclined and split arches, this bridge was one of the first to contribute to the reputation of Santiago Calatrava. Indeed, the 60-degree inclination of the lateral steel arches appears almost like a stylistic signature of the architect-engineer, not so much because he has repeated it on other occasions but because of the willful appearance of imbalance, or "frozen motion," that suffuses this bridge as well as his other work. Crossing a kind of no-man's-land originally created by the existence of railway lines, the bridge links the Bach de Roda and Felipe II streets, reconnecting a large section of the city to the sea. Its recognizable form is a testimony to the accuracy of the theory of Calatrava that peripheral urban areas can indeed be regenerated by such a symbolic intervention. Combining powerful concrete supports, monolithic granite columns and a steel arch structure which grows progressively lighter as it rises, the Bach de Roda-Felipe II Bridge also demonstrates Calatrava's adherence to a hierarchy of materials and forms, chosen in relation to their distance from the ground. Despite its very different structural nature, the Lyon Station employs a similar hierarchy.

Mit ihrer Gesamtlänge von 128 m und ihrem Paar zweigeteilter, gekippter Bögen war diese Brücke eine der ersten, die den Ruf Santiago Calatravas begründete. In der Tat erscheint die 60-Grad-Neigung der seitlichen Stahlbögen beinahe wie eine stilistische Signatur des Ingenieurarchitekten, nicht so sehr, weil er sie an anderer Stelle wiederholte, sondern wegen des Eindrucks gewollten Ungleichgewichts oder „eingefrorener Bewegung", die diese Brücke ebenso wie sein übriges Werk kennzeichnet. Die Brücke, die eine Art Niemandsland mit Bahnanlagen überquert, verbindet die Bach-de-Roda- mit der Felipe-II-Straße und stellt damit den Zugang eines großen Teils der Stadt zum Meer wieder her. Ihre markante

Form ist Beleg für Calatravas Theorie, dass sich städtische Randbezirke durch solch symbolische Intervention tatsächlich wieder beleben lassen. Die Brücke, für deren Bau mächtige Betonstützen, monolithische Granitpfeiler sowie eine mit zunehmender Höhe leichter werdende Stahlbogenkonstruktion kombiniert wurden, veranschaulicht darüber hinaus Calatravas Festhalten an einer Hierarchie der Materialien und Formen, die in Relation zu ihrer Distanz zum Erdboden verwendet werden. Ungeachtet ihres höchst unterschiedlichen konstruktiven Charakters kommt beim Bahnhof in Lyon eine ähnliche Hierarchisierung zur Anwendung.

D'une longueur totale de 128 mètres et doté d'arches jumelles inclinées qui se répondent, ce pont fut l'un des premiers à asseoir la réputation de Santiago Calatrava. L'inclinaison à 60 degrés des arcs latéraux en acier semble être devenue la signature stylistique de l'architecte-ingénieur, non pas tant parce qu'il l'a répétée dans d'autres occasions, mais à cause de cet audacieux déséquilibre donnant l'impression d'un « mouvement figé » que dégagent ses ponts autant que ses autres réalisations. Franchissant une sorte de no-man's land jadis occupé par des voies de chemin de fer, le pont qui relie les rues Bach de Roda et Felipe II connecte de nouveau une grande partie de la ville à la mer. Sa forme si identifiable témoigne de la pertinence de la théorie de Calatrava, pour lequel les zones urbaines périphériques peuvent être régénérées par ce type d'intervention symbolique. En associant de puissants supports en béton, des colonnes monolithiques en granit et une structure d'arcs en acier qui s'allège en s'élevant, cet ouvrage illustre par ailleurs la hiérarchie de matériaux et de formes voulue par l'architecte, qui les choisit en fonction de leur distance par rapport au sol. Malgré sa nature structurelle très différente, la gare de Lyon-Saint Exupéry applique une hiérarchie similaire.

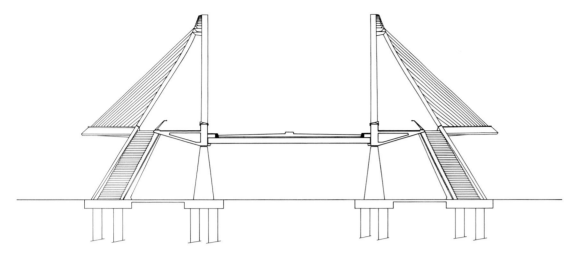

The design of bridges often appears to be subjected to a kind of paralysis, with just three or four basic types dominating the world over. Time and again, Santiago Calatrava has shown that this is not some fatality born of the rules of engineering, but rather a lack of a pertinent combination of knowledge and aesthetic sense. Calatrava's bridges do what they are meant to do while exploring new forms.

Da nur drei oder vier Grundtypen von Brücken weltweit vorherrschen, hat es den Anschein, als befiele die Architekten bei der Planung eine Art Blockade. Santiago Calatrava hat immer wieder bewiesen, dass es sich dabei nicht um einen durch die Regeln des Ingenieurwesens bedingten schicksalhaften Verlauf handelt, sondern um den Mangel einer passenden Kombination von Kenntnis und ästhetischem Gespür. Calatravas Brücken erfüllen ihren Zweck und sondieren dabei neue Formen.

La conception de ponts est souvent victime d'une sorte de paralysie : trois ou quatre types seulement semblent dominer partout dans le monde. À chaque fois, Santiago Calatrava a montré qu'il ne s'agit pas là d'une fatalité née des lois de l'ingénierie mais plutôt d'un déficit du lien indispensable entre connaissances techniques et sens esthétique. Ses ponts répondent à leur fonction tout en explorant de nouvelles formes.

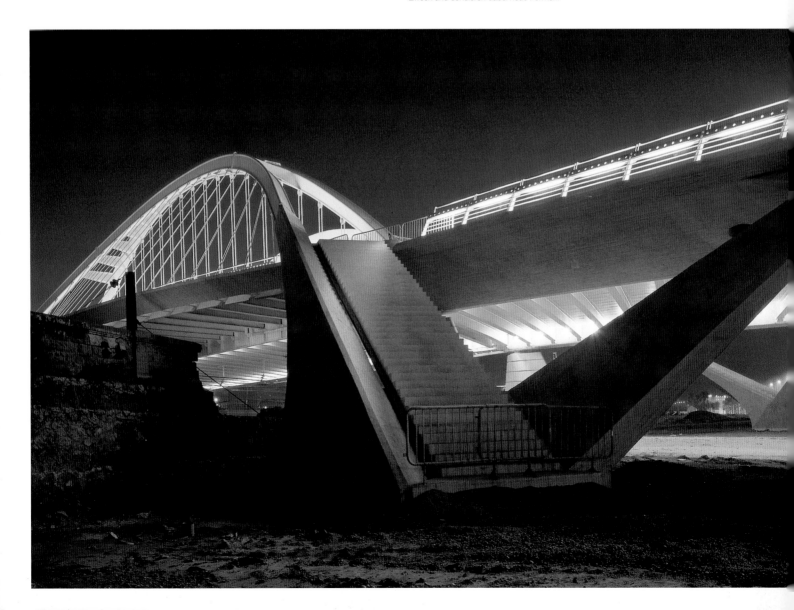

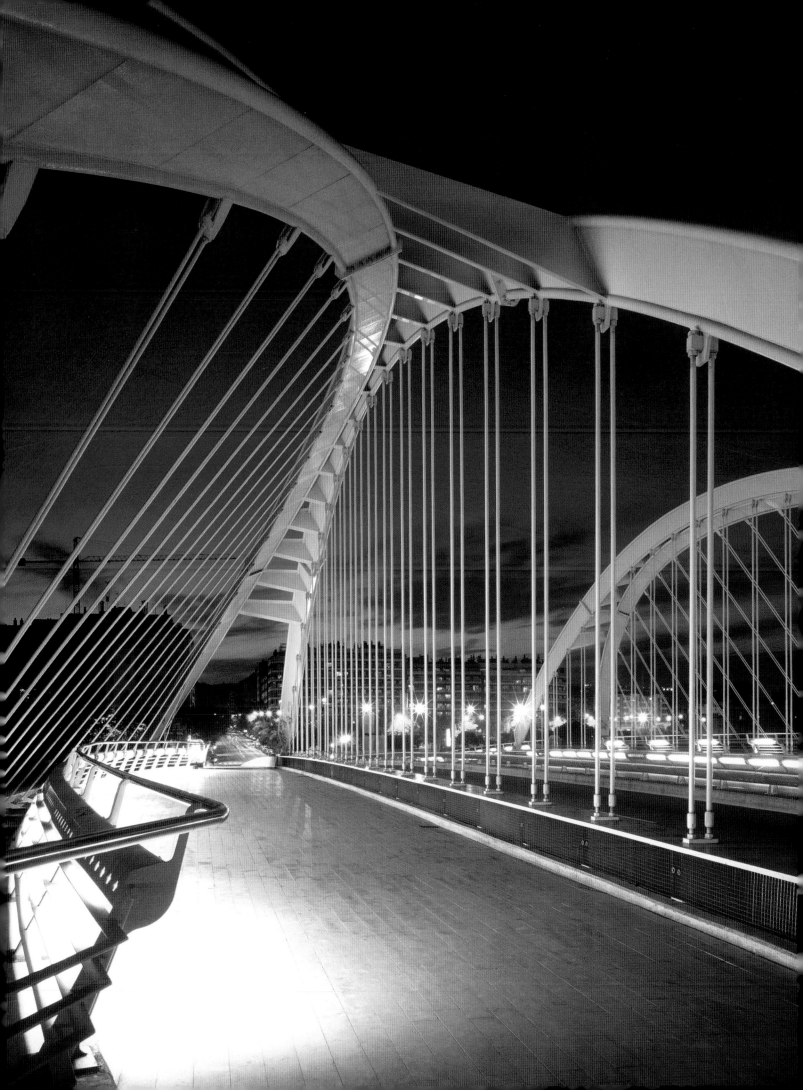

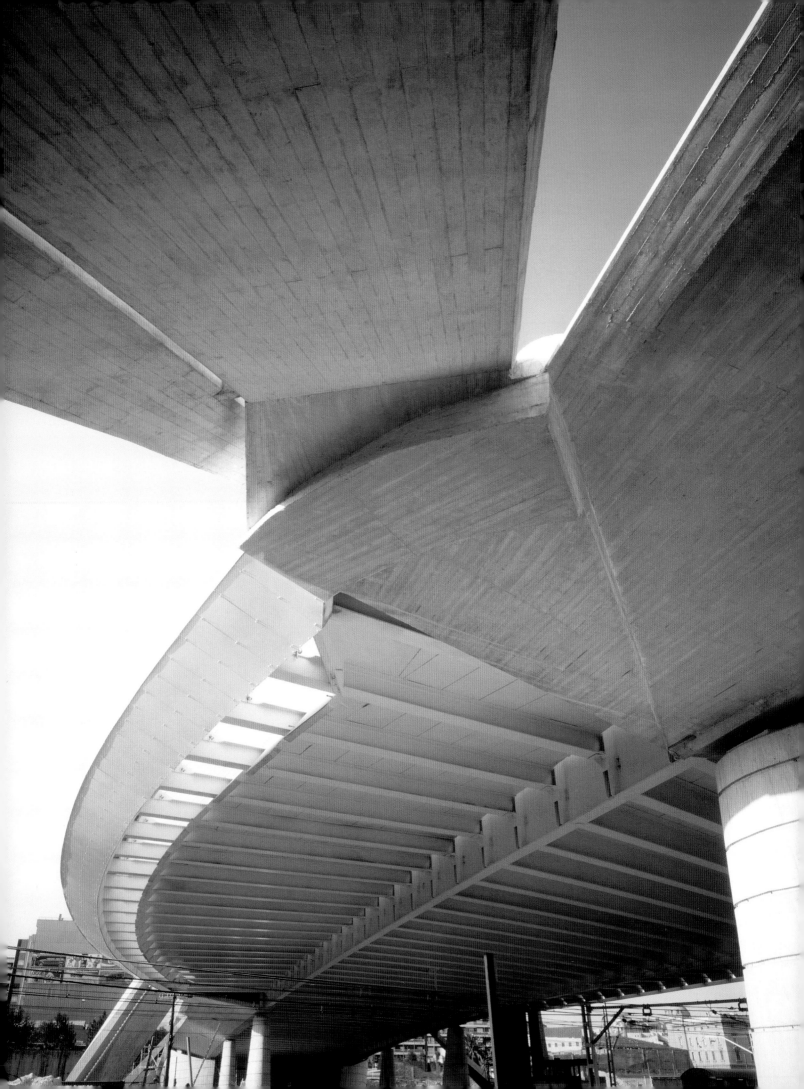

The thin bed and simple, dynamic arches of the bridge give it a forward-looking, modern appearance that may well withstand the judgment of time.

Die dünne Tafel und die einfachen, dynamischen Bögen der Brücke verleihen ihr ein zukunftsorientiertes, modernes Erscheinungsbild, das sich sehr wohl als zeitlos erweisen könnte.

Le mince tablier et les arches simples et dynamiques du pont lui donnent un aspect moderne et presque futuriste qui supportera sans doute le verdict du temps.

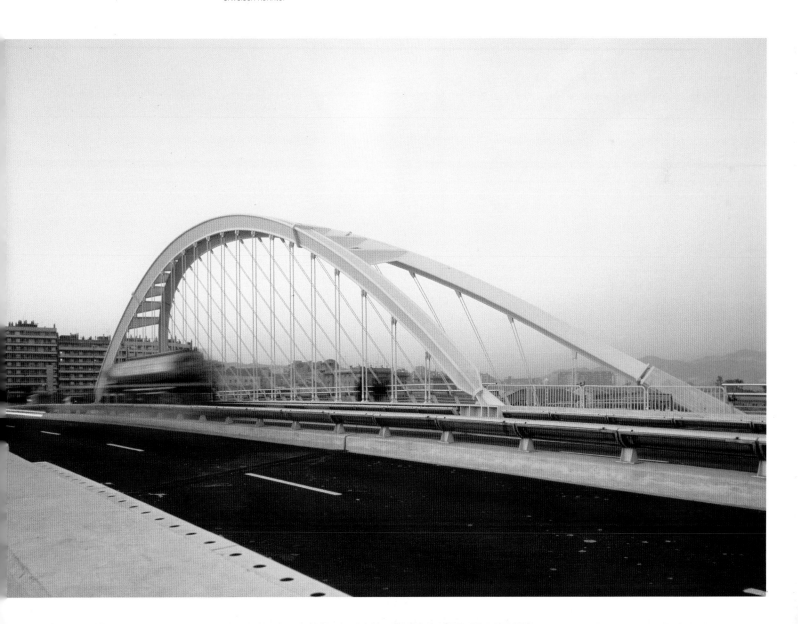

Galería en Toronto

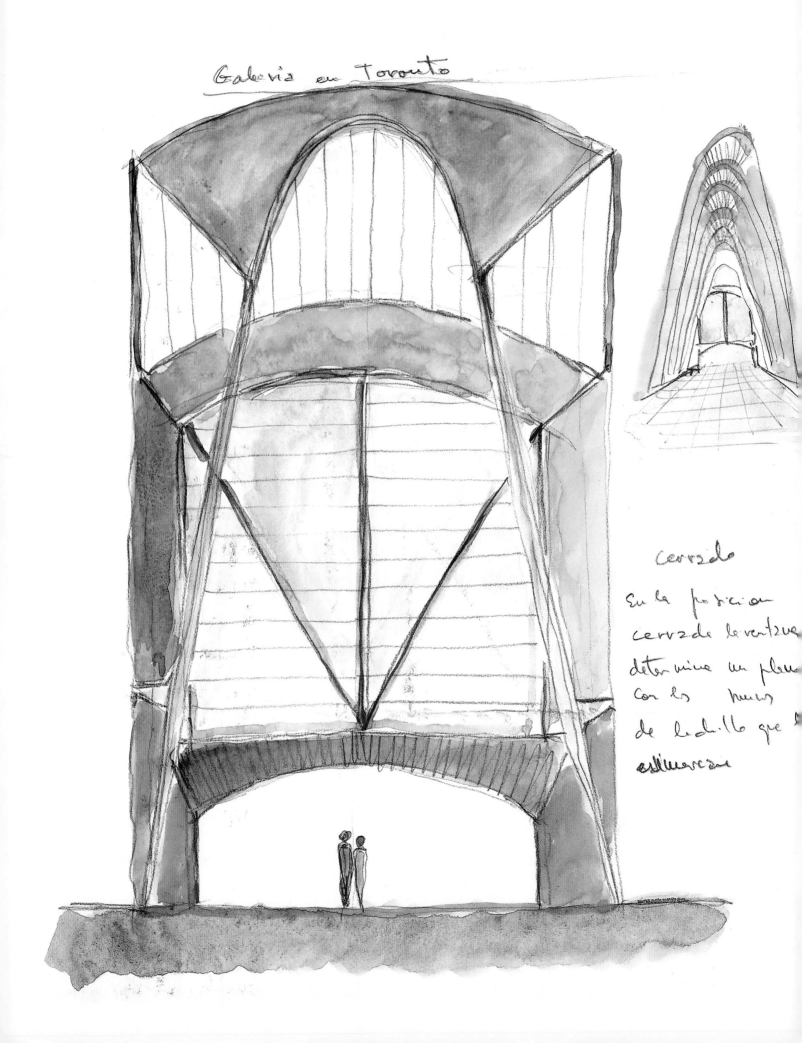

cerrada

En la posición
cerrada la ventana
determina un plano
con los muros
de ladrillo que lo
enmarcan

BCE PLACE: GALLERIA AND HERITAGE SQUARE

Toronto, Canada. 1987–1992.

Al Final de la galería en el vínculo entre galería y plaza aparece una ventana de grandes dimensiones capaz de optimizar la apertura entre galería y plaza en el tramo superior.

Este elemento que se descompone en dos

enmarcado por el arco y las jambas de ladillo y ~~toma~~ un carácter escultural explícito

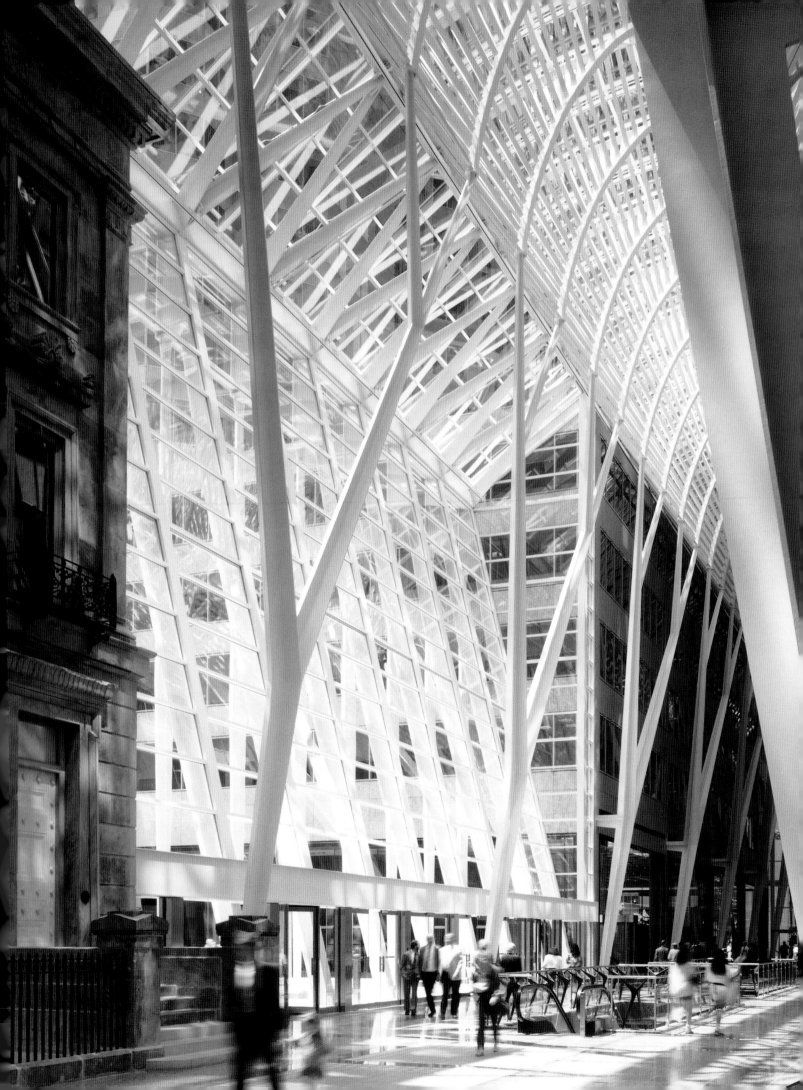

Project
BCE PLACE: GALLERIA AND HERITAGE SQUARE

Location
TORONTO, CANADA

Client
BROOKFIELD DEVELOPMENT CORPORATION, TORONTO

Length / Height / Width
130 METERS / 27 METERS / 14 METERS

What would otherwise be a dull, uninteresting space between large buildings becomes a focal point for the city in the hands of the architect. Soaring volumes may not serve a purpose in the most rigorous utilitarian sense, but it is this extra space that generates the success of the project.

Ein ansonsten öder, reizloser Ort zwischen hohen Gebäuden wird in den Händen des Architekten zu einem urbanen Brennpunkt. Hoch aufragende Baukörper mögen im strikt utilitaristischen Sinn keinen Zweck erfüllen, aber es ist dieser zusätzliche Raum, der den Erfolg des Projekts generiert.

Entre les mains de l'architecte, ce qui aurait pu n'être qu'un volume sans intérêt entre deux grands immeubles est devenu un lieu d'attraction pour la ville. Ses volumes élancés ne sont peut-être pas fonctionnels au sens utilitariste du terme, mais cet espace généreux a assuré le succès du projet.

The structural typology of the tree, present in projects as diverse as the Oriente Station in Lisbon, the Science Museum in Valencia and the St. John the Divine proposal is also at the heart of the Bell Canada Enterprises Place, Galleria and Heritage Square in Toronto. Here, Calatrava worked with the New York office of corporate architects Skidmore, Owings & Merrill to create a six-story, 130-meter-long, 14-meter-wide, and 27-meter-high gallery connecting two towers with a white painted, welded steel and glass passageway. As *The New York Times* said, "This gallery is nothing if not Gaudí-esque." With this design, Calatrava reaches back to some of the roots of Western architecture, in an almost literal sense, using the image of the tree to create a great urban space with links to the Gothic tradition as well as to that of more modern figures like Gaudí. The transition from Calatrava's Galleria to Heritage Square is marked by two large, rotating glass panels or "wings" that take the place of more elaborate folding doors originally proposed by the architect. A circular fountain designed by Calatrava, and made of steel tubes that open like a flower is placed in the square itself. There is also a link in this proposal, which far exceeded the original competition program, to the covered spaces of Europe, such as the Galleria Vittorio Emanuele in Milan, although in typical, radical fashion, the architect conceived his project as a freestanding element between existing buildings. As the architect's project description says, "It appears as a new typology for weather-protected precincts. In this case, it is also a focal point for an entrance to Toronto's subterranean, central pedestrian network. A space-defining function has thus been created that imposes a new point of orientation upon these otherwise disparate structures."

Die Struktur des Baums, die in so unterschiedlichen Projekten wie dem Bahnhof Oriente in Lissabon, dem Wissenschafts-Museum in Valencia und dem Entwurf für St. John the Divine deutlich wird, liegt auch der Galerie und dem Heritage Square des Bell Canada Enterprises Place in Toronto zugrunde. Hier arbeitete Calatrava mit dem New Yorker Architekturbüro Skidmore, Owings & Merrill an der Konzeption einer sechsgeschossigen, 130 m langen, 14 m breiten und 27 m hohen Galerie zusammen, die zwei Türme durch einen weißgestrichenen Durchgang aus geschweißtem Stahl und Glas verbindet. Der Kommentar der *New York Times* dazu lautete: „Diese Galerie erinnert stark an Gaudí." Calatrava griff hier auf bestimmte Wurzeln der westlichen Architektur zurück, die er fast wörtlich zitiert. Er verwendete das Bild des Baums, um einen bedeutenden urbanen Raum zu schaffen, der Verbindungen zur gotischen Tradition, aber auch zu modernen Baumeistern wie Gaudí aufweist. Der Übergang von Calatravas Galerie zum Heritage Square wird von zwei großflächigen, sich drehenden Glasscheiben oder „Flügeln" hervorgehoben, anstelle der ursprünglich vom Architekten geplanten kunstvolleren Falttüren. Auf dem Platz selbst befindet sich ein von Calatrava entworfener kreisrunder Brunnen aus Stahlröhren, die sich einer Blüte gleich entfalten. Darüber hinaus gibt es bei diesem Projekt eine Verbindung, die weit über die Wettbewerbsausschreibung hinausgeht, und zwar zu den überdachten urbanen Räumen Europas, wie die Galleria Vittorio Emanuele in Mailand, wiewohl der Architekt in typisch radikaler Manier sein Projekt als freistehendes Element zwischen vorhandenen Gebäuden konzipierte. In der Beschreibung des Architekten heißt es dazu: „Es erscheint als neues Modell für witterungsgeschützte Bereiche. Hier signalisiert es außerdem einen Eingang zu Torontos unterirdischem, zentralem Wegenetz für Fußgänger. So entstand eine raumbegrenzende Funktion, die diesen ansonsten disparaten Bauten zu einem neuen Orientierungspunkt verhilft."

La typologie arborescente, présente dans des projets aussi divers que la gare de l'Orient à Lisbonne, le musée des Sciences à Valence et le projet pour la cathédrale Saint John the Divine à New York, est au cœur de cette réalisation. Calatrava a travaillé avec l'agence new-yorkaise d'architecture institutionnelle Skidmore, Owings & Merrill pour créer cette galerie en acier laqué blanc et verre de 130 mètres de long, 14 mètres de large et 27 mètres de haut qui réunit au niveau du sol deux tours d'assez grande hauteur. Comme l'écrivit le *New York Times*, « Cette galerie est pour le moins gaudiesque ». Calatrava se rapproche de certaines racines (au sens quasi littéral du terme) de l'architecture occidentale en utilisant l'image de l'arbre pour créer un vaste espace urbain lié à la tradition gothique ou à des interventions plus modernes comme celles de Gaudí. La transition entre la galerie et l'Heritage Square est marquée par deux grands pans de verre pivotants ou « ailes » qui remplacent les portes articulées plus élaborées proposées à l'origine par l'architecte. Également dessinée par Calatrava, une fontaine circulaire en tubes d'acier qui s'ouvre comme une fleur est installée sur la place même. On pourrait également voir ici un lien avec d'autres espaces couverts européens, comme la Galleria Vittorio Emanuele à Milan, bien qu'à sa façon caractéristique et radicale, l'architecte ait conçu un projet indépendant des bâtiments qu'il relie. Comme le descriptif de l'agence le note : « [Ce projet] invente une nouvelle typologie d'espace protégé des intempéries. Ici, il constitue également un signal pour l'une des entrées du réseau souterrain piétonnier du centre de Toronto. Une fonction de définition de l'espace a ainsi été créée, qui impose un nouveau point d'orientation au milieu de ces structures par ailleurs disparates. »

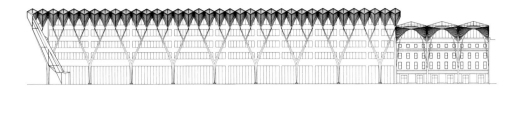

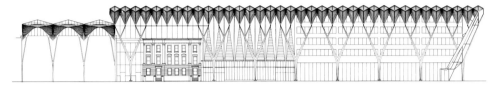

LONGITUDINAL SECTIONS
1:200

The fundamentally repetitive use of tree-like forms on a large scale creates much greater spatial variety than might be expected because of the complexity of the structure, but also because of the variations in light and shadow that it introduces to the space.

Der sich im Grunde wiederholende Gebrauch baumartiger Formen in großem Maßstab erzeugt eine weit größere räumliche Vielfalt als man erwarten könnte, wegen der Komplexität des Gebäudes, aber auch wegen der abwechslungsreichen Licht- und Schattenführung, die dadurch im Raum entsteht.

Le recours répétitif à des piliers arboriformes à grande échelle crée une diversité spatiale beaucoup plus importante que l'on pouvait s'y attendre, du fait de la complexité de la structure mais aussi à cause des variations d'ombre et de lumière qu'ils introduisent dans l'espace.

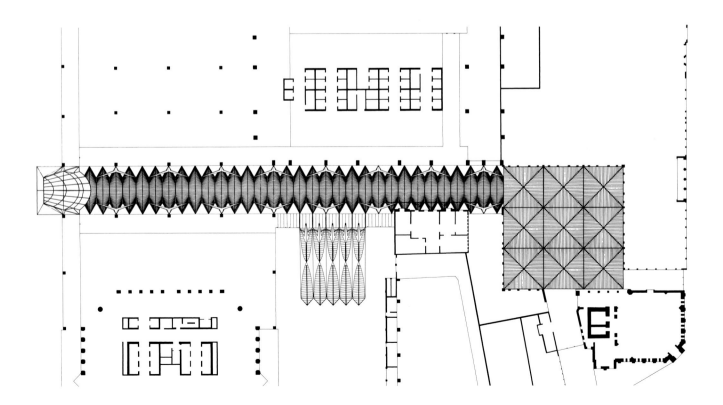

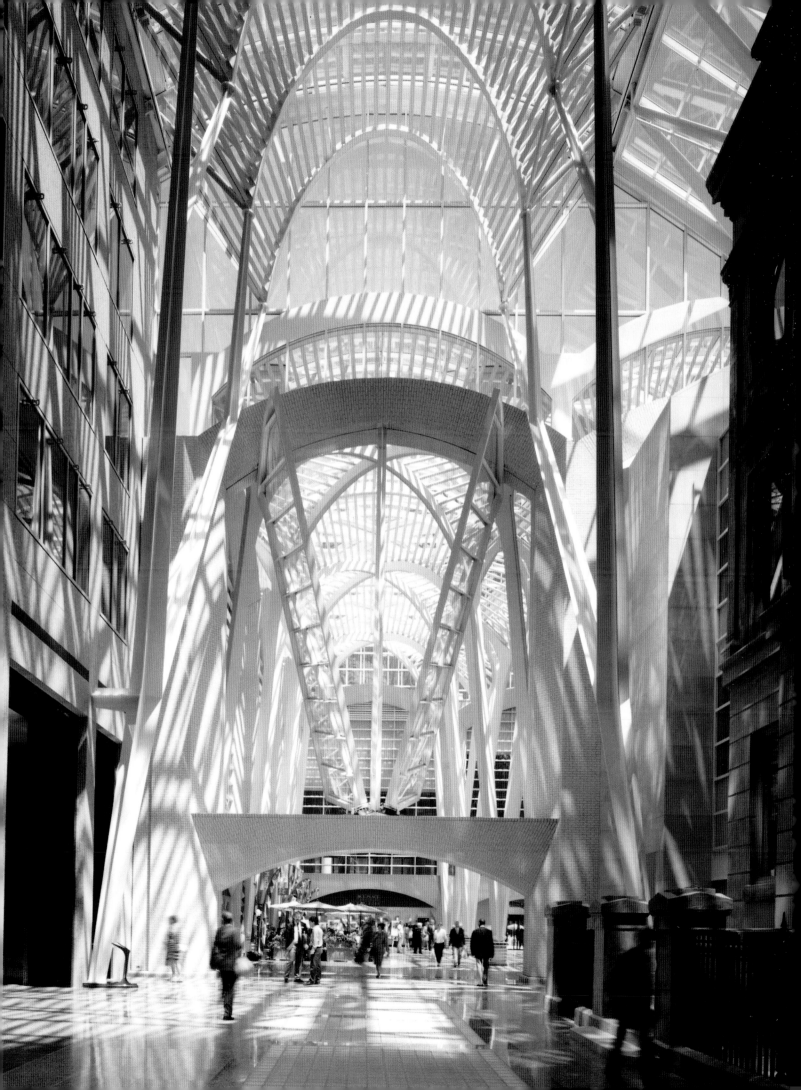

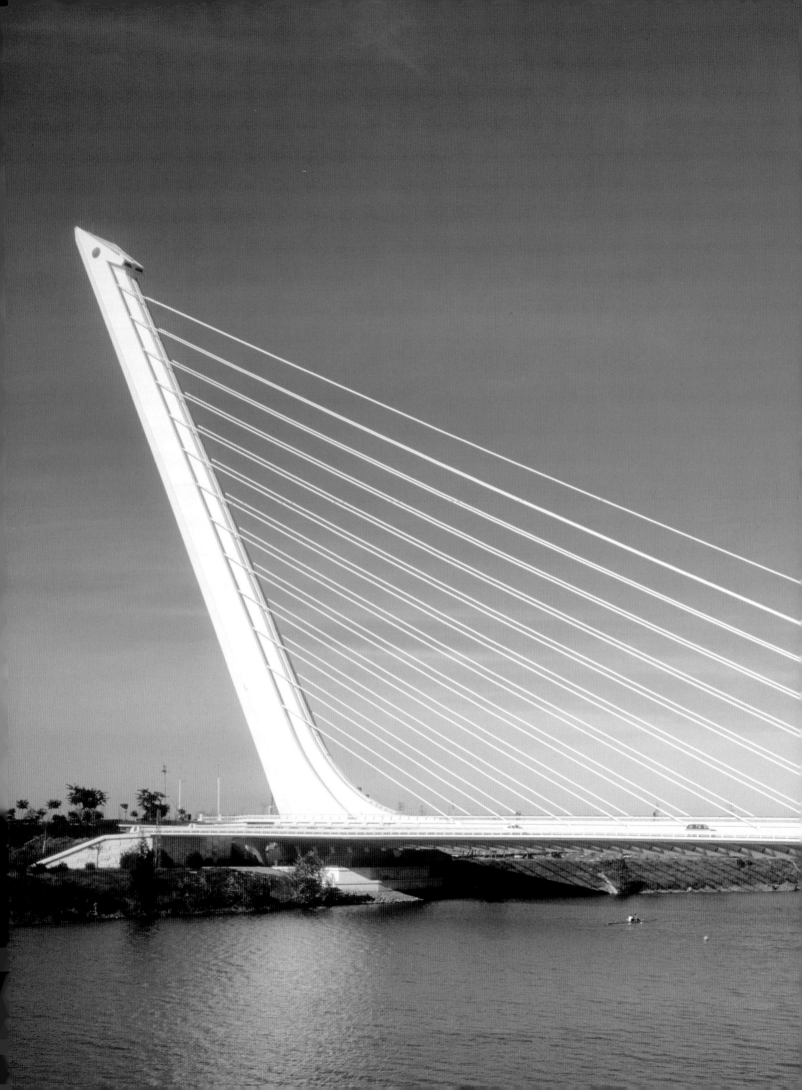

ALAMILLO BRIDGE AND LA CARTUJA VIADUCT

Seville, Spain. 1987–1992.

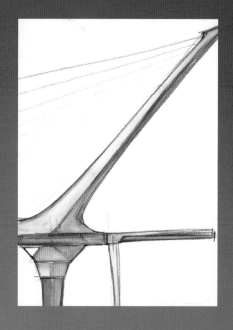

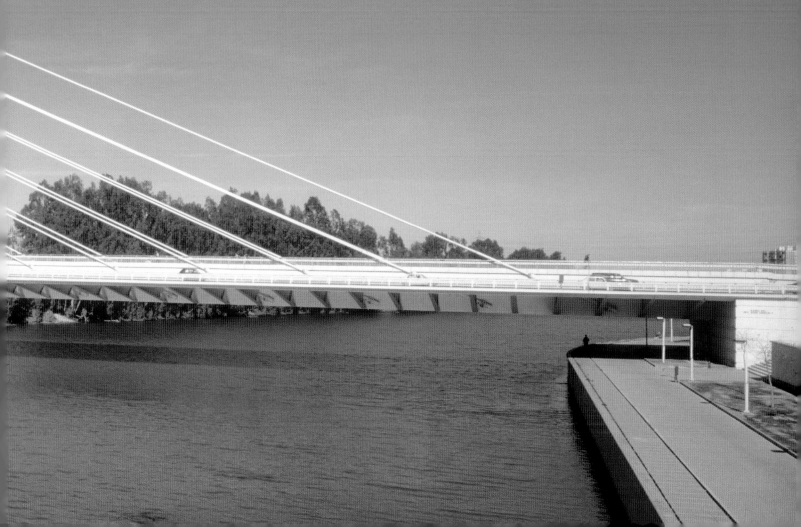

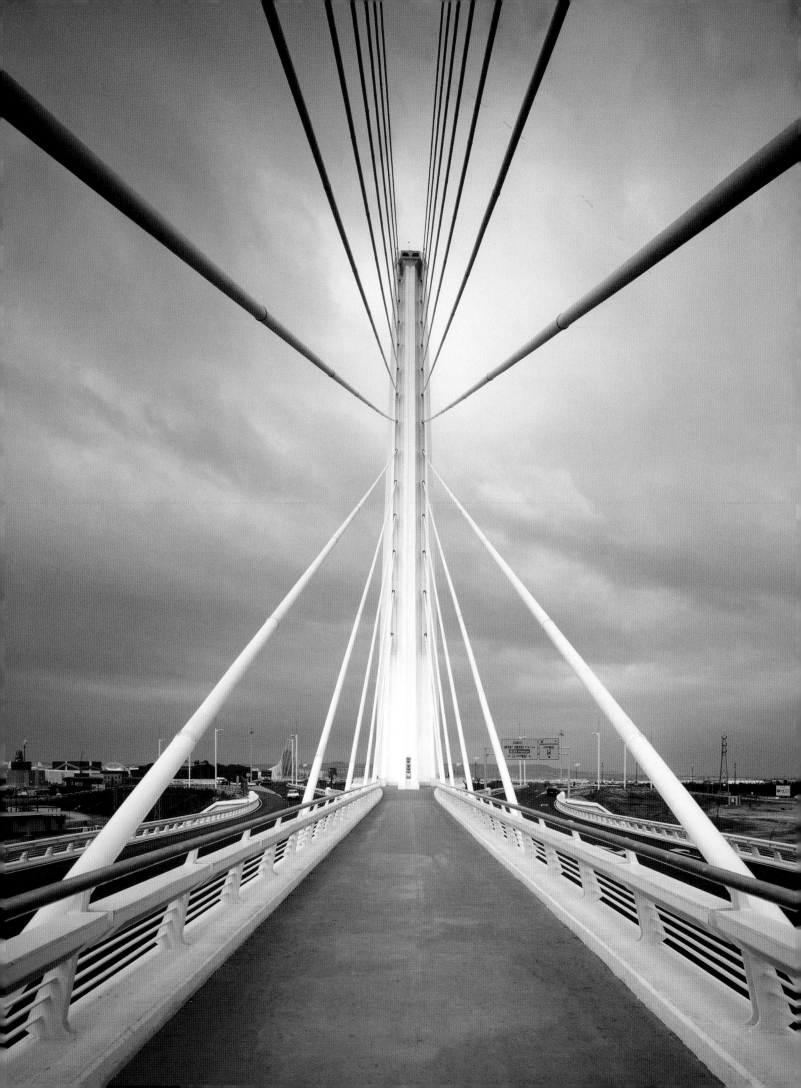

Project
ALAMILLO BRIDGE AND LA CARTUJA VIADUCT

Location
SEVILLE, SPAIN

Client
REGIONAL GOVERNMENT OF ANDALUSIA, SEVILLE

Span
200 METERS

Pylon height
142 METERS

Even if the Seville fair itself left less of a mark than its organizers might have hoped, Calatrava's bridge with its dramatic angled tower remains. Might it be that bridges are less ephemeral than buildings?

Selbst wenn die Expo in Sevilla weniger Spuren hinterließ als ihre Organisatoren gehofft haben mögen, bleibt Calatravas Brücke mit ihrem spektakulär geneigten Turm erhalten. Könnte es sein, dass Brücken weniger kurzlebig sind als Gebäude?

Même si l'Expo de Séville n'a pas laissé une empreinte aussi marquante que ses organisateurs l'avaient espéré, le pont de Calatrava et son pylône à l'inclinaison spectaculaire demeurent. Les ponts seraient-ils moins éphémères que les bâtiments ?

Part of a plan initiated by the government of the region of Andalusia on the occasion of Expo '92, this bridge has a 200-meter span over the Meandro de San Jerónimo, a shallow branch of the Guadalquivir River. Its most striking feature is a 142-meter-high pylon, inclined at an angle of 58 degrees, the same as that of the Pyramid of Cheops. Filled with cement, this tower is sufficiently massive to counterbalance the bridge deck, obviating the need for backstays, and allowing the bridge to be held up with just 13 pairs of cables. Santiago Calatrava's personal research on the Alamillo Bridge involved a 1986 sculpture called *Running Torso* made of cubes of marble held in equilibrium at an angle by a wire under tension. His drawings of running figures also come to mind. He originally proposed a second bridge, located 1.5 kilometers from the first one, with a mirror image pylon at the point where the road crosses the same river again, but the client opted instead for the 526-meter-long Puente de La Cartuja Viaduct, with its two 10-meter-wide lanes, which was used as the northern entrance to the Expo '92 site. Conceptually speaking the Alamillo Bridge is clearly innovative, simplifying basic bridge design and allowing for the use of only half the normal number of cable stays. The double bridge concept would have created an enormous, partially imaginary triangle, with its point high in the sky above the Expo site. Frequently imitated by other engineers and architects, the inclined pylon of the Alamillo Bridge stands out as a symbol of modern Seville. Without suggesting any specific influence, it can be noted that the Dutch architect Ben van Berkel, author of the Erasmus Bridge in Rotterdam (inaugurated in 1996), worked in 1988 in the office of Santiago Calatrava just before creating his own firm, UN Studio, with Caroline Bos.

Die Alamillo-Brücke, die mit einer Spannweite von 200 m den Meandro San Jeronimo, einen flachen Seitenarm des Guadalquivir, überquert, ist Teil einer von der Regierung der Region Andalusien anlässlich der Expo '92 initiierten Planung. Ihr markantestes Merkmal ist der 142 m hohe Brückenpfeiler, der in einem Winkel von 58 Grad, dem der Cheopspyramide entsprechend, geneigt ist. Der mit Zement gefüllte Turm ist wuchtig genug, um als Gegengewicht der Brückentafel zu dienen; er macht rückseitige Verankerungen überflüssig und ermöglicht es, dass die Brücke von nur 13 Seilpaaren gehalten wird. Zu Santiago Calatravas persönlichen Studien zur Alamillo-Brücke gehört die 1986 entstandene Skulptur „Rennender Torso". Sie besteht aus Marmorkuben, die von einem gespannten Draht in Schräglage im Gleichgewicht gehalten werden. Auch seine Zeichnungen von laufenden Figuren fallen einem dazu ein. Ursprünglich hatte er im Abstand von 1,5 km eine zweite Brücke über den Guadalquivir vorgeschlagen, die spiegelbildlich positioniert werden

sollte, aber der Auftraggeber entschied sich stattdessen für das 526 m lange La-Cartuja-Viadukt mit seinen zwei 10 m breiten Fahrspuren, das als nördlicher Eingang zum Gelände der Expo '92 dient. In konzeptueller Hinsicht ist die Alamillo-Brücke innovativ, da sie den grundlegenden Brückenbau vereinfacht und mit der Hälfte der üblicherweise nötigen Seilverankerungen auskommt. Die Planung mit der doppelten Brücke hätte ein riesiges, teilweise imaginäres Dreieck geschaffen, dessen Spitze hoch oben im Himmel über dem Expogelände gelegen hätte. Der von anderen Ingenieuren und Architekten häufig nachgeahmte geneigte Pylon der Alamillo-Brücke fällt als Symbol des modernen Sevilla ins Auge. Ohne spezifische Einflüsse andeuten zu wollen, bleibt festzuhalten, dass der Niederländer Ben van Berkel, Architekt der 1996 eingeweihten Erasmusbrücke in Rotterdam, kurz vor Gründung seiner eigenen Firma UN Studio mit Caroline Bos, 1988 im Büro von Santiago Calatrava tätig war.

Construit dans le cadre d'un plan initié par le Gouvernement de la région d'Andalousie à l'occasion d'Expo '92, ce pont de 200 mètres de portée franchit le Meandro San Jeronimo, un bras peu profond du Guadalquivir. Sa caractéristique la plus spectaculaire est un pylône de 142 mètres de haut incliné à 58° (le même angle que la pyramide de Khéops). Le poids de cette tour remplie de ciment suffit à contrebalancer celui du tablier, éliminant le recours à des haubans arrière et permettant que treize paires de câbles seulement soutiennent l'ouvrage. Les recherches personnelles de Santiago Calatrava sur ce projet ont débuté en 1986 à partir d'une de ses sculptures, *Running Torso,* faite de cubes de marbre inclinés maintenus en équilibre par un fil de fer en tension. On pense également à ses dessins de figures en train de courir. À l'origine il avait proposé un second pont, à 1,5 km du premier, doté d'un pylône identique incliné dans le sens inverse, mais le client préféra la solution du viaduc de La Cartuja. Long de 526 mètres avec deux voies de dix mètres de large, ce dernier est utilisé pour desservir l'entrée nord d'Expo '92. Sur le plan conceptuel, le pont Alamillo est novateur par la simplification qu'apporte sa conception et l'utilisation de la moitié seulement des haubans normalement nécessaires. Le double pont aurait créé un énorme triangle « chapeautant » le site de l'Expo. Fréquemment imité par d'autres ingénieurs et architectes, ce pylône incliné est aujourd'hui l'un des symboles de la Séville moderne. Sans pour autant suggérer une influence, on peut noter que l'architecte néerlandais Ben van Berkel, auteur du pont Erasmus à Rotterdam (inauguré en 1996), travaillait en 1988 chez Calatrava, juste avant de fonder sa propre agence, UN Studio, avec Caroline Bos.

The very dramatic form of the bridge is accentuated by the lack of backstays, an engineering feat that resulted from careful calculations and above all an imagination freed from the bonds of conventional solutions.

Die fulminante Form der Brücke wird durch das Fehlen von Verankerungen unterstrichen, eine technische Meisterleistung, möglich dank sorgfältiger Berechnungen und einer von konventionellen Sachzwängen befreiten Vorstellungskraft.

La forme très spectaculaire du pont est renforcée par l'absence de haubans arrière, exploit d'ingénierie qui résulte de calculs poussés et surtout d'une imagination libérée des pesanteurs des solutions conventionnelles.

Though the sketch of a human figure by Calatrava on the right is not specifically related to this bridge project, it does illustrate the architect's fascination with movement and tension, two elements that inform the Alamillo Bridge design.

Obgleich Calatravas Skizze einer menschlichen Figur rechts nicht speziell mit diesem Brückenprojekt in Zusammenhang steht, veranschaulicht sie, wie sehr der Architekt von Bewegung und Spannung fasziniert ist, zwei Faktoren, ohne die die Alamillo-Brücke nicht denkbar wäre.

Bien que le croquis d'une figure humaine par Calatrava (à droite) ne soit pas spécifiquement relié à ce projet, il illustre sans aucun doute la fascination de l'architecte pour le mouvement et la tension, deux éléments qui nourrissent le dessin du pont Alamillo.

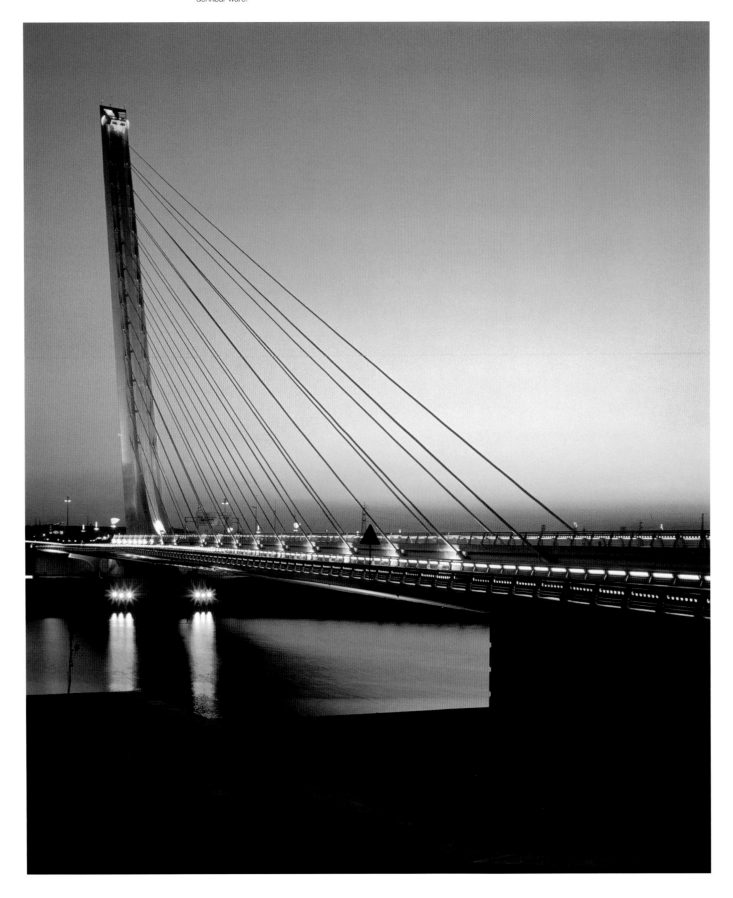

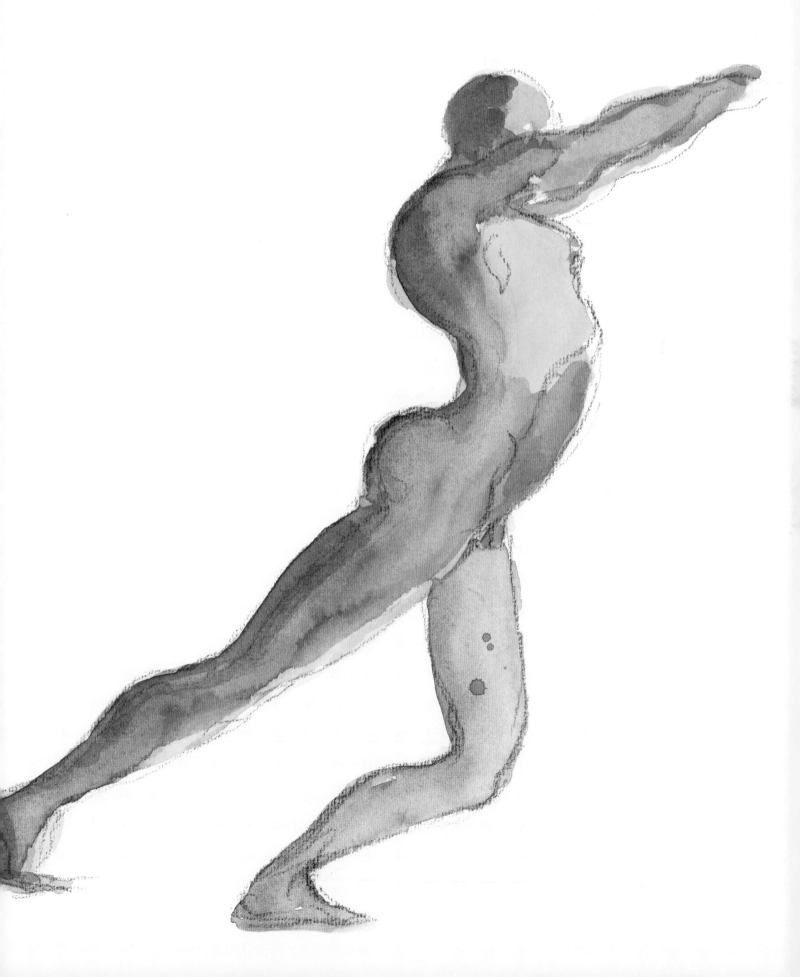

MONTJUIC COMMUNICATIONS TOWER

Barcelona, Spain. 1989–1992.

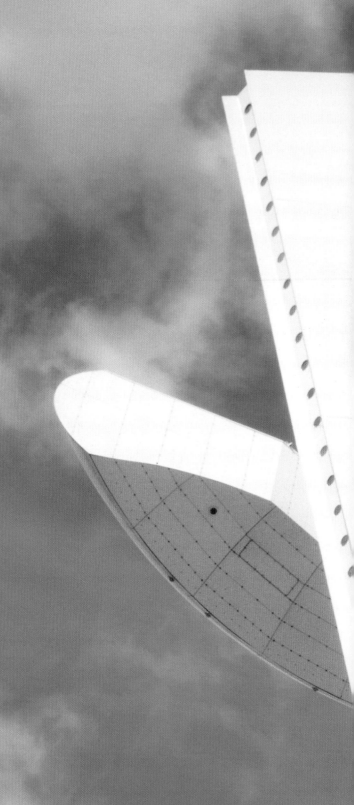

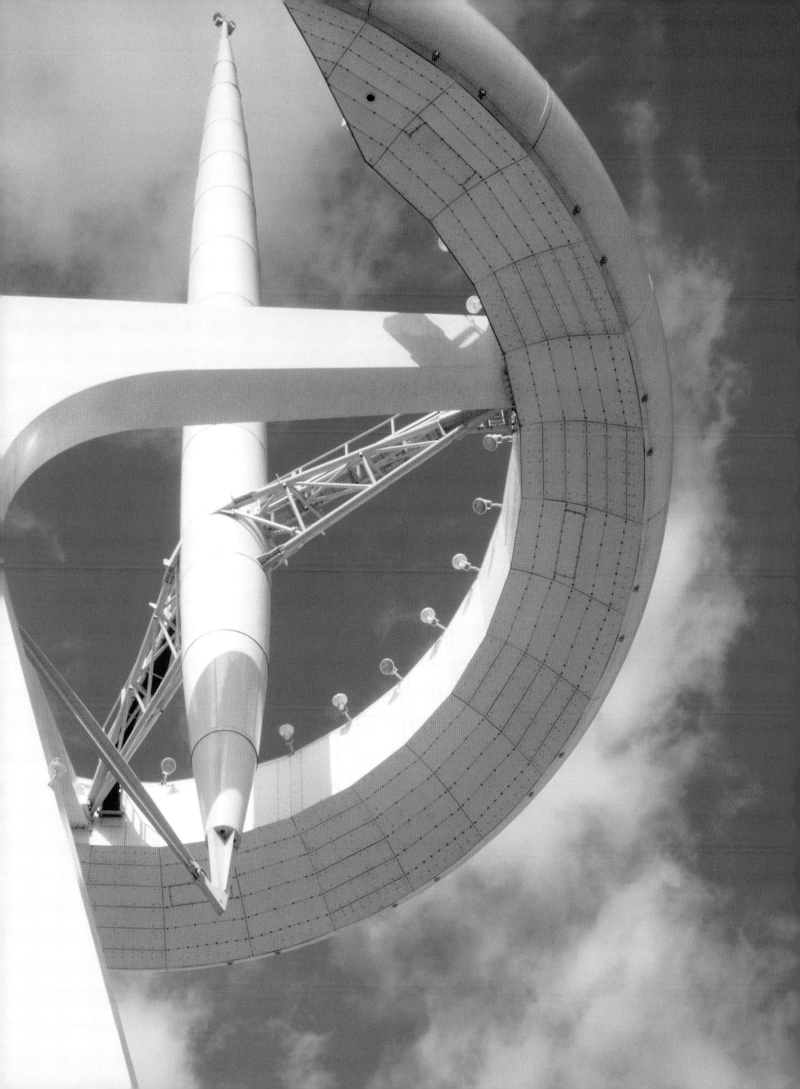

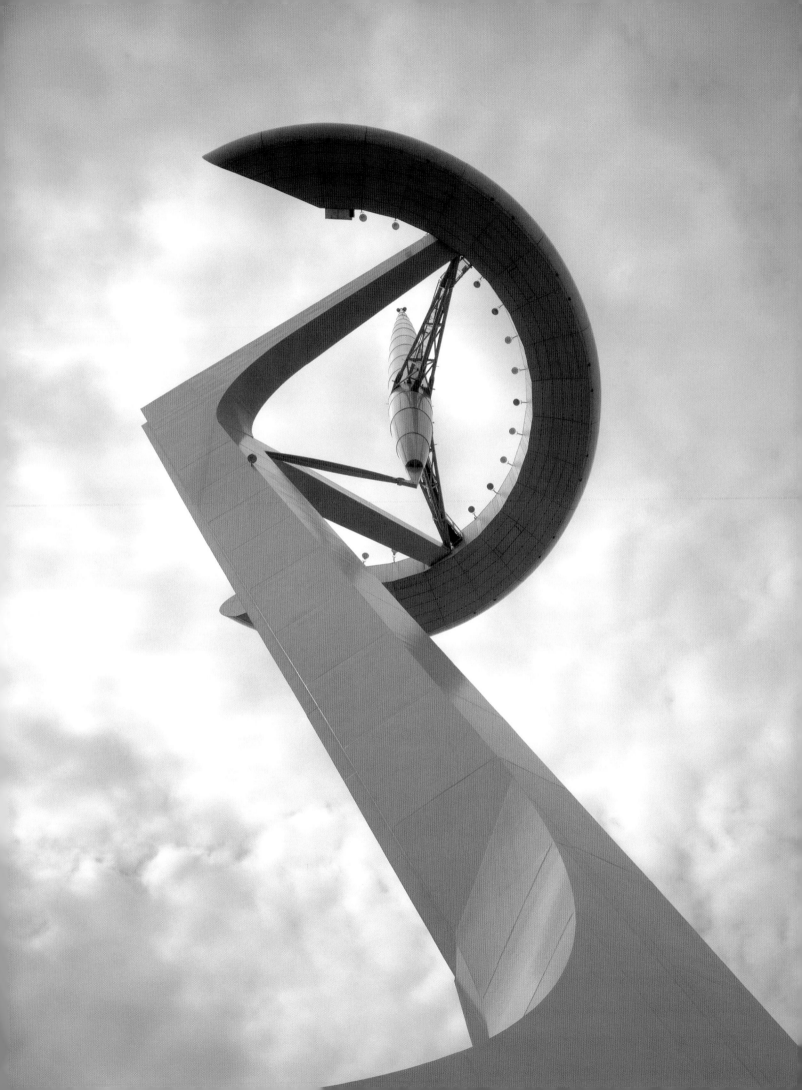

Project
MONTJUIC COMMUNICATIONS TOWER

Location
BARCELONA, SPAIN

Client
TELEFONICA S. A.

Height
136 METERS

The page of sketches to the right shows the Montjuic Telecommunications Tower with a relatively high degree of accuracy as compared to the completed structure, seen from below on the left. This fact underlines the interest and importance of Calatrava's sketches.

Auf dem Skizzenblatt rechts ist der Montjuic Fernmeldeturm mit recht hoher Exaktheit wiedergegeben im Vergleich zur links zu sehenden Untersicht des fertigen Baus. Dieser Vergleich unterstreicht die Wichtigkeit und Bedeutung von Calatravas Skizzen.

Cette page de croquis montre la tour de télécommunications de Montjuic avec un degré de précision relativement avancé par rapport à la réalisation de la structure, vue ici à gauche, depuis le sol. Elle souligne l'intérêt et l'importance des croquis de l'architecte.

Located near the Palau Sant Jordi designed by the Japanese architect Arata Isozaki, the Montjuic Communications Tower is 136 meters high. Built like its neighbor for the 1992 Olympic Games, it is based on an inclined trunk with an annular element containing the actual antennas above. Although, because of its angle and its pointed tip, it may recall a javelin, the tower is based on Calatrava's own drawings of a kneeling figure making an offering. This image might well be appropriate to the original Olympic context of the site. The three-point base of the structure may also bring to mind ancient object design. The base, closed by a door formed by metal blades, is related to his studies of the human eye. This door was developed along similar lines to the loading bay doors at the Ernsting's Warehouse in Coesfeld-Lette, Germany. Acting like a sundial, the trunk projects a shadow onto the circular platform. The platform at the base, a brick drum containing the communications equipment imposed at the time of the competition, is covered in broken tiles, evoking the Park Güell by Antoni Gaudí. Related at once to the geographic and solar locations of the site, the Montjuic Tower is at once a symbol of the Olympic Games, but also of the progressive, artistically oriented history of Barcelona itself. Calatrava's sense of drama and suspended equilibrium is just as evident in this tower as it is in any of his bridges. The structure is by no means anthropomorphic, but it is sufficiently related to the body and its movement to somehow generate a sentiment of familiarity in the minds of viewers.

In der Nähe des von dem japanischen Architekten Arata Isozaki errichteten Palau Sant Jordi steht der 136 m hohe Montjuïc-Fernmeldeturm. Wie sein Nachbar für die Olympischen Spiele 1992 konzipiert, besteht der Turm aus einem geneigten Schaft mit einem ringförmigen Element, in dem die eigentlichen Antennen untergebracht sind. Obwohl der Turm aufgrund seiner Neigung und der zugespitzten Form an einen Speer erinnert, fußt er doch auf Calatravas Zeichnungen einer ein Opfer darbringenden, knienden Figur. Dieses Bild entspräche dem olympischen Kontext des Ortes. Der auf drei Punkten ruhende Unterbau des Turms könnte ebenfalls an antike Objektgestaltung erinnern. Der Sockel, der mit einem aus Metallblättern bestehenden Tor verschlossen wird, steht in Zusammenhang mit Calatravas Studien des menschlichen Auges. Dieses Tor wurde nach ähnlichen Richtlinien entwickelt wie die Tore der Laderampen im Lagerhaus

Ernsting's in Coesfeld. Der wie der Zeiger einer Sonnenuhr wirkende Schaft wirft einen Schatten auf das kreisförmige Podium. Das aus Backsteinen gemauerte, runde Podium, das die zur Zeit des Wettbewerbs geforderte Fernmeldetechnik enthält, ist mit Ziegelscherben bedeckt, die an den Parque Güell von Antoni Gaudí denken lassen. Der ebenso auf die geografischen wie solaren Bedingungen des Geländes bezogene Torre de Montjuïc gilt gleichermaßen als Symbol der Olympischen Spiele wie der fortschrittlichen, künstlerisch ausgerichteten Geschichte Barcelonas. Calatravas Gespür für Dramatik und zeitweilig aufgehobenes Gleichgewicht ist in diesem Turm ebenso augenfällig wie in jeder seiner Brücken. Der Bau ist keineswegs anthropomorph, aber er ist hinreichend auf den Körper und seine Bewegungen bezogen, um im Kopf der Betrachter ein gewisses Gefühl der Vertrautheit aufkommen zu lassen.

Située près du Palau Sant Jordi conçu par l'architecte japonais Arata Isozaki, cette tour mesure 136 mètres de haut. Construite, comme son voisin, à l'occasion des Jeux olympiques de 1992, elle est constituée d'un fût incliné soutenant en partie supérieure un élément annulaire contenant les antennes. Si elle peut évoquer l'image d'un javelot, elle est issue d'un dessin de l'architecte représentant un personnage agenouillé en position d'offrande, situation peut-être appropriée dans le contexte olympique. Le socle tripode peut également rappeler un objet ancien. Sa porte en ailettes métalliques est issue des études de Calatrava sur le thème de l'œil humain et rappelle celles des sas de chargement de l'entrepôt Ernsting's en Allemagne. Jouant le rôle du style d'un cadran solaire, le fût projette son ombre sur la plate-forme circulaire. Celle-ci, en forme de tambour de brique, contient les équipements de communications prévus au cahier des charges de l'époque, et est habillée de tesselles de carrelage, dans l'esprit des bancs du parc Güell d'Antoni Gaudí. Par ce lien avec la géographie et la course du soleil, la tour de Montjuic est devenue un symbole des Jeux mais aussi celui d'une capitale catalane progressiste et ouverte sur l'art. Le sens du spectaculaire de Calatrava manifesté dans cet équilibre en suspension est aussi évident dans cette tour que dans ses ponts. Elle n'est en rien anthropomorphique mais cependant assez liée au corps et à ses mouvements pour générer un sentiment de familiarité.

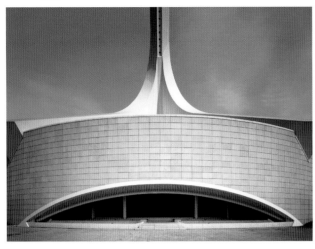 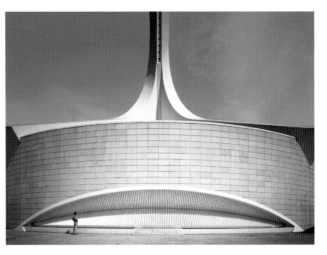

The spectacular form of the tower and its base are closely related to Calatrava's fascination with the human eye. Although its shape is not as simple as that of the earlier Collserola project, the angled tower is a monument to the art of the engineer.

Die fulminante Form des Turms und seines Sockels stehen in engem Zusammenhang mit Calatravas Interesse am menschlichen Auge. Wenngleich seine Form nicht so schlicht ist wie die des vorangegangenen Collserola-Projekts, ist der geneigte Turm ein Monument für das Können des Ingenieurs.

La forme spectaculaire de la tour et de sa base est étroitement liée à la fascination de Calatrava pour l'œil humain. Bien qu'elle ne soit pas aussi simple que celle du projet antérieur pour Collserola, cette tour inclinée est un monument à l'art de l'ingénieur.

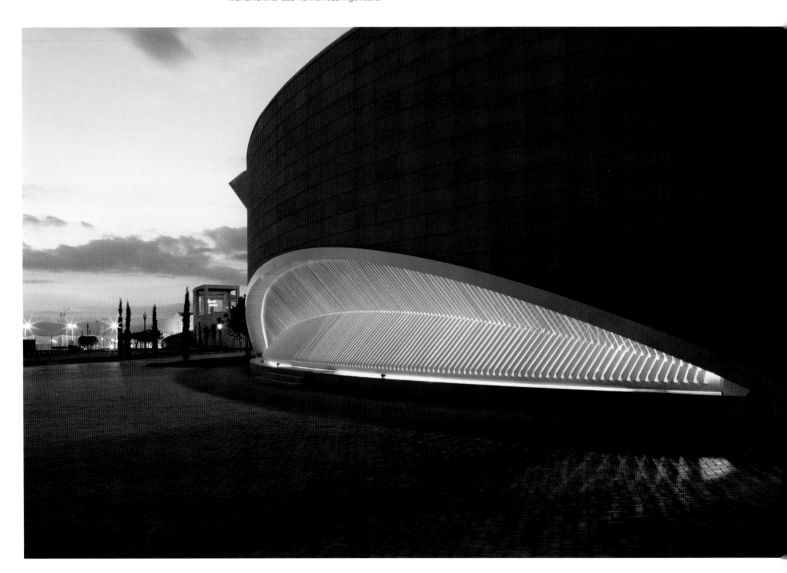

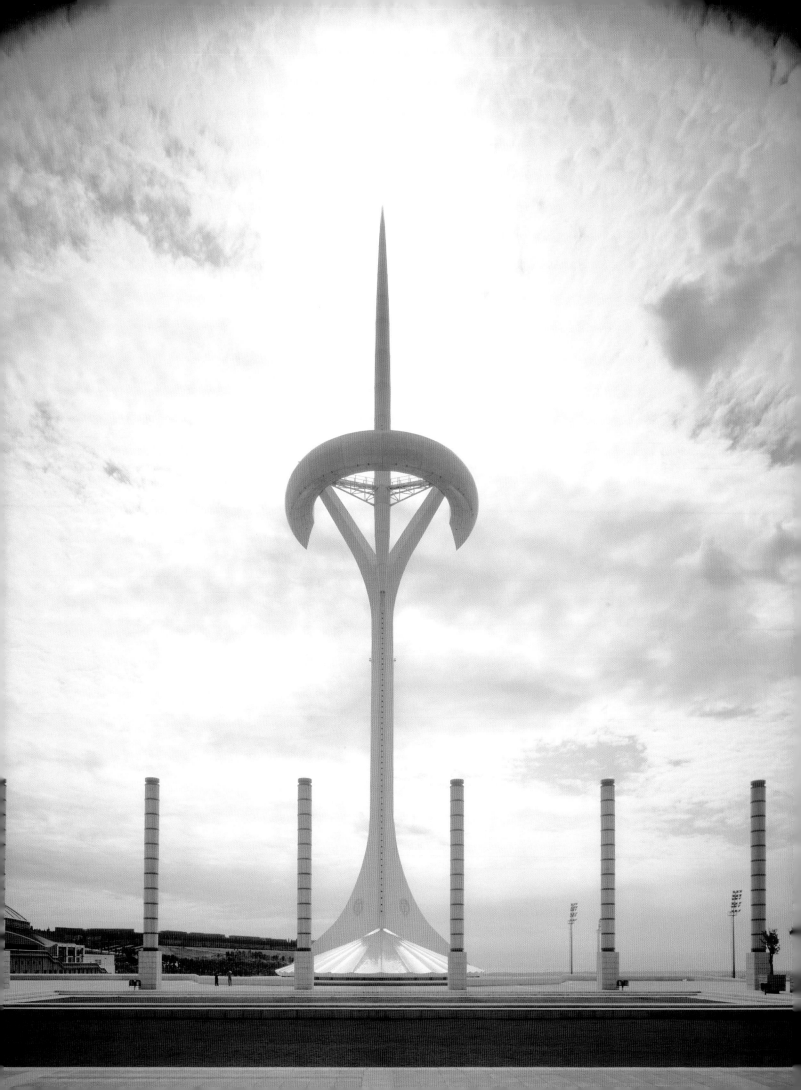

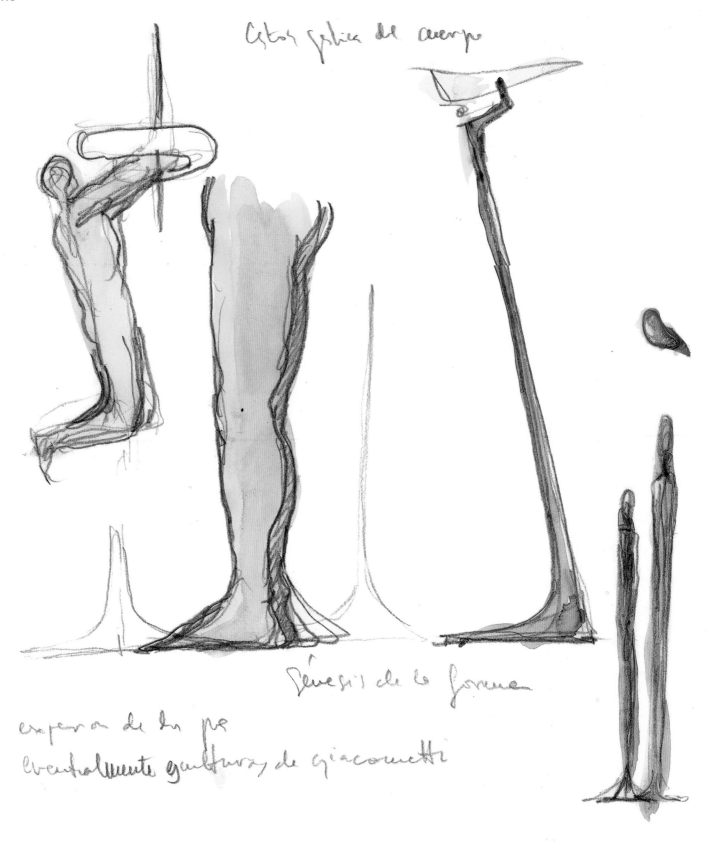

As is most often the case, the architect's sketches reveal many of the ideas that are at the origin of his projects. A kneeling figure, who might be imagined to hold the Olympic flame, or an athlete balanced in motion like the *Discobolus* by Myron are the sublimated references here.

Wie so häufig offenbaren die Skizzen des Architekten viele der Ideen, die am Anfang seiner Projekte stehen. In diesem Fall sind die sublimierten Bezugspunkte eine kniende Figur, von der man sich vorstellen kann, sie hielte die olympische Flamme, oder ein in Bewegung erstarrter Athlet, wie der Diskobol des Myron.

Comme la plupart du temps, les croquis de l'architecte illustrent les multiples pistes qui sont à l'origine de ses projets. Une silhouette agenouillée, qui pourrait tenir la flamme olympique, ou un athlète saisi dans l'équilibre de son geste, comme le Discobole de Myron, sont les références spirituelles de ces dessins.

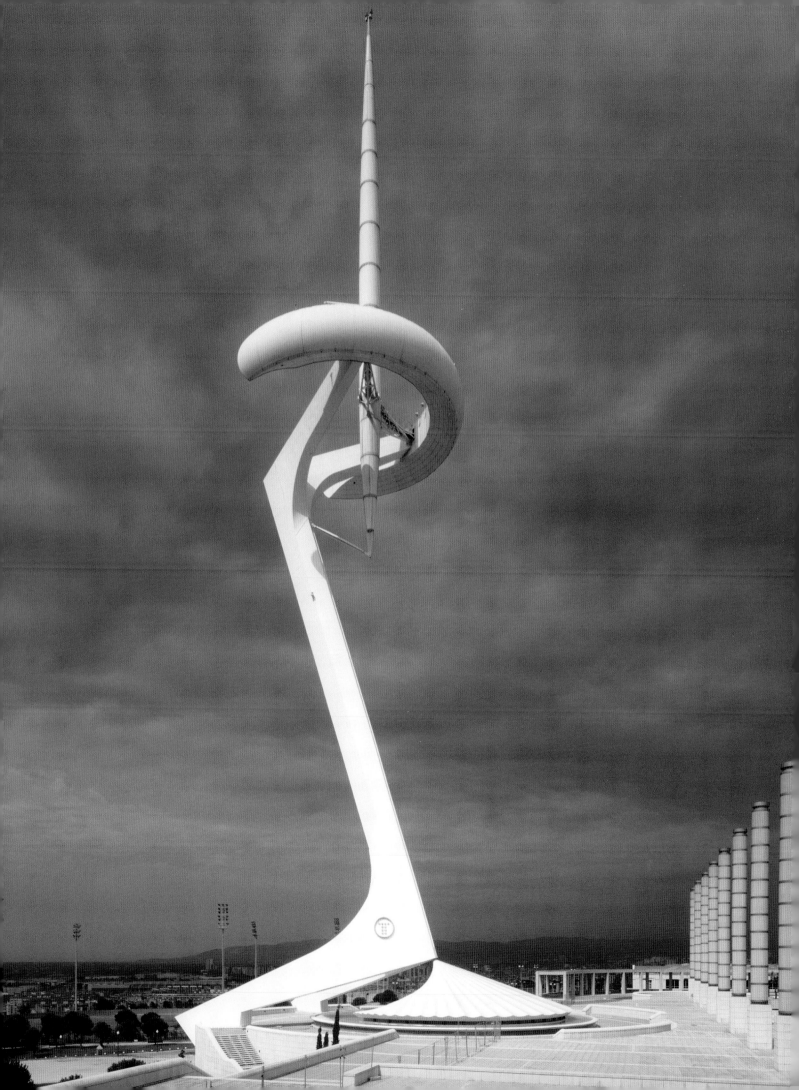

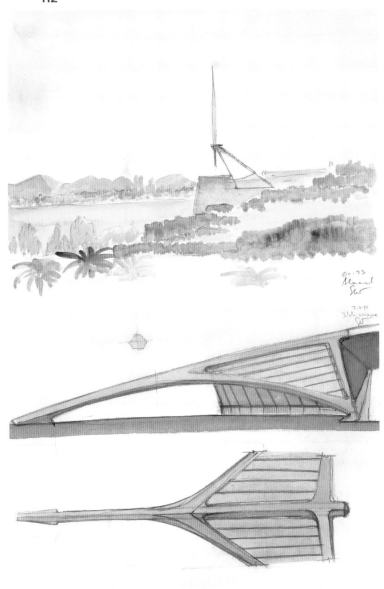

Informed by the knowledge of the engineer, the drawings of the architect might resemble those of an artist. The difference of course is that the pure artist is freed from the constraints of practicality, while Calatrava integrates them in ways that are obvious only to him.

Erfüllt vom Wissen des Ingenieurs könnten die Zeichnungen des Architekten denen eines Künstlers ähneln. Natürlich ist letzterer frei von den Zwängen der Funktionalität, während Calatrava ihnen mit Methoden gerecht wird, die sich nur ihm alleine erschließen.

Nourris des connaissances de l'ingénieur, les dessins de l'architecte peuvent aussi ressembler à ceux d'un artiste. La différence est que l'artiste est libre des contraintes de la réalité tandis que Calatrava les intègre d'une façon qui n'est évidente que pour lui.

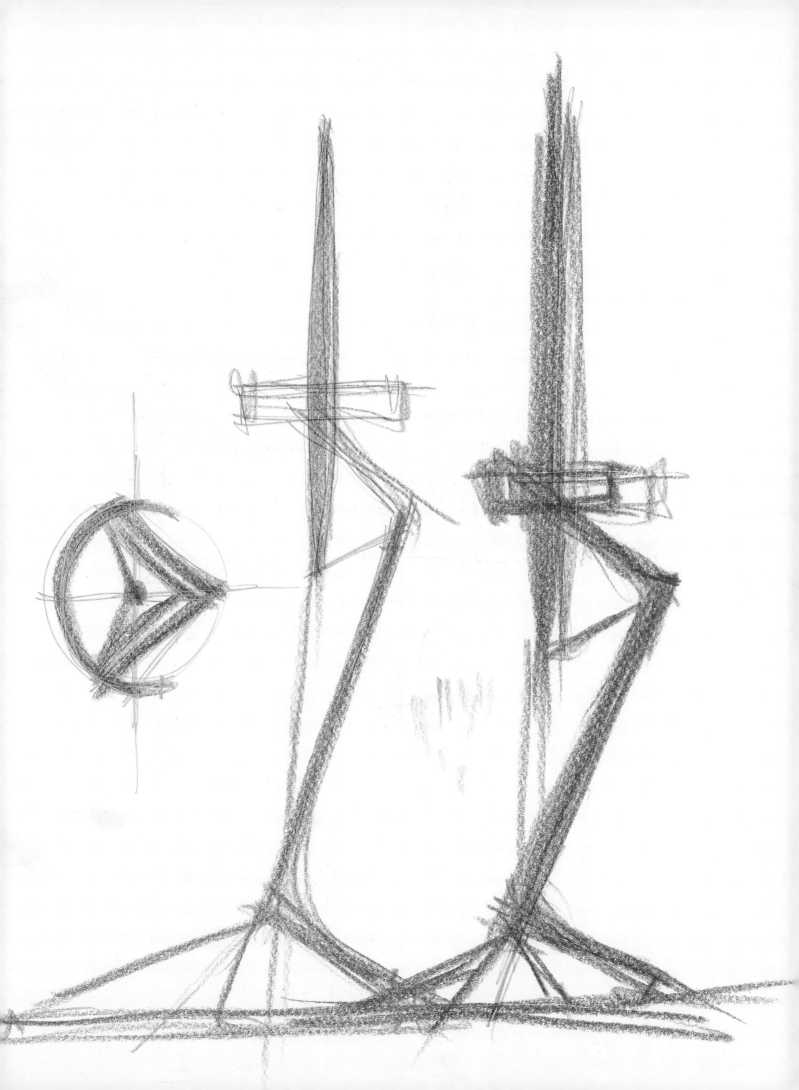

ZURICH UNIVERSITY, LAW FACULTY

Zurich, Switzerland. 1989–2004.

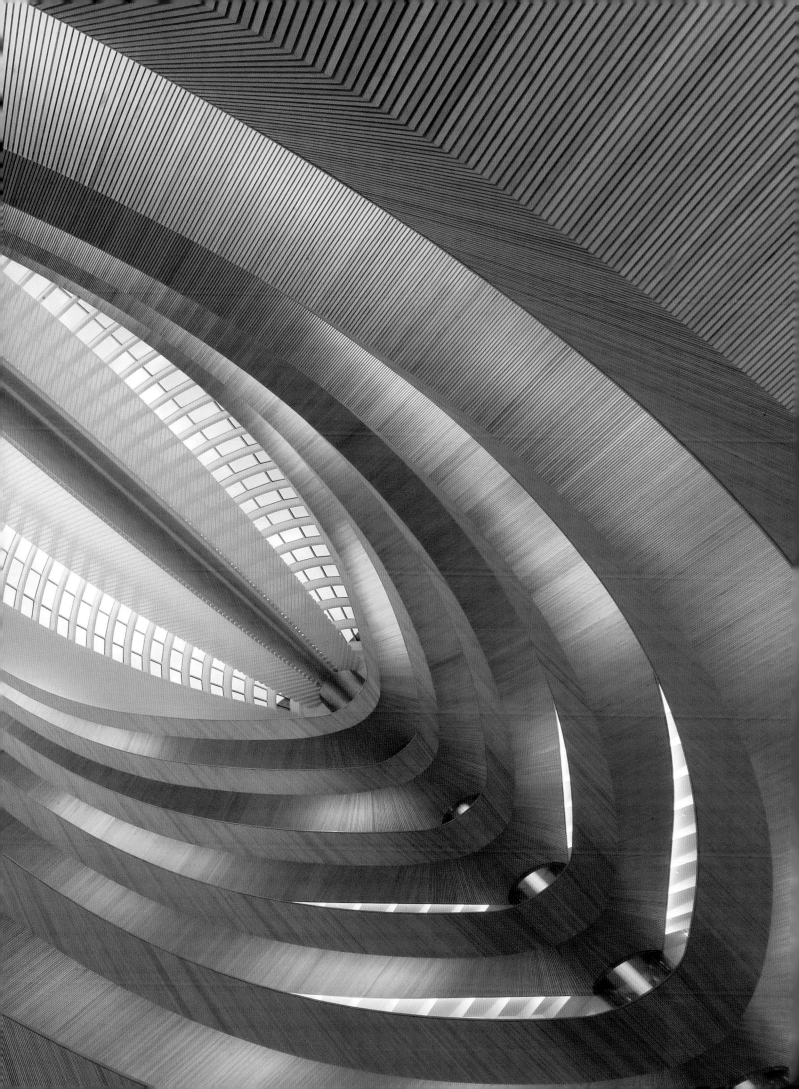

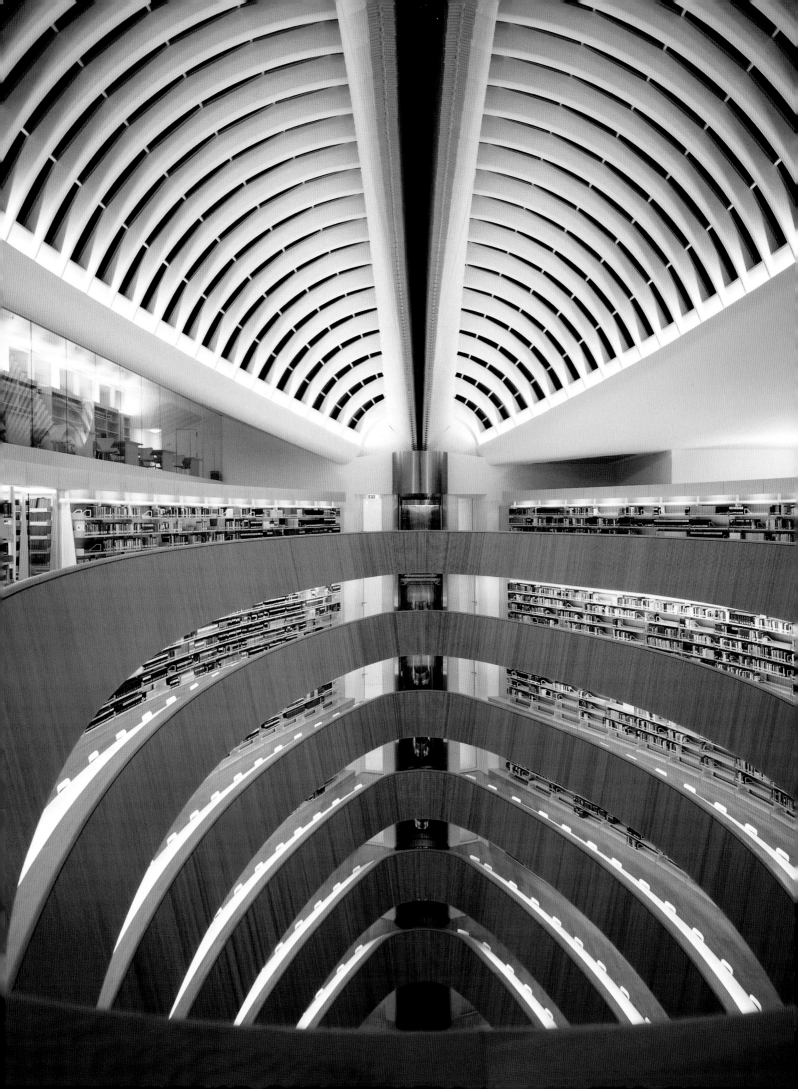

Project
ZURICH UNIVERSITY, LAW FACULTY

Location
ZURICH, SWITZERLAND

Client
CANTON OF ZURICH

Cost
$ 30 MILLION

The Faculty of Law of the University of Zurich had been divided into eight different buildings. The facilities for the faculty and the library, including the second largest rare law book collection in Switzerland, were housed in a building designed in 1908 by Hermann Fiertz as a high school and laboratory. Santiago Calatrava was asked in 1989 to study additions to two wings added to this structure in 1930 in order to modernize and enlarge them. Rather than filling in the existing courtyard with floor space, Calatrava proposed to create an atrium in place of the courtyard. In the final design, Calatrava created workspaces for the students, with direct access to the library and seminar spaces. A series of seven oval reading levels are hung within the atrium, "staggered on each level so that it is no longer the floor area that increases as they approach the roof but the space they circumscribe." This design allows natural light to penetrate deeper into the heart of the structure and its reading area. To support the cascade of galleries, eight attachment points have been created within or against the walls of the existing façade. As the architect describes the design, "The basic structure of each gallery is formed by a steel torsion tube, from which T-shaped, tapering steel beams cantilever in a regular rhythm. Each gallery is braced by balustrades, which have been designed as load-bearing trusses. By channeling the forces away from the center of the atrium, this design also leaves the basement areas free of obstruction." He goes on to say that "an important aspect of the design is the complete independence of old and new. The reading room, the two new stories and the roof are treated as separate from the existing building, both architectonically and with regard to materials." Ever a master of spectacular shapes, Santiago Calatrava has created what is in good part a library that is at once practical for its users and architecturally inspiring. As is the case in many of Calatrava's projects, this structure evolved and matured over a relatively long period. It might be ventured that the ovoid form of the library may also echo that of the female sex, source of life, much as the library is the source of knowledge. Calatrava's own admitted sources do not include this type of reference, but the observer may be excused for thinking along lines inspired by his long fascination with the human body.

Die Rechtswissenschaftliche Fakultät der Universität Zürich war auf acht Standorte verteilt. Die Einrichtungen für die Fakultät und die Bibliothek, darunter die zweitgrößte Sammlung seltener juristischer Bücher in der Schweiz, waren in einem 1908 von Hermann Fiertz als Schule und Labor entworfenen Gebäude untergebracht. Santiago Calatrava wurde 1989 aufgefordert, sich Gedanken über Anbauten an zwei 1930 ergänzte Flügel zu machen, mit dem Ziel, diese Gebäude zu modernisieren und zu vergrößern. Anstatt nun nach Vorstellung der Universität, den vorhandenen Hof zuzubauen, schlug Calatrava vor, ihn in ein Atrium umzuwandeln. Im endgültigen Entwurf plante Calatrava hier Arbeitsplätze für die Studenten mit direktem Zugang zur Bibliothek und den Seminarräumen. Innerhalb des Atriums wurde eine Folge von sieben ovalen Leseebenen aufgehängt, „und zwar nach Ebenen gestaffelt, so dass mit der Annäherung an das Dach nicht mehr die Bodenfläche zunimmt, sondern der von ihnen umschriebene Raum." Diese Bauweise lässt Tageslicht tiefer in das Gebäudeinnere und die Lesezonen eindringen. Um diese Kaskade von Galerien abzustützen, wurden acht Befestigungspunkte innerhalb oder an den Wänden der vorhandenen Fassade geschaffen. Der Architekt beschreibt seinen Entwurf so: „Die grundlegende Konstruktion jeder Empore besteht aus einer Torsionsröhre aus Stahl, von der T-förmige, sich verjüngende Stahlträger in regelmäßigen Abständen vorkragen. Jede Empore wird von Brüstungen versteift, die als tragende Fachwerkbinder konzipiert wurden. Da die Kräfte vom Zentrum des Atriums abgelenkt werden, erlaubt diese Planung ein stützenfreies Untergeschoss." Er führt weiter aus: „Ein wichtiger Aspekt des Entwurfs ist die völlige Autonomie von Alt und Neu. Der Lesesaal, die beiden neuen Geschosse und das Dach werden sowohl in architektonischer Hinsicht als auch in Bezug auf die Materialien als vom bestehenden Gebäude verschieden behandelt." Stets ein Meister spektakulärer Formgebung, hat Santiago Calatrava eine Bibliothek geschaffen, die gleichermaßen zweckdienlich für ihre Benutzer wie architektonisch inspirierend ist. Wie bei vielen Projekten Calatravas reifte auch dieser Entwurf über einen relativ langen Zeitraum. Man könnte soweit gehen anzunehmen, die Eiform des Bibliotheksbaus solle auf das weibliche Geschlecht als Ursprung des Lebens anspielen, ebenso wie die Bibliothek als Quelle des Wissens gilt. Calatrava bekennt sich nirgends zu dieser Art von Bezug, jedoch sei es dem Betrachter gestattet, derartige Überlegungen anzustellen, angesichtst von Calatravas Fasziniertheit vom menschlichen Körper.

La Faculté de droit de l'Université de Zurich répartit ses activités entre huit immeubles. Les installations pour le corps professoral et la bibliothèque, qui contient la seconde plus vaste collection helvétique de livres rares de droit, se trouve dans un bâtiment conçu en 1908 par Hermann Fiertz pour accueillir un collège et des laboratoires. En 1989, Santiago Calatrava reçut commande d'une étude pour agrandir et moderniser deux ailes ajoutées dans les années 1930. Plutôt que de combler la cour existante, il proposa de remplacer celle-ci par un atrium. Dans son projet final, il créa des espaces de travail supplémentaires pour les étudiants avec un accès direct à la bibliothèque et aux salles de séminaire. Sept espaces de lecture de forme ovale sont ainsi suspendus dans l'atrium, « décalés de niveau en niveau, de telle façon que ce n'est plus la surface au sol qui s'accroît au fur et à mesure que l'on monte vers la toiture mais l'espace qu'ils circonscrivent ». Cette disposition permet à la lumière naturelle de mieux pénétrer au cœur même de la structure et des zones de lecture. Pour soutenir cette cascade de galeries, huit points d'attache ont été créés à l'intérieur ou contre les murs de la façade existante. Comme l'explique l'architecte : « La structure de base de chaque galerie est constituée d'un tube en acier en torsion d'où partent en porte-à-faux, selon un rythme régulier, des poutres d'acier en T effilé. Chaque galerie est entretoisée par des balustrades qui sont en fait des fermes porteuses. En canalisant la charge au-delà du centre de l'atrium, cette conception libère en même temps le rez-de-chaussée de toute obstruction. » Il poursuit : « Un aspect important du projet est la totale indépendance du nouveau par rapport à l'ancien. La salle de lecture, les deux étages neufs et la toiture sont traités séparément des bâtiments existants, aussi bien architectoniquement qu'en termes de matériaux. » Grand maître des formes spectaculaires, Santiago Calatrava a ainsi créé une bibliothèque qui est à la fois pratique pour ses usagers et d'une architecture inspirée. Cette structure aussi a évolué et mûri sur une assez longue période. On pourrait avancer que sa forme ovoïde fait écho à celle d'un sexe féminin, source de vie comme la bibliothèque est source de savoir. Calatrava ne reconnaît pas ce type de référence, mais l'observateur peut se prendre au jeu de sa fascination durable pour le corps humain.

Inserted into an existing courtyard, the new law library, whose central space is visible to the left, shows to what extent the architect is capable of occupying a space and making it his own, even within the relatively tight constraints of this project.

Die in einen vorhandenen Hof eingefügte neue Juristische Bibliothek, deren zentraler Raum links zu sehen ist, zeigt, in welchem Maß der Architekt fähig ist, Raum zu besetzen und sich zu eigen zu machen, selbst bei den eher beschränkten Verhältnissen dieses Projekts.

Insérée dans une cour existante, la nouvelle bibliothèque de droit dont le volume central est visible ici à gauche, montre à quel point l'architecte sait occuper un espace et se l'approprier, même dans le cadre des contraintes relativement fortes d'un projet tel que celui-ci.

Rather than creating closed reading rooms, the architect chose a much more surprising solution, cantilevered platforms that run around the elliptical, or rather ocular, central atrium of the library.

Anstelle abgeschlossener Lesesäle entschied sich der Architekt für eine weit ausgefallenere Lösung: vorkragende Podien, die das elliptische oder augenförmige zentrale Atrium der Bibliothek umziehen.

Plutôt que de créer des salles de lecture fermées, l'architecte a préféré une solution beaucoup plus surprenante : des plateaux en porte-à-faux qui rayonnent à partir de l'atrium central en ellipse, ou en forme d'œil, de la bibliothèque.

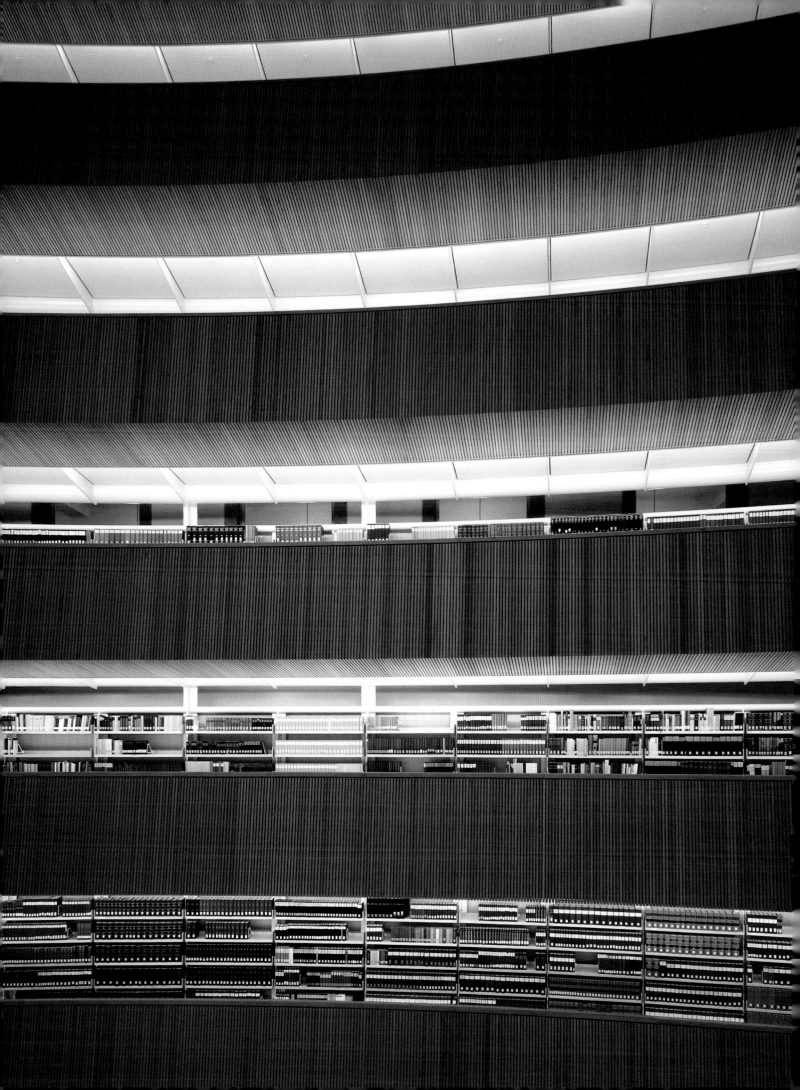

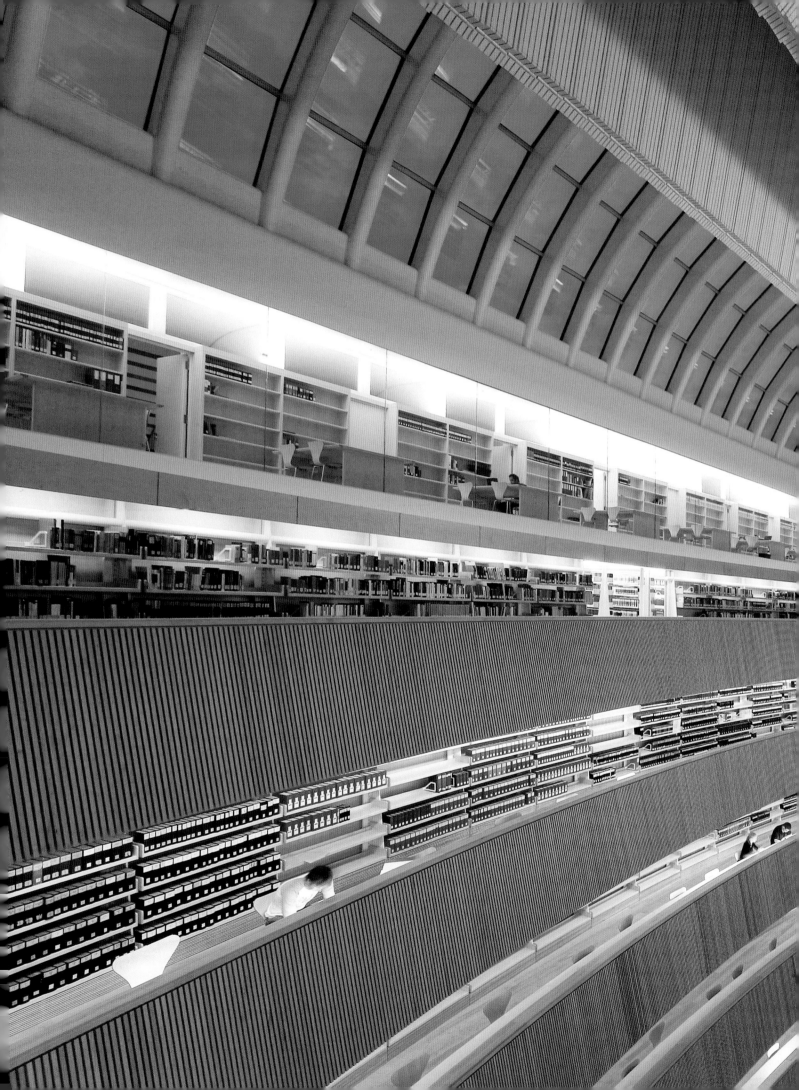

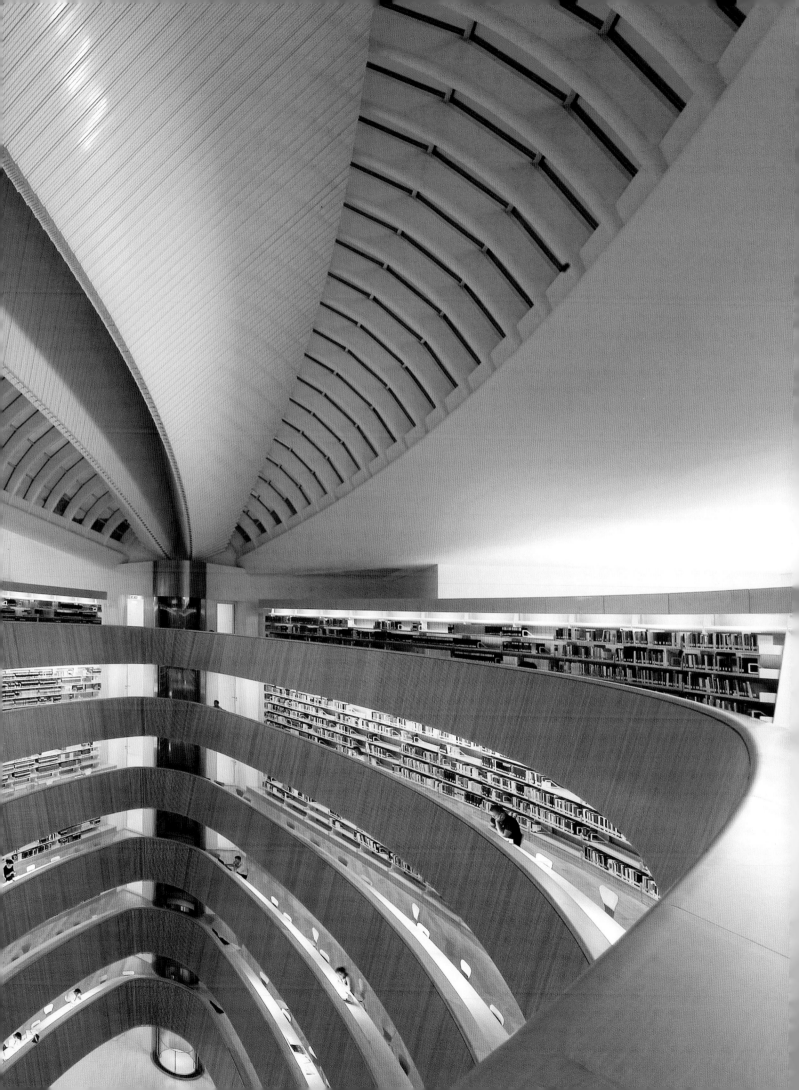

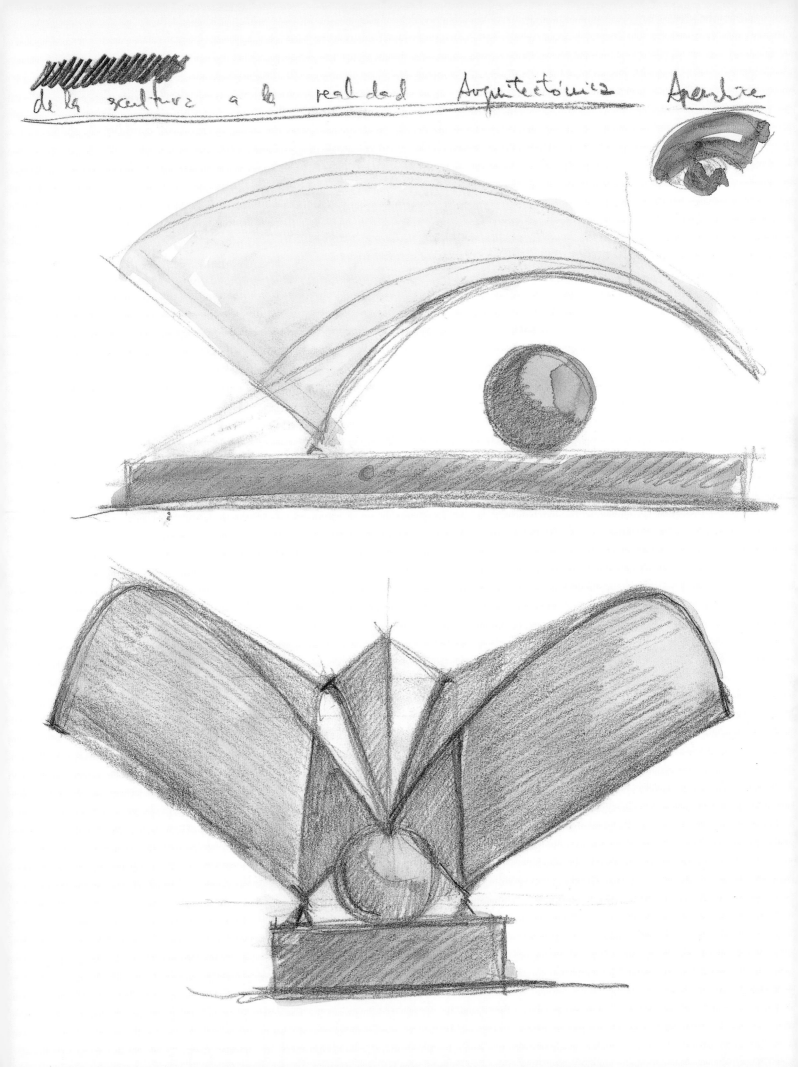

LYON-SAINT EXUPÉRY AIRPORT RAILWAY STATION

Satolas, France. 1989–1994.

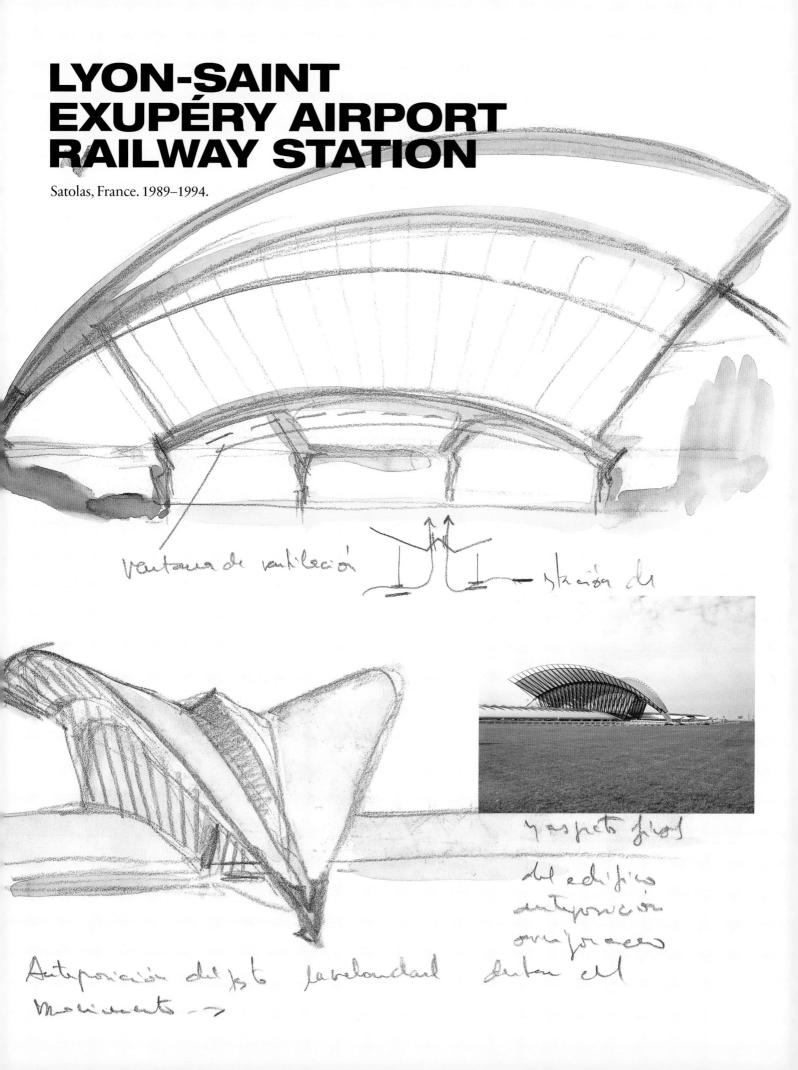

Procedimiento de Ventilación del hall de
acceso a los deambulatorios
la disposición de los ventanas laterales permite el
aprovechamiento de las corrientes convectivas
para la ventilación del hall de viajeros.

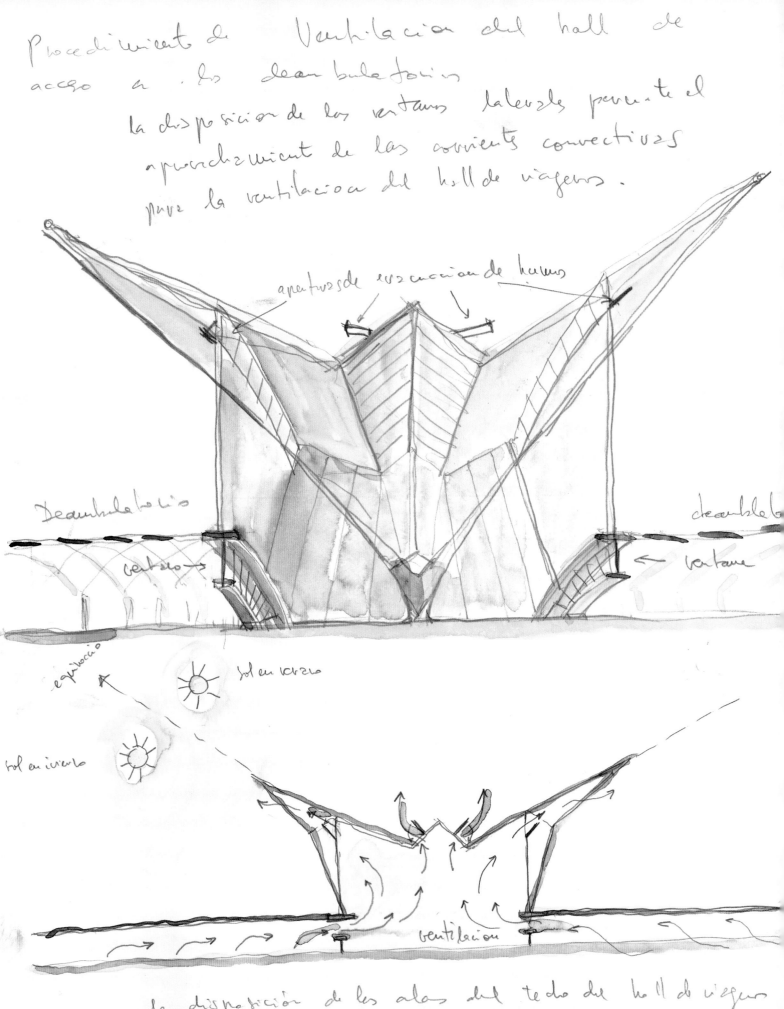

apertura de evacuación de humos

Deambulatorio deambulatorio
ventana → ← ventana

equinocio
sol en verano
sol en invierno

ventilación

la disposición de las alas del techo del hall de viajeros
al lado sur permite que durante los meses de verano haya
sombra al interior del hall.

Project
LYON-SAINT EXUPÉRY AIRPORT RAILWAY STATION

Location
SATOLAS, FRANCE

Client
RHÔNE-ALPES REGIONAL GOVERNMENT AND SNCF

Floor area
5600 m²

Cost
600 MILLION FRANCS (1994 VALUE)

Calatrava's sketches show his interest not only in overall form, but also in such factors as the movement of air through the completed structure, and the way, in this instance, in which it reacts to the problem of solar heat gain.

Calatravas Skizzen belegen, dass sein Interesse nicht nur der Gesamtform gilt, sondern auch Faktoren wie der Luftzirkulation im fertigen Bauwerk und der Art, wie sie in diesem Fall das Problem des Sonnenwärmegewinns bewältigt.

Les croquis de Calatrava montrent son intérêt non seulement pour la forme d'ensemble mais aussi pour des facteurs comme le mouvement de l'air à travers la structure achevée et la manière dont elle réagira à la chaleur due à l'ensoleillement.

Originally called the Lyon Satolas Station, this project is surely one of Calatrava's best-known works. The architect was the winner of a competition organized by the Rhône-Alpes Region and Lyon Chamber of Commerce and Industry (CCIL). The competition brief called for a building that would provide smooth passenger flow while creating an exciting and symbolic "gateway to the region." Despite its obvious similarity to a sort of prehistoric bird, the shape of this 5600-square-meter facility, which was designed for the French national railway company (SNCF) serving to connect the high-speed train network (TGV) to the Lyon Airport in Satolas, is more closely related to Calatrava's sculptures than to any animal. The winged design may recall Eero Saarinen's TWA Terminal at Kennedy Airport (1957–62), but its function and aspects such as the 500-meter-long covered platform for the trains differentiate it from its predecessor in a decisive manner. Built at a total cost of 600 million francs in three phases, the station accommodates six tracks, with the middle two encased in a concrete shell for trains that pass through at high speed (300 km/h) without stopping. A 180-meter-long steel connecting bridge linking the facility to the airport terminal itself gives the plan a shape which might bring to mind a stingray as much as a bird. Its essential feature remains the main hall with its 1300-ton roof, measuring 120 x 100 meters, with a maximum height of 40 meters and a span of 53 meters. Largely cast-in-place concrete using local white sand was used, giving the building a "natural" muted color.

Dieses anfänglich Bahnhof Lyon-Satolas genannte Projekt zählt sicherlich zu Calatravas bekanntesten Bauten. Er konnte einen von der Region Rhône-Alpes und der Lyoner Handels- und Industriekammer (CCIL) ausgeschriebenen Wettbewerb für sich entscheiden. In der Ausschreibung wurde ein Gebäude verlangt, das einen reibungslosen Passagierverkehr gewährleisten und darüber hinaus als reizvolles, symbolisches „Tor zur Region" fungieren sollte. Das für die Société nationale des chemins de fer français (SNCF) konzipierte Gebäude, das den Flughafen von Lyon in Satolas an das Netz der Hochgeschwindigkeitszüge (TGV) anbinden sollte, ist ungeachtet seiner augenfälligen Ähnlichkeit mit einer Art prähistorischem Vogel enger mit Calatravas Skulpturen als mit irgendeinem Tier verwandt. Der „geflügelte" Bau mag an Eero Saarinens TWA-Terminal (1957–62) am Kennedy-Airport in New York erinnern, aber seine Funktion und Teilaspekte wie der 500 m

lange überdachte Bahnsteig für die Züge unterscheiden ihn deutlich von seinem Vorgänger. Der für Gesamtkosten in Höhe von umgerechnet 91,5 Millionen Euro in drei Bauabschnitten errichtete Bahnhof verfügt über sechs Gleisanlagen, wobei die zwei mittleren in einer Betonröhre verlaufen und durchfahrenden Hochgeschwindigkeitszügen (300 km/h) vorbehalten sind. Eine 180 m lange Stahlbrücke, die den Bahnhof mit dem Flughafenterminal verbindet, gibt dem Grundriss eine Form, die an einen Stachelrochen oder einen Vogel erinnert. Der maßgebliche Bauteil ist jedoch die Haupthalle mit ihren Abmessungen von 120 x 100 m, einer maximalen Höhe von 40 m und einer Spannweite von 53 m unter dem 1300 t schweren Dach. Es kam in erster Linie vor Ort gegossener Beton zum Einsatz, für den heimischer weißer Sand verwendet wurde, der dem Gebäude eine „natürliche", gedämpfte Farbe verleiht.

Ce projet – qui s'appelait à l'origine gare de Lyon-Satolas) – fruit d'un concours organisé par la Région Rhône-Alpes et la Chambre de commerce et d'industrie de Lyon, certainement l'une des œuvres plus célèbres de Calatrava. Il s'agissait d'un bâtiment destiné à faciliter les déplacements des voyageurs et à faire en même temps office de « porte » symbolique de la région. Malgré son évidente ressemblance avec quelque oiseau préhistorique, cet ensemble de 5600 mètres carrés conçu pour la SNCF afin de relier une ligne de TGV à l'aérogare Saint Exupéry est en fait plus apparenté aux sculptures de Calatrava qu'à un quelconque animal. Le dessin en ailes peut rappeler le terminal TWA d'Eero Saarinen pour l'aéroport Kennedy à New York (1957–62), mais sa fonction et divers éléments comme ses 500 mètres de quais couverts le différencient radicalement de ce prédécesseur. Construite en trois phases pour un budget de 600 millions de francs, la gare est desservie par six voies, les deux du centre, réservées aux trains qui la traversent à 300 km/h sans s'arrêter, étant enfermées dans une coque en béton. La passerelle en acier de 180 mètres de long qui connecte directement les quais au terminal de l'aéroport donne au plan une allure de raie manta ou d'oiseau. L'élément le plus caractéristique de la gare reste le grand hall dont la couverture de 1300 tonnes mesure 120 x 100 mètres pour une hauteur maximale de 40 mètres et une portée de 53 mètres. Le béton, en grande partie coulé sur place à partir de sable blanc local, donne à l'ensemble une couleur neutre, « naturelle ».

la Estación de Lyon Sàtolas

vista lateral
de la estacion
seccion por
el eje medio

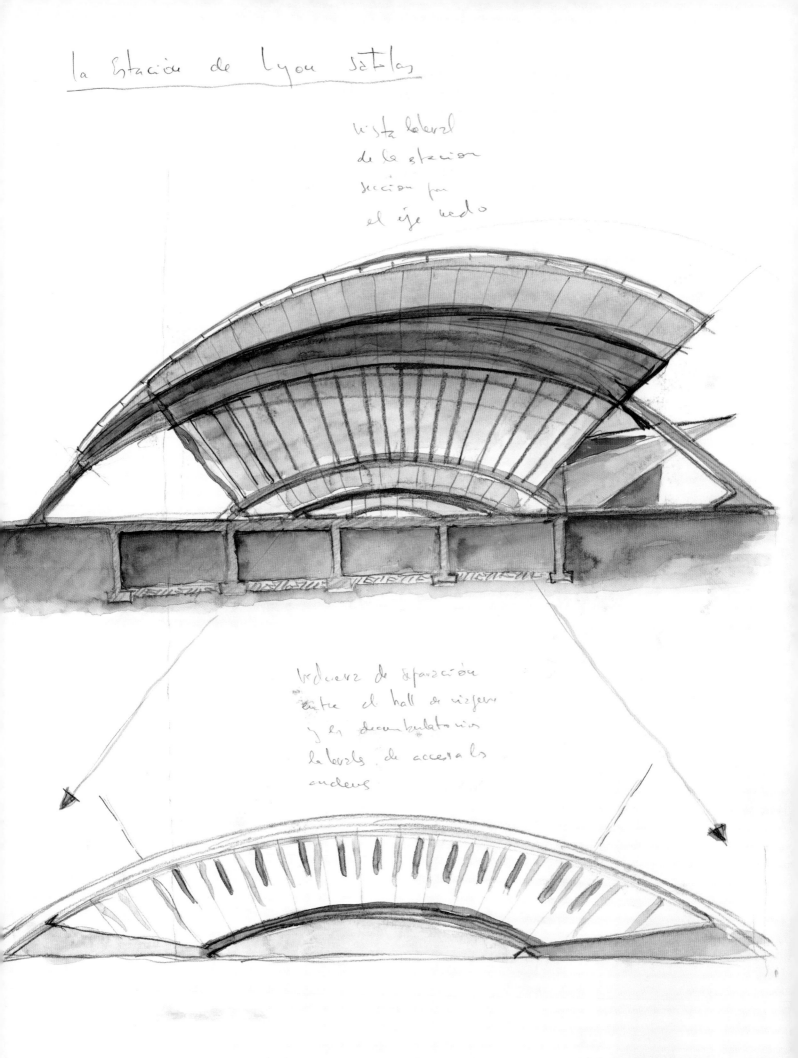

refuerzo de separación
entre el hall de viajeros
y los deambulatorios
a los niveles de acceso a los
andenes

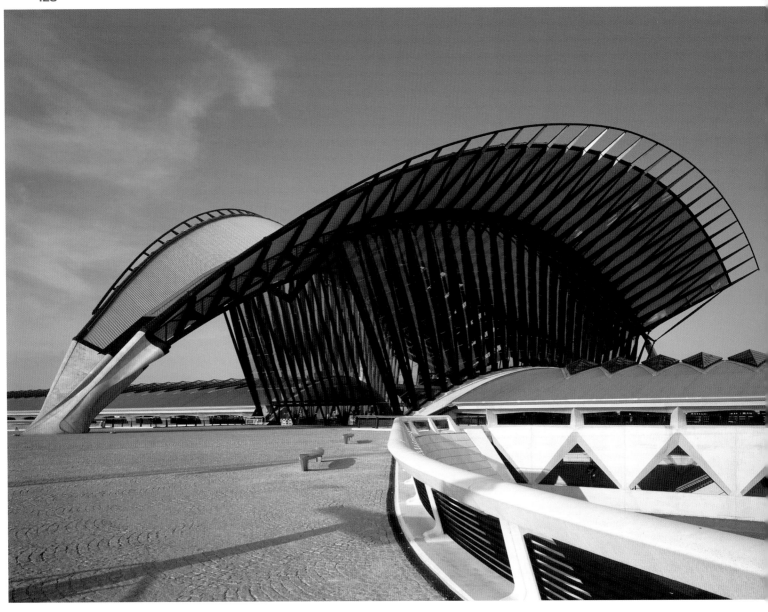

Calatrava's design for Lyon has been com-
pared to a prehistoric bird, with its swoop-
ing beak planted in the earth. The dramatic
angling of its surfaces and its ample glazing
make it a functional and spectacular facility.

Calatravas Entwurf für Lyon wurde mit einem
prähistorischen Vogel verglichen, dessen
Schnabel zur Erde herabstößt. Die eminente
Verkantung seiner Oberflächen und deren
großflächige Verglasung machen den Bau
ebenso imposant wie funktional.

Le projet de Calatrava pour Lyon a été com-
paré à un oiseau préhistorique au bec planté
dans le sol. Ses angles impressionnants et
ses vitrages généreux en font une gare à la
fois spectaculaire et fonctionnelle.

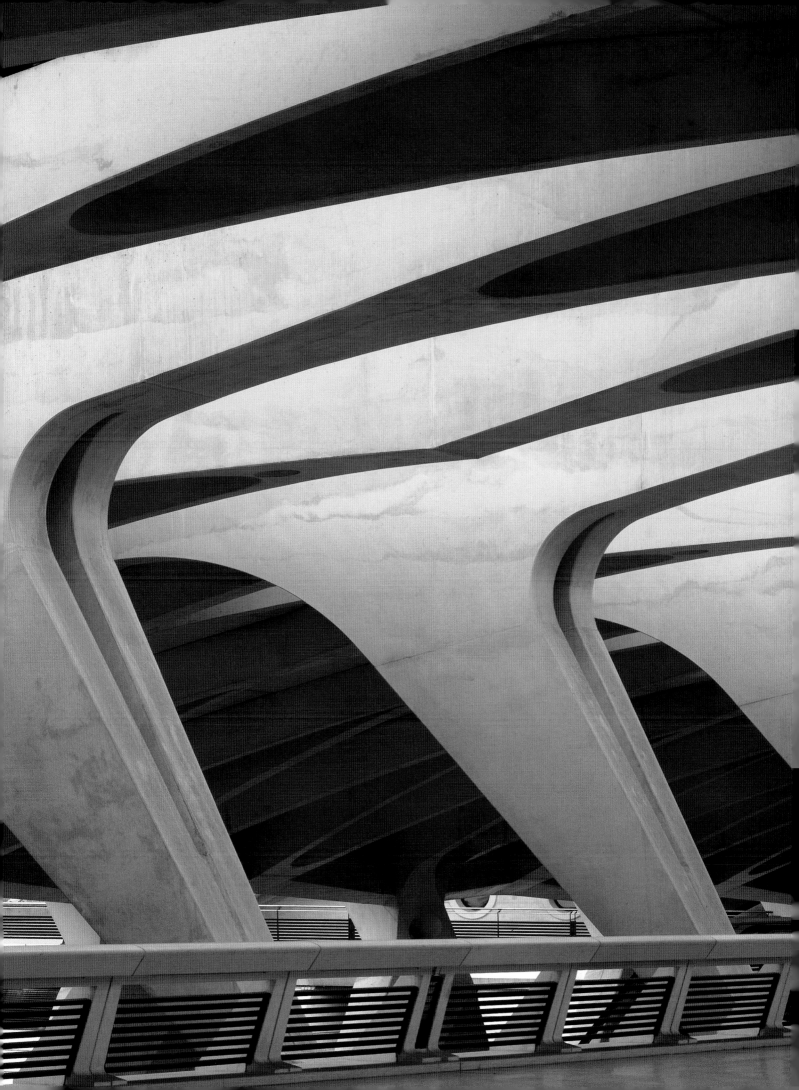

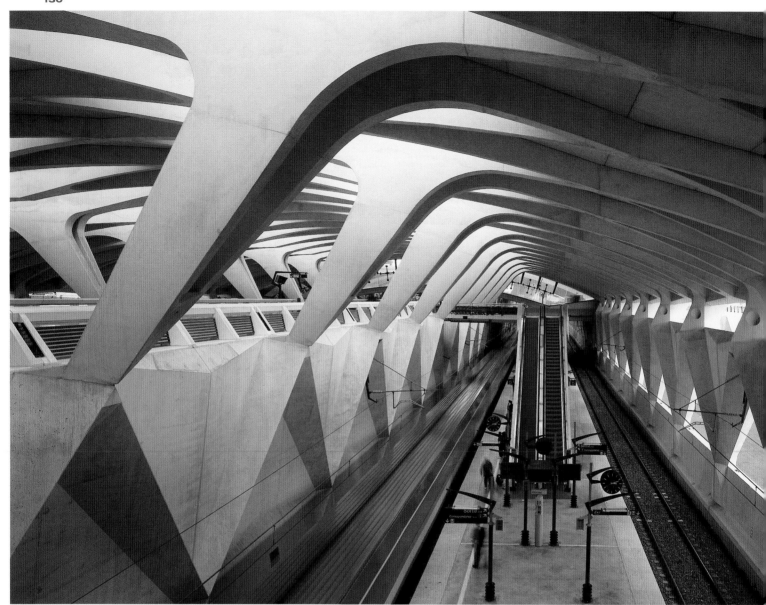

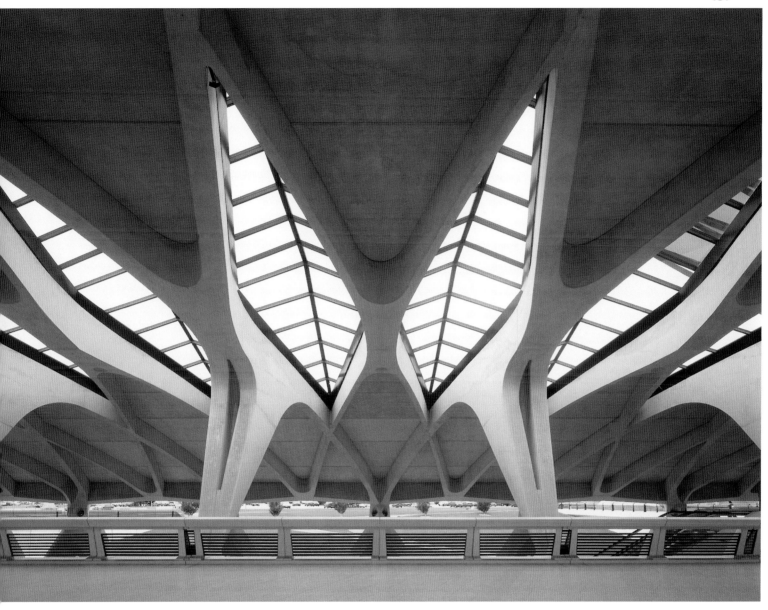

As he did in his Zurich Railway Station, Calatrava succeeds in carrying over the themes of the exterior of the terminal in its soaring interiors. Saint Exupéry Station is one of the first stations in France to reverse the long trend toward anonymous and ugly railway facilities.

Wie schon bei seinem Züricher Bahnhof gelang es Calatrava, die Attribute des Terminal-Außenbaus in die himmelhohen Innenräume zu übertragen. Saint Exupéry ist einer der ersten Bahnhöfe Frankreichs, der den seit langem bestehenden Trend zu gesichtslosen, hässlichen Bahngebäuden umkehrt.

Comme pour la gare de Zurich, Calatrava réussit ici à transférer la thématique visuelle de l'extérieur à l'intérieur. Lyon-Saint Exupéry est l'une des premières réalisations en France à contrarier la tendance habituelle à construire des gares aussi laides qu'anonymes.

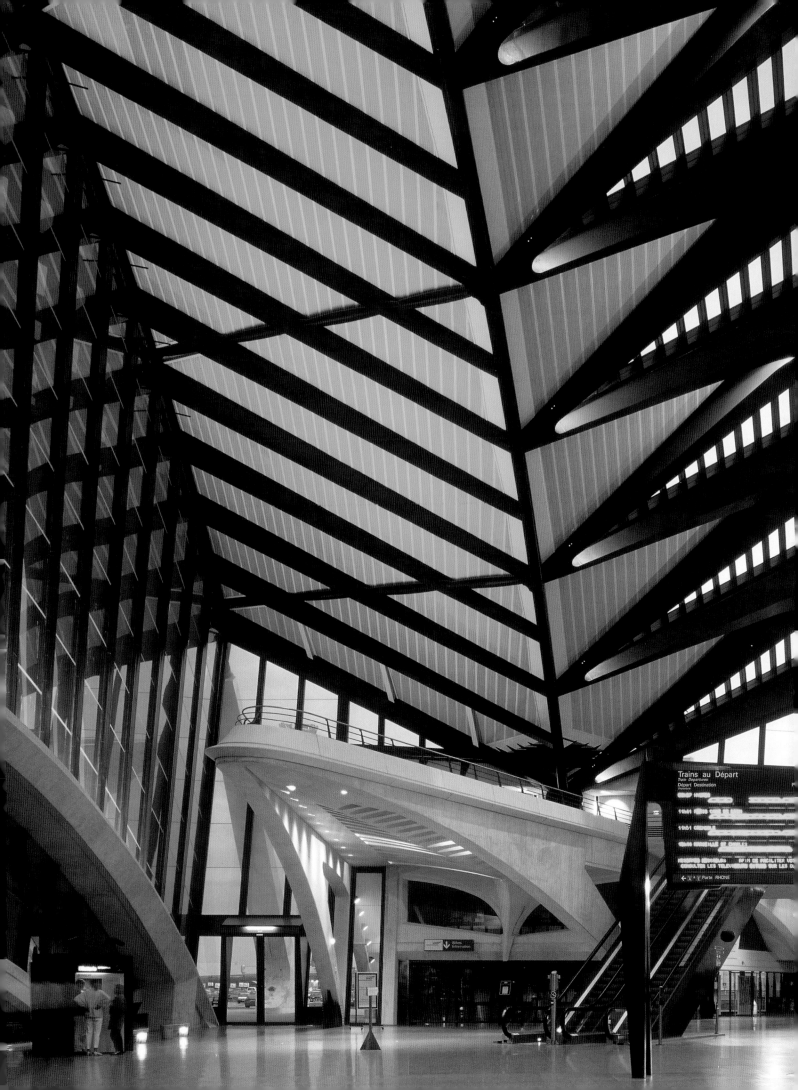

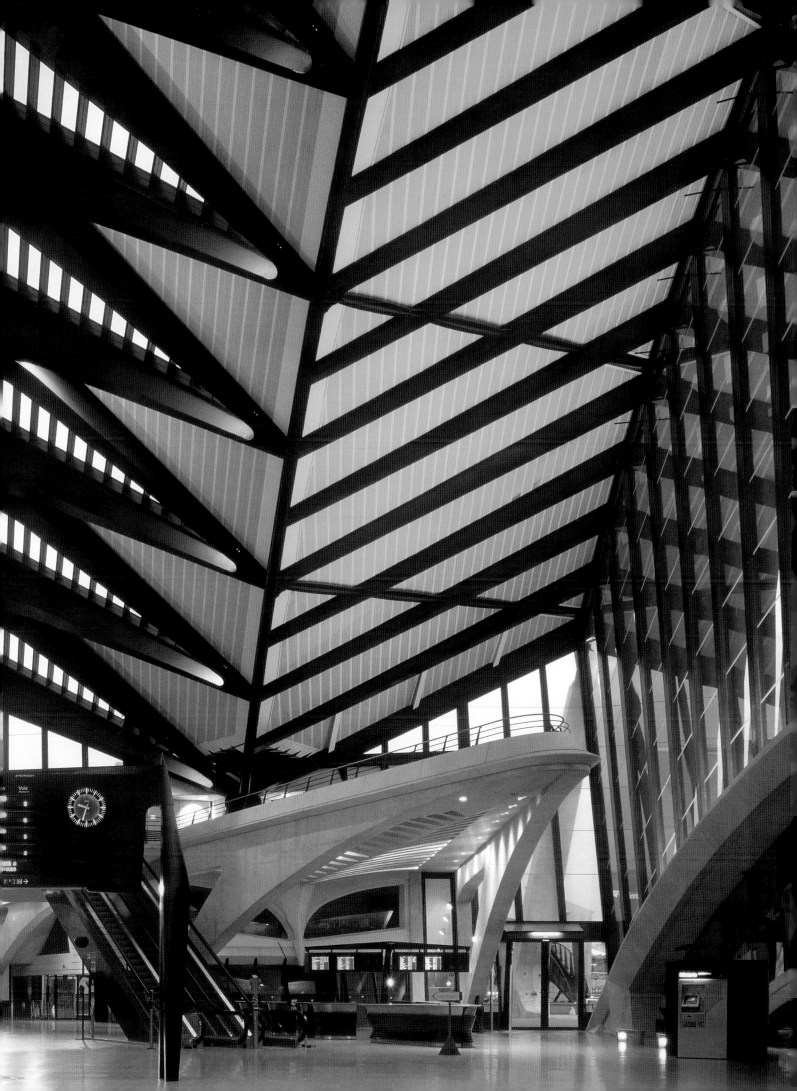

2110621

The progressive narrowing of the supports
and ceiling of the station lends to its dynamic
feeling. Whether or not the soaring space
specifically evokes a bird or not, movement
is certainly one of its sources of inspiration.

Die zunehmende Verengung der Stützen
und der Decke des Bahnhofs trägt zu seiner
dynamischen Anmutung bei. Ob der hoch
aufragende Raum nun speziell an einen
Vogel erinnert oder nicht, in jedem Fall zählt
Bewegung zu seinen Inspirationsquellen.

Le rapprochement progressif des supports
et du plafond de la gare crée un sentiment
de dynamisme. Que l'architecte ait songé ou
non à un oiseau, le mouvement est certaine-
ment ici l'une de ses sources d'inspiration.

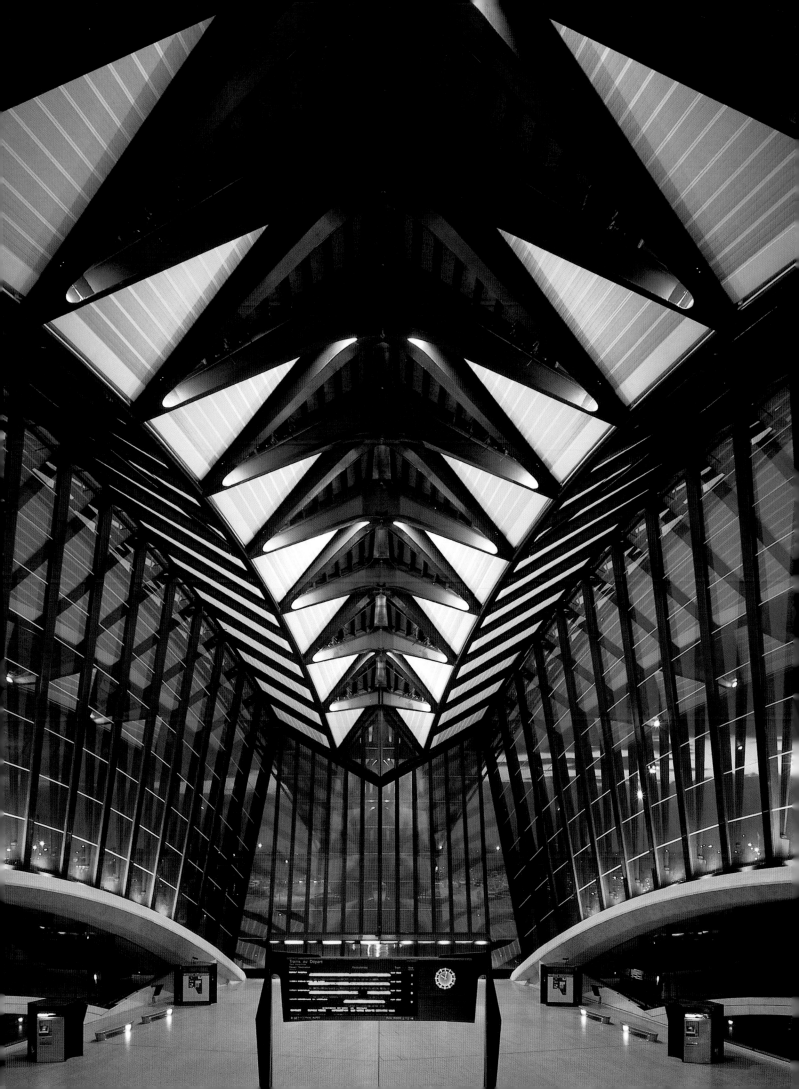

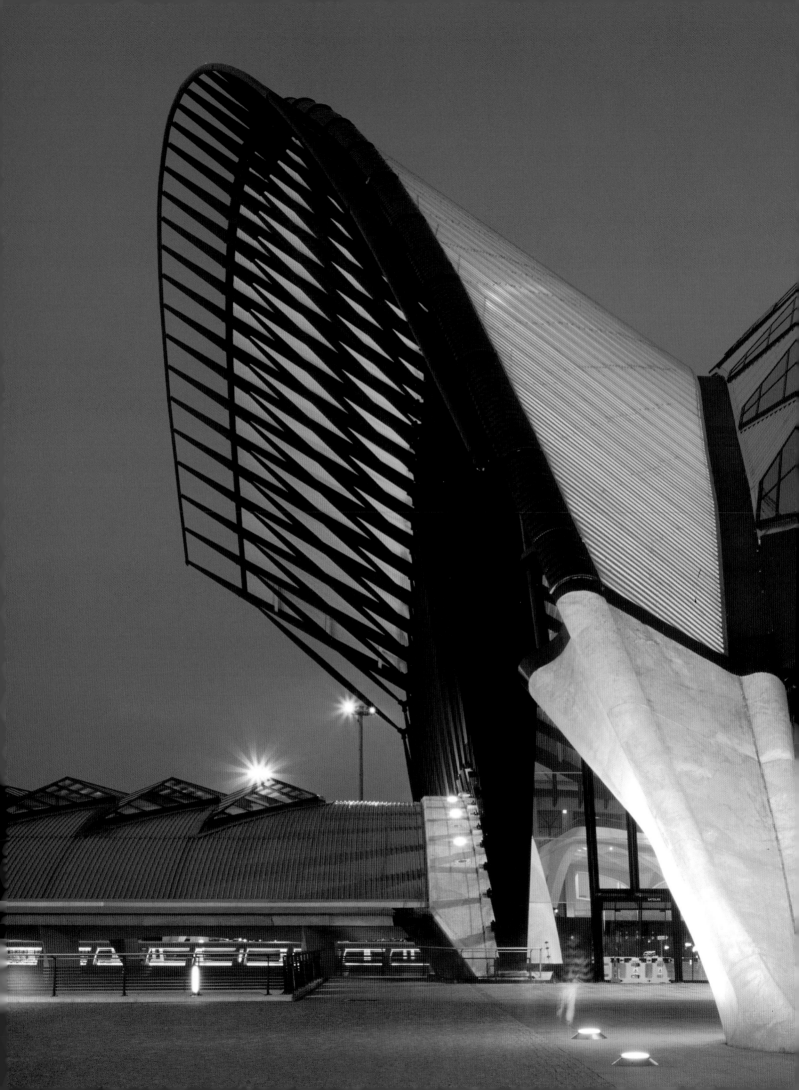

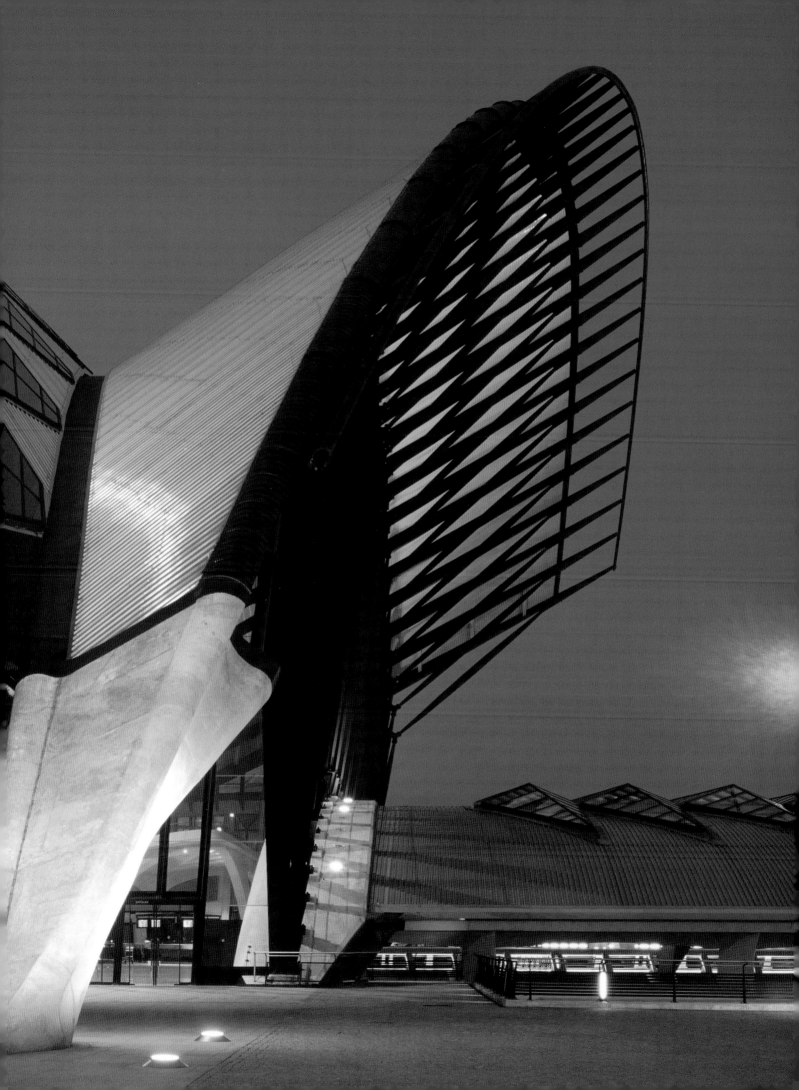

PUERTO BRIDGE

Ondarroa, Spain. 1989–1995.

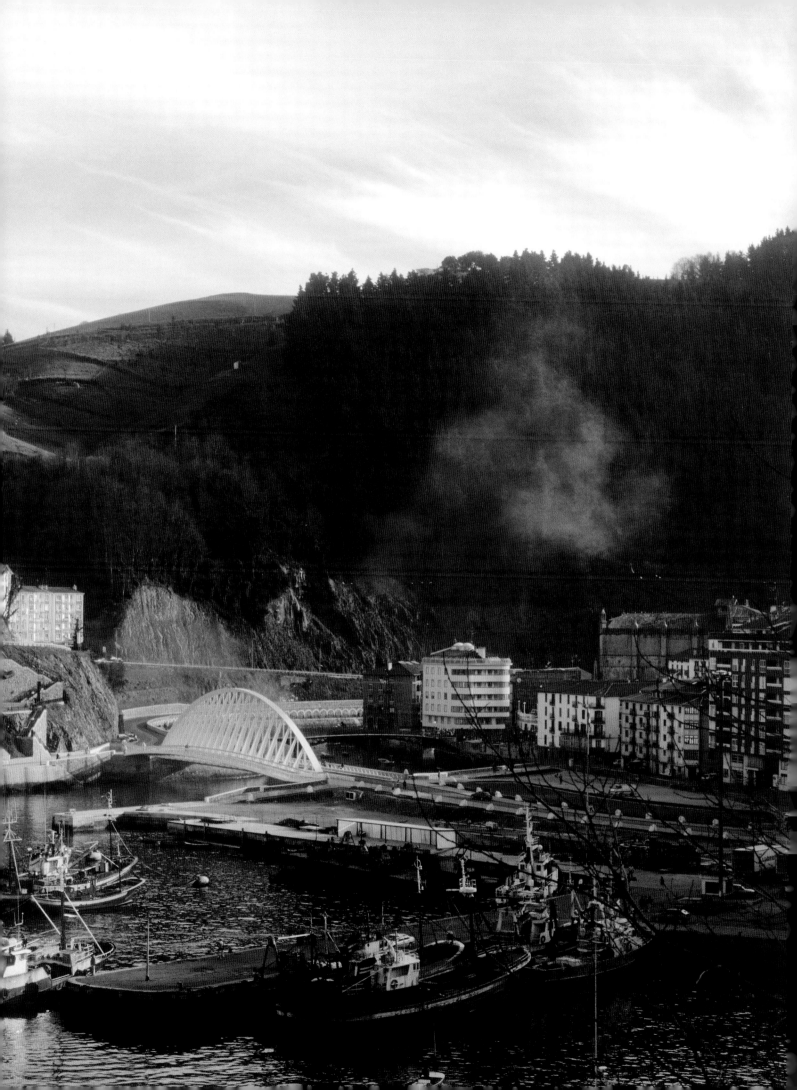

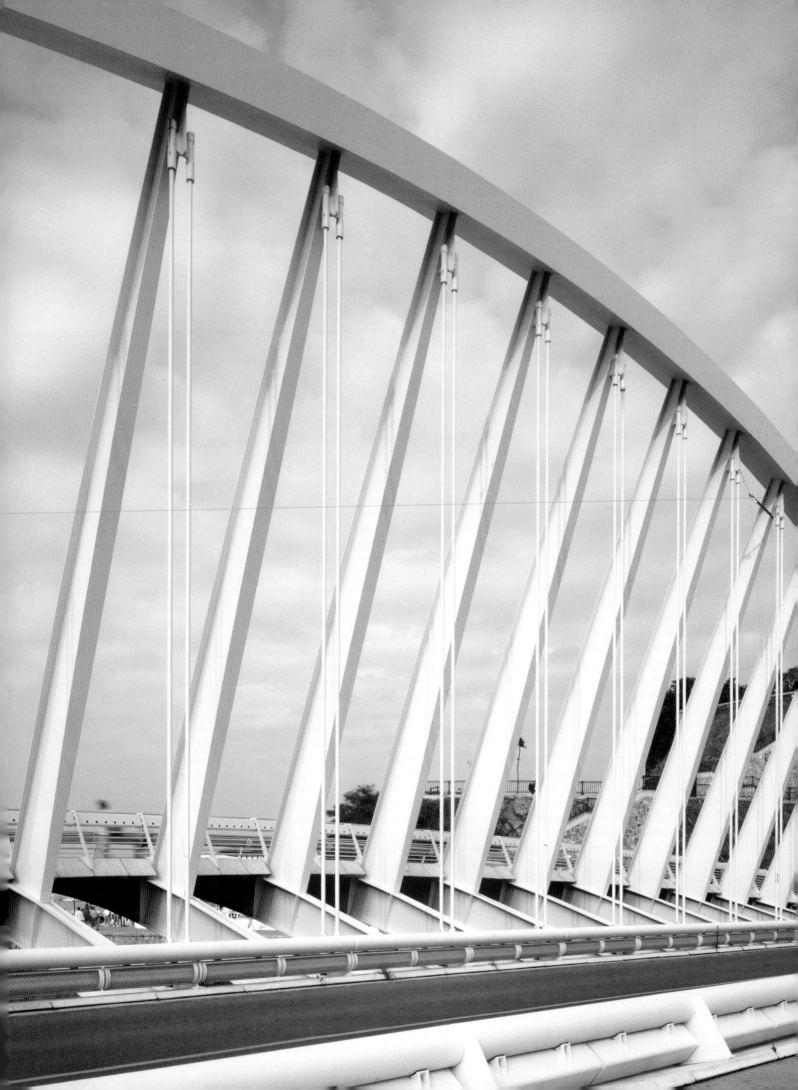

Project
PUERTO BRIDGE

Location
ONDARROA, SPAIN

Client
MUNICIPALITY OF ONDARROA

Length and maximum span
71.5 METERS

Calatrava's bridges may be his purest form of expression, blending the rigor of engineering with his driving desire to surprise and to make the laws of construction obey his will.

In Calatravas Brücken mag sein Gestaltungswille am reinsten zum Ausdruck kommen, da hier technische Exaktheit und sein leidenschaftlicher Wunsch, zu verblüffen und sich die Gesetze des Bauens untertan zu machen, zusammentreffen.

Les ponts de Calatrava sont sans doute sa forme d'expression la plus pure, mêlant la rigueur de l'ingénierie à son profond désir de surprendre et de soumettre les lois de la construction à sa volonté.

Ondarroa is a small seaport situated at the mouth of the Artibai River on the Basque coast of Spain, not far from Bilbao. Santiago Calatrava's motor and pedestrian bridge with its single inclined arch stands like a gateway to the city, its crisp aerial outlines contrasting with the tightly packed modern buildings that line the curved waterway. It has a 71.5-meter span with a width varying between 20.9 and 23.7 meters. The steel arch structure has an unusual pedestrian walkway that is curved, unlike the 11-meter-wide main deck, leaving a large gap at the center between the motorway and the footpath. Walkers who prefer a more direct route can also use the sidewalk that runs next to the road. Radiating steel braces placed every 2.86 meters carry the arch and the projecting curved walkway, with powerful double cables reaching down vertically to hold the road deck. This bridge, along with those in Valencia and Orleans, are of a type developed by Calatrava. The characteristics of this new bridge type are that the horizontal bearing structure of the bridge acts as a stiffener of the structural system "permitting it to resist torsion stresses and minimizing torsion strain." This system allows the arch to be positioned asymmetrically in relation to the deck, strengthening the impression of movement.

Ondarroa ist ein kleiner Seehafen an der Mündung des Artibai und liegt unweit von Bilbao an der baskischen Küste. Santiago Calatravas Auto- und Fußgängerbrücke wirkt mit ihrem einzelnen, geneigten Bogen wie ein Stadttor, dessen klare, luftige Umrisse sich von den dicht gedrängt stehenden, modernen Gebäuden abheben, die die Biegung des Flusses säumen. Die Brücke hat eine Spannweite von 71,5 m bei einer Breite von 20,9 bis 23,7 m. Die Stahlbogenkonstruktion zeichnet sich durch einen ungewöhnlichen Laufgang für Passanten aus, dessen Biegung anders verläuft als die der 11 m breiten Hauptbrückentafel, so dass in der Mitte zwischen Fahrbahn und Fußweg eine beträchtliche Lücke entsteht. Passanten, die einen direkteren Weg bevorzugen, können auch den neben der Fahrbahn verlaufenden Fußweg benutzen. Im Abstand von 2,86 m angebrachte speichenförmige

Stahlverstrebungen tragen den Bogen und den ausschwingenden Fußweg, während mächtige, vertikal nach unten ausgreifende Doppelseile die Fahrstraße halten. Wie die Brücken in Valencia und Orléans, entspricht auch diese einer von Calatrava entwickelten Form. Dieser neue Brückentypus zeichnet sich dadurch aus, dass das horizontale Tragwerk der Brücke als Versteifung des konstruktiven Systems fungiert und es „ihm ermöglicht, Torsionsspannung zu widerstehen und Torsionsverformung zu minimieren". Bei diesem System lässt sich der Bogen im Verhältnis zur Brückentafel asymmetrisch positionieren und so der Eindruck von Bewegung verstärken.

Ondarroa est un petit port à l'embouchure de l'Artibai sur la côte basque, non loin de Bilbao. Le pont en arc de Santiago Calatrava, destiné aux voitures et aux piétons, joue le rôle de porte d'entrée dans la petite ville. Ses lignes dynamiques et aériennes contrastent avec l'alignement serré des immeubles modernes qui occupent le front de mer en anse. Sa portée est de 71,5 mètres pour une largeur de 20,9 à 23,7 mètres. L'arc d'acier soutient une étonnante passerelle piétonnière dont la courbure est différente de celle du tablier principal de 11 mètres de large réservé aux voitures, ce qui crée un important hiatus central entre les deux voies. Les piétons qui préfèrent un chemin plus direct peuvent également utiliser le trottoir le long de la route. Des entretoises d'acier disposées en rayons tous les 2,86 mètres soutiennent l'arc et la passerelle incurvée en porte-à-faux, tandis que de puissantes paires de câbles perpendiculaires descendent de l'arc pour soutenir le tablier principal. Ce pont, comme ceux de Valence et d'Orléans, est d'un type nouveau, mis au point par Calatrava. Sa caractéristique est que la structure porteuse horizontale du pont agit comme un raidisseur du système, « permettant de résister aux contraintes de torsion et d'en minimiser les déformations ». L'arc peut ainsi être disposé asymétriquement par rapport au tablier, ce qui renforce l'impression de mouvement.

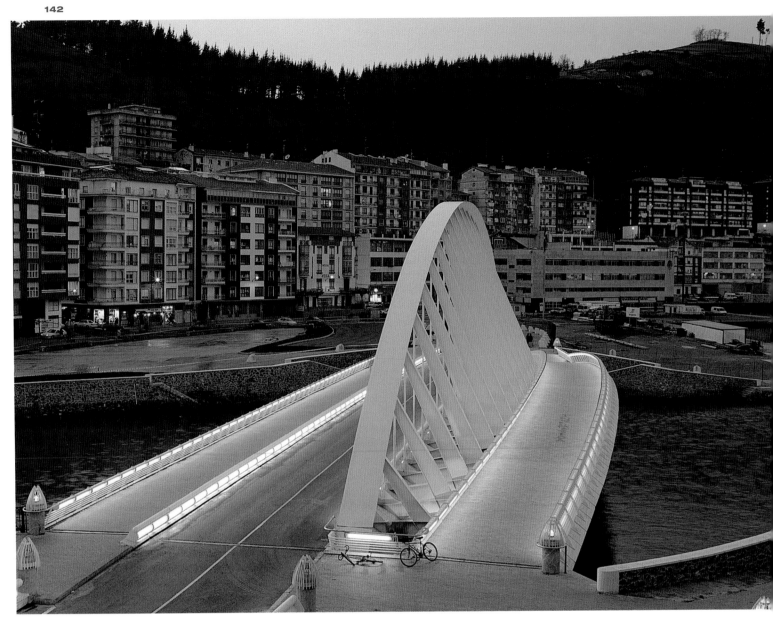

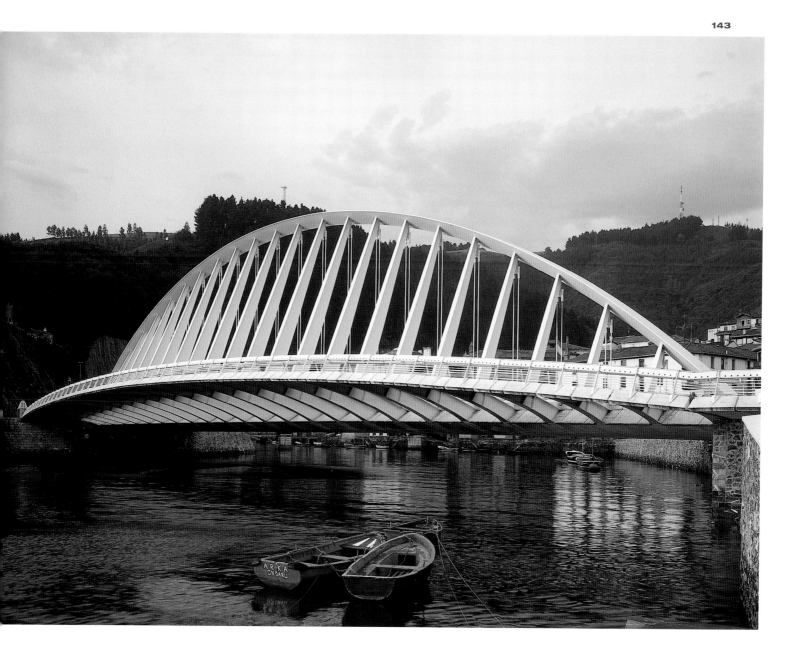

Starting with the basic principles of engineering, Calatrava goes on to imbue his bridges with a sense of movement, and references to other forms. It is not important to know if he is thinking of an eyelid once again, or even the overturned hull of a boat, this bridge speaks to its users in a language that is somehow familiar.

Calatrava, der mit elementaren technischen Prinzipien beginnt, verleiht seinen Brücken sodann den Eindruck von Bewegung und Anklänge an andere Formen. Es spielt keine Rolle, ob er ein weiteres Mal an ein Augenlid dachte oder gar an einen umgedrehten Bootskörper, die Brücke spricht ihre Nutzer in einer irgendwie vertrauten Sprache an.

Partant des principes de base de l'ingénierie, Calatrava insuffle à ses ponts une impression de mouvement, non sans référence à d'autres formes. Peu importe de savoir s'il pense une fois encore à une paupière ou à la coque inversée d'un bateau : ce pont parle au spectateur dans un langage aux inflexions familières.

CAMPO VOLANTÍN FOOTBRIDGE

Bilbao, Spain. 1990–1997.

1:20

1 60 1 60

CAMPO VOLANTÍN FOOTBRIDGE

BILBAO, SPAIN

75 METERS

Cantilevered or suspended, the shapes imagined by the architect-engineer always show the forces that play on them in a dynamic way, almost giving the impression that they are about to take flight or run forward.

Gleich ob auskragend oder hängend, die von dem Ingenieur-Architekten erdachten Formen zeigen stets die auf sie einwirkenden Kräfte in dynamischer Weise und erwecken fast den Eindruck, als seien sie im Abheben oder Weglaufen begriffen.

En porte-à-faux ou suspendues, les formes imaginées par l'architecte-ingénieur montrent toujours les forces en jeu de façon dynamique, donnant presque l'impression qu'elles vont prendre leur envol ou s'enfuir.

This inclined parabolic arch structure has a total span of 75 meters. Serving to link a rundown commercial area called Uribitarte with the city of Bilbao across the Nervion River the Campo Volantín Footbridge is one aspect of a vast campaign of urban renewal, which includes Frank Gehry's Guggenheim Bilbao Museum, subway stations by Sir Norman Foster, and Calatrava's own Sondica Airport project. As in many other designs by Santiago Calatrava, an apparent disequilibrium, or rather a sense of frozen movement, is heightened by the lightness of the structure and the steel uprights that run from the arch to the deck of the bridge every 5.7 meters. Its spectacular night lighting and its glass-surfaced deck emphasize the symbolic importance of the bridge, which may indeed have participated in urban renewal. As the architect explains, this project actually came to be realized in two distinct episodes. In 1990, Calatrava created a design for what was then known as the Uribitarte Bridge site, on behalf of a client engaged in an exchange of land with the municipality. The second design was commissioned by local authorities, who were sympathetic to the original idea of making an urban statement but wanted to avoid any association with the project's previous incarnation. The bridge now takes its name not from the Uribitarte, but from the Campo de Volantín, a street on the opposite bank.

Die Brücke mit einem geneigten Parabelbogen hat eine Gesamtspannweite von 75 m. Sie verbindet das heruntergekommene Geschäftsviertel Uribitarte mit der auf der anderen Seite des Nervión bzw. der Ría de Bilbao gelegenen Innenstadt und ist Teil einer groß angelegten Sanierungsmaßnahme der Stadt. Dazu gehören außerdem Frank Gehrys Guggenheim-Museum, Untergrundstationen von Sir Norman Foster sowie der gleichfalls von Calatrava geplante Flughafen Sondica. Wie bei zahlreichen anderen Entwürfen Santiago Calatravas wird ein scheinbares Ungleichgewicht oder besser der Eindruck einer „angehaltenen Bewegung" durch die Leichtigkeit des Bauwerks mit den Stahlstützen verstärkt, die sich jeweils im Abstand von 5,7 m zwischen Bogen und Brückentafel erheben.

Die spektakuläre nächtliche Beleuchtung sowie die mit Glas belegte Brückentafel unterstreichen die symbolische Bedeutung der Brücke, die Anteil an der Stadtsanierung hat. Dem Architekten zufolge wurde dieses Projekt in zwei getrennten Schritten realisiert. 1990 fertigte Calatrava im Auftrag eines Bauherrn, der in einen Grundstückstausch mit der Kommune involviert war, einen Entwurf für die damals als Standort der Uribitarte-Brücke bekannte Örtlichkeit an. Der zweite Entwurf wurde von den örtlichen Behörden in Auftrag gegeben, die die ursprüngliche Idee eines städtebaulichen Impulses aufgreifen, aber jegliche Assoziation an die Vorgeschichte des Projekts vermeiden wollten. Die Brücke wurde nun nicht nach Uribitarte benannt, sondern erhielt ihren Namen vom Campo de Volantín, einer Straße am gegenüberliegenden Ufer.

Cette structure en arc parabolique d'une portée totale de 75 mètres reliant une zone commerciale en déshérence appelée Uribitarte à la ville de Bilbao, de l'autre côté du fleuve Nervión, fait partie d'un vaste programme de rénovation urbaine comprenant le musée Guggenheim de Frank Gehry, les stations de métro de Norman Foster et le projet pour l'aéroport de Sondica par Calatrava. Comme dans plusieurs de ses précédents travaux, le déséquilibre apparent, ou plutôt le sentiment de mouvement figé, est mis en valeur par la légèreté de la structure et les montants verticaux en acier qui descendent de l'arc vers le tablier tous les 5,7 mètres. Un éclairage nocturne spectaculaire et un tablier en verre renforcent l'impact symbolique de ce pont qui a joué un rôle actif dans la rénovation du centre de la ville. Comme l'explique l'architecte, ce projet a été réalisé en deux phases. En 1990, il avait dessiné des plans pour ce qui était alors le site du pont d'Uribitarte, à la demande d'un client qui échangeait des terrains avec la municipalité. Le second projet fut commandité par la municipalité elle-même qui appréciait l'idée originale mais voulait éviter toute association avec la première approche. Le pont a aujourd'hui abandonné le nom d'Uribitarte pour celui de Campo Volantín, une rue située sur la rive opposée.

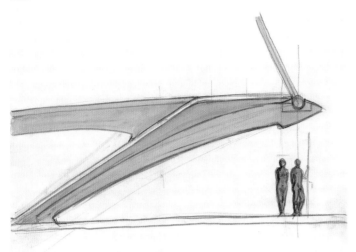

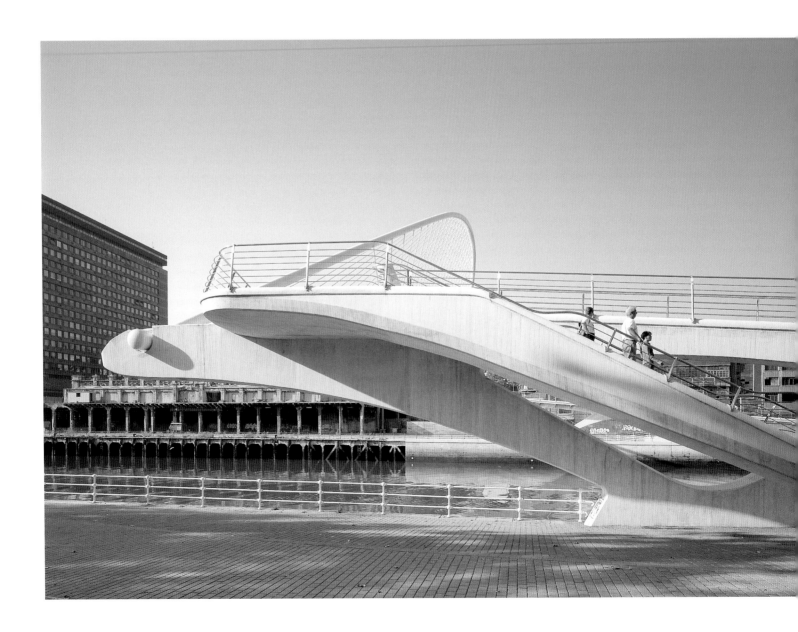

Located just up the river from Gehry's Bilbao Guggenheim, the Campo Volantín Footbridge participates in the astonishing renovation of the dull, industrial city by a few significant works of architecture. It's simplicity and lightness contrasts with the otherwise gray surroundings.

Die unweit von Gehrys Guggenheim-Museum gelegene Campo Volantín-Fußgängerbrücke ist Teil einer erstaunlichen Auffrischung dieser öden Industriestadt durch einige wenige bedeutsame Bauwerke. Schlichtheit und Leichtigkeit der Brücke steht in Kontrast zur ansonsten grauen Umgebung.

Un peu en amont du Guggenheim Bilbao de Frank Gehry, la passerelle de Campo Volantín participe à l'étonnante rénovation de cette ville industrielle grâce à quelques interventions architecturales. Sa simplicité et sa légèreté contrastent avec l'environnement grisâtre.

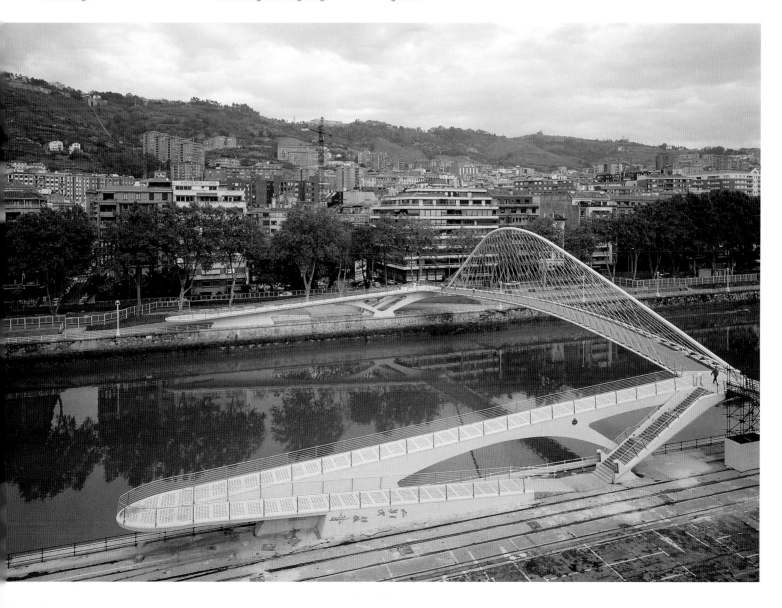

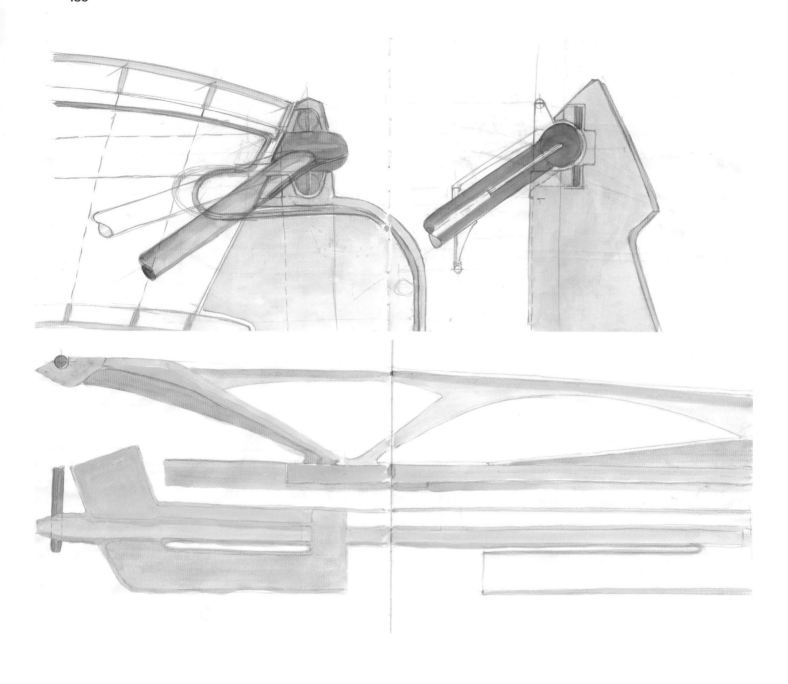

The architect's sketches reveal the integration of carefully thought-out details of structure with the overall effect he seeks in the profile of the bridge. These are not two different processes but part of a unified approach.

Die Skizzen des Architekten offenbaren die Einbeziehung sorgfältig durchdachter baulicher Details in die Gesamtwirkung, die er mit dem Profil der Brücke anstrebt. Dabei handelt es sich um zwei verschiedene Arbeitsgänge, die gleichwohl Teil einer einheitlichen Auffassung sind.

Les croquis de l'architecte montrent l'intégration de détails de la structure mûrement réfléchis dans l'effet d'ensemble qu'il recherche à travers le profil du pont. Ce ne sont pas deux processus distincts, mais les composantes d'une approche globale.

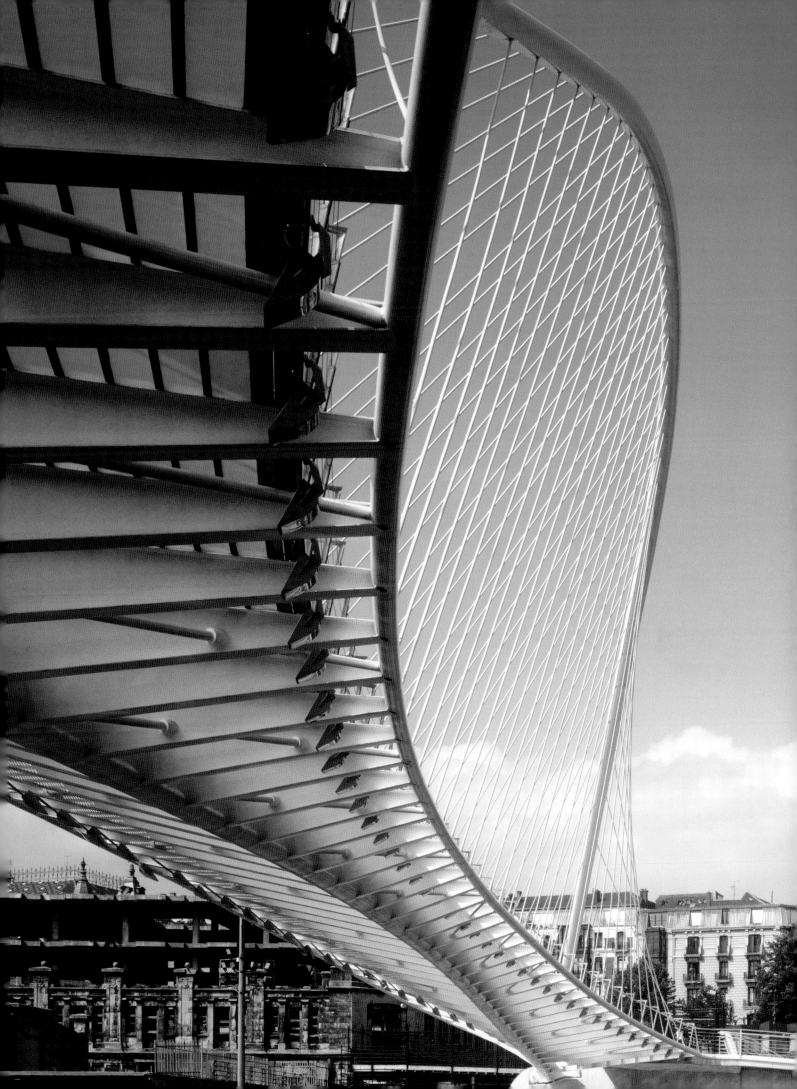

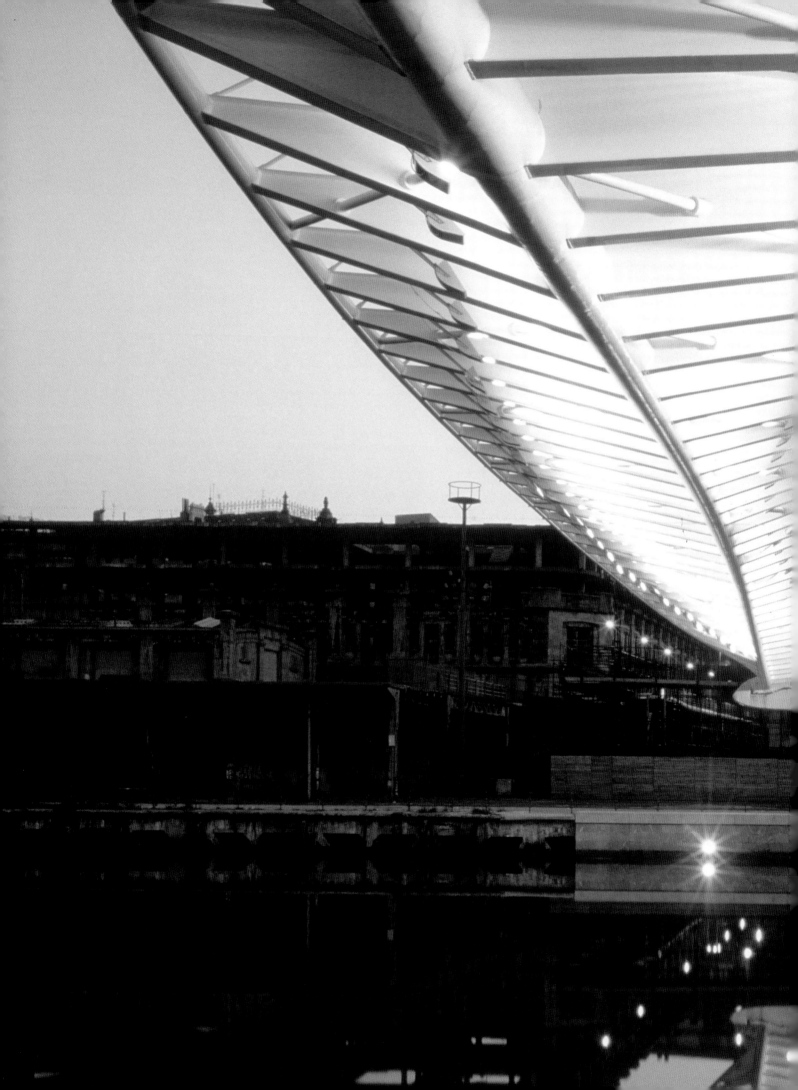

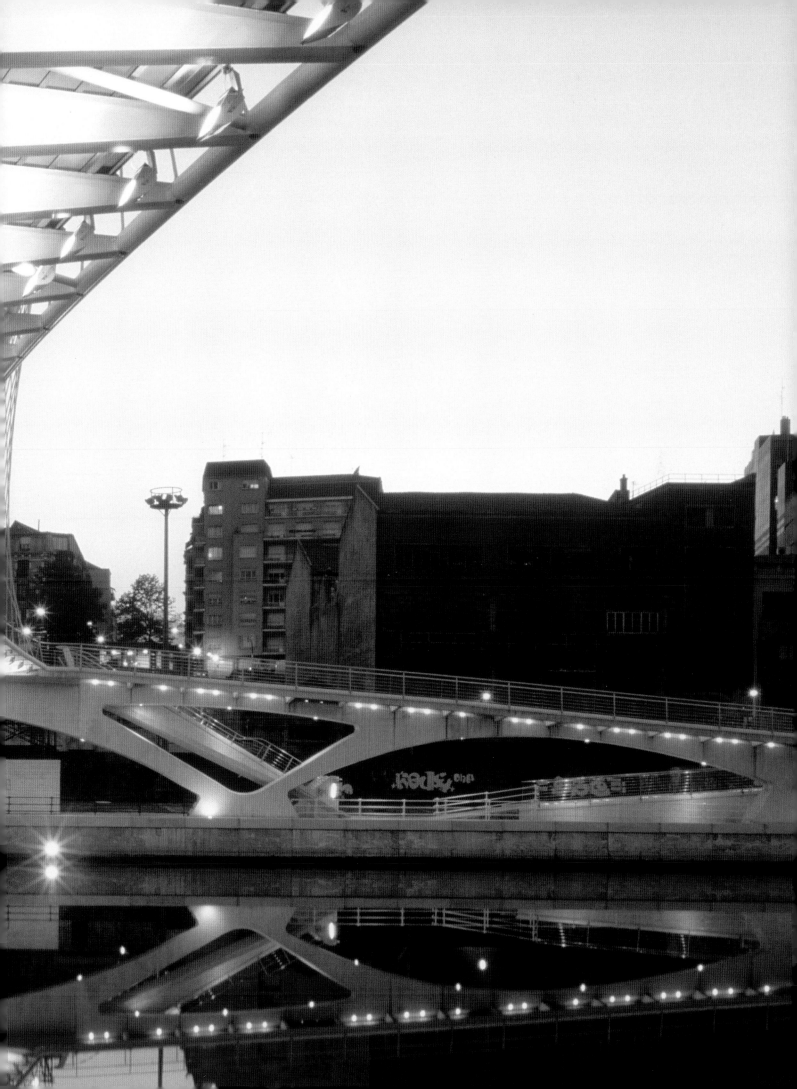

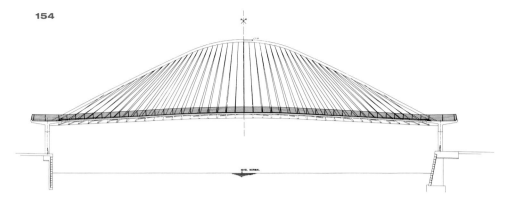

NIVEL NORMAL

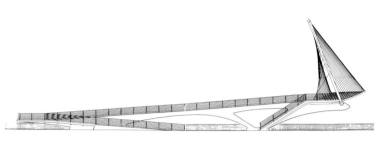

ALZADO HACIA EL MUELLE

Although the curvature of the bridge seems simple and elegant, it of course complicates the engineering, a fact that Calatrava in no way reveals in his design.

Die anscheinend einfache, elegante Krümmung der Brücke verkompliziert natürlich die technische Planung, ein Umstand, den Calatravas Entwurf in keiner Weise sichtbar macht.

Même si la courbe du pont paraît simple et élégante, sa conception est bien évidemment complexe, ce que Calatrava ne révèle absolument pas dans ses esquisses.

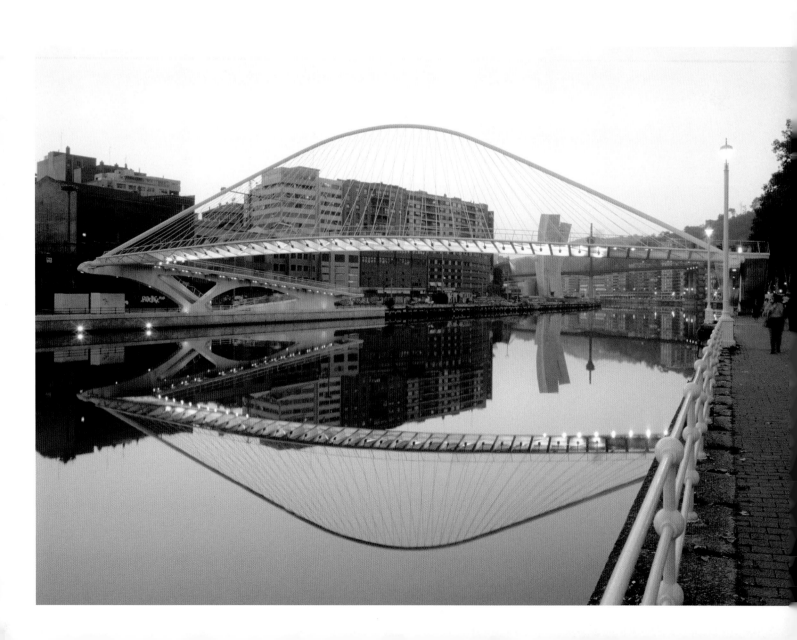

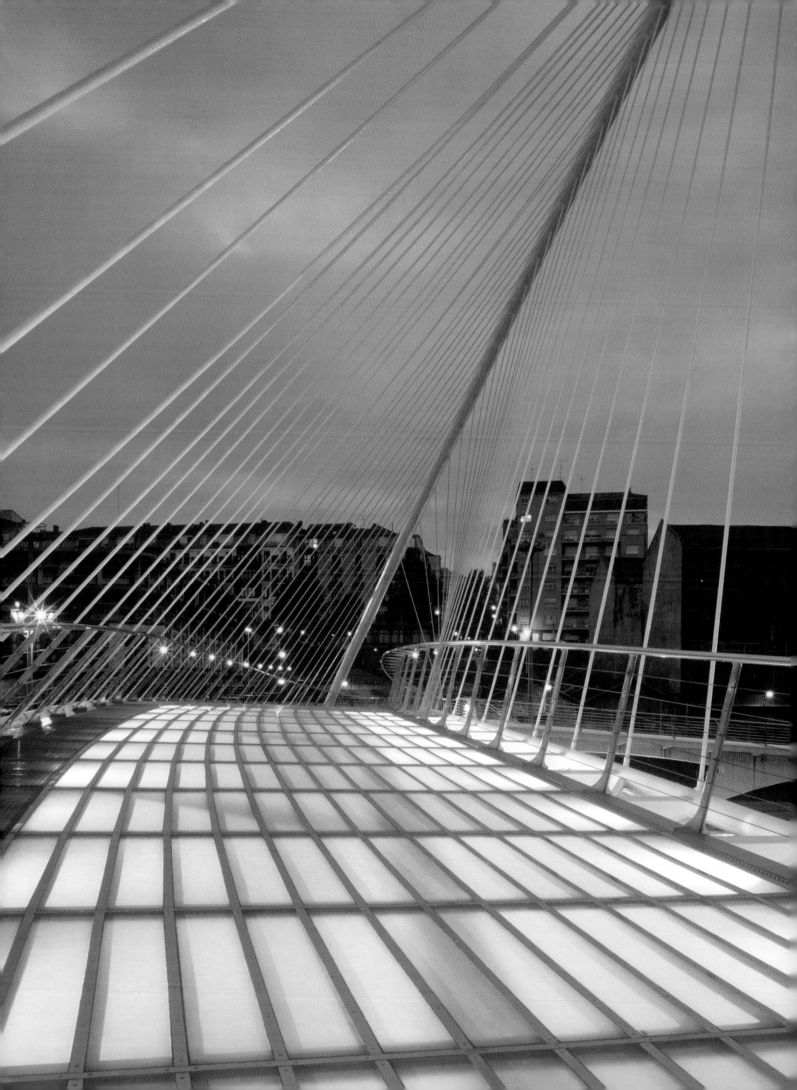

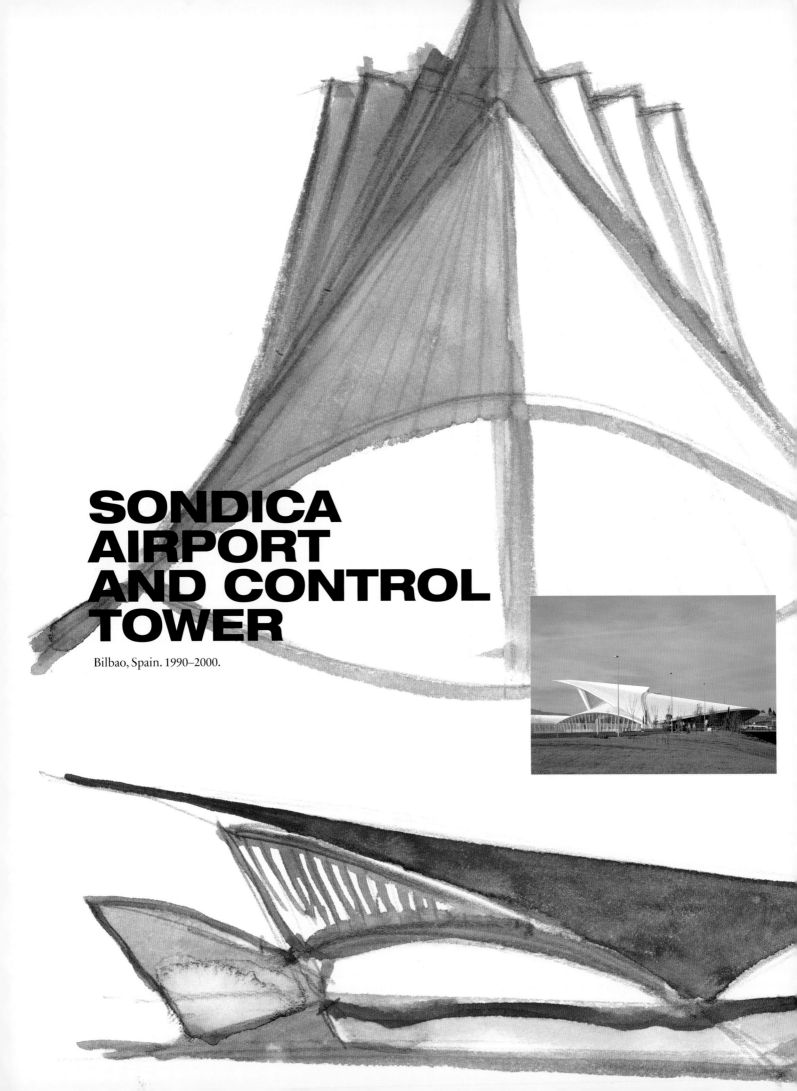

SONDICA
AIRPORT
AND CONTROL
TOWER

Bilbao, Spain. 1990–2000.

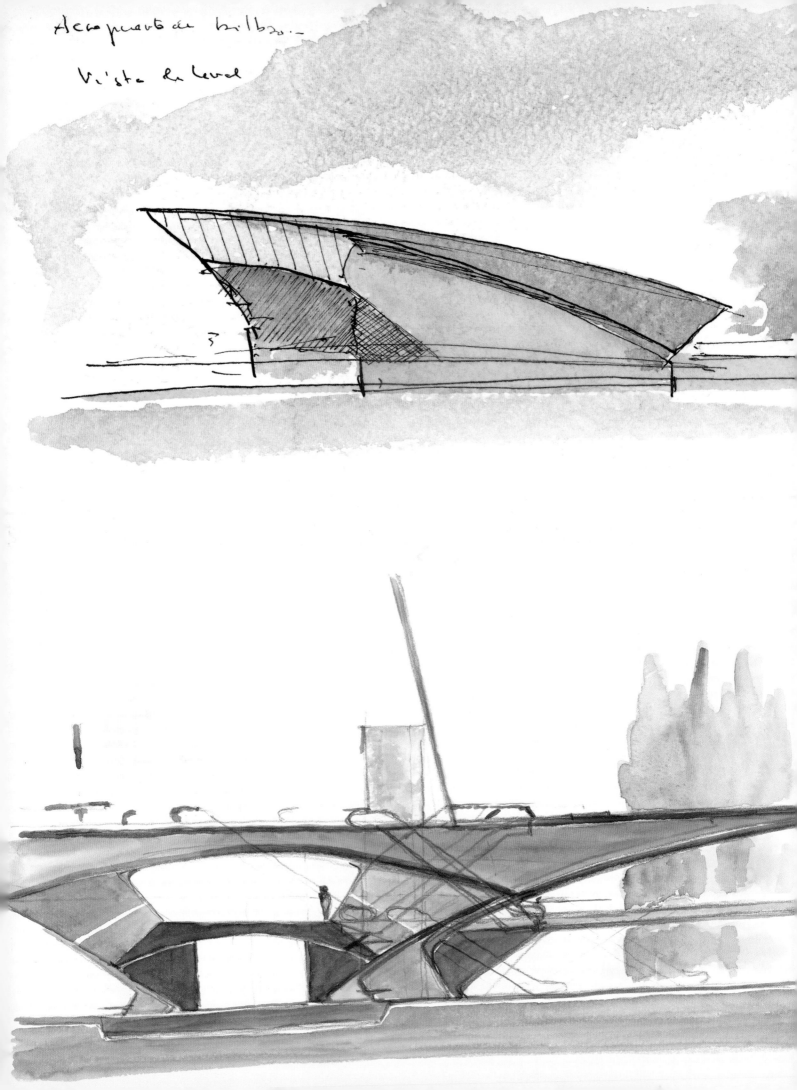

Aeropuerto de bilbao...
Viste de lewel

Project
SONDICA AIRPORT AND CONTROL TOWER

Location
BILBAO, SPAIN

Client
AEROPUERTOS ESPAÑOLES Y NAVEGACIÓN AÉREA

Height of control tower
42 METERS

Terminal floor area
29 000 m²

After having been asked in 1990 to design a new four-gate airport facility for the Basque city of Bilbao, Santiago Calatrava was commissioned four years later to double the size of the terminal, located 10 kilometers north of the city. The architect responded with a triangular plan, amply glazed structure whose roof sweeps upward in the direction of the landing field. Where glass is not used, the concrete structure is treated with a unifying aluminum cladding. Recalling an eyelid in elevation, and perhaps a steel-ribbed ray in plan, the structure can simultaneously handle the arrival and departure of eight aircraft through lateral wings that are intended for possible future expansion. Like Frank Gehry's Guggenheim Bilbao, this project underlines the will of Bilbao to compete in architectural and cultural terms with southern Spanish cities such as Barcelona. Departures are located on the upper floor, and arrivals below. Able to handle two million passengers a year as of 2000, Sondica Airport was conceived to eventually receive up to five times more travelers. Parking facilities for 1500 vehicles are connected to the terminal via a 100-meter underground passageway and are clearly integrated into the plan both visually and in terms of function. The architect's overall plan for the airport also provided for future facilities such as hotels. Santiago Calatrava's design for the new Bilbao Airport facilities included the construction, of a 42-meter-high control tower, located 270 meters from the terminal building (1993–96). Calatrava was selected on the basis of a separate limited competition and for reasons of airport function the control tower was given priority in the construction schedule over the other buildings. Inverting the normal typology for such structures, the tower is designed to have a progressively larger volume as it rises, culminating in a control deck with 360-degree visibility. Originally, the architect proposed that a single, central concrete pillar support the roof of the air traffic control room, but this idea was rejected by the client in favor of steel support located along the edges of the space. Built of reinforced concrete with some aluminum cladding, the tower has become the symbol of the airport itself.

Nachdem man ihn 1990 gebeten hatte, für die baskische Stadt Bilbao einen neuen Flughafen mit vier Flugsteigen zu entwerfen, erhielt er vier Jahre später den Auftrag, die Abmessungen des 10 km nördlich der Stadt gelegenen Terminals zu verdoppeln. Die Antwort des Architekten sah einen großzügig verglasten Bau mit dreieckigem Grundriss vor, dessen Dach sich in Richtung auf das Vorfeld nach oben erhebt. Wo kein Glas verwendet wird, erhielt der Betonbau eine harmonisierende Aluminiumverkleidung. Der Bau, der an ein sich öffnendes Augenlid oder im Grundriss vielleicht an die Umrisse eines Rochens mit stählernen Rippen erinnert, kann dank der für einen künftigen Ausbau gedachten Seitenflügel gleichzeitig den An- und Abflug von acht Flugzeugen abwickeln. Ebenso wie Frank Gehrys Guggenheim-Museum unterstreicht dieses Projekt die Absicht Bilbaos, sich in architektonischer und kultureller Hinsicht mit anderen spanischen Städten wie Barcelona zu messen. Abfliegende Passagiere werden über die obere Ebene, ankommende über die untere abgefertigt. Der Flughafen Sondica, der seit dem Jahr 2000 jährlich zwei Millionen Passagiere abfertigt, ist letzten Endes auf die fünffache Zahl von Fluggästen ausgelegt. Parkmöglichkeiten für 1500 Fahrzeuge sind mit dem Terminal durch eine 100 m lange, unterirdische Passage verbunden und in die Anlage in visueller wie funktioneller Hinsicht klar integriert. Der Gesamtplan des Architekten für den Flughafen sieht auch künftige Einrichtungen wie Hotels vor. Ebenfalls Teil des Projekts ist ein 42 m hoher Kontrollturm, der 270 m vom 1993–96 entstandenen Terminal entfernt steht. Calatrava kam aufgrund eines separaten, geschlossenen Wettbewerbs zum Zuge. Um den Flughafen funktionsfähig zu machen, entstand der Tower vor den übrigen Gebäuden. In Umkehrung der üblichen Form derartiger Bauten vergrößert der Turm mit zunehmender Höhe sein Volumen und endet in einer Kontrollebene mit unbehinderter Rundumsicht. Ursprünglich hatte der Architekt einen einzelnen, zentralen Betonpfeiler vorgesehen, der das Dach des Kontrollraums stützen sollte, aber die Idee wurde vom Auftraggeber abgelehnt zugunsten von Stahlstützen entlang der Ränder des Raumes. Der aus Stahlbeton errichtete Turm ist teilweise mit Aluminium verkleidet und wurde inzwischen zum Symbol des ganzen Flughafens.

Après la commande, en 1990, d'une nouvelle aérogare à quatre passerelles d'embarquement implantée à dix kilomètres au nord de la ville basque espagnole de Bilbao, Santiago Calatrava se vit confier quatre ans plus tard le doublement du premier projet. Le bâtiment de plan triangulaire et généreusement vitré, se caractérise par une couverture qui s'élève vers le ciel dans l'axe des pistes. Les parties en béton sont unifiées par un habillage en aluminium. Rappelant une paupière (en élévation) voire une raie (sur plan), la structure peut traiter simultanément l'arrivée et le départ de huit appareils grâce à des passerelles latérales conçues pour permettre une future extension. Comme le musée Guggenheim de Frank Gehry, ce projet exprime la volonté de la Ville de Bilbao de rivaliser, en termes d'architecture et de culture, avec d'autres villes espagnoles, notamment Barcelone. Les départs s'effectuent au niveau supérieur, et les arrivées à celui des pistes. Cet aéroport, d'une capacité de trafic de deux millions de passagers par an en 2000, pourra un jour en recevoir dix millions. Les parkings pour 1500 véhicules sont raccordés au terminal par un passage souterrain de 100 mètres de long et totalement intégrés au plan, aussi bien visuellement que fonctionnellement. Le plan masse de l'aéroport prévoit également l'implantation d'équipements futurs tels que des hôtels. Ce projet comprenait par ailleurs la construction d'une tour de contrôle de 42 mètres de haut, à 270 mètres du terminal (1993–96). Calatrava a été choisi lors d'un concours sur invitation et, pour des raisons de fonctionnement, la tour a eu la priorité sur les autres constructions. Inversant la typologie habituelle de ce genre de structure, elle se présente sous forme d'un volume en cornet qui s'élargit peu à peu avant de culminer dans une plate-forme offrant une visibilité à 360 degrés. À l'origine, l'architecte avait proposé qu'un pilier central unique en béton soutienne la salle de contrôle du trafic aérien, mais cette idée a été refusée par le client, qui a préféré des piliers en acier à la périphérie de la salle. Édifiée en béton armé et partiellement habillée d'aluminium, la tour est devenue le symbole de l'aéroport.

The raylike form seen elsewhere in Calatrava's oeuvre is visible in the sketch to the left. The photo of the site and new building below emphasizes the metaphor of flight implicit in the overall design.

Die Rochenform, die man aus Calatravas Werk kennt, ist in der Skizze links wiederzuerkennen. Das Foto der Baustelle und des neuen Gebäudes (unten) verdeutlicht die Metapher des Fliegens, die den gesamten Entwurf prägt.

La forme de raie, déjà vue dans l'œuvre de Calatrava, réapparaît dans le croquis de gauche. Les photos du site et du nouveau bâtiment, en bas, mettent en évidence la métaphore du vol implicite dans le projet d'ensemble.

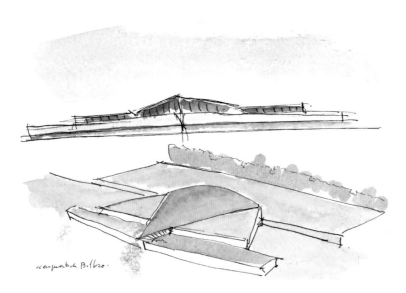

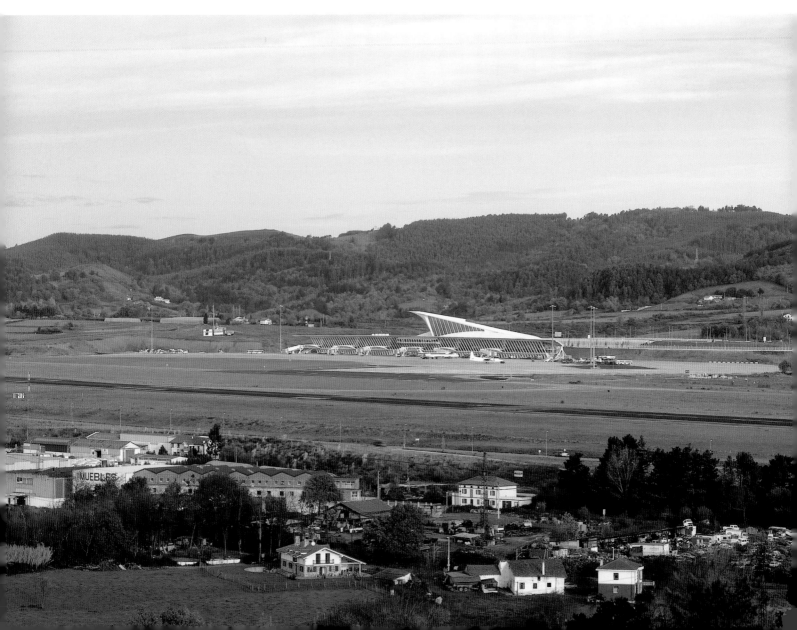

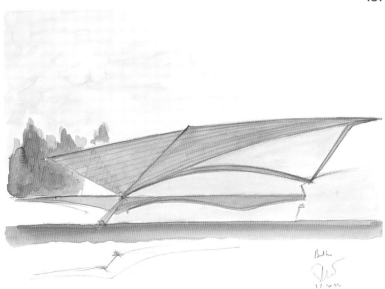

The architect's sketches, such as the one above are a remarkably faithful representation of the final result, seen below. By skewing his forms forward, he imparts the feeling of take off to the static buildings associated with flight.

Die Skizzen des Architekten, wie die oben abgebildete, liefern eine bemerkenswert genaue Darstellung des unten zu sehenden Endergebnisses. Indem er seine Formen nach vorne abschrägt, verleiht er den statischen Flughafengebäuden die Dynamik des Abhebens.

Les croquis de l'architecte (tel celui ci-dessus) sont une représentation remarquablement fidèle du résultat final (ci-dessous). En effilant les formes vers l'avant, il crée une impression d'envol dans un bâtiment statique.

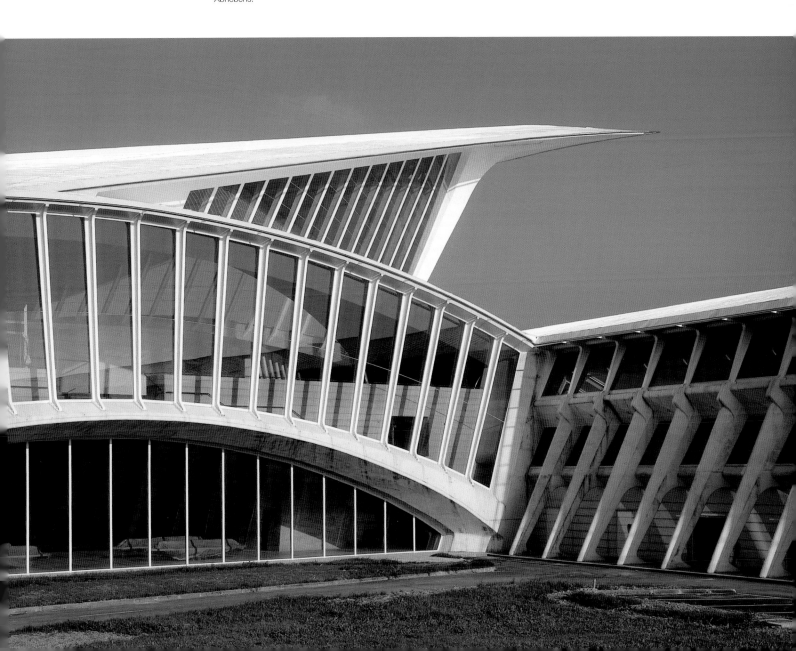

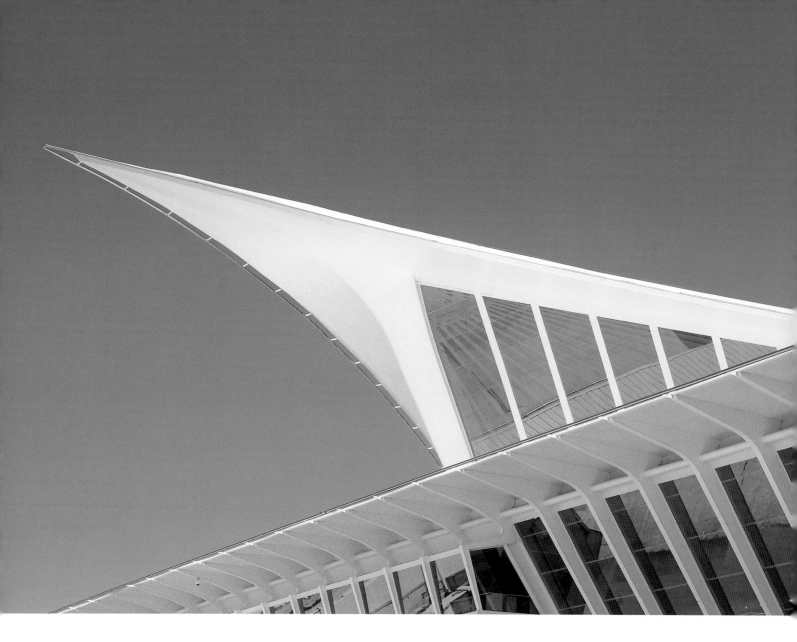

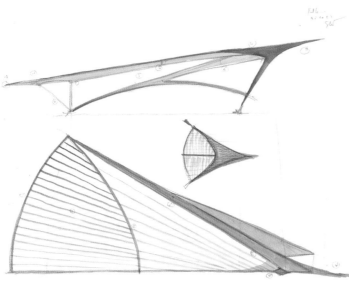

Fascinated by the idea of movement in architecture, if not specifically with flight, Calatrava nonetheless frequently calls on an apparently aviary vocabulary, most clearly visible in the sketches reproduced on the right.

Von der Idee der Bewegung in der Architektur fasziniert, macht Calatrava nicht nur bei Flughafenterminals Gebrauch von an Vögel erinnernden Formen, deutlich erkennbar an seinen rechts abgebildeten Skizzen.

Fasciné par l'idée de mouvement en architecture, si ce n'est spécifiquement par le vol, Calatrava fait souvent appel à un vocabulaire formel qui évoque l'oiseau, comme le montrent les croquis reproduits à droite.

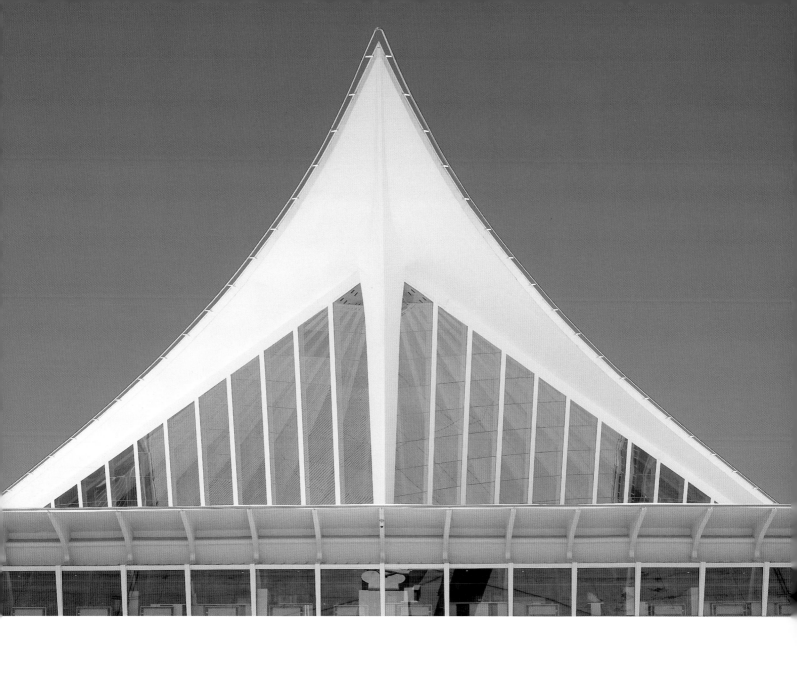

The raking cantilevered roof and forms of the airport carry an obvious relation to Calatrava's work on bridges, appearing to defy gravity but based in a natural comprehension of the engineering involved.

Das stark geneigte, vorkragende Dach und die Formen des Flughafens lassen eine offensichtliche Verbindung zu Calatravas Brückenentwürfen erkennen, die auch der Schwerkraft zu trotzen scheinen und sich doch auf ein natürliches Verständnis der beteiligten Technik stützen.

Le profil du toit et l'inclinaison des éléments en porte-à-faux de l'aéroport montrent une relation évidente avec les recherches de Calatrava sur les ponts, semblant défier la gravité mais s'appuyant sur une compréhension intuitive de l'ingénierie.

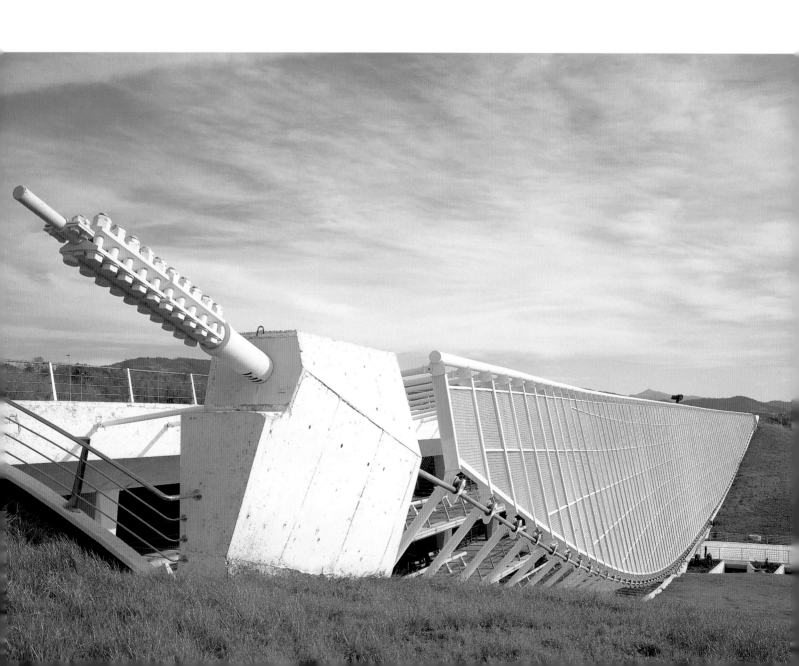

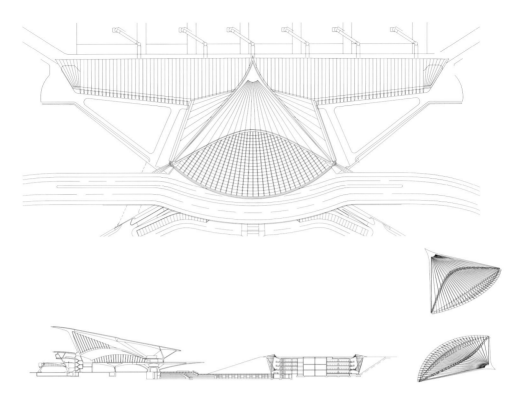

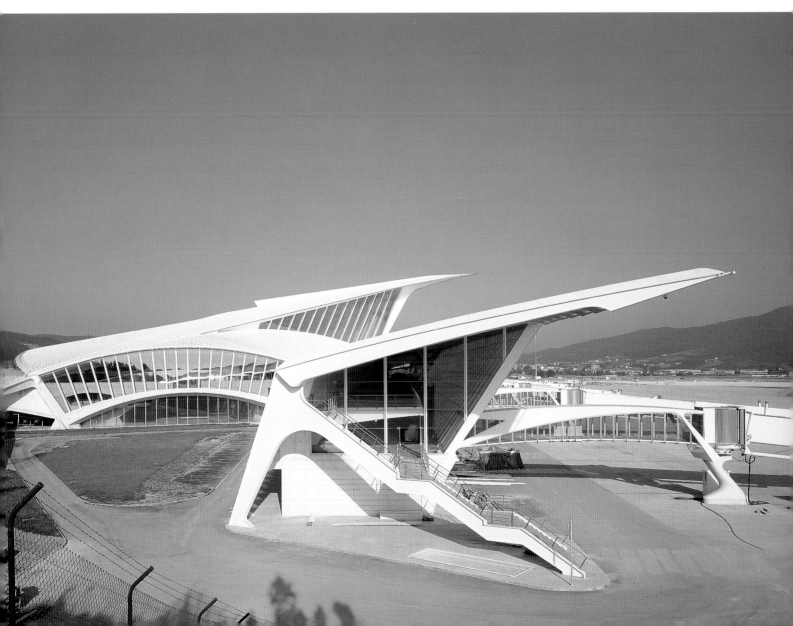

Much as he does with bridges, here Calatrava has taken a basic form, that of the airport control tower, usually subject to very little aesthetic effort, and turned it into a sculptural object that nonetheless is fully capable of its intended functions.

Ähnlich wie bei Brücken nahm sich Calatrava hier eine Grundform, die des Flughafen-Kontrollturms, dem gewöhnlich wenig ästhetische Überlegung zuteil wird, und verwandelte ihn in ein plastisches Objekt, das dennoch seiner vorgesehenen Funktion zur Gänze gerecht wird.

En grande partie comme pour ses ponts, Calatrava se saisit ici d'une forme de base, celle de la tour de contrôle, généralement un peu négligée sur le plan esthétique, pour en faire un objet sculptural qui n'en remplit pas moins parfaitement sa fonction première.

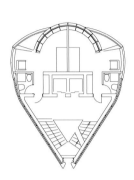
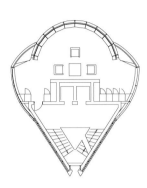
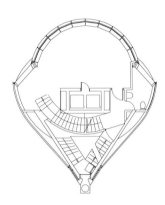

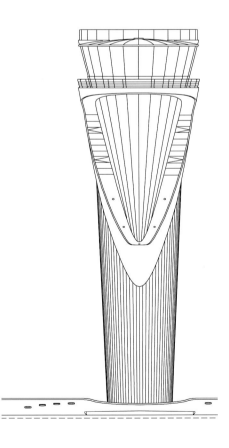
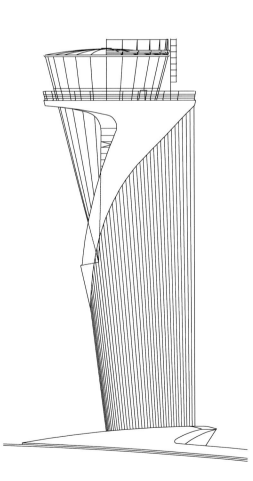
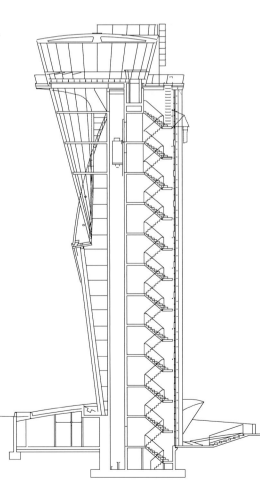

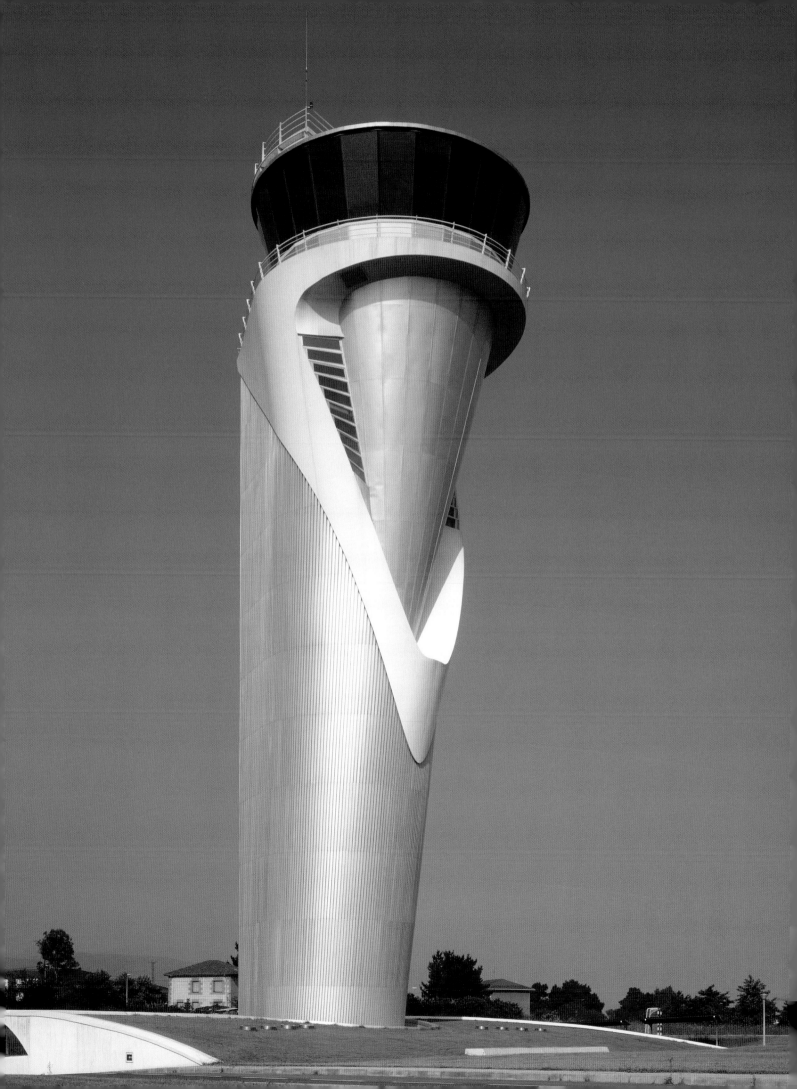

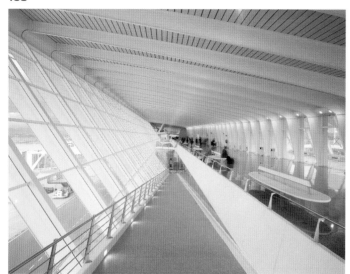

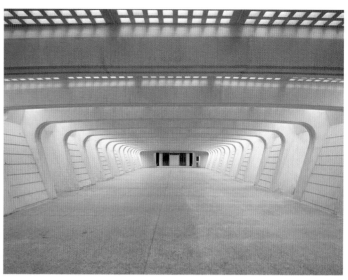

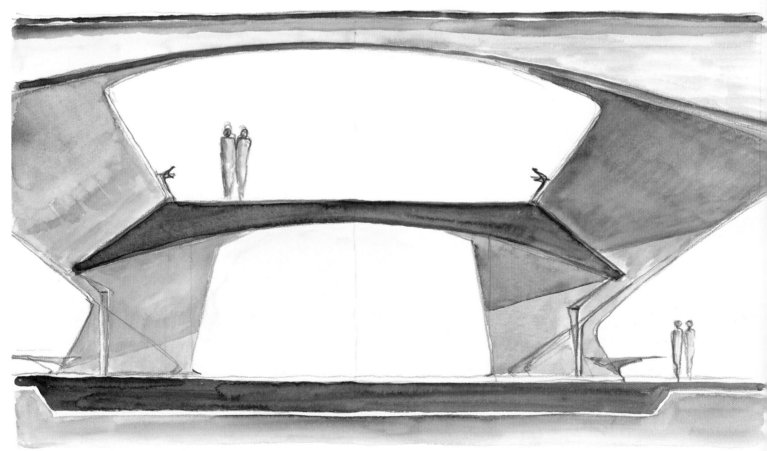

The cantilevered or ribbed forms seen in the Zurich or Lyon Railway Stations are again present here with variations and an apparent effort to simplify forms, or to render them more pure.

Die bei den Bahnhöfen von Zürich und Lyon auskragenden oder gerippten Formen kommen auch hier vor, jedoch abgewandelt und in dem offensichtlichen Bemühen, sie zu vereinfachen oder unverfälschter wiederzugeben.

Les formes nervurées ou en porte-à-faux déjà vues à Zurich ou dans la gare de Lyon-Saint Exupéry réapparaissent ici, mais dans une variante et une tentative de simplification qui les rend encore plus pures.

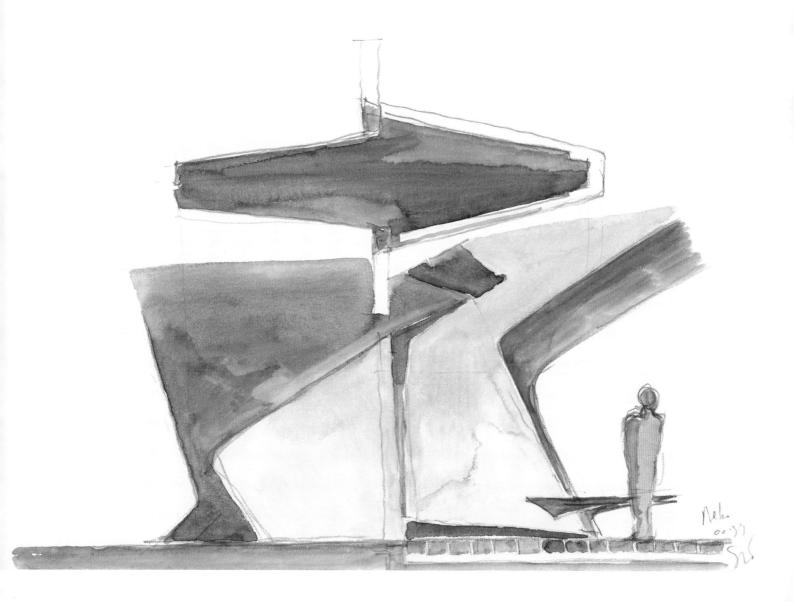

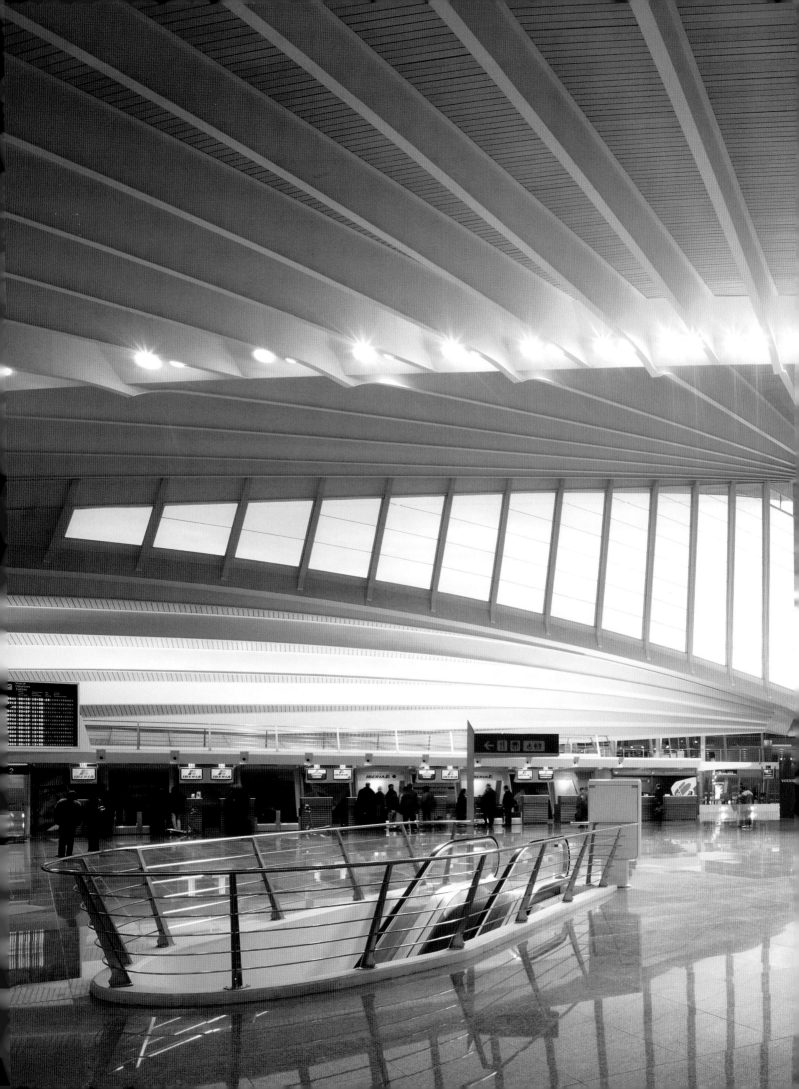

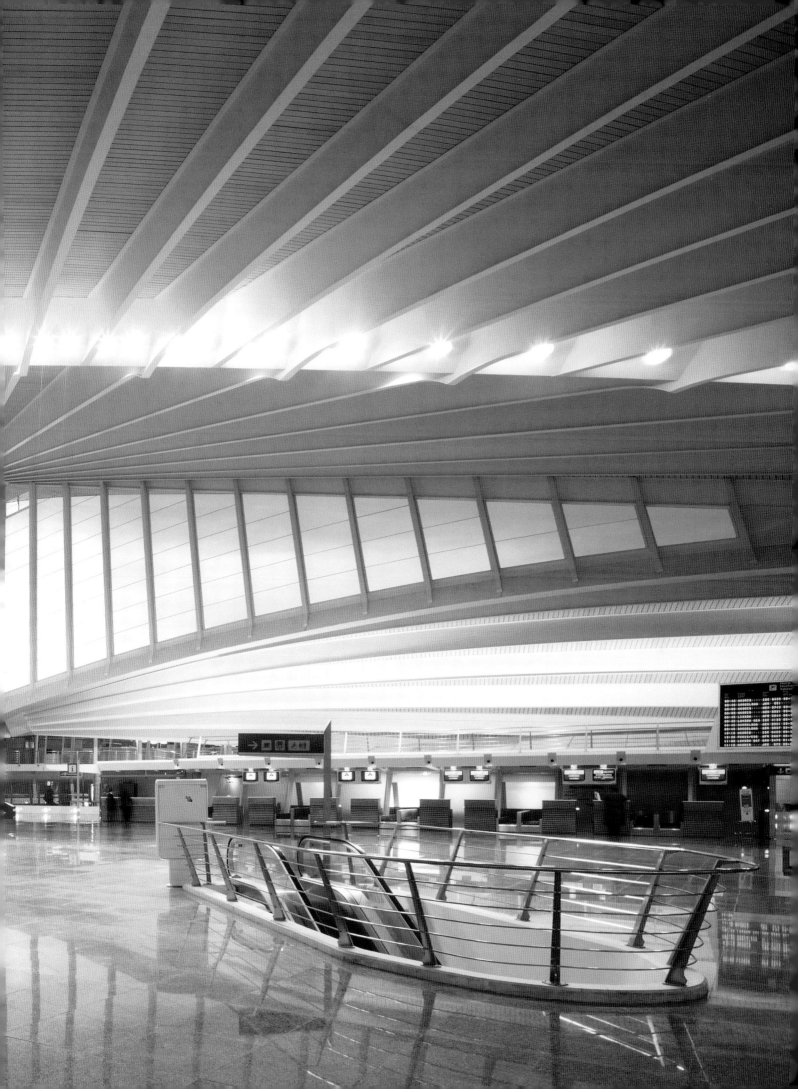

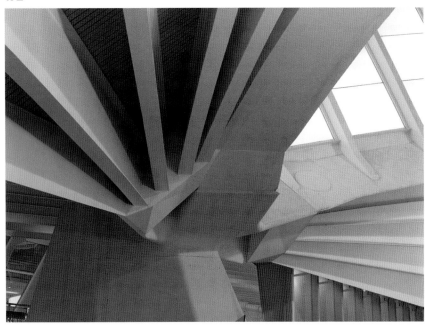

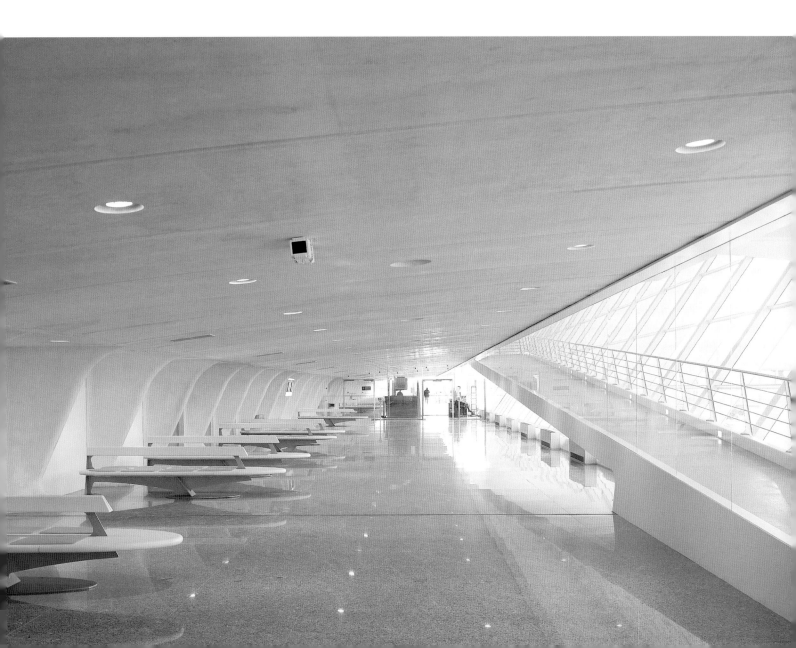

Paying careful attention to such factors as the detailing of the repeated concrete supports seen below, the architect gives them a presence that they would otherwise lack. Light also plays an important role, giving variety and movement to the space.

Indem er sich der Gestaltung von Elementen wie den unten abgebildeten sich wiederholenden Betonstützen mit großer Sorgfalt widmet, verleiht der Architekt ihnen eine sonst fehlende Präsenz. Auch Licht spielt eine wichtige Rolle, da es dem Raum Abwechslung und Bewegung verleiht.

En travaillant des éléments comme le détail des piliers de béton répétés (ci-dessous), l'architecte leur confère une présence qu'ils n'auraient pas eue sans ce traitement. La lumière, qui crée une impression de mouvement et de variété à l'intérieur du volume, joue également un rôle important.

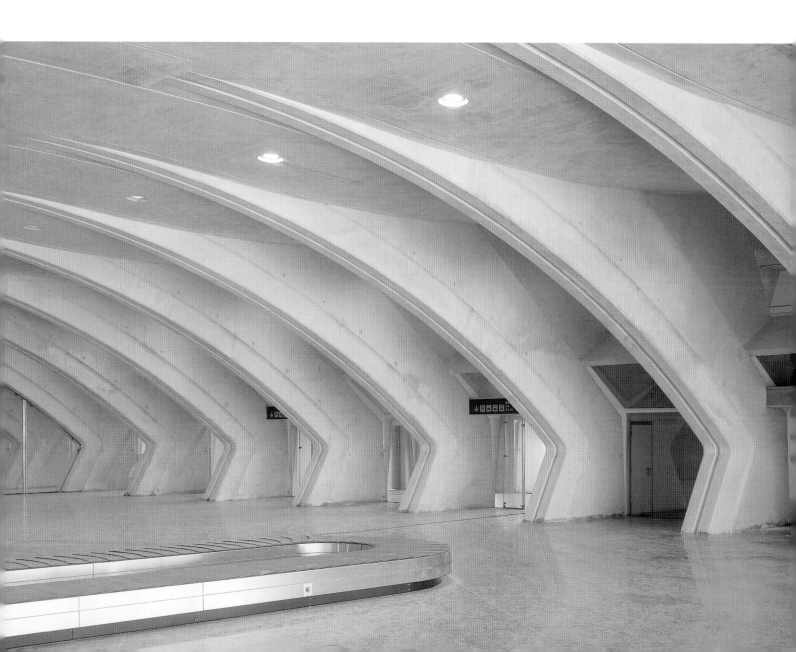

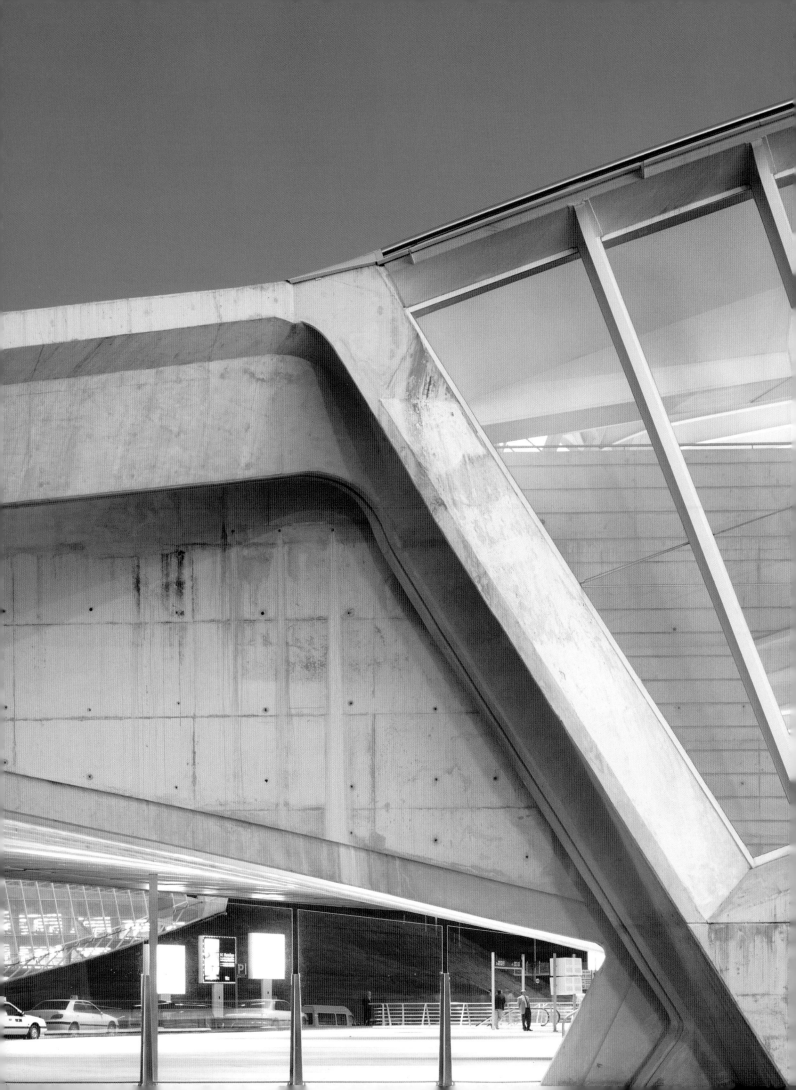

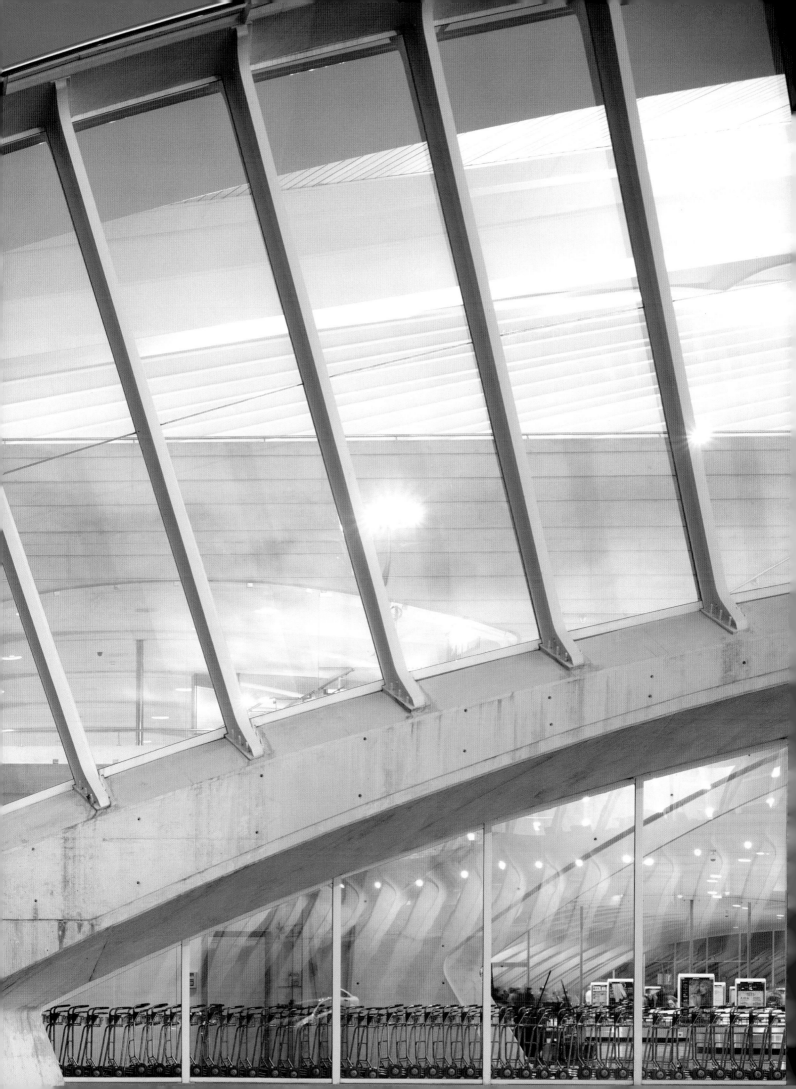

Maquete n° ② Pabellon de Ruwait

Pabellonde Vanu
tots

Pina
fots

- planos
- alerts

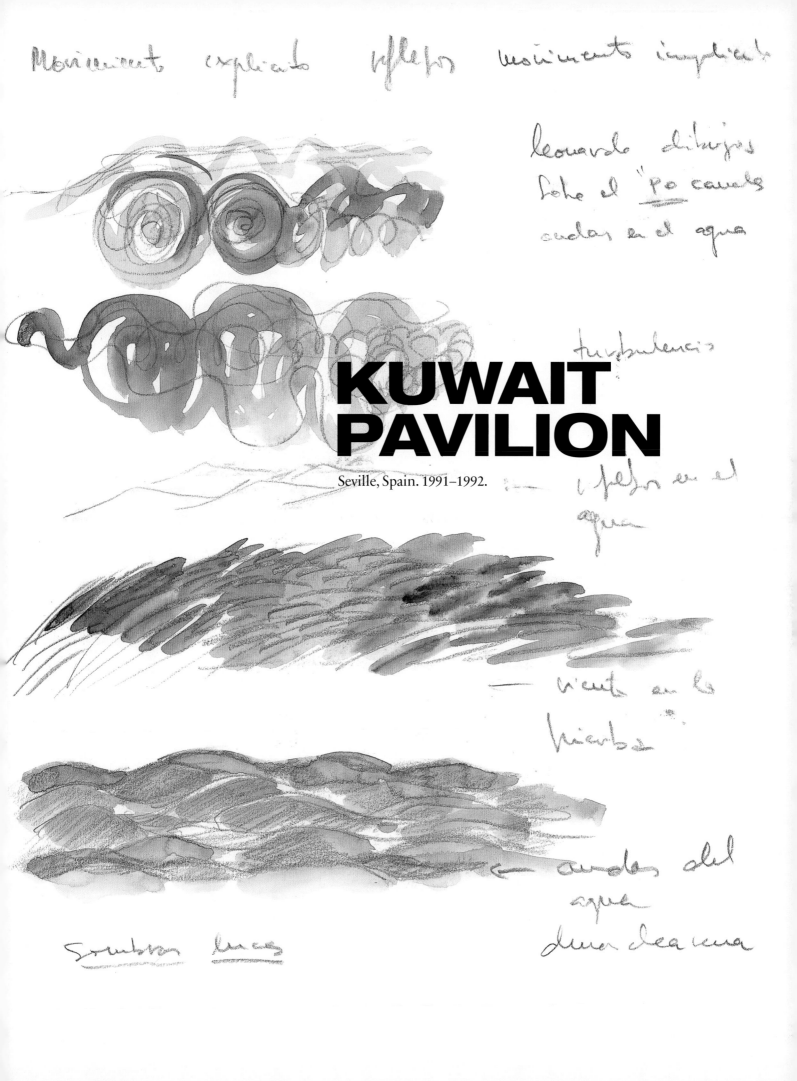

KUWAIT PAVILION

Seville, Spain. 1991–1992.

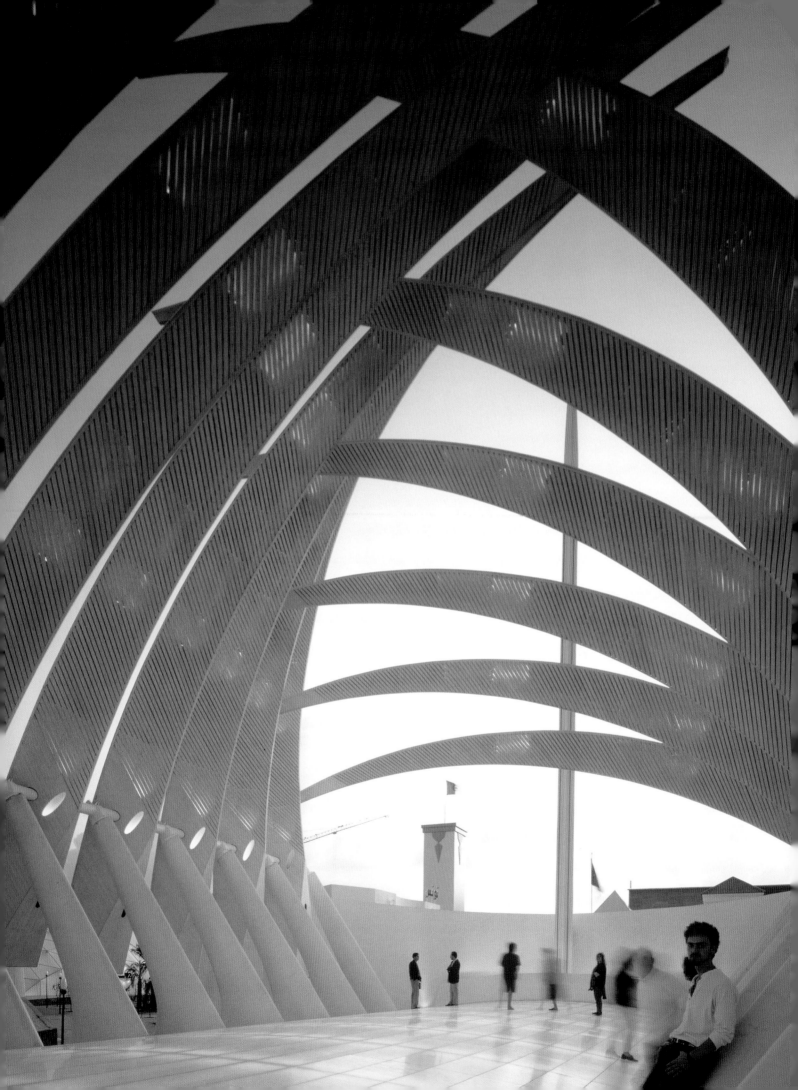

Project
KUWAIT PAVILION
Location
EXPO '92, CARTUJA ISLAND, SEVILLE, SPAIN
Client
STATE OF KUWAIT

Closing fingers, waving palm fronds, the rib cage of some prehistoric creature—all of these images inspired by the natural world might come to mind when viewing the Kuwait Pavilion, and yet Calatrava renders the source of his shapes abstract in the final analysis.

Beim Anblick des Pavillons könnte man an verschiedene, von der Natur inspirierte Bilder denken, wie sich zur Faust schließende Finger, wehende Palmblätter, die Rippen einer prähistorischen Kreatur, und doch verweist Calatrava in seiner abschließenden Analyse auf abstrakte Quellen für seine Formen.

Doigts refermés, palmes ondulant dans le vent, cage thoracique de quelque animal préhistorique – toutes ces images inspirées du monde naturel viennent à l'esprit devant le pavillon du Koweit, ce qui n'empêche pas Calatrava, au final, de styliser ses sources par l'abstraction.

History recalls that the period of Expo '92 was particularly difficult for Kuwait. Invaded by Iraq on August 2, 1990, the country was freed by an international coalition led by the United States on February 28, 1991. Santiago Calatrava was commissioned to design a pavilion intended to serve as an international symbol and to allow visitors to become more familiar with the culture of the Persian Gulf emirate. His plan called for a raised covered square plaza glazed with laminated structural glass panels superimposed with a thin layer of translucent marble and defined by two curved walls. An open, triangulated timber latticework structure supported the glass and marble surface and created the main exhibition area. Perhaps the most visible feature of the architecture was a series of moveable ribs, reaffirming Calatrava's interest in movement along lines similar to his proposal for the articulated dome of the Reichstag in Berlin. As the architect describes the design, "17 scimitar-shaped ribs, each 25 meters in length, form the main articulated structure. Each rib is computer controlled by a separate electric drive to open in fifteen preprogrammable positions up to the vertical and, when closed, to interlace with the others to form a cover, which repeats the slatted structure of the trusses spanning the space below. An infinite variety of patterns can be created against the open sky."

Historisch war die Zeit der Expo '92 für Kuwait von besonderen Problemen gekennzeichnet. Das am 2. August 1990 vom Irak besetzte Land wurde am 28. Februar 1991 von einer internationalen Koalition unter Führung der Vereinigten Staaten befreit. Santiago Calatrava erhielt den Auftrag, einen Pavillon zu gestalten, der als internationales Symbol dienen und es Besuchern ermöglichen sollte, die Kultur des Emirats am Persischen Golf näher kennen zu lernen. Seine Planung sah eine erhöhte, überdachte Plaza mit quadratischem Grundriss vor, verglast mit mehrschichtigen Bauglasplatten, die wiederum von einer dünnen Schicht lichtdurchlässigen Marmors überfangen und von zwei geschwungenen Wänden begrenzt sein sollte. Eine offene Holzkonstruktion aus Dreieckfachwerk trägt die Glas-Marmorflächen und definiert den Hauptausstellungsbereich. Das vielleicht auffälligste

Merkmal des Gebäudes ist eine Reihe beweglicher Rippen, eine erneute Bestätigung von Calatravas Interesse an Bewegung, vergleichbar mit seiner Planung für die gelenkig gelagerte Kuppel des Berliner Reichstags. Der Architekt beschreibt den Entwurf folgendermaßen: „17 gekrümmte, jeweils 25 m lange Rippen bilden den gegliederten Hauptbaukörper. Jede Rippe lässt sich von einem separaten elektrischen Antrieb computergesteuert in 15 vorprogrammierbaren Positionen bis zum vertikalen Stand öffnen und in geschlossenem Zustand mit den anderen Rippen verflechten. So entsteht eine Abdeckung, die die Lamellenstruktur der Verstrebungen über den darunter liegenden Raum wiederholt. Vor dem freien Himmel lässt sich so eine unendliche Vielfalt von Mustern erzeugen."

L'histoire se souvient que la période de l'Expo '92 était particulièrement difficile pour le Koweït. Envahi par l'Irak le 2 août 1990, le pays avait été libéré par une coalition internationale conduite par les États-Unis, le 28 février 1991. Santiago Calatrava reçut alors commande d'un pavillon qui serait un symbole aux yeux du monde et permettrait aux visiteurs de se familiariser avec la culture de cet émirat du Golfe persique. Son plan s'organisait autour d'une plate-forme carrée surélevée, au sol en panneaux de verre structurel feuilleté revêtu d'une fine couche de marbre translucide, et dont l'espace central n'était délimité que par deux murs incurvés. Une structure ouverte triangulée en treillis de bois soutenait cet ensemble qui composait le principal espace d'expositions. L'élément le plus visible était cependant un ensemble de « côtes » mobiles qui illustrait l'intérêt de l'architecte pour ce système proche de la proposition qu'il avait faite pour le dôme articulé du Reichstag à Berlin. Il décrivait le projet ainsi : « Dix-sept nervures en cimeterre, de vingt-cinq mètres de long chacune, forment l'essentiel de cette structure articulée. Chaque nervure, contrôlée par un ordinateur commandant des moteurs électriques selon quinze positions pré-programmables jusqu'à la verticale, se joint aux autres pour constituer une couverture fermée. Celle-ci reproduit la structure en treillis des poutres de l'espace situé dessous. Une infinie variété de motifs peuvent ainsi se dessiner sur la toile de fond du ciel. »

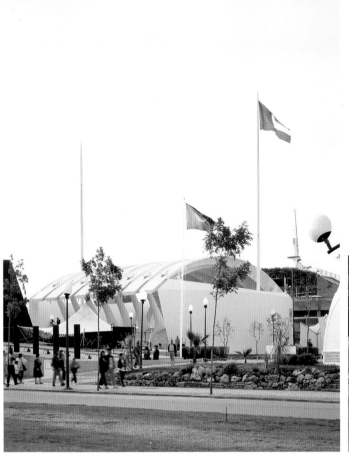

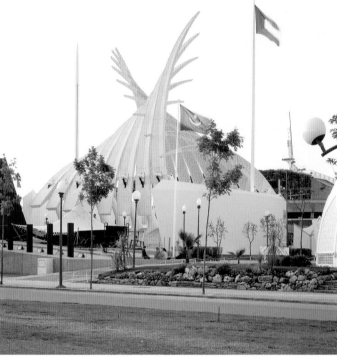

As he had on a smaller scale with the Ernsting's Warehouse, Calatrava here experiments with actual, physical movement, using finger-like projections that open and close over the building. Resembling bleached ribs in the open position, these prosthetic elements seal off the structure in a neat dome when closed.

Wie er es in kleinerem Maßstab beim Lagerhaus der Firma Ernsting's getan hatte, experimentiert Calatrava hier mit tatsächlicher Bewegung und verwendet fingerförmige Auskragungen, die sich über dem Gebäude öffnen und schließen. Die in geöffnetem Zustand Rippen ähnelnden prosthetischen Elemente schließen sich über dem Pavillon beinahe zu einer Kuppel.

Comme il l'avait fait à plus petite échelle pour l'entrepôt Ernsting's, Calatrava se livre ici à des expérimentations avec le mouvement réel, physique, à travers ces éléments qui, tels des doigts, s'ouvrent et se ferment au-dessus du bâtiment. Ressemblant à des côtes blanchies en position ouverte, ils se referment pour constituer une sorte de coupole.

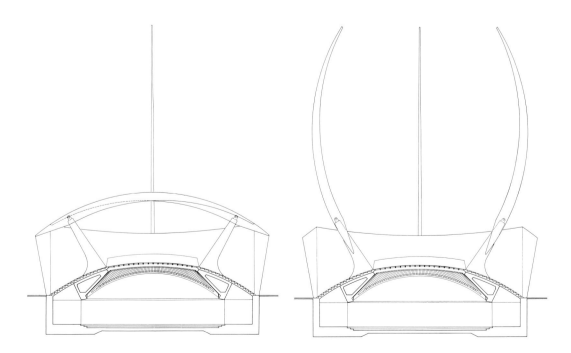

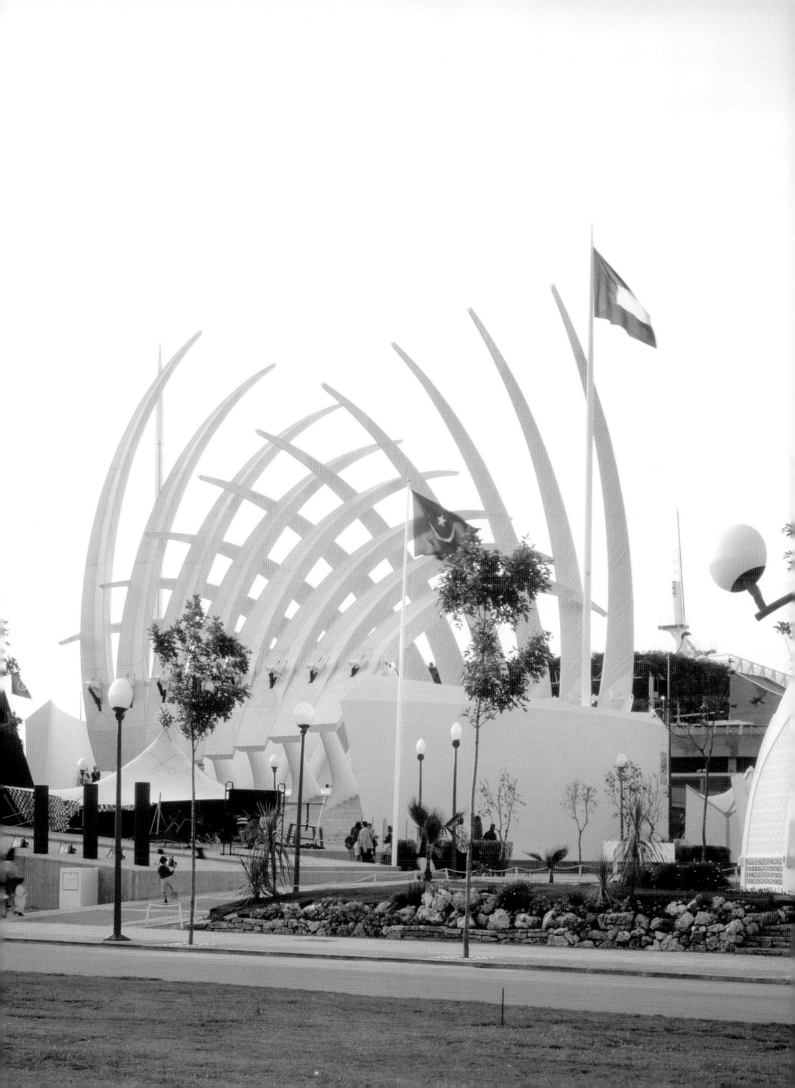

These side views make the mechanism of the pavilion easier to understand. Fitting into each other like the fingers of two hands, the ribs assume a natural form that remains wholly unexpected in contemporary architecture.

Mithilfe dieser seitlichen Ansichten ist die Funktionsweise des Pavillons besser zu verstehen. Die wie die Finger zweier Hände ineinander greifenden Rippen nehmen eine in der zeitgenössischen Architektur gänzlich überraschende Form an.

Ces vues latérales permettent de mieux comprendre le mécanisme appliqué au pavillon. Se croisant comme les doigts de deux mains, les « côtes » affichent une forme naturelle, vision totalement inattendue dans l'architecture contemporaine.

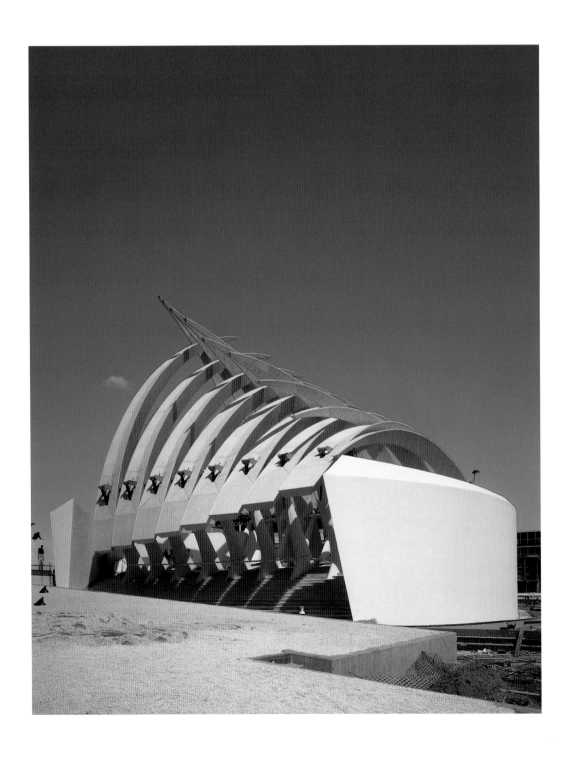

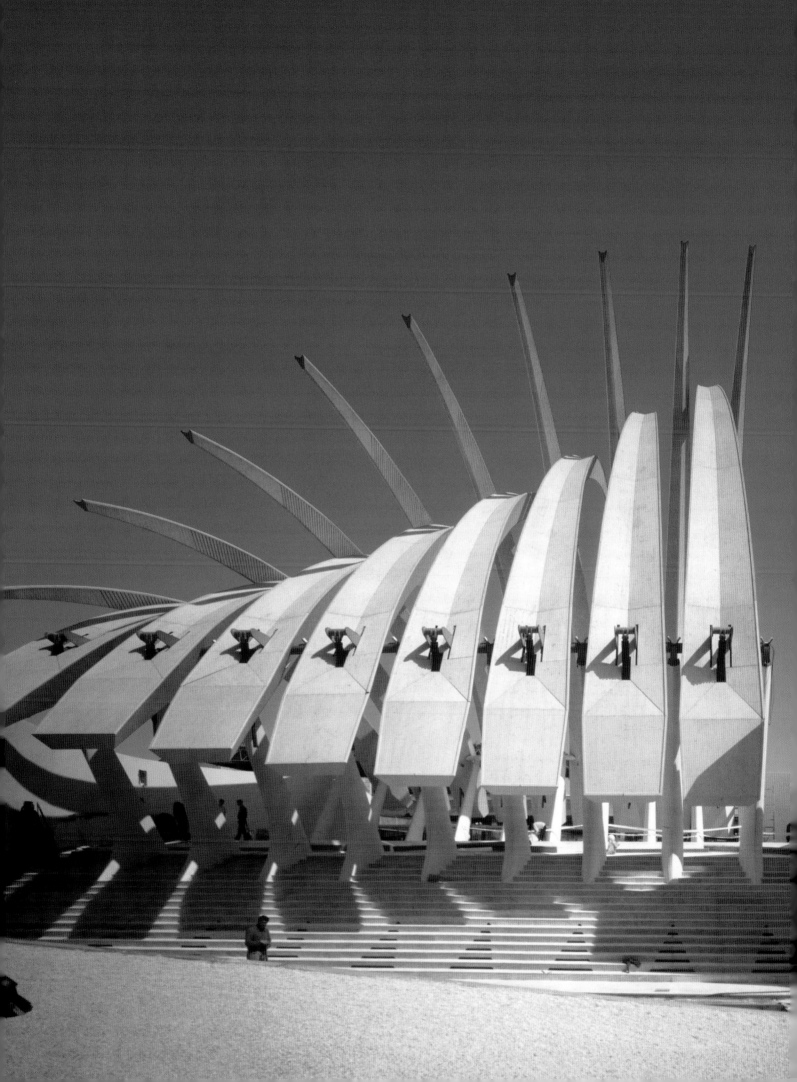

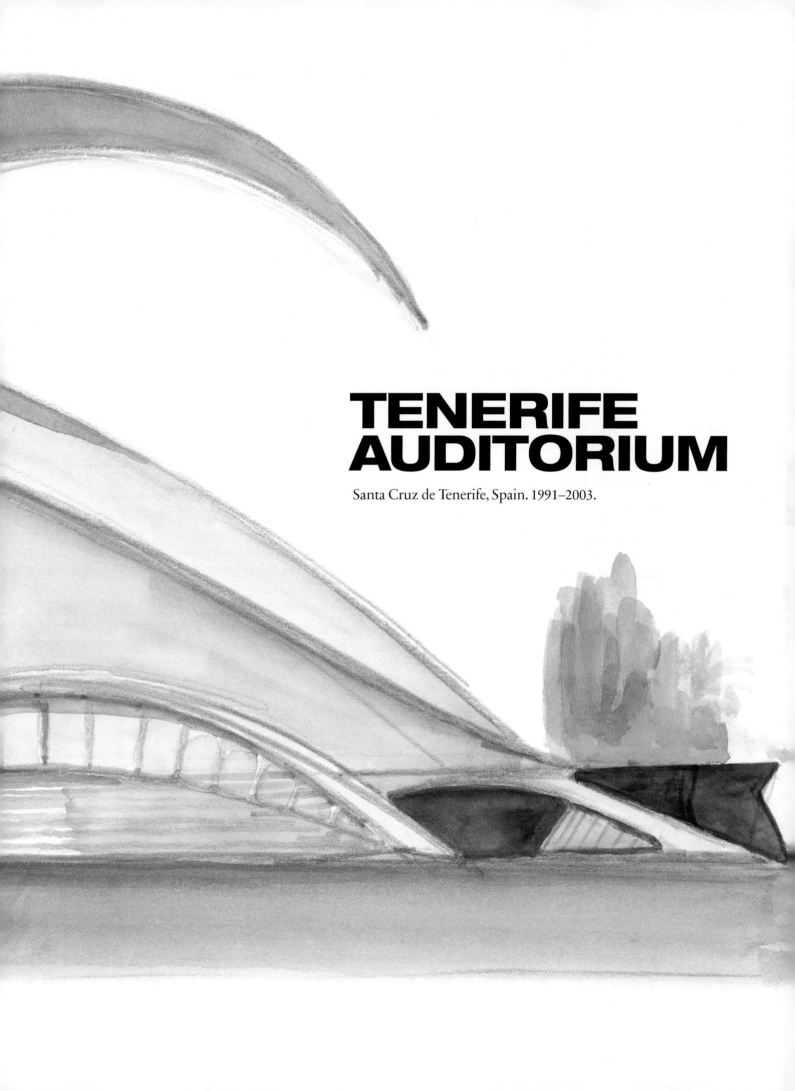

TENERIFE AUDITORIUM

Santa Cruz de Tenerife, Spain. 1991–2003.

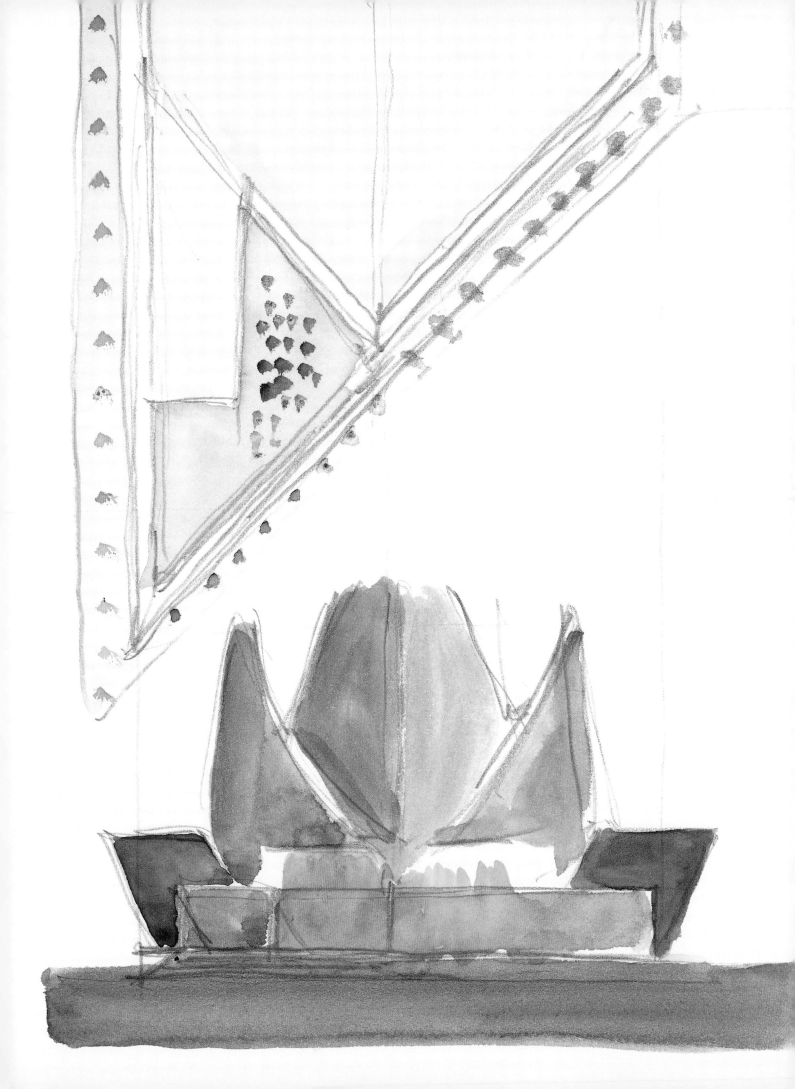

Project
TENERIFE AUDITORIUM

Location
SANTA CRUZ DE TENERIFE, CANARY ISLANDS, SPAIN

Client
TENERIFE TOWN COUNCIL

Capacity
1558 SEATS (MAIN CONCERT HALL); 428 SEATS (CHAMBER MUSIC HALL)

Cost
$ 82 MILLION

Completed in 2003, this 1558-seat capacity concert hall is located at the intersection of the Tres de Mayo Avenue and Maritima Avenue in the city of Santa Cruz de Tenerife. The facility also includes a chamber music hall with seating for 428. On this site in the harbor, the city expressed "a desire for a dynamic, monumental building that would not only be a place for music and culture but would also create a focal point for the area." With its distinctive concrete shell roof, in a curved triangular form culminating 60 meters above the plaza surrounding the building, this concert hall is one of the most visually spectacular structures designed by Calatrava. Beyond the basic functions of the project, the hall clearly takes on a symbolic value by the very nature of its appearance, in a way that might recall Jørn Utzon's Sydney Opera House. Located on a 154 x 100-meter rectangular site that has the particularity of including a 60-meter change in levels, the concert hall is set on a stepped platform or plinth that contains technical facilities and changing rooms. As the architect says of the actual concert space, "To fine tune the acoustics, the wood paneling of the interior takes on a crystalline form, which also contributes to the drama of the space. These fittings were determined by investigations on models at 1:10. The placing of sound reflectors was determined by laser tests, which also helped define the dimensions of the vaulted interior. Instead of having stage curtains, the auditorium is provided with a concertina screen of vertical aluminum slats, which upon opening lift up into the auditorium to act as a sound-reflector above the orchestra pit." The roof of the shell of the structure is clad in broken tile, while local volcanic basalt is used for much of the paving and the cladding of the plinth. A 50-meter-high dome covers the main hall, recalling a number of Santiago Calatrava's studies of the human eye and its lid.

Diese 2003 fertig gestellte Konzerthalle mit 1558 Sitzplätzen liegt an der Kreuzung der Avenida Tres de Mayo mit der Avenida Maritima in der Stadt Santa Cruz de Tenerife. Der Bau umfasst außerdem einen Kammermusiksaal mit 428 Plätzen. An dieser Stelle im Hafen wünschte sich die Stadt „ein dynamisches, monumentales Bauwerk, das nicht nur ein Ort für Musik und Kultur sein sollte, sondern auch ein Wahrzeichen für die Gegend". Mit ihrem charakteristischen Betonschalendach, das sich in gebogener Dreiecksform 60 m über die das Gebäude umgebende Plaza aufschwingt, stellt die Konzerthalle in visueller Hinsicht einen der ungewöhnlichsten Bauten Calatravas dar. Über seine Funktionalität hinaus erhält das Projekt allein durch sein Aussehen eine symbolische Wertigkeit, die an Jørn Utzons Opernhaus von Sydney denken lässt. Das 154 x 100 m große, rechteckige Gelände der Konzerthalle weist einen Höhenunterschied von 60 m auf. Die Halle selbst wurde auf einem abgetreppten Sockel errichtet, in dem technische Einrichtungen und Umkleideräume untergebracht sind. Zum eigentlichen Konzertraum sagt der Architekt: „Um die Akustik genau abzustimmen, erhielt die Holzverkleidung des Innenraums eine kristalline Formgebung, die außerdem zur Dramatik des Raumes beiträgt. Über diese Einbauten wurde nach Versuchen mit einem Modell im Maßstab 1:10 entschieden. Die Platzierung von Klangreflektoren wurde durch Lasertests bestimmt, die auch halfen, die Abmessungen des gewölbten Innenraums festzulegen. Anstelle von Bühnenvorhängen ist das Auditorium mit einem Ziehharmonikaschirm aus vertikalen Aluminiumlamellen ausgerüstet, der sich beim Öffnen in das Auditorium hinein erhebt und über dem Orchestergraben als Klangreflektor fungiert." Die Decke der Schalenkonstruktion des Gebäudes ist mit Kachelscherben ausgekleidet, während für einen Großteil der Pflasterung und die Sockelverkleidung heimischer, vulkanischer Basalt verwendet wurde. Der Hauptsaal ist von einer 50 m hohen Kuppel überwölbt, die an einige Studien Calatravas zum menschlichen Auge und Augenlid erinnert.

Achevé en 2003, ce complexe réunissant une salle de concerts de 1558 places et une salle pour musique de chambre de 428 places est situé à l'angle des avenues Tres de Mayo et Maritima à Santa Cruz de Tenerife. Pour ce terrain jouxtant le port, la ville avait exprimé « le désir d'un bâtiment monumental et dynamique qui serait non seulement un lieu destiné à la musique et à la culture mais également un centre d'attraction pour toute cette zone ». Avec son toit extrêmement original en coque de béton dessinant un triangle incurvé et culminant à 60 mètres au-dessus d'une place, cette salle de concerts est l'un des projets les plus spectaculaires de Calatrava. La valeur symbolique et la nature même de cette présence prennent le pas sur les fonctions basiques de l'équipement, comme dans le cas de l'Opéra de Jørn Utzon à Sydney. Construite sur un terrain rectangulaire de 154 x 100 mètres qui a la particularité de présenter une différence de niveaux de 60 mètres, la salle est posée sur un terre-plein, un socle en gradins dont la base contient les équipements techniques et les loges des artistes. Comme l'architecte l'explique, pour la grande salle, « C'est pour des raisons d'acoustique que nous avons donné au lambrissage en bois de l'intérieur ce relief facetté, cristallin, qui contribue également à l'aspect spectaculaire du volume. Ces équipements ont été élaborés à l'aide d'études menées sur des maquettes au 1/10. Les emplacements des réflecteurs sonores ont été déterminés par des tests au laser qui ont également permis de définir les dimensions de la voûte intérieure. Au lieu d'un rideau de scène, l'auditorium est équipé d'un écran de lattes d'aluminium verticales qui s'élève dans les cintres et sert de réflecteur sonore au-dessus de la fosse d'orchestre. » La coque est revêtue de tesselles de carrelage et un basalte local a été retenu pour le pavage de la plupart des sols et l'habillage du socle. La coupole de 50 mètres de haut qui couvre l'entrée principale rappelle un certain nombre d'études de Santiago Calatrava sur l'œil et la paupière.

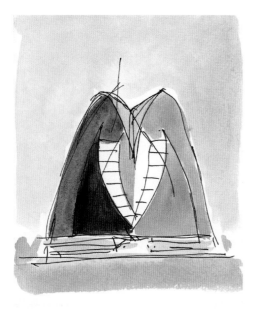

On an unprecedented scale in his oeuvre, the Tenerife building carries some of Calatrava's familiar preoccupations to new heights. An eye, or perhaps even forms inspired by female anatomy, inform the architecture without becoming explicit.

In einem Ausmaß, das in Calatravas Oeuvre beispiellos ist, steigert das Opernhaus von Teneriffa einige seiner bekannten Lieblingsmotiven zu neuen Höhen. Ein Auge oder vielleicht sogar von der weiblichen Anatomie inspirierte Formen beseelen die Architektur, ohne jedoch deutlich zu werden.

D'une échelle sans précédent dans son œuvre, le projet de Tenerife illustre certaines des préoccupations familières de Calatrava, poussées ici vers de nouveaux sommets. Un œil, ou peut-être des formes inspirées de l'anatomie féminine, sont présents sans être pour autant évidents.

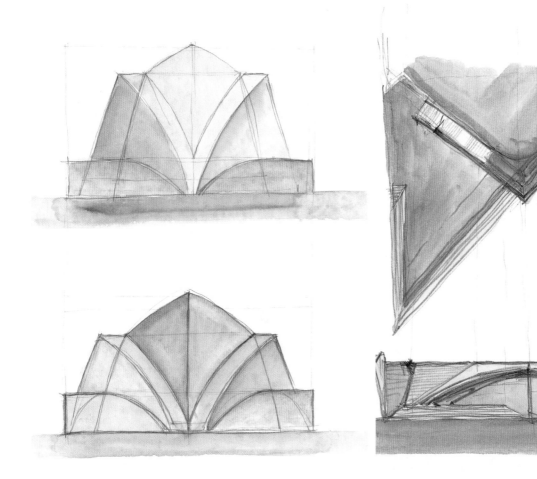

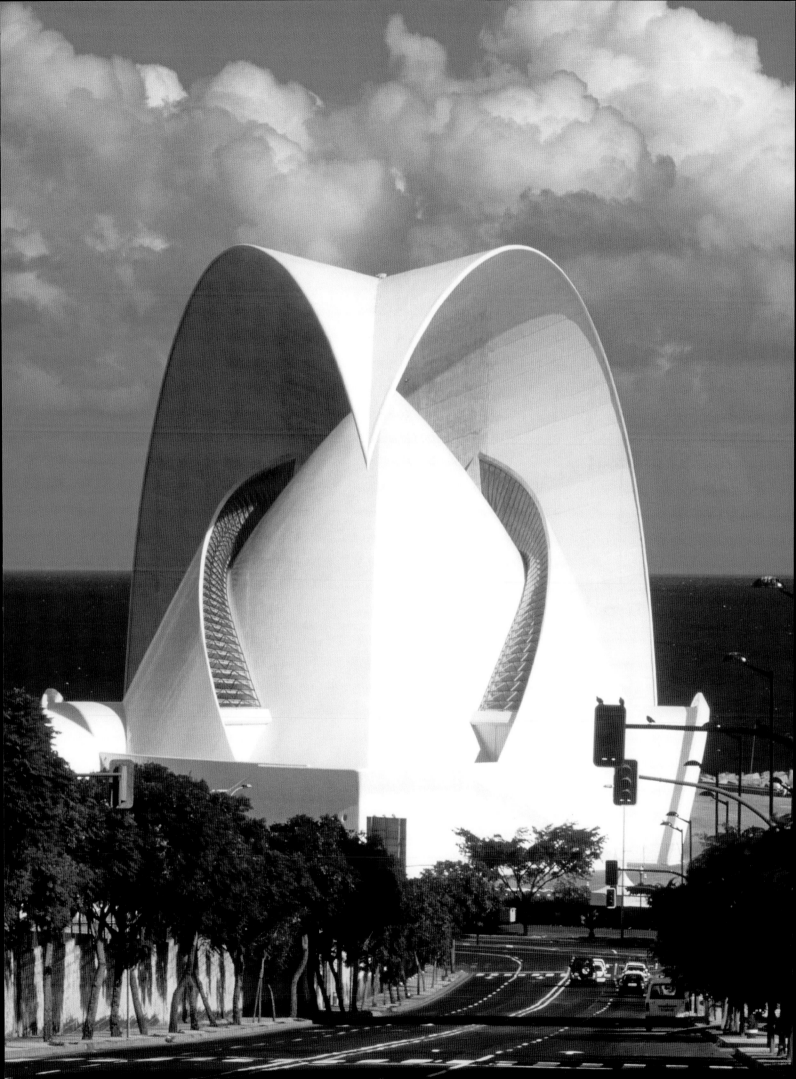

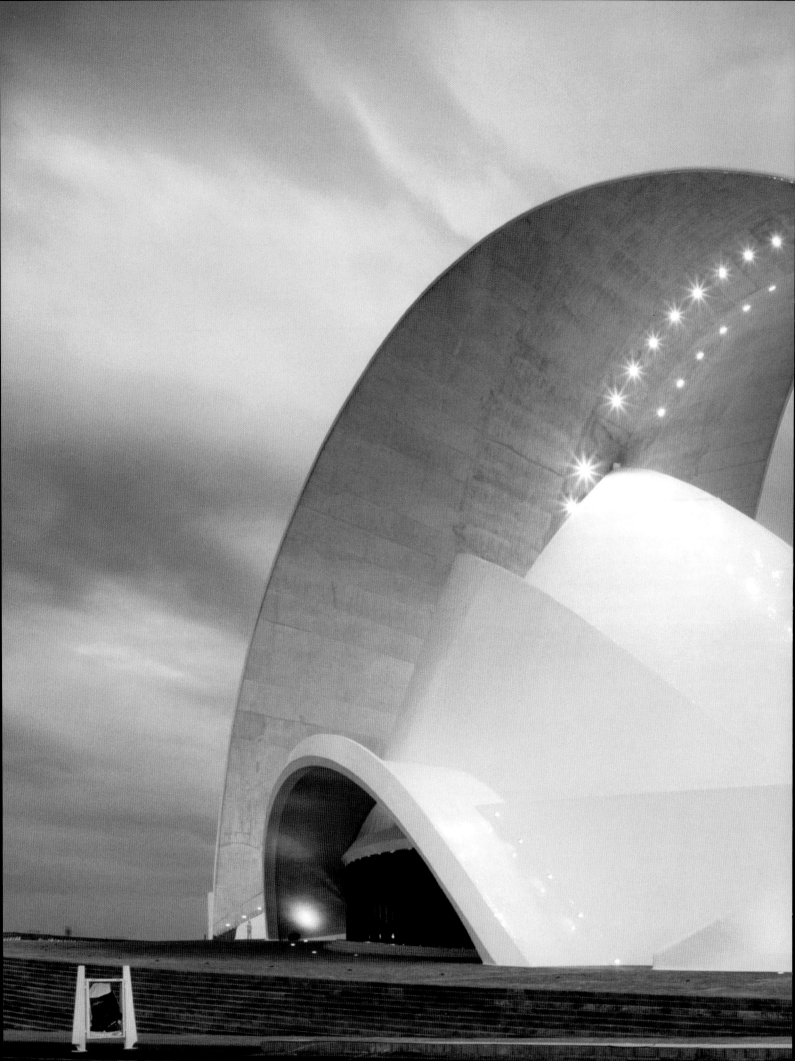

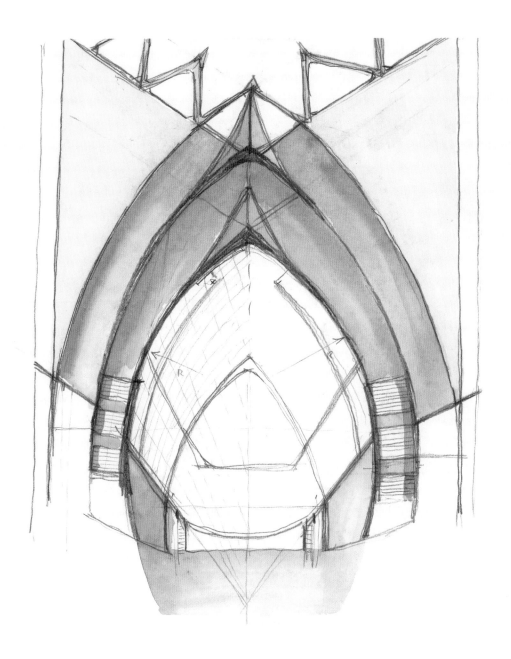

As is most usually the case, Calatrava's relatively simple sketches outline both the final form of the building and its essential structural reality. This sort of combination of aesthetics and the hard facts of engineering and construction is almost unique in contemporary architecture.

Wie beinahe immer geben Calatravas eher simple Skizzen sowohl die endgültige Form des Bauwerks als auch seine wesentliche konstruktive Realität wieder. Diese Kombination aus Ästhetik und den harten technischen und baulichen Fakten ist in der zeitgenössischen Architektur fast ohne Beispiel.

Comme très souvent, les croquis relativement simples de Calatrava font ressortir à la fois la forme finale du projet et sa réalité structurelle essentielle. Cette façon de conjuguer l'esthétique et avec l'aspect pratique et technique de la construction est quasi unique dans l'architecture contemporaine.

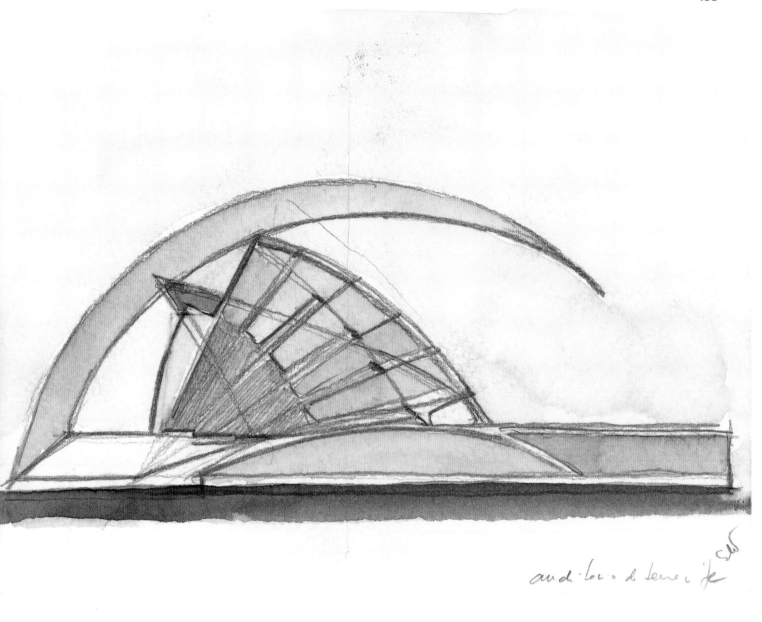

auditorio de tenerife

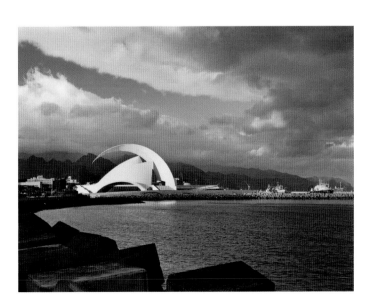

Interior volumes are in complete harmony with the exterior shapes of the building as can be seen in this confrontation of images. Light and shadow animate the forms in ways that are also part of Calatrava's thought process.

Wie man an dieser Gegenüberstellung von Bildern sieht, harmonieren die Innenräume aufs Beste mit den äußeren Formen des Gebäudes. Licht und Schatten beleben die Formen in einer Weise, die auch Teil von Calatravas Überlegungen ist.

Les volumes internes sont en complète harmonie avec les formes extérieures, comme le montre cette confrontation d'images. L'ombre et la lumière animent les formes dans une approche spécifique qui fait partie du processus de pensée de Calatrava.

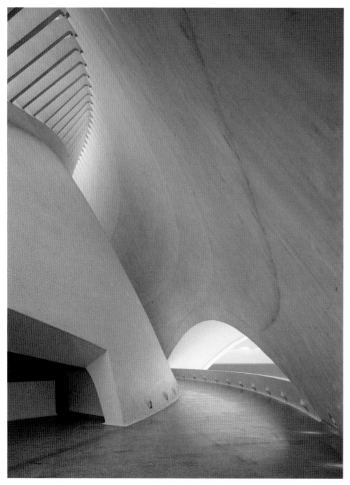

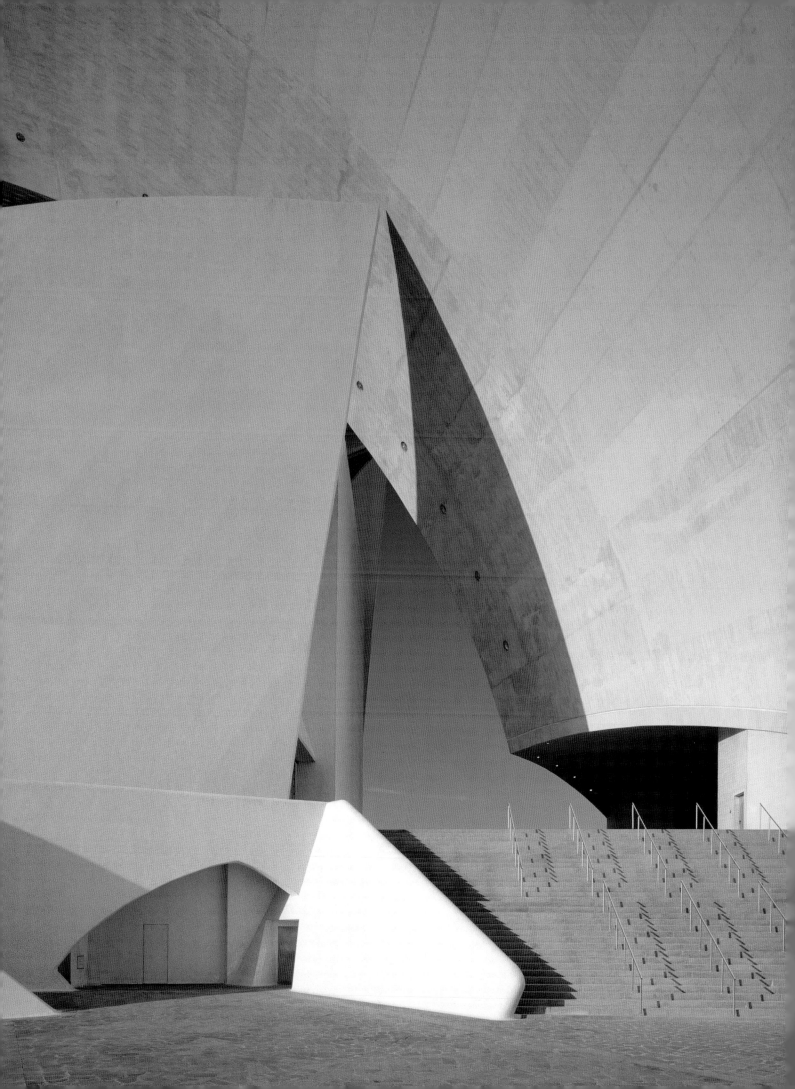

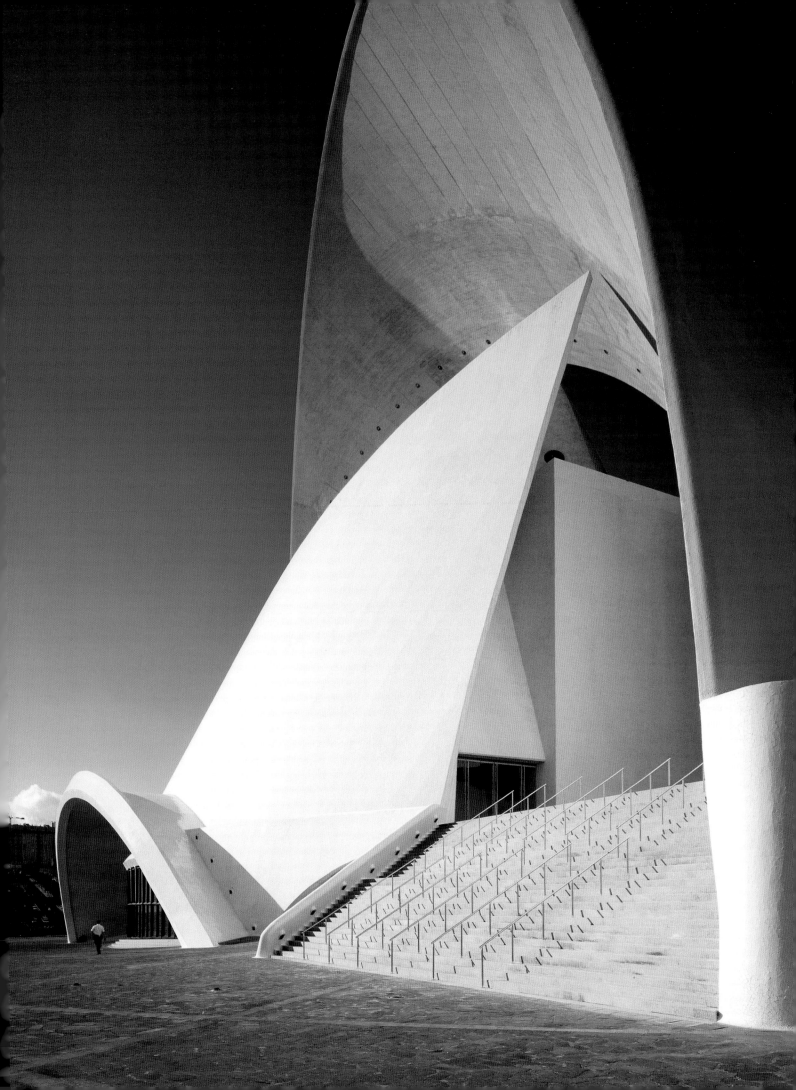

The challenge in this instance may well be to generate usable and indeed astonishing interior spaces given the overtly sculptural nature of the exterior design. A theater of course does not pose the same problems as a museum, and here the architect gives free rein to his imagination.

Angesichts des skulpturalen Charakters des Außenbaus könnte die Herausforderung in diesem Fall darin bestanden haben, nutzbare und wirklich überraschende Innenräume zu schaffen. Naturgemäß stellen sich bei einem Theater nicht dieselben Probleme wie bei einem Museum, und hier lässt der Architekt seiner Fantasie freien Lauf.

Le défi était peut-être ici de créer des espaces intérieurs pratiques mais étonnants, en relation avec la nature ouvertement sculpturale de l'extérieur. Un théâtre ne pose pas les mêmes problèmes qu'un musée et l'architecte a pu laisser libre cours à son imagination.

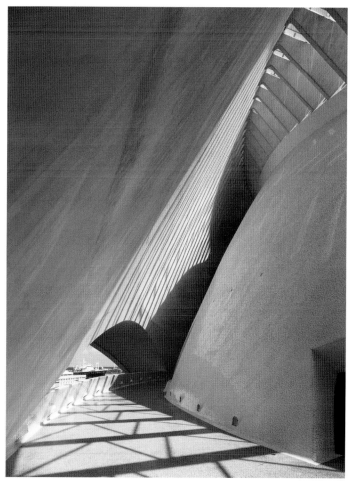
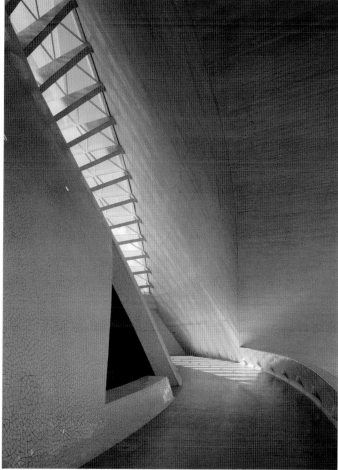

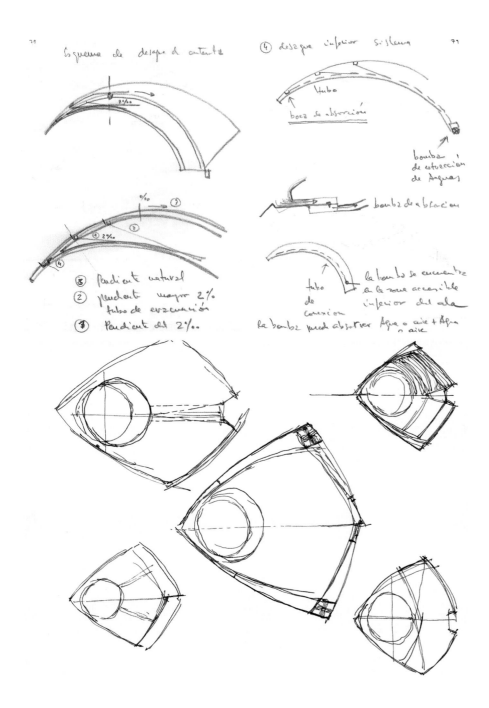

Night lighting completes the dramatic presence of the building, while the sketches above hint at inspiration from natural forms that might include a ray, a shape also seen in the Lyon-Saint Exupéry Airport Railway Station.

Die nächtliche Beleuchtung vervollkommnet die spektakuläre Präsenz des Gebäudes, die Skizzen oben hingegen lassen an natürliche Formen denken; ähnlich wie für den Bahnhof Saint Exupéry in Lyon käme auch hier ein Rochen in Frage.

L'éclairage nocturne affirme la présence spectaculaire du bâtiment. Les croquis ci-dessus montrent une inspiration tirée de formes naturelles comme celle de la raie, déjà repérable dans la gare de Lyon-Saint Exupéry.

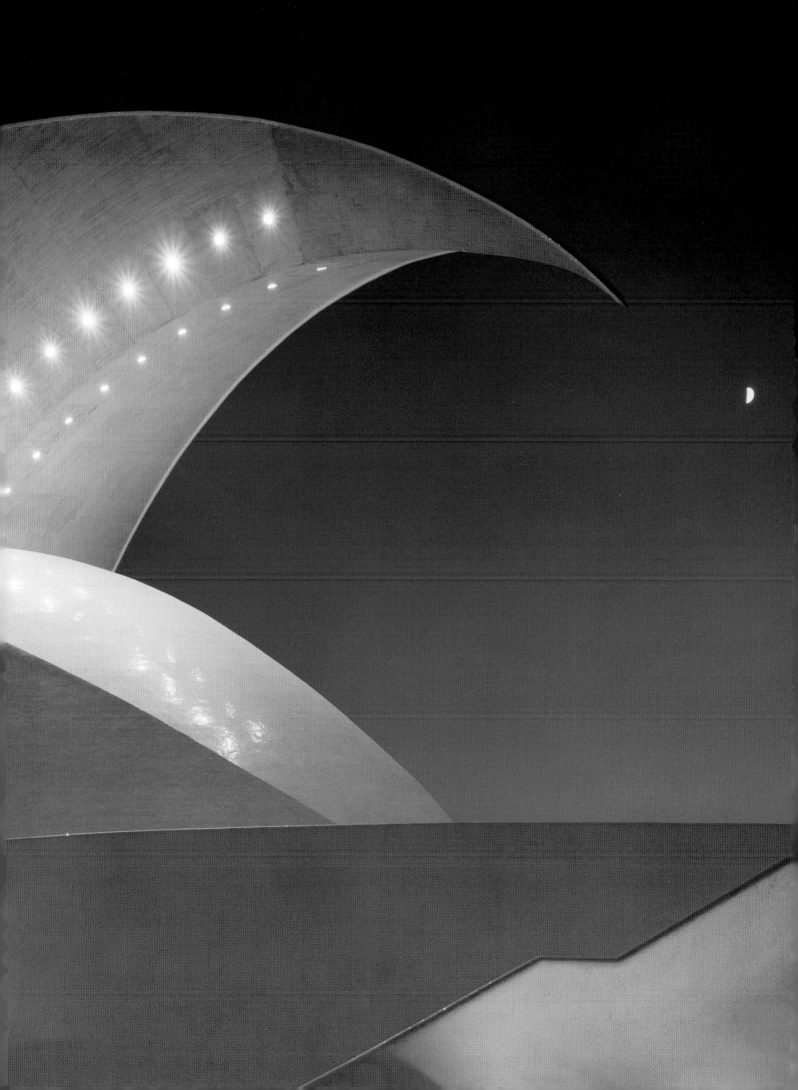

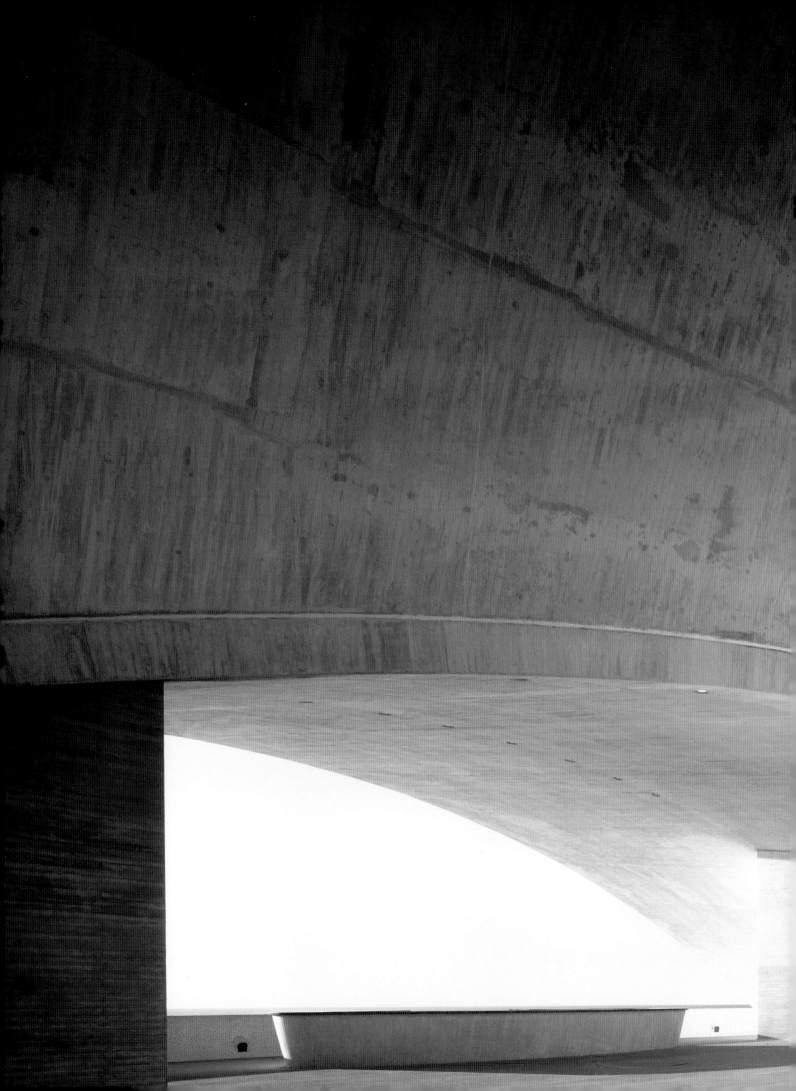

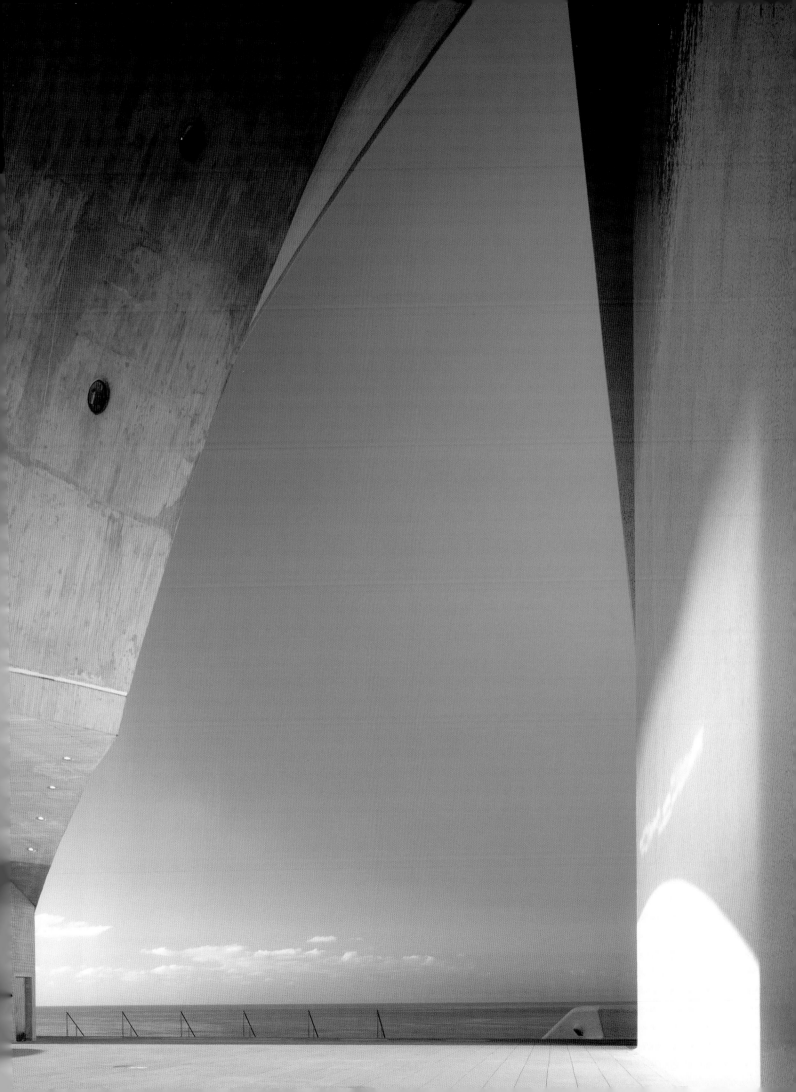

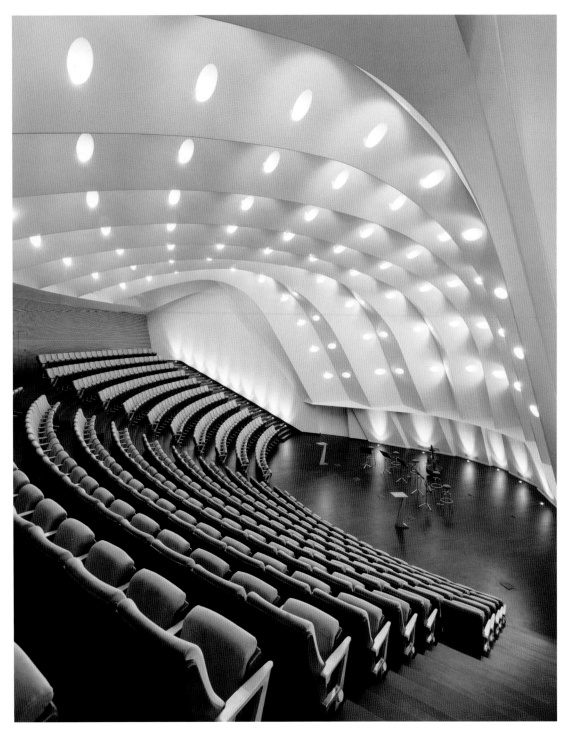

Dealing here with both acoustics and aesthetics, the radiating sunlike form seen in the auditorium to the right confirms that the natural world is a source of inspiration as it is for the exterior forms. There is an almost mystical power in this architecture, criticized by some for its apparent extravagance.

Die einer strahlenden Sonne ähnelnde Form im Inneren des Auditoriums (rechts) wird ästhetischen und akustischen Anforderungen gerecht und bestätigt, dass die Natur nicht nur Inspirationsquelle für die Außengestaltung ist. Die von einigen wegen ihrer offenkundigen Extravaganz gescholtene Architektur Calatravas verfügt über eine fast mystische Kraft.

Liée à l'acoustique et à l'esthétique, la forme de l'auditorium, semblable à un soleil rayonnant (à droite), confirme que le monde naturel est une source d'inspiration à l'intérieur comme à l'extérieur du bâtiment. Cette architecture, critiquée par certains pour son apparente extravagance, dégage une puissance quasi mystique.

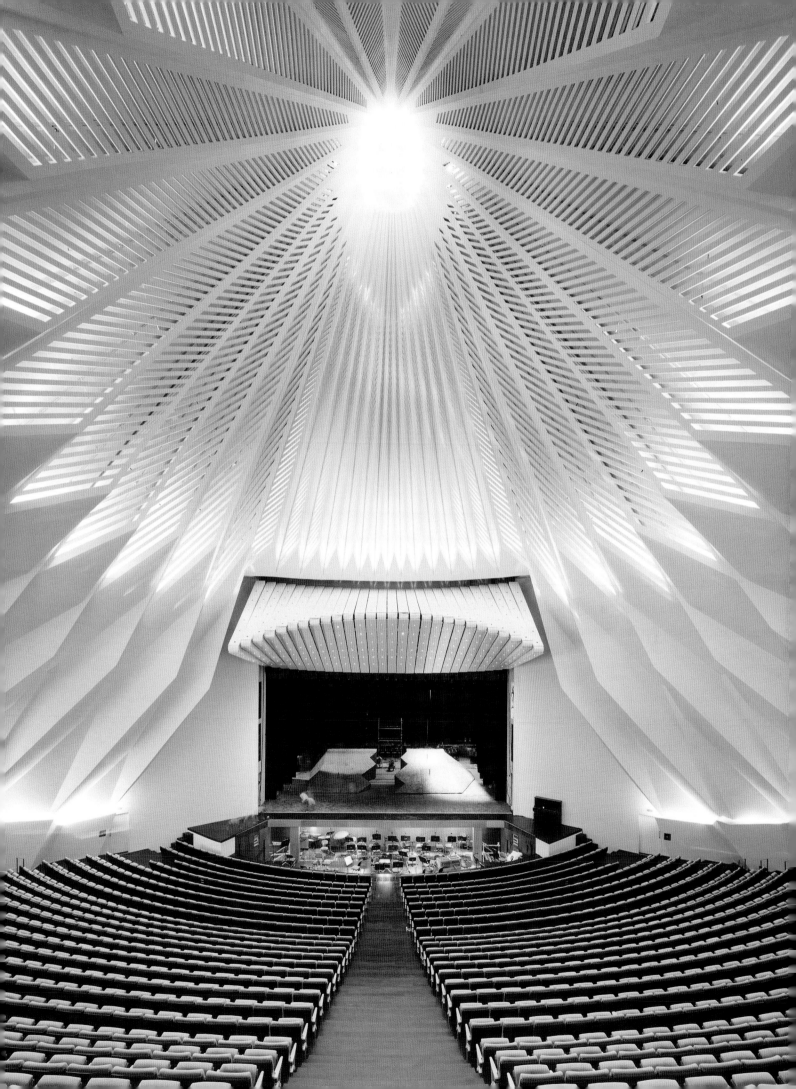

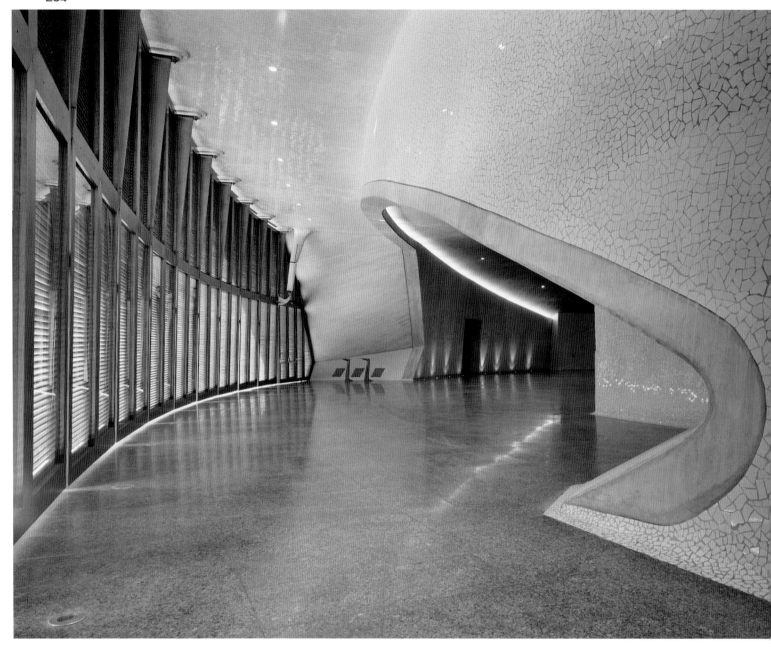

Sweeping curves, large openings, and care-
fully calculated lighting characterize these
interior views, where anthropomorphic inspi-
ration seems present without delving into
overt imitation or quotation.

Diese Innenansichten, in denen anthropo-
morphe Einflüsse präsent scheinen, ohne in
offenkundige Nachahmung oder Anführung
zu verfallen, sind geprägt von schwungvol-
len Linien, großen Öffnungen und sorgfältig
geplanter Beleuchtung.

Des courbes généreuses, de vastes ouver-
tures et un éclairage soigneusement calculé
caractérisent ces vues de l'intérieur. L'inspi-
ration anthropomorphique semble présente
sans tomber dans l'imitation ni la citation.

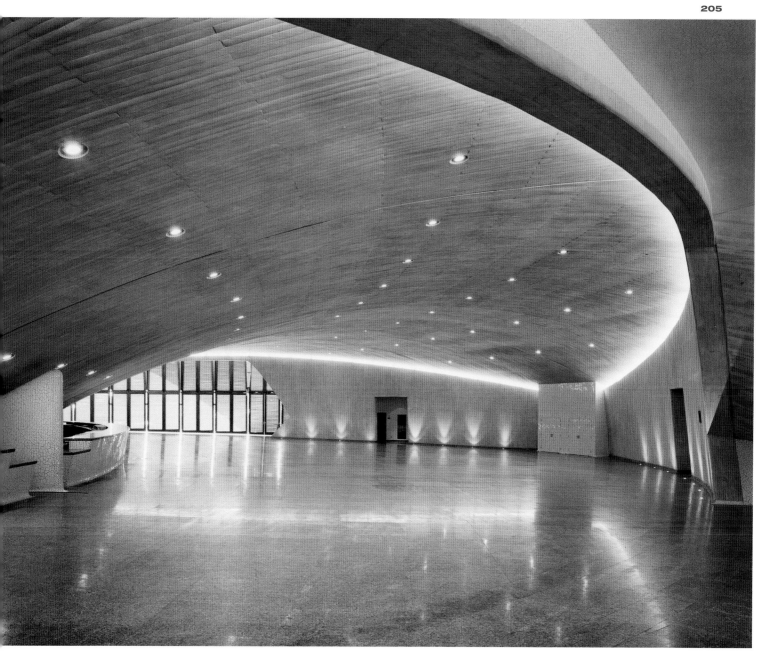

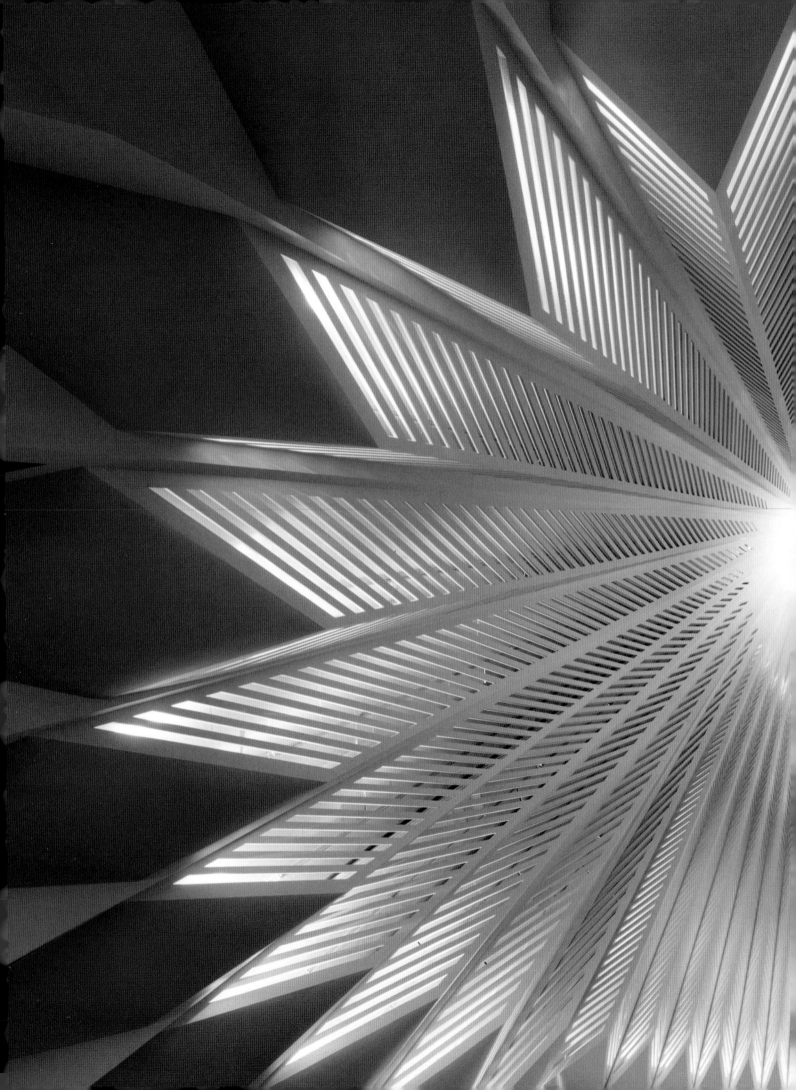

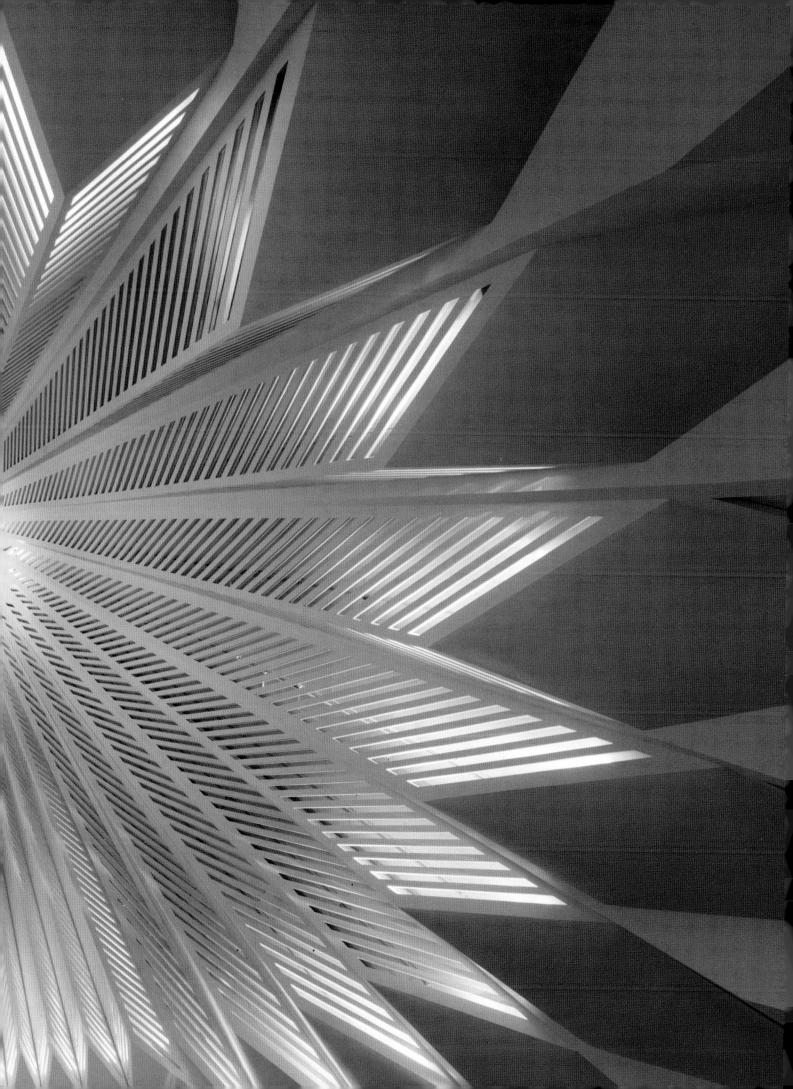

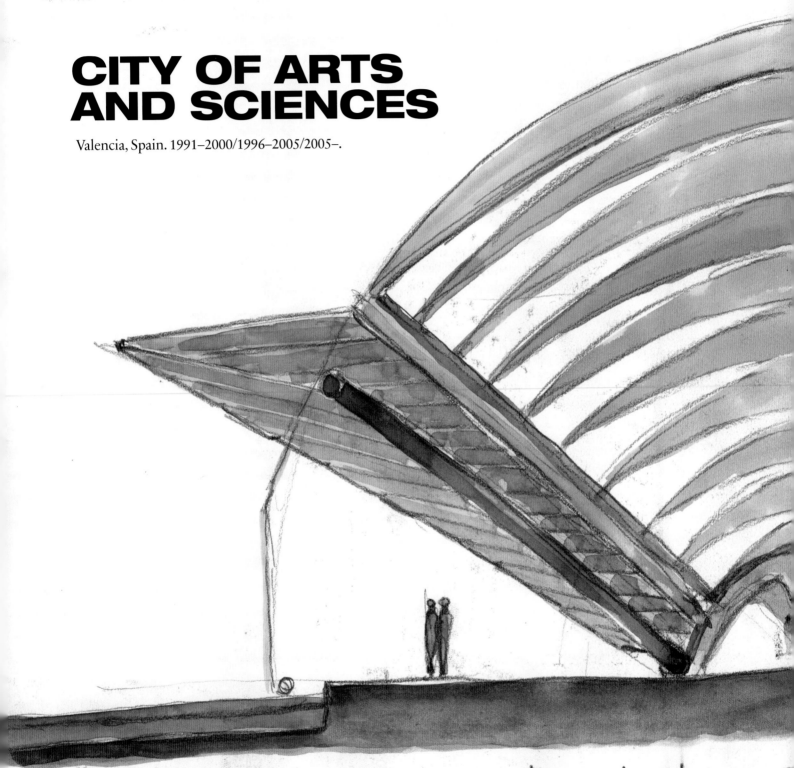

Sección transversal
con la cancela abierta

CITY OF ARTS
AND SCIENCES

Valencia, Spain. 1991–2000/1996–2005/2005–.

sección transversal con una parte abierta y la otra cerrada
se observa que el estanque ha sido introducido hacia
interior a modo que la cancela en posición cerrada queda
inaccesible desde el interior y desde el exterior
por causa del agua

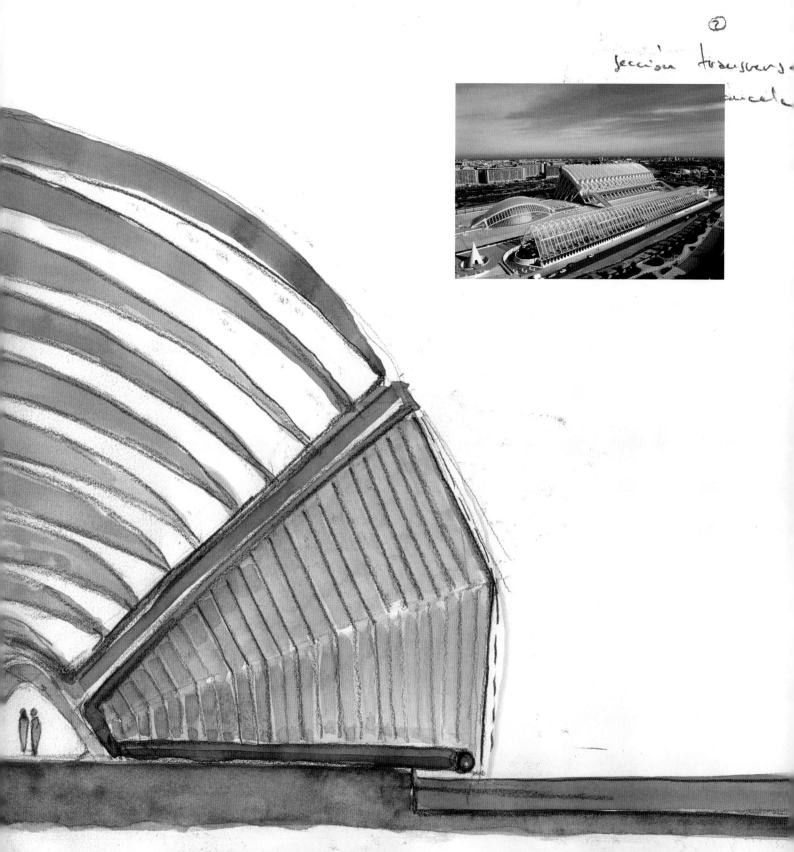

Cuando la cancela esta en posición cerrada la envolvente de
angulos exteriores es un circulo en cada sección, que c...
...ponde a la sección. de toda la cascara por un p...
vertical perpendicular al eje longitudinal del edifi...

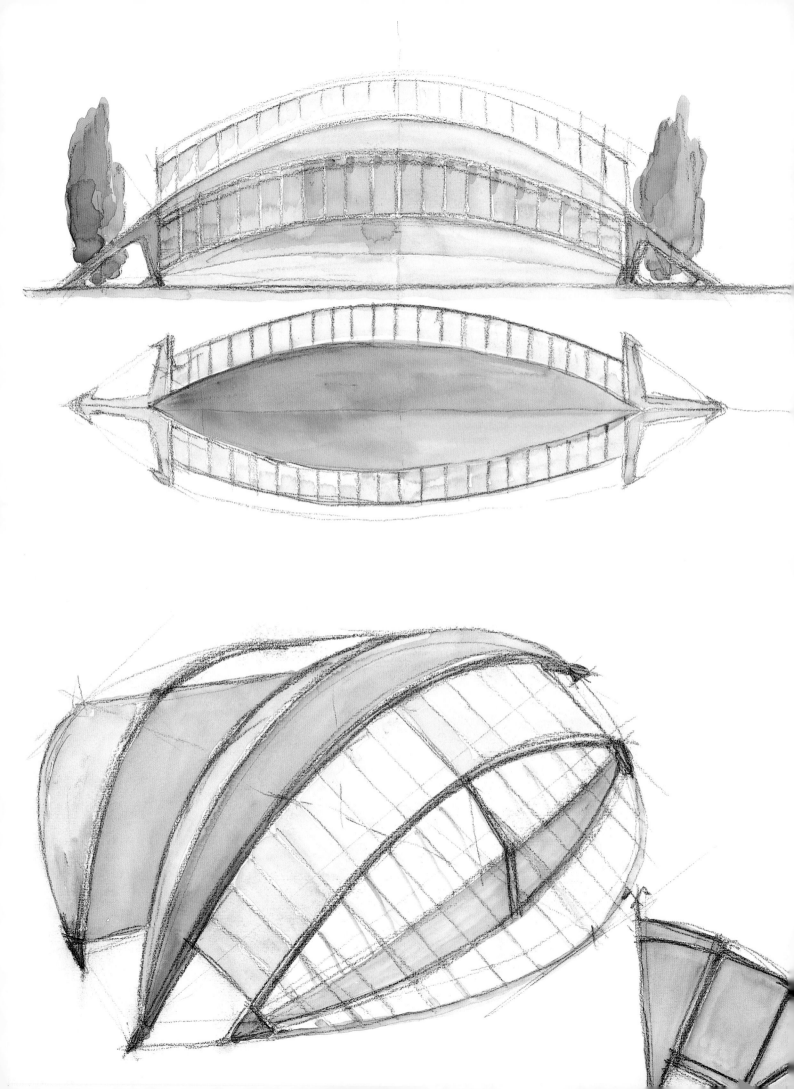

Project
PLANETARIUM, SCIENCE MUSEUM, AND L'UMBRACLE

Location
VALENCIA, SPAIN

Client
GENERALITAT VALENCIANA, CITY OF ARTS AND SCIENCES S. A.

Though the metaphor of an eye—the architect's eye—is frequently present in the work of Calatrava, these sketches show the particular attention he pays to the actual realization of such forms on a large scale, a more complex task than it might seem at first glance.

Obgleich die Metapher des Auges – das des Architekten – im Werk Calatravas häufig vorkommt, belegen diese Skizzen die besondere Aufmerksamkeit, die er der tatsächlichen Umsetzung solcher Formen in großem Maßstab widmet, eine komplexere Aufgabe, als es auf den ersten Blick scheint.

Bien que la métaphore de l'œil – celui de l'architecte – soit fréquente dans l'œuvre de Calatrava, ces croquis montrent l'attention particulière qu'il porte à la réalisation concrète de ces formes à grande échelle, tâche beaucoup plus complexe qu'il pourrait sembler au premier abord.

Part of a long-standing effort on the part of the government of Valencia to rehabilitate a 35-hectare area at the eastern periphery of the city, lodged between a large highway and the Turia River, Calatrava's City of Arts and Sciences took more than 10 years to be completed. A native of Valencia, he won a 1991 competition for the project that included a telecommunications tower sitting on three elongated feet. This tower would have been the most visible element of the complex, rising to a height of 327 meters. A change in city government led to a replacement of the tower in 1996 by a music center, the Palau de les Arts, or Opera House, completed by Calatrava in 2006. The planetarium, an IMAX theater, with its elliptical, or rather eye-shaped plan and hemispheric dome with movable ribbed covering and an area of almost 2600 square meters, was built between 1995 and 1998. As Calatrava's sketches for this structure show clearly, he was inspired by the shape of an eye for the design. Indeed the eye (of the architect) is a frequent theme in his work. The 241-meter-long, 41 530-square-meter Príncipe Felipe Science Museum is based on an asymmetrical repetition of tree and riblike forms filled with glass to admit ample daylight. A structure known as L'Umbracle is a promenade and parking garage, built within an open arcade that is intended as "a contemporary reinvention of the winter garden." With its spectacular domed Planetarium this complex is visually arresting, but for reasons independent of the architect's design, detailing of the project was not handled as skillfully as it might have been. The Opera House completed this ambitious composition.

Bis zur Fertigstellung von Calatravas Ciudad de las Ciencias sollten mehr als zehn Jahre vergehen; sie ist Teil des langjährigen Bemühens der Stadtregierung von Valencia, ein 35 ha großes Gebiet am Ostrand der Stadt zu sanieren, das eingezwängt zwischen einer vielbefahrenen Straße und dem Fluss Turia liegt. Der nahe Valencia geborene Calatrava konnte einen 1991 ausgeschriebenen Wettbewerb für das Projekt, zu dem ein auf drei hoch aufragenden Stützen stehender Fernmeldeturm gehörte, für sich entscheiden. Dieser 327 m hohe Turm wäre das auffälligste Element des Komplexes gewesen. Ein Wechsel in der Stadtregierung führte 1996 zu einem Austausch des Turmes gegen ein Musikzentrum, den 2006 von Calatrava fertig gestellten Palau de les Arts. Zwischen 1995 und 1998 entstanden das Planetarium und ein IMAX-Kino mit elliptischem oder besser augenförmigem

Grundriss, einer Halbkuppel mit beweglicher Rippenabdeckung und einer nahezu 2600 m² großen Fläche. Wie Calatravas Skizzen für dieses Gebäude deutlich zeigen, bezog er die Anregung für diesen Entwurf unmittelbar von der Form des Auges. Tatsächlich wird das Auge (des Architekten) in seinem Werk häufig thematisiert. Das 241 m lange, 41 530 m² umfassende Wissenschaftsmuseum Príncipe Felipe fußt auf der asymmetrischen Wiederholung baum- und rippenartiger Formen, die mit Glas ausgefacht wurden, um reichlich Tageslicht einfallen zu lassen. Dieser Komplex mit dem markanten überkuppelten Planetarium fällt ins Auge, wenngleich aus Gründen, für die der Architekt nicht verantwortlich zeichnet, da die bauliche Durchbildung des Projekts nicht so geschickt wie eigentlich möglich umgesetzt wurde. Der Palau de les Arts (Opernhaus) komplettiert dieses ehrgeizige Projekt.

Dans le cadre d'un programme à long terme mené par la municipalité de Valence pour la réhabilitation d'une zone de trente-cinq hectares en périphérie orientale de la ville, entre une autoroute et le fleuve Turia, le chantier de la Cité des sciences conçue par Calatrava aura duré dix ans. Né à Valence, l'architecte avait remporté, en 1991, le concours pour ce projet qui comprenait également une tour de télécommunications reposant sur trois longs pieds. Cette tour de 327 mètres en aurait été l'élément le plus visible. Un changement de municipalité a conduit, en 1996, au remplacement de la tour par une Cité de la musique, le Palau de les Arts, achevé en 2006. Le planétarium et la salle IMAX de plan elliptique dotée d'une coupole hémisphérique mobile (de 2600 mètres carrés) à couverture nervurée ont été construits entre 1995 et 1998. Comme le montrent clairement ses croquis préparatoires, Santiago Calatrava s'est directement inspiré de la forme d'un œil, thème récurrent dans son œuvre. Le Musée des sciences Príncipe Felipe se déploie sur 241 mètres de long pour une surface de 41 530 mètres carrés et utilise la répétition asymétrique de formes de nervures et « d'arbres » largement vitrées. La construction appelée « l'Umbracle » consiste en une promenade et un parking aménagés à l'intérieur d'une galerie en arcade ouverte qui est « une relecture contemporaine du jardin d'hiver ». Avec son planétarium au dôme spectaculaire, ce complexe est visuellement très surprenant, mais pour des raisons indépendantes du projet fourni par l'architecte, sa mise en œuvre n'a pas été aussi habile qu'elle aurait dû l'être. Le Palau de les Arts (l'Opéra) a parachevé cette ambitieuse composition.

El planetario de la ciudad de las ciencias
Valencia

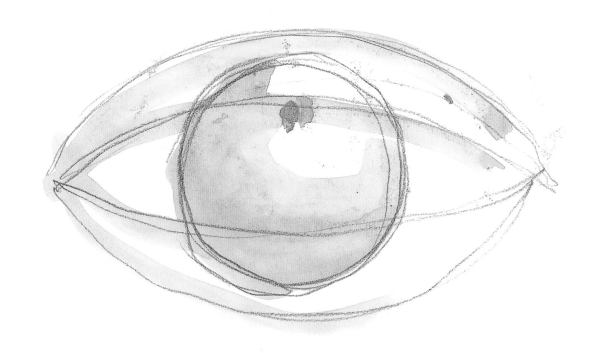

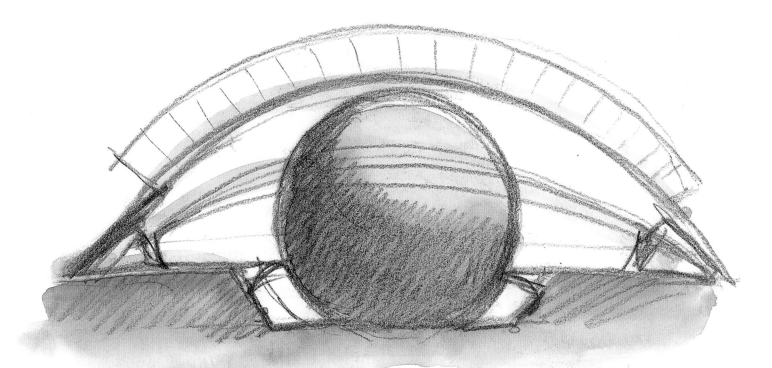

ida del ojo para lo interiorcion del mundo
visión interna ida de proyección hacia el interior

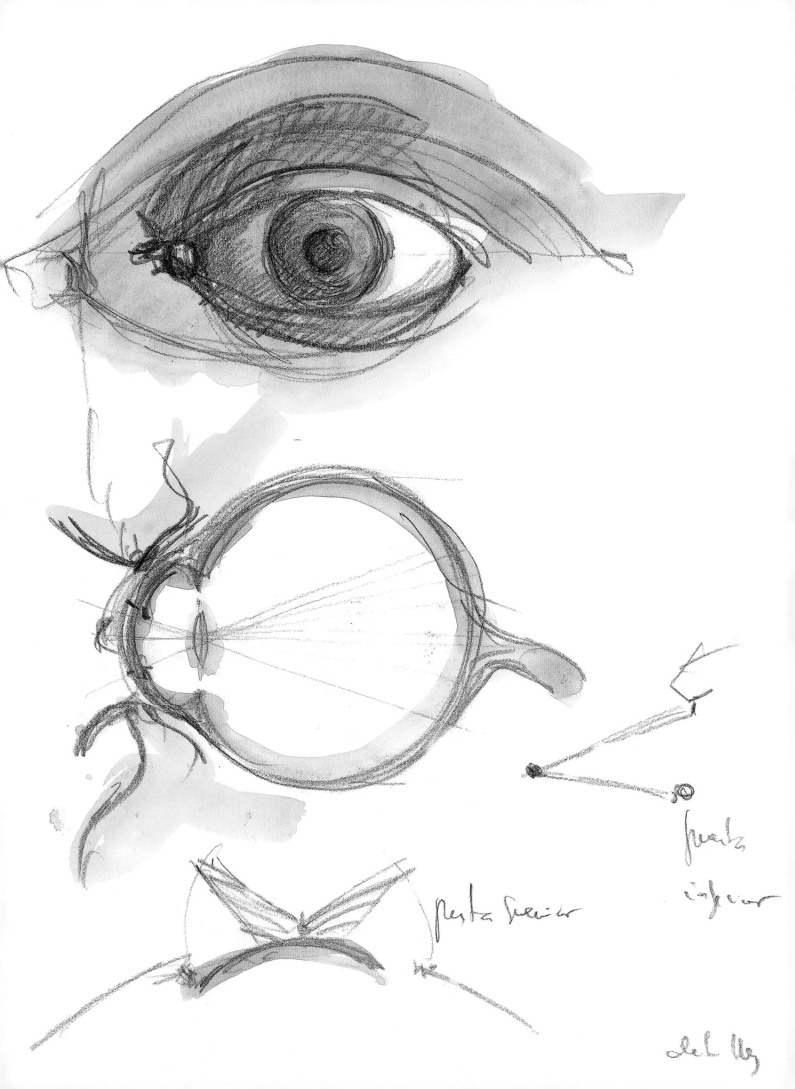

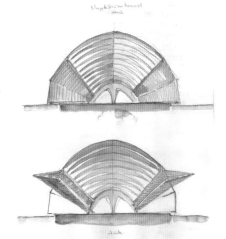

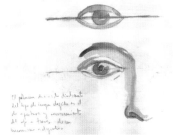

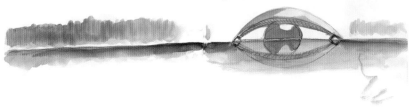

The Planetarium of the Valencia City of Sciences may be Calatrava's most explicit reference to the human eye, and his sketches for the project make this link clear. The moveable sunshade on the structure further heightens this expression of his fascination with vision.

Das Planetarium der Ciudad de las Sciencias in Valencia könnte Calatravas eindeutigster Verweis auf das menschliche Auge sein, und die Skizzen für dieses Projekt verdeutlichen diese Beziehung. Wie sehr er vom Sehen fasziniert ist, wird von den beweglichen Sonnenblenden noch unterstrichen.

Le planétarium de la Cité des sciences de Valence est peut-être la référence la plus explicite de Calatrava à l'œil humain, comme le montrent clairement ses croquis. L'auvent mobile renforce cette expression de sa fascination pour la vision.

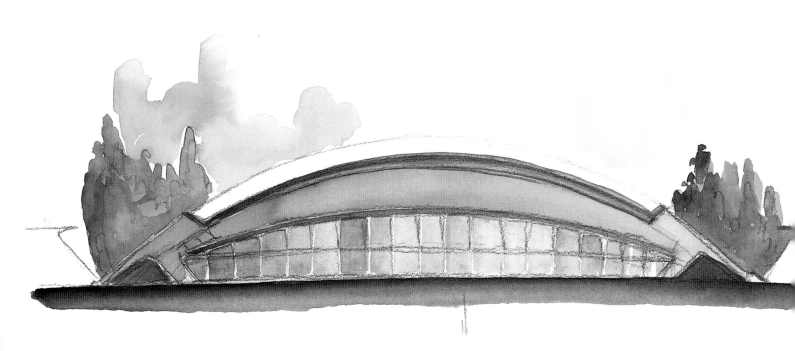

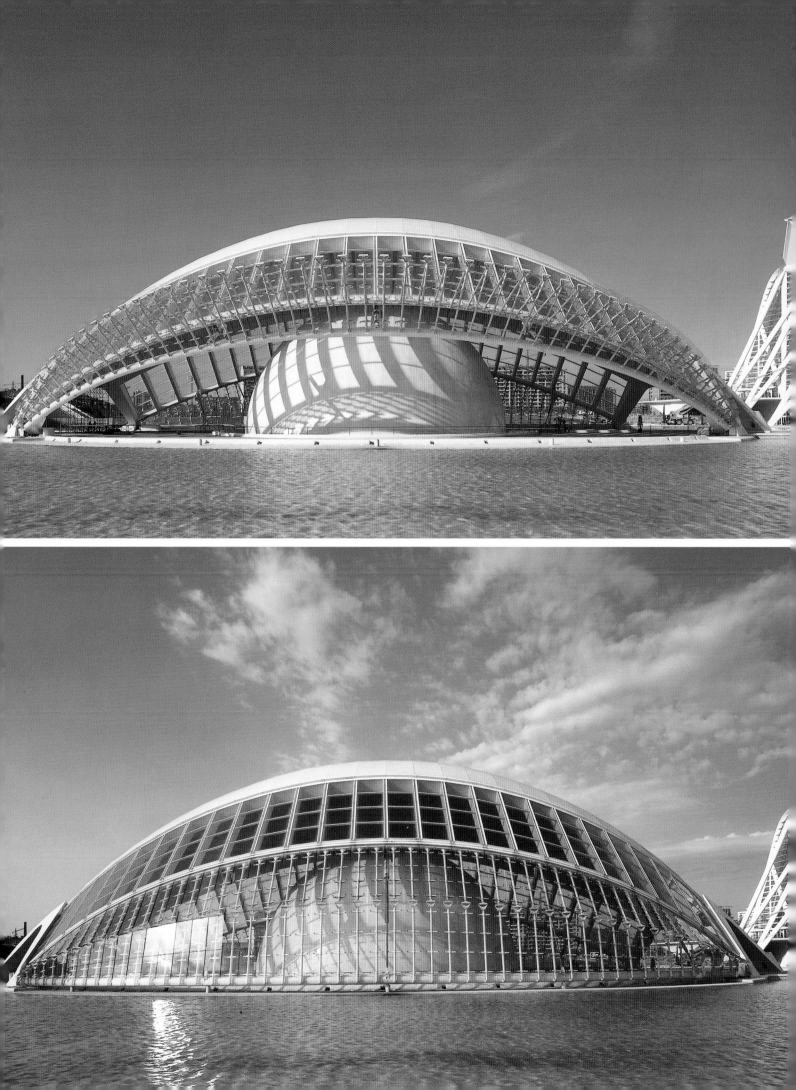

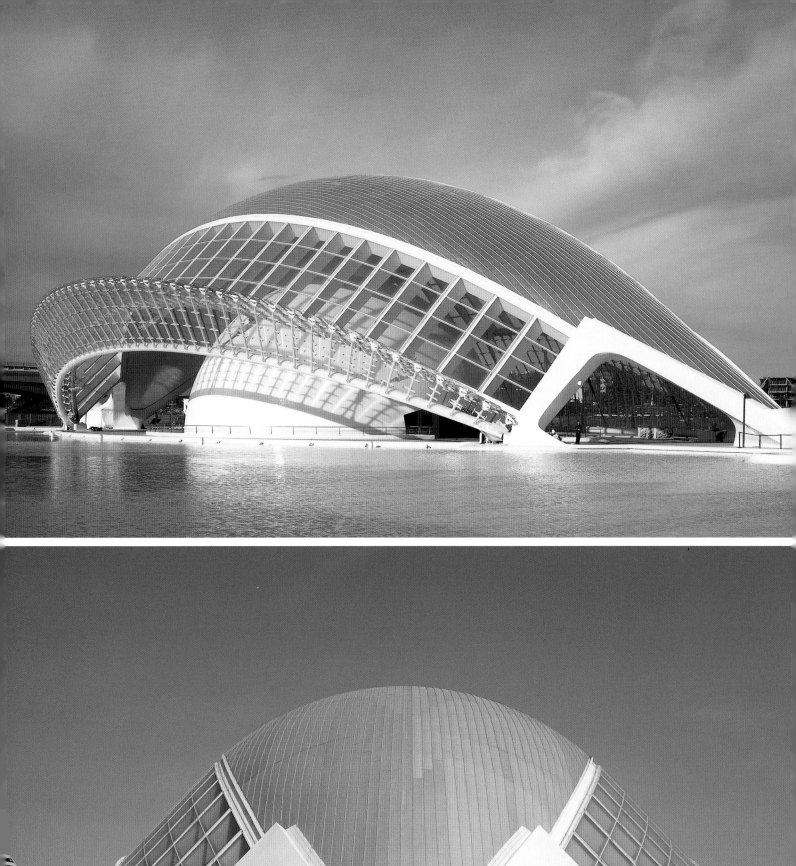
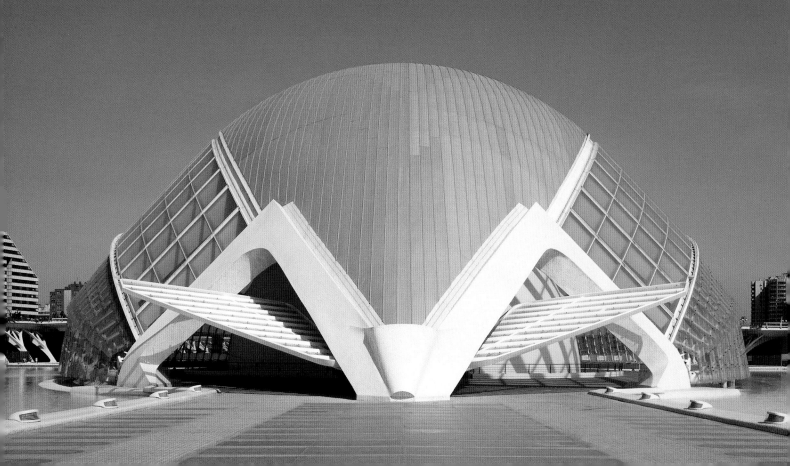

The swooping anchor of the structure may bring to mind that of the Lyon-Saint Exupéry Airport Railway Station, but here there is a fundamental symmetry that is not part of the French design.

Die abgesenkte Spitze des Gebäudes könnte an den Bahnhof am Flughafen Saint Exupéry erinnern, aber hier herrscht eine grundsätzliche Symmetrie, die nicht Teil des französischen Projekts ist.

L'ancrage rabattu de la structure peut rappeler la gare de Lyon-Saint Exupéry, mais traitée ici dans une symétrie qui n'existe pas dans le projet français.

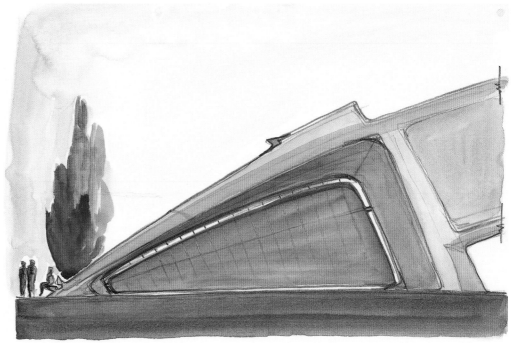

Fuente de la plaza de Alcoy

[handwritten notes in Spanish]

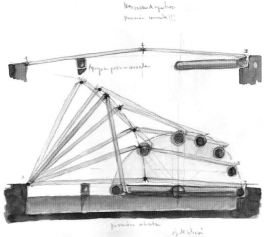

[handwritten notes in Spanish]

plantas y sección

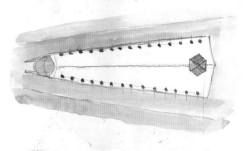

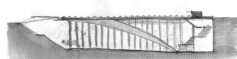

[handwritten notes in Spanish]

[handwritten notes in Spanish]

Calatrava frequently draws human figures in his designs, underlining both his own analysis of proportions and the relation of the human body to the architecture.

Calatrava zeichnet häufig menschliche Figuren auf seine Entwürfe und unterstreicht damit seine eigene Analyse der Proportionen sowie den Bezug des menschlichen Körpers zur Architektur.

Calatrava dessine fréquemment des silhouettes humaines dans ses projets pour éclairer à la fois son analyse des proportions et la relation entre le corps humain et l'architecture.

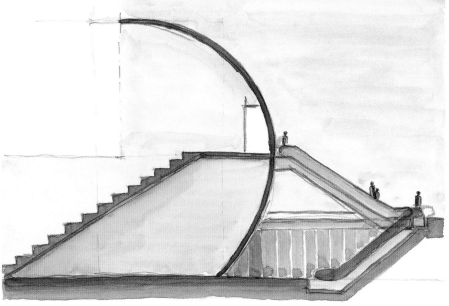

Calatrava's drawings for this project, in particular the one in the middle (left) bring to mind those of Étienne-Louis Boullée for Newton's Cenotaph.

Calatravas Zeichnungen zu diesem Projekt, insbesondere die in der Mitte links rufen die Étienne-Louis Boullées für Newtons Kenotaph in Erinnerung.

Les dessins de Calatrava pour ce projet, en particulier celui du centre (à gauche), font penser à ceux d'Étienne-Louis Boullée pour le cénotaphe de Newton.

The half sphere necessary for the projection of IMAX movies is the kind of geometric form that stimulates the imagination of Calatrava; it represents the human eye, but also the spheres of the cosmos.

Die für das Vorführen von IMAX-Filmen nötige Halbkugel ist die Art geometrischer Form, die Calatravas Fantasie anregt; sie stellt das menschliche Auge, aber auch die Himmelskörper dar.

La demi-sphère nécessaire à la projection des films au format Imax est le type de forme géométrique qui stimule l'imagination de l'architecte. Elle représente l'œil humain mais aussi les sphères du cosmos.

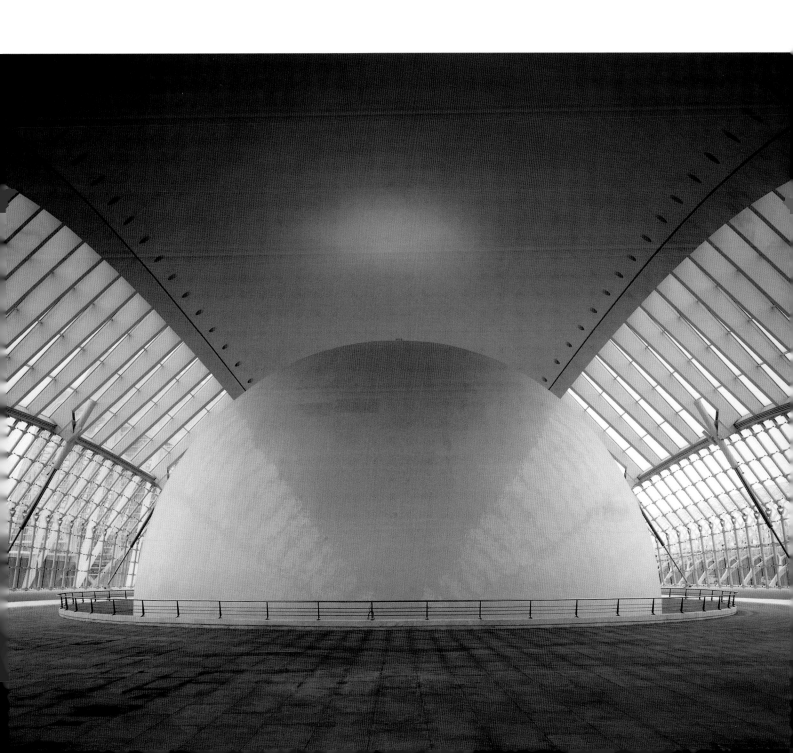

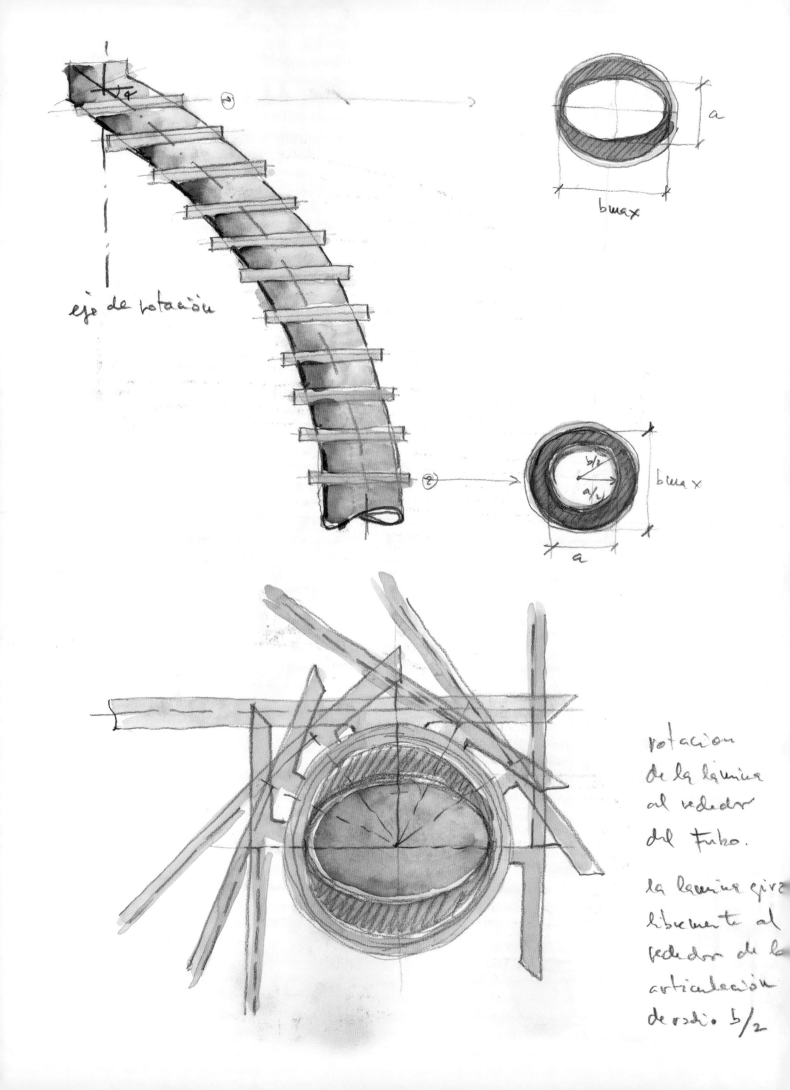

eje de rotación

b_{max}

a

$b/2$

$a/2$

b_{max}

a

rotación
de la lámina
al rededor
del tubo.

la lámina gira
libremente al
rededor de la
articulación
de radio $b/2$

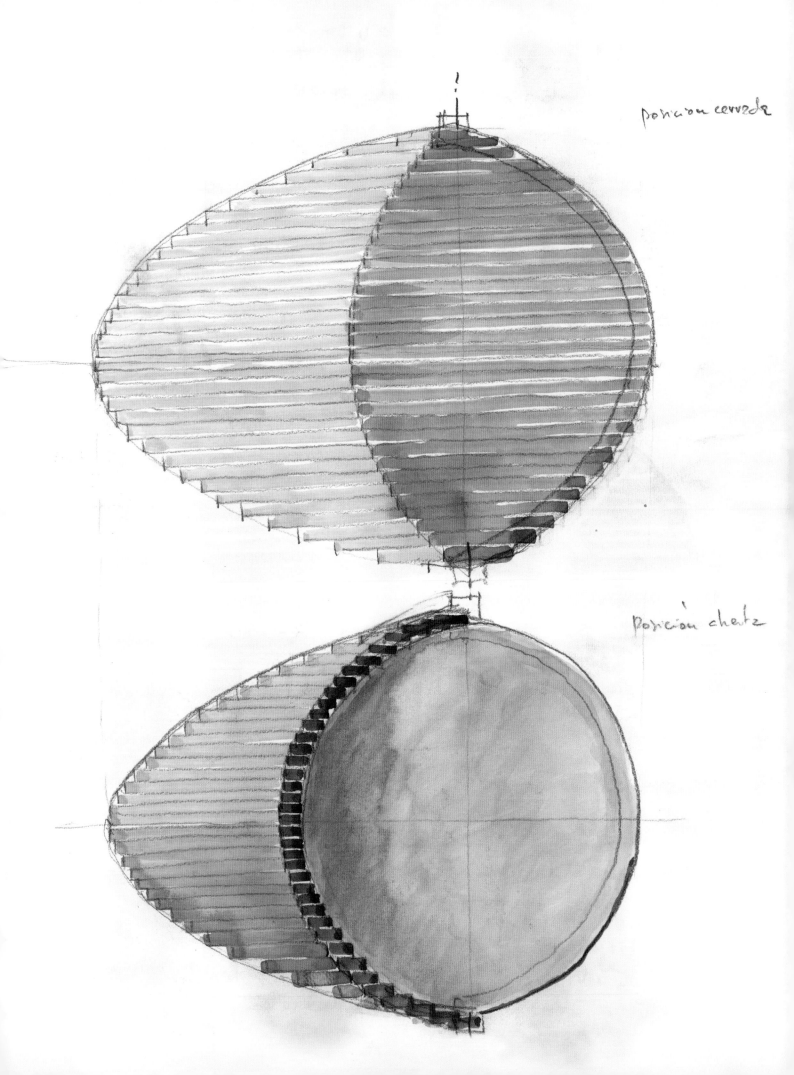

posición cerrada

posición abierta

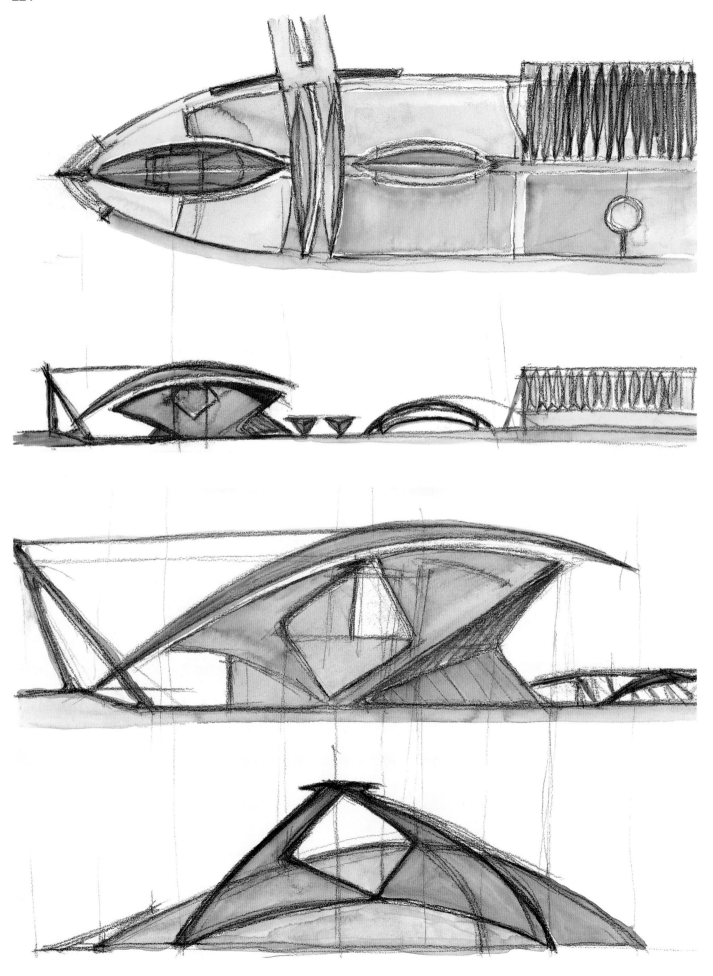

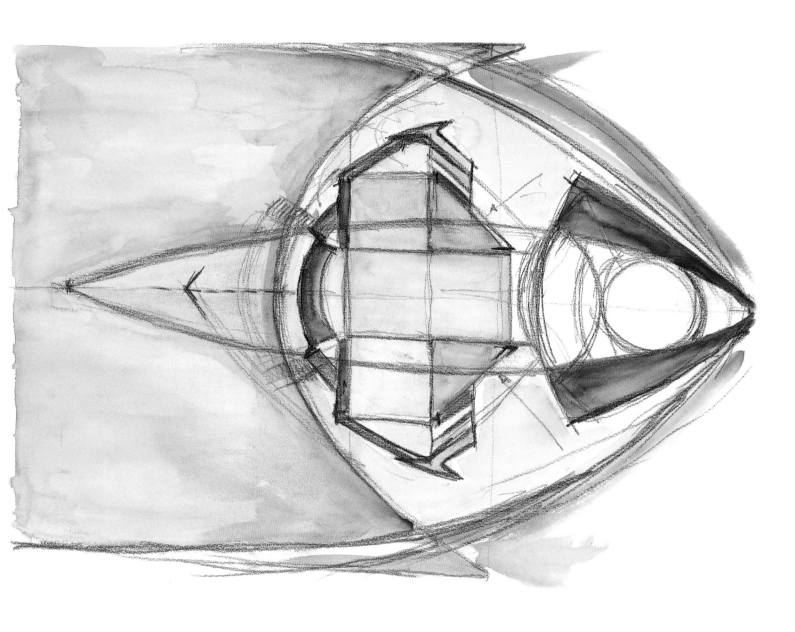

In these sketches, Calatrava outlines the succession of forms that constitute his City of Sciences, with the Planetarium in the center (above, left). His cantilevered or slanting forms consistently bring to mind the idea of motion.

Auf diesen Skizzen stellt Calatrava die Abfolge der Formen dar, aus denen sich seine Ciudad de las Sciencias mit dem Planetarium in der Mitte (oben, links) zusammensetzt. Die auskragenden oder geneigten Formen lassen alle an Bewegung denken.

Dans ces croquis, Calatrava esquisse la série de formes qui constituent sa Cité des sciences avec, au centre, le planétarium (ci-dessus, à gauche). Ces formes inclinées ou en porte-à-faux font que l'on a toujours en tête l'idée de mouvement.

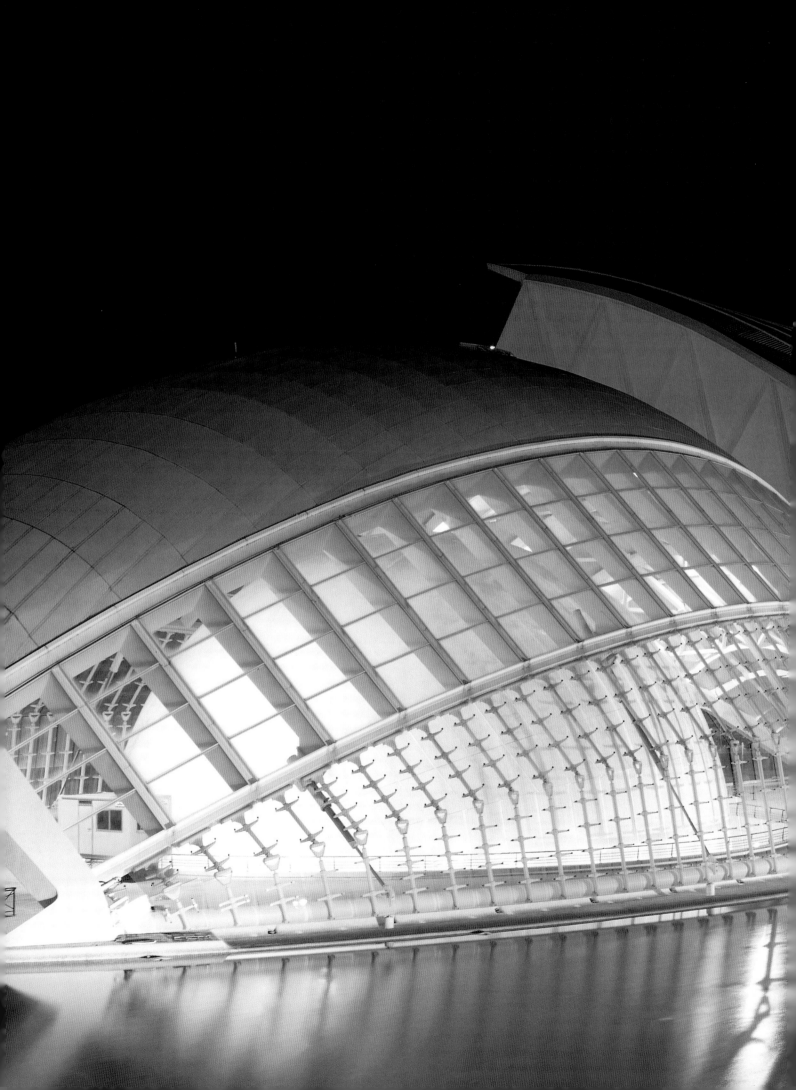

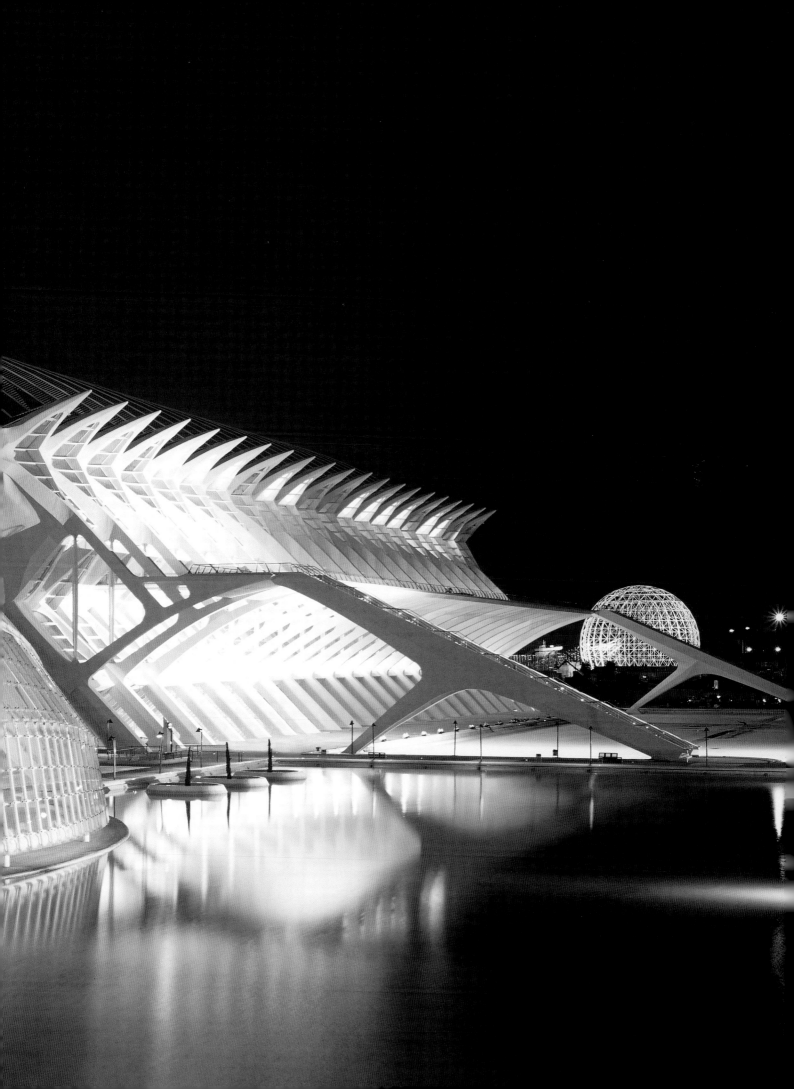

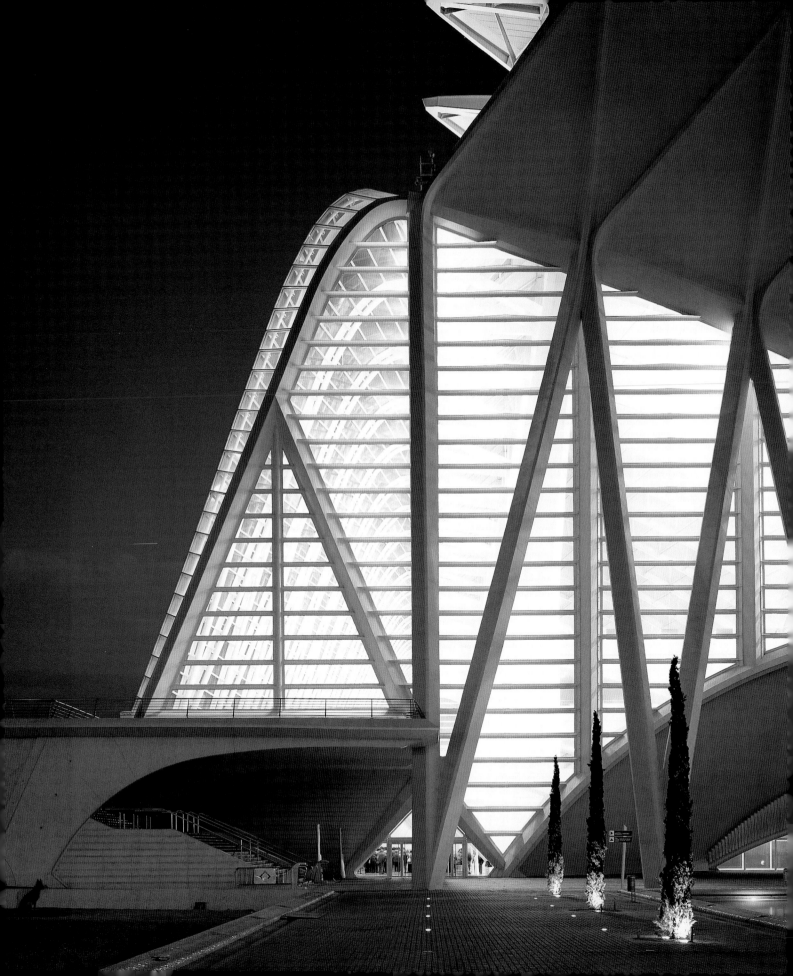

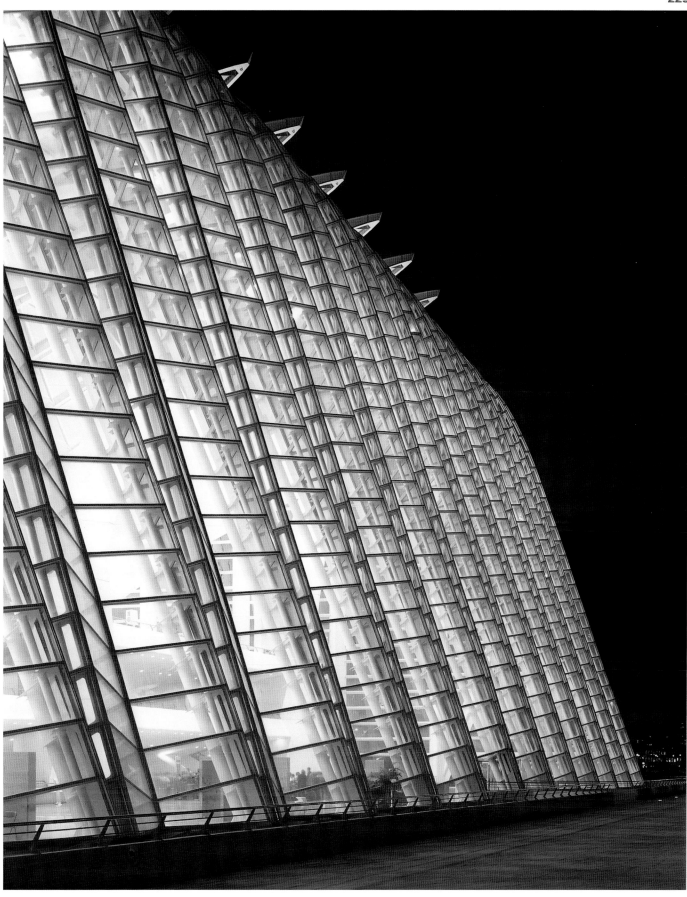

Throughout the oeuvre of Calatrava, forms are rendered more dynamic by the use of large glazed surfaces. Lit from within at night, they are the source of the continuous variation of interior lighting during the day.

In Calatravas Oeuvre werden Formen dynamischer durch den Einsatz großflächiger Verglasungen. Diese bei Nacht von innen beleuchteten Räume sind die Quelle der sich tagsüber verändernden Innenbeleuchtung.

Dans l'œuvre de Calatrava, les formes tirent un dynamisme du recours à de larges surfaces vitrées. Éclairées de l'intérieur pendant la nuit, elles sont à la source des variations permanentes de la luminosité pendant la journée.

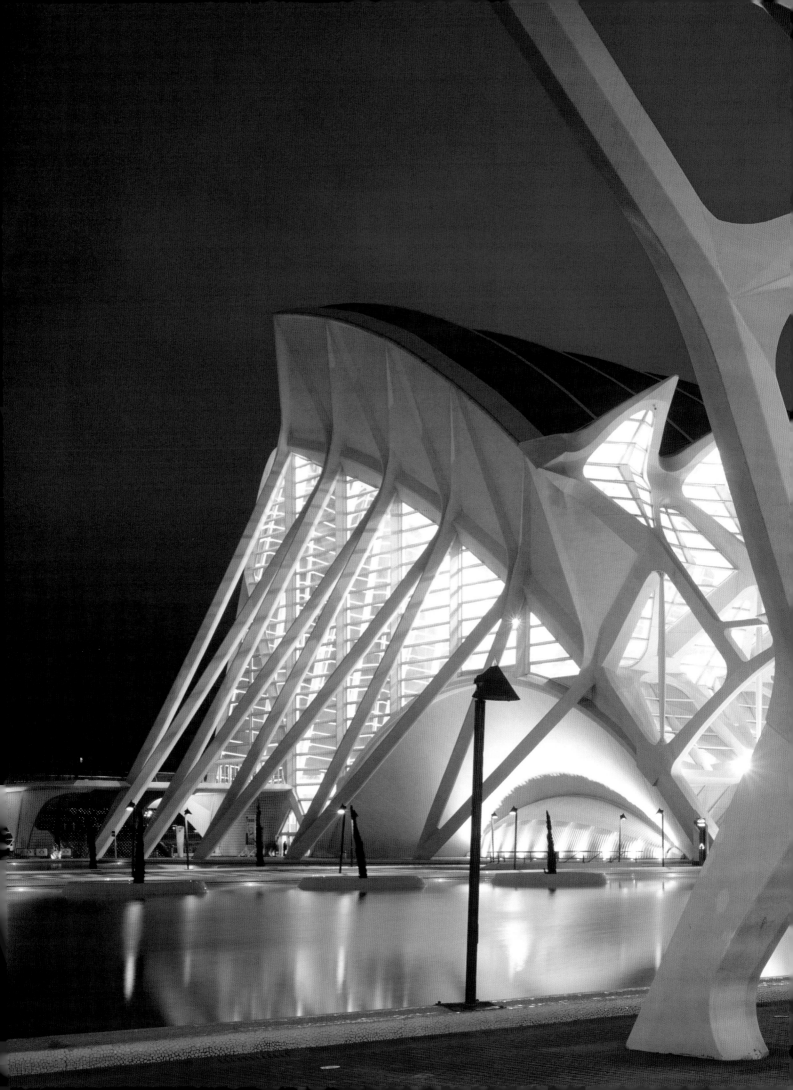

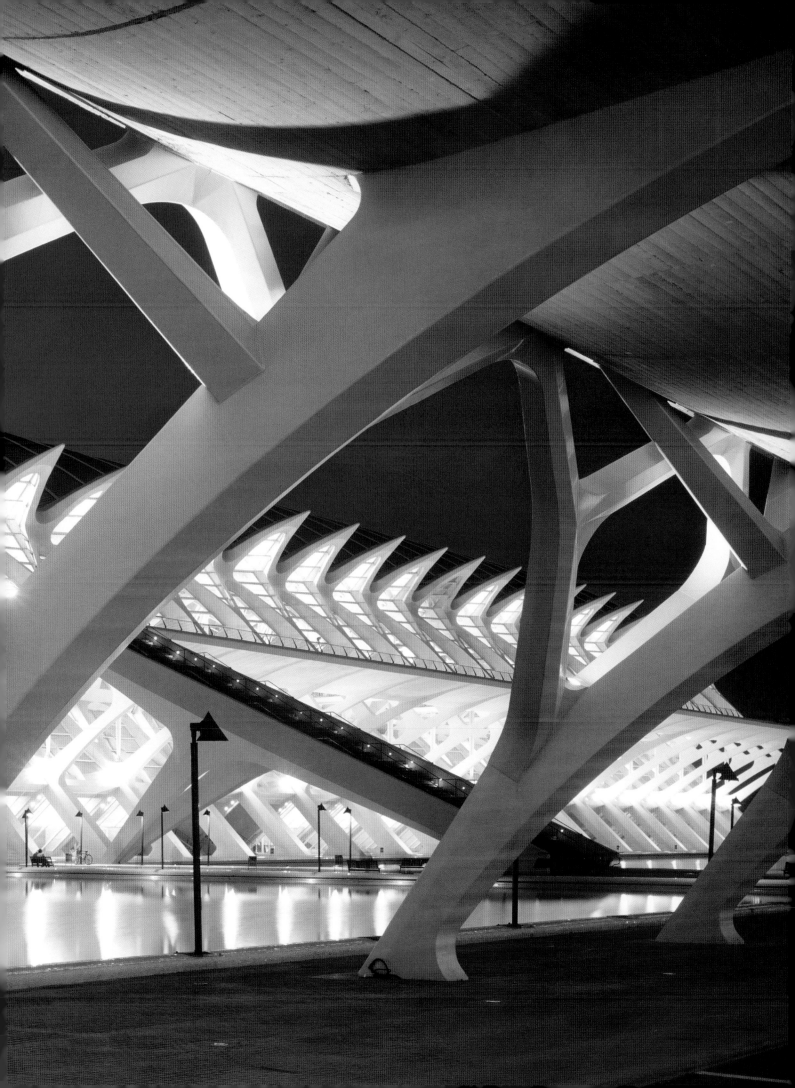

The ribbed shapes used by the architect are not unlike those that appear in earlier works, but here, his effort to simplify and render even more powerful this vocabulary is evident. The natural world is never far removed from his design process.

Die von Calatrava hier verwendeten Rippen-formen ähneln denen früherer Projekte, in diesem Fall ist jedoch das Bemühen, diese Formensprache zu vereinfachen und noch ausdrucksvoller zu gestalten, offenkundig. Die Natur ist während des Gestaltungsprozesses stets präsent.

Ces formes nervurées ne sont pas sans rapport avec celles vues dans des œuvres antérieures, mais ici, l'effort de simplification de ce vocabulaire pour lui donner encore plus de force est évident. Le monde naturel n'est jamais très loin du processus de conception.

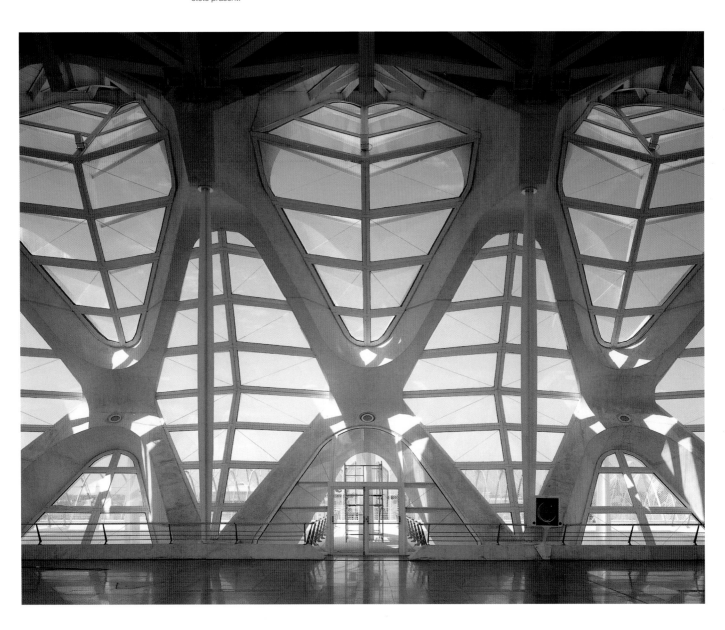

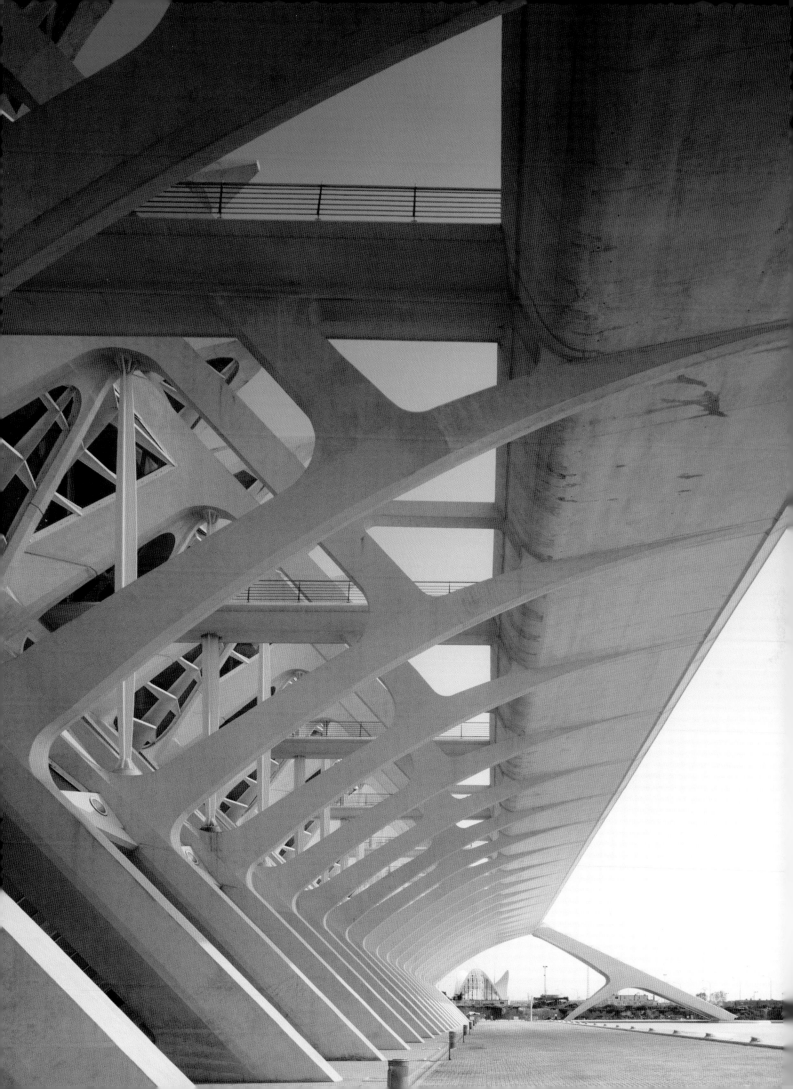

Calatrava is clearly working in a different register than the great majority of famous contemporary architects, shunning computer-generated "new" forms in favor of a gamut of shapes that are intimately linked to art and the natural world.

Calatrava arbeitet eindeutig anders als die große Mehrheit namhafter zeitgenössischer Architekten, indem er vom Computer erzeugte „neue" Formen zugunsten einer Vielzahl von Formen verschmäht, die in engem Zusammenhang mit Kunst und Natur stehen.

À l'évidence, Calatrava travaille dans un registre différent de celui de la plupart des grands architectes contemporains, préférant aux formes « nouvelles » générées par ordinateur une gamme de formes intimement liées à l'art et à la nature.

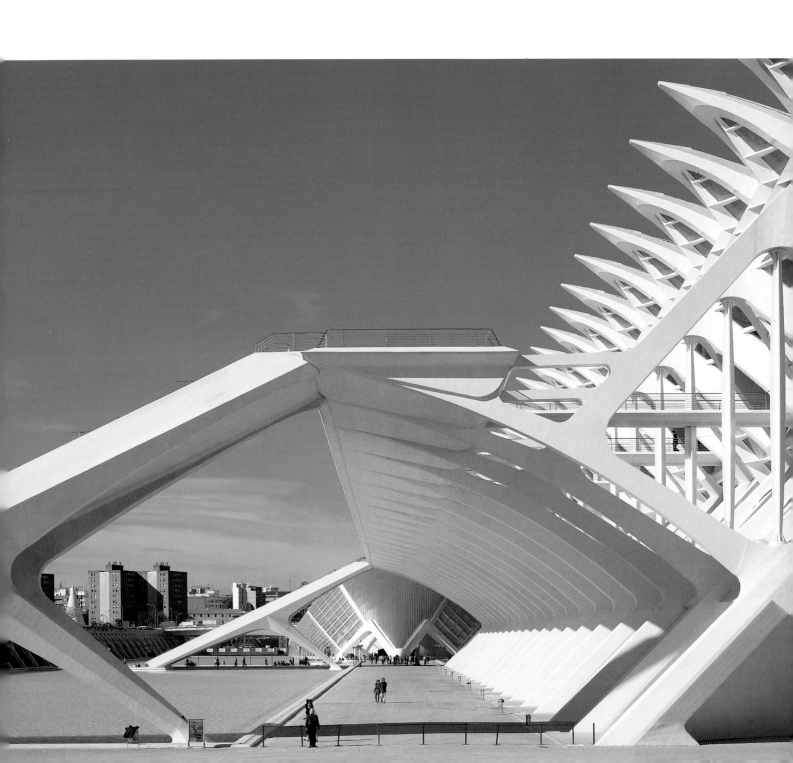

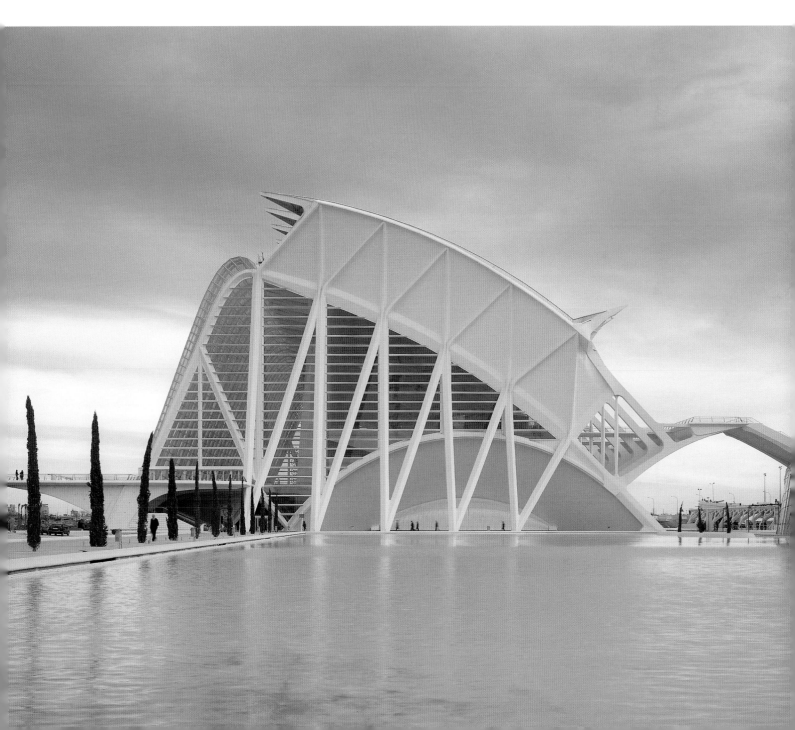

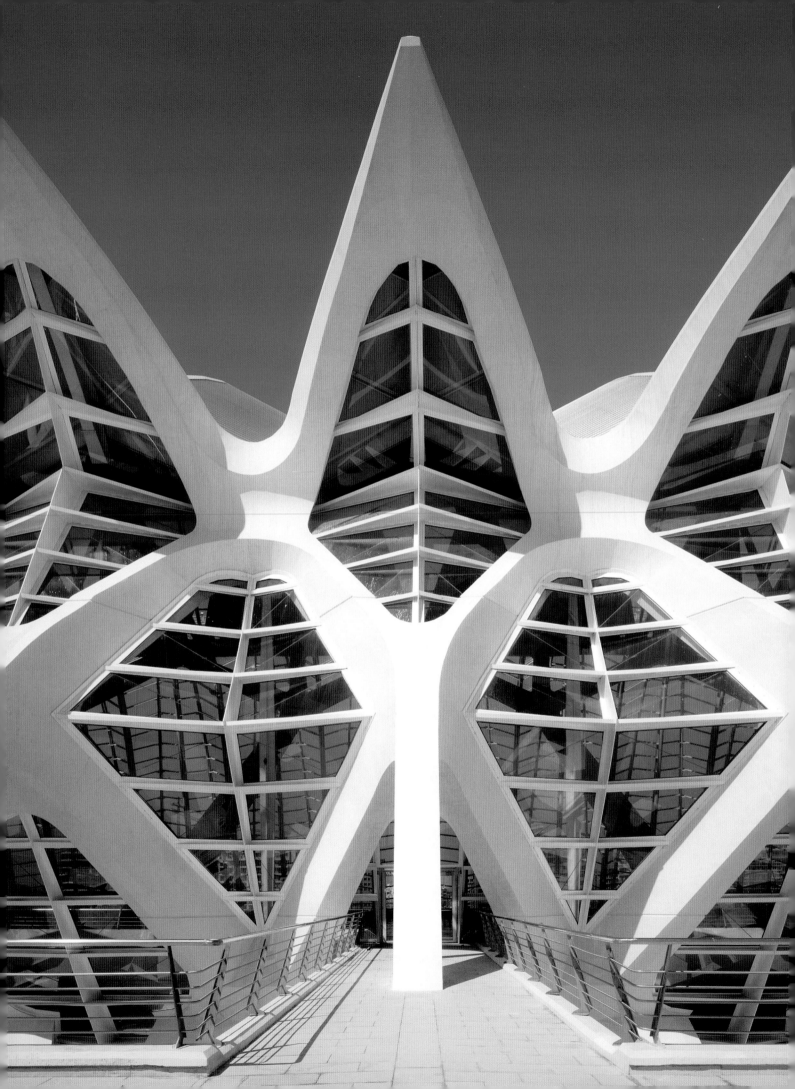

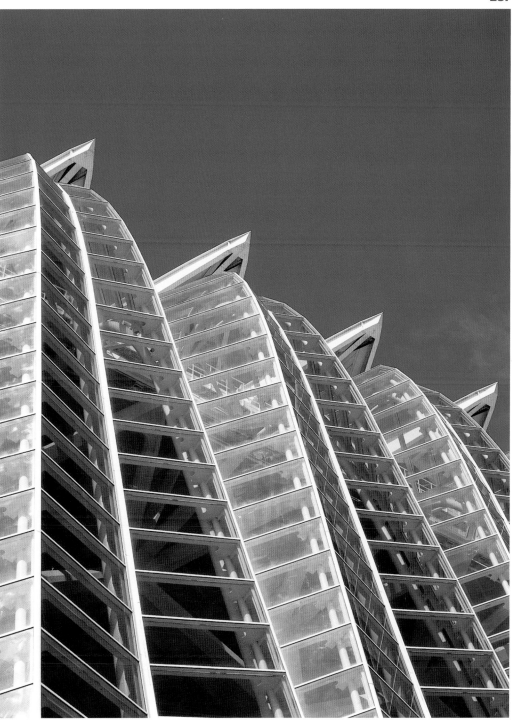

The architect solves design problems in a continuous process that leads from his knowledge of engineering to that of architecture and materials, and is rooted in his own profound aesthetic sense.

Der Architekt löst Entwurfsprobleme in einem kontinuierlichen Prozess, der von seinem technischen Verständnis zu seinen Kenntnissen von Architektur und Materialien führt und in seinem profunden ästhetischen Empfinden wurzelt.

L'architecte résout les problèmes de conception en un processus continu qui passe par sa connaissance de l'ingénierie, de l'architecture et des matériaux, mais qui prend sa source dans une authentique sensibilité esthétique.

Though it may bring to mind the atrium of BCE Place, Calatrava's work in Valencia, is reaching for an even higher dimension, both literally and figuratively. This is an architecture of a soaring spirit.

Wenngleich dieses Projekt an den BCE Place erinnern mag, ist Calatravas Anspruch hier in Valencia sowohl im Wort- als auch im übertragenen Sinn ein noch höherer. Dies ist die Architektur eines hochfliegenden Geistes.

Bien que l'on puisse penser à l'atrium de BCE Place, cette intervention de Calatrava à Valence atteint une dimension encore supérieure, aussi bien littéralement que figurativement. Cette architecture tient de l'élévation spirituelle.

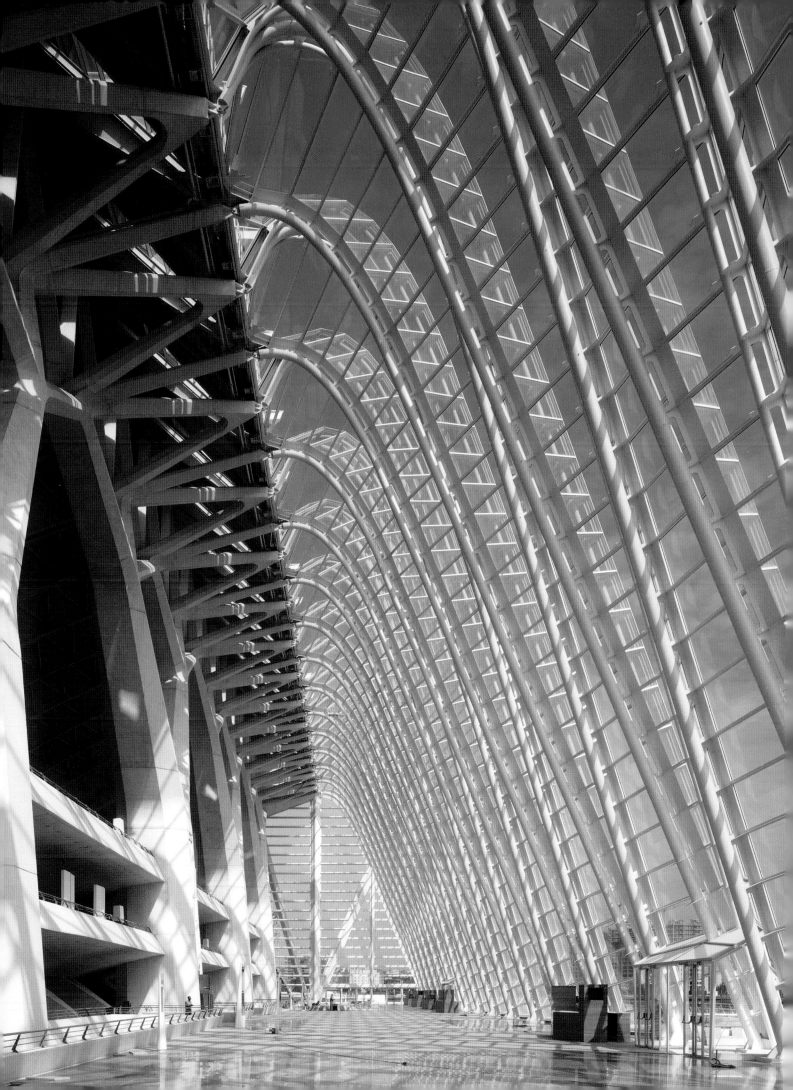

Project
OPERA HOUSE

Location
VALENCIA, SPAIN

Client
GENERALITAT VALENCIANA, CITY OF ARTS AND SCIENCES S. A.

Building area
44 100 m²

Site area, Opera House
3.3 HECTARES

Usually quite intent on the use of white in his buildings, Calatrava here delves into a surprising composition with a dark blue fragmented surface. This abstract image is indicative of the power that his buildings embody, without ever becoming overtly monumental.

Calatrava bevorzugt gewöhnlich bei seinen Bauten die Farbe Weiß, lässt sich hier jedoch auf eine überraschende Komposition mit einer dunkelblauen, fragmentierten Oberfläche ein. Dieses abstrakte Bild ist bezeichnend für die seinen Bauten innewohnende Kraft, die gleichwohl ohne manifeste Monumentalität auskommen.

Généralement plutôt attaché à l'utilisation du blanc, Calatrava surprend ici par une composition de surface fragmentée bleu foncé. Cette image abstraite est révélatrice de la force qu'incarne cet édifice sans qu'il soit pour autant lourdement monumental.

Conceived as the final element in the City of Arts and Sciences complex, rising to a height of 75 meters on its western edge, the Valencia Opera House was "designed as a series of apparently random volumes, which become unified through their enclosure within two symmetrical, cutaway concrete shells. These forms are crowned by a steel sheath, which projects axially from the entrance concourse out over the uppermost contours of the curvilinear envelope. The structure that results defines the identity of the opera house, enhancing its symbolic and dynamic effect within the landscape, while offering protection to the terraces and facilities beneath." Calatrava defines the design as being akin to a "monumental sculpture." The central volume of the complex is occupied by the 1706-seat auditorium as well as the equipment required for the stage settings. A smaller auditorium, conceived mainly for chamber music, seats 380, while a large auditorium to the east, partially covered by the open shell, can seat 1520 people. The first concert was held on October 8, 2005, but the opera house was actually completed late in 2006. The architect created two large murals for the main auditorium and restaurant and two low relief sculptures. Located adjacent to the main building is a 400-seat auditorium for experimental theater and dance, with gallery space for art exhibitions. The five structures of the complex are linked by gardens and bodies of water.

Als abschließendes Element der Stadt der Künste und Wissenschaft konzipiert, entstand das am Westrand der Anlage erbaute, 75 m hohe Opernhaus als „Reihe scheinbar zufälliger Baukörper, die durch zwei symmetrische, ausgeschnittene Betonschalen zusammengeschlossen werden. Diese Formen werden von einer stählernen Scheide bekrönt, die vom Eingangsvorplatz in axialer Richtung über den höchsten Punkt der gebogenen Umhüllung reicht. Dieses Element bestimmt die Identität des Opernhauses und steigert seine symbolische und dynamische Wirkung in der Landschaft, während es gleichzeitig den Terrassen und darunterliegenden Einrichtungen Schutz bietet." Calatrava zufolge ähnelt dieser Entwurf einer „monumentalen Skulptur". Der zentrale Raum des Komplexes enthält das Auditorium mit

1706 Sitzplätzen sowie die für die Bühnenbilder erforderlichen Vorrichtungen. Ein in erster Linie für Kammermusik vorgesehenes Auditorium bietet 380 Plätze, während in einer größeren, nach Osten gelegenen Halle 1520 Personen Platz finden; sie ist teilweise von der offenen Betonschale überdeckt. Das erste Konzert fand am 8. Oktober 2005 statt, aber das Opernhaus wird erst Ende 2006 vollständig fertig sein. Für den Hauptsaal und das Restaurant schuf der Architekt zwei großflächige Wandbilder sowie zwei Reliefs. Neben dem Hauptgebäude befindet sich ein Auditorium mit 400 Sitzplätzen für experimentelles Theater und Tanz sowie einem Galerieraum für Kunstausstellungen. Zwischen den fünf Baukörpern des Komplexes befinden sich verbindende Grünanlagen und Wasserflächen.

Élément final implanté à l'ouest du complexe de la Cité des arts et des sciences, l'Opéra de Valence a été « conçu comme une série de volumes apparemment aléatoires, unifiés par leur réunion en deux coques de béton symétriques découpées. Ces formes culminant à 75 mètres sont couronnées par un fourreau d'acier, qui jaillit dans l'axe du hall d'entrée au-dessus des contours les plus élevés de l'enveloppe curviligne. La structure qui en résulte définit avec force l'identité de cet Opéra et met en valeur son aspect symbolique et dynamique au cœur du paysage, tout en offrant une protection aux terrasses et installations qu'elle surplombe. » Calatrava dit de ce projet qu'il est analogue à une « sculpture monumentale ». Le volume central est occupé par une salle de 1706 places et par les équipements de scène. Une salle plus petite, dévolue à la musique de chambre, peut accueillir 380 auditeurs et une seconde grande salle à l'est, en partie protégée par une coque ouverte, 1520 personnes. Le premier concert s'est déroulé le 8 octobre 2005 mais l'Opéra n'a été vraiment achevé qu'en 2006. L'architecte a créé deux grandes œuvres murales dans la salle principale et le restaurant et deux sculptures en bas-relief. À proximité du bâtiment principal, se trouve également une salle de 400 places consacrée au théâtre expérimental et à la danse, dotée d'une galerie d'expositions. Les cinq constructions sont reliées par des jardins et des bassins.

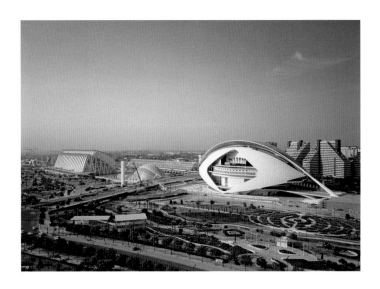

A helmet, a snake's head, or a craft from a distant world. All of these images might be applied to these forms, and yet none of them are accurate. Like his compatriot Salvador Dalí, Santiago Calatrava has an extraordinarily fertile imagination from which his architecture emerges. His buildings are an incontestable expression of his mind.

Ein Helm, der Kopf einer Schlange oder Fahrzeug aus einer fernen Welt. All diese Bilder könnte man auf diese Formen anwenden, freilich ist keines davon zutreffend. Wie sein Landsmann Salvador Dalí verfügt Santiago Calatrava über eine außerordentlich schöpferische Fantasie, aus der seine Architektur entsteht. Seine Bauten veranschaulichen zweifelsfrei sein Denken.

Un casque, une tête de serpent ou un engin venu d'un autre monde – toutes ces images peuvent s'appliquer à ces formes sans qu'aucune soit exactement la bonne. Comme son compatriote Salvador Dalí, Santiago Calatrava possède une imagination extraordinairement fertile, d'où naissent ses formes architecturales. Ses réalisations sont incontestablement l'expression de sa pensée.

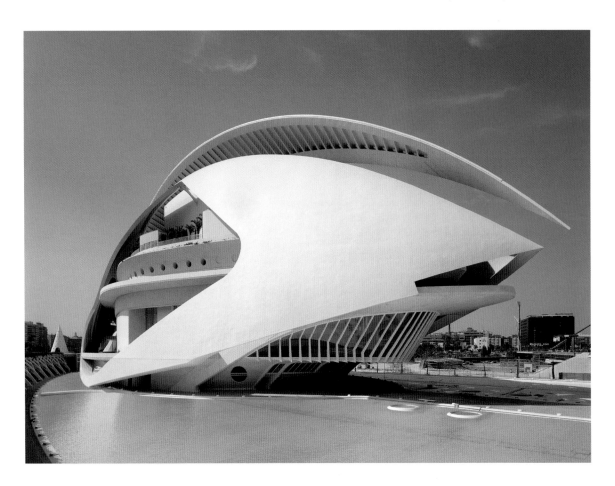

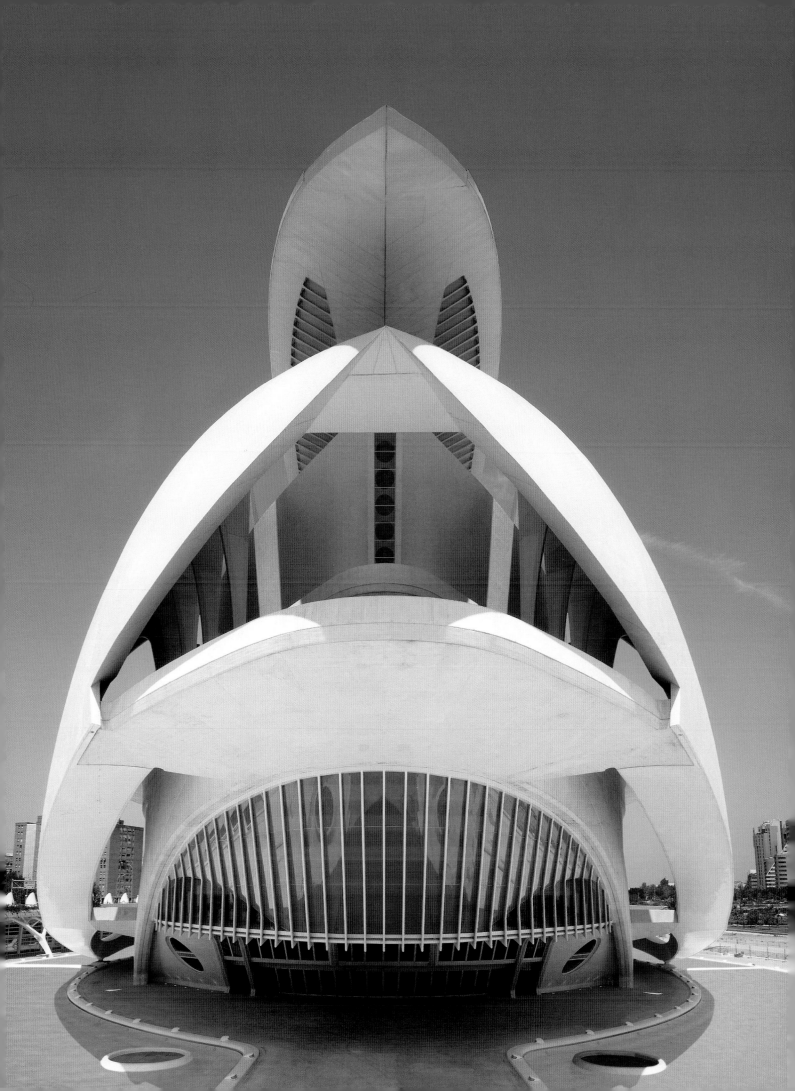

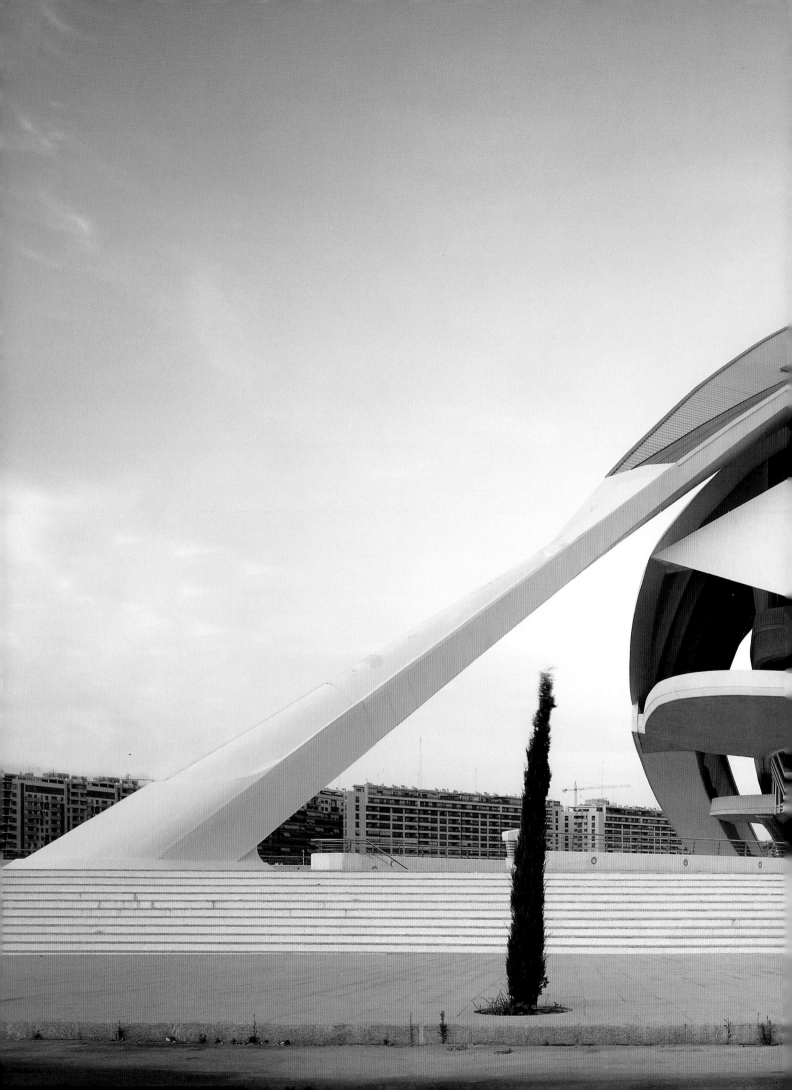

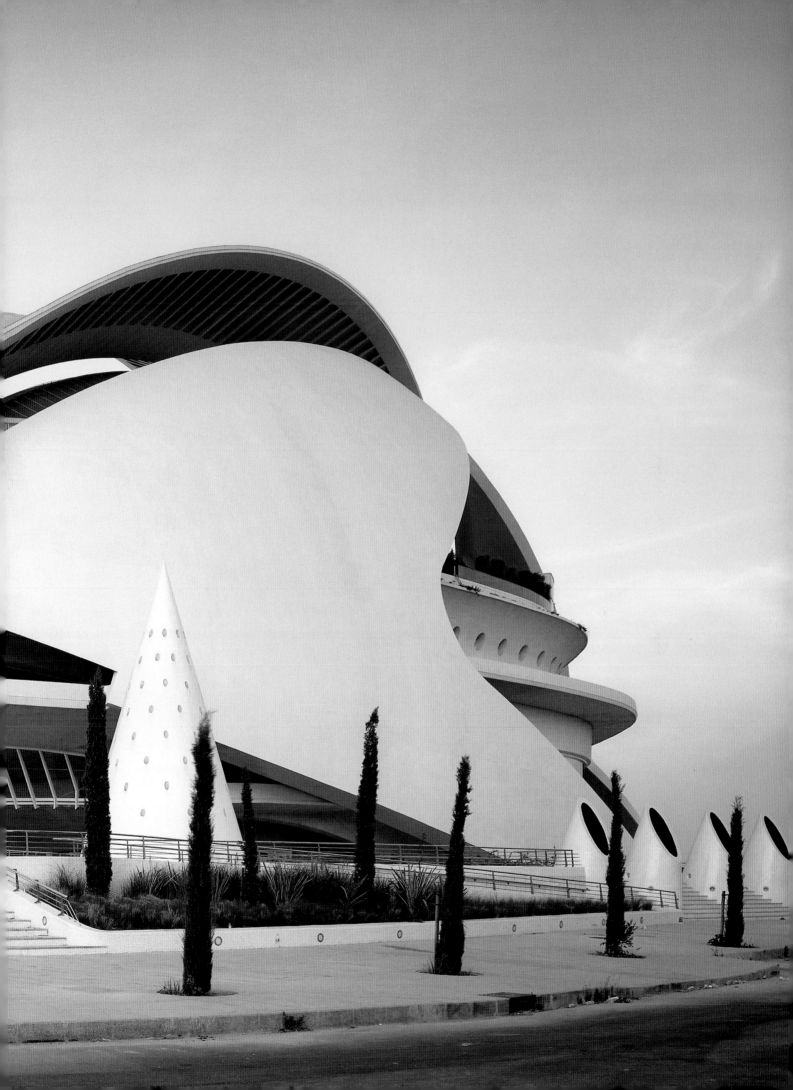

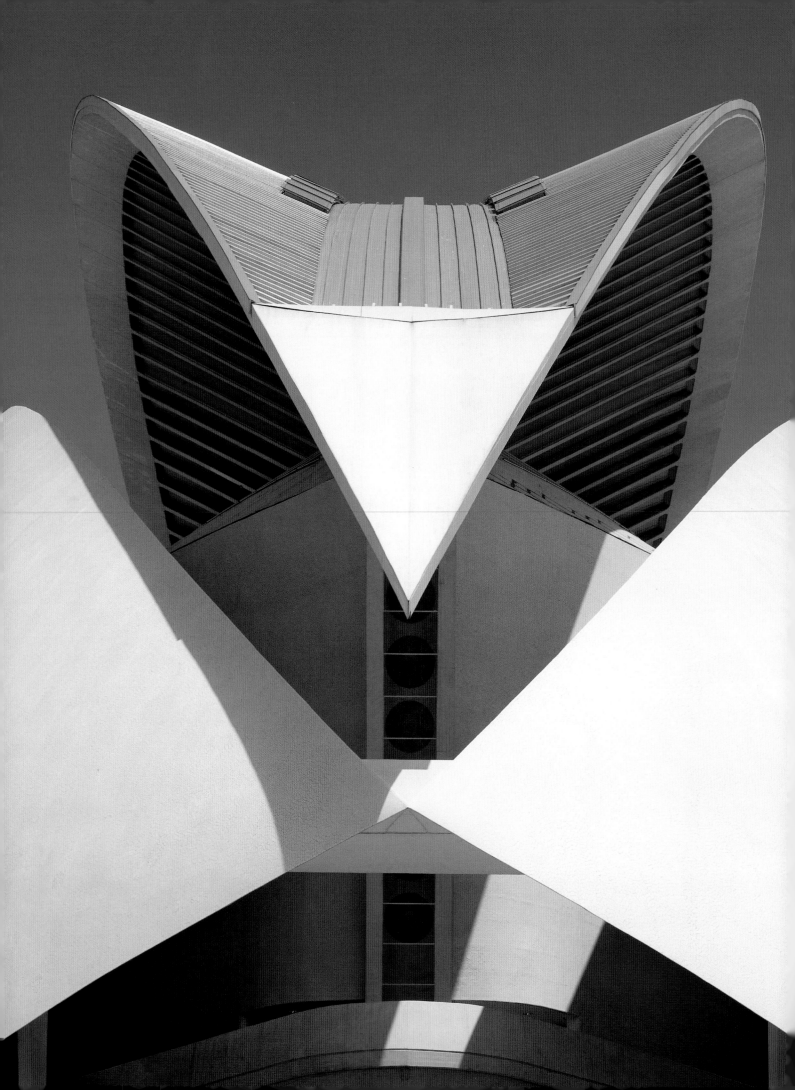

Though the image to the left may bring to mind Calatrava's Tenerife Auditorium, he ventures here into different territory, approaching an almost Surrealist range of shapes.

Obgleich die Abbildung links an Calatravas Auditorium in Teneriffa erinnern mag, wagt er sich hier auf ein anderes Gelände und kommt dabei einer nahezu surrealistischen Formenskala nahe.

Si l'image de gauche peut rappeler l'auditorium de Tenerife, Calatrava se risque ici sur un territoire différent, abordant une gamme de formes quasi surréalistes.

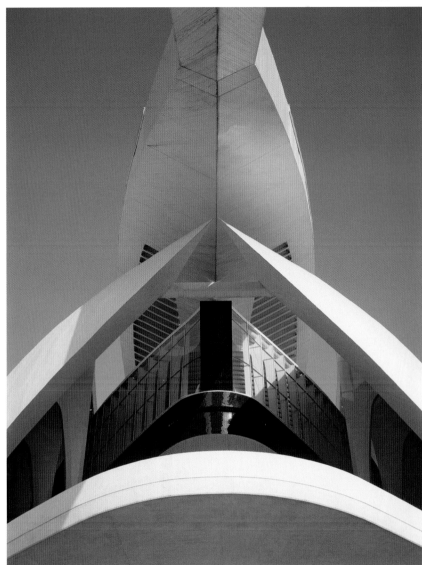

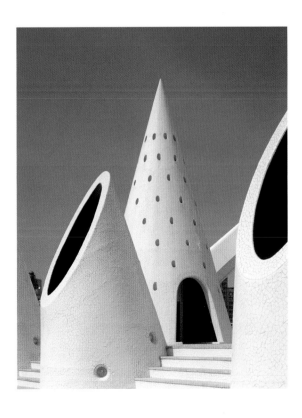

The use of a broken tile surface recalls the inventiveness of Antoni Gaudí, a figure Calatrava clearly admires. Indeed few structures, aside from Gaudí's Sagrada Familia, could be considered comparable to Calatrava's current work.

Die mit Fliesenscherben bedeckte Oberfläche erinnert an den Erfindungsreichtum Antoni Gaudís, den Calatrava zweifellos bewundert. Tatsächlich können, abgesehen von Gaudís Sagrada Familia, nur wenige Bauwerke Calatravas derzeitigem Schaffen das Wasser reichen.

L'utilisation d'une couverture en tesselles de céramique rappelle l'inventivité d'Antoni Gaudí, personnage très admiré par Calatrava mais dont peu de réalisations, en dehors de la Sagrada Familia, sont comparables au travail actuel de l'architecte.

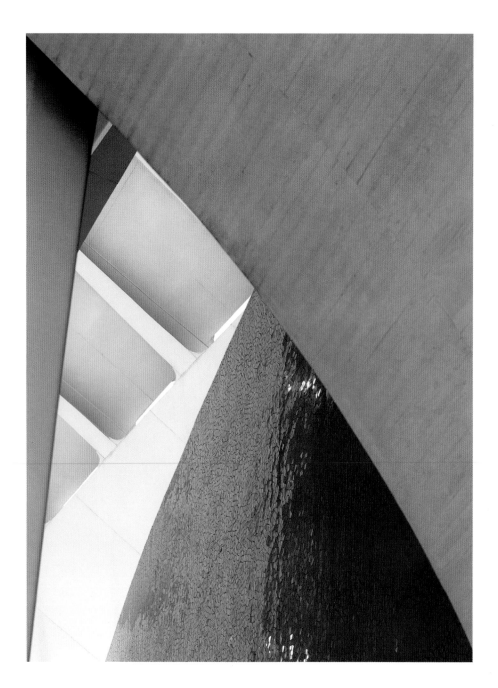

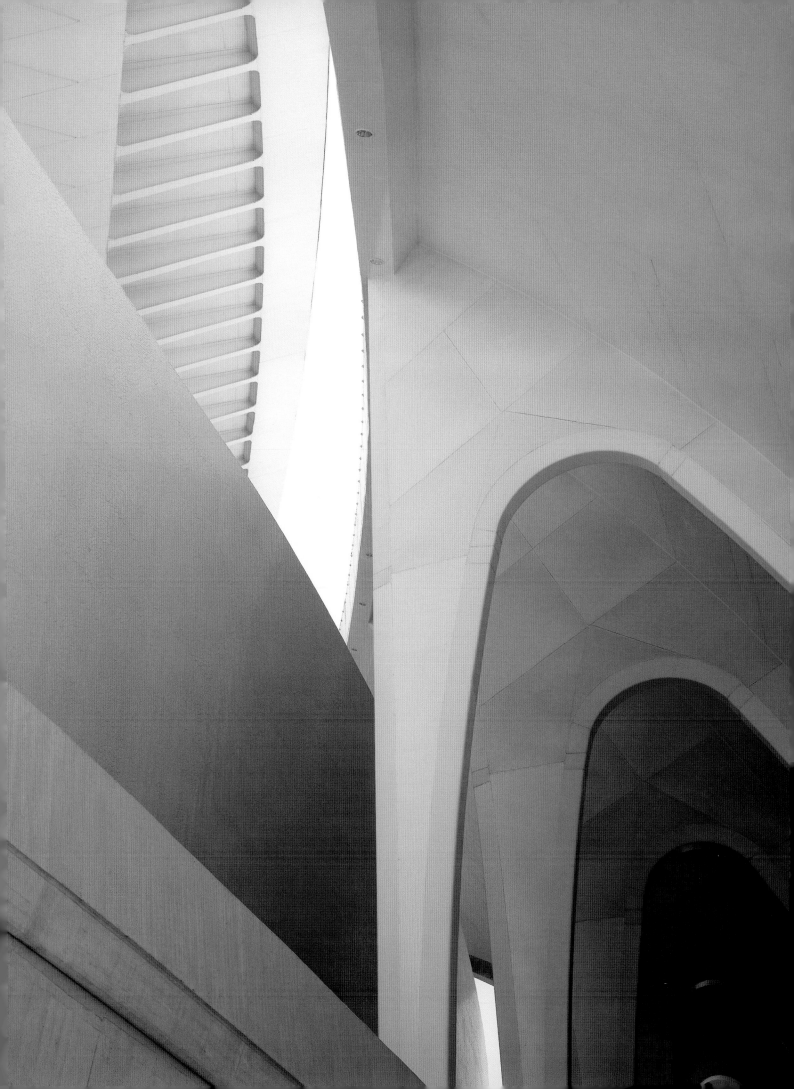

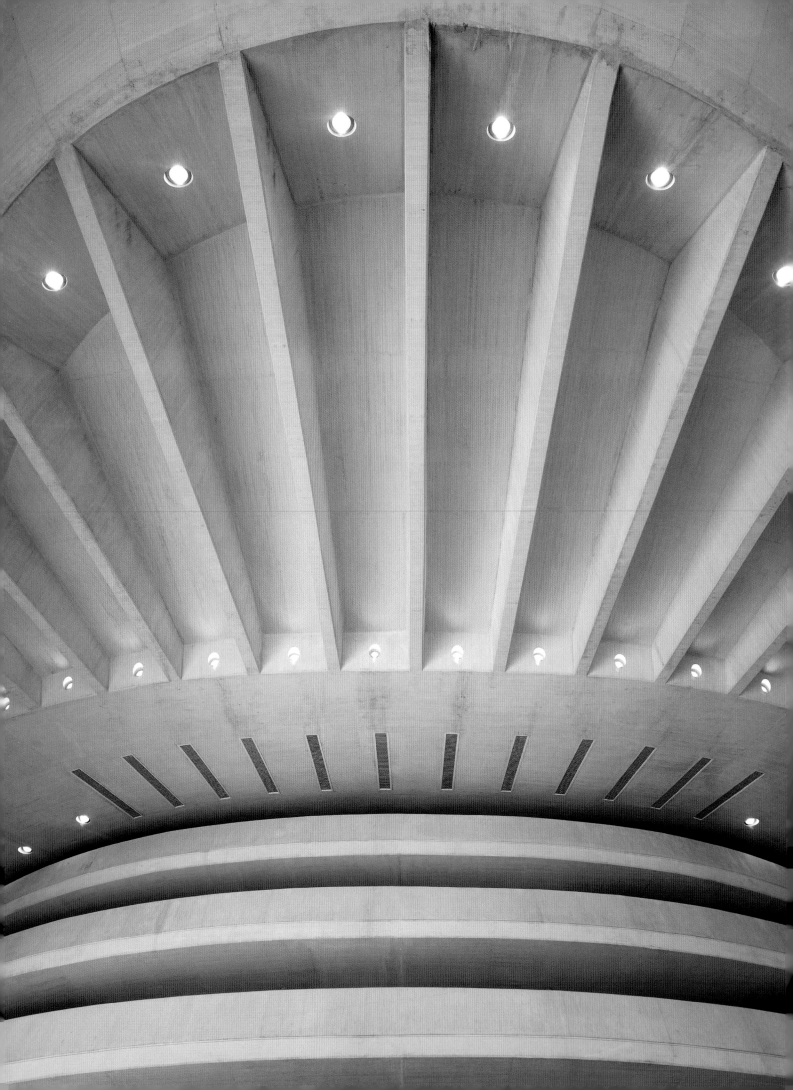

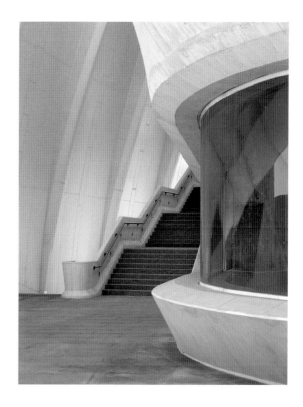

Where the repetition of identical forms in Modernist architecture led often to a kind of inherent boredom, Calatrava makes repetition the source of variety and movement by introducing curves, or fanlike shapes as is the case in these images.

Wo in der architektonischen Moderne die Wiederholung identischer Formen häufig eher öde wirkt, lässt Calatrava aus Wiederholung Vielfalt und Bewegung entstehen, indem er Biegungen oder fächerförmige Elemente einbringt, wie auf diesen Abbildungen zu sehen.

Alors que la répétition de formes identiques a, dans l'architecture moderniste, souvent conduit à un ennui intrinsèque, Calatrava en fait une source de variété et de mouvement en introduisant des courbes ou des motifs en éventail, comme le montrent ces images.

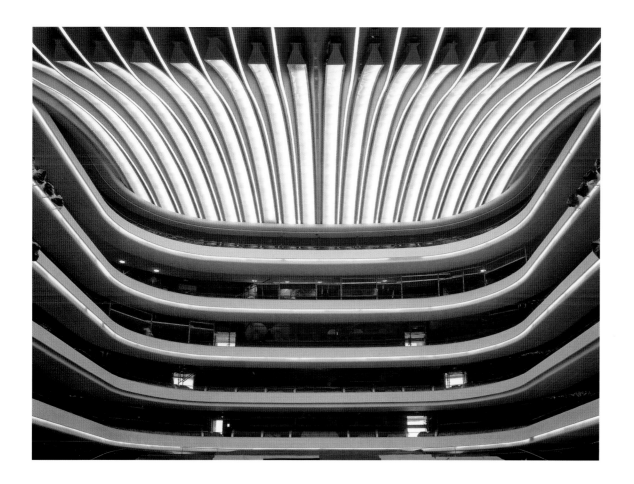

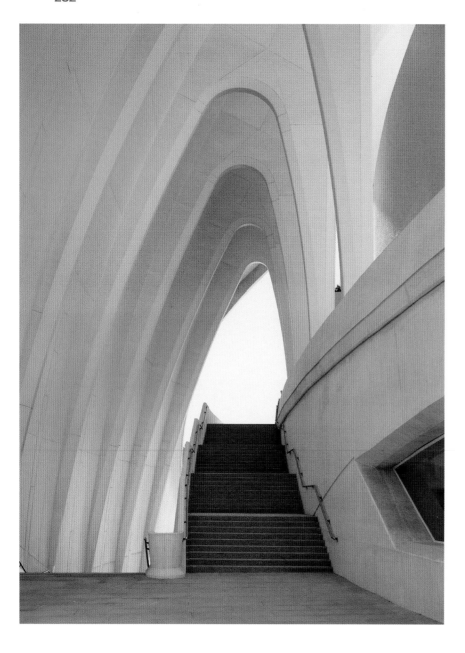

While some contemporary architects, who shall remain unnamed, seek innovation in extravagant but often unusable forms, the vocabulary of Calatrava is rooted in a sense of design and engineering which proceeds more from within than from an imposed and dysfunctional artistic ambition.

Während einige zeitgenössische Architekten, die ungenannt bleiben sollen, Innovation in überspannten, oft unbrauchbaren Formen suchen, fußt die Formensprache Calatravas auf einem Gespür für Gestaltung und Technik, das eher aus seinem Inneren handelt, als aus aufgesetztem, künstlerischem Ehrgeiz.

Tandis que certains architectes contemporains (dont nous tairons le nom) recherchent l'innovation dans des formes extravagantes mais parfois inutilisables, le vocabulaire de Calatrava s'enracine dans une approche de conception et d'ingénierie qui part de l'intérieur plutôt que d'une abusive et problématique ambition artistique.

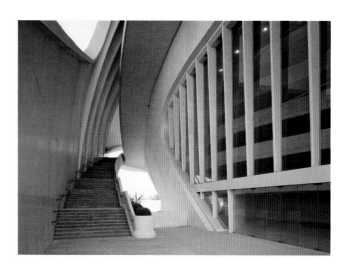

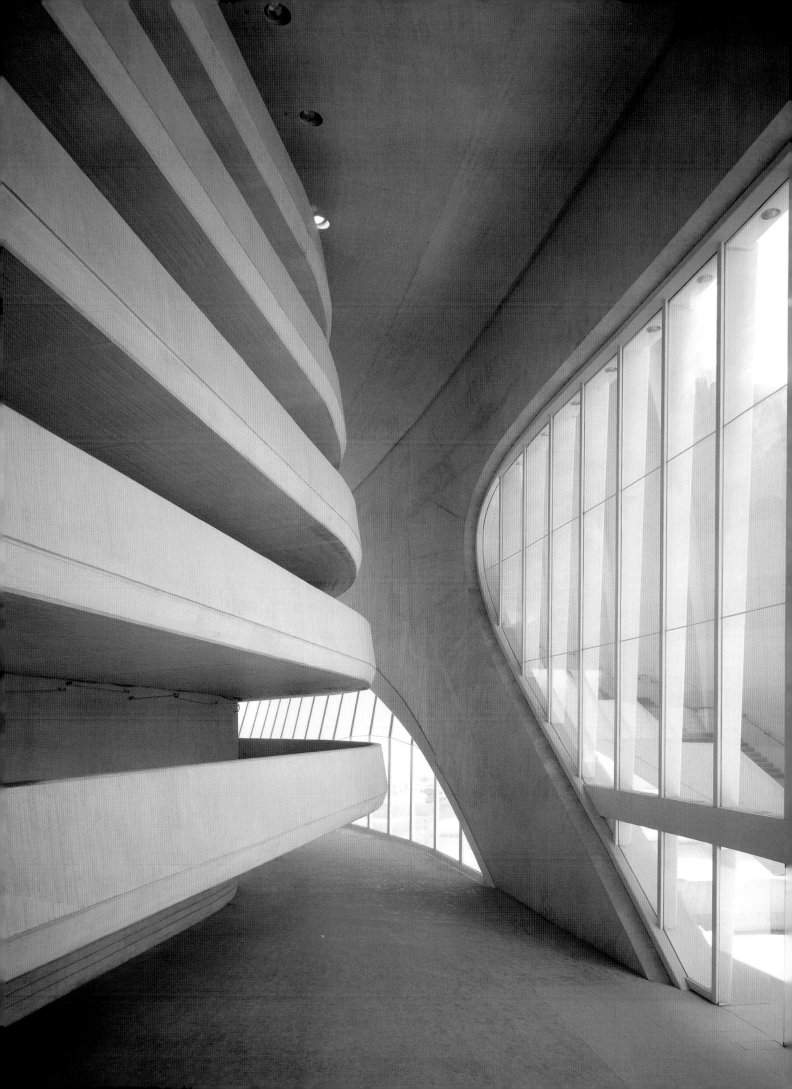

Concepto General de las puertas en relación a la estación de metro.

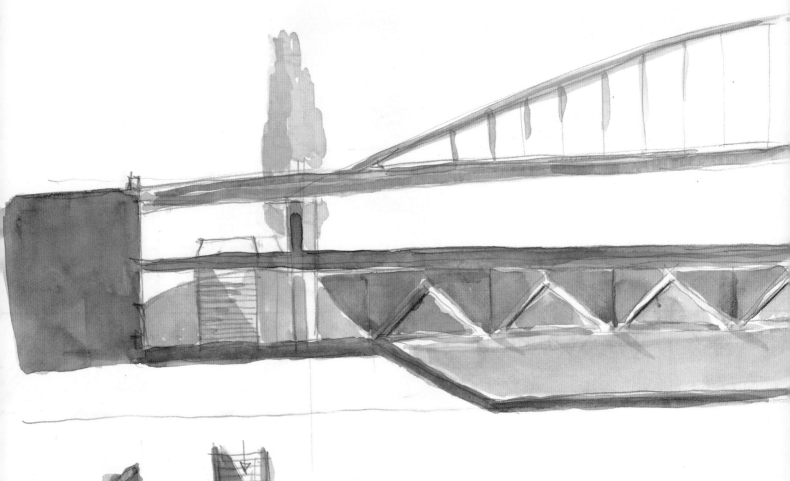

Distribución de las respecto a la sección del conjunt. estaci

cuando las puert plaza en el anti lee en su integri cance fuese de p

ALAMEDA BRIDGE AND SUBWAY STATION

Valencia, Spain. 1991–1995.

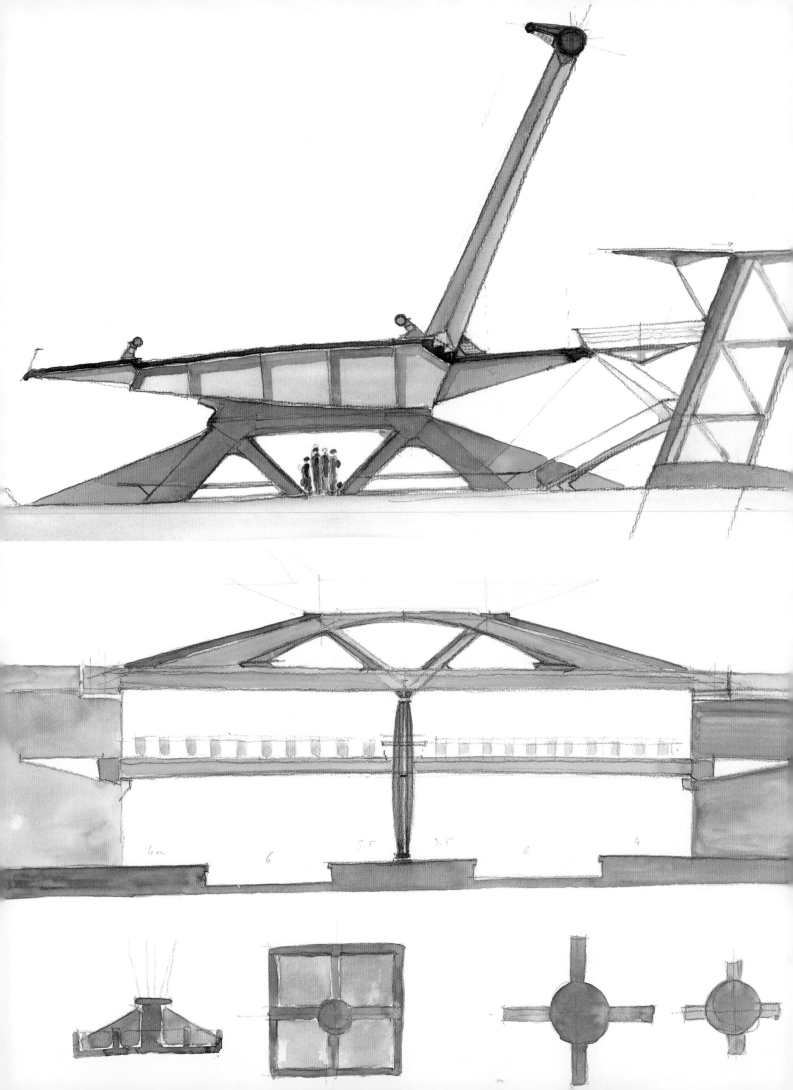

Project

ALAMEDA BRIDGE AND SUBWAY STATION

Location
VALENCIA, SPAIN

Client
REGIONAL GOVERNMENT OF VALENCIA

Span
130 METERS

Height of arch
14 METERS

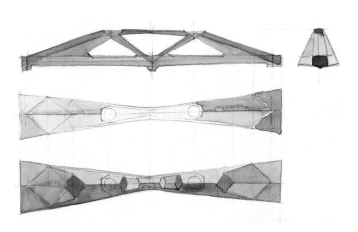

Calatrava's sketches sometimes bring to mind engineering drawings of another era, before the daunting complexities of computer-driven design overwhelmed the pencil and the hand. This is not to say that he is behind the times, but rather that Calatrava cannot readily be compared to his contemporaries.

Calatravas Skizzen erinnern bisweilen an die einer anderen Zeit, ehe die beängstigenden Komplexitäten des computergestützten Entwerfens Bleistift und Hand verdrängt haben. Das soll nicht heißen, dass er sich nicht auf der Höhe der Zeit befände, sondern eher, dass er nicht ohne weiteres mit seinen Zeitgenossen vergleichbar ist.

Les croquis de Calatrava font parfois penser à des dessins d'ingénieurs d'une autre époque, avant que les audacieuses complexités de la conception assistée par ordinateur ne remplacent le crayon et la main. Cela ne veut pas dire pour autant que Calatrava est dépassé mais qu'il échappe à la comparaison avec la plupart de ses contemporains.

Santiago Calatrava is a native of Valencia, and he has certainly left his mark there. One of his first projects was the competition-winning design for a bridge over the dry bed of the Turia River. The Turia ran through the middle of Valencia until it was diverted, subsequent to massive floods in 1957. The Barcelona architect Ricardo Bofill designed the park that presently occupies the location of the river. Calatrava's 26-meter-wide span runs above the subway entrance he also designed. Marking the crossing point of two subway lines, the station was originally intended to be open to the sky, but the plan was modified to place it under the former riverbed. In the completed design, an exterior public plaza signals the presence of the station with a ribbed roof and translucent glass openings at river level, bringing light into the station. Calatrava's use of broken ceramic tiles in the decor of the plaza is an intentional homage to Antoni Gaudí. Mechanical doors that can be closed flush with the pavement to seal the station open to frame the entrances. As the architect's office describes the project, "Due to constraints of construction and scheduling, the bridge was built simultaneously with the adjacent station. Once the station was complete, the bridge was winched into position. The distinctiveness of the bridge and the void of the riverbed combine here to create a singular urban experience."

Santiago Calatrava wurde bei Valencia geboren und hat seine Heimatstadt mit seinen Bauten bereichert. Eines seiner ersten Projekte war der Wettbewerbsentwurf für eine Brücke über das ausgetrocknete Flussbett des Turia. Der Turia floss mitten durch Valencia, ehe er 1957 nach großflächigen Überflutungen umgeleitet wurde. Ricardo Bofill gestaltete den Park, den man in dem früheren Flussbett anlegte. Die 26 m breite Brücke verläuft über dem ebenfalls von Calatrava entworfenen U-Bahneingang. Die am Schnittpunkt zweier U-Bahnlinien liegende Station sollte ursprünglich nicht überdacht sein; letztendlich wurde sie jdoch unter das ehemalige Flussbett verlegt. In der fertigen Anlage markiert ein oberirdi-

scher Platz mit einem gerippten Dach und verglasten Öffnungen auf dem Niveau des Flussbetts die Station. Dass Calatrava zur Dekoration der Plaza Keramikscherben verwendet, ist als bewusste Reverenz an Antoni Gaudí zu verstehen. Mechanische Türen, die sich bündig mit der Pflasterung schließen lassen, um die Station absperren zu können, überdachen in geöffnetem Zustand die Eingänge. In der Projektbeschreibung heißt es: „Aufgrund von Einschränkungen bei Bau und Zeitplanung entstand die Brücke gleichzeitig mit der benachbarten U-Bahnstation. Als die Station fertig war, wurde die Brücke mithilfe einer Winde in ihre Position gehoben. Zusammen lassen die unverwechselbare Brücke und die Leerstelle des Flussbetts eine einzigartige urbane Situation entstehen."

Natif de Valence, Santiago Calatrava y a assurément laissé une empreinte durable. L'un de ses premiers projets, remporté à l'issue d'un concours, fut la conception d'un pont sur le lit asséché de la Turia. La Turia traversait Valence jusqu'à ce que la grave inondation de 1957 oblige à en détourner son cours. L'architecte barcelonais Ricardo Bofill a conçu un parc dans le lit du fleuve. L'ouvrage de 26 mètres de long de Calatrava passe au-dessus de l'entrée de métro qu'il a également conçue. Au croisement de deux lignes, la station avait été prévue totalement ouverte sur l'extérieur mais fut finalement installée sous le lit de la rivière. Dans le projet définitif, une place publique signale la présence de la station par une toiture nervurée, et des ouvertures en verre translucide pratiquées au niveau du fleuve apportent la lumière naturelle à l'intérieur. Le décor en tesselles de céramique de la place est un hommage appuyé à Antoni Gaudí. Des portes à fermeture automatique au ras du sol pavé encadrent les entrées. Le descriptif de l'opération par l'agence précise : « En raison de contraintes de construction et de calendrier, le pont fut construit en même temps que la station, puis treuillé en position une fois celle-ci achevée. L'aspect étonnant de ce pont enjambant le lit asséché du fleuve donne naissance à une étrange expérience urbaine. »

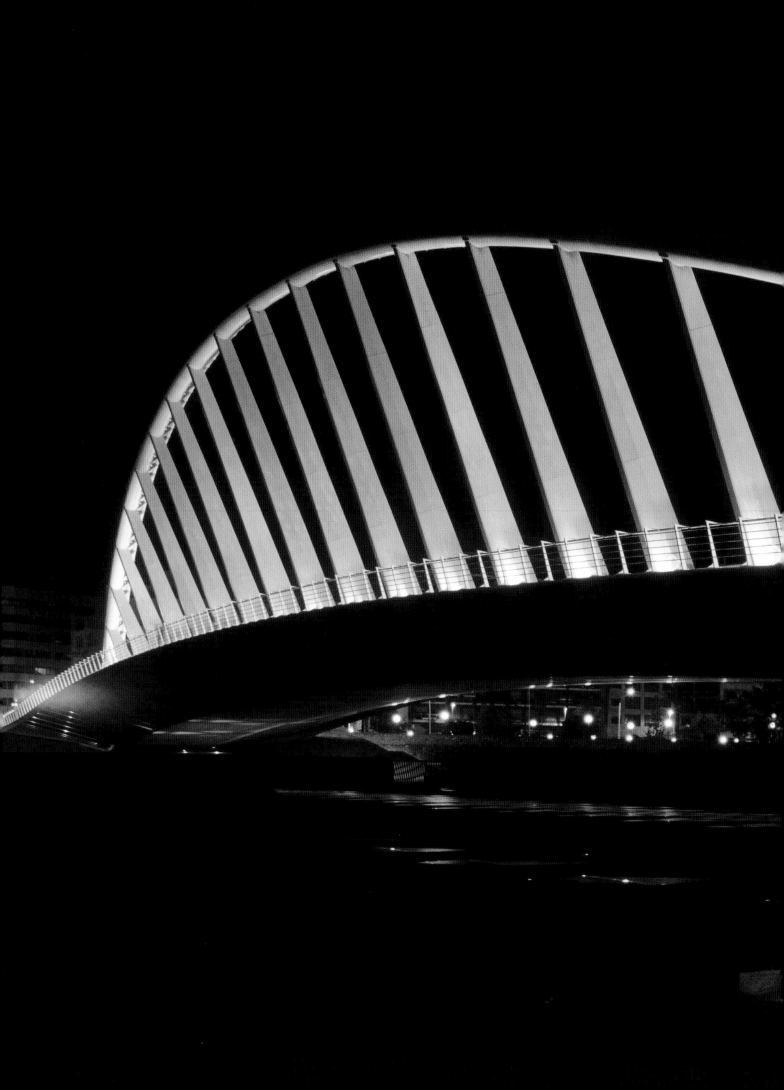

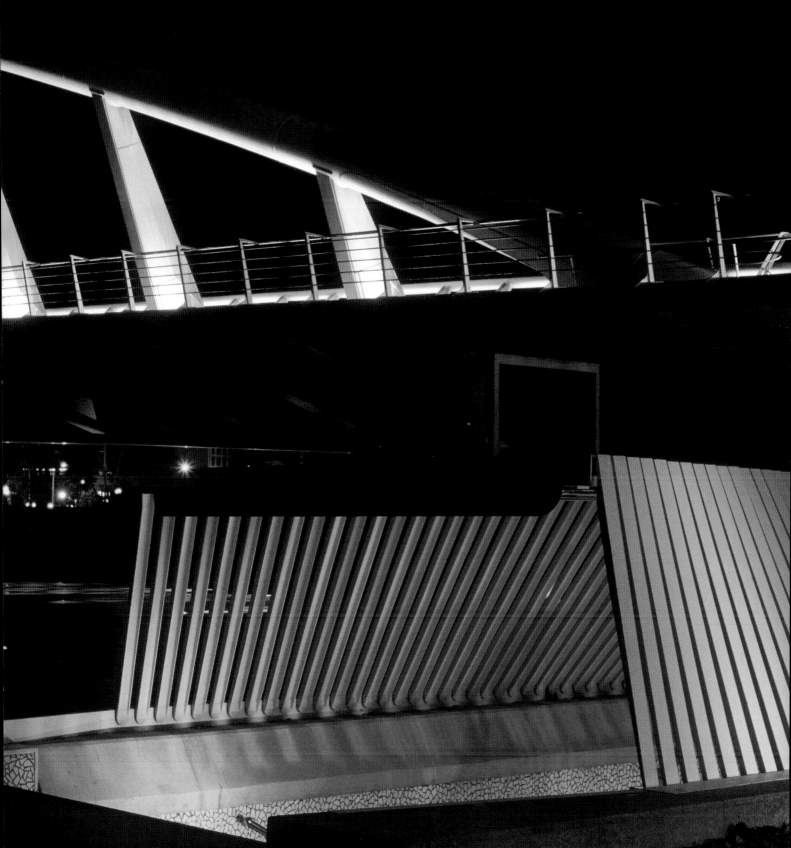

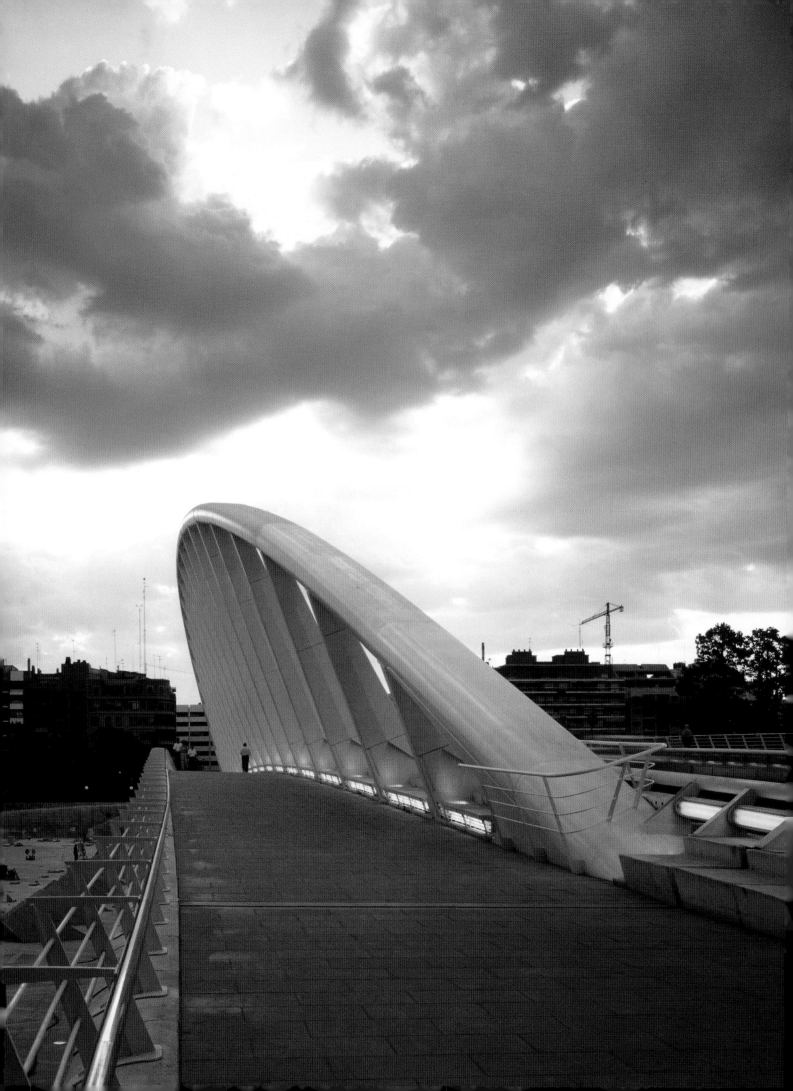

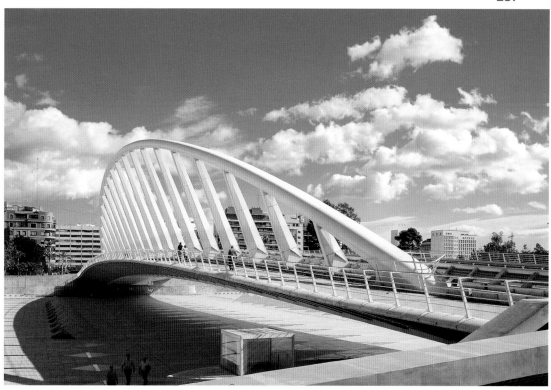

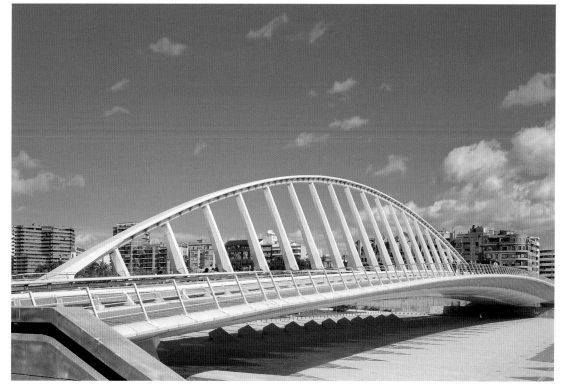

The tilted arc of this bridge, a distant cousin of Calatrava's exploration of the form of the human eyelid for example, is at once sculptural and functional.

Der geneigte Bogen dieser Brücke, ein entfernter Verwandter von Calatravas Experimenten mit der Form des menschlichen Augenlids, ist gleichzeitig skulptural und funktional.

L'arc incliné de ce pont, lointain cousin de l'exploration par Calatrava des contours de la paupière humaine, par exemple, est à la fois sculptural et fonctionnel.

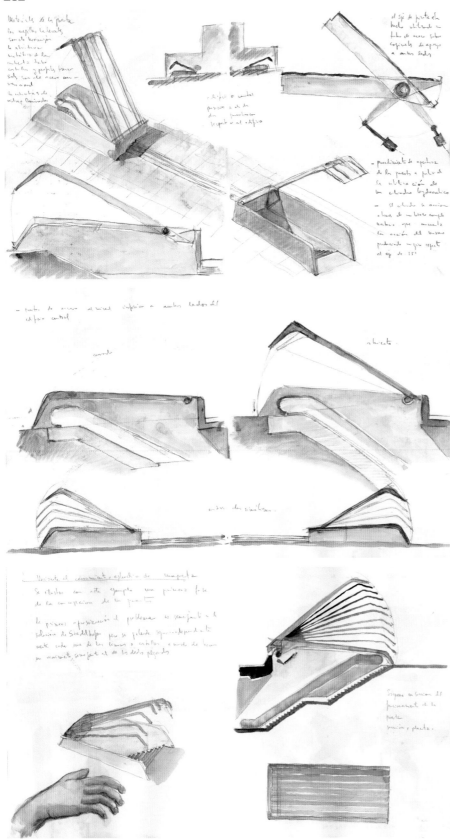

A doorway that seals the subway entrance is shown in the sketches above, revealing its relation to the human hand. Here, as elsewhere, the idea is sublimated into a form that does not immediately bring to mind the hand, but still seems to proceed from shared knowledge of anatomy.

Das den Eingang zur U-Bahn versiegelnde Tor ist auf den Skizzen oben zu sehen, die seine Beziehung zur menschlichen Hand zeigen. Wie auch in anderen Fällen wurde die Idee so weit sublimiert, dass man nicht sofort an eine Hand denkt, aber ihre Herkunft mit anatomischem Grundwissen erkennen kann.

Un portail fermant l'entrée du métro apparaît dans les croquis ci-dessus. Sa forme peut rappeler celle d'une main. Ici comme ailleurs, l'idée est sublimée en une forme qui, si elle n'évoque pas directement la main, semble néanmoins procéder d'une bonne connaissance de l'anatomie.

Desplazamiento del conjunto a diversas posiciones
vista axiomometria : dos de los triangulos son
fijos

artiulación

T₁ y T₂ son triangulos
fijos

chasnela

eje de rotación A

a lo largo del borde se ordenan los diferentes
ejes de rotación de las diferentes laminas todos
ellos son paralelos al eje principal transversal

direccion como a todas las chasnelas

posición cerrada.

los materiales que componen la puerta son fundamentalmente
acero inoxidable las charnelas son prefabricadas el cilindo
de elevación es hidráulico y capaz por el mecanismo de
parada de mantener la puerta abierta. Trabajada con

posición abierta

situación según el tipo de solicitación
el interés de la puerta con este mecanismo es el de crear
una situación ambivalente para el uso libre de la plan
(posición cerrada) o el uso de la sala (posición abierta)

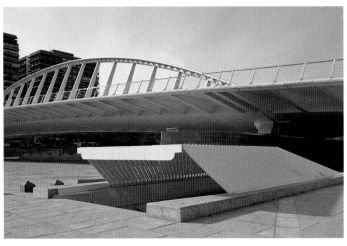

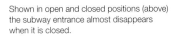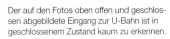

Shown in open and closed positions (above) the subway entrance almost disappears when it is closed.

Der auf den Fotos oben offen und geschlossen abgebildete Eingang zur U-Bahn ist in geschlossenem Zustand kaum zu erkennen.

L'entrée de métro que l'on voit ci-dessus en position ouverte et fermée, disparaît presque une fois fermée.

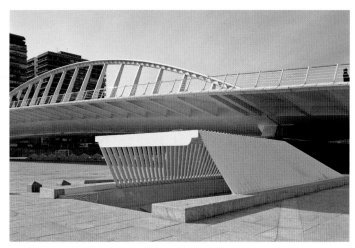

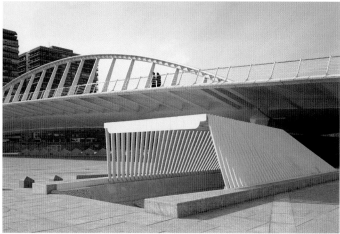

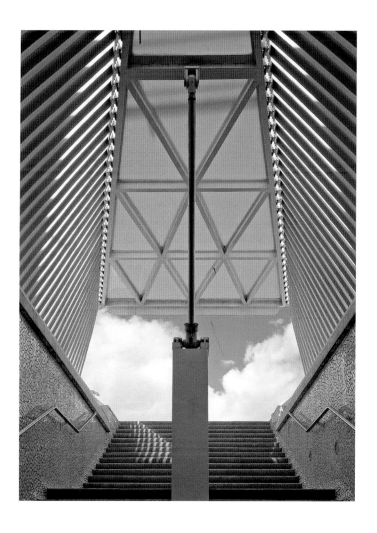

Despite the extreme discretion of the closed doorway, almost flush with the earth, the open entrance forms an architectural element in its own right, coherent vis-à-vis the bridge and also entirely functional and efficient.

Einerseits ist der Eingang extrem unauffällig, wenn er geschlossen fast im Boden verschwindet, andererseits stellt er geöffnet ein eigenes architektonisches Element dar, das zur Brücke passt und absolut funktional ist.

Malgré son extrême discrétion, cette entrée qui, une fois fermée, se trouve presque dans l'alignement du sol, constitue une composante architecturale en soi quand elle est ouverte, cohérente par rapport au pont et parfaitement fonctionnelle.

The areas below grade where the subway platforms are located retain Calatrava's sense of clarity and dynamic design. While the bridge arches above, the subway station forms another opening or passage in its own right.

Die unterirdischen Bereiche mit den Bahnsteigen bewahren Calatravas Gefühl für klare, dynamische Gestaltung. Während sich oberirdisch die Brückenbögen erheben, bildet die U-Bahnstation eine eigenständige Erweiterung oder Verbindung.

Les zones en sous-sol, celles des quais du métro, font preuve de cet esprit de clarté et de dynamisme chers à Calatrava. Sous le pont en arc, la station de métro constitue un autre élargissement ou passage tout à fait autonome.

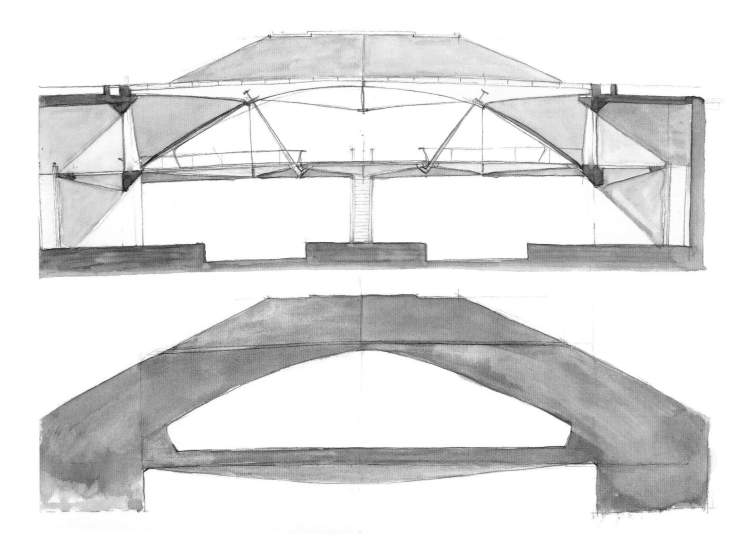

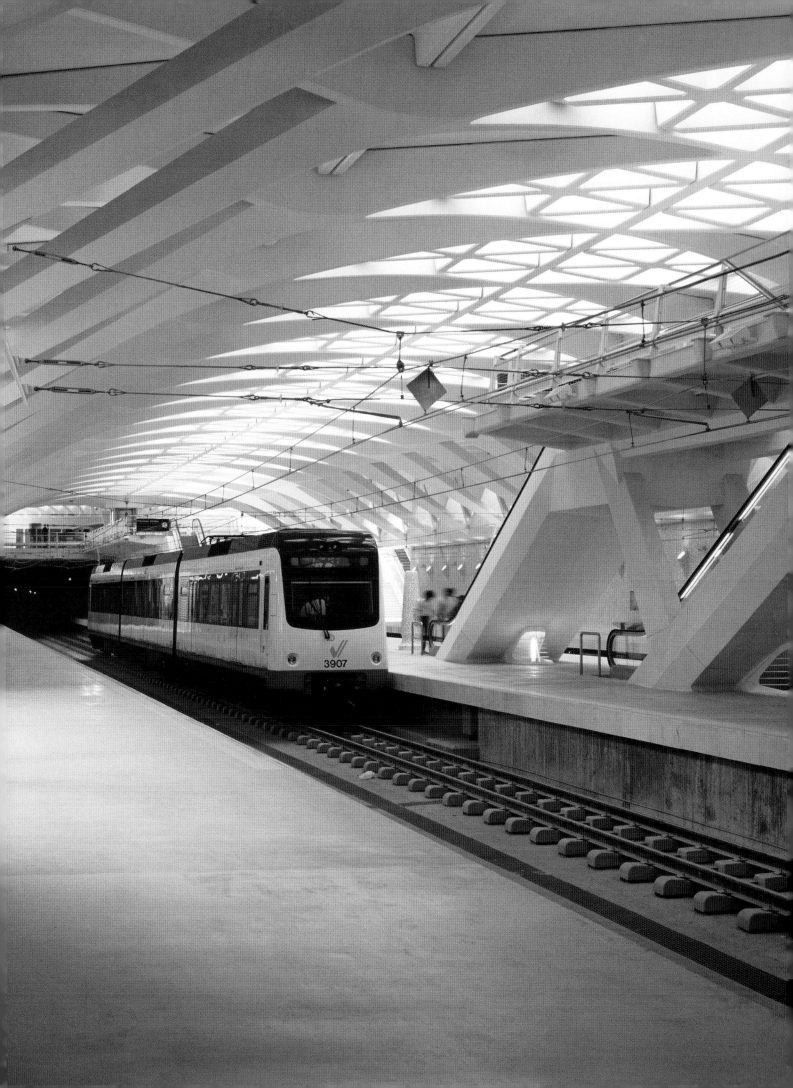

Platforms or walkways almost hanging in space, with inclined supports or generous overhead lighting are all hallmarks of Calatrava's sense of public space.

Nahezu frei im Raum hängende Plattformen oder Laufgänge mit schräg stehenden Stützen sowie großzügige Oberbeleuchtung sind kennzeichnend für Calatravas Umgang mit öffentlichem Raum.

Les quais ou les passerelles sont presque suspendus dans l'espace. Leurs piliers inclinés et leur généreux éclairage zénithal sont typiques des espaces publics conçus par Calatrava.

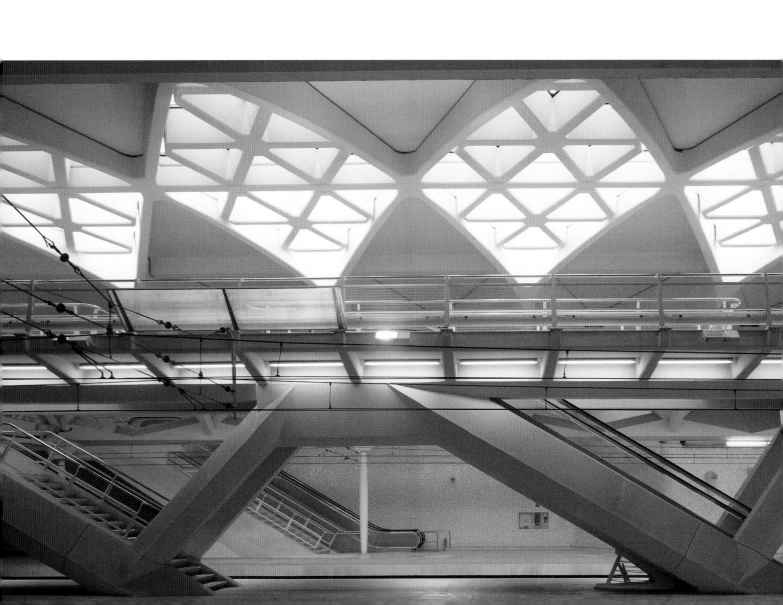

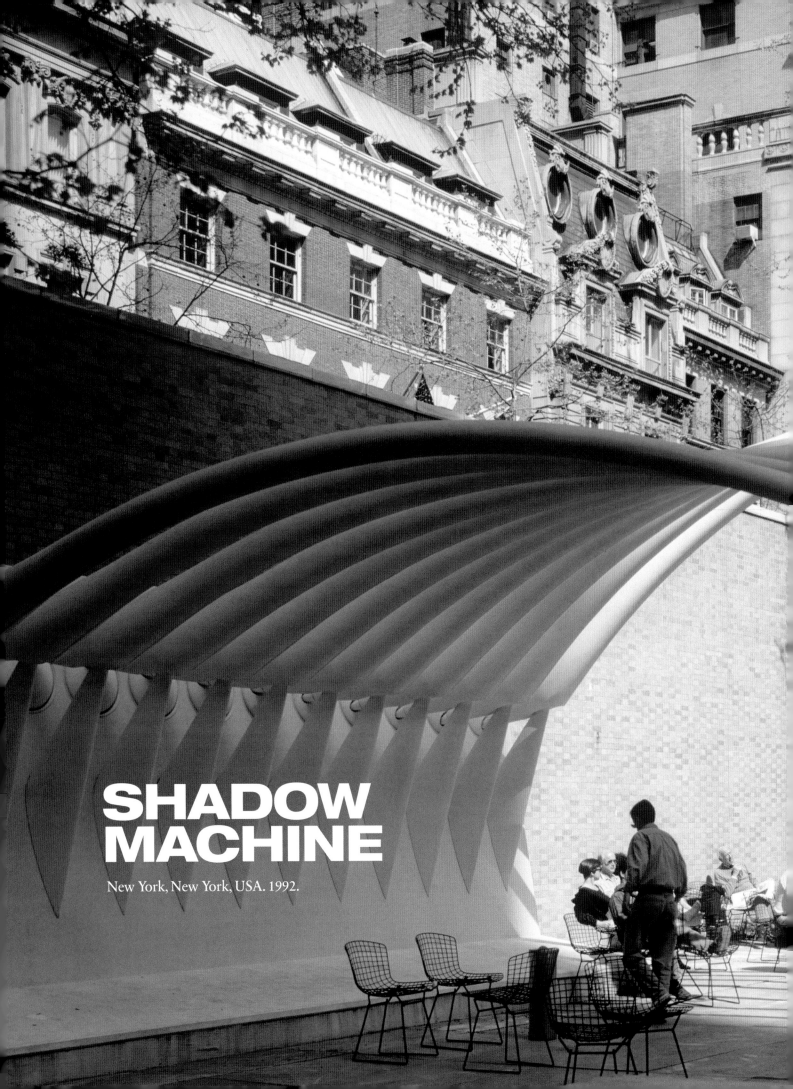

SHADOW MACHINE

New York, New York, USA. 1992.

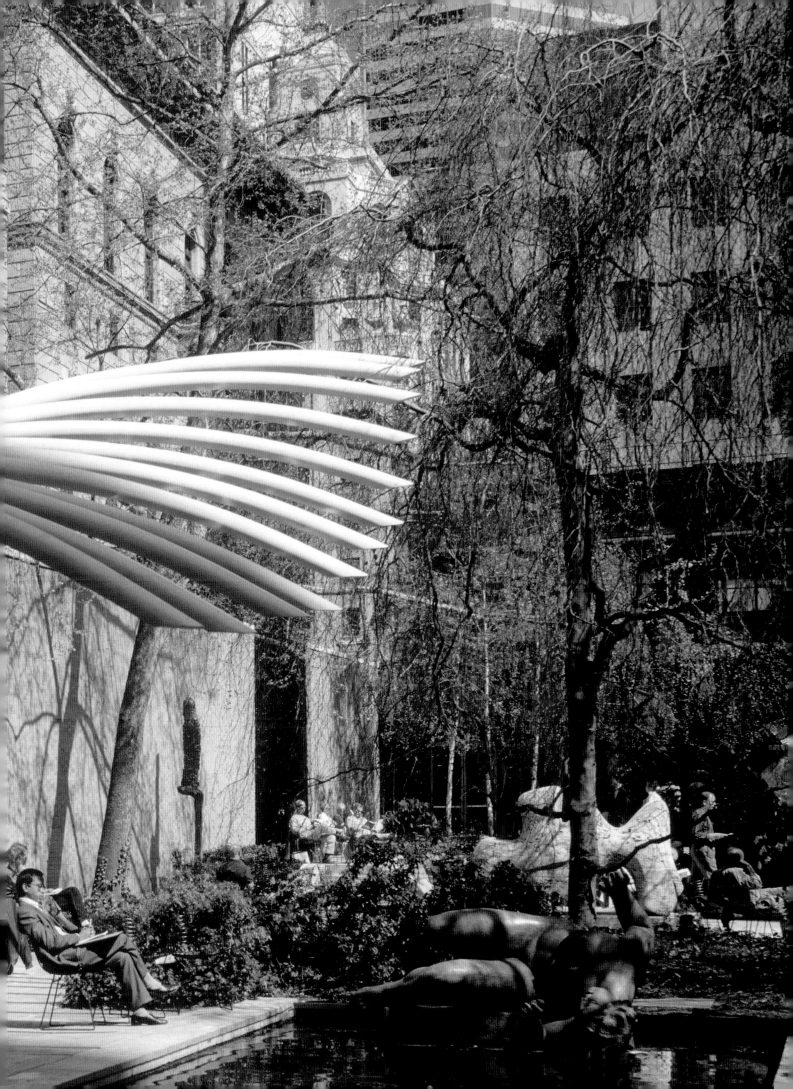

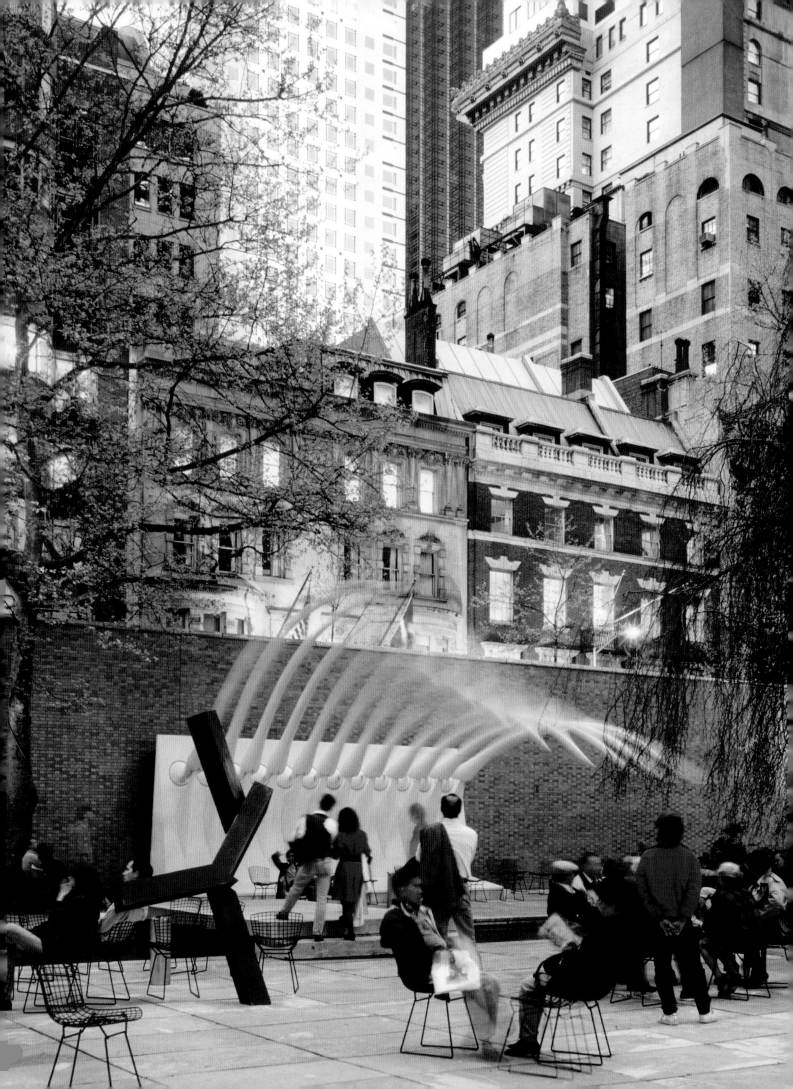

SHADOW MACHINE
Location
THE MUSEUM OF MODERN ART, NEW YORK, NEW YORK, USA
Client
MUSEUM OF MODERN ART
Sponsor
HOLDER BANK

With the backdrop of the New York skyline behind MoMA's sculpture court, the *Shadow Machine* is seen in this image in movement, blurred by time-lapse photography. Where architecture usually remains all too static, Calatrava gives life to his sculpture.

Mit der New Yorker Skyline hinter dem Skulpturengarten des MoMA ist die „Shadow Machine" auf dieser Abbildung in Bewegung und durch den verwendeten Zeitraffer überdies verschwommen zu sehen. Im Gegensatz zur gemeinhin allzu statischen Architektur erfüllt Calatrava seine Skulpturen mit Leben.

La *Shadow Machine* est montrée ici en action sur fond de paysage new-yorkais derrière le jardin des sculptures du MoMA. Alors que l'architecture reste en règle générale très statique, Calatrava donne vie à cette sculpture.

As part of a 1992 monographic exhibition at the Museum of Modern Art, Santiago Calatrava was able, through the support of a private Swiss bank, to create a kinetic sculpture he had originally designed for the Swissbau Concrete Pavilion in Basel (1988). Set in the Abby Aldrich Rockefeller Sculpture Garden designed in 1953 by Philip Johnson, the sculpture was made of 12 molded, precast concrete "fingers," each eight meters long and weighing 600 kilos. These ribs were set into a 30-ton rear support panel that had to be lowered into place over the back wall of the garden. Called "fingers" in part because of the ball and socket structure that allowed each rib to move, the sculpture was intended to create variable shadow patterns in the garden and was widely praised by visitors and the press. Because it did not have any discernable purpose, the *Shadow Machine* is more easily classified as a sculpture than as architecture, but it did put into use numerous principles of engineering and movement in design of which Calatrava has been a pioneer since his earliest work.

Als Teil der monografischen Ausstellung 1992 im Museum of Modern Art war es Santiago Calatrava durch die Unterstützung einer Schweizer Privatbank möglich, eine kinetische Skulptur zu realisieren, die er ursprünglich für den Swissbau Betonpavillon in Basel (1988) entworfen hatte. Die Skulptur, die im 1953 von Philip Johnson konzipierten Abby Aldrich Rockefeller Sculpture Garden aufgestellte wurde, besteht aus zwölf vorgefertigten Beton-„fingern", die jeweils 8 m lang sind und 600 kg wiegen. Diese Finger oder Rippen wurden in eine 30 t schwere, rückseitige Stützwand eingefügt, die über die rückwärtige Gartenmauer auf ihren Platz hinuntergelassen werden musste. Mithilfe der Finger, die ihre Beweglichkeit einer Kugelgelenkkonstruktion verdanken, sollte die Skulptur im Garten variable Schattenmuster werfen und stieß damit bei Besuchern und Presse auf breite Zustimmung. Da sie keinem erkennbaren Zweck dient, ist die „Shadow Machine" eher als Skulptur denn als Architektur einzustufen, obgleich sie zahlreiche Prinzipien von Technik und Bewegung im Design zur Anwendung bringt, in denen Calatrava von Anfang an wegweisend war.

Dans le cadre d'une exposition monographique organisée en 1992 au Museum of Modern Art de New York, Santiago Calatrava, grâce au soutien d'une banque suisse, a pu réaliser la sculpture cinétique qu'il avait conçue à l'origine pour le Pavillon du béton du salon Swissbau à Bâle en 1988. Placée dans le Abby Aldrich Rockefeller Sculpture Garden conçu en 1953 par Philip Johnson, cette œuvre se compose de douze « doigts » moulés en béton précontraint de 8 mètres de long et de 600 kg chacun. Ils ont été rattachés à un panneau de 30 tonnes mis en place en passant par-dessus le mur du jardin. Appelés « doigts » à cause des articulations qui leur permettaient de bouger, ces éléments qui modulaient l'ombre en fonction du soleil furent énormément appréciés par les visiteurs et par la presse. Parce que sa fonction n'est pas évidente d'emblée, cette *Shadow Machine* (Machine à ombre) est plus facilement classée dans la catégorie sculpture qu'architecture, mais elle met en pratique un certain nombre de principes d'ingénierie et de dynamique dont Calatrava s'est fait le pionnier dès ses premiers travaux.

The installation of the *Shadow Machine* in the sculpture court of the Museum of Modern Art is no small homage to the talents of Santiago Calatrava, not only as an architect but also as a sculptor. His sketches (this page) again emphasize the sense of motion and the profound relationship to the human body that permeates his work.

Die Aufstellung der „Shadow Machine" im Skulpturenhof des Museum of Modern Art ehrt Santiago Calatrava nicht nur als Architekt, sondern auch als Bildhauer. Seine Skizzen (diese Seite) zeichnen sich wiederum aus durch ein sein Werk durchdringendes Gefühl für Bewegung und ein profundes Verhältnis zum menschlichen Körper.

L'installation de la *Shadow Machine* au MoMA n'est pas un mince hommage au talent de Santiago Calatrava, celui de l'architecte mais aussi celui du sculpteur. Ses croquis (ci-contre et ci-dessous) soulignent une fois de plus le sens de mouvement et la relation profonde avec le corps humain qui marquent son œuvre.

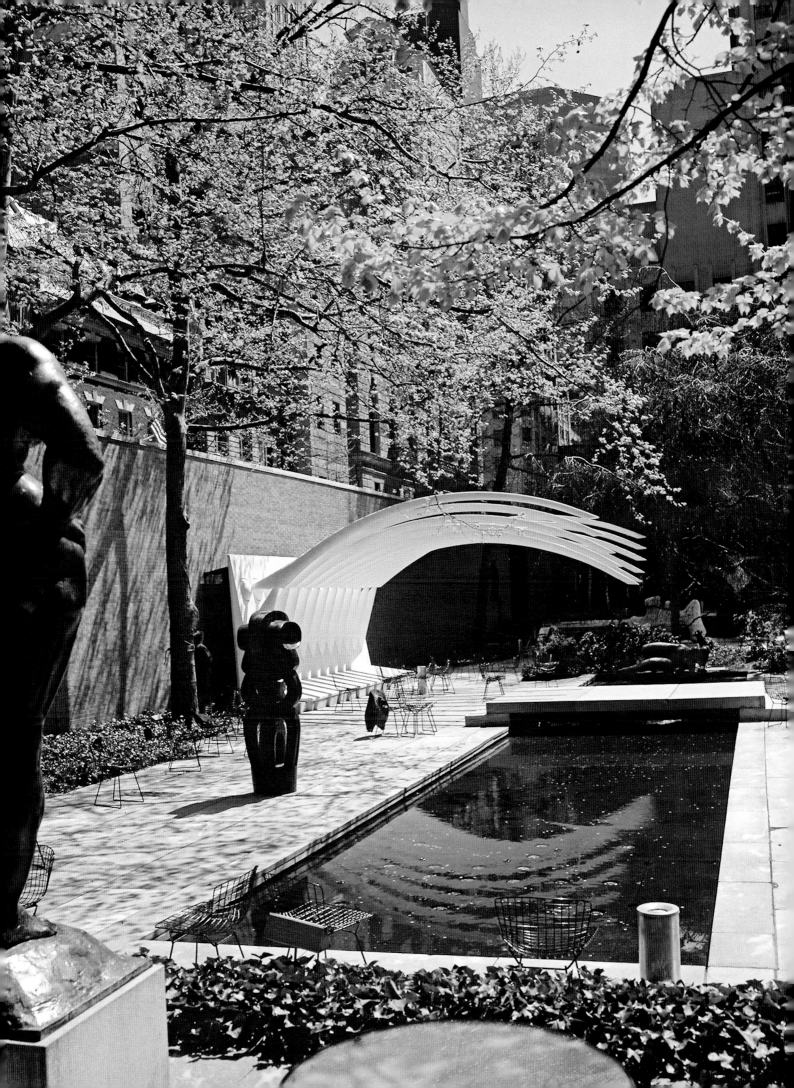

Installed in Venice, the work becomes a metaphor for waves, undulating like the city's canals. This natural metaphor, not obvious in the courtyard of MoMA, forcefully underlines the roots of Calatrava's designs in the shared vocabulary of the living world.

Das in Venedig aufgestellte Werk wird zur Metapher für Wellen indem es die Bewegung der städtischen Kanäle aufgreift. Die im Garten des MoMA nicht offenkundige Naturmetapher unterstreicht eindringlich die Wurzeln von Calatravas Ideen im gemeinsamen Vokabular der belebten Welt.

Installée à Venise, l'œuvre est devenue une métaphore des vagues, ondulant comme l'eau des canaux de la cité. Cette métaphore naturelle, qui n'était pas évidente dans la cour du MoMA, met en valeur les racines des recherches de Calatrava dans le vocabulaire expressif du monde du vivant.

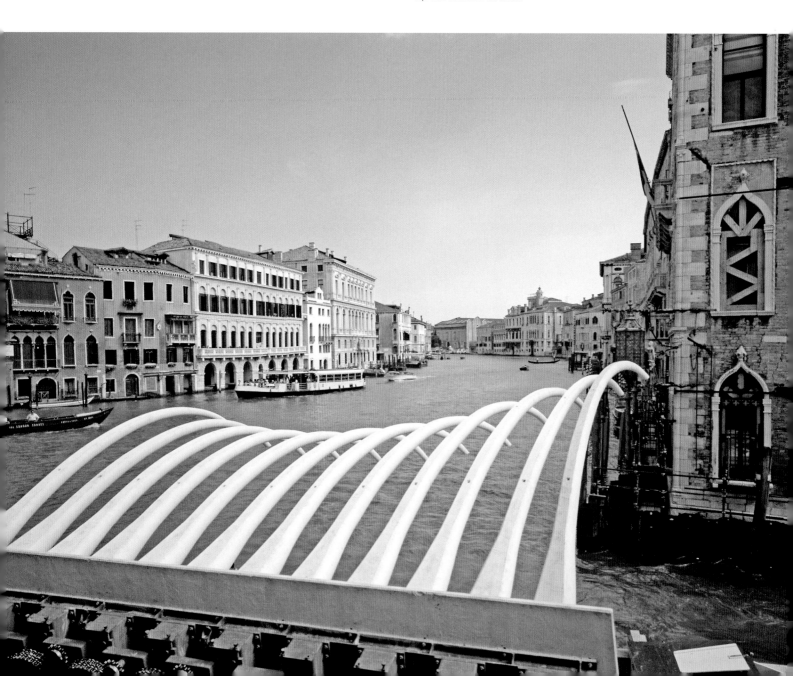

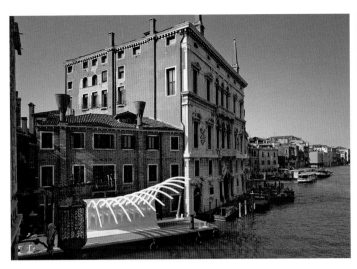

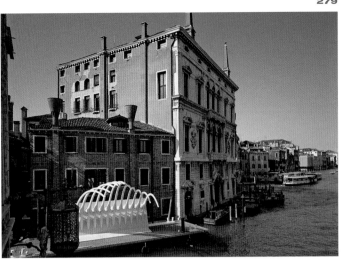

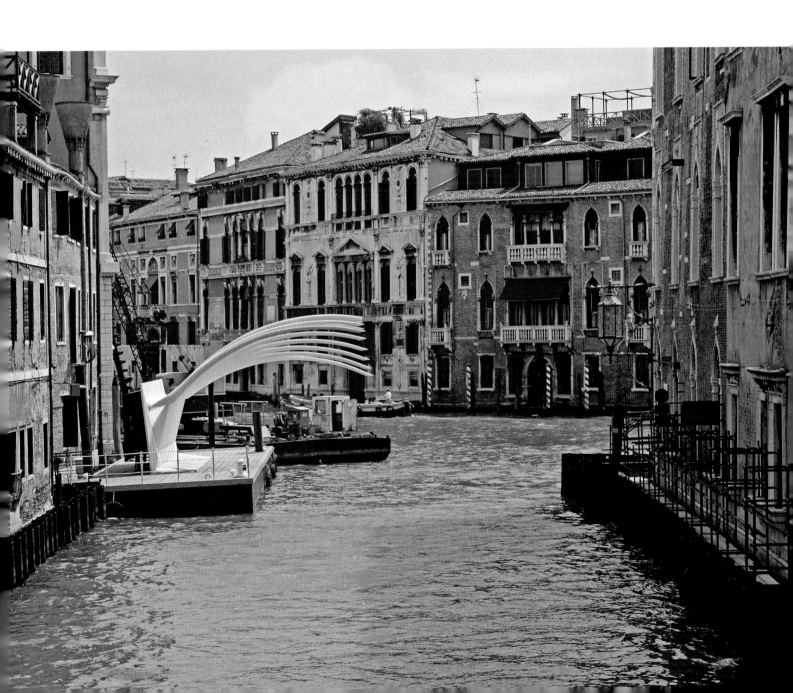

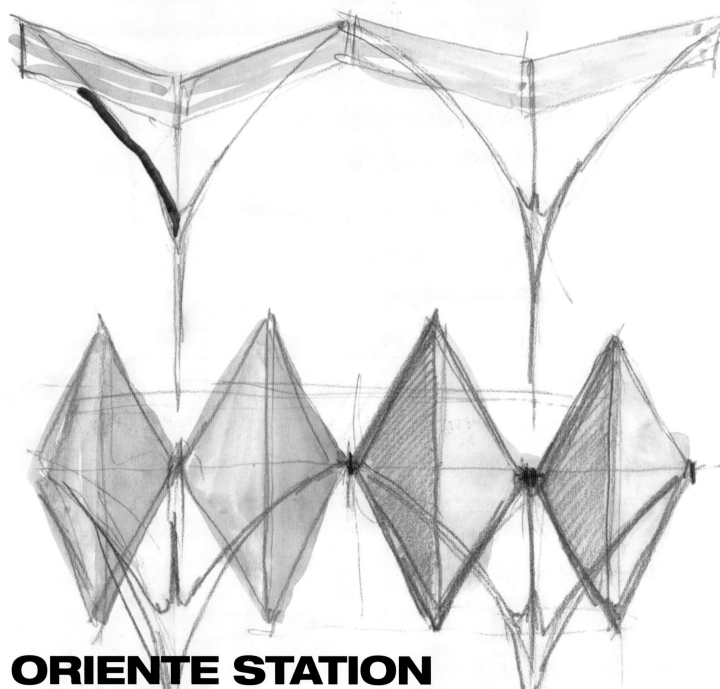

Comparacion destructuras móviles con la naturaleza

ARBOLES BAUSCHANZLY

ORIENTE STATION

Lisbon, Portugal. 1993–1998.

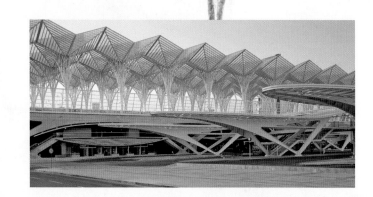

el sistema estático del árbol

arbol
seco

Arboles de la estación de Lisboa, dinámica contemplativa de estación terminal, síntesis de geometría y movimiento relativo de las partes entre sí

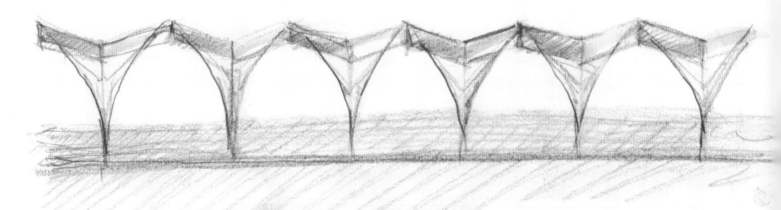

VER MUSEO CIUDAD DE LAS CIENCIAS DE VALENCIA

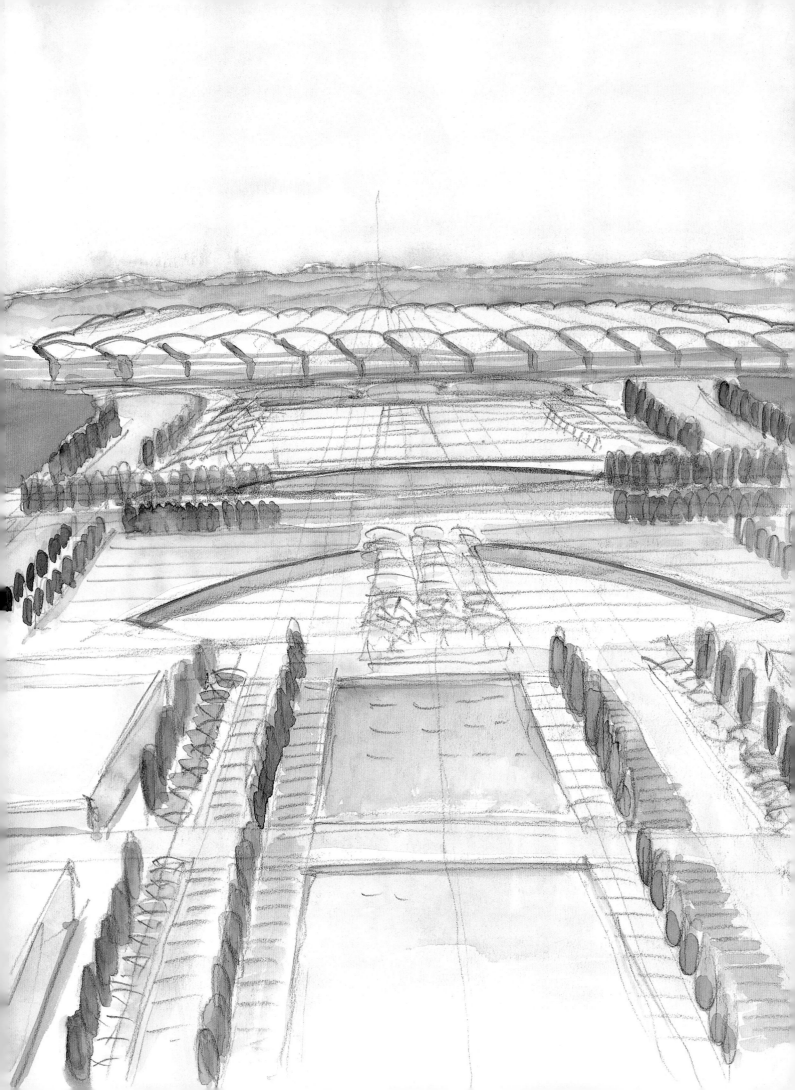

Project
ORIENTE STATION
Location
LISBON, PORTUGAL
Client
G.I.L. EXPO '98

In this sketched overview of the new station, the architect presents an almost Arcadian view of what was to become a much more dense urban site. Nonetheless, his idea of "trees on a hill" remained the guiding force in the design.

Auf dieser Skizze präsentiert der Architekt eine beinahe arkadische Vision des neuen Bahnhofs, der heute in weitaus dichterer Bebauung steht. Gleichwohl blieb sein Gedanke von „Bäumen auf einem Hügel" die treibende Kraft dieses Entwurfs.

Dans ce croquis d'ensemble de la nouvelle gare, l'architecte offre une vision presque arcadienne d'un site urbain qui va pourtant subir une forte densification. Malgré tout, son idée des « arbres sur une colline » reste le thème directeur du projet.

Part of an ambitious plan concerning the Universal Exposition of 1998 that was held in the Portuguese capital, this new train station is located in a former industrial zone about five kilometers from the historic center of Lisbon, not far from the broad Tagus River. The most spectacular aspect of the project is undoubtedly the 78 x 238-meter covering over the eight raised railway tracks whose typology might recall that of a forest. The architect, winner of an invited competition, was obliged to make do with the existing tracks, set up on a nine-meter-high embankment. Rather than emphasizing the break between the city and the river implied by the station, Calatrava has sought, here as elsewhere, to open passageways and re-establish links. Prior to the station's construction, the railway tracks had marked a distinct barrier between the residential and industrial parts of the city. The new complex includes two large glass and steel awnings over the openings, measuring no less than 112 meters in length and 11 meters in width. There is a bus station and car park, a metro station below, and a longitudinal gallery including commercial spaces included in Calatrava's brief. Ticketing and service facilities are located five meters below the tracks, with an atrium marking the longitudinal gallery five meters lower, and the opening on the river side intended as the main access point, serving the area that has developed subsequent to the 1998 event. As the architect concludes, "Conceived as the Expo's primary transport connection, Oriente Station has proven to be the main component in the transformation of the area. It has become one of Europe's most comprehensive transport nodes: an important interchange for high-speed intercity trains, rapid regional transport, standard rail services, and tram and metro networks."

Dieser neue Bahnhof ist Teil einer ambitionierten Planung im Zusammenhang mit der Expo 1998, die in der portugiesischen Hauptstadt stattfand. Er liegt in einem ehemaligen Industriegebiet, etwa 5 km vom historischen Zentrum Lissabons entfernt, unweit des breiten Flusses Tejo. Der eindrucksvollste Teil des Projekts ist zweifellos die 78 x 238 m große Überdachung über den acht erhöhten Bahngleisen, die mit ihren filigranen Verzweigungen an ein Wäldchen erinnert. Calatrava, der einen geschlossenen Wettbewerb gewonnen hatte, musste mit den vorhandenen, auf einer 9 m hohen Böschung verlaufenden Gleisanlagen arbeiten. Anstatt nun die von den Bahnanlagen hervorgerufene Trennung zwischen Stadt und Fluss zu unterstreichen, war er hier wie anderswo bestrebt, Durchgänge zu öffnen und Verbindungen wieder herzustellen. Vor der Erbauung des Bahnhofs hatten die Bahngleise eine deutliche Barriere zwischen den Wohngebieten und dem industriell

genutzten Teil der Stadt dargestellt. Der neue Komplex umfasst zwei großflächige Schutzdächer aus Stahl und Glas über den Zugängen, die beide nicht weniger als 112 m lang und 11 m breit sind. Zu Calatravas Auftrag gehörten außerdem ein Busbahnhof und ein Parkhaus, eine unterirdische U-Bahnstation sowie eine lang gestreckte Galerie, die auch Ladengeschäfte umfasst. Fahrkartenschalter und Dienstleistungen sind 5 m unterhalb der Gleisanlage untergebracht; ein Atrium zeigt die weitere 5 m tiefer liegende Galerie an. Die zum Fluss hin gelegene Erschließung ist als Hauptzugang vorgesehen und dient dem Gebiet, das sich hier seit der Expo entwickelt hat. Abschließend äußert sich der Architekt: „Konzipiert als der Hauptverkehrsknotenpunkt der Expo, erwies sich der Bahnhof Oriente als wichtigste Komponente bei der Umgestaltung der Gegend. Er wurde zu einem der bedeutendsten Verkehrsknotenpunkte Europas für Hochgeschwindigkeitszüge, die zwischen Großstädten verkehren, für schnelle Regionalzüge, normale Eisenbahndienste sowie Straßen- und U-Bahnen."

Élément d'un vaste programme lié à l'Exposition mondiale de Lisbonne (1998), cette nouvelle gare ferroviaire est située dans une ancienne zone industrielle, à cinq kilomètres environ du centre historique de la capitale, à proximité du Tage. L'aspect le plus spectaculaire de ce projet est sans aucun doute la couverture (238 x 78 mètres) des huit voies surélevées dont la typologie peut évoquer une forêt. L'architecte, qui a remporté le concours restreint, devait tenir compte des voies existantes passant sur un talus de neuf mètres de haut qui constituait une barrière entre la partie résidentielle de la ville et les rives du Tage. Plutôt que d'accentuer cette rupture entre la ville et le fleuve, Calatrava a cherché ici, comme souvent, à ouvrir des passages et à rétablir des liens. Le nouveau complexe comprend deux immenses auvents de verre et d'acier de 112 x 11 mètres suspendus au-dessus des entrées. Le cahier des charges incluait également une gare routière, un parking, une station de métro et une galerie commerciale souterraine tout en longueur. Les guichets sont situés à cinq mètres sous les quais, ainsi qu'un atrium signalant la galerie commerciale cinq mètres plus bas. L'ouverture côté fleuve, principal point d'accès, dessert la zone qui a connu un fort développement depuis l'Exposition. Comme l'explique l'architecte : « Conçue comme le principal site de correspondances de transports de l'Expo, la gare de l'Orient est devenue un facteur essentiel de la transformation de ce secteur, l'une des plates-formes d'échanges entre les trains à grande vitesse, les transports rapides régionaux, les trains classiques, le tram et le réseau de métro les plus complètes d'Europe. »

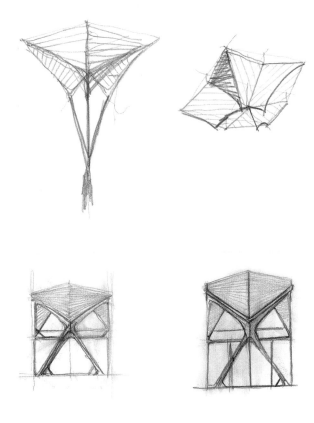

The surprising sketches above relate some of Calatrava's structural designs to the position of the crucifixion. So too might the image of a bird, or of da Vinci's "Vitruvian Man" come to mind. These references and others are sublimated while somehow remaining present enough to elicit the viewer's adhesion.

Die Skizzen oben stellen eine Verbindung zwischen Calatravas baulichen Entwürfen und der Darstellung einer Kreuzigung her. Ebenso könnte man an einen Vogel oder an Da Vincis Proportionsstudie nach Vitruv denken. Diese Bezüge sind auf eine höhere Ebene verlagert, wenngleich sie präsent genug bleiben, um die Aufmerksamkeit des Betrachters zu fesseln.

Les surprenants croquis ci-dessus font le lien entre certains projets structurels de l'architecte et la crucifixion. Un oiseau ou l'homme de Vitruve par Léonard de Vinci peuvent également venir à l'esprit. Ces références, et d'autres, sont sublimées tout en restant d'une certaine façon assez présentes pour emporter l'adhésion du spectateur.

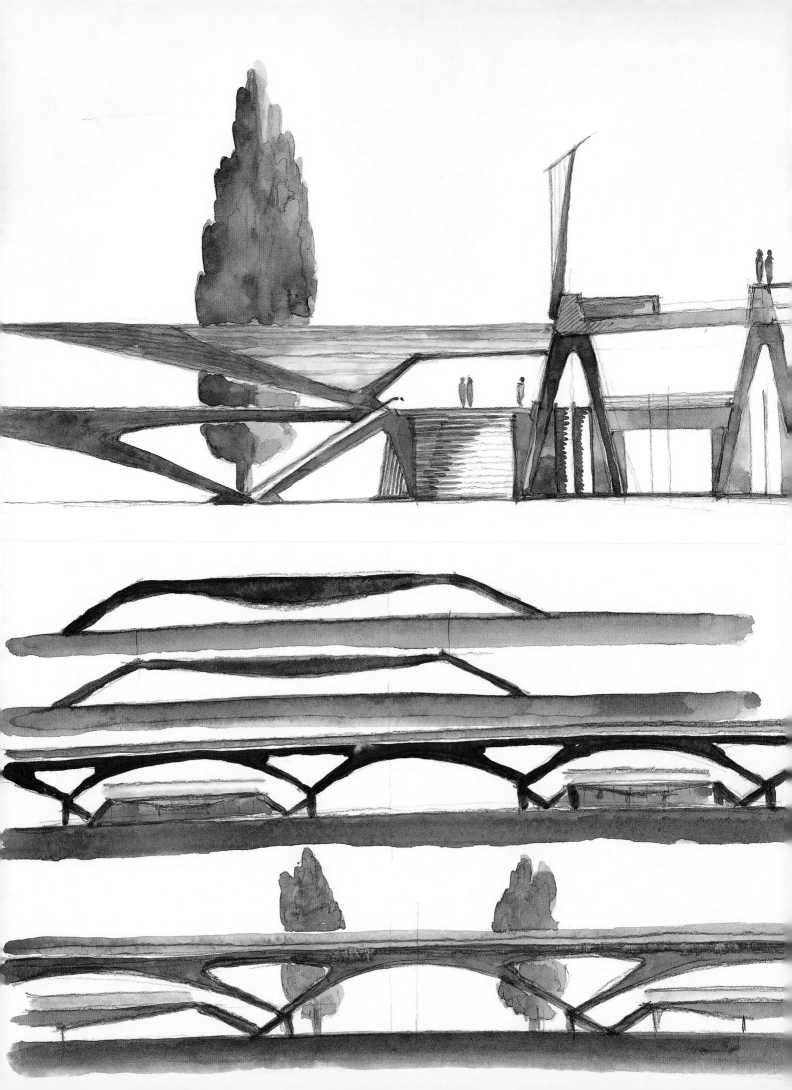

The situation of the Lisbon Oriente Station dictated that the railway lines be located above the entrance level, in something of an inversion of the typical relation. The architect's sketches explore solutions that allow for this difference of level while maintaining a fundamental lightness.

Die Lage des Lissabonner Bahnhofs Oriente brachte es mit sich, dass die Gleise in Umkehrung der üblichen Verhältnisse oberhalb der Eingangsebene verlaufen. In seinen Skizzen sondiert der Architekt Lösungen für diesen Niveauunterschied, behält jedoch immer die grundsätzliche Leichtigkeit bei.

La localisation de la gare de l'Orient à Lisbonne déterminait le passage des voies audessus du niveau de l'entrée, soit l'inversion, en quelque sorte, du schéma habituel. Les croquis de l'architecte explorent des solutions qui prennent en compte cette différence de niveaux tout en conservant leur légèreté fondamentale.

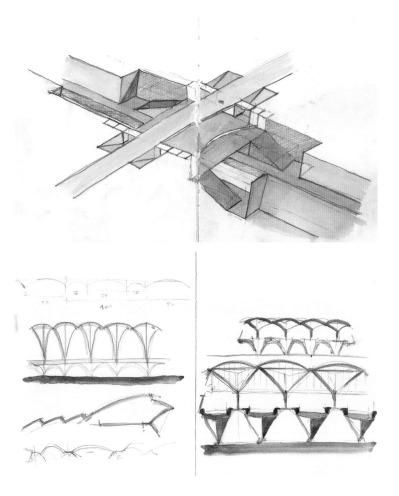

In aligning his treelike forms on the top of the elevated railway platform, the architect makes reference to a poem by Fernando Pessoa, but also to his own spontaneous thought that such a hillside, whether natural or artificial, should be covered with trees.

Indem er seine baumartigen Formen auf dem erhöhten Bahnsteig in Reih und Glied ausrichtet, nimmt er Bezug auf ein Gedicht Fernando Pessoas, aber ebenso auf einen eigenen Gedanken, demzufolge ein Hang, gleich ob natürlich oder künstlich, mit Bäumen bestanden sein sollte.

En alignant ces silhouettes ressemblant à des arbres au sommet des quais surélevés de la gare, l'architecte se réfère à un poème de Fernando Pessoa, mais aussi à sa propre réflexion, laquelle lui dicte qu'un flanc de colline, artificielle ou naturelle, doit être planté d'arbres.

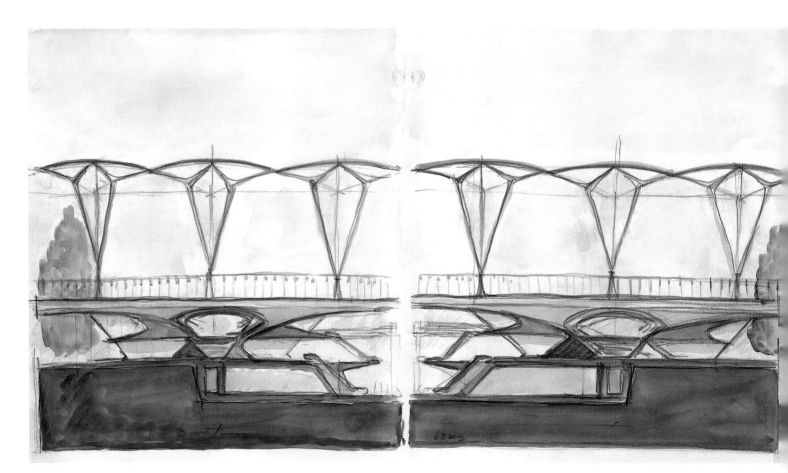

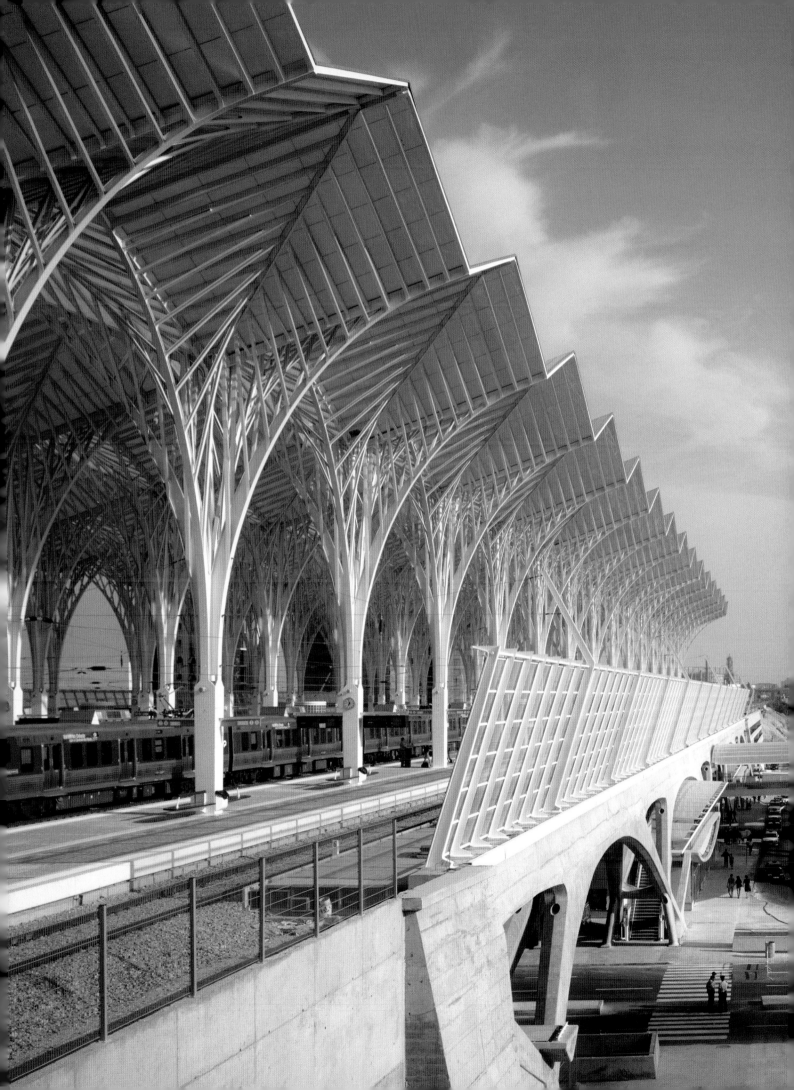

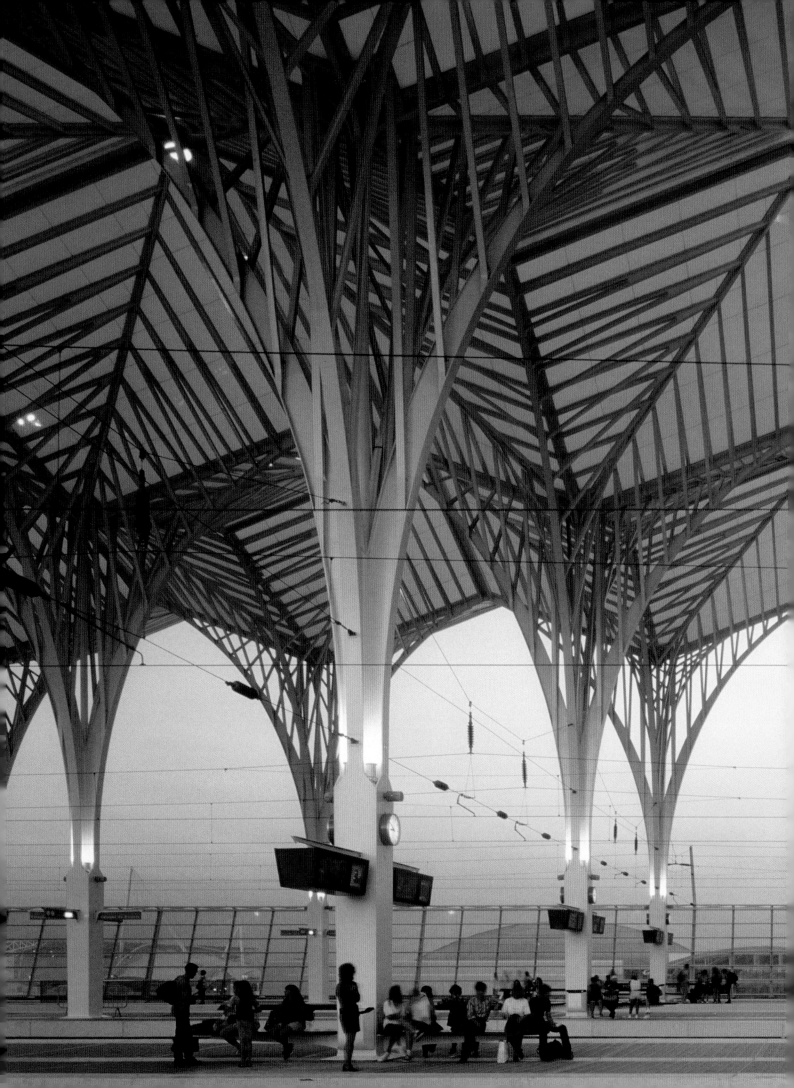

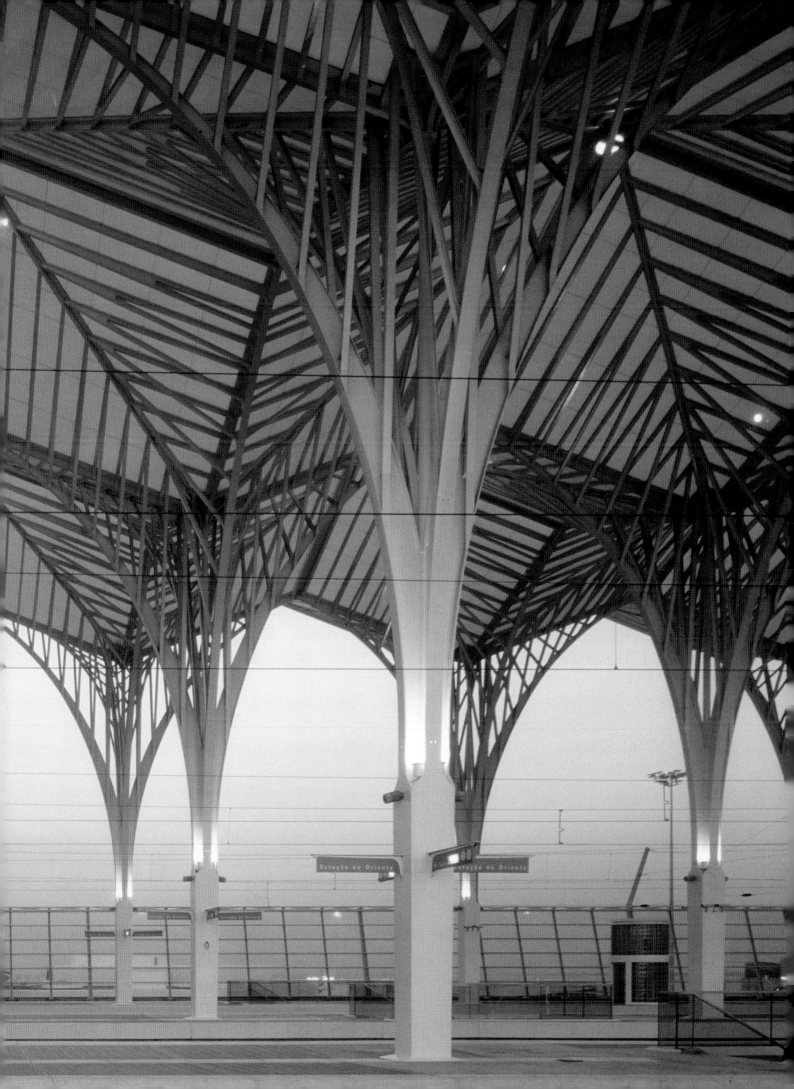

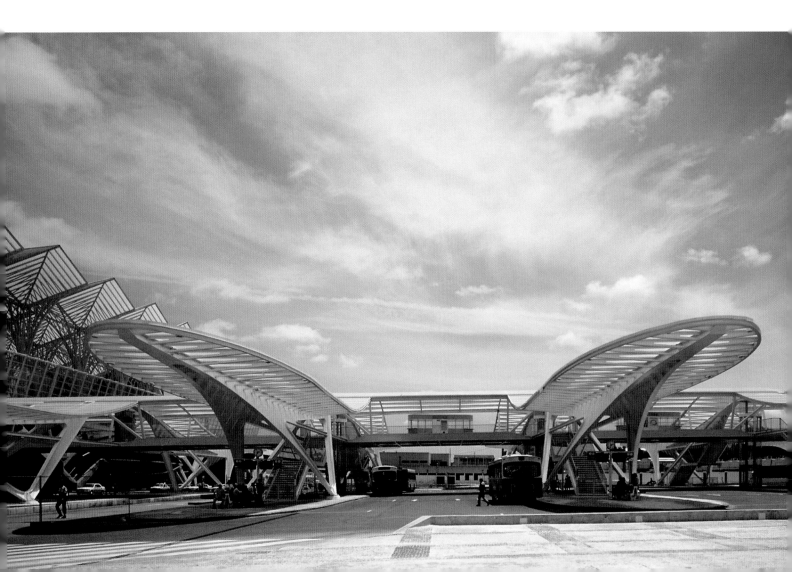

The sharply angled supports of the station inevitably give it a sensation of movement, but Calatrava's own sketch (above) highlights a kind of human movement that might not have immediately come to mind. Once seen, this sketch is difficult to forget when viewing the architecture.

Die geneigten Stützen des Bahnhofs verleihen ihm eine bewegte Anmutung, aber Calatravas Skizze (oben) hebt eine Art menschlicher Bewegung heraus, die vielleicht nicht unmittelbar aufgefallen wäre. Danach fällt es allerdings schwer, diese Skizze beim Anblick des Gebäudes zu vergessen.

Les supports fortement inclinés de la gare créent inévitablement un sentiment de mouvement, mais le croquis de Calatrava (ci-dessus) met l'accent sur une sorte de mouvement humain dont la perception n'était pas évidente au premier coup d'œil. Ce croquis est difficile à oublier voyant le projet achevé.

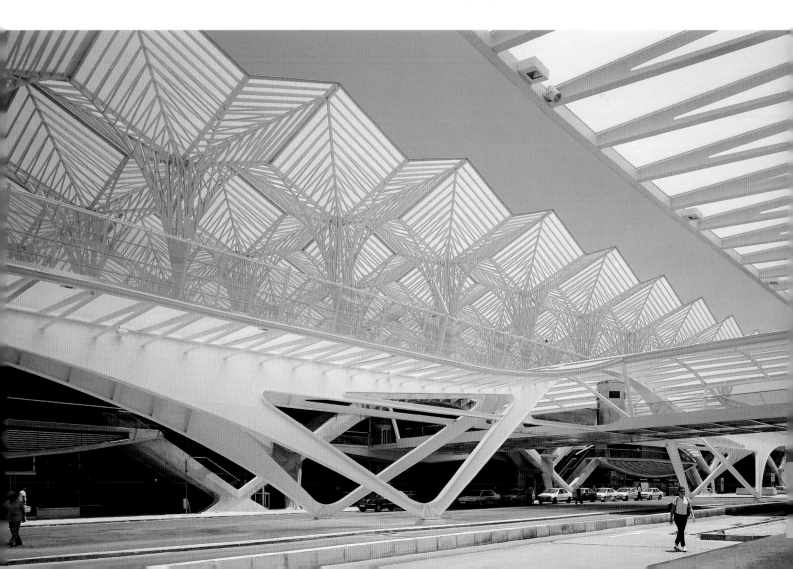

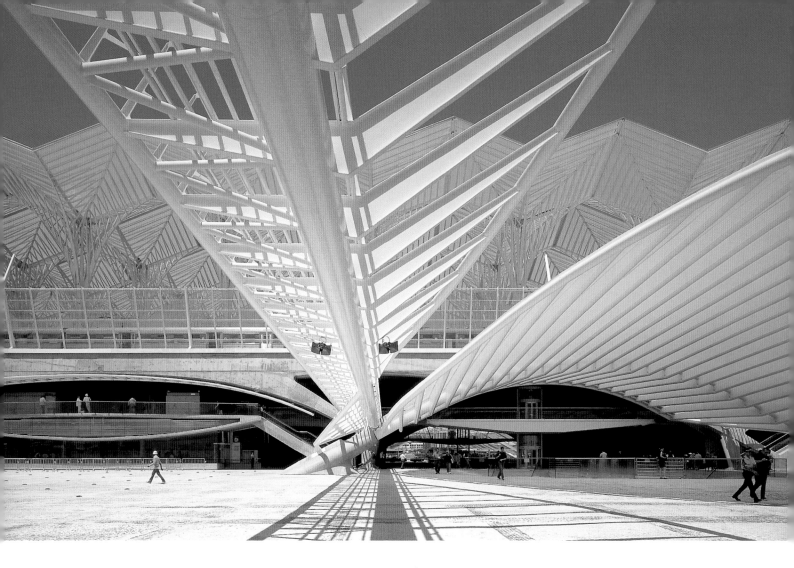

Again avoiding any hint of the displaced monumentality while dealing with a very large surface, the architect rather emphasizes a light beauty that is surely confirmed by his consistent use of light colors, and in particular white.

Wiederum gelingt es Calatrava, beim Umgang mit einer sehr großen Oberfläche ohne Monumentalität auszukommen und stattdessen auf lichte Schönheit zu setzen, die durch den Einsatz von hellen Farben, insbesondere von Weiß, noch unterstrichen wird.

Évitant une fois encore toute allusion à la monumentalité pour traiter ces énormes surfaces, l'architecte préfère mettre en valeur une beauté toute de légèreté que vient souligner l'utilisation récurrente de couleurs pâles, et en particulier du blanc.

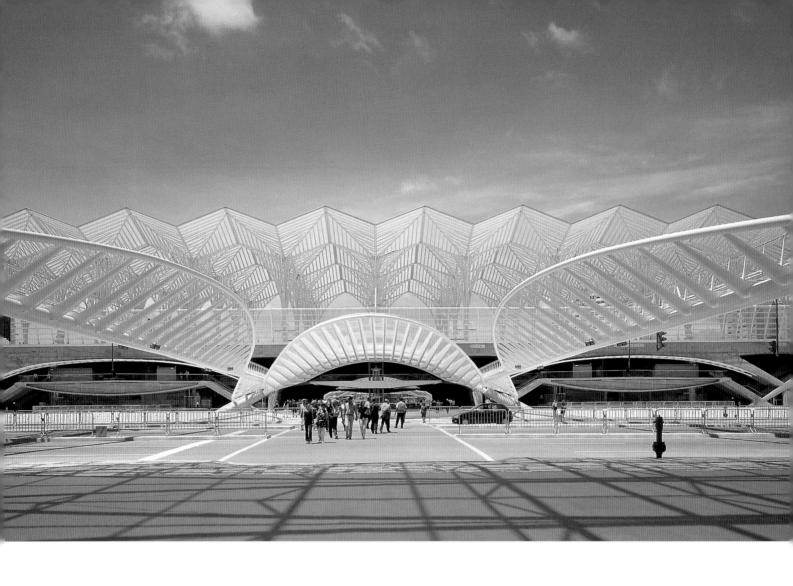

The tree columns of the station platform might be more complex than they really need to be, but this complexity lends itself to the play of light and variety of visual experiences offered to the everyday commuter.

Die baumartigen Pfeiler des Bahnsteigs mögen vertrackter als nötig sein, aber ihr komplexer Aufbau sorgt für das Spiel des Lichts und die Vielfalt visueller Erfahrungen, die der Berufspendler dort erleben kann.

Les colonnes en forme d'arbres du quai de la gare sont peut-être plus complexes que nécessaires, mais cette complexité se prête au jeu de la lumière et offre une diversité d'effets visuels au voyageur quotidien.

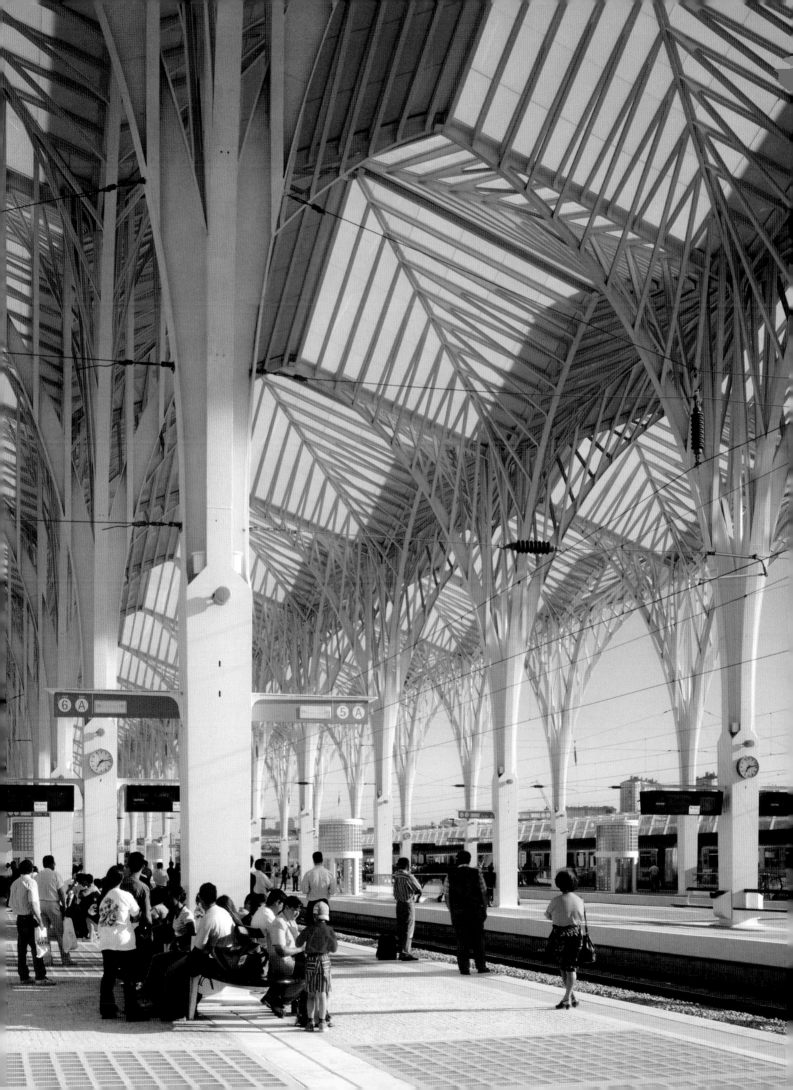

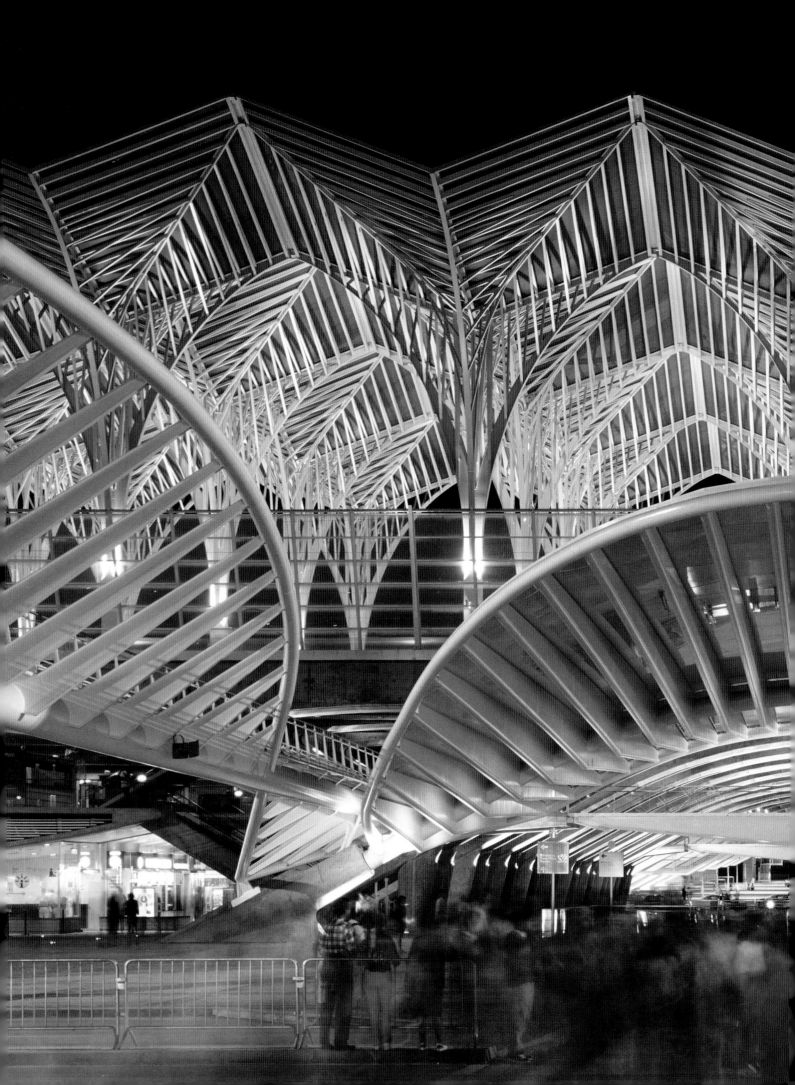

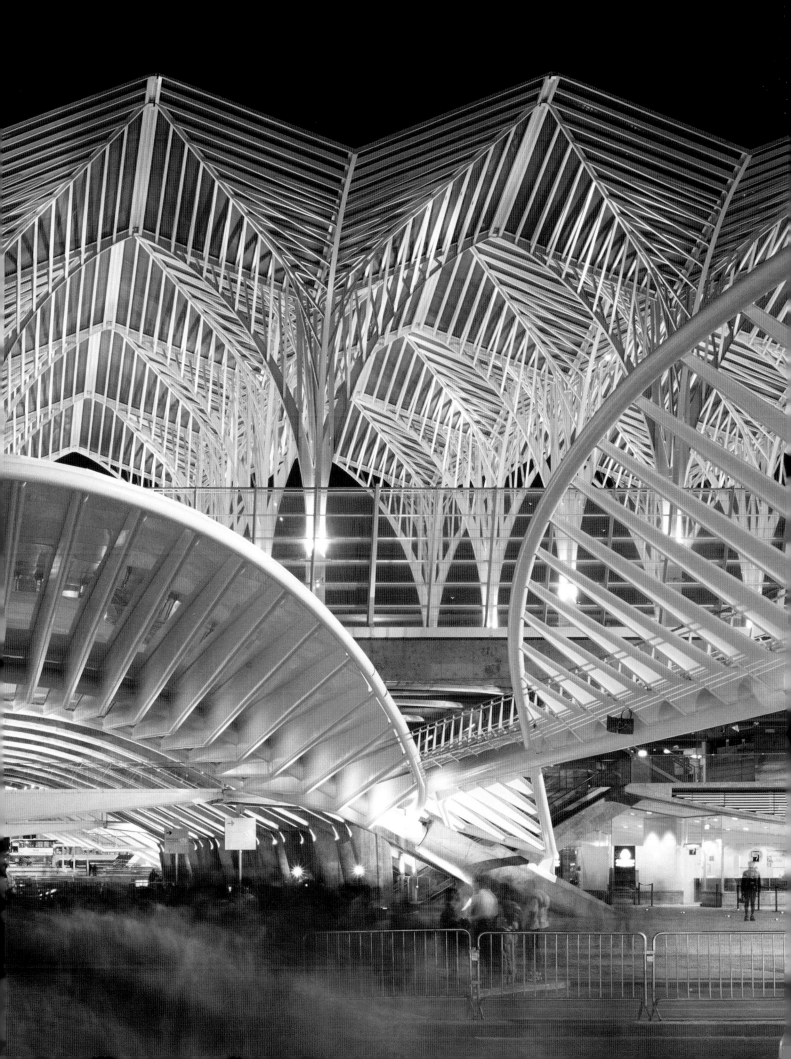

Successive ribs, like those seen in numerous other Calatrava projects, cover the Oriente Station galleries (right). Offering large, column-free spaces under structures designed to accept the very considerable weight of trains, the architect makes engineering seem effortless.

Wie in zahlreichen anderen Projekten Calatravas sind auch die Galerien des Bahnhofs Oriente von nebeneinander angeordneten Rippen überfangen (rechts). Unter baulichen Gefügen, die das beträchtliche Gewicht von Zügen tragen sollen, stehen großflächige, stützenfreie Räume zur Verfügung und die Technik erscheint problemlos.

Des successions de nervures, comme dans de nombreux autres projets de l'architecte, recouvrent les galeries de la gare de l'Orient (à droite). En créant ces vastes volumes sans colonne sous une structure conçue pour supporter le poids considérable des trains, l'architecte semble effacer toute notion d'effort.

halle

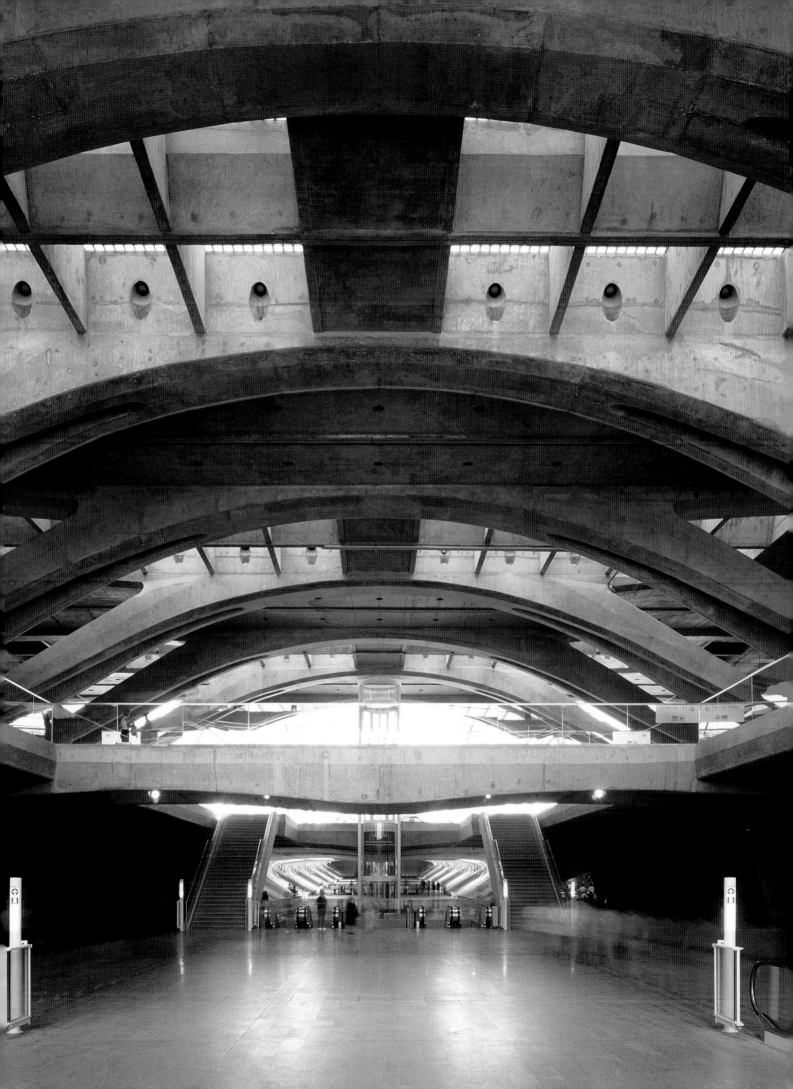

Where a few ugly, thick columns might have done the trick, Calatrava skews his supports and gives his entire design an apparent disequilibrium that never seems threatening.

Da, wo es auch ein paar hässliche, plumpe Stützen getan hätten, stellt Calatrava seine Pfeiler schräg und verleiht dem ganzen Bau ein scheinbares Ungleichgewicht, das jedoch nie bedrohlich wirkt.

Alors que quelques grosses colonnes épaisses auraient pu faire l'affaire, Calatrava effile ses supports et confère à son projet une impression de déséquilibre qui n'est jamais menaçant.

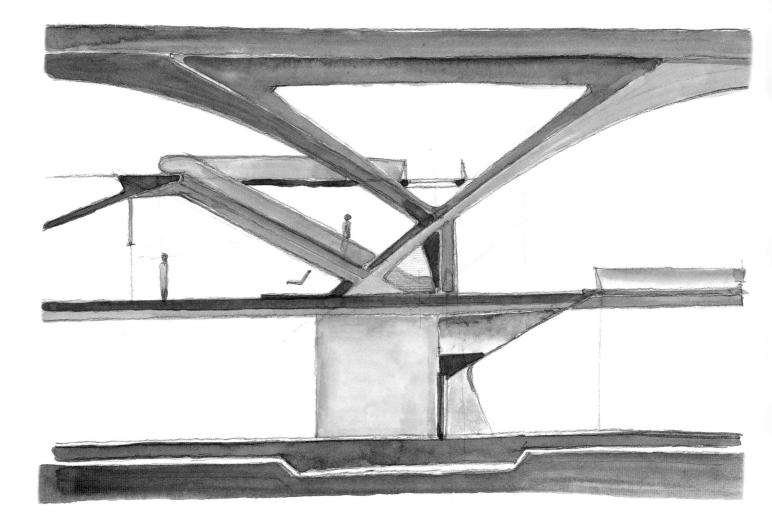

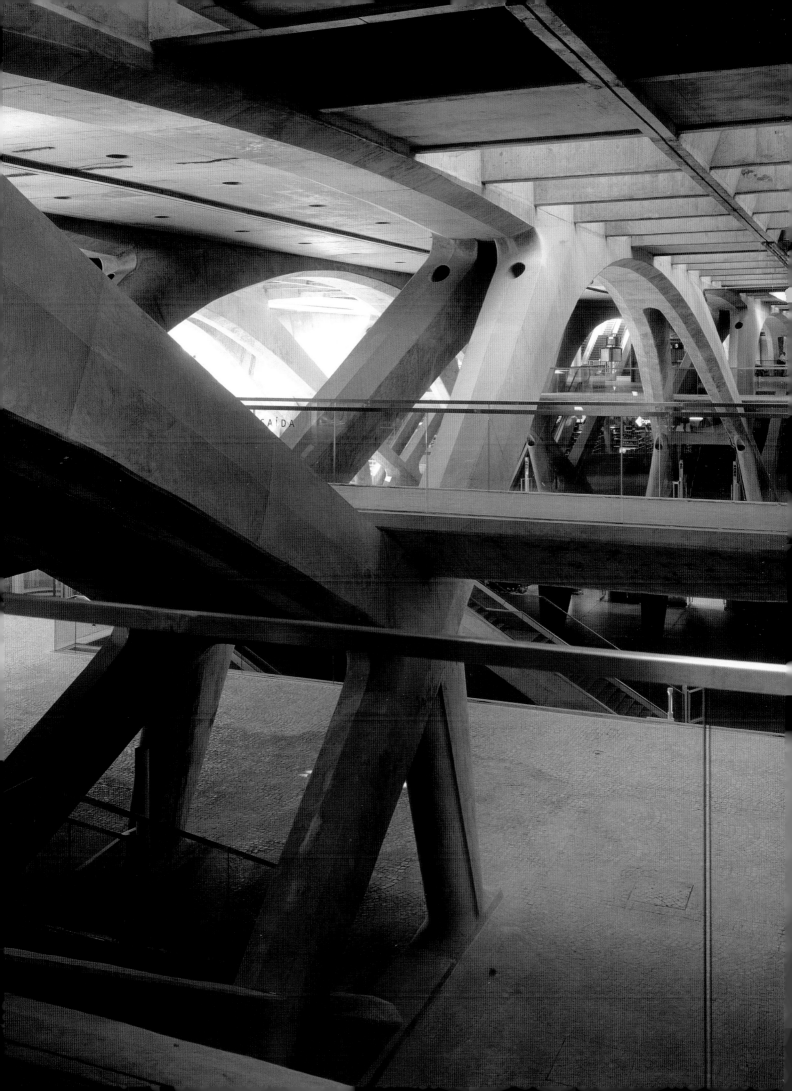

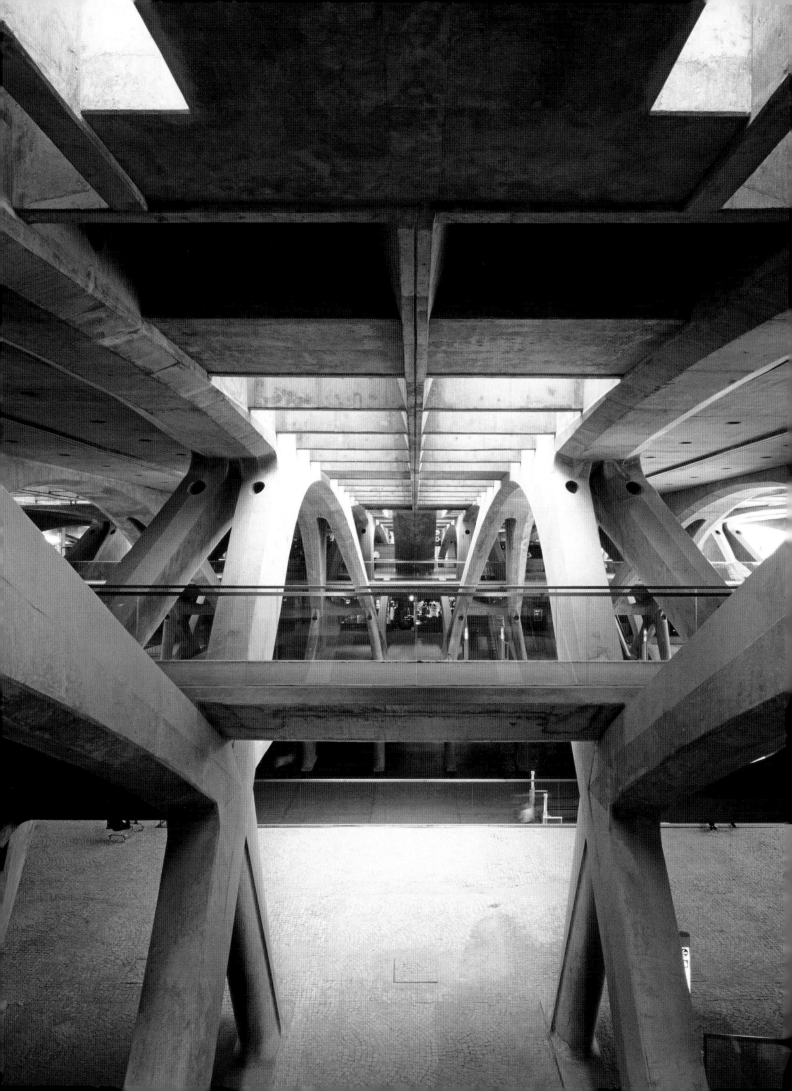

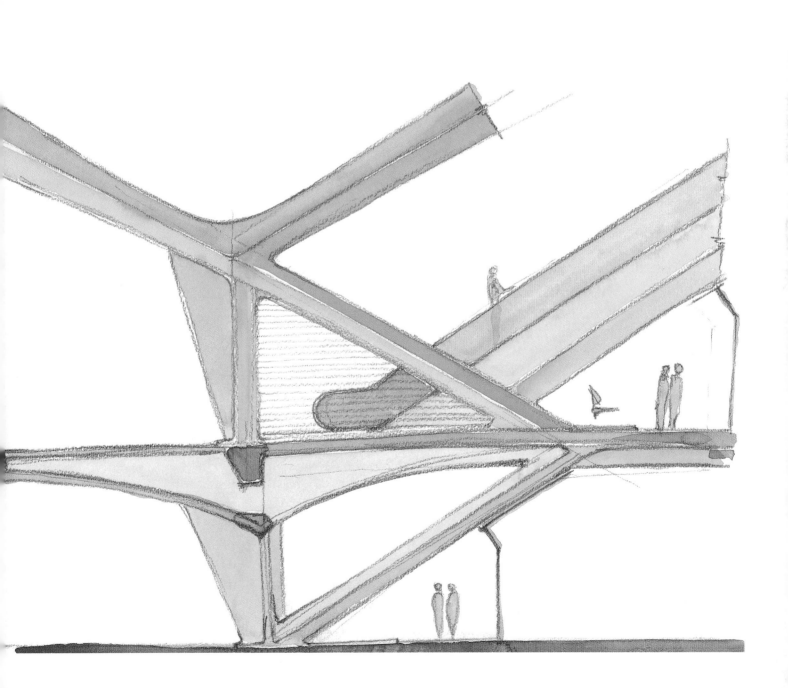

Because his shapes are often inspired by the human body in movement, it seems perfectly natural to move through these spaces, where light is the other essential element.

Da seine Formen häufig vom menschlichen Körper in Bewegung inspiriert sind, scheint es vollkommen natürlich, sich durch diese Räume zu bewegen, in denen Licht ein weiteres wesentliches Element ist.

Parce que les formes de Calatrava sont souvent inspirées du corps humain en mouvement, les déplacements dans ces espaces se font de façon parfaitement naturelle. La lumière y joue, aussi, un rôle essentiel.

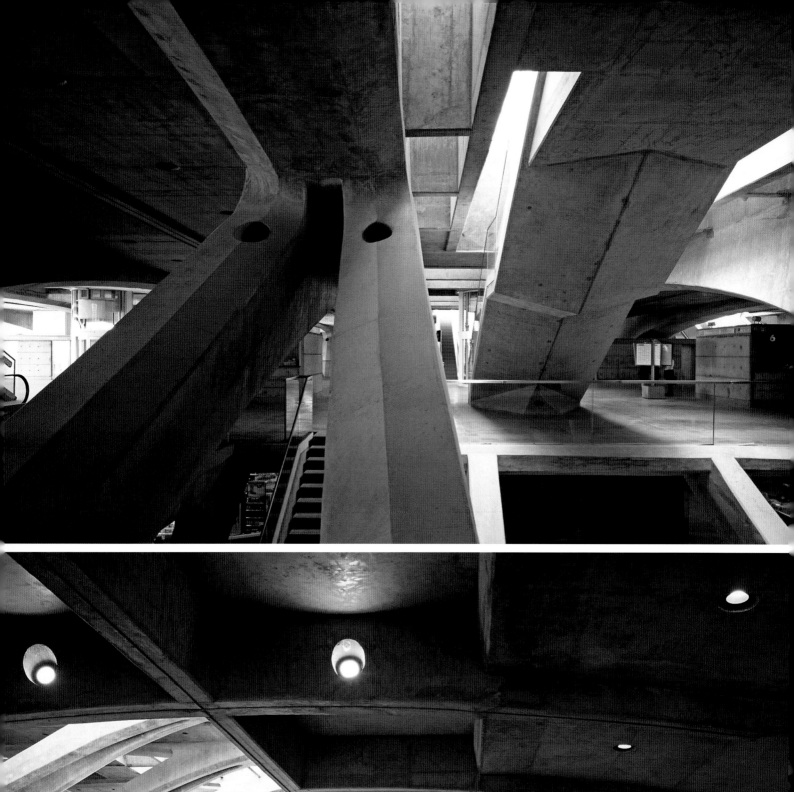
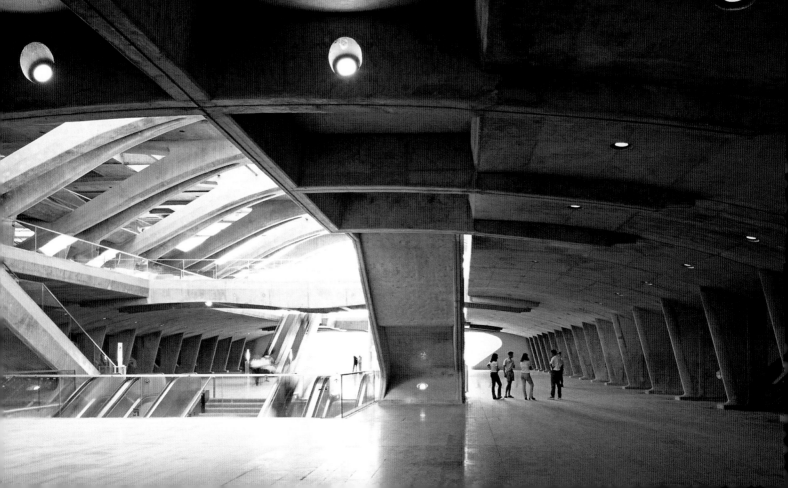

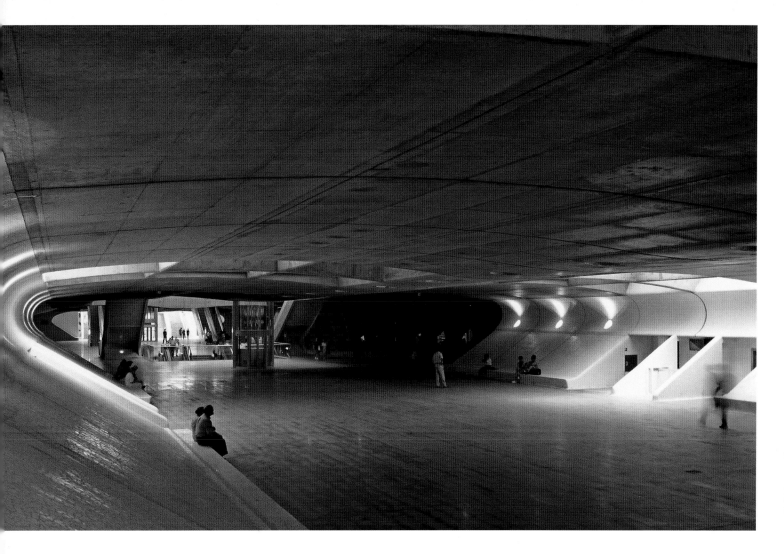

In the galleries of the station, Calatrava achieves a kind of dynamic solidity, an architecture that is at once firm and yet also abstract.

In den Galerien des Bahnhofs erreicht Calatrava eine Art dynamischer Festigkeit, eine Architektur, die gleichzeitig beständig und doch auch abstrakt ist.

Dans les galeries de la gare, Calatrava donne forme à une sorte de massivité dynamique. C'est une architecture à la fois solide et abstraite.

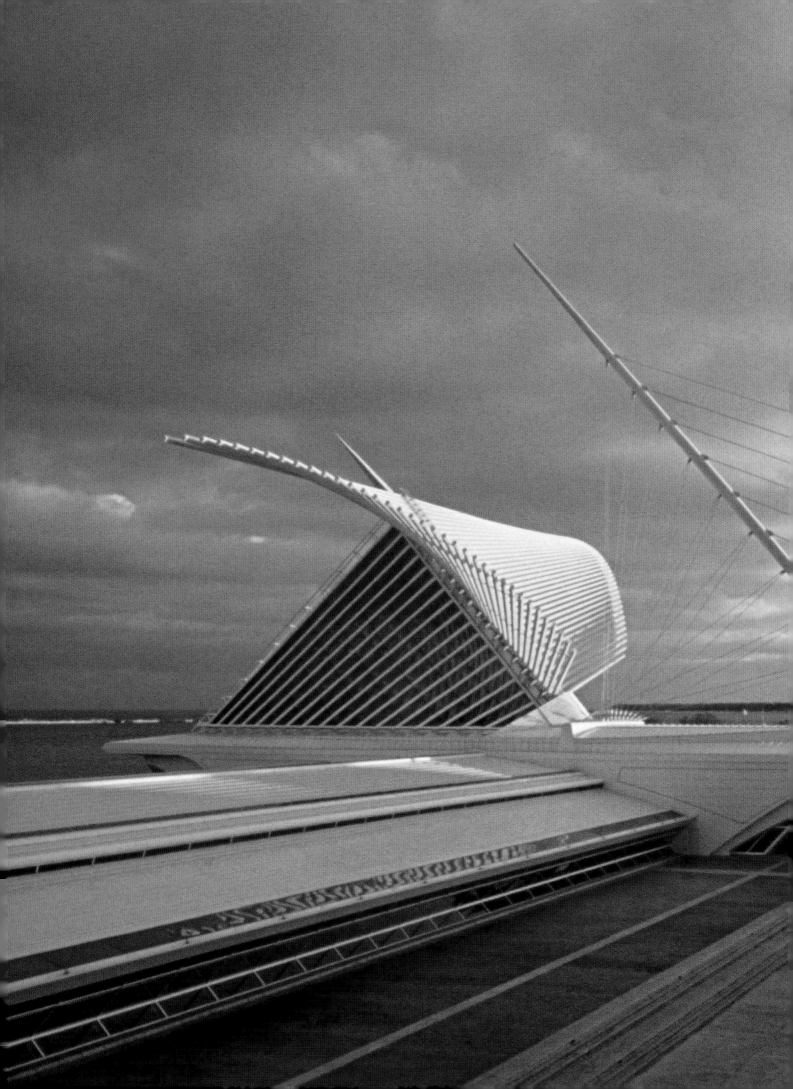

MILWAUKEE ART MUSEUM

Milwaukee, Wisconsin, USA. 1994–2001.

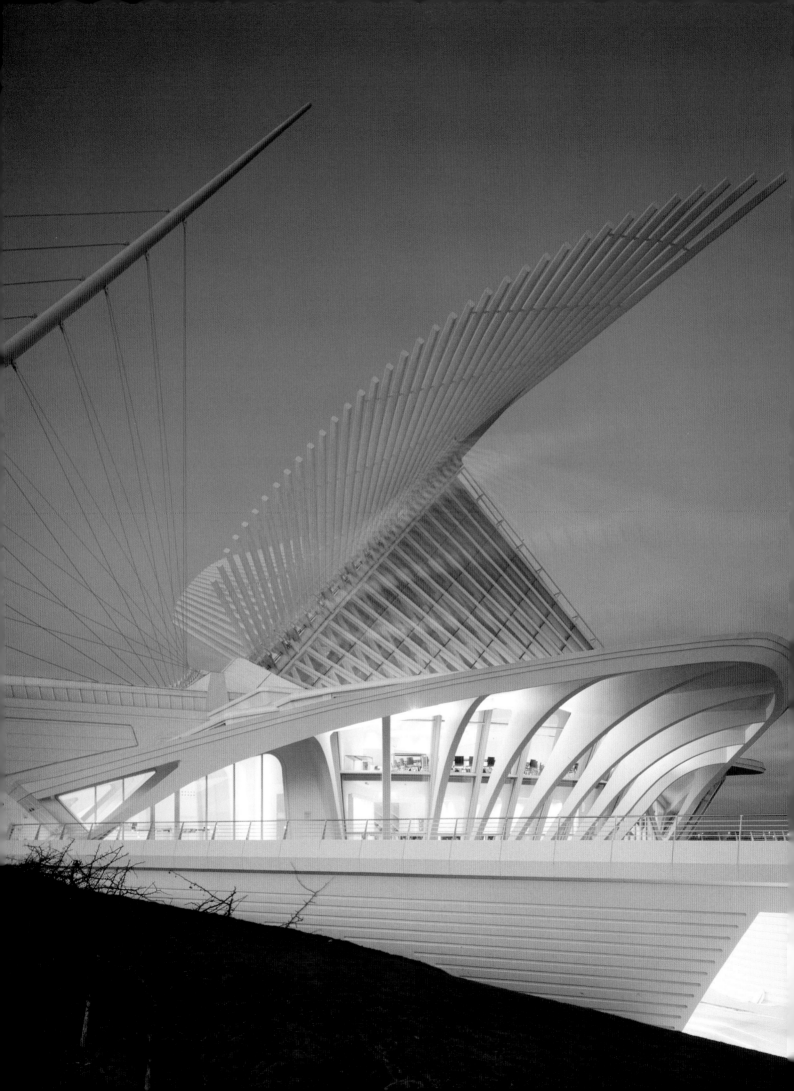

Project
MILWAUKEE ART MUSEUM
Location
MILWAUKEE, WISCONSIN, USA
Client
MILWAUKEE ART MUSEUM
Floor area
13 200 m²

The forms imagined by Santiago Calatrava are so original that it is difficult to classify him in any established trend in contemporary architecture. This is undoubtedly because he synthesizes parallel interests in architecture, art, and engineering.

Die von Calatrava erdachten Formen sind so ursprünglich, dass es schwerfällt, ihn irgendeinem etablierten Trend in der zeitgenössischen Architektur zuzuordnen. Dies liegt zweifellos daran, dass er seine parallelen Interessen an Architektur, Kunst und Technik verbindet.

Les formes imaginées par l'architecte sont si originales qu'il est difficile de le ranger dans une quelconque catégorie de l'architecture contemporaine. C'est sans doute parce qu'elles illustrent la synthèse de ses intérêts parallèles pour l'architecture, l'art et l'ingénierie.

The Milwaukee Art Museum was housed in a 1957 structure designed by Eero Saarinen as a War Memorial overlooking Lake Michigan. The architect David Kahler added a large slab structure to the Museum in 1975. In 1994, the Trustees of the Milwaukee Art Museum considered a total of 77 architects for a "new grand entrance, a point of orientation for visitors, and a redefinition of the museum's identity through the creation of a strong image." Santiago Calatrava won the competition with his proposal for a 27-meter-high glass and steel reception hall shaded by a moveable sunscreen (baptized the "Burke Brise Soleil"). Made of steel plates welded and stiffened inside, the 115-ton brise soleil consists of two equal wing elements formed by 36 fins whose lengths range between 32 and eight meters. A computerized system automatically overrides the manual control of the structure when wind speed exceeds 40 miles per hour. As the architect explains the overall project, "The design adds 13 200 square meters to the existing 14 900 square meters, including a linear wing (made of glass and stainless steel, with lamella roof) that is set at a right angle to Saarinen's structure. The design allows for future expansion, offset from but symmetrical to the exhibition facilities, on the other side of the Kahler building. At shore level, the expansion houses: the atrium; 1500 square meters of gallery space for temporary exhibitions; an education center with 300-seat lecture hall; and a gift shop. The 100-seat restaurant, which is placed at the focal point of the pavilion, commands panoramic views onto the lake." Although Calatrava generally denies specific biomorphic inspiration in his work, the Quadracci Pavilion has a decidedly birdlike quality to it, especially when the "wings" of the brise soleil are open. Calatrava is also responsible for the Reiman Bridge, a suspended pedestrian link between downtown and the lakefront. Public gardens for the complex were designed by the noted landscape architect Dan Kiley.

Das Kunstmuseum von Milwaukee war in einem 1957 von Eero Saarinen als Kriegsgedenkstätte errichteten Bau mit Blick auf den Lake Michigan untergebracht. 1975 ergänzte der Architekt David Kahler das Museum um einen großen Plattenbau. 1994 zogen die Treuhänder des Kunstmuseums von Milwaukee insgesamt 77 Architekten in Betracht für die Schaffung eines „neuen, imposanten Eingangs, eines Orientierungspunktes für Besucher und einer Neubestimmung der Identität des Museums durch ein neu zu schaffendes, starkes Image." Santiago Calatrava gewann den Wettbewerb mit seinem Entwurf einer 27 m hohen Empfangshalle aus Glas und Stahl, die mittels eines beweglichen Sonnensegels (Spitzname „Burke Brise Soleil") beschattet werden kann. Die aus geschweißten, innen versteiften Stahlplatten zusammengesetzte, 115 t schwere Sonnenblende besteht aus zwei gleichgroßen Flügeln aus 36 Rippen, deren Länge zwischen 32 und 8 m variiert. Wenn die Windgeschwindigkeit 65 km/h übersteigt, hebt ein Computersystem die manuelle Steuerung der Anlage auf. Mit den folgenden Worten erläutert der Architekt das gesamte Projekt: „Der

Entwurf ergänzt die vorhandenen 14 900 m² um 13 200 m², darunter ein aus Glas und Edelstahl bestehender linearer Flügel mit Lamellendach, der im rechten Winkel zu Saarinens Bau steht. Die Planung ermöglicht künftige Erweiterungen, die zwar abgesetzt von den Ausstellungsräumen, aber symmetrisch zu ihnen stehend, auf der anderen Seite des Gebäudes von Kahler errichtet werden könnten. In dem auf Höhe des Sees liegenden Erweiterungsbau sind das Atrium, 1500 m² Galerieräume für Wechselausstellungen, ein Lernzentrum mit einem Vortragssaal mit 300 Plätzen und ein Museumsladen untergebracht. Von dem im Zentrum des Pavillons liegenden Restaurant mit 100 Plätzen bieten sich weiträumige Ausblicke auf Lake Michigan." Obgleich Calatrava im Allgemeinen von spezifischen biomorphen Anklängen in seinem Werk nichts wissen will, erinnert der Quadracci-Pavillon doch stark an einen Vogel, insbesondere wenn die „Flügel" der Sonnenblende geöffnet sind. Calatrava zeichnet darüber hinaus auch für die Reiman Bridge verantwortlich, eine Hängebrücke für Passanten, die Innenstadt und Seeufer verbindet. Die öffentlichen Gartenanlagen des Komplexes gestaltete der renommierte Landschaftsarchitekt Dan Kiley.

Le Milwaukee Art Museum occupait un bâtiment d'Eero Saarinen de 1957 donnant sur le lac Michigan et conçu pour être un mémorial de guerre. L'architecte David Kahler y avait ajouté, en 1975, une importante construction en barre, et, en 1994, les administrateurs du musée consultèrent soixante-dix-sept architectes pour créer « une nouvelle entrée de prestige, un centre d'orientation pour les visiteurs » et pour « redéfinir l'identité du musée par une image forte ». Santiago Calatrava remporta le concours grâce à sa proposition d'un hall d'accueil de 27 mètres de haut, en verre et en acier, protégé par un écran solaire mobile (appelé « Burke Brise Soleil »). Ce brise-soleil de 115 tonnes en plaques d'acier soudées et armées de raidisseurs, se compose de deux ailes constituées de trente-six ailettes de 8 à 32 mètres de longueur. Un ordinateur prend le relais des commandes manuelles lorsque la vitesse du vent dépasse 65 km/h. Comme l'explique l'architecte : « Le projet ajoute 13 200 mètres carrés aux 14 900 mètres carrés existants. Cette extension comprend une aile rectiligne (en verre et acier à toit en lames), implantée à angle droit du bâtiment de Saarinen. Une extension future est prévue, symétrique aux salles d'expositions, de l'autre côté de l'immeuble de Kahler. Au niveau du lac se trouvent une cour intérieure, 1500 mètres carrés d'espaces pour expositions temporaires, un centre éducatif avec une salle de conférences de 300 places et une boutique de cadeaux. Le restaurant de cent couverts, situé au centre du pavillon, bénéficie de vues panoramiques sur le lac. » Bien que Calatrava réfute généralement l'idée d'une inspiration biomorphique, le Quadracci Pavilion n'en fait pas moins penser à un oiseau, en particulier lorsque les « ailes » du brise-soleil sont ouvertes. Il est également l'auteur du pont Reiman, une passerelle piétonnière suspendue entre le centre-ville et les bords du lac. Les jardins du complexe ont été réalisés par le célèbre architecte paysagiste Dan Kiley.

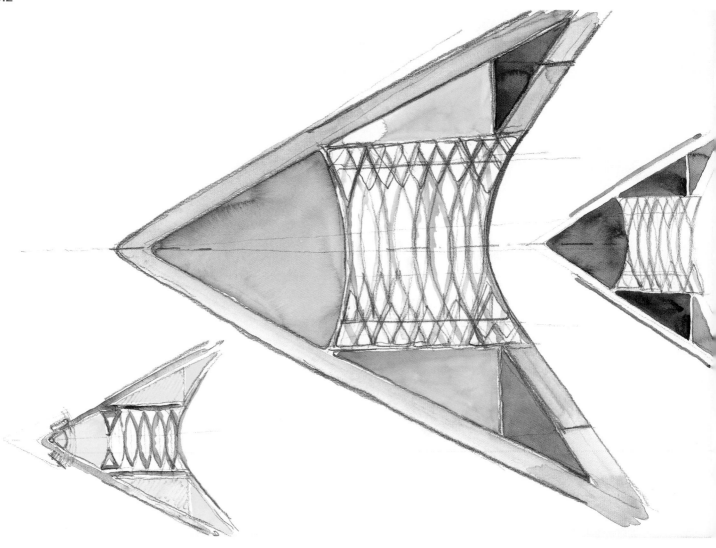

The raylike form seen in other Calatrava plans reappears here, but, typically, the architect has altered it both to fit the circumstances and because as a matter of method he refines his ideas over considerable periods of time.

Die von anderen Grundrissen Calatrava bekannte Rochenform taucht hier wieder auf, wenngleich sie der Architekt in typischer Manier verändert hat, zum einen, um sie den Gegebenheiten anzupassen, zum anderen, weil er methodisch seine Ideen über beträchtliche Zeiträume weiterentwickelt.

La forme d'une raie, déjà observée dans d'autres projets de Calatrava, réapparaît ici, mais à sa façon caractéristique, l'architecte l'a modifiée, non seulement pour l'adapter au contexte mais aussi parce qu'il perfectionne systématiquement ses idées, sur des périodes de temps considérables.

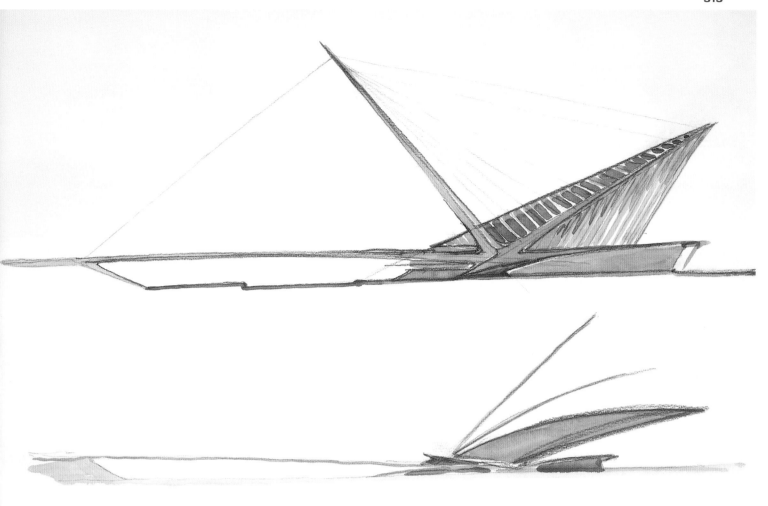

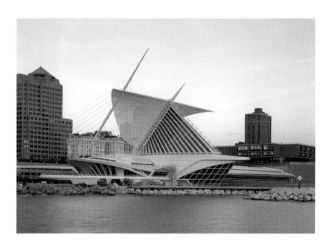

With its angled spike pointing up like a bridge mast, the building appears to take flight from the water, or perhaps to advance towards it, a strange creature made of forms that somehow remain familiar.

Mit seinem schrägen Mast, der wie ein Brückenpfeiler aufragt, scheint sich das Gebäude vom Wasser abzuheben oder auch Kurs darauf zu nehmen, eine fremdartige Kreatur, deren Formen dennoch irgendwie bekannt erscheint.

Avec sa pointe inclinée dressée comme le pylône d'un pont, le bâtiment semble prendre son envol depuis la surface de l'eau, ou s'avancer vers elle telle une créature étrange composée de formes qui pourtant paraissent familières.

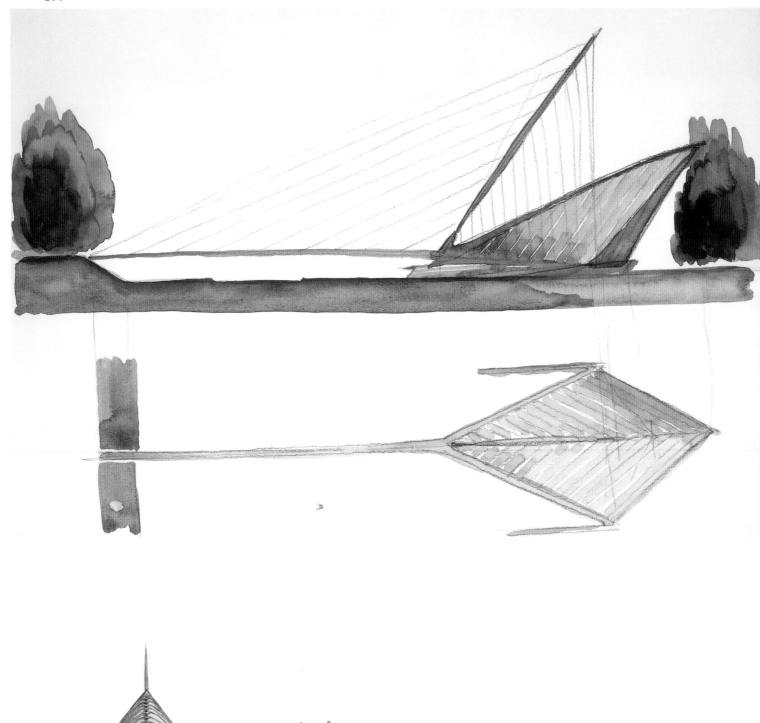

As the sketches above show, Calatrava has integrated a bridge directly into the design, using the angled spike support both to hold the bridge and to anchor the actual museum structure.

Wie die Skizzen oben zeigen, integrierte Calatrava eine Brücke unmittelbar in den Entwurf und nutzt dabei die schräge Maststütze, um die Brücke zu halten und den Museumsbau selbst zu verankern.

Comme le montrent les croquis ci-dessus, Calatrava a d'emblée intégré le pont dans son projet, utilisant le pylône incliné à la fois pour soutenir ce dernier et pour ancrer le bâtiment du musée.

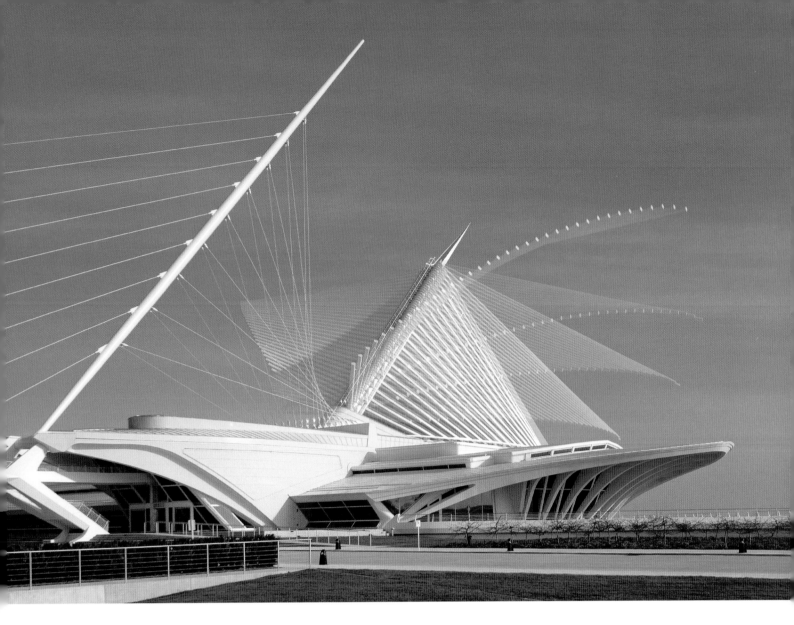

Time-lapse photography (above) shows the winglike positions of the Burke Brise Soleil, surely one of the largest examples of Calatrava's continual efforts to bring actual movement into his architecture and sculpture.

Mit dem Zeitraffer aufgenommene Fotos (oben) zeigen die flügelgleichen Positionen des Sonnensegels, bestimmt eines der stattlichsten Beispiele für Calatravas ständige Bemühungen, Bewegung in seine Bauten und Skulpturen zu bringen.

La photographie prise au ralenti (ci-dessus) montre les positions successives du Burke Brise Soleil, sans doute l'un des plus importants exemples des efforts continuels de l'architecte pour insuffler du mouvement à ses architectures et à ses sculptures.

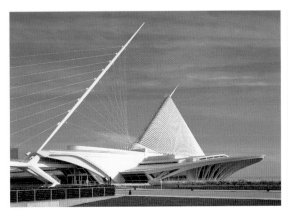

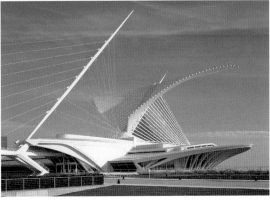

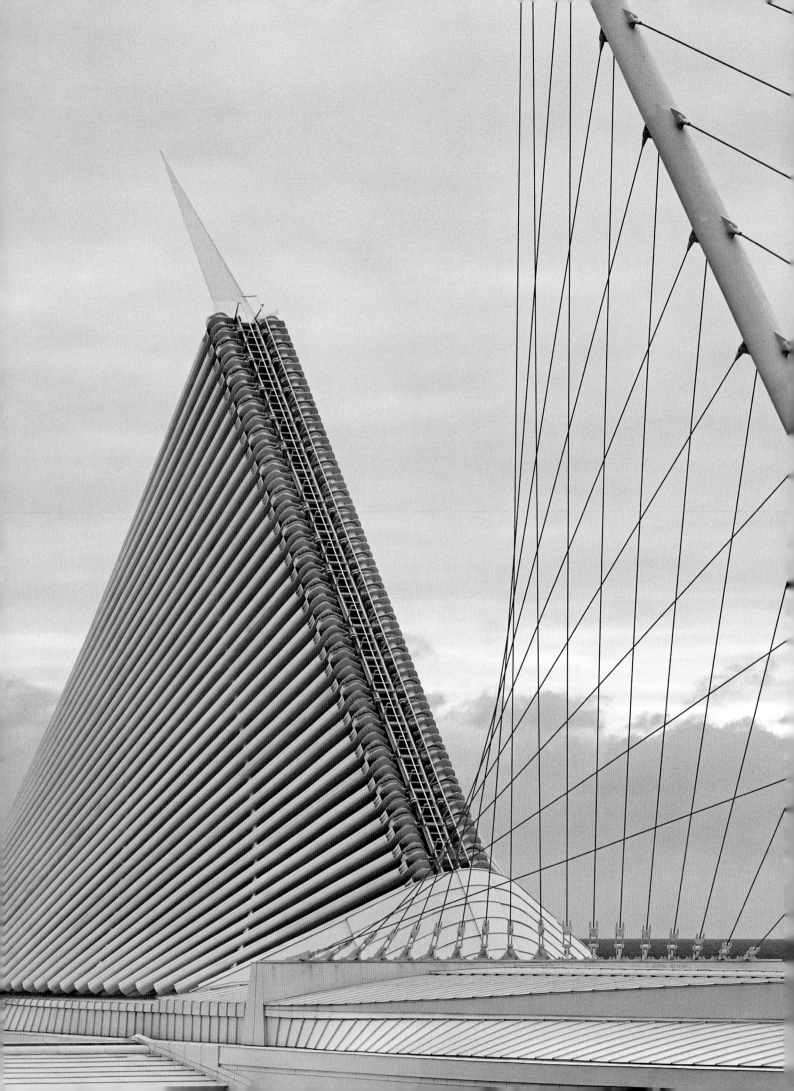

The folded "wings" of the Brise Soleil assume a compact, simple form (left). Below, sketches show the relationship between the pedestrian bridge and the museum structure, forming a continuous composition.

Die zusammengelegten „Flügel" des Sonnensegels ergeben eine kompakte, einfache Form (links). Die Skizzen unten zeigen die Beziehung zwischen Fußgängerbrücke und Museumsbau, die eine zusammenhängende Komposition ergeben.

Repliées, les « ailes » du brise-soleil prennent une forme simple et compacte (à gauche). Les croquis ci-dessous montrent la relation entre la passerelle piétonnière et le musée, qui dessinent une composition continue.

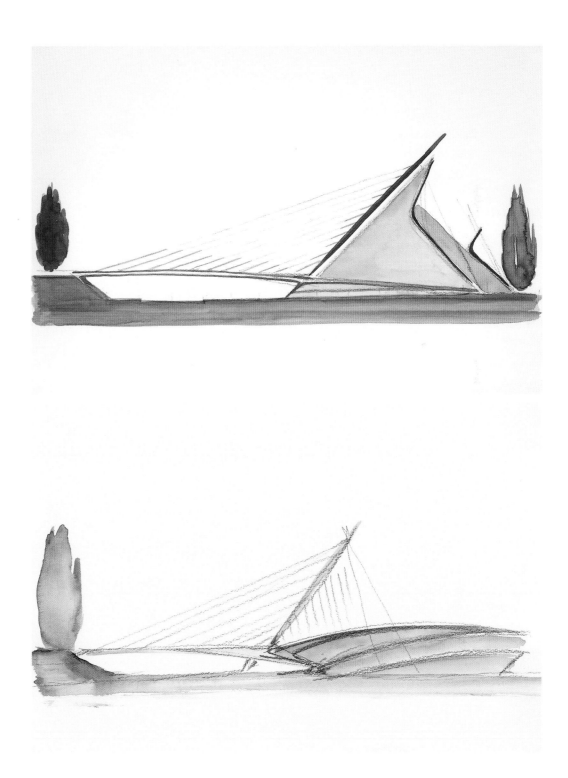

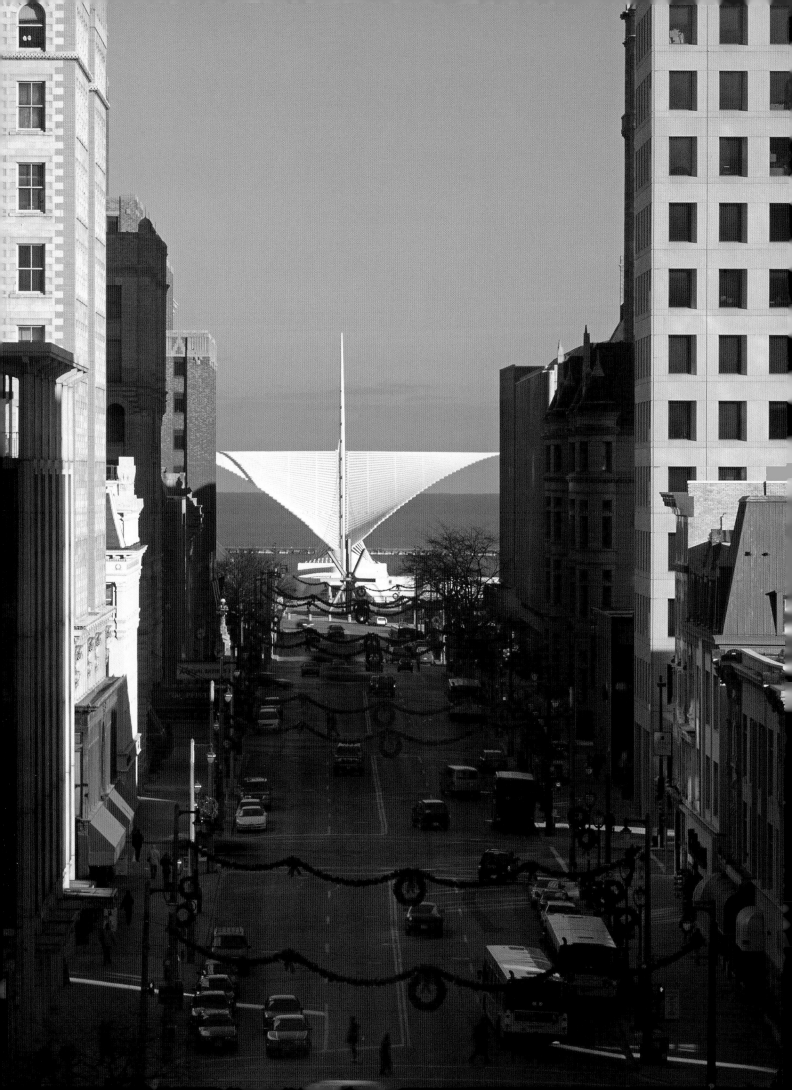

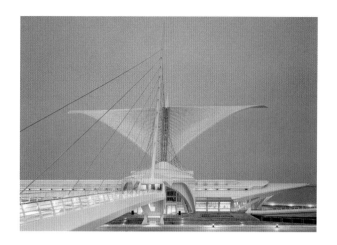

Seen from the city with its "wings" spread, Calatrava's building stands out in any circumstances, breaking the stolid geometric rhythm of the aligned office buildings, soaring up and out toward the lake.

Mit ausgebreiteten „Flügeln" von der Stadt aus gesehen, fällt Calatravas Bau in jedem Fall ins Auge, indem er den geometrischen Rhythmus der in gerader Linie ausgerichteten Bürobauten unterbricht und sich über und auf den See hinaus erhebt.

Vu depuis la ville et avec les « ailes » déployées, le bâtiment se détache avec force. Il rompt le rythme géométrique massif de l'alignement d'immeubles de bureaux en s'élevant au-dessus et vers le lac.

As surprising as the cantilevered platforms designed by Calatrava may appear, they are clearly thought-out in terms of scale and location to offer spectacular views, and to allow visitors to better participate in the architecture itself, seeing it from different angles.

So frappant die von Calatrava konzipierten auskragenden Plattformen erscheinen mögen, im Hinblick auf Maßstäblichkeit und Standort sind sie doch eindeutig durchdacht. Von ihnen bieten sich fulminante Ausblicke und sie gestatten den Besuchern, die Architektur von verschiedenen Blickwinkeln aus besser zu erfahren.

Aussi surprenantes puissent-elles paraître, ces plates-formes en porte-à-faux sont clairement conçues, dans leur échelle et leur implantation, pour offrir des vues spectaculaires et permettre aux visiteurs de mieux apprécier l'architecture en la voyant sous différents angles.

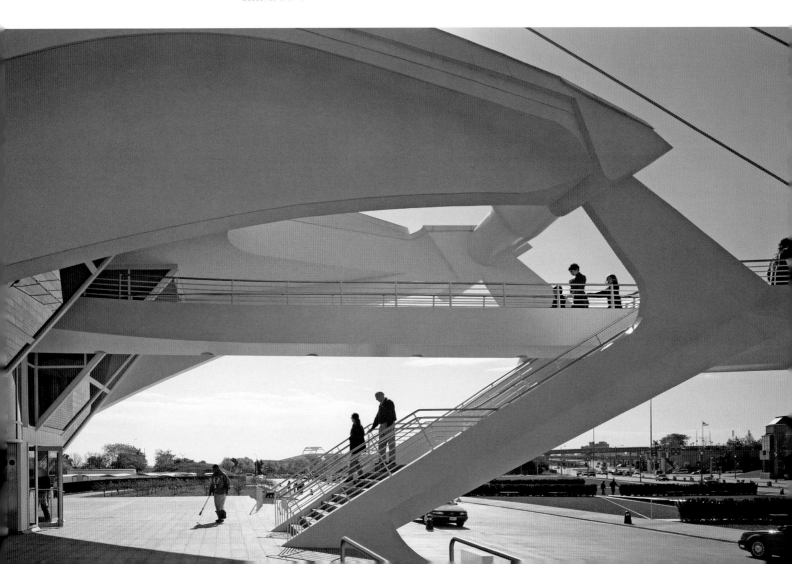

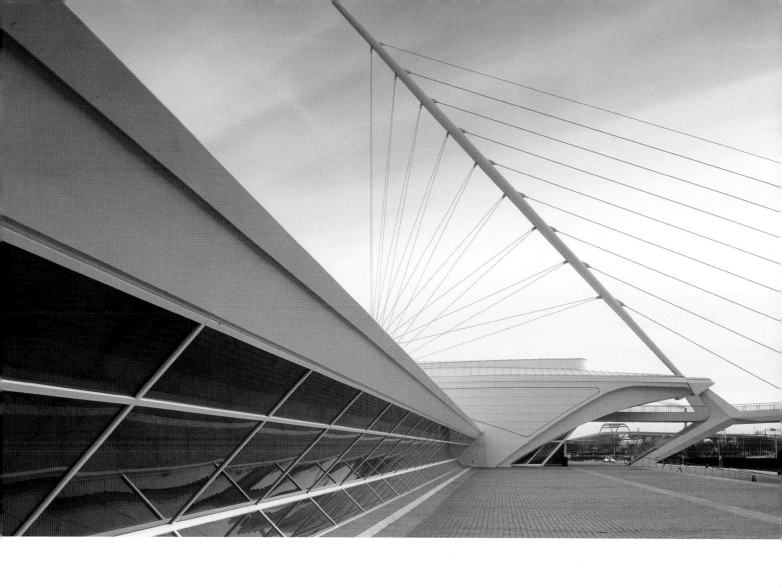

The architect's sketches regularly place human figures in their context, but Calatrava's purpose is not as calculated as that of Le Corbusier's Modulor for example.

Auf den Skizzen des Architekten erscheinen immer wieder menschliche Figuren, wenngleich Calatrava, anders als beispielsweise Le Corbusier mit seinem Modulor, keinen bestimmten Zweck mit ihnen verfolgt.

Les croquis de l'architecte comprennent régulièrement des figures humaines, mais l'objectif de Calatrava n'est pas aussi utilitaire que celui de Le Corbusier avec son Modulor, par exemple.

The unexpected shapes of openings and passageways give a variety to the architecture which is consistently designed with respect to the exteriors of the building. These interiors thus seem to have a natural rapport with the outside of the structure.

Die überraschenden Formen von Öffnungen und Durchgängen lassen die Architektur, die im Hinblick auf das Äußere des Gebäudes konsequent gestaltet wurde, vielfältig erscheinen. Diese Innenräume scheinen folglich ein natürliches Verhältnis zum Außenbau zu unterhalten.

Les formes inattendues des ouvertures et des passages confèrent à l'architecture un aspect diversifié toujours conçu dans le respect de l'extérieur des bâtiments. Les intérieurs semblent entretenir un rapport naturel avec l'extérieur de la structure.

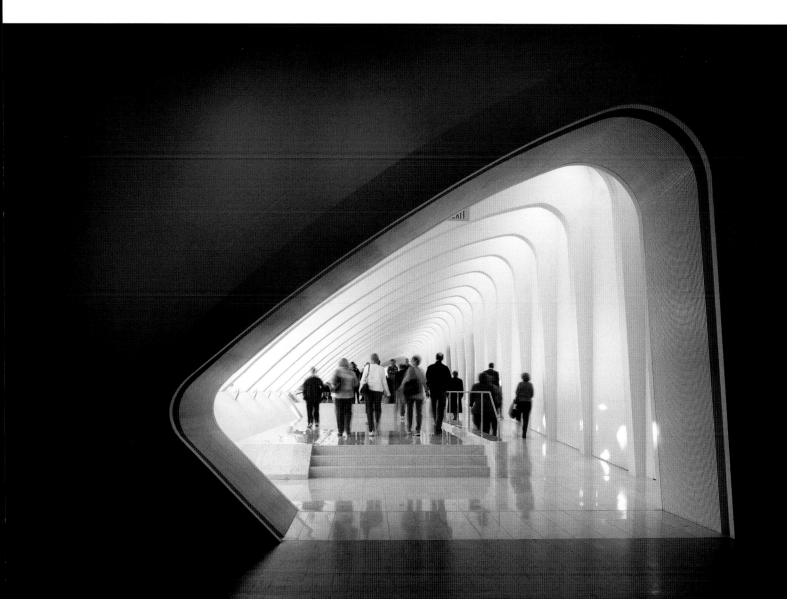

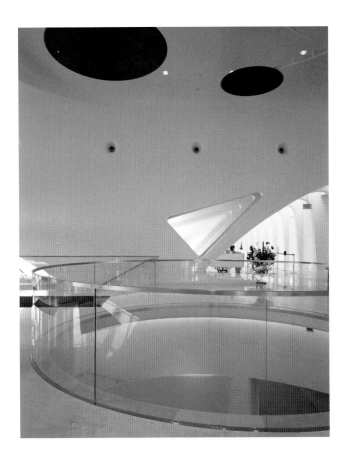

The museum interiors of course make space for the exhibition of art, but they also offer numerous surprises such as the large arched window and fan-shaped opening above it seen to the right.

Die Räume des Museums bieten natürlich Raum für die Präsentation von Kunst, aber sie halten darüber hinaus zahlreiche Überraschungen bereit, wie etwa das großflächige Bogenfenster und die fächerförmige Öffnung darüber (rechte Seite).

Si l'intérieur du musée est consacré à la présentation d'œuvres d'art, il ménage aussi de nombreuses surprises, comme la grande fenêtre en arc et l'ouverture en éventail qui la surmonte (page de droite).

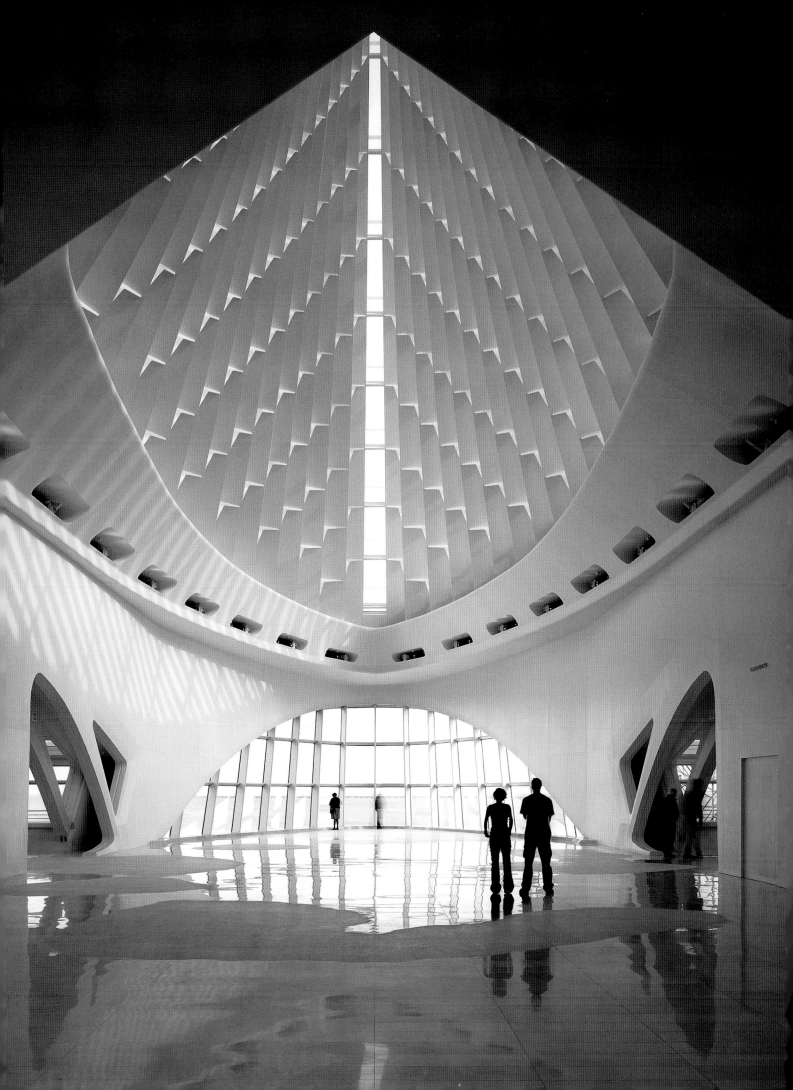

A number of Calatrava's sketches may bring to mind those of da Vinci. The structure of the eye linked to the optic nerve might be evoked in the drawings below. The actual architecture, as seen to the right, is not specifically anthropomorphic however.

Eine Reihe von Calatravas Skizzen mögen an die Da Vincis erinnern, so könnten die Zeichnungen unten Erinnerungen an den Aufbau eines mit dem Sehnerv verbundenen Auges wecken. Die tatsächliche Architektur (rechts) weist dagegen keine spezifisch anthropomorphen Merkmale auf.

Plusieurs croquis de Calatrava peuvent évoquer ceux de Vinci. La structure de l'œil et du nerf optique sont reconnaissables dans le dessin ci-dessous. La réalisation architecturale, à droite, n'est cependant pas spécifiquement anthropomorphique.

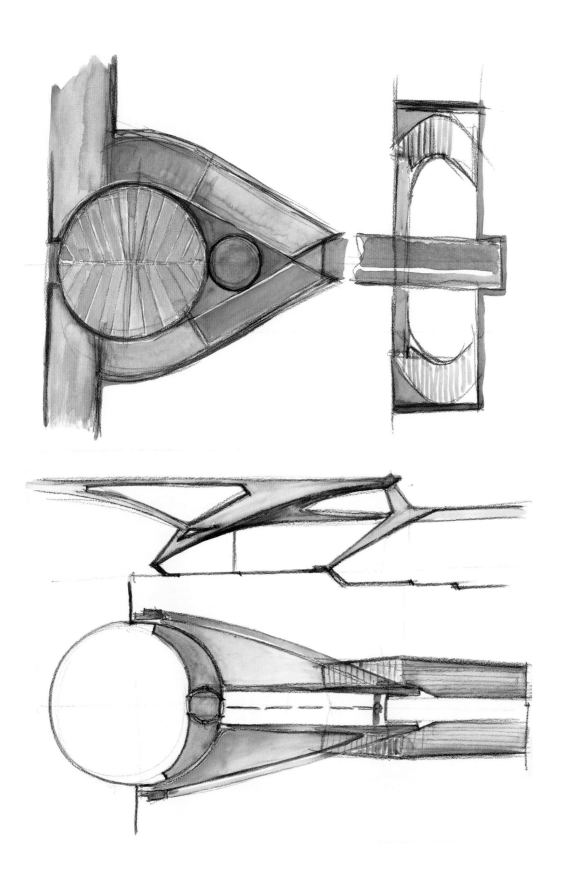

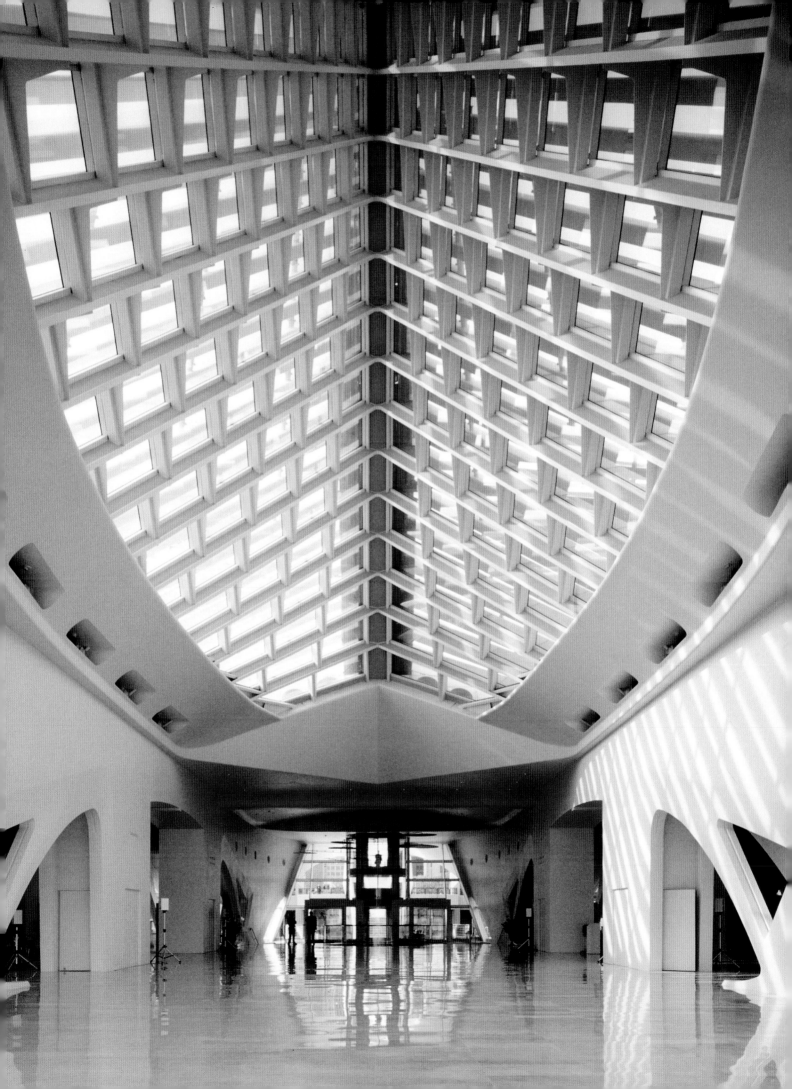

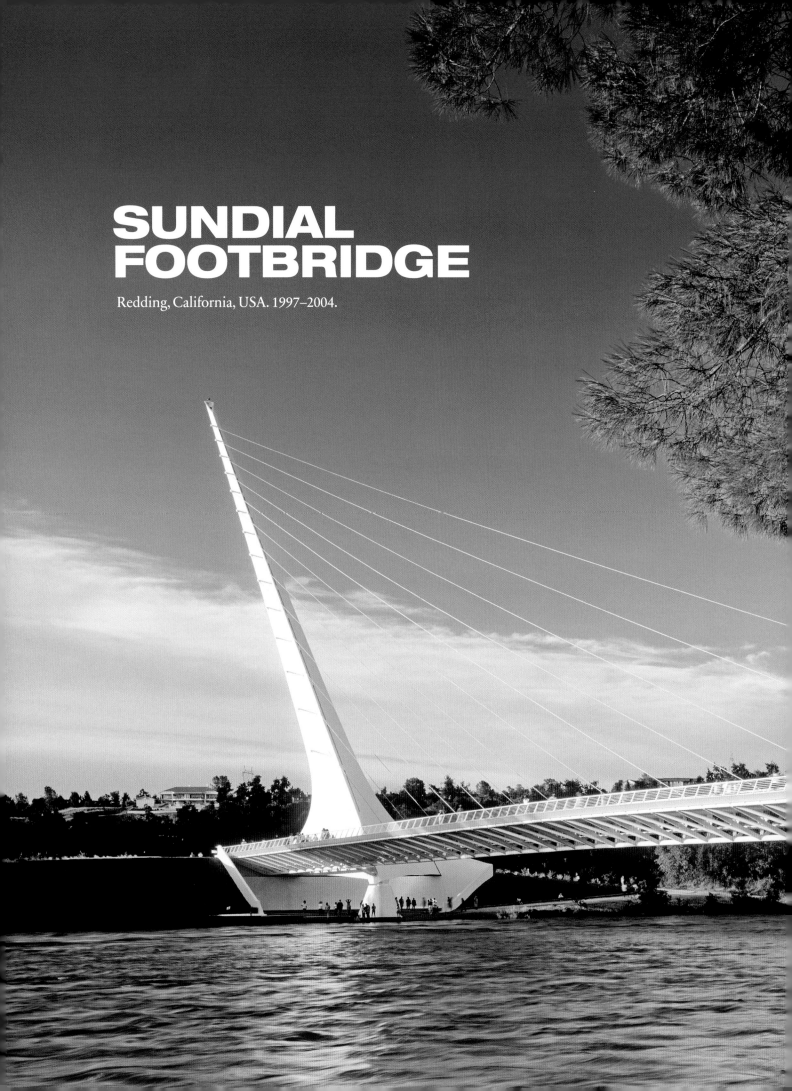

SUNDIAL FOOTBRIDGE

Redding, California, USA. 1997–2004.

Project
SUNDIAL FOOTBRIDGE

Location
REDDING, CALIFORNIA, USA

Client
CITY OF REDDING AND TURTLE BAY EXPLORATION PARK

Span
213 METERS

Cost
$ 15 MILLION

Imagined like a pure form in space, a bridge by Calatrava is more than a crossing point, it is also an expression of the forces of nature, and of the undeniable inventiveness of a single man—all this while retaining the rigor and intelligence formed by years of university studies.

Erdacht als reine Form im Raum ist eine von Calatrava entworfene Brücke mehr als ein Übergang, sie ist ebenso Ausdruck der Kräfte der Natur und der Erfindungsgabe eines einzelnen Mannes – mit all dem Verstand und der Strenge, die in langen Jahren an der Universität erworben wurden.

Imaginé comme une pure forme dans l'espace, un pont de Calatrava est plus qu'un simple outil de franchissement. C'est aussi l'expression des forces de la nature et de l'inventivité indéniable d'une personnalité dont la rigueur et l'intelligence ont été aiguisées par des années d'études universitaires.

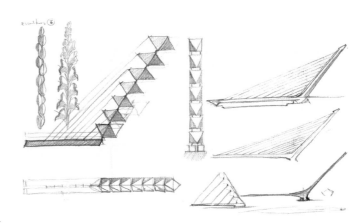

In 1997 the city of Redding, a northern California community of 89 000 people, and the McConnell Foundation retained Santiago Calatrava to design a $15 million pedestrian bridge over the Sacramento River, linking Turtle Bay's planned main exhibition building with its 81-hectare arboretum. It was in the mid-1980s that three Redding museums decided to create a new complex on 24 hectares of Sacramento riverfront property donated by the city of Redding; the Turtle Bay Exploration Park is now a 121-hectare area centered on the Turtle Bay Museum. Serving as a downtown entrance to Redding's Sacramento River trail system, the bridge sought to avoid damaging the salmon-spawning pond located in the river, and thus has no columns in the water. It was also intentionally made translucent to avoid casting shadows. A cable-stayed bridge, it has a 66-meter pylon on the north bank of the river and weighs a relatively light 1600 tons. The name of the bridge is derived from the fact that it has a precise north-south orientation, allowing the main pylon to function as a sundial. Calatrava created a sloping platform at the base of the pylon to allow visitors to view the noonday sun as it passes through specially conceived slots.

Die Stadt Redding liegt im nördlichen Kalifornien und zählt 89 000 Einwohner; sie erteilte 1997 gemeinsam mit der McConnell Foundation Santiago Calatrava den Auftrag, für die Summe von 15 Millionen Dollar eine Fußgängerbrücke über den Sacramento zu entwerfen und damit ein von der Gemeinde Turtle Bay geplantes Ausstellungsgebäude mit dem 81 ha umfassenden Arboretum zu verbinden. Mitte der 1980er-Jahre hatten drei der in Redding ansässigen Museen beschlossen, auf einem 24 ha großen, von der Stadt Redding zur Verfügung gestellten Gelände am Ufer des Sacramento eine neue Anlage zu errichten. Dieser Turtle Bay Exploration Park umfasst heute eine Fläche von 121 ha, in deren Zentrum das Turtle Bay Museum steht. Die Brücke bildet vom Stadtzentrum kommend den Zugang zum Wegenetz entlang des Sacramento. Da man die Lachsaufzucht im Fluss nicht beeinträchtigen wollte, musste die Brücke ohne im Wasser stehende Stützen auskommen. Außerdem wurde die Brücke bewusst lichtdurchlässig konzipiert, um keine Schatten zu werfen. Die Spannseilbrücke wird am Nordufer des Flusses von einem 66 m hohen Pylon gestützt und hat mit 1600 t ein relativ niedriges Gewicht. Der Name der Brücke geht zurück auf ihre genaue Nord-Süd-Ausrichtung, die den Pylon als Zeiger einer Sonnenuhr fungieren lässt. Calatrava schuf am Sockel des Pylons eine schräge Rampe, von der aus Besucher sehen können, wie die Mittagssonne durch eigens zu diesem Zweck eingeschnittene Schlitze fällt.

En 1997, Redding, une ville de 89 000 habitants du nord de la Californie et la McConnell Foundation retinrent la proposition de Calatrava pour une passerelle piétonnière sur le Sacramento destinée à relier le futur bâtiment d'expositions du parc de découverte de Turtle Bay à son arboretum de 81 hectares. C'est au milieu des années 1980 que trois musées de Redding avaient décidé de créer un nouveau complexe de 24 hectares, en bordure de la rivière, sur un terrain donné par la ville. Ce « Turtle Bay Exploration Park » est aujourd'hui un domaine de 121 hectares centré autour du Turtle Bay Museum. Le pont, qui permet d'accéder au réseau de promenade le long du Sacramento, est situé en un point du fleuve où frayent les saumons. C'est pourquoi il a été décidé qu'il n'y aurait pas à cet endroit de piliers s'appuyant sur le fond de la rivière et que le tablier serait translucide afin ne pas projeter d'ombre sur le lit. Le pont à haubans est soutenu par un pylône de 66 mètres de haut implanté sur la rive nord et il est relativement léger (1600 tonnes). Son nom est dû à son orientation nord-sud précise, qui lui permet de faire office de cadran solaire. Calatrava a prévu à la base du pylône une plate-forme qui permet de suivre le déplacement du soleil à travers des encoches.

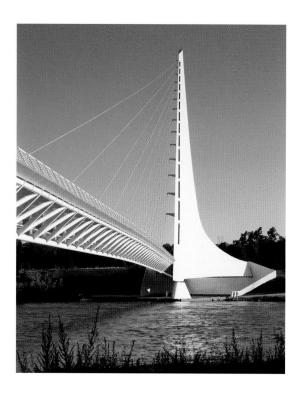

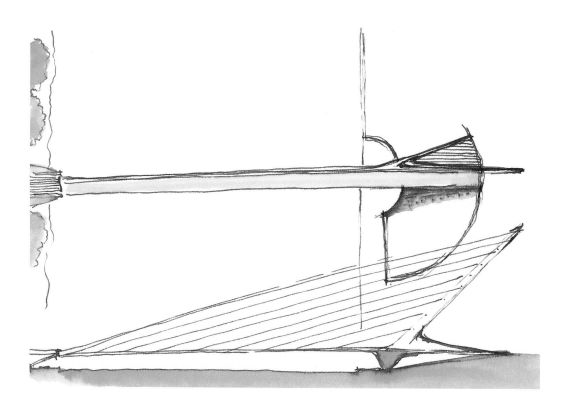

The powerful elegance of Calatrava's design is evident in these pictures, but also in the sketch above, that gives a very accurate idea of the finished bridge.

Die gewaltige Eleganz von Calatravas Entwurf ist in diesen Bildern augenfällig, aber auch in der Skizze oben, die eine sehr genaue Vorstellung von der fertigen Brücke vermittelt.

La puissante élégance du projet de Calatrava est évidente dans ces images, mais aussi dans le croquis ci-dessus, qui donne une idée très précise du pont achevé.

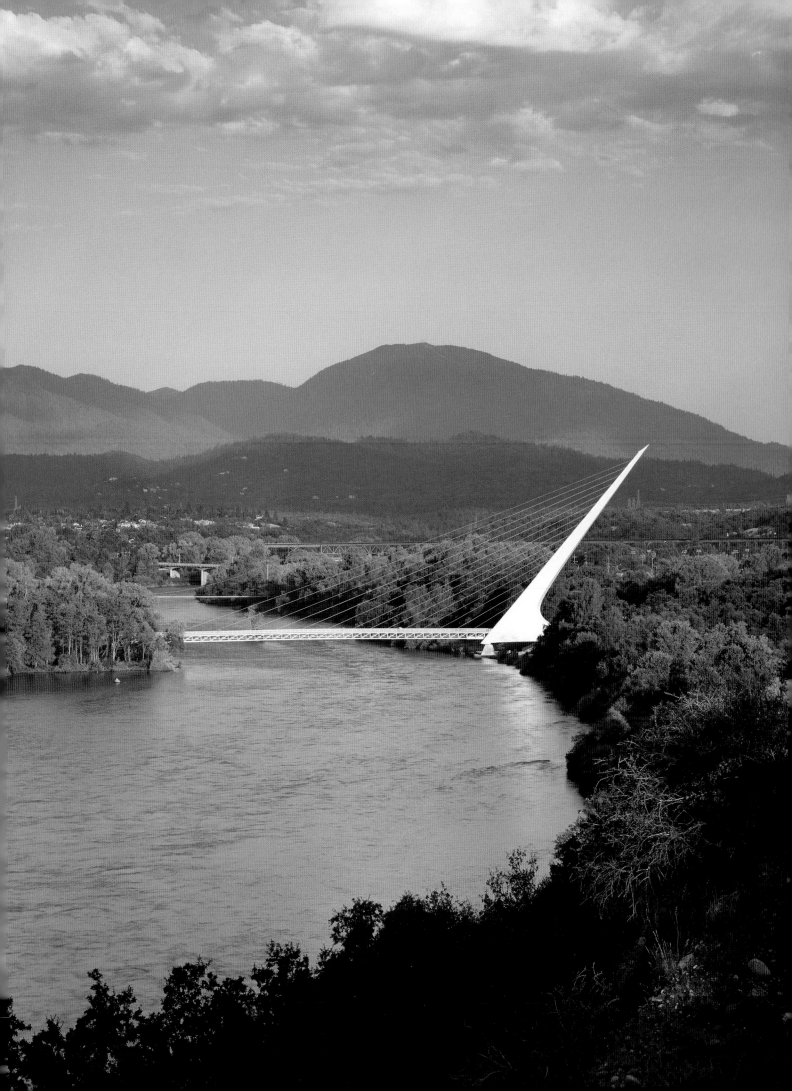

A good part of Calatrava's art lies in his mastery of engineering and the basic calculations that allow for the apparent lightness of the finished design. He uses the very tension that holds the structure up to impart a dynamic appearance.

Ein Gutteil von Calatravas Kunst liegt in seiner Beherrschung der Technik und grundlegenden Berechnungen, die die Leichtigkeit des realisierten Entwurfs ermöglichen. Er nutzt genau die Spannung, die das Bauwerk aufrecht stehen lässt, um ein dynamisches Erscheinungsbild zu erzeugen.

Une bonne partie de l'art de Calatrava tient à sa maîtrise de l'ingénierie et des calculs mathématiques qui permettent de conserver aux projets achevés leur apparente légèreté. Il se sert de la tension même de la structure pour créer un aspect dynamique.

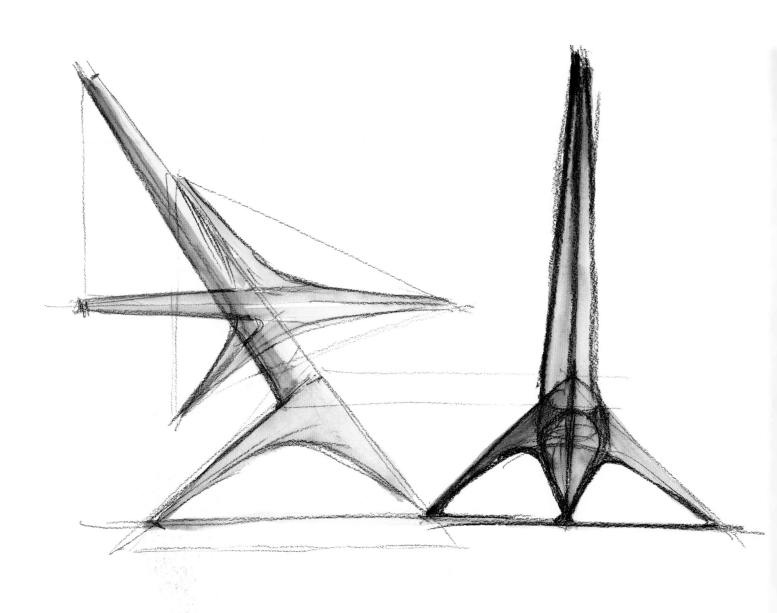

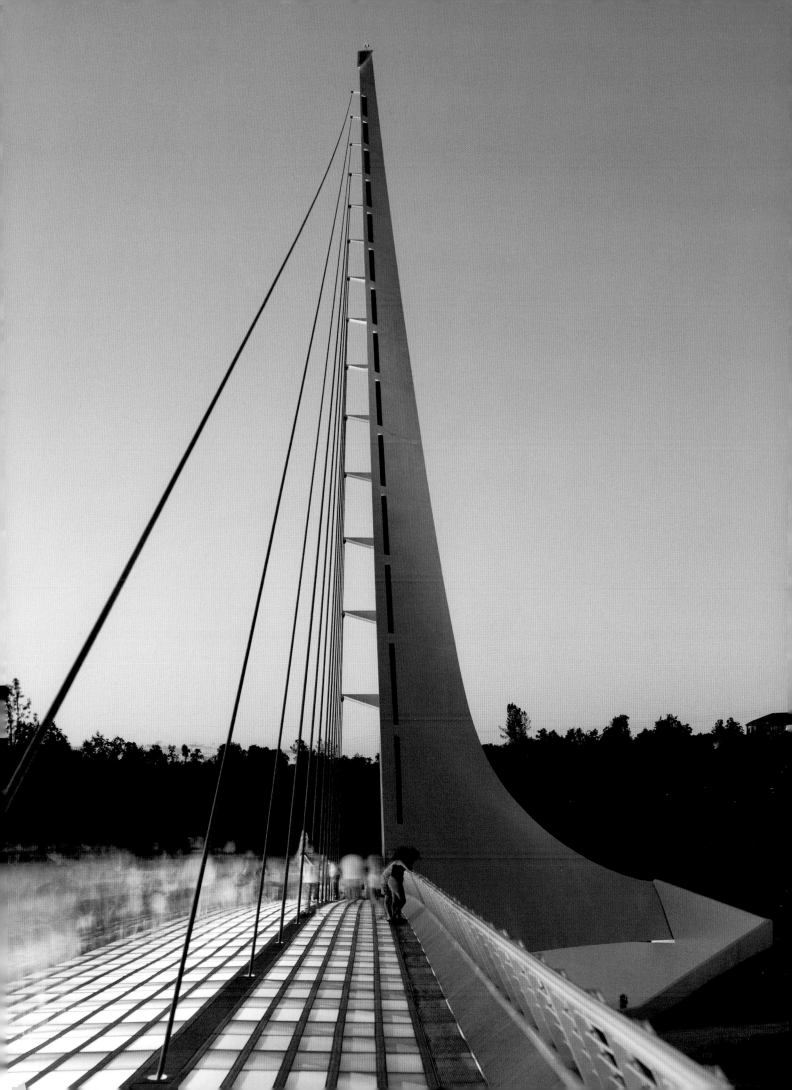

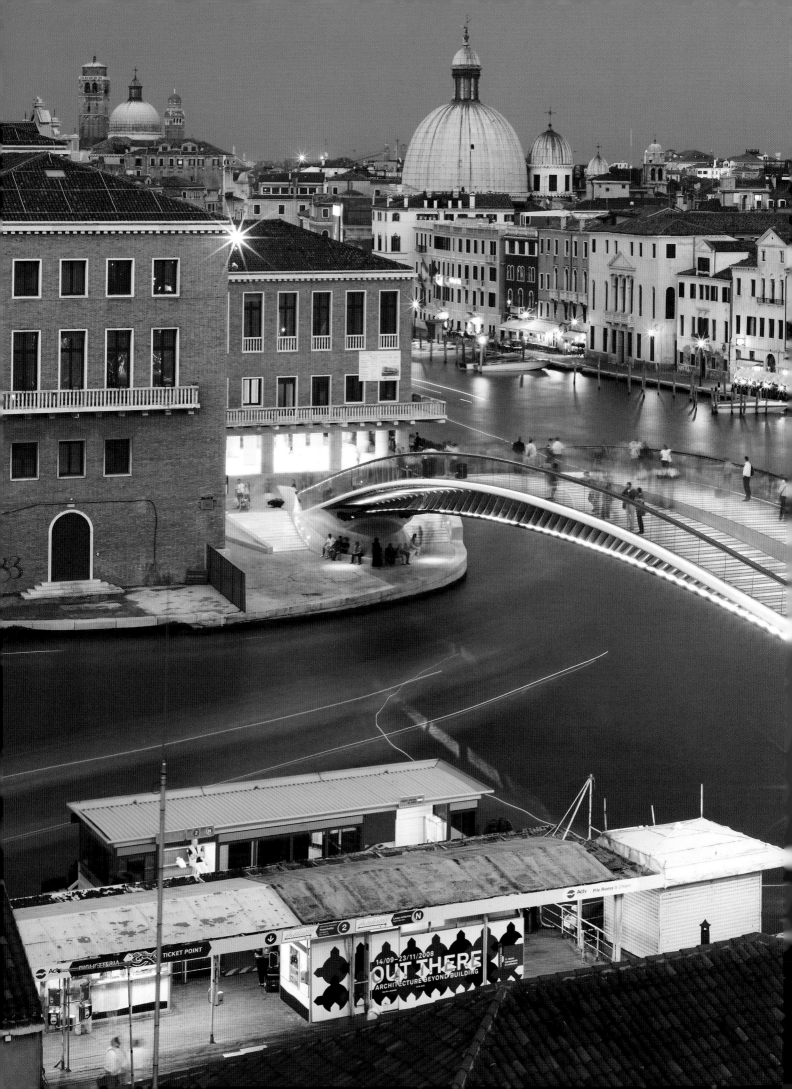

FOURTH BRIDGE ON THE CANAL GRANDE

Venice, Italy. 1999–2008.

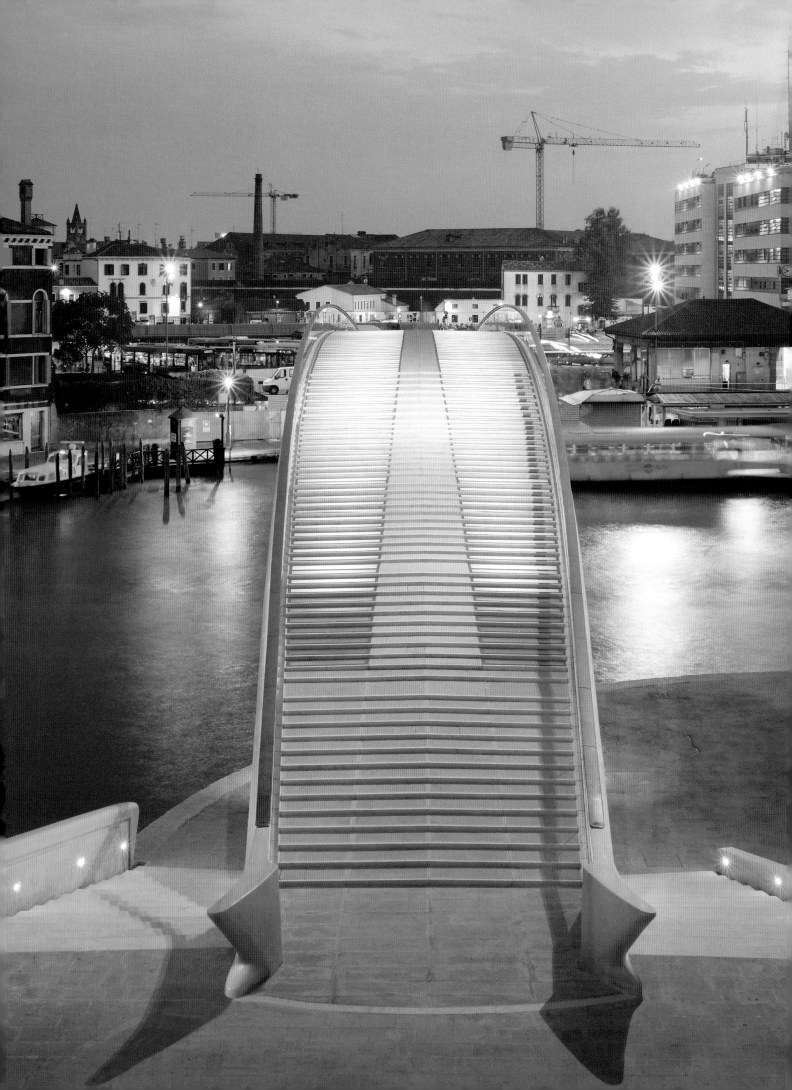

Project

FOURTH BRIDGE ON THE CANAL GRANDE

Location
VENICE, ITALY

Client
MUNICIPALITY OF VENICE

Cost
€ 6.7 MILLION

The bridge is located close to the busy central railway station of Venice, relatively far from the entrance to the Grand Canal at Saint Mark's Square.

Die Brücke liegt unweit des geschäftigen Hauptbahnhofs von Venedig und damit relativ weit entfernt von der Mündung des Canal Grande am Markusplatz.

Le pont se trouve à proximité de la très animée gare de Venise, relativement éloigné de l'embouchure du Grand Canal à la place Saint-Marc.

The aptly named Quarto Ponte sul Canal Grande pedestrian bridge is only the fourth to be built over Venice's Grand Canal since the 16th century. It was first spanned by the Rialto Bridge, built in 1588–91. Suggested as early as 1488, the Accademia Bridge was not built until 1854. The original steel structure, designed by Alfred Neville, was demolished and replaced by a wooden bridge in 1934. This second bridge, in bad condition, was razed and replaced by the present identical bridge in 1985. Designed by Eugenio Miozzi, the Scalzi Bridge replaced an older iron bridge in 1934 and connects the sestieri of Santa Croce and Cannaregio near the Santa Lucia Railway Station. Calatrava's new bridge, for which he was selected by a public commissioning process in 1999, connects the Piazzale Roma Bus Station to the railway station. His design was approved in February 2001 and the project approved in April 2002, with a budget of 6.7 million euros. Conscious of the high visibility of this location and its historical significance, Calatrava says, "Care has been taken to integrate the bridge with the quays on either side. The steps and ramps are designed to add vitality to both sides of the canal, while the abutments (which are crescent-shaped) leave pedestrians free access to the quays. The areas at either end act as extensions of the bridge, creating new celebratory spaces for Venice. On the south side, the design also provides a new passage between Piazzale Roma and the mooring platforms for the ACTV water transport." The bridge is 101 meters long, with a central span of 80 meters. Its width varies, from 5.39 meters (at either foot) to 9.38 meters at the midpoint. The bridge rises from a height of 3.2 meters at the foot to 9.28 meters at midpoint. The all-steel structural element consists of a central arch of very large radius (180 meters), with two side arches and two lower arches.

Wie der Name sagt, ist die Fußgängerbrücke seit dem 16. Jahrhundert erst das vierte Bauwerk dieser Art, das über den Canal Grande errichtet wurde. Das erste war die 1588–91 erbaute Rialto-Brücke. Erst 1854 wurde die bereits 1488 erwähnte Accademia-Brücke realisiert. Die von Alfred Neville geplante, ursprüngliche Stahlbrücke wurde zerstört und 1934 durch eine Holzbrücke ersetzt. Nachdem diese zweite Brücke baufällig geworden war, ersetzte man sie 1985 durch eine identische. Die von Eugenio Miozzi entworfene Scalzi-Brücke entstand 1934 anstelle einer alten Eisenbrücke und verbindet die Stadtteile Santa Croce und Cannaregio in der Nähe des Bahnhofs Santa Lucia. Calatravas neue Brücke, für die er 1999 durch ein öffentliches Auftragsverfahren ausgewählt wurde, verbindet den Busbahnhof an der Piazzale Roma mit dem Bahnhof. Sein Entwurf wurde im Februar 2001, das Projekt mit einem

Budget von 6,7 Millionen Euro im April 2002 genehmigt. Eingedenk des öffentlichkeitswirksamen Standorts und seiner historischen Bedeutung sagt Calatrava: „Wir haben uns bemüht, die Brücke in die Kaianlagen auf beiden Seiten einzugliedern. Die Treppen und Rampen sollen beide Seiten des Kanals optisch beleben, während die halbmondförmigen Widerlager den Passanten freien Zugang zu den Kaianlagen gewähren. Die Areale an beiden Enden fungieren als Erweiterungen des Brückenraums und bieten Venedig neuen Platz zum Feiern. Auf der Südseite entsteht außerdem ein neuer Durchgang zwischen der Piazzale Roma und den Anlegestellen des ACTV." Die Brücke misst 101 m, mit einer zentralen Spannweite von 80 m. Die Breite variiert von 5,39 m am Fuß bis auf 9,38 m im Scheitelpunkt, die Brücke erhebt sich von 3,2 m Höhe am Fuß zu 9,28 m in der Mitte. Das zur Gänze aus Stahl gefertigte Tragwerk besteht aus einem mittleren Bogen mit dem sehr großen Radius von 180 m und wird auf beiden Seiten von zwei weiteren, flacheren Bögen eingefasst.

Ce pont est le quatrième seulement que l'on ait construit depuis le XVIe siècle sur le Grand Canal de Venise. Le premier fut le pont du Rialto (1588–91), le second le pont de l'Accademia, envisagé en 1488 mais édifié en acier en 1854 seulement par Alfred Neville, puis remplacé par un ouvrage en bois en 1934 (luimême reconstruit à l'identique en 1985). Enfin, le pont des Scalzi, conçu par Eugenio Miozzi, avait supplanté un ancien pont de fer en 1934 pour relier les quartiers de Santa Croce et de Cannaregio, près de la gare de Santa Lucia. Le pont de Santiago Calatrava, qui a fait l'objet d'une commande publique en 1999, connecte la gare routière de la Piazzale Roma à la gare de chemin de fer. Son plan a été approuvé en février 2001 et le budget de 6,7 millions d'euros en avril 2002. Conscient de la haute visibilité du site et de la signification historique de l'ouvrage, Calatrava commente : « Nous avons pris soin d'intégrer le pont au quai à ses deux extrémités. Les marches et les rampes sont conçues pour donner plus de vitalité aux deux rives du canal, tandis que les culées (en croissant) laissent libre accès aux quais. Les deux rives ont été traitées en nouveaux espaces publics pour Venise. Au sud, le projet prévoit également un nouvel ouvrage entre la Piazzale Roma et les plates-formes d'amarrage des *vaporetti*. » Le pont mesure 101 mètres de long et sa portée centrale 80 mètres. Sa largeur varie de 5,39 mètres au départ à 9,38 mètres au centre. Il s'élève de 3,20 mètres à la base jusqu'à 9,28 mètres en partie centrale. La construction entièrement en acier consiste en une arche de très grand rayon (180 mètres), deux arches latérales et deux arches inférieures.

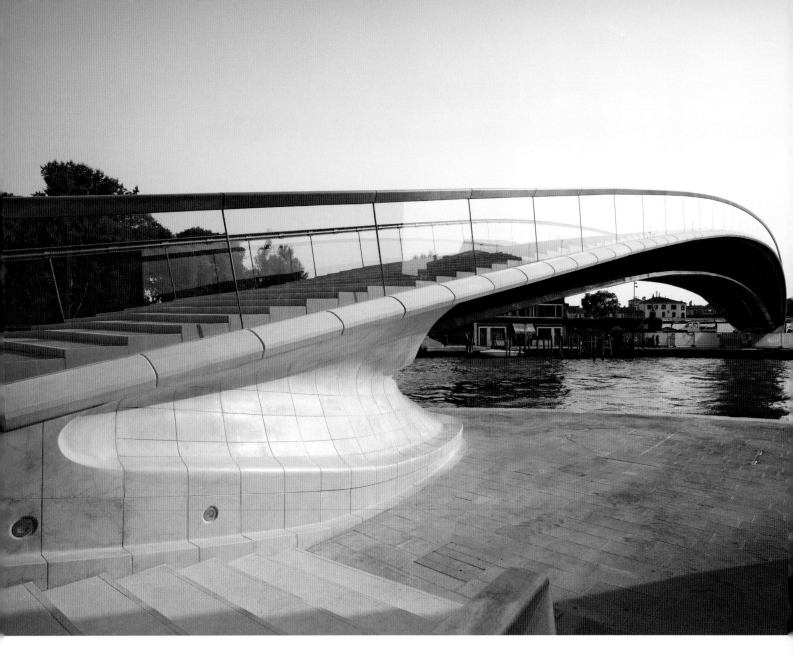

Models of the bridge (below) hardly do justice to the sweeping simplicity of its arch, seen above with the carefully crafted stonework that rises up from the embankment to the main span.

Modelle der Brücke (unten) werden dem ausgreifenden, aber schlichten Schwung des Bauwerks kaum gerecht, wie oben im Bild zu sehen. Das sorgsam gearbeitete Mauerwerk am Ufer schwingt sich zum eigentlichen Brückenbogen empor.

Les maquettes du pont (ci-dessous) ne rendent pas justice à la simplicité de son arche, vue ci-dessus. À noter le travail de la pierre très soigné de la culée qui semble jaillir de la rive.

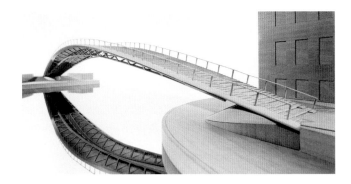

Sketches by Santiago Calatrava and a night lighting scheme give more color to the bridge than it has during the day. Its simple handrails and glass protection contribute to the overall impression of elegance and economy of means.

Auf Skizzen Calatravas und bei nächtlicher Beleuchtung gibt sich die Brücke farbiger als tagsüber. Die schlichten Handläufe und Glasgeländer tragen zum eleganten Gesamtbild bei und zeugen vom reduzierten Materialeinsatz.

Les croquis de Calatrava et l'éclairage nocturne donnent une impression beaucoup plus colorée du pont qu'en journée. La simplicité du traitement des garde-corps contribue au sentiment général d'élégance et d'économie de moyens.

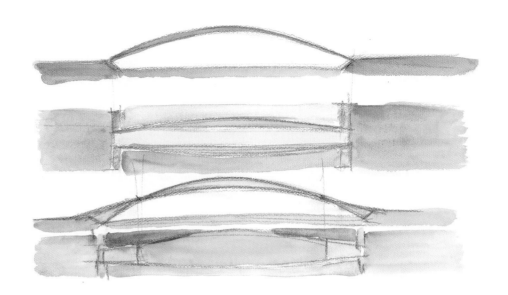

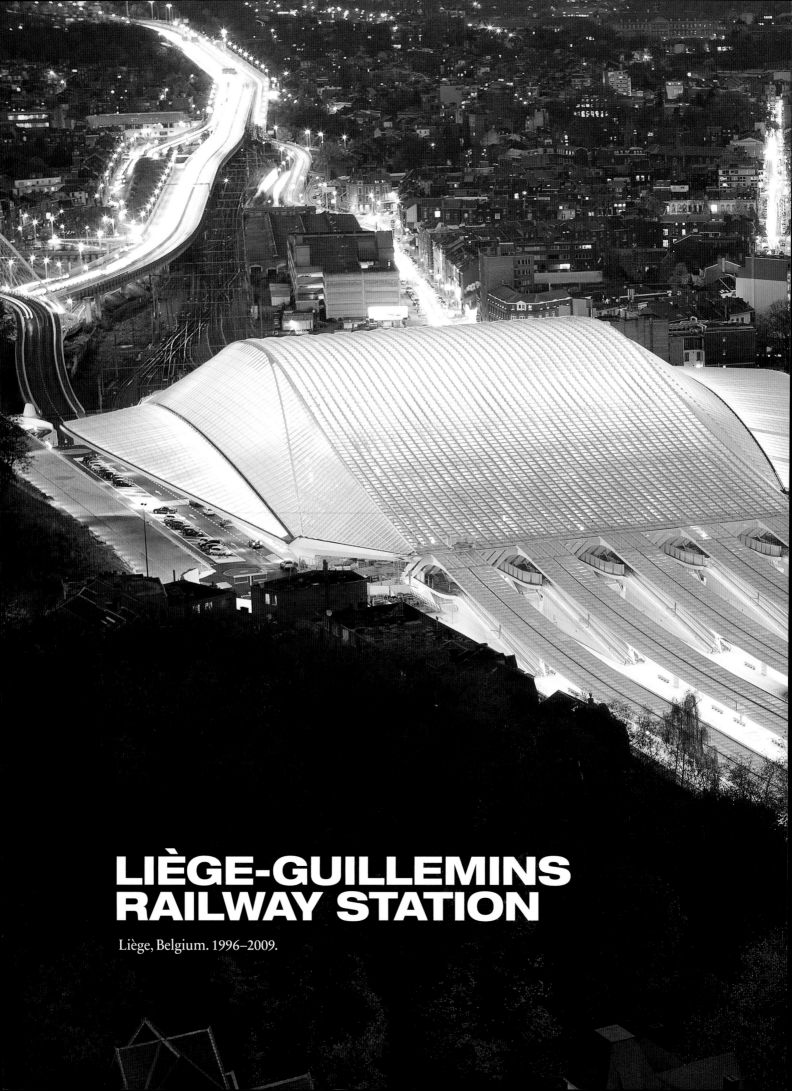

LIÈGE-GUILLEMINS RAILWAY STATION

Liège, Belgium. 1996–2009.

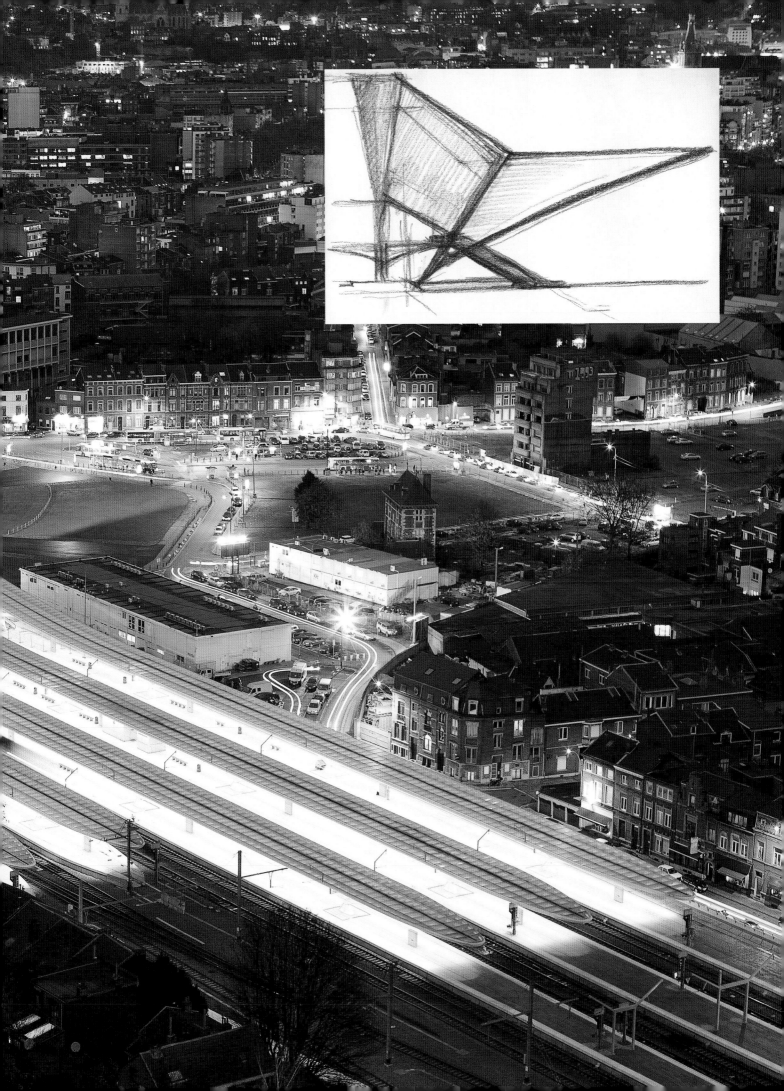

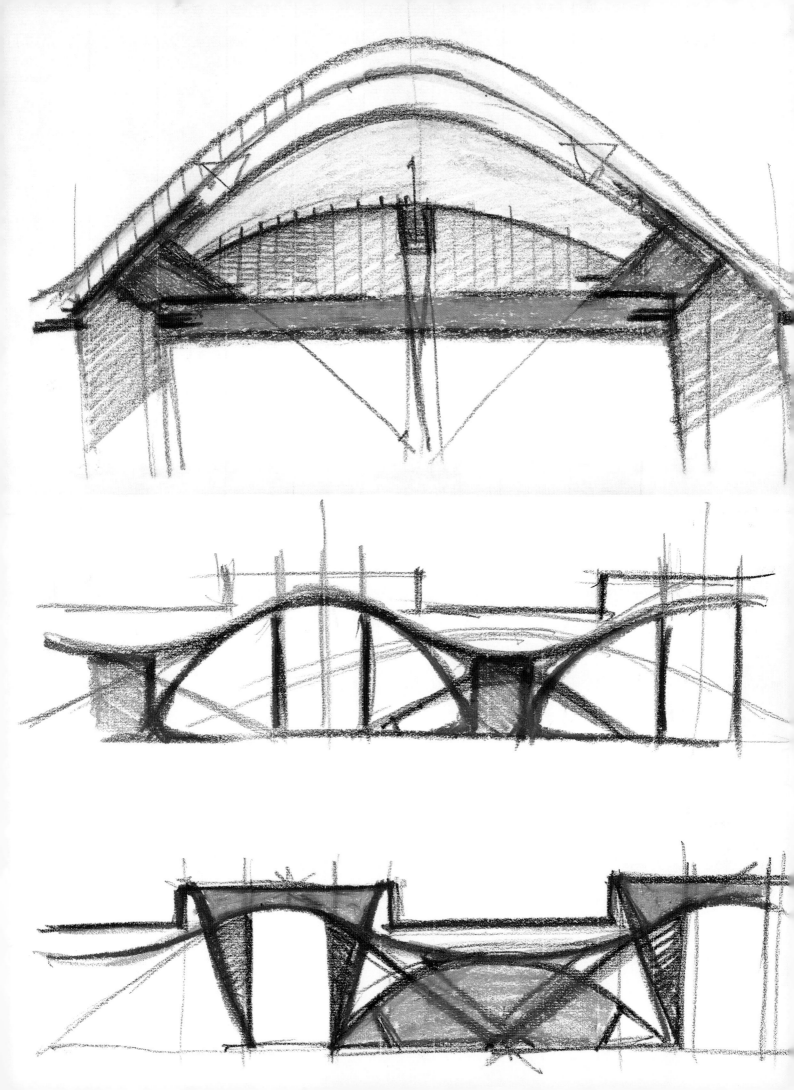

Project
LIÈGE-GUILLEMINS RAILWAY STATION

Location
LIÈGE, BELGIUM

Client
SNCB-HOLDING/INFRABEL/EURO LIÈGE TGV

Santiago Calatrava's sketches render the wavelike form of the station roof explicit and show the relative simplicity of the engineering solutions chosen.

In den Skizzen Calatravas wird die wellenartige Form des Bahnhofsdachs augenfällig. Zugleich veranschaulichen sie die hier gewählten, vergleichsweise einfachen bautechnischen Lösungen.

Les croquis de Santiago Calatrava explicitent la forme en vague de la couverture de la gare et illustrent la simplicité relative des solutions techniques retenues.

For a number of years, the French rapid trains (TGV) bound for Cologne in Germany passed through the Belgian city of Liège at a pace that recalled the 19th century more than the 21st. Along with the inevitable modernization of the train lines concerned, it was also necessary to update the stations along the line from Brussels to Germany. Santiago Calatrava received the commission to design the new Liège-Guillemins Station, largely because of his experience in the field, in projects such as Lyon-Saint Exupéry and the Oriente Station in Lisbon. Much as he had in Lisbon, he conceived the station as a link between two distinct areas of the city of Liège, which previously had been separated by the railroad tracks. On the north side of the site is a rundown urban area, laid out in a typical 19th-century scheme. On the south side, on the slopes of the Cointe Hill, is a less dense, landscaped residential area. Calatrava's design bridges these two areas with a 200-meter passenger terminal, built symmetrically along a northwest-southeast axis. The arched roof of the terminal building extends over the five platforms for another impressive 145 meters. A monumental vault made of glass and steel allows the station to be completely open to the city. Pedestrian bridges and a walkway under the tracks allow for fluid communication between the two sides of the station. Particular attention was paid to the architectural detailing of these spaces. Basing his design on the open transition from interior to exterior, Calatrava resolutely rejected the monumental façade that has traditionally characterized railway stations, at least until they became underground rabbit warrens in the image of New York's Penn Station. Given the need to keep the station functioning throughout construction, techniques learned from building bridges were employed to install the main elements at night.

Viele Jahre lang passierten die französischen Hochgeschwindigkeitszüge auf dem Weg nach Köln die belgische Stadt Lüttich mit einer Geschwindigkeit, die eher an das 19. als an das 21. Jahrhundert gemahnte. Neben der fälligen Instandsetzung der betroffenen Gleisanlagen war es auch notwendig, die Bahnhöfe entlang der Verbindung von Brüssel nach Deutschland zu modernisieren. Santiago Calatrava erhielt den Auftrag, den neuen Bahnhof Liège-Guillemins zu entwerfen, in erster Linie aufgrund seiner Erfahrung auf diesem Gebiet mit Projekten wie dem Bahnhof Lyon-Saint Exupéry und dem Lissaboner Bahnhof Oriente. Ähnlich wie in Lissabon, konzipierte er auch hier den Bahnhof als Bindeglied zwischen zwei verschiedenartigen Stadtteilen von Lüttich, die zuvor durch die Gleise getrennt waren. Im Norden des Geländes befindet sich ein in typischer Manier des 19. Jahrhunderts angelegtes, vernachlässigtes städtisches Areal. Auf der Südseite liegt auf den Hängen des Cointe ein weniger dicht besiedeltes, begrüntes Wohngebiet. Calatrava verband diese beiden Areale mit einem 200 m langen Passagierterminal, das symme-

trisch entlang einer von Nordwest nach Südost verlaufenden Achse entstand. Das gewölbte Dach des Terminals überspannt mit eindrucksvollen 145 m fünf Bahnsteige. Dank eines monumentalen Bogens aus Glas und Stahl kann der Bahnhof zur Stadt hin vollständig offen bleiben. Fußgängerbrücken sowie ein Laufgang unter dem Gleiskörper ermöglichen einen ungestörten Verkehr zwischen den beiden Bahnhofsseiten. Der architektonischen Ausgestaltung dieser Räume wurde besondere Aufmerksamkeit gewidmet. Calatrava, dessen Entwurf auf dem offenen Übergang zwischen Innen- und Außenraum fußt, lehnte die monumentale Fassade ab, wie sie traditionellerweise für Bahnhöfe typisch war, ehe sie in der Art der New Yorker Penn Station zu unterirdischen Maulwurfsbauten wurden. Da der Bahnhof während der gesamten Bauzeit in Betrieb bleiben musste, kamen beim Brückenbau erprobte Techniken zur Anwendung, und die Hauptelemente wurden nachts installiert.

Pendant un certain nombre d'années, les TGV Paris-Cologne traversaient Liège à une allure qui évoquait plus le XIXᵉ siècle que le XXIᵉ. Il était nécessaire de moderniser non seulement les voies, mais aussi les gares entre Bruxelles et l'Allemagne. Santiago Calatrava reçut commande de la gare de Liège-Guillemins en grande partie grâce à son expérience dans ce domaine, illustrée par des projets comme la gare de Lyon-Saint Exupéry ou celle de l'Orient à Lisbonne. Comme il le fit au Portugal, il a conçu ici une gare qui fait lien entre deux zones distinctes de la ville jusqu'alors séparées par les voies ferrées : au nord, une zone urbaine délabrée typique de l'urbanisme du XIXᵉ siècle; au sud, sur les flancs de la colline de Cointe, une zone résidentielle paysagée, moins dense. Le projet de Calatrava jette un pont entre ces deux quartiers, avec un terminal pour passagers de 200 mètres de long de part et d'autre d'un axe nord-ouest/sud-est. La couverture voûtée du bâtiment se prolonge au-dessus des cinq quais par un impressionnant auvent de 145 mètres de long. La voûte monumentale en acier et en verre donne l'impression que la gare est complètement ouverte sur la ville. Des passerelles pour piétons et un passage sous les voies fluidifient la circulation entre les deux côtés de la gare. Une attention particulière a été portée à la qualité de réalisation architecturale de ces espaces. En misant sur une transition ouverte entre l'intérieur et l'extérieur, Calatrava a résolument rejeté le principe de façade monumentale qui a si longtemps caractérisé les gares, du moins jusqu'à ce qu'elles disparaissent sous terre, comme Penn Station à New York. Étant donné la nécessité de maintenir la gare en activité pendant le chantier, des techniques empruntées à la construction de ponts ont été utilisées pour poser les principaux composants en nocturne.

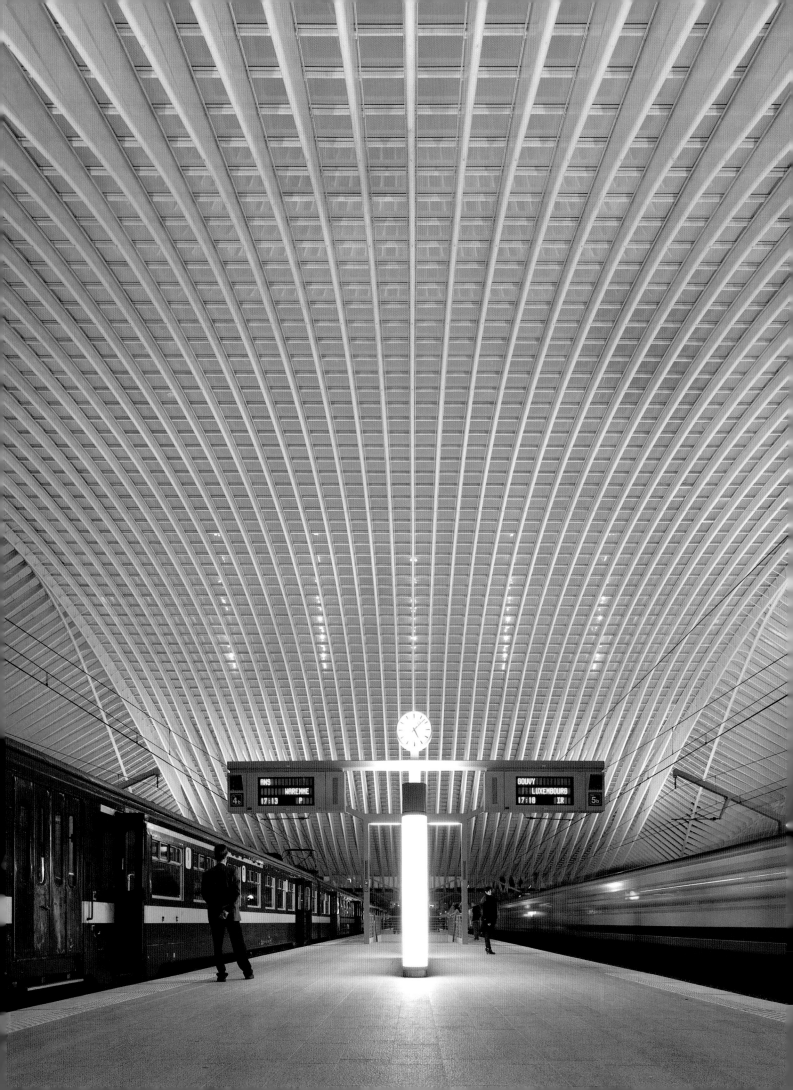

A sketch by the architect (left) echoes the ribbed, soaring design of the canopy and roof structure seen in completed form to the far left.

Eine Skizze des Architekten (links) deutet das rippenartige, hoch auffliegende Vordach und die Dachkonstruktion an, die auf der linken Seite als fertiger Bau zu sehen sind.

Un croquis de l'architecte (à gauche) illustre la forme nervurée en projection de l'auvent et la structure de la toiture, que l'on aperçoit achevés page de gauche.

Below, the broad, bright arch over the tracks imagined by the architect is an ode to movement and a modern vision of rail transport.

Unten: Der vom Architekten gestaltete weite, leuchtende Bogen über den Gleisen ist ein Lobgesang auf die Bewegung und eine moderne Vision vom Schienentransport.

Ci-dessous, dans une vision contemporaine du transport ferroviaire, l'immense arche éclatante de lumière qui protège les quais est comme une ode au mouvement.

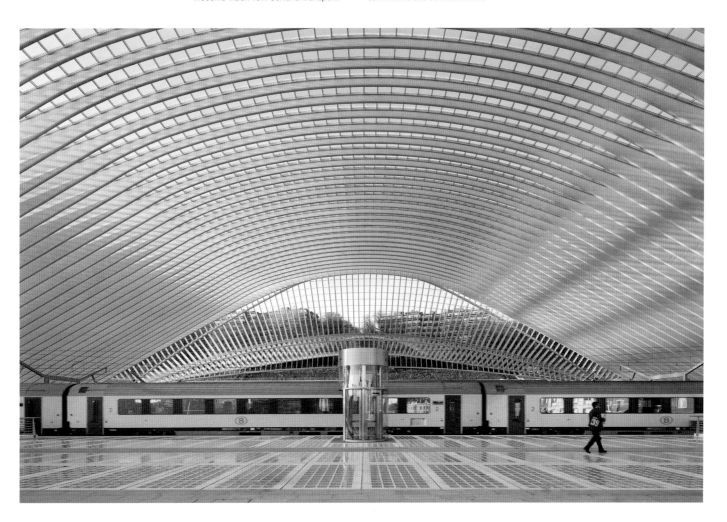

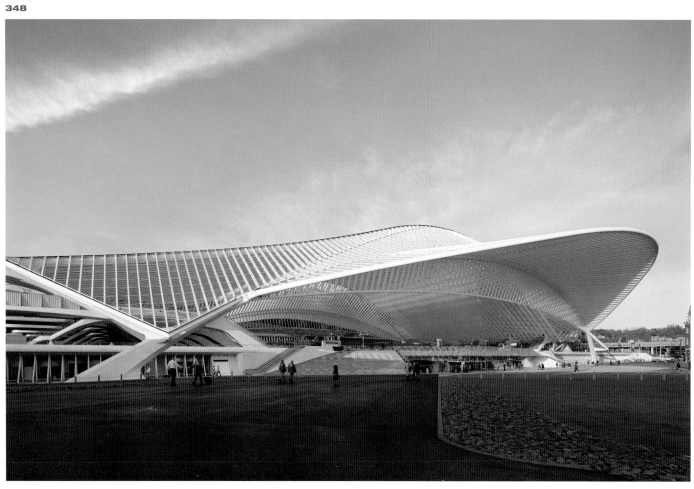

Photos and drawings highlight the soaring canopies and main arch of the Liège high-speed railway station. Calatrava has also completed train stations in Zurich, Lyon, and Lisbon.

Aufnahmen und Zeichnungen lassen die sich dramatisch aufschwingenden Vordächer und den zentralen Bogen des TGV-Bahnhofs in Lüttich deutlich werden. Calatrava realisierte auch Bahnhöfe in Zürich, Lyon und Lissabon.

Les photos et les dessins soulignent la projection des auvents et de l'arc principal de la gare des trains à grande vitesse de Liège. Calatrava a également réalisé des gares à Zurich, Lyon et Lisbonne.

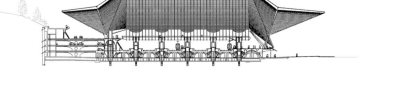

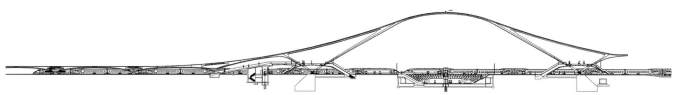

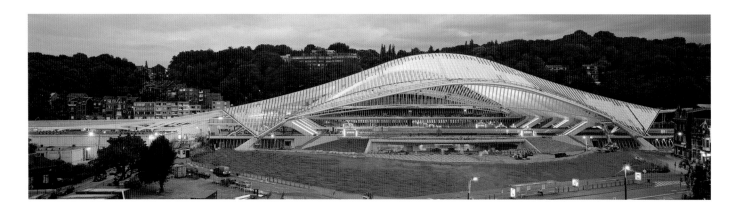

A sketch by the architect, right, shows the relation of the station to the city, with the square in the foreground and the great central arch of the building visible. Below, the vast open space covered by the arch seen in the sketch.

Eine Skizze des Architekten (rechts) zeigt das Verhältnis des Bahnhofs zur Stadt: rechts vorn ein Platz, außerdem die monumentale, zentrale bogenförmige Aufwerfung des Baus. Unten: ein Foto des offenen, vom Bogen überspannten Bereichs.

Un croquis de l'architecte, à droite, montre la relation entre la gare, la place qui lui fait face et le grand arc décrit par la couverture de la gare. Ci-dessous, vue de l'intérieur de l'ample espace protégé par l'arche.

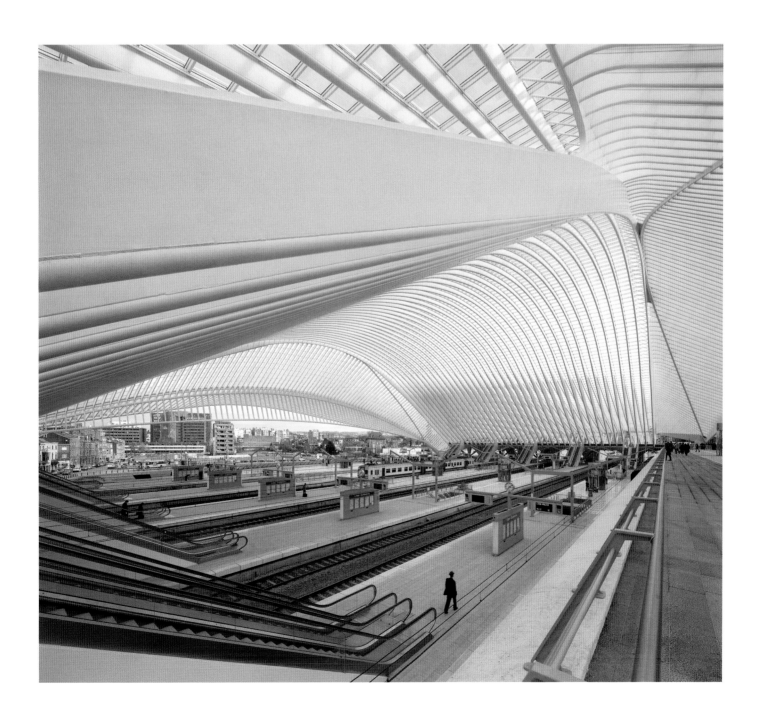

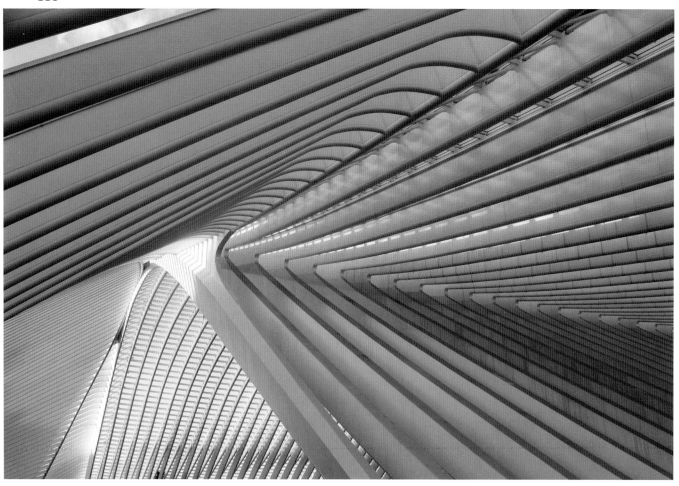

Interior views of the station show the continuity with much earlier work like the Zurich Stadelhofen station and with more recent projects such as the Milwaukee Art Museum. The architect seems to be moving toward ever lighter, more aerial designs.

Innenansichten des Bahnhofs belegen die Kontinuität zu wesentlich früheren Arbeiten wie dem Bahnhof in Zürich Stadelhofen, sowie zu jüngeren Projekten, etwa dem Milwaukee Art Museum. Der Architekt scheint sich immer stärker auf lichtere, durchlässigere Entwürfe hinzubewegen.

Ces vues intérieures de la gare montrent une continuité avec une réalisation beaucoup plus ancienne – la gare de Stadelhofen à Zurich –, mais aussi avec des projets plus récents comme le Musée d'art de Milwaukee. L'architecte semble s'orienter vers des réalisations encore plus légères et aériennes.

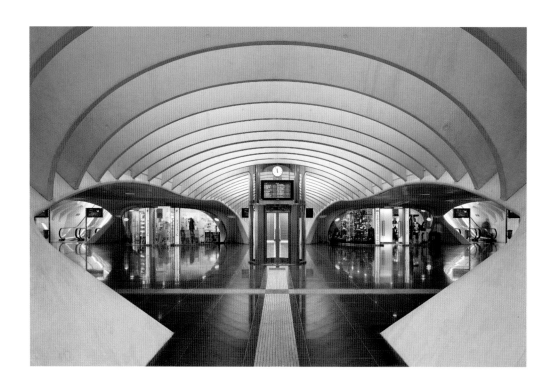

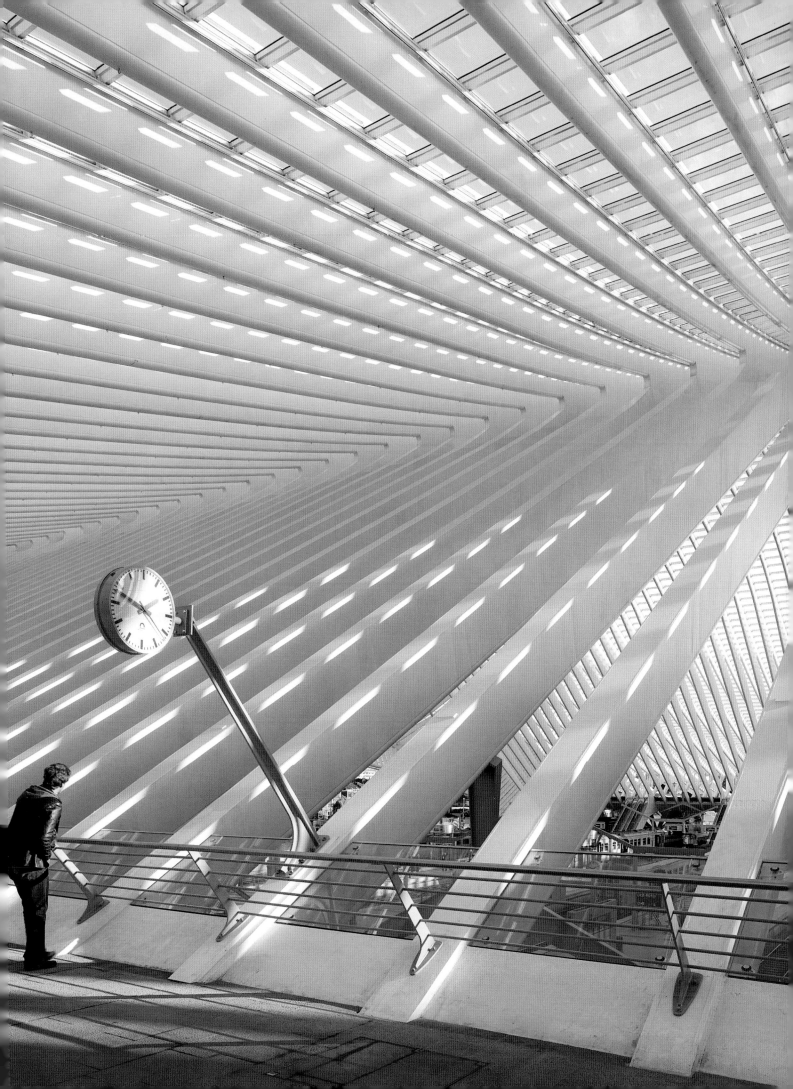

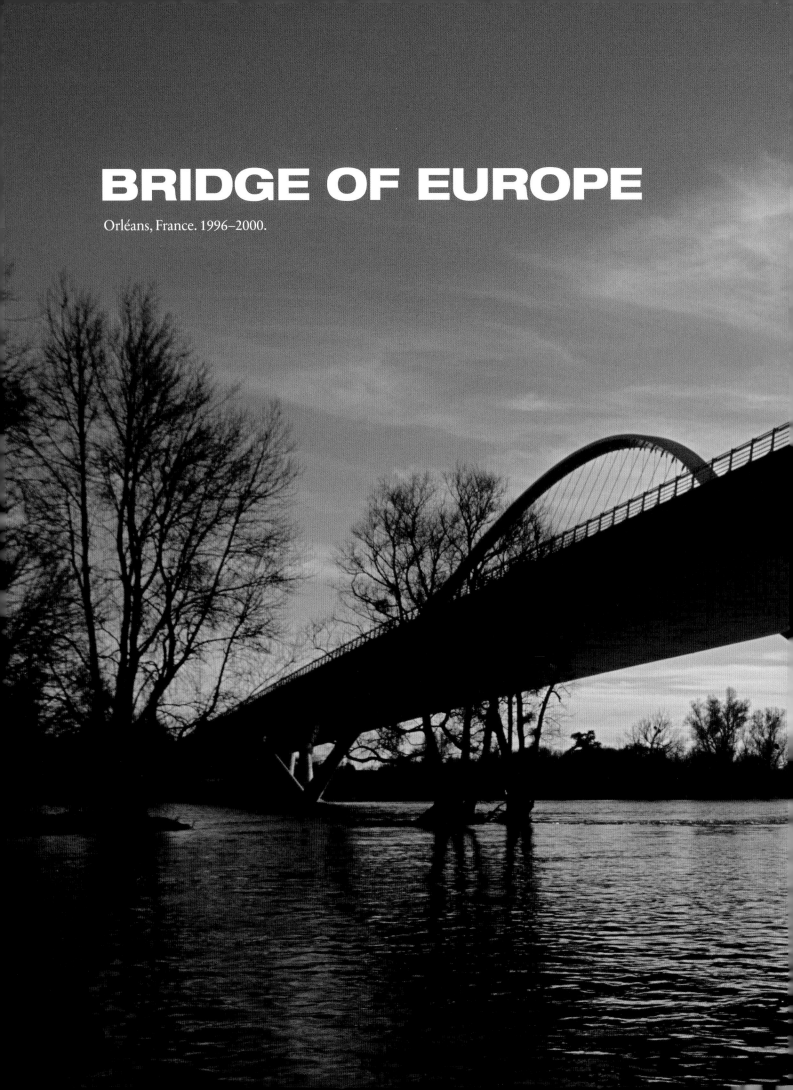

BRIDGE OF EUROPE

Orléans, France. 1996–2000.

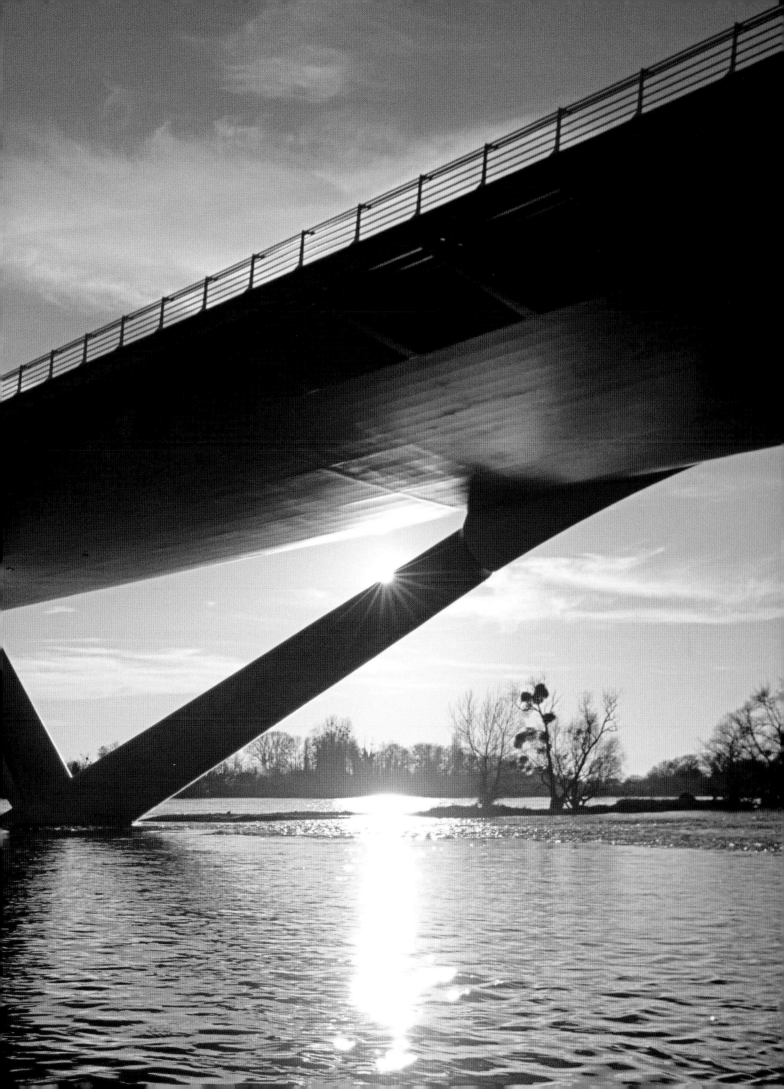

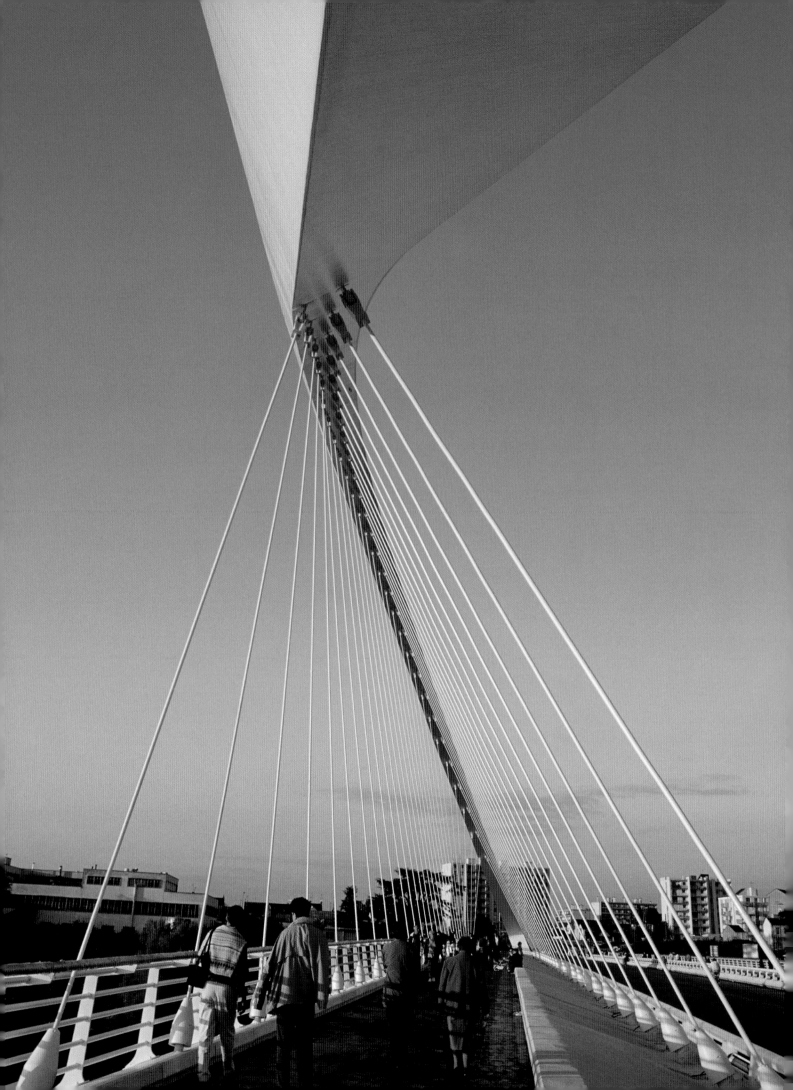

Project
BRIDGE OF EUROPE
Location
ORLÉANS, FRANCE
Client
CITY OF ORLÉANS
Length
378 METERS

With its tilted arc and pedestrian sidewalks, the bridge is at once a symbol for the city and a useful thoroughfare that can be enjoyed on foot as well as in a vehicle.

Die Brücke mit ihren geneigten Bögen und Gehwegen ist zugleich Symbol für die Stadt als auch zweckmäßige Magistrale, an der man sich zu Fuß wie auch in einem Fahrzeug erfreuen kann.

Son arc incliné et ses trottoirs piétonniers font que ce pont est à la fois un symbole de la ville et un franchissement utile dont on peut profiter aussi bien à pied qu'en voiture.

The consortium of local communities (Syndicat Intercommunal à Vocation Multiple, or SIVOM) of the region of Orléans organized a competition in 1996 for the design and realization of a new bridge over the Loire River, linking Saint-Jean-de-la-Ruelle to the north and Saint-Pryvé-Saint-Mesmin to the south. The Orléans area had continually registered increase in motor vehicle traffic and the bridge was conceived in part to relieve urban congestion. Calatrava won the competition for this entrance to the city, which is intended to give a dynamic image of its surroundings, and to provide a modern note for a city that has a particularly rich and vibrant history. This urban bridge fully illustrates the importance that Santiago Calatrava places on the integration of his work into its historic and environmental context. As he says, the composition of the bridge makes reference to the old George V crossing (Pont George V). A road deck in asphalt and concrete walkways were chosen to emphasize the link to the existing urban patterns. Here, Calatrava's signature inclined arch can be seen as an "open book" offering its users views of the city and of the Loire River. The symmetrical piers of the bridge in a sense create a new gateway for Orléans, a city of about 120 000 located 130 kilometers southwest of Paris. Double stainless steel covered cables support the deck of the bridge. The environmental impact of the pylons on the riverbed is reduced to a minimum, to accommodate for the instability of the soil but also to preserve the natural flow of the Loire and its ability to form a reflection. The concrete pylons and their mirror image in the water combine to create the form of an elongated oval.

Das Syndicat Intercommunal à Vocation Multiple oder SIVOM der Region Orléans organisierte 1996 einen Wettbewerb für Entwurf und Bau einer neuen Brücke über die Loire, die Saint-Jean-de-la-Ruelle im Norden und Saint-Pryvé-Saint-Mesmin im Süden miteinander verbinden sollte. In der Gegend von Orléans hatte man eine ständige Zunahme des Autoverkehrs festgestellt, und die Brücke sollte die häufig durch Staus verstopfte Stadt entlasten. Calatrava konnte den Wettbewerb für diesen Eingang zur Stadt für sich entscheiden. Die Brücke sollte ihrer Umgebung zu einem dynamischen Erscheinungsbild verhelfen und der Stadt, die sich durch eine besonders reiche und lebendige Geschichte auszeichnet, eine moderne Note hinzufügen. Diese Stadtbrücke veranschaulicht aufs Beste die Bedeutung, die Santiago Calatrava der Integration seiner Bauten in den historischen und standortbedingten Kontext beimisst. Ihm zufolge nimmt die Gestaltung der Brü-

cke Bezug auf den alten Pont George V. Die Wahl fiel auf eine asphaltierte Straße und Gehsteige aus Beton, um die Verbindung zu vorhandenen urbanen Vorgaben zu unterstreichen. In diesem Fall kann man Calatravas Leitmotiv, den geneigten Bogen, als „aufgeschlagenes Buch" verstehen, das dem Leser Blicke auf die Stadt und die Loire eröffnet. Die symmetrischen Brückenpfeiler bilden in gewissem Sinn ein neues Stadttor für Orléans, eine 130 km südwestlich von Paris gelegene Stadt mit etwa 120 000 Einwohnern. Mit nicht rostendem Stahl ummantelte Doppelseile tragen die Brückentafel. Der umweltrelevante Einfluss der Pylone auf das Flussbett ist auf ein Minimum reduziert, um der Instabilität des Baugrunds Rechnung zu tragen sowie das natürliche Fließen der Loire und die Möglichkeit der Spiegelung zu erhalten. Die Betonpylone und ihr Spiegelbild im Wasser ergeben gemeinsam die Form eines gestreckten Ovals.

C'est en 1996 que le Syndicat intercommunal à vocation multiple (Sivom) de l'agglomération d'Orléans a organisé un concours pour la conception et la réalisation d'un nouveau franchissement de la Loire entre Saint-Jean-de-la-Ruelle au nord et Saint-Pryvé-Saint-Mesmin au sud. Orléans, ville de 120 000 habitants au sud-ouest de Paris, connaissait un accroissement continu de la circulation automobile et ce nouveau pont devait réduire la congestion urbaine. Calatrava remporta le concours avec une proposition qui fait aussi office de porte urbaine et donne une image de dynamisme et de modernité à une cité dont le passé fut particulièrement riche et mouvementé. Ce pont illustre pleinement l'importance qu'accorde Santiago Calatrava à l'intégration de ses créations dans leur contexte historique et environnemental. Comme il l'explique, la forme de l'ouvrage fait référence à l'ancien pont George V. Un tablier en asphalte et des trottoirs en béton renforcent le lien avec les pratiques urbaines existantes. Ici, la marque de l'architecte, l'arc incliné, peut se prendre comme un « livre ouvert » offrant à ses usagers une vue sur la ville et sur la Loire. Les piles symétriques créent en quelque sorte une nouvelle porte de la ville. Les câbles doubles en acier inoxydable soutiennent le tablier. L'impact environnemental des pylônes sur le lit de la rivière est réduit au minimum pour des raisons de stabilité du sol mais aussi pour préserver le flux naturel du fleuve et l'effet esthétique du reflet de l'arche à sa surface. Les pylônes en béton et leur reflet dans l'eau se combinent pour former un immense ovale étiré.

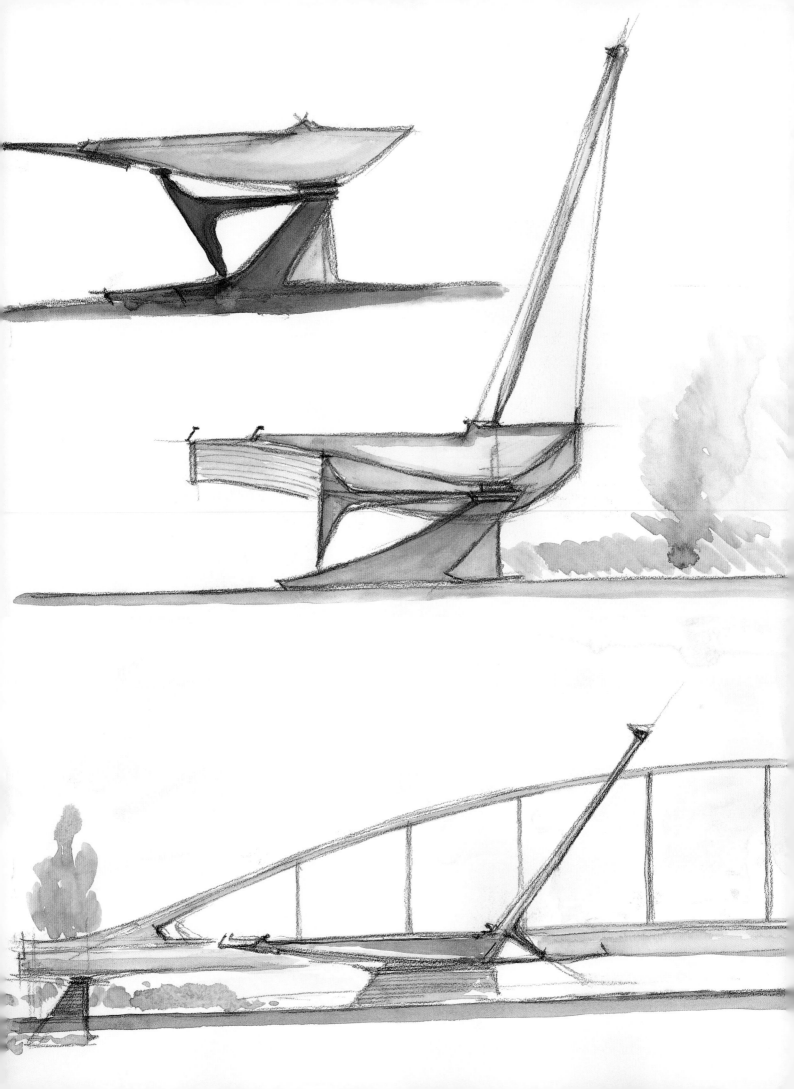

Calatrava's study sketches for the bridge reveal the variety of forms he worked on, while the fundamental lines of the bridge, as seen in the photo below, are clean and dynamic, arcing over the river with characteristic lightness.

Calatravas Brückenstudien enthüllen die Vielfalt an Formen, die er erarbeitet hat, während die Grundlinien der Brücke auf dem Foto unten klar und dynamisch sind und den Fluss mit charakteristischer Leichtigkeit überbrücken.

Les croquis d'étude pour le pont révèlent la variété des formes sur lesquelles Calatrava a travaillé. Le dessin de l'ouvrage, comme le montre la photo ci-dessous, est net et dynamique, s'incurvant au-dessus de l'eau avec une légèreté caractéristique.

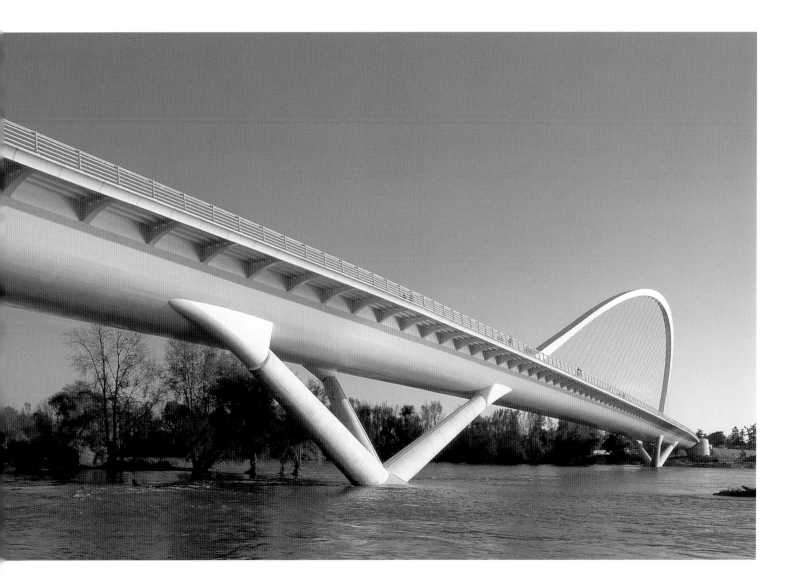

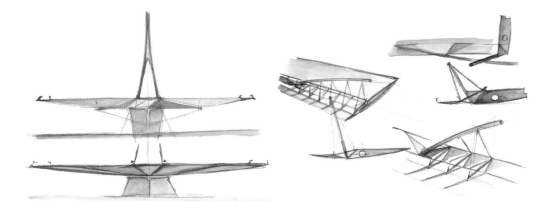

The light arching form of the bridge may not be unique in its design, but it is quite distant from what one has come to expect of more utilitarian crossing points, created by engineers who are not inclined to use their imagination.

Die leichte Bogenform der Brücke mag in ihrer Gestaltung nicht einzigartig sein, aber es liegen Welten zwischen ihr und den von fantasielosen Ingenieuren geschaffenen, utilitaristischen Übergängen.

La forme de l'arc aérien du pont n'est peut-être pas extrêmement originale, mais elle est tout de même assez éloignée de ce que l'on attend de franchissements plus utilitaires dessinés par des ingénieurs qui libèrent rarement leur imagination.

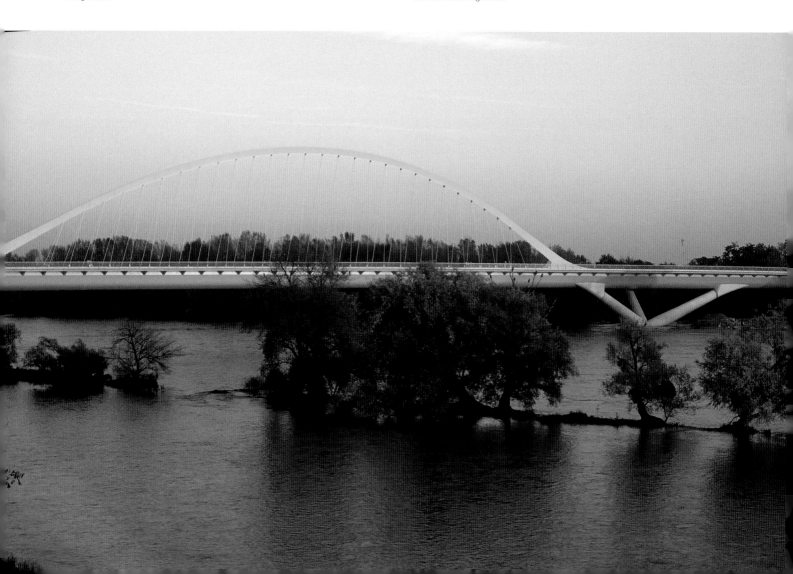

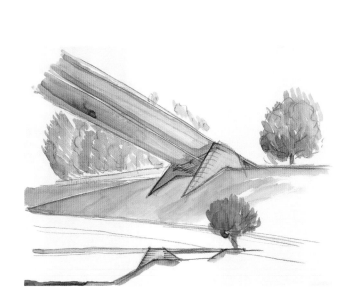

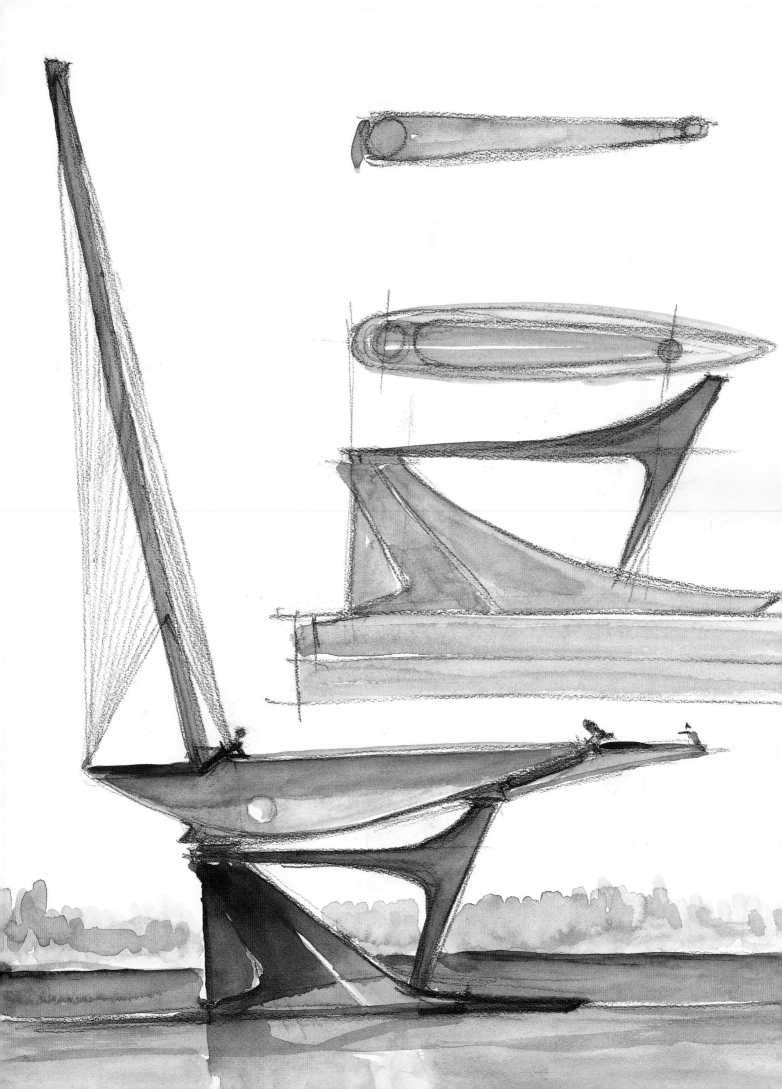

Again showing the tilted arc from a frontal position in the sketch to the left, the architect also carefully explores the form of the supports, essential elements in the overall elegance of the bridge.

Auf der Skizze links ist wiederum der schrägstehende Bogen von vorne zu sehen, was zeigt, dass der Architekt auch die Form der Stützen, wesentlich für die Wirkung der Brücke, überlegt wählte.

Dans le croquis de gauche montrant l'arc incliné en position frontale, l'architecte explore avec soin la forme des pylônes, éléments essentiels de l'élégance d'ensemble du pont.

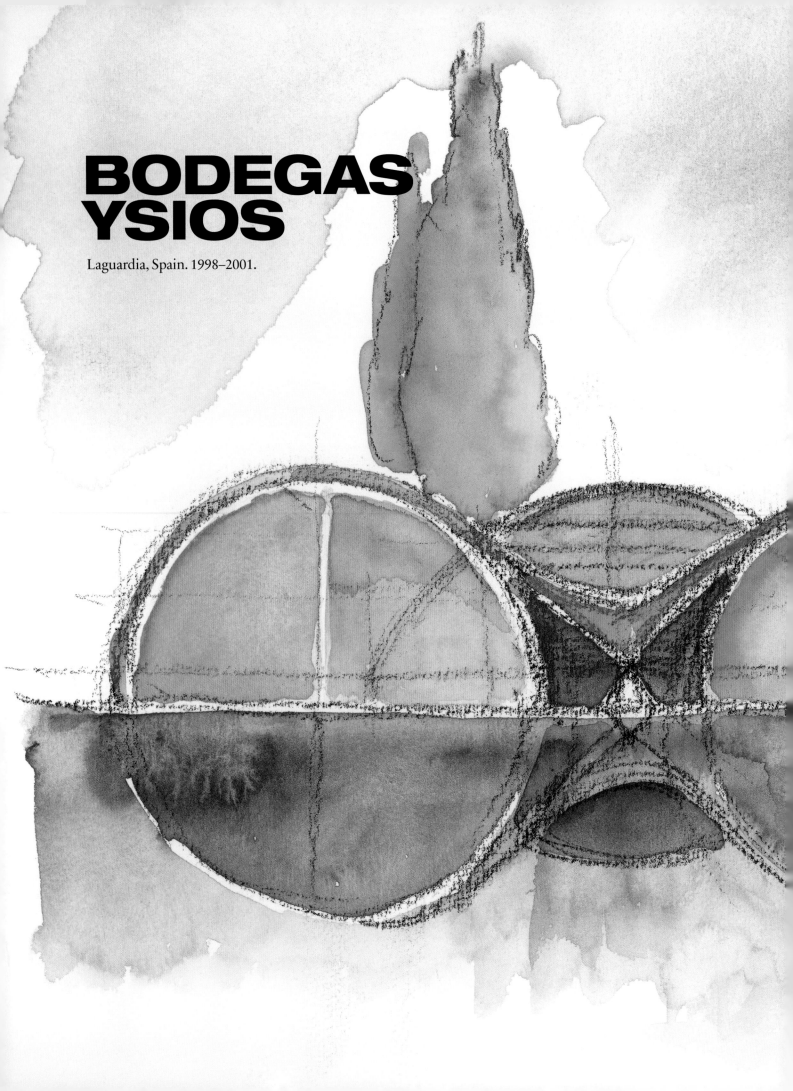

BODEGAS YSIOS

Laguardia, Spain. 1998–2001.

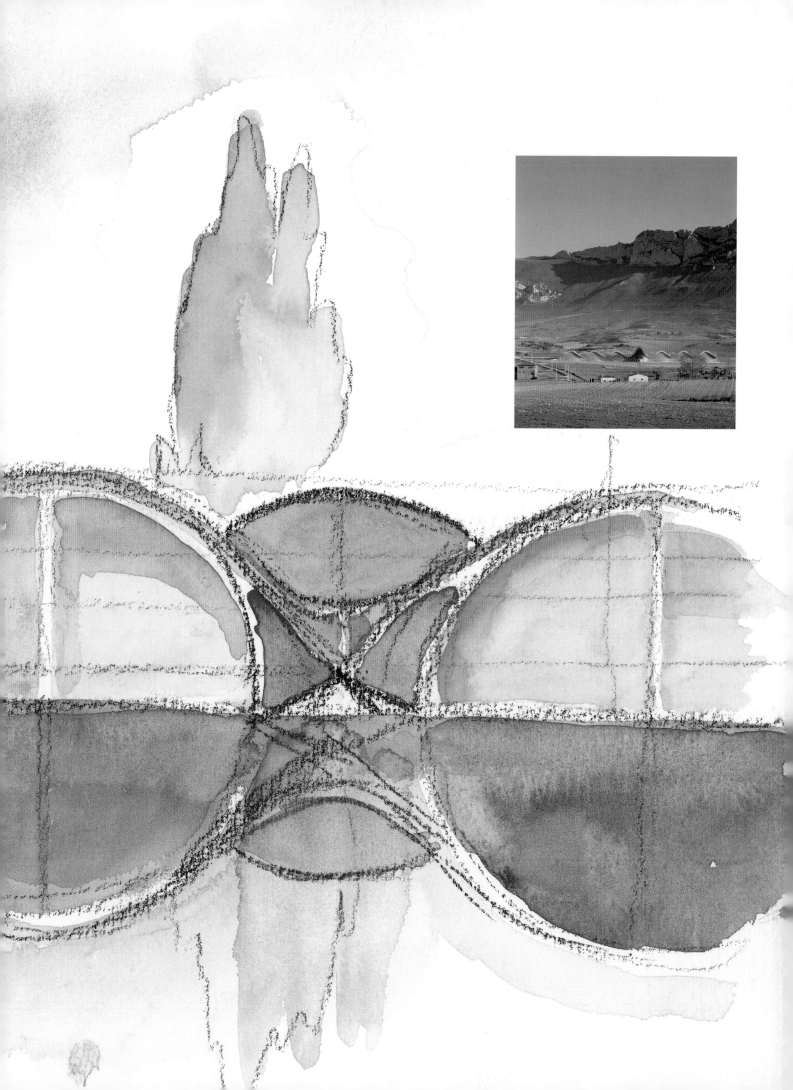

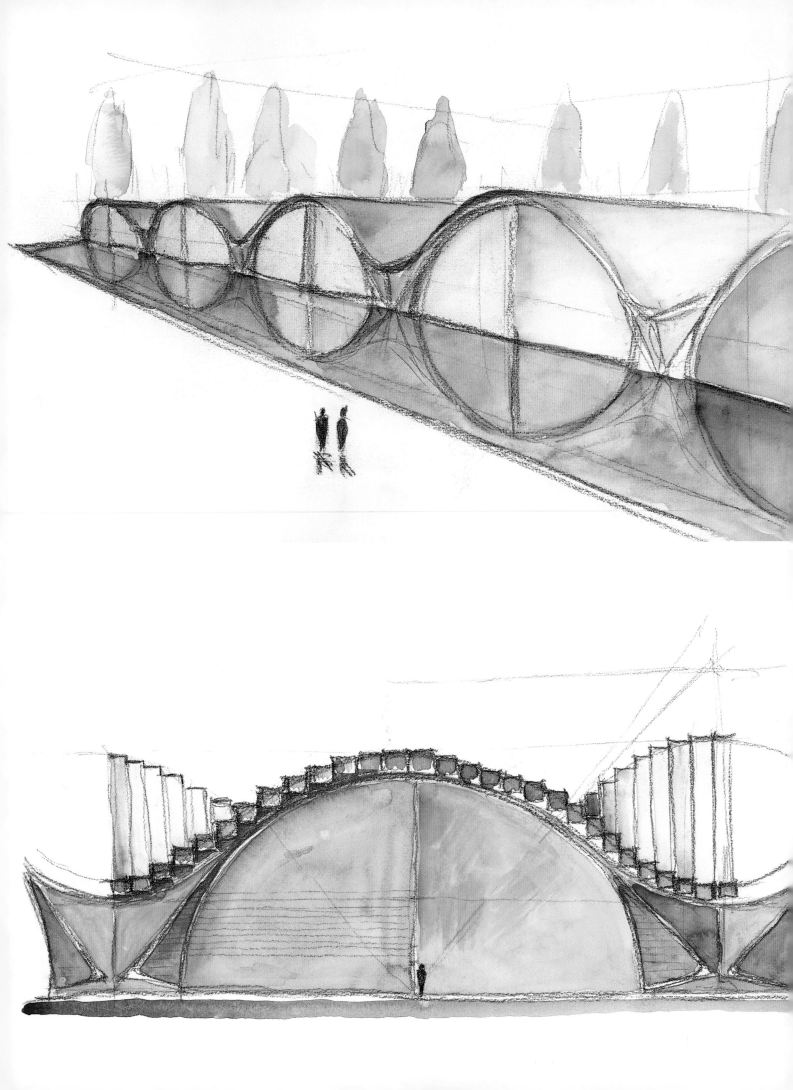

Project
BODEGAS YSIOS
Location
LAGUARDIA, ÁLAVA, SPAIN
Client
BODEGAS & BEBIDAS GROUP
Floor area
8000 m²
Cost
$10 MILLION

The undulating form of the roof of the building again recalls that of a human eye when it is reflected in the sketch on the upper left. Calatrava renews the traditional architecture of the vineyard with this structure.

Die gewellte Form des Daches erinnert in der Skizze oben links wieder an die des menschlichen Auges. Calatrava erneuert mit diesem Bau die traditionelle Architektur der Weinberge.

La ligne ondulée du toit rappelle un œil humain comme le souligne le croquis en haut, à gauche. Avec ce projet, Calatrava renouvelle l'architecture traditionnelle des installations viticoles.

The Bodegas & Bebidas Group wanted a building that would be an icon for its prestigious new Rioja Alavesa wine. They called on architect Santiago Calatrava to design an 8000-square-meter winery complex, a building that had to be designed to make, store, and sell wine. Vineyards occupy half of the rectangular site. A difference in height of 10 meters from the north to the south of the site complicated the design. The linear program of the winemaking process dictated that the structure should be rectangular and it was set along an east-west axis. Two longitudinal concrete load-bearing walls, separated from each other by 26 meters, trace a 196-meter-long sinusoidal shape in plan and in elevation. These walls are covered with wooden planks, which are mirrored in a reflecting pool and "evoke the image of a row of wine barrels." The roof, composed of a series of laminated wood beams, is designed as a continuation of the façades. The result is a "ruled surface wave," which combines concave and convex surfaces as it evolves along the longitudinal axis. The roof is clad in aluminum, creating a contrast with the warmth of the wooden façades and yet continuing their design. A visitor's center conceived as a "balcony that overlooks the winery and the vineyard" is situated in the center of the structure.

Die Gruppe Bodegas & Bebidas wünschte ein Gebäude, das als Signum für ihren prestigeträchtigen, neuen Rioja-Alavesa-Wein dienen konnte. Sie wandte sich an Santiago Calatrava, der eine 8000 m² große Anlage gestalten sollte, in der Wein hergestellt, gelagert und verkauft werden konnte. Die Hälfte des rechtwinkligen Geländes wird von Rebstöcken eingenommen. Ein zwischen dem nördlichen und südlichen Teil des Geländes bestehender Höhenunterschied von 10 m erschwerte die Aufgabe. Der lineare Ablauf der Weinherstellung gab die Rechtwinkligkeit des Gebäudes vor, das entlang einer Ost-West-Achse errichtet wurde. Zwei längs verlaufende, tragende Betonwände, zwischen denen ein Abstand von 26 m liegt, folgen in Grund- und Aufriss einer Wellenform. Diese Wände sind mit Holzbohlen verschalt, die sich in einem Wasserbecken spiegeln und „das Bild einer Reihe von Weinfässern hervorrufen". Das aus aneinander gereihten Schichtholzbalken bestehende Dach ist als Fortführung der Fassade konzipiert. Entlang der Längsachse entsteht so eine regelmäßig gewellte Oberfläche, bei der konkave und konvexe Flächen kombiniert sind. Das mit Aluminium verkleidete Dach kontrastiert mit der Wärme der Holzfassaden, führt deren Formgebung jedoch weiter. Ein Besucherzentrum, das als „Balkon, der Kellerei und Rebstöcke überschaut," gestaltet ist, befindet sich in der Mitte des Gebäudes.

Le groupe Bodegas & Bebidas souhaitait construire un bâtiment qui symbolisât son prestigieux Rioja Alavesa. Il fit appel à Santiago Calatrava pour ce chai de 8000 mètres carrés dédié à l'élaboration, la conservation et la commercialisation de ce nouveau vin. Une dénivellation de dix mètres entre la partie nord et la partie sud compliquait l'aménagement de ce terrain rectangulaire occupé pour moitié par des vignes. Le processus linéaire de fabrication du vin exigeait un bâtiment rectangulaire, qui fut implanté est-ouest. Deux murs porteurs en béton, séparés de 26 mètres, dessinent une forme sinusoïdale de 196 mètres de long, en plan comme en élévation. Ils sont habillés d'un bardage de bois qui se reflète dans un bassin et « évoquent un alignement de barriques ». Le toit, réalisé en poutres de bois lamellé, est dans le prolongement des façades. Il en résulte un effet de « vague » alternant surfaces convexes et concaves tout au long de l'axe longitudinal. L'aluminium qui habille la toiture contraste avec le bois chaleureux des façades. Au centre des installations est implanté le centre d'accueil des visiteurs, conçu comme « un balcon dominant le chai et le vignoble ».

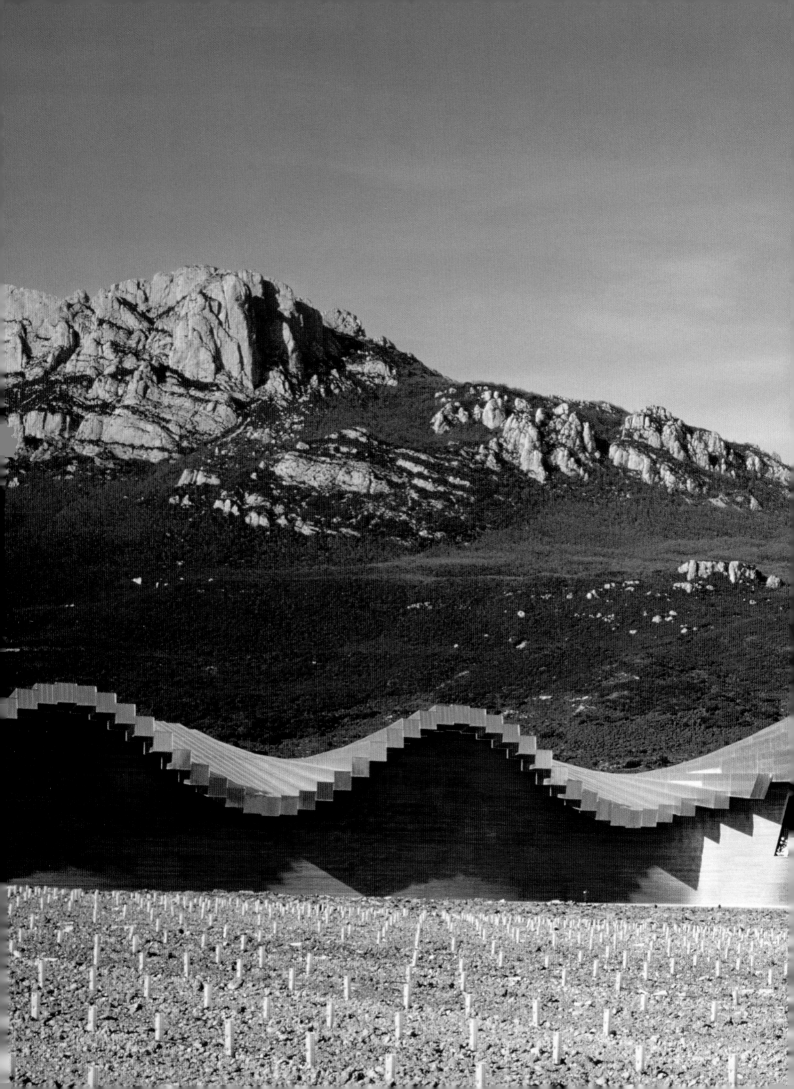

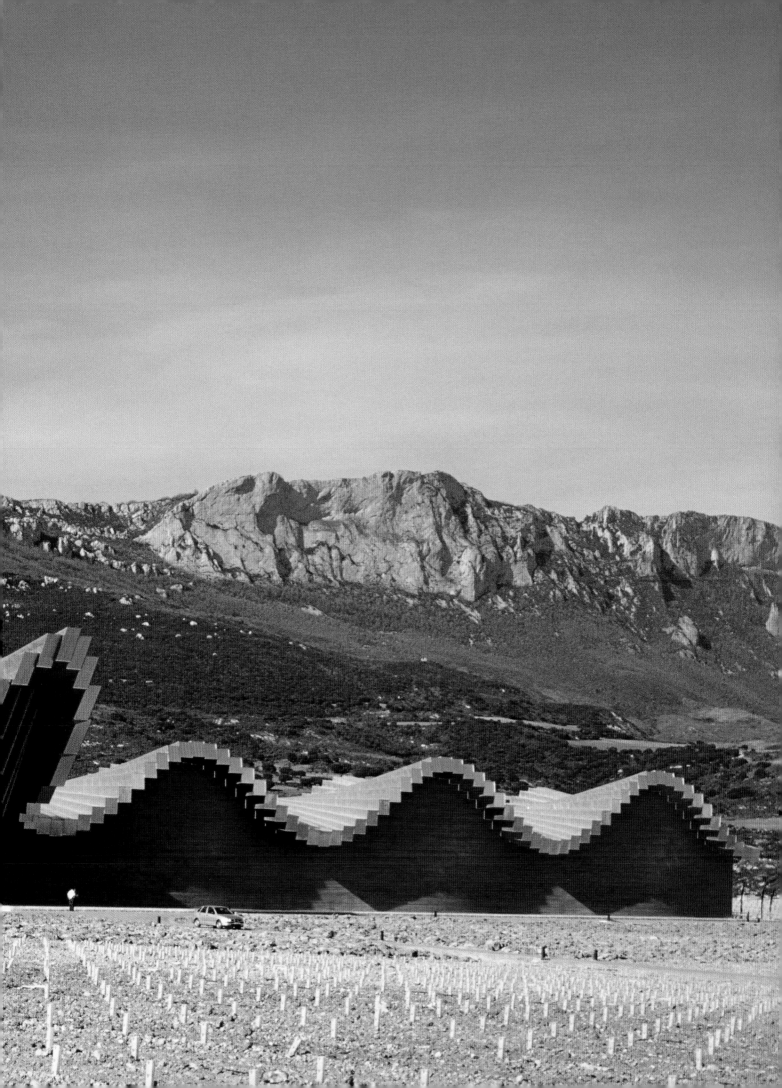

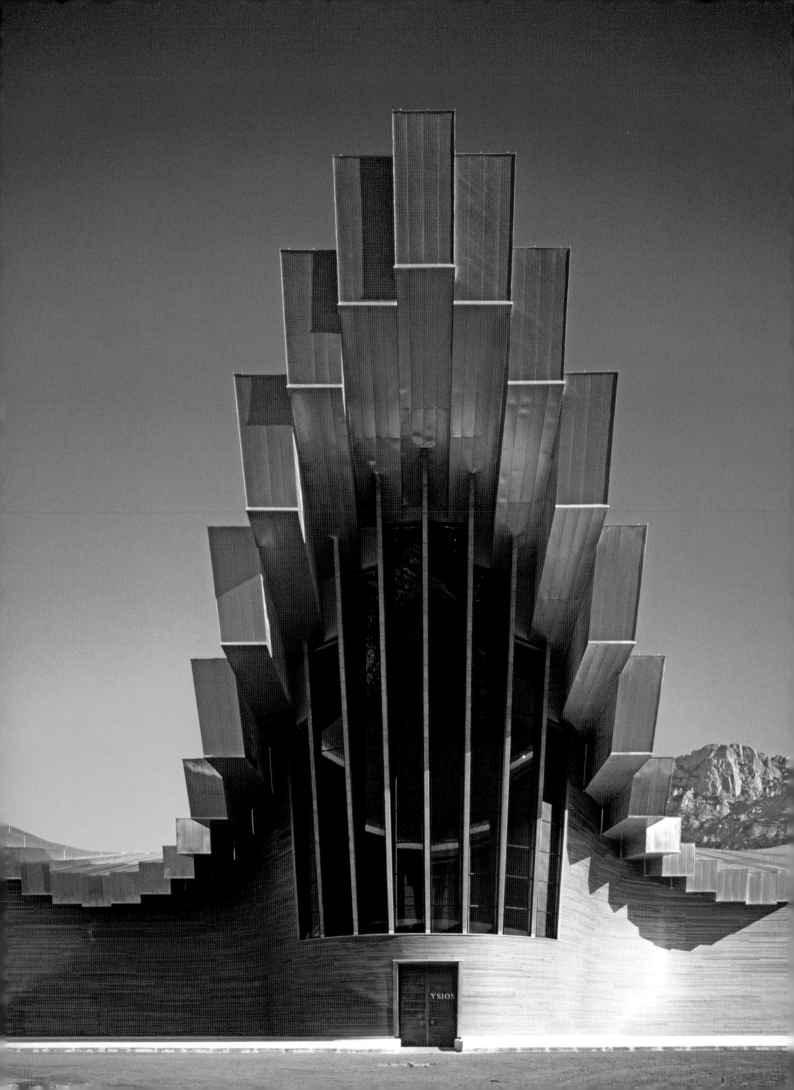

The strong undulating roof of the building defines its overall form. Sketches below relate its height to those of trees.

Das stark gewellte Dach des Gebäudes bestimmt die Gesamtform. In den Skizzen unten ist seine Höhe im Verhältnis zu Bäumen dargestellt.

La forte ondulation du toit définit sa forme d'ensemble. Les croquis ci-dessous montrent le rapport d'échelle avec la hauteur des arbres.

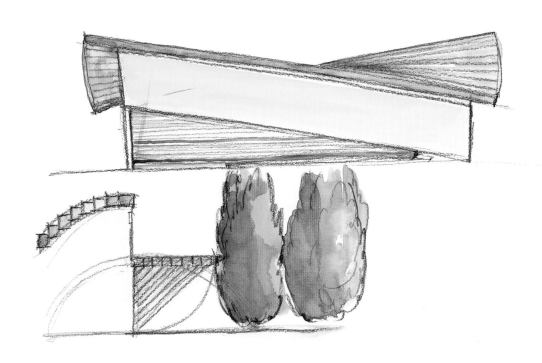

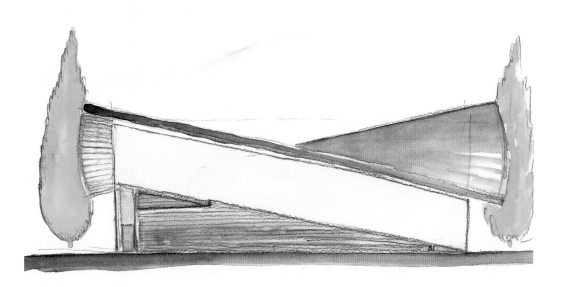

Despite their apparent simplicity, Calatrava's sketches (below) offer a very accurate vision of the completed structure, as the roof detail to the right demonstrates.

Ungeschadet ihrer scheinbaren Einfachheit geben Calatravas Skizzen (unten) eine sehr genaue Ansicht des fertigen Gebäudes wieder, wie der Dachausschnitt rechts veranschaulicht.

Malgré leur simplicité apparente, les croquis de Calatrava (ci-dessous) offrent une vision très précise de la structure achevée, comme le prouve ce détail du toit (à droite).

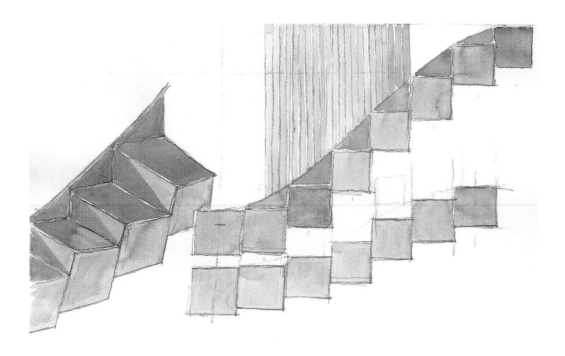

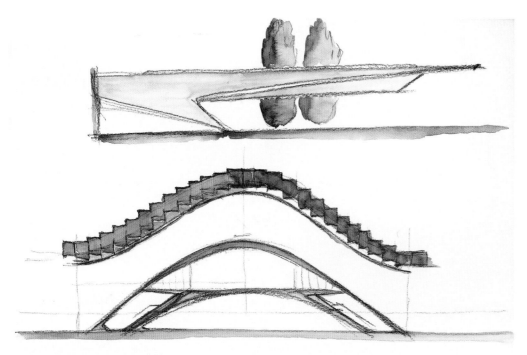

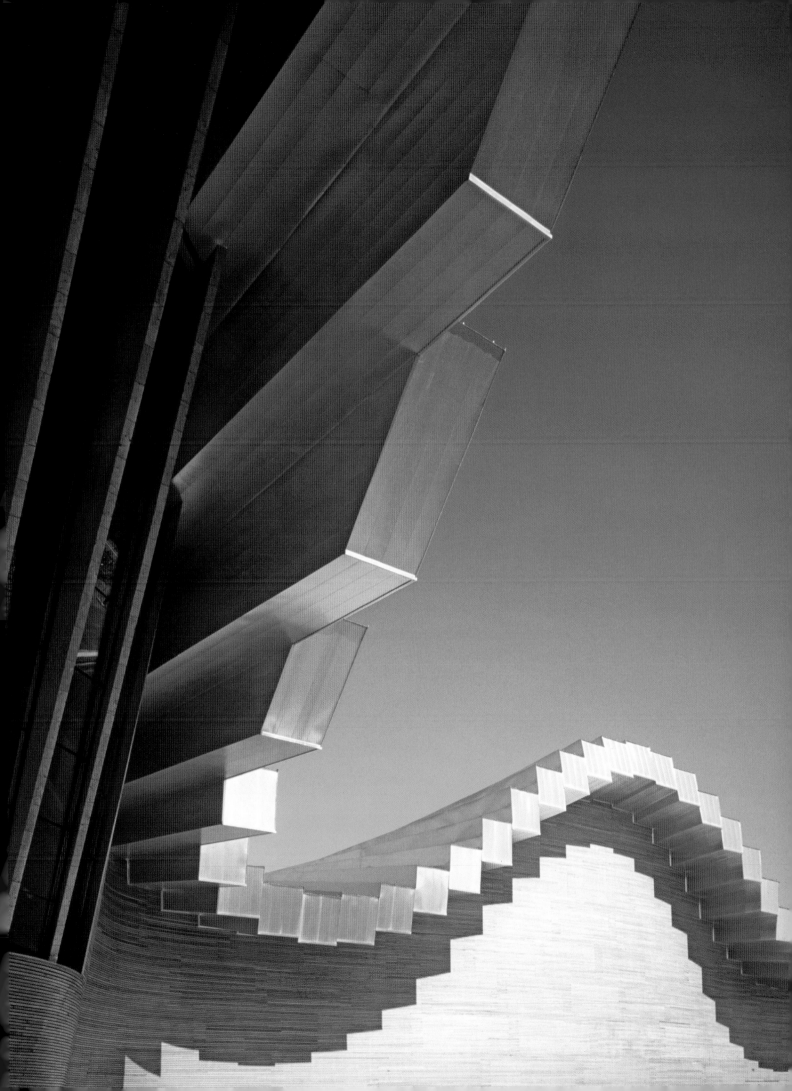

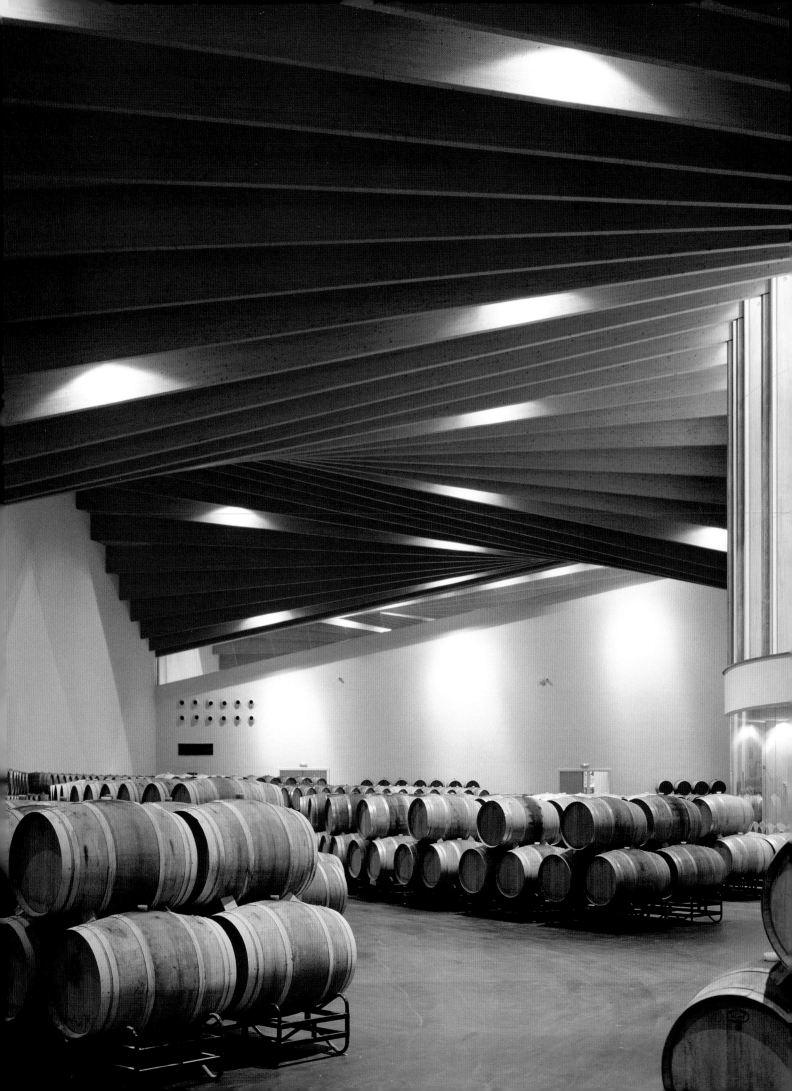

Unlike some very well-known architects who consistently privilege exterior appearance in their work, Calatrava can be recognized almost immediately by his mastery of interior spaces, conceived in harmony with the outer shell of the building.

Im Gegensatz zu einigen wohlbekannten Architekten, die in ihrem Schaffen beständig das äußere Erscheinungsbild vorrangig behandeln, ist Calatrava an der meisterhaften Gestaltung der Innenräume erkennbar, die er in Übereinstimmung mit der äußeren Gebäudehülle konzipiert.

Contrairement à certains architectes célèbres qui, dans leurs travaux, privilégient systématiquement l'aspect extérieur, ceux de Calatrava sont immédiatement reconnaissables à la maîtrise des volumes intérieurs conçus en harmonie avec l'enveloppe extérieure du bâtiment.

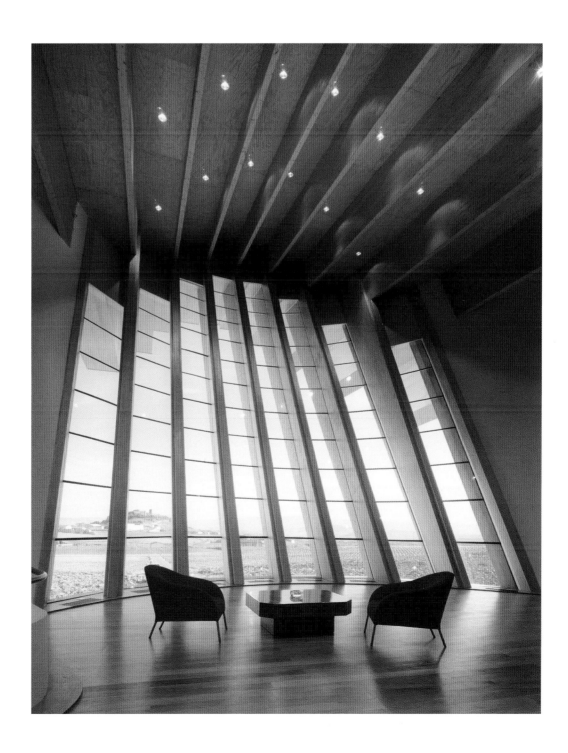

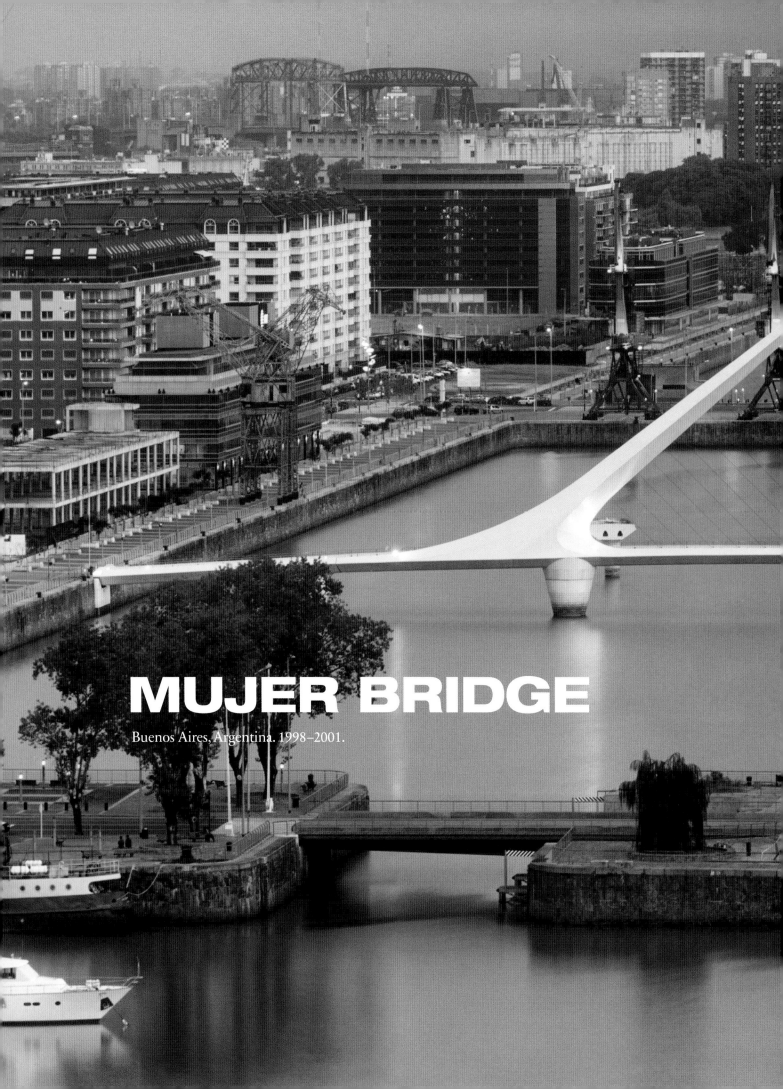

MUJER BRIDGE

Buenos Aires, Argentina. 1998–2001.

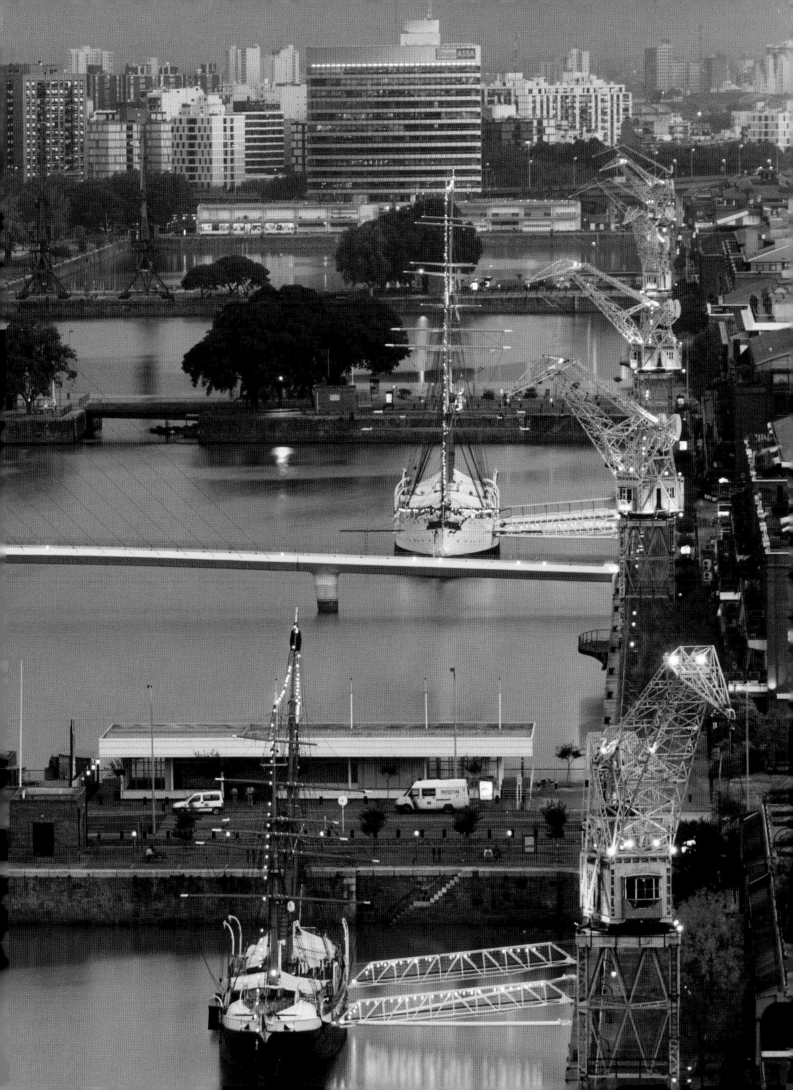

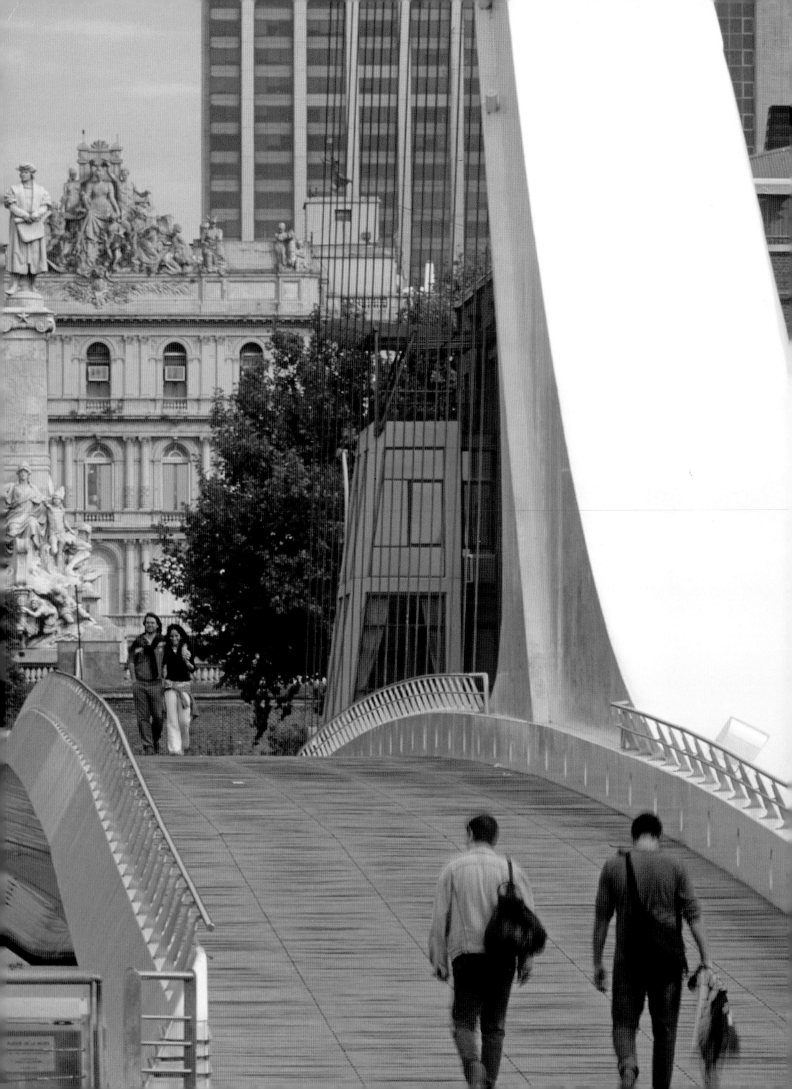

Project
MUJER BRIDGE

Location
PUERTO MADERO, BUENOS AIRES, ARGENTINA

Client
GONZÁLEZ S.A. GROUP

Length
160 METERS

Cost
€ 6 MILLION

The pedestrian bridge offers a modestly inclined deck that is quite convivial. In the image to the left, the strong support mast contrasts with the scale of the people crossing the bridge.

Die Fußgängerbrücke zeichnet sich durch eine leicht geneigte, recht heitere Brückentafel aus. Auf dem Bild links bildet der starke Stützmast einen augenfälligen Kontrast zur Größe der Passanten auf der Brücke.

La passerelle piétonnière présente un tablier légèrement incliné, assez convivial. Dans l'image de gauche, le solide pylône contraste avec l'échelle des passants franchissant le pont.

Beginning in the late 1980s, Buenos Aires began to take an interest in urban planning and development strategies designed to attract international capital, and in particular sought to revitalize the city's rundown port area, the Puerto Madero. Named after the engineer Eduardo Madero, who proposed the construction of the port in 1881, the area was already idle by 1925 when a new port was built to the north. Various proposals, including one by Le Corbusier (1929), sought to revitalize the area, but it was not until 1989 that the Corporación Antiguo Puerto Madero formulated a redevelopment master plan for the 170-hectare site. In this instance, the client asked Calatrava to design a footbridge for Dock 3 in the Puerto Madero, which was insufficiently connected to the city. His solution, the Puente de la Mujer, is "a structure that consists of a rotating suspension bridge, 102 meters long, set between a pair of fixed approach spans. The central section is suspended by cables from an inclined pylon 39 meters high. This section of the bridge can rotate 90 degrees to allow free passage of water traffic. The weight of the mechanical tower balances the weight of the pylon, allowing the rotational system to be simplified. With its night lighting, the bridge has become a symbol for the regeneration of this part of the capital."

Ende der 1980er-Jahre begann Buenos Aires, sich für Stadtplanung und Erschließungsstrategien zu interessieren, mit denen internationales Kapital angelockt werden konnte. Insbesondere war man bestrebt, das heruntergekommene Hafengebiet der Stadt, den Puerto Madero, neu zu beleben. Benannt nach dem Ingenieur Eduardo Madero, der 1881 den Ausbau des Hafens befürwortet hatte, wurde die Anlage bereits 1925 stillgelegt, als im Norden ein neuer Hafen erbaut wurde. Verschiedene Planungen, darunter eine von Le Corbusier aus dem Jahr 1929, wollten das Gebiet regenerieren, aber erst 1989 legte die Corporación Antiguo Puerto Madero einen Gesamtplan zur Sanierung des 170 ha großen Geländes vor. Dafür gab der Auftraggeber bei Calatrava den Entwurf einer Fußgängerbrücke für Dock 3 in Arbeit, das mit der Stadt nur unzureichend verbunden war. Seine Lösung, die Puente de la Mujer, sieht „eine Konstruktion vor, die aus einer 102 m langen, drehbaren Hängebrücke zwischen zwei feststehenden Zufahrten besteht. Der mittlere Abschnitt hängt an Seilen, die an einem 39 m hohen, geneigten Pylon befestigt sind. Dieser Brückenabschnitt kann um 90 Grad gedreht werden, um dem Schiffsverkehr freie Durchfahrt zu gewähren. Das Gewicht des technischen Masts gleicht das Gewicht des Pylonen aus und ermöglicht ein vereinfachtes Drehverfahren. Dank ihrer nächtlichen Beleuchtung wurde die Brücke zum Symbol für die Wiederbelebung dieses Teils der Hauptstadt."

À la fin des années 1980, la ville de Buenos Aires lança une réflexion sur ses stratégies de développement urbain afin d'attirer les investisseurs internationaux. Elle s'attacha en particulier à la rénovation d'un ancien port en piteux état, Puerto Madero, ainsi nommé en hommage à l'ingénieur Eduardo Madero qui en avait initié la construction en 1881. Le lieu était déjà délabré en 1925 et un nouveau port avait été creusé plus au nord. Diverses propositions, notamment une de Le Corbusier en 1929, cherchèrent à revitaliser cette zone, mais il fallut attendre 1989 pour que la Corporación Antiguo Puerto Madero propose un plan directeur pour ce site de 170 hectares. C'est dans ce cadre que le client demanda à Santiago Calatrava de concevoir une passerelle pour le Dock 3, mal relié à la ville. Sa solution, le Puente de la Mujer, est « un pont tournant de 102 mètres de long posé entre deux voies d'accès fixes. La partie centrale est suspendue par des câbles à un pylône de 39 mètres. Elle pivote à 90 degrés pour permettre le passage des navires. Le poids du mécanisme équilibre celui du pylône, ce qui a permis de simplifier le système de pivot. Avec son spectaculaire éclairage nocturne, le pont est devenu un symbole de la renaissance de cette partie de la capitale. »

Reduced to their most basic forms, the sketches below nonetheless project an accurate image of the bridge design down to the number of stays required to guarantee its stability.

Die auf ihre elementarsten Bestandteile reduzierten Skizzen unten liefern dennoch ein genaues Bild des Brückenentwurfs bis hin zur Anzahl der für die Stabilität erforderlichen Verstrebungen.

Même s'ils sont très schématiques, les croquis ci-dessous offrent une image assez exacte du pont ainsi que du nombre de haubans requis pour en assurer sa stabilité.

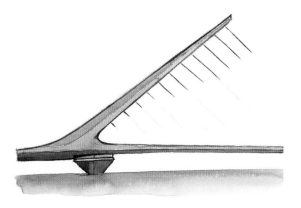

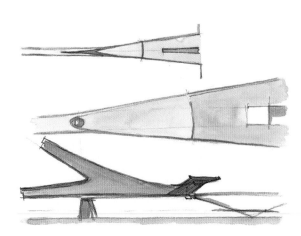

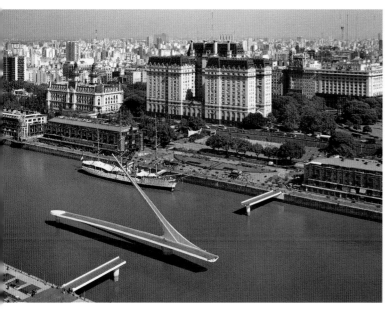
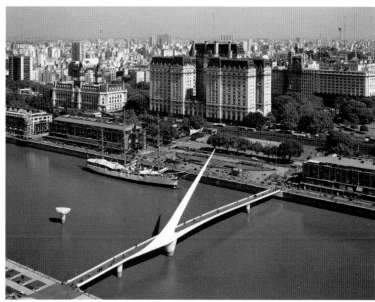

Three images, one (bottom) taken in a time-lapse mode, show the bridge in its open and closed positions. Rather than working with a more conventional drawbridge scheme, the architect has decided to make the entire central section of the bridge pivot to allow free passage on the river.

Drei Aufnahmen, eine davon im Zeitraffer, zeigen die Brücke geöffnet und geschlossen. Statt mit einem herkömmlichen Zugbrücken-entwurf zu arbeiten, entschied sich der Architekt, den kompletten Hauptteil der Brücke drehbar zu lagern, um freie Durchfahrt auf dem Fluss zu gewähren.

Trois images, dont un prise en pause, montrent le pont en position ouverte et fermée. Plutôt que de travailler sur un schéma plus classique de pont mobile, l'architecte a choisi de faire pivoter la totalité de la section centrale pour libérer le passage sur le fleuve.

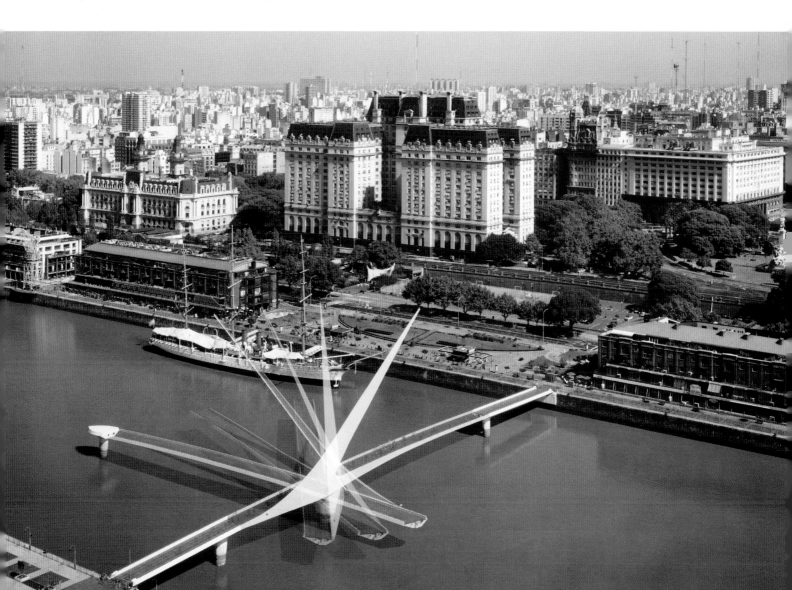

...v2 ③ torp elicoidal

sculture ④ Vauizvtzl torbo. ⑤bris

a b

TURNING
TORSO

Malmö, Sweden. 1999–2004.

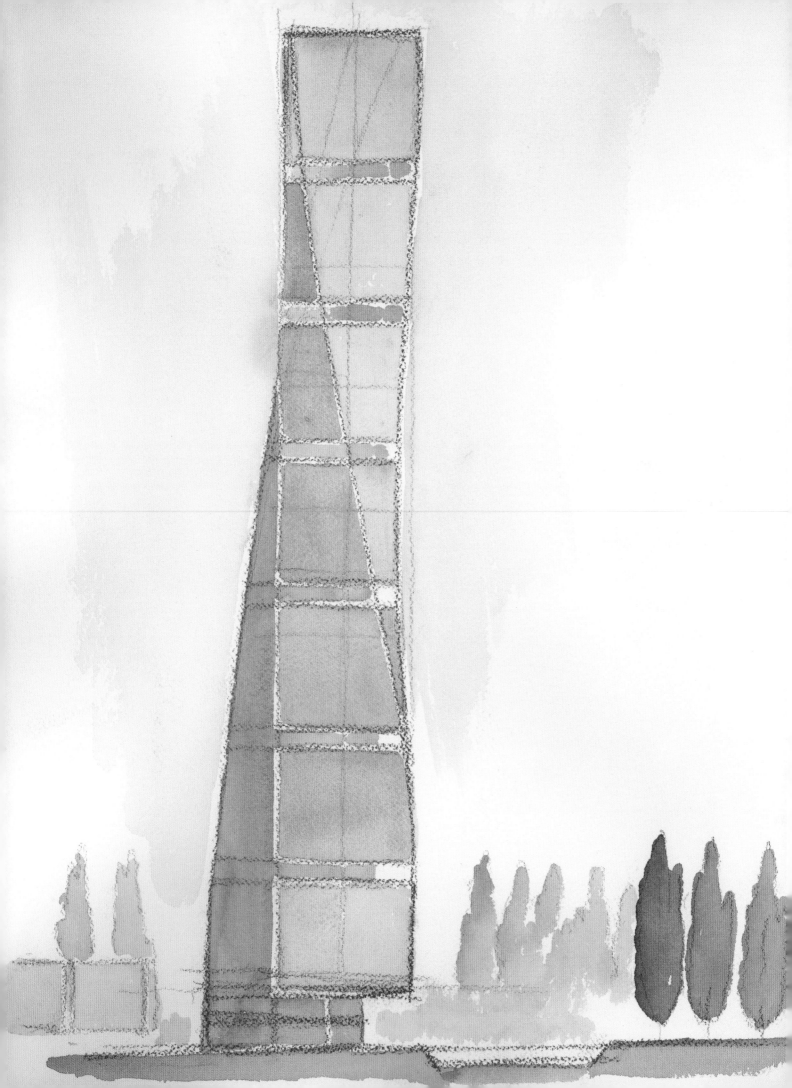

Project
TURNING TORSO

Location
MALMÖ, SWEDEN

Client
HSB, MALMÖ

Height
190 METERS

The twisting design of the tower is readily comprehensible in the sketch to the left. The similarity with a number of Calatrava's sculptures, some dating back more than 20 years is also clear.

Der gedrehte Entwurf des Turms ist auf der Skizze links ohne weiteres verständlich. Außerdem ist die Ähnlichkeit mit einigen zum Teil vor über zwanzig Jahren entstandenen Skulpturen Calatravas deutlich.

La forme en torsion de la tour est mise en lumière par le croquis de gauche. La similarité avec plusieurs sculptures de l'architecte, dont certaines datent de plus de vingt ans, est évidente.

Calatrava's Turning Torso building in Malmö, Sweden (1999–2004), is the result of his intense interest in sculpture, an art he often treats as a study in statics. Calatrava first created a sculpture in which "seven cubes are set around a steel support to produce a spiral structure, which resembles a twisting human spine." His tower in Malmö was designed for a prominent site in the city on the occasion of the 2001 European Housing Expo there. Malmö was selected amongst Swedish cities after a competition to host "Bo01, the European Housing Expo 2001," which was intended to "start a debate on how we wish to live in the city of tomorrow." The "City of Tomorrow" exhibition theme was examined from a variety of angles: ecological, social, technical, and human sustainability. Calatrava's project was one of 44 building and art projects carried out, mostly by local and Scandinavian architects, in the city's Western Harbor area. Santiago Calatrava does not hesitate to refer to the "sculptural presence" of the completed building, which is 190 meters tall and twists a total of 90 degrees from base to top. Malmö is the third largest city in Sweden, situated in the southernmost province of Skåne, near Copenhagen, Denmark. It has about 270 000 inhabitants, and nearly 600 000 in the metropolitan area. Malmö was one of the earliest industrial cities of Scandinavia, but has in recent decades been struggling to adapt to a postindustrial economy. As the architect explains the relationship of the tower to the sculpture, "In the Turning Torso building, the spiraling tower is composed of nine box units, each of five floors. The equivalent in the tower of the sculpture's steel support is the nucleus of internal elevators and stairs, through which the box units communicate." The cubes of the original sculpture are replaced by "sub-buildings" each of which has a floor area of approximately 2200 square meters, with each floor within these boxes accommodating from one to five residence units around the vertical nucleus. Areas in the "spine" are reserved for common facilities such as meeting rooms or a gym. As is often the case, the engineering used by Calatrava simplified and accelerated construction greatly, relying on prefabricated elements for the exterior steel structure and façade for example.

Calatravas 1999–2004 erbautes Hochhaus „Drehender Torso" in Malmö ist das Ergebnis seines leidenschaftlichen Interesses an Skulptur, eine Kunstform, die er häufig als Studie zur Statik behandelt. Calatrava schuf zu Anfang eine Skulptur, bei der „sieben Kuben um eine Stahlstütze angeordnet wurden, die eine an ein gedrehtes menschliches Rückgrat erinnernde Spiralkonstruktion bilden." Sein Turm in Malmö wurde anlässlich der hier stattfindenden European Housing Expo 2001 für einen markanten Standort in der Stadt entworfen. Unter mehreren schwedischen Städten fiel die Wahl auf Malmö als gastgebende Stadt dieser Ausstellung, bei der „eine Diskussion darüber beginnen sollte, wie wir in der Stadt von morgen leben wollen". Das Ausstellungsthema, „Die Stadt von morgen", wurde aus einer Vielzahl von Blickwinkeln betrachtet, so ging es um ökologische, soziale, technische und menschliche Nachhaltigkeit. Calatravas Projekt war eines von 44 Gebäuden und Kunstprojekten, die vorrangig von heimischen und skandinavischen Architekten im westlichen Hafengebiet der Stadt realisiert wurden. Calatrava zögert nicht, von der „plastischen Präsenz" des fertig gestellten Gebäudes zu sprechen, das bei einer Höhe von 190 m zwischen Basis und Spitze eine Drehung von 90 Grad vollzieht. Malmö ist die drittgrößte Stadt Schwedens und liegt in der südlichsten Provinz Skåne, nahe Kopenhagen. Es hat etwa 270 000, das Einzugsgebiet fast 600 000 Einwohner. Malmö gehörte zu den frühesten Industriestädten Skandinaviens, kämpft aber in jüngerer Zeit darum, eine postindustrielle Ökonomie zu entwickeln. Die Beziehung des Turms zur Skulptur erläutert der Architekt wie folgt: „Bei dem Gebäude ‚Drehender Torso' ist der gedrehte Turm aus neun Kastenelementen zusammengesetzt, die jeweils fünf Geschosse umfassen. Der Stahlstütze der Skulptur entspricht im Turm der innere Kern aus Aufzügen und Treppen, mittels derer die Kastenelemente miteinander kommunizieren." An die Stelle der Kuben der Skulptur traten „Sub-Gebäude", von denen jedes eine Fläche von etwa 2200 m² umfasst. Innerhalb dieser Kästen gruppieren sich auf jedem Geschoss zwischen ein und fünf Wohneinheiten um den vertikalen Kern. Flächen im „Rückgrat" sind Gemeinschaftseinrichtungen wie Versammlungsräumen oder einem Fitnesszentrum vorbehalten. Wie so oft vereinfachte und beschleunigte die von Calatrava verwendete Technik die Bauarbeiten erheblich, da er beispielsweise bei der außen liegenden Stahlkonstruktion und der Fassade auf vorgefertigte Elemente zurückgriff.

La *Turning Torso* de Calatrava, construite en 1999–2004 à Malmö, est l'aboutissement de son intérêt permanent pour la sculpture, art qu'il traite souvent comme une étude de statique. Il s'agissait à l'origine d'une pièce dans laquelle « sept cubes empilés sur un support en acier créaient une structure en spirale ressemblant à une colonne vertébrale vrillée ». La tour éponyme a été conçue pour un site très visible de Malmö, la troisième ville de Suède (270 000 habitants, près de 600 000 pour son agglomération), située dans la province méridionale de Scanie en face de Copenhague, la capitale danoise. C'est l'un des premiers centres industriels scandinaves, mais elle se bat depuis de longues années pour s'adapter à l'économie post-industrielle. En 2001, s'y tint « BoO1, Exposition européenne sur le logement 2001 » qui se proposait de « lancer un débat sur la façon dont nous souhaitons vivre dans la ville de demain ». Le thème de l'exposition, « La Cité de Demain », était analysé sous divers angles : écologique, social, technique et développement durable. La proposition de Calatrava fut l'un des quarante-quatre projets d'art et d'architecture réalisés dans la zone ouest du port, confiés pour la plupart à des architectes locaux ou scandinaves. L'architecte insiste sur la « présence sculpturale » de cet immeuble qui mesure 190 mètres de haut et pivote de 90 degrés entre sa base et son sommet. Il explique le lien entre la sculpture et la tour *Turning Torso* en ces termes : « La tour en spirale est composée de neuf boîtes de cinq étages. L'équivalent du support en acier de la sculpture est le noyau d'escaliers et d'ascenseurs par lequel les boîtes communiquent. » Les cubes de la sculpture sont ici des « sous-immeubles » de 2200 mètres carrés environ, dont chaque niveau accueille de un à cinq appartements. Certains espaces ont été réservés à des équipements collectifs, notamment des salles de réunions et de gymnastique. Comme souvent, l'ingénierie de Calatrava a grandement simplifié et accéléré le processus de construction, par exemple en utilisant des éléments préfabriqués pour la structure extérieure en acier ou la façade.

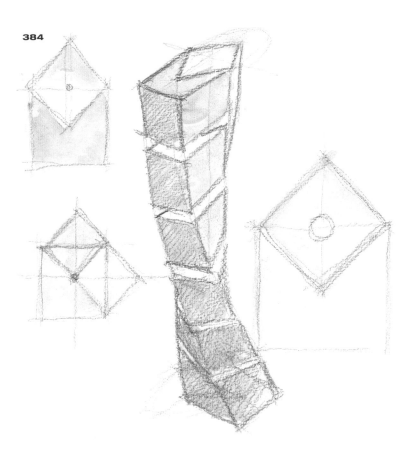

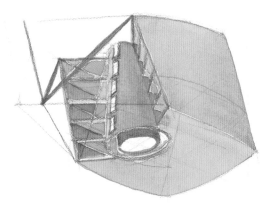

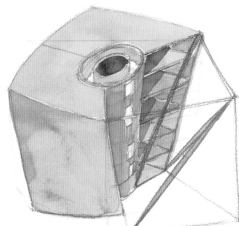

Clearly related to Calatrava's sculptures that place blocks of granite in a tensioned spiral, these sketches also establish the link he imagines to the male torso.

Diese Skizzen, eindeutig verwandt mit Calatravas Skulpturen, bei denen er Granitblöcke in einer gespannten Spirale anordnet, stellen darüber hinaus die von ihm gedachte Verbindung zum männlichen Torso her.

Clairement liés aux sculptures de Calatrava réalisées à partir de blocs de granit superposés en spirale, ces croquis montrent également le lien qu'il entrevoit avec l'image d'un torse masculin.

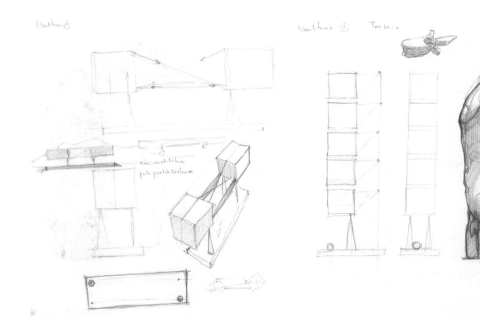

Although the sketch below does not specifically correspond to the completed tower in Sweden, its fundamental idea of rotated, piled cubes is that of the actual building.

Obgleich die Skizze unten nicht genau mit dem fertigen Turm in Schweden übereinstimmt, ihr Grundgedanke der um eine Achse gedrehten, gestapelten Kuben entspricht der des wirklichen Gebäudes.

Bien que le croquis ci-dessous ne corresponde pas spécifiquement à la tour réalisée en Suède, l'idée fondamentale de cubes empilés en une colonne vrillée subsiste.

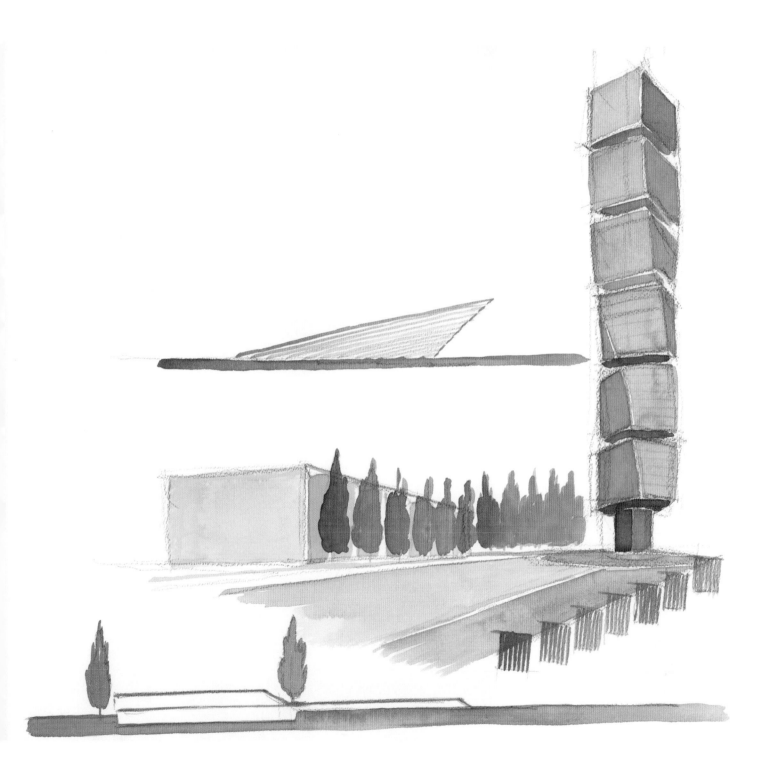

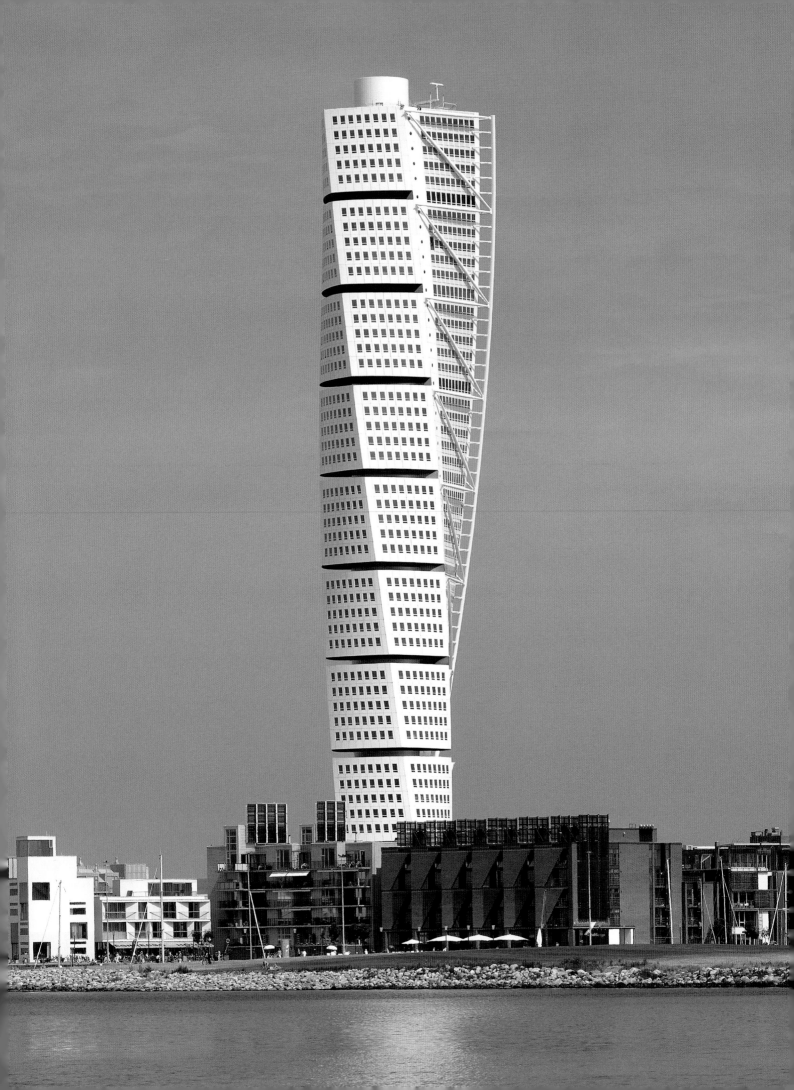

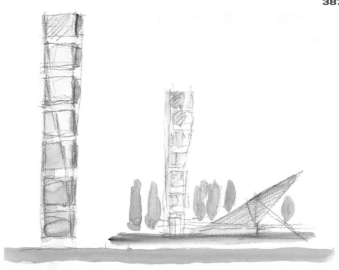

The relation of the completed building to a human figure is rendered explicit in the title "Turning Torso," but, in any case, the architect pursues his fascination with the idea of motion, real or implied in architecture.

Die Beziehung des fertigen Bauwerks zum menschlichen Körper ist im Titel „Turning Torso" explizit enthalten; in jedem Fall jedoch geht der Architekt der ihn faszinierenden Vorstellung von realer oder implizierter Bewegung in der Architektur nach.

La relation entre l'immeuble achevé et la figure humaine est rendue explicite par son nom de « Turning Torso ». L'architecte retrouve ici sa fascination pour l'idée du mouvement en architecture, qu'il soit réel ou implicite.

Where engineering of tall buildings has tended to take the most obvious approach, by stacking each story in a pile and reducing floor area as the building rises, Calatrava uses his knowledge of the analysis of loads (force, moment, torque) on a physical system in static equilibrium to produce a surprising solution.

Im Gegensatz zum naheliegendsten Verfahren beim Bau hoher Gebäude, indem man nämlich mit zunehmender Höhe Stockwerke mit abnehmender Geschoßfläche aufeinander stapelt, nutzt Calatrava seine Kenntnis der Lastenberechnung (Kraft, Moment, Torsionsmoment) auf eine Raumanordnung in statischem Gleichgewicht, um eine verblüffende Lösung zu generieren.

Alors que l'ingénierie des immeubles de grande hauteur a tendance à adopter l'approche la plus facile consistant à empiler des niveaux de surface dégressive au fur et à mesure qu'ils s'élèvent, Calatrava utilise ses connaissances en analyse des charges (force, moment, couple) pour imaginer un système physique en équilibre statique qui débouche sur une solution surprenante.

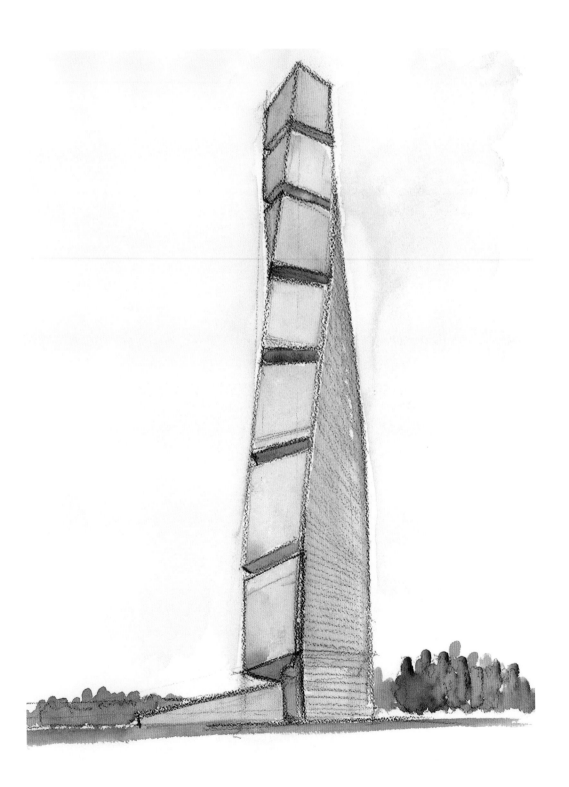

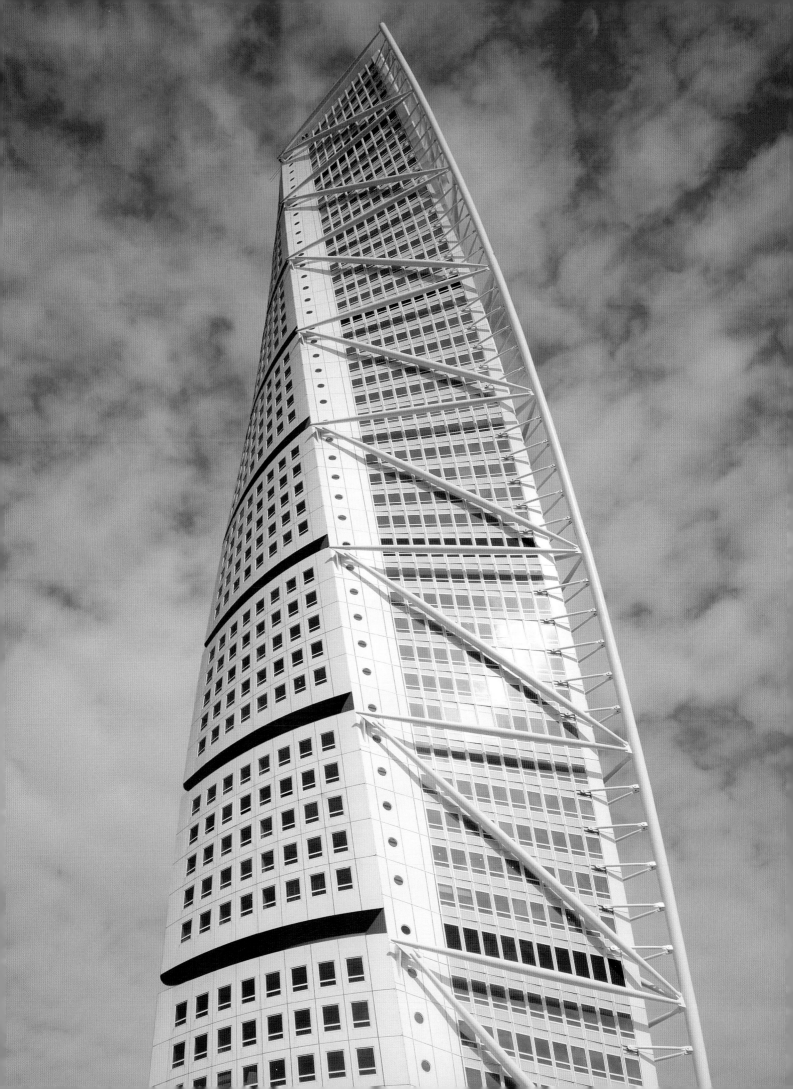

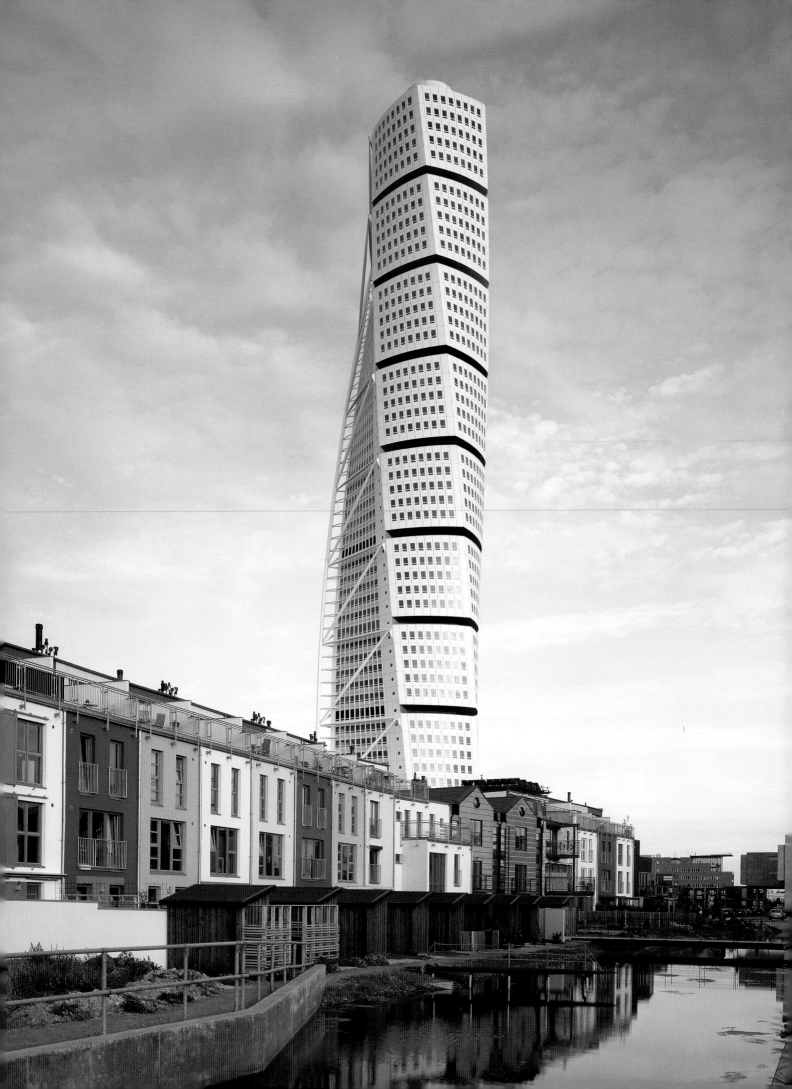

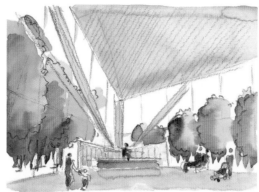

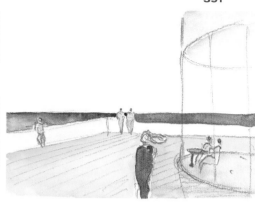

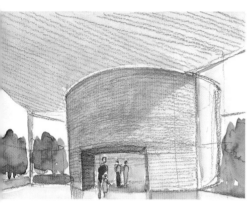

Calatrava's sketches for entry areas and the lower part of the building immediately bring to mind his interest in sculpture, confirmed by the overall view of the tower seen to the left.

Calatravas Skizzen für die Eingangsbereiche und den unteren Gebäudeteil erinnern unmittelbar an sein Interesse für Skulptur, was auch durch die Gesamtansicht des Turms (links) deutlich wird.

Les croquis des zones d'entrée et de la partie inférieure du bâtiment évoquent directement l'intérêt de l'architecte pour la sculpture, ce que confirme la vue d'ensemble de la tour (à gauche).

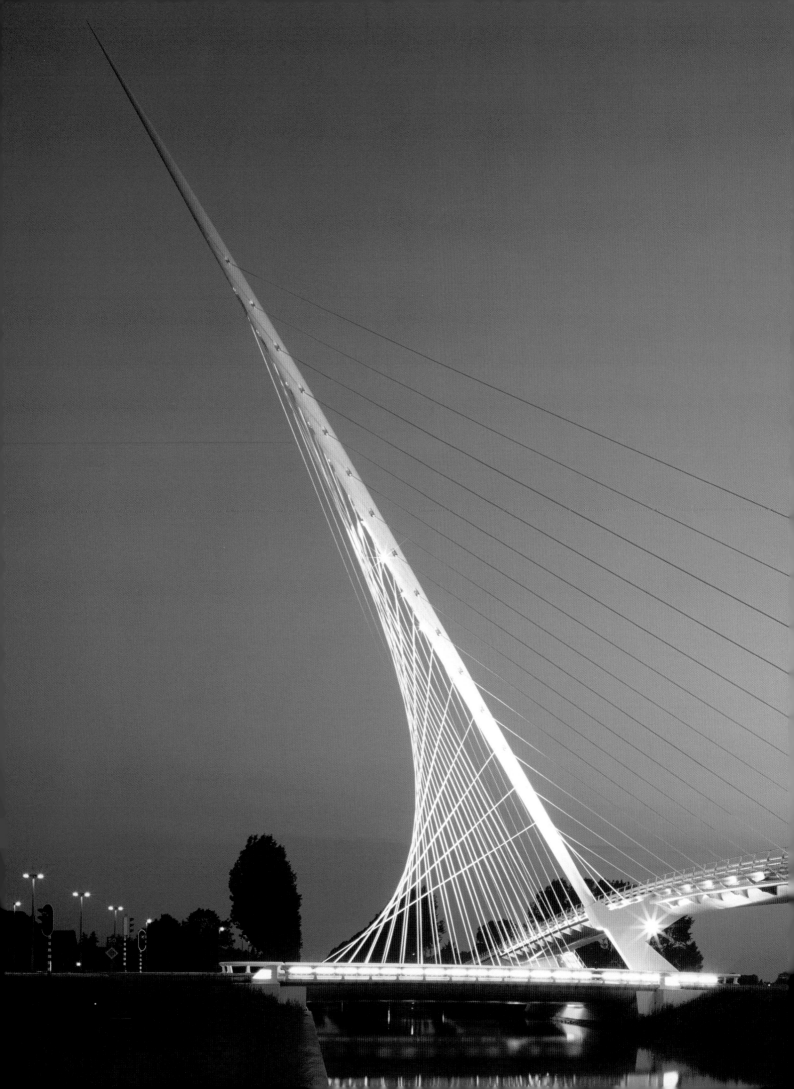

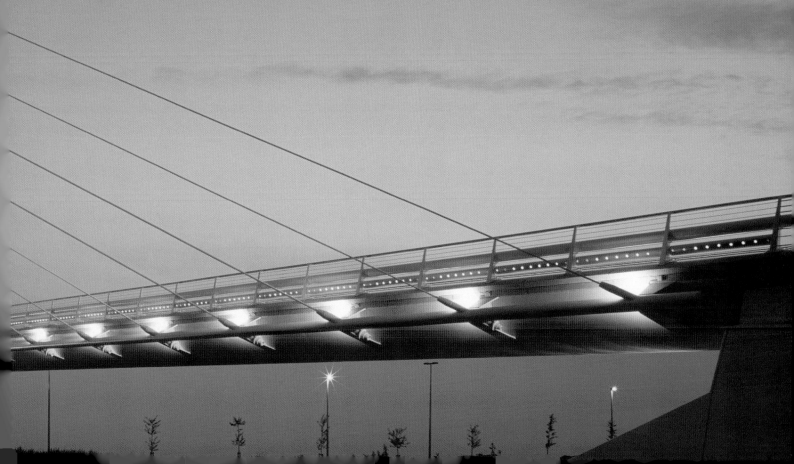

BRIDGES OVER
THE HOOFDVAART

Hoofddorp, The Netherlands. 1999–2004.

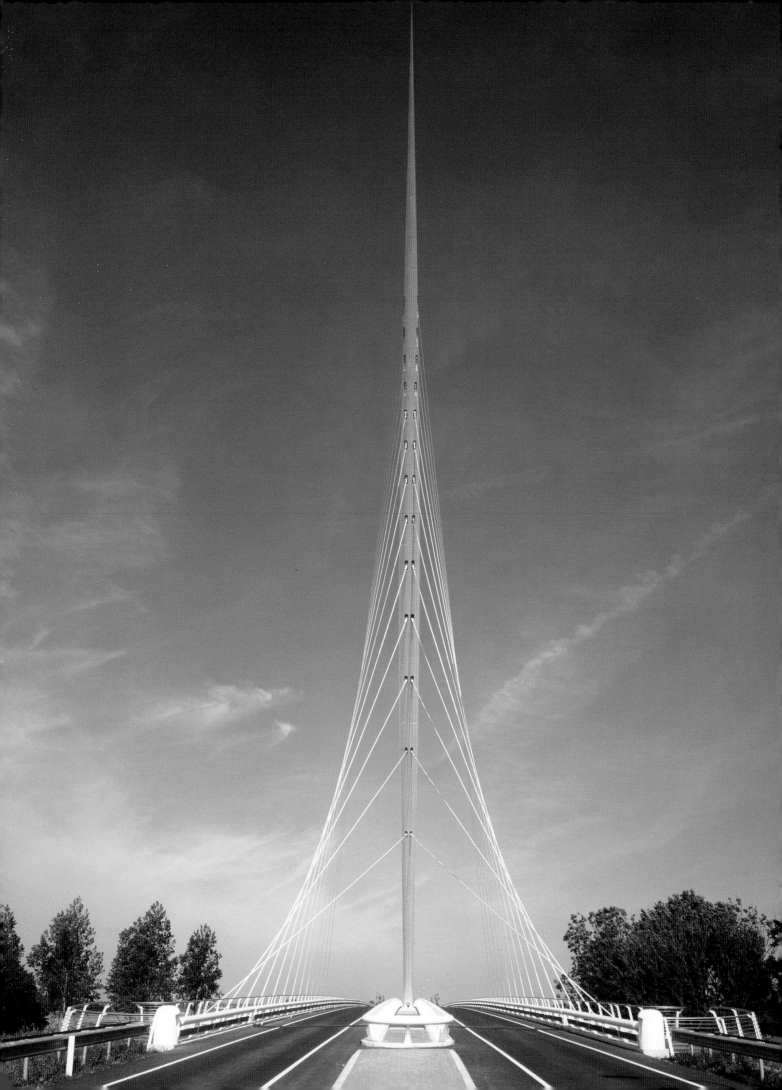

Project
BRIDGES OVER THE HOOFDVAART

Location
HOOFDDORP, THE NETHERLANDS

Client
HAARLEMMERMEER DISTRICT COUNCIL, HOOFDDORP

Cost
€ 6 MILLION (LYRE) / € 9 MILLION (HARP) / € 4 MILLION (LUTE)

The extreme simplicity and thinness of the support mast as seen in this picture is a measure of the talent of the architect-engineer.

Die extreme Einfachheit und Schlankheit des hier zu sehenden Stützmastes belegt die Fähigkeit des Architekten/Entwurfsingenieurs.

L'extrême simplicité et la finesse du pylône que montre cette image sont à la mesure du talent de l'architecte-ingénieur.

Like many other areas in The Netherlands, the area of Haarlemmermeer, located to the west of Amsterdam's Schiphol Airport, has undergone considerable development in recent years. The construction of 17 000 new housing units located on either side of the Hoofdvaart canal led the town to decide on the construction of three new bridges. Aside from improving vehicular and pedestrian traffic in the area, the bridges were intended from the outset to serve as landmarks. Conceiving his intervention as a series of "variations on a theme," Calatrava noted the strong horizontal presence of the landscape and canal and decided to introduce vertical counterpoints. Cable-stayed bridges with spindle-shaped pylons with varying angles, the bridges have been nicknamed the Lyre (Citer), the Harp (Harp) and the Lute (Luit) by local residents. Adapting happily to these names, the architect explains, "The Lyre is the new gateway to Hoofddorp, located south of the city at the Nieuwe Bennebroekerweg Junction, a traffic node that will be linked to the A4 motorway. The Lyre is in fact two connected spans—a lower bridge (19.6 meters) and a flyover (148.8 meters)—whose cables are ingeniously linked to the pylon, which rises to a height of 58 meters. The Harp marks the entrance to the area of Nieuw Vennep, at the northern Vennep Bypass. Local traffic passes below, while traffic for the bypass goes over the 142.8-meter span of the bridge. The Harp has the largest pylon of the three bridges: 82 meters in length, and rising to a height of 72 meters. The Lute provides access to the Toolenburg-Oost district of Hoofddorp, at the Toolenburg traffic intersection. The Council's original plans called for the construction of a traffic roundabout at this location next to the Hoofdvaart canal. My design instead situates the roundabout above the Hoofdvaart by constructing the Lute out of two curved roadways, each 26.25 meters long, supported from a pylon that is 40 meters high."

Wie in vielen anderen Gegenden der Niederlande wurden auch in dem westlich des Amsterdamer Flughafens Schiphol gelegenen Gebiet von Harlemmermeer in jüngster Zeit beachtliche Bauvorhaben durchgeführt. Der Bau von 17 000 neuen Wohneinheiten zu beiden Seiten des Hoofdvaart-Kanals machte die Planung von drei neuen Brücken erforderlich. Die Brücken, die den Fahrzeug- und Passantenverkehr in der Gegend verbessern sollten, waren darüber hinaus von Anfang an als markante Bauwerke geplant. Calatrava, der sich das Vorhaben als eine Reihe von „Variationen über ein Thema" vorstellte, nahm die stark ausgeprägte Horizontalität von Landschaft und Kanal auf und beschloss, vertikale Elemente dagegenzusetzen. Die Schrägseilbrücken mit unterschiedlich geneigten, gedrehten Pylonen wurden von der einheimischen Bevölkerung mit den Spitznamen Zither (Citer), Harfe (Harp) und Laute (Luit) belegt. Der Architekt, der sich diese Namen erfreut zu Eigen machte, erläutert: „Die Zither ist das neue Eingangstor nach Hoofddorp; es liegt südlich der Stadt an der Nieuwe-Bennebroekerweg-Kreuzung, einem Verkehrs-

knotenpunkt, der mit der Schnellstraße A4 verbunden wird. Die Zither besteht in Wirklichkeit aus zwei miteinander verbundenen Brücken, einer 19,6 m hohen ‚Unterbrücke' und einer 148,8 m hohen Überführung, deren Seile auf raffinierte Weise mit dem 58 m hohen Pylon verbunden sind. Die Harfe bezeichnet den Eingang zum Gebiet von Nieuw Vennep an der nördlichen Umgehungsstraße von Vennep. Der Ortsverkehr nutzt die untere Brücke, während der Verkehr zur Umgehungsstraße den 148,8 m hohen Brückenbogen überquert. Der Brückenpfeiler der Harfe ist mit einer Länge von 82 m der größte der drei Brücken und erhebt sich auf eine Höhe von 72 m. Die Laute erschließt an der Toolenburg-Kreuzung das zu Hoofddorp gehörige Gebiet von Toolenburg-Oost. Die ursprüngliche Planung des Stadtrats sah an dieser Stelle neben dem Hoofdvaart-Kanal einen Kreisverkehr vor. Calatravas Plan verlegte den Kreisel stattdessen über den Hoofdvaart, indem er die Laute mit zwei, jeweils 26,25 m langen, geschwungenen Fahrbahnen errichtete, die von einem 40 m hohen Pylon getragen werden."

Comme beaucoup d'autres régions des Pays-Bas, la zone de l'Haarlemmermeer, située à l'ouest de l'aéroport amstellodamois de Schipol, a connu un développement considérable au cours de ces dernières années. La construction de dix-sept mille nouveaux logements de chaque côté du canal d'Hoofdvaart a conduit la ville à décider de créer trois nouveaux ponts. En dehors de leur fonction de base, ils devaient avoir un caractère monumental et emblématique. Concevant son intervention comme une série de « variations sur un même thème », Calatrava s'appuya sur la forte horizontalité du paysage et du canal pour y introduire des contrepoints verticaux. Ses ponts suspendus, dont les pylônes en forme de navette sont inclinés selon des angles différents, ont été surnommés La Lyre (Citer), La Harpe (Harp) et Le Luth (Luit) par les autochtones. Appréciant ces dénominations spontanées, l'architecte explique que « La Lyre est la nouvelle porte d'entrée sud d'Hoofddorp, au carrefour de Nieuwe Bennebroekerweg, un échangeur qui sera relié à l'autoroute A4. L'ouvrage se compose en fait de deux travées connectées, un pont inférieur (19,6 mètres) et un autopont (148,8 mètres) dont les câbles sont ingénieusement reliés au pylône qui s'élève à 58 mètres. La Harpe marque l'entrée de la zone de Nieuw Vennep au nord de la rocade de Vennep. La circulation locale s'écoule dessous, tandis que celle qui rejoint la rocade passe sur le tablier de 142,8 mètres. Il possède le plus grand pylône de ces trois ouvrages : 82 mètres de long pour 72 mètres de haut. Le Luth donne accès au quartier Toolenburg-Est de Hoofddorp et au carrefour de Toolenburg. À l'origine, les plans prévoyaient à cet emplacement un rond-point près du canal. » Calatrava a déplacé celui-ci au-dessus du canal en construisant un ouvrage à deux voies en courbe de 26,25 mètres de long, soutenues par un pylône de 40 mètres de haut.

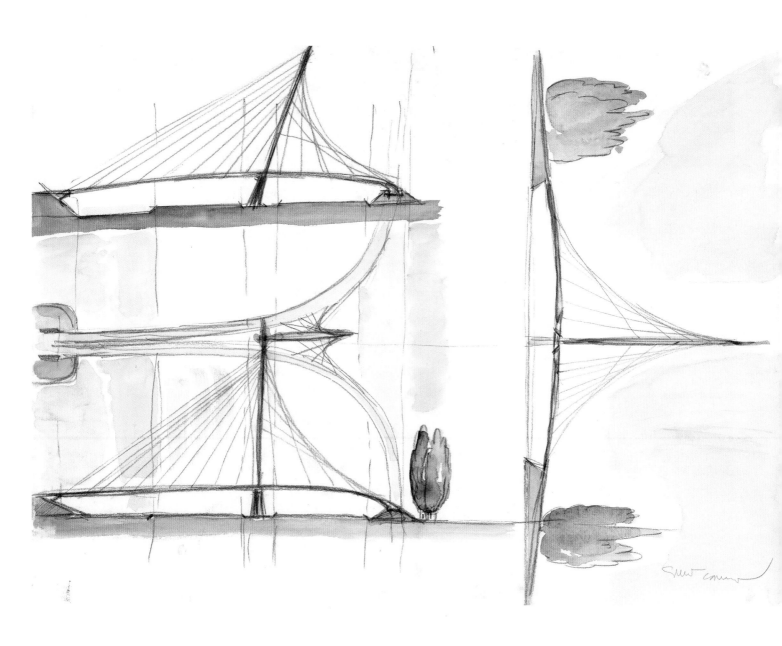

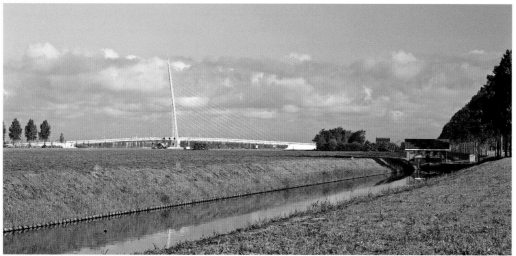

Calatrava's sketches and one of the completed bridges (left) show his analysis of the angling of the towers and simultaneously view the design from above and from the side.

Calatravas Skizzen und eine der fertigen Brücken (links) dokumentieren seine Berechnung der schrägstehenden Masten und betrachten das Projekt von oben und von der Seite.

Les croquis de Calatrava et l'un des ponts achevés (à gauche) illustrent la façon dont il analyse l'inclinaison des tours, et montrent le projet en vue aérienne et latérale.

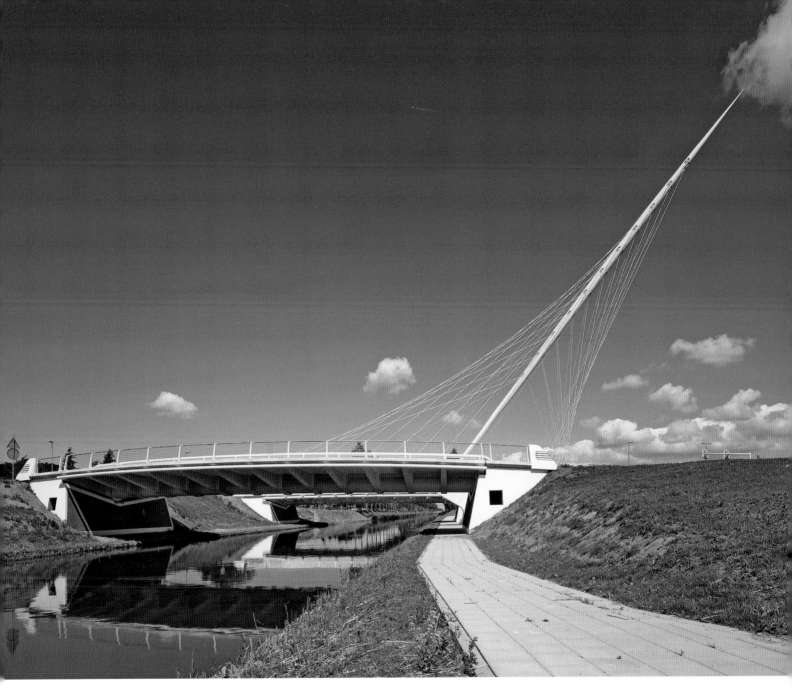

Like a sculpture rising from the flat Dutch landscape, Calatrava's bridge signals its presence and its originality *vis-à-vis* the other nearby bridges through the specific angle of the support tower. Below, sketches explore methods for anchoring the bridges.

Wie eine Skulptur, die sich aus der flachen holländischen Landschaft erhebt, signalisiert Calatravas Brücke gegenüber den anderen nahe gelegenen Brücken ihre Präsenz und ihre Eigenart durch die Neigung ihres Tragmastes. Die Skizzen unten sondieren Methoden zur Verankerung der Brücken.

Comme une sculpture se dressant au cœur du plat pays hollandais, le pont de Calatrava signale sa présence et son originalité par rapport aux ponts proches grâce à l'angle spécifique de son pylône. En bas, croquis de l'ancrage des ponts.

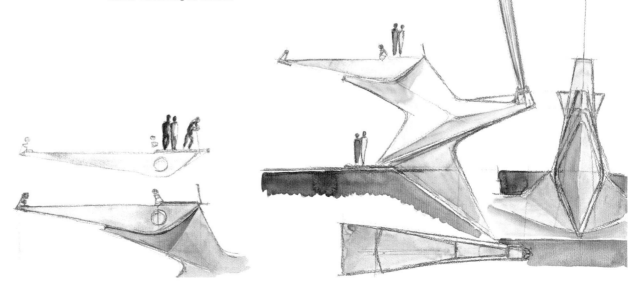

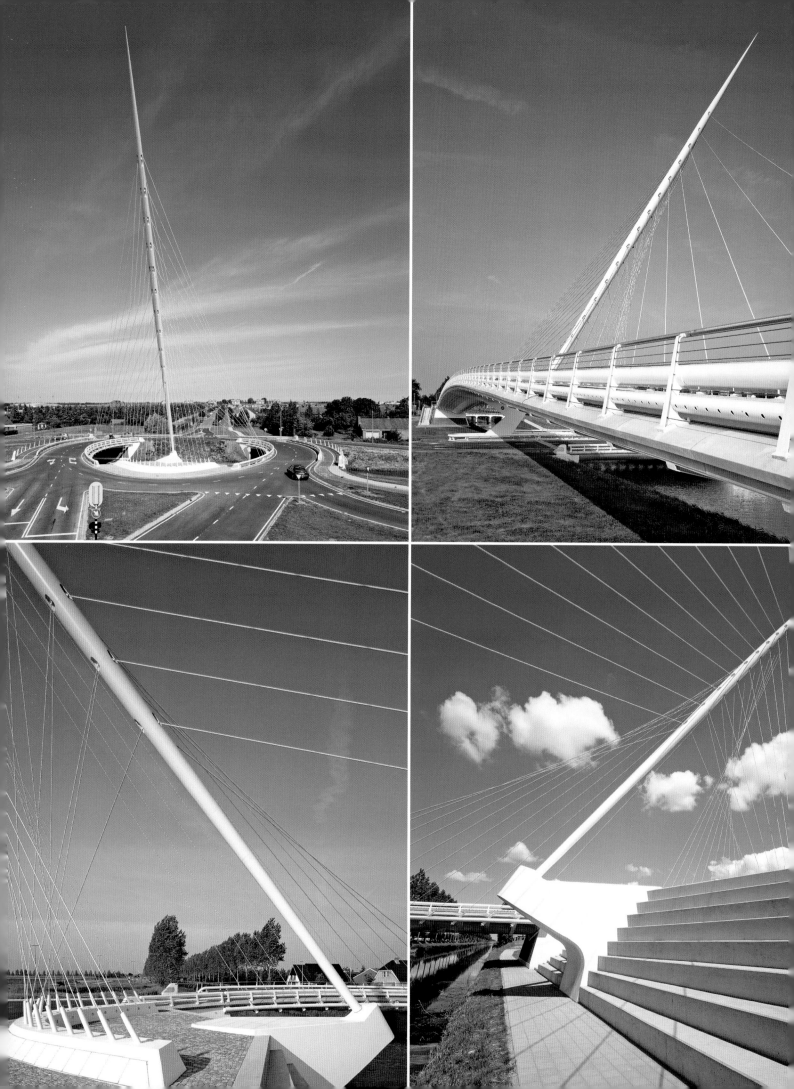

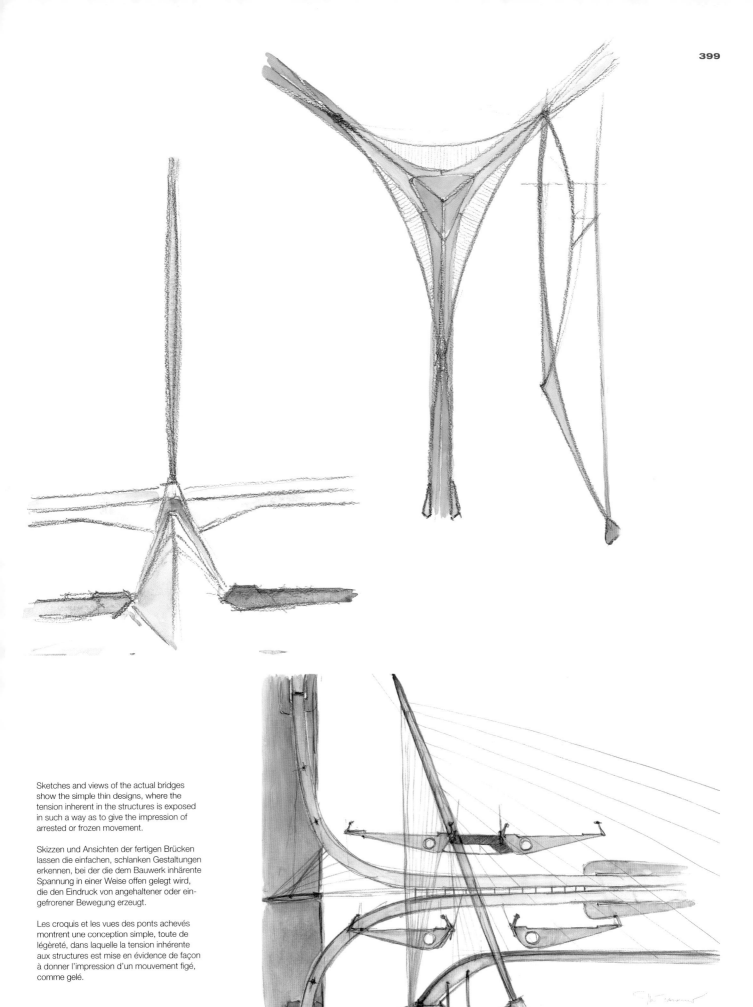

Sketches and views of the actual bridges show the simple thin designs, where the tension inherent in the structures is exposed in such a way as to give the impression of arrested or frozen movement.

Skizzen und Ansichten der fertigen Brücken lassen die einfachen, schlanken Gestaltungen erkennen, bei der die dem Bauwerk inhärente Spannung in einer Weise offen gelegt wird, die den Eindruck von angehaltener oder ein- gefrorener Bewegung erzeugt.

Les croquis et les vues des ponts achevés montrent une conception simple, toute de légèreté, dans laquelle la tension inhérente aux structures est mise en évidence de façon à donner l'impression d'un mouvement figé, comme gelé.

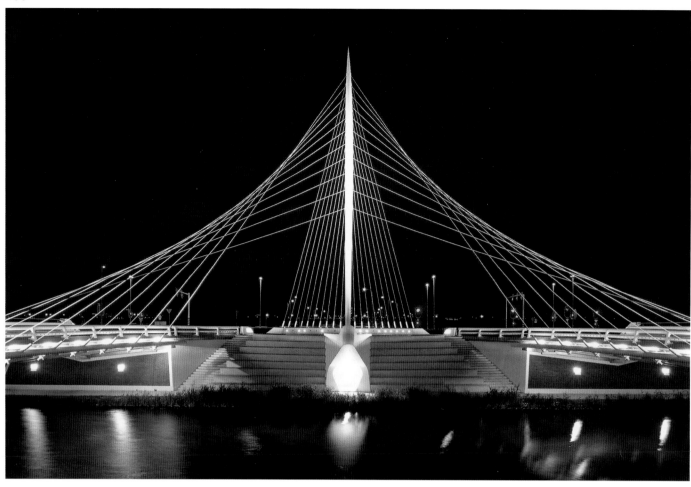

In these bridges, even the stays, usually a cumbersome presence, participate in the lightness and elegance of the design. The whole becomes a large-scale sculpture which happens to serve a purpose.

Bei diesen Brücken sind sogar die Verstrebungen, gewöhnlich eher klobige Elemente, an der Leichtigkeit und Eleganz des Erscheinungsbildes beteiligt. Das Ganze gleicht einer großformatigen Skulptur, die nebenbei auch einem Zweck dient.

Dans ces ponts, même les haubans, qui sont souvent encombrants, participent à la légèreté et l'élégance du projet. L'ensemble se transforme en une sculpture de grandes dimensions, mais qui remplit une fonction.

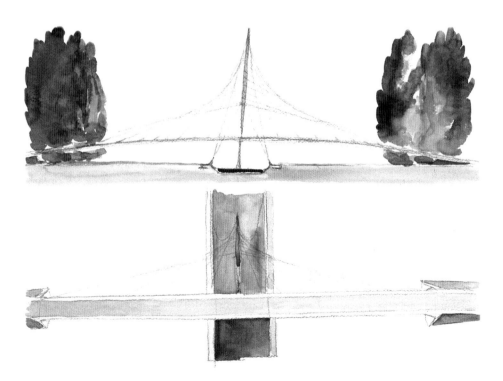

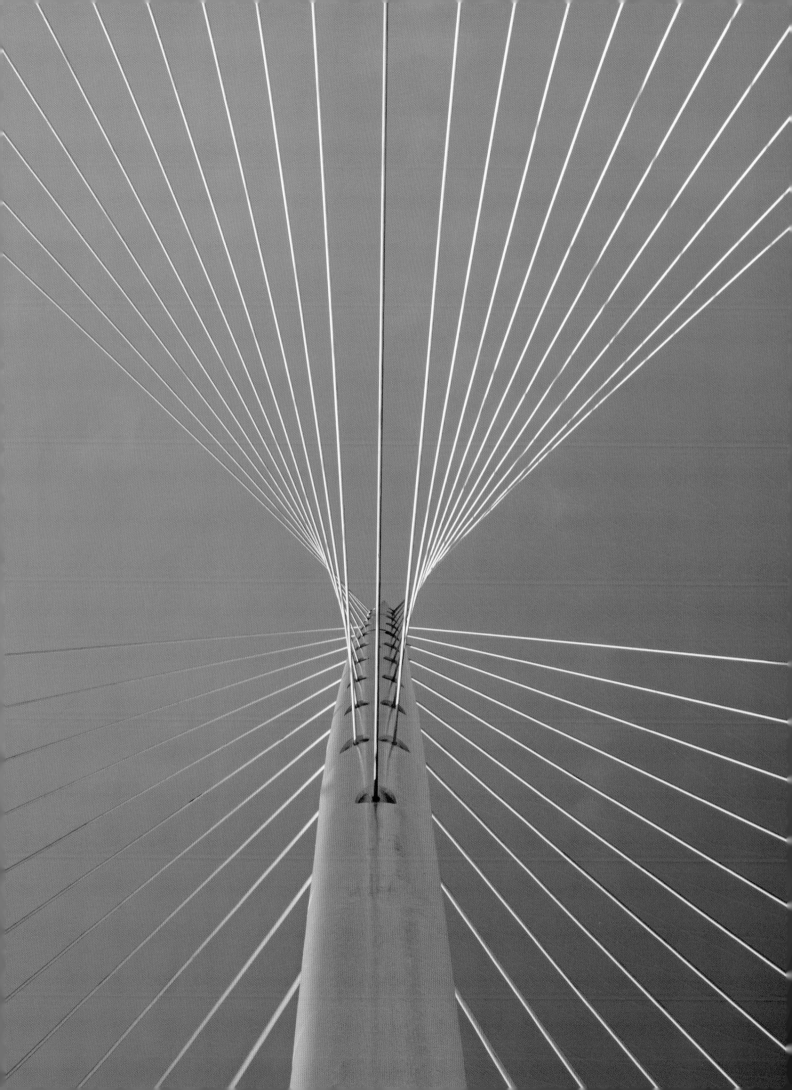

The curvature of the bridge seen below, usually a source of engineering problems, is turned by Calatrava into yet another way to approach the simple, pure solutions that seem to flow directly from his imagination.

Aus der Krümmung der unten abgebildeten Brücke, gewöhnlich Quelle technischer Schwierigkeiten, gewinnt Calatrava ein weiteres Verfahren, um zu den einfachen, klaren Lösungen zu gelangen, die anscheinend unmittelbar aus seiner Vorstellung fließen.

La courbure du pont (en bas), généralement source de problèmes techniques, fournit à Calatrava une occasion supplémentaire de se rapprocher de la solution simple et épurée qui semble directement issue de son imagination.

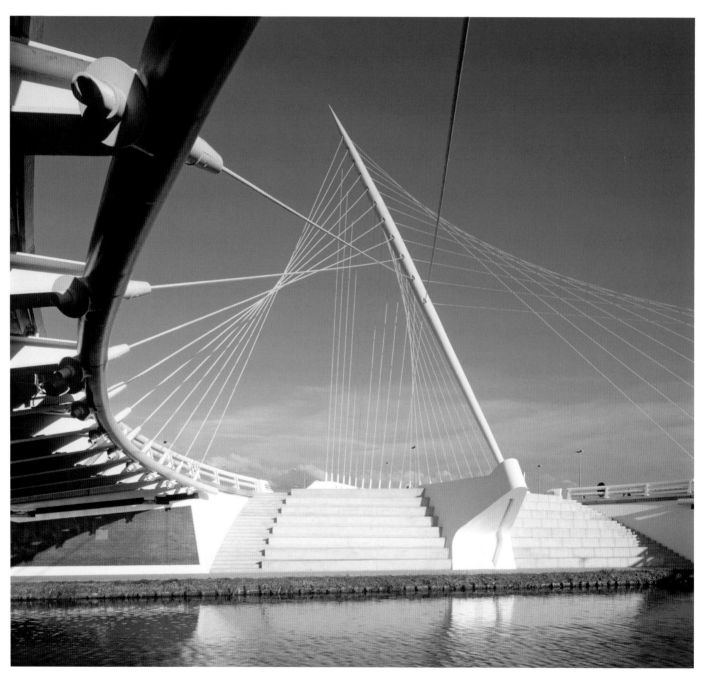

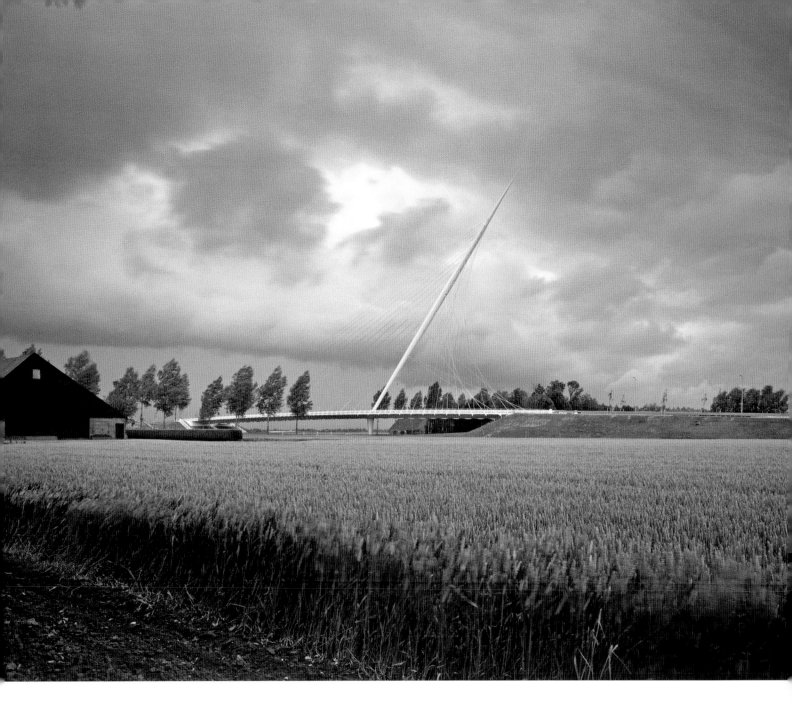

Against this typical Dutch sky and flat land-scape, the long tapered form of the bridge tower seems to be hovering in space, with no obvious means of support.

Vor diesem typisch holländischen Himmel und der flachen Landschaft scheint die lang gestreckte, konische Form des Brückenmas-tes ohne offensichtliche Stützen im Raum zu schweben.

Se détachant sur ce ciel et ce paysage typi-quement hollandais, la longue forme effilée du pylône semble suspendue dans l'espace sans aucun support visible.

THE NEW YORK TIMES CAPSULE

New York, New York, USA. 1999–2001.

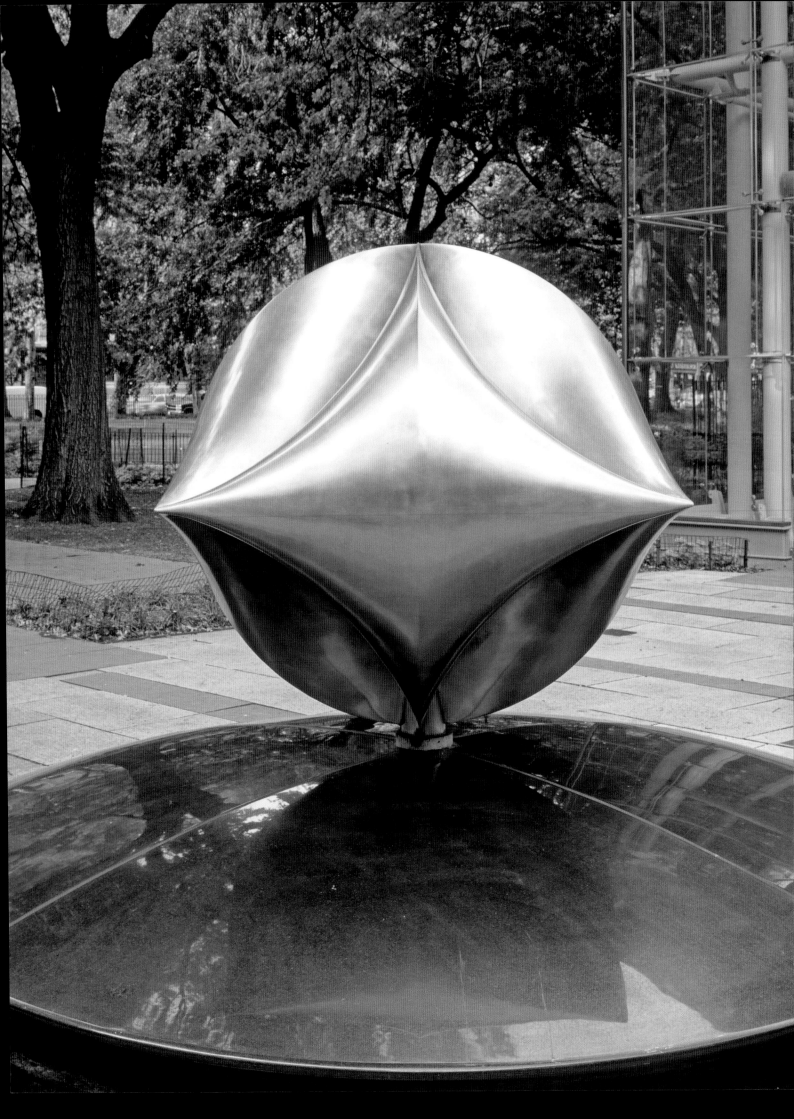

Project
THE NEW YORK TIMES CAPSULE

Location
THE AMERICAN MUSEUM OF NATURAL HISTORY, NEW YORK, NEW YORK, USA

Client
THE NEW YORK TIMES COMPANY FOUNDATION

Calatrava's simple sketch seen on this page corresponds directly to the shape of the completed capsule seen to the left.

Die auf dieser Seite abgebildete einfache Skizze Calatravas scheint direkt der Form der fertigen Kapsel, links, zu entsprechen.

Le petit croquis de Calatrava correspond exactement à la forme de la capsule achevée (à gauche).

In 1999, *The New York Times Magazine* organized an international competition to design a capsule, which would contain objects documenting life on earth in the 20th century, and which would be sealed until January 1, 3000. Santiago Calatrava's design was selected from fifty competition entries submitted from 15 countries. The artifacts were selected by *The New York Times*, based on suggestions made by visitors to an exhibition at the Museum of Natural History, and through the newspaper's Web site. The chosen objects were treated with preservatives and specially packed. On March 28, 2001, the artifacts were placed inside *The New York Times Capsule*, and the capsule was welded shut. The capsule, made of polished stainless steel, measures 1.5 meters in diameter, weighs 600 kilos, and contains 1.4 cubic meters of storage space. Its form, resembling a flower, was derived from a series of sculptures by Calatrava that explores the properties of folded spherical frames. His ongoing interest in sculpture despite a heavy schedule of architectural work shows the importance that Santiago Calatrava gives this aspect of his activity, which is in many senses at the origin of his architecture. The challenge of designing an object intended to last 1000 years or more also surely spoke to his sense of the permanence of the forms that animate all of his work.

Das *New York Times Magazine* organisierte 1999 einen internationalen Wettbewerb für die Gestaltung einer Kapsel, die bestimmte Objekte zur Dokumentation des Lebens auf der Erde im 20. Jahrhundert aufnehmen und bis zum 1. Januar 3000 versiegelt bleiben sollte. Aus 15 Ländern wurden 50 Wettbewerbsbeiträge eingereicht, unter denen man sich für Santiago Calatravas Entwurf entschied. Die Objekte waren von der *New York Times* ausgewählt worden, basierend auf Vorschlägen, die Besucher einer Ausstellung im Museum of Natural History abgegeben oder über die Website der Zeitung eingereicht hatten. Die Objekte wurden mit Konservierungsmitteln behandelt und speziell verpackt. Am 28. März 2001 wurden sie in

die *New York Times* Capsule eingelegt und diese zugeschweißt. Die aus poliertem Edelstahl bestehende Kapsel hat einen Durchmesser von 1,5 m, wiegt 600 kg und umfasst 1,4 m³ Rauminhalt. Die einer Blüte ähnelnde Form stammt von einer Reihe von Skulpturen Calatravas, die die Eigenschaften gefalteter sphärischer Gehäuse ausloten. Sein Interesse an Skulptur, das ungeachtet eines mit Architekturaufträgen angefüllten Terminplans anhält, zeugt von der Bedeutung, die Calatrava jenem Teil seiner Arbeit beimisst, der in vieler Hinsicht als Ausgangspunkt seiner Architektur gelten kann. Die Herausforderung, ein Objekt zu entwerfen, das 1000 Jahre oder länger bestehen soll, sprach darüber hinaus gewiss sein Empfinden für die Dauerhaftigkeit der Formen an, die sein gesamtes Oeuvre inspiriert.

En 1999, le *New York Times Magazine* organisa un concours international pour une capsule devant contenir des artefacts illustrant la vie sur la planète Terre au XXᵉ siècle et qui resterait scellée jusqu'au 1ᵉʳ janvier 3000. La proposition de Santiago Calatrava fut sélectionnée parmi cinquante participations venues de quinze pays. Les artefacts furent choisis par le journal à partir des suggestions des visiteurs d'une exposition organisée au Museum of Natural History et de celles d'internautes. Les objets furent spécialement conditionnés pour leur conservation et emballés puis, le 28 mars 2001, déposés dans la Capsule que l'on souda hermétiquement. Faite d'acier inoxydable, elle mesure 1,5 mètre de diamètre et pèse 600 kilos pour un volume intérieur de 1,4 mètre cube. Sa forme de fleur est inspirée d'une série de sculptures de l'architecte explorant les propriétés des ossatures sphériques pliées. Malgré l'ampleur et le nombre de ses projets architecturaux, Calatrava accorde toujours beaucoup d'importance à ces recherches sculpturales qui sont, à de nombreux égards, à l'origine de son architecture. Le défi qui consistait à concevoir un objet destiné à perdurer un millier d'années illustre également le sens de la permanence des formes qui anime l'ensemble de son œuvre.

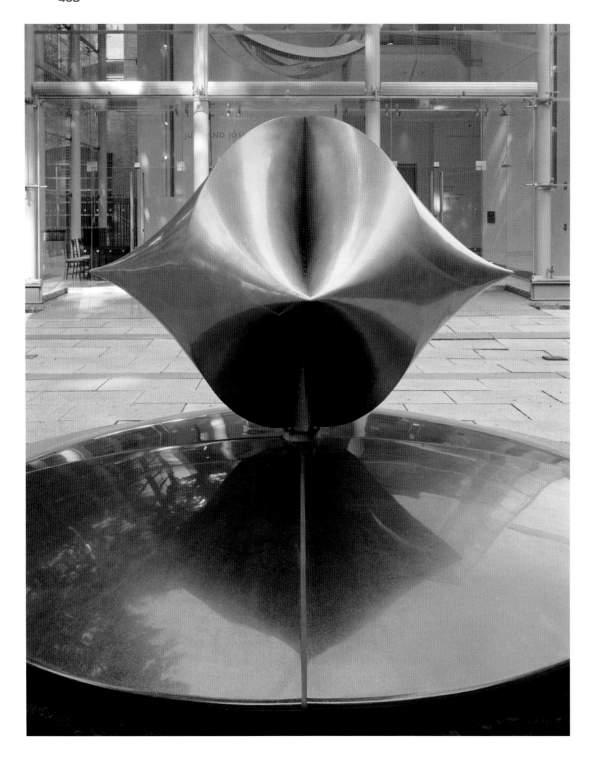

Intended to last for 1000 years, The New York Times Capsule adopts a seemingly inviolable form made of polished stainless steel. Though it resembles a flower or a seed pod, the shape is derived from the architect's study of spheres.

Für die New York Times Capsule, die einen Zeitraum von 1000 Jahren überdauern soll, wählte Calatrava eine anscheinend unzerstörbare Form aus poliertem Edelstahl. Obgleich sie einer Blume oder einer Samenkapsel ähnelt, ist ihre Form den Kugelstudien des Architekten entnommen.

Prévue pour durer mille ans, la capsule en acier inoxydable poli du *New York Times* a adopté une forme qui paraît inviolable. Bien qu'elle ressemble à une fleur ou à une gousse végétale, elle est issue d'une recherche de l'architecte sur les sphères.

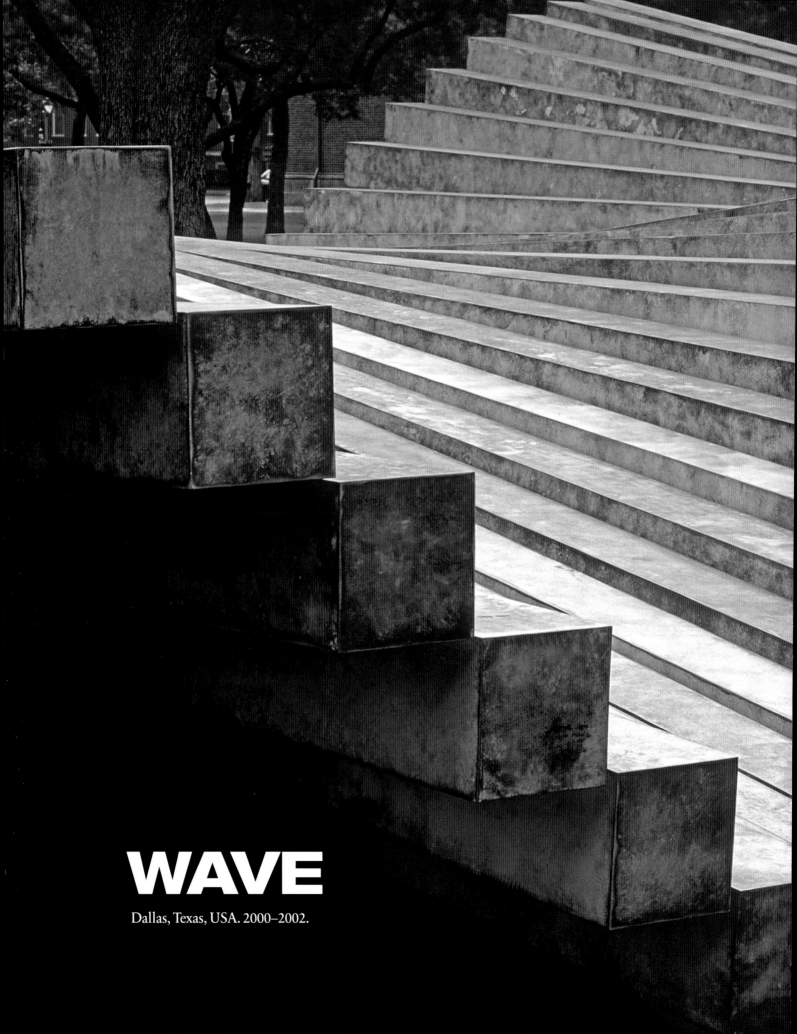

WAVE

Dallas, Texas, USA. 2000–2002.

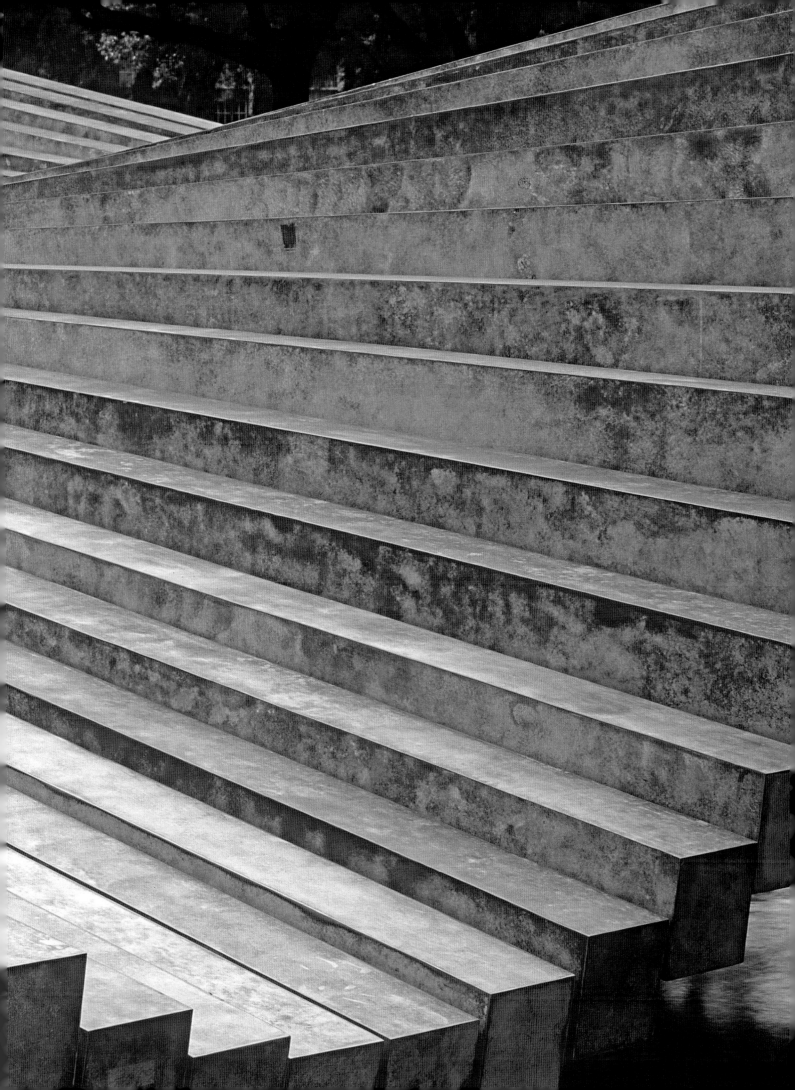

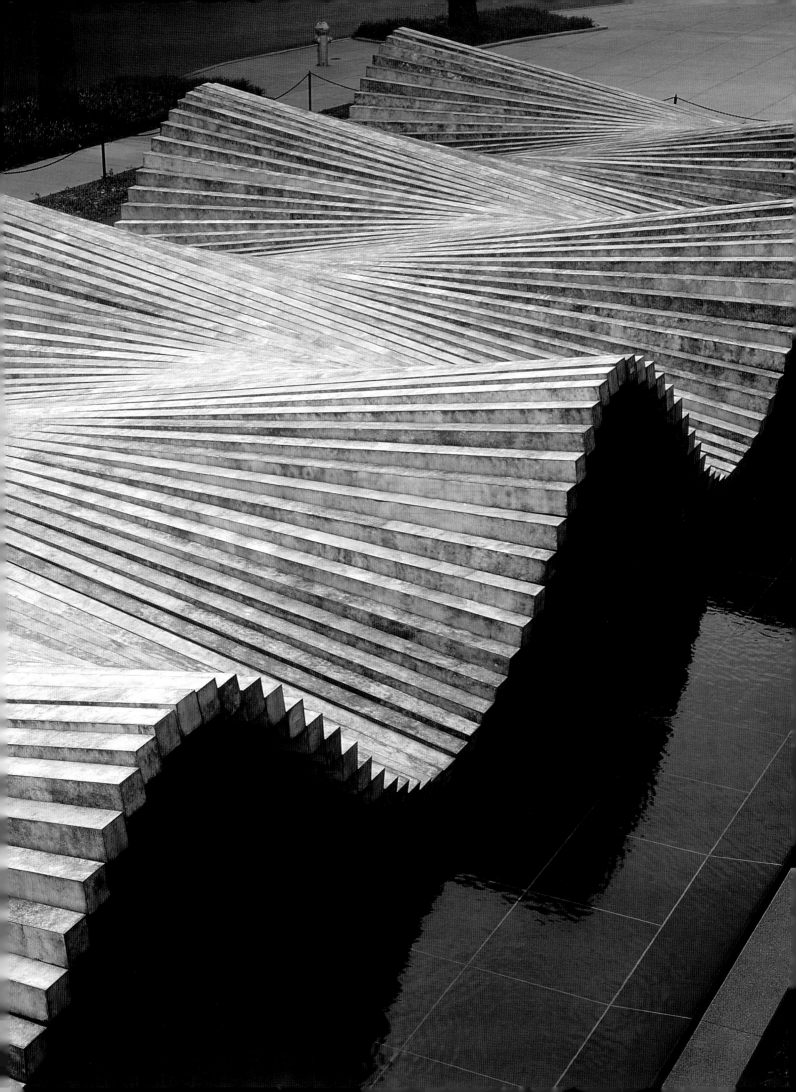

Project
WAVE

Location
MEADOWS MUSEUM, SOUTHERN METHODIST UNIVERSITY, DALLAS, TEXAS, USA

Client
MEADOWS MUSEUM WITH THE SUPPORT OF THE ROSINE FOUNDATION FUND OF COMMUNITIES FOUNDATION OF TEXAS, AND MARY ANNE AND RICHARD CREE OF DALLAS

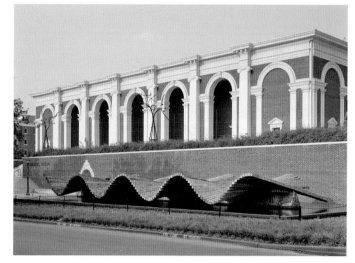

Calatrava's *Wave* sculpture embodies many of the concerns that he has expressed throughout his career both as a sculptor and as an architect, or even as an engineer. Similar shapes, ranging from the early Ernsting's doors to much more recent work, can be seen in his buildings. The key here is movement of course.

Calatravas Skulptur „Wave" umfasst viele der Dinge, die für ihn im Lauf seines Schaffens als Architekt und Bildhauer, ja sogar als Ingenieur wichtig waren. Von den Toren der Firma Ernsting's bis zu Arbeiten weit neueren Datums wiederholen sich in seinen Bauten ähnliche Formen. Das Schlüsselelement ist hier natürlich die Bewegung.

La sculpture de Calatrava baptisée *Wave* matérialise nombre des préoccupations qu'il a exprimées au cours de sa carrière, tant de sculpteur que d'architecte et même d'ingénieur. Des formes similaires – des premières portes Ernsting's à des réalisations plus récentes – se retrouvent dans ses bâtiments. Ici le mot clé est, bien sûr, « mouvement ».

Santiago Calatrava began a relationship with the Meadows School of the Arts at Southern Methodist University (SMU) in November 2000, when he received the school's Algur H. Meadows Award for Excellence in the Arts. In March 2001, the new building of the Meadows Museum opened with "Poetics of Movement: The Architecture of Santiago Calatrava" as its inaugural special exhibition. In connection with that exhibition, the museum asked Calatrava to create an outdoor sculpture, to be sited at a reflecting pool on the building's plaza. *Wave*, measuring 12 meters in depth and 27.5 meters in length, is made up of 129 equal bronze bars. The bars are connected to a mechanism that makes them rock sequentially, giving them a wavelike motion. The sculpture is installed over the shallow water of the black granite reflecting pool, which reflects its movement. At night, lighting in the pool illuminates the sculpture from below. Almost architectural in scale, *Wave* remains a sculpture, and evidence of Santiago Calatrava's ongoing interest both in art and in works that move.

Santiago Calatravas Beziehung zur Meadows School of the Arts an der Southern Methodist University (SMU) begann im November 2000, als er von dem Institut mit dem Algur H. Meadows Award for Excellence in the Arts ausgezeichnet wurde. Im März 2001 wurde der Neubau des Meadows Museums mit der Exposition „Poetics of Movement: The Architecture of Santiago Calatrava" als erster Sonderausstellung eröffnet. Im Zusammenhang damit bat das Museum Calatrava, eine Außenskulptur zu gestalten, die am Wasserbecken auf der Plaza des Gebäudes zu stehen kommen sollte. Die „Wave" (Welle) genannte, 12 m tiefe und 27,5 m lange Skulptur besteht aus 129 gleichartigen Bronzestäben. Diese sind durch einen Mechanismus verbunden, der sie in regelmäßiger Abfolge schaukeln lässt und so eine Wellenbewegung erzeugt. Die Skulptur ist über einem flachen, aus schwarzem Granit gefertigten Wasserbecken installiert, in dem sich ihre Bewegungen spiegeln. Nachts wird sie von im Becken verankerten Scheinwerfern von unten beleuchtet. Von nahezu architektonischen Ausmaßen bleibt „Wave" eine Skulptur und zeugt von Calatravas anhaltendem Interesse an Kunst und an beweglichen Objekten.

Les relations entre Santiago Calatrava et la Meadows School of Arts de la Southern Methodist University (SMU) remontent à novembre 2000, lorsqu'il reçut le Prix d'excellence artistique Algur H. Meadows. En mars 2001, le nouveau bâtiment du Meadows Museum a ouvert, avec pour exposition inaugurale, « Poétique du mouvement : l'architecture de Santiago Calatrava ». Parallèlement à cette manifestation, le musée demanda à l'architecte de créer une sculpture pour le bassin qui se trouve sur l'esplanade du bâtiment. *Wave,* qui mesure 12 mètres par 27,5 mètres, est constituée de 129 barres de bronze de dimensions égales, reliées à un mécanisme qui les anime séquentiellement pour reproduire un mouvement de vague reflété par l'eau du bassin en granit noir. La nuit, des projecteurs placés sous l'eau illuminent la pièce. De dimensions presque architecturales, *Wave* reste cependant une sculpture et une illustration de l'indéfectible intérêt de l'architecte pour l'art et les œuvres mobiles.

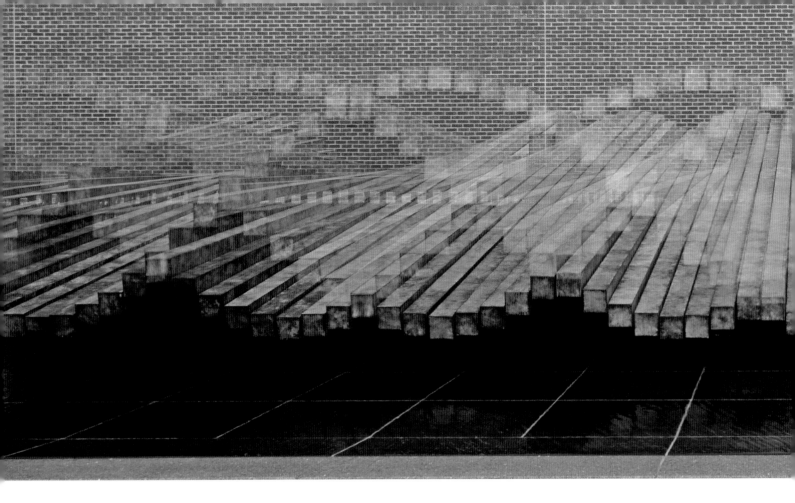

In time-lapse photography (above) or in a fixed position (below), the *Wave* carries its name well. It might be noted that this undulating shape is closely related to that of the roof of the Bodega Ysios.

Ob auf Aufnahmen mit dem Zeitraffer (oben) oder in einer fixierten Position (unten), die *Wave* trägt ihren Namen zu Recht. Die gewellte Form ist eng mit dem Dach der Bodega Ysios verwandt.

Sur cette photographie à intervalles de pose (en haut) ou en position fixe (en bas) la *Wave* (vague) porte bien son nom. Cette forme sinueuse est très proche de celle utilisée pour la couverture du chai des Bodegas Ysios.

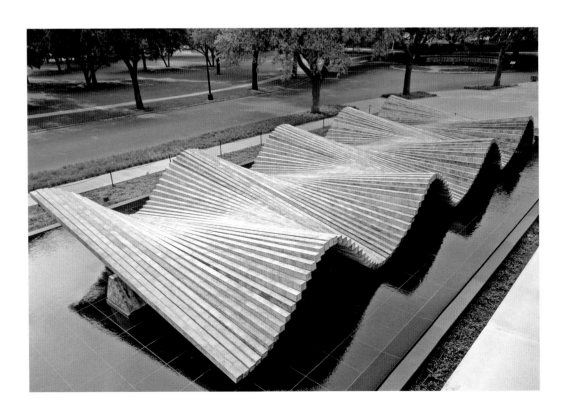

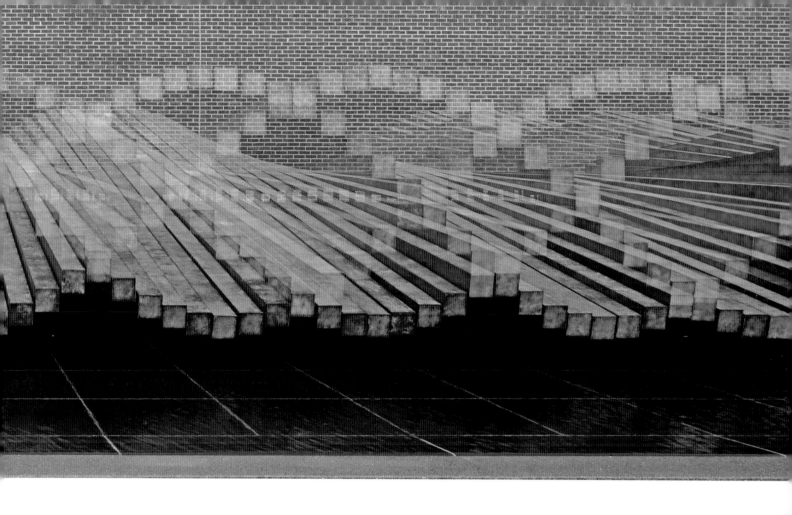

Though the sketches of a stretched male body above may not be specifically related to the *Wave* sculpture, they nonetheless point to the sources of inspiration of the architect-sculptor.

Obgleich die Skizzen eines ausgestreckten, männlichen Körpers nicht unbedingt mit der Skulptur zusammenhängen mögen, weisen sie doch auf die Inspirationsquellen für den Architekten und Bildhauer hin.

Si ces croquis d'un corps masculin en extension ne sont pas spécifiquement liés aux recherches pour la sculpture *Wave*, ils dévoilent néanmoins les sources d'inspiration de l'architecte-sculpteur.

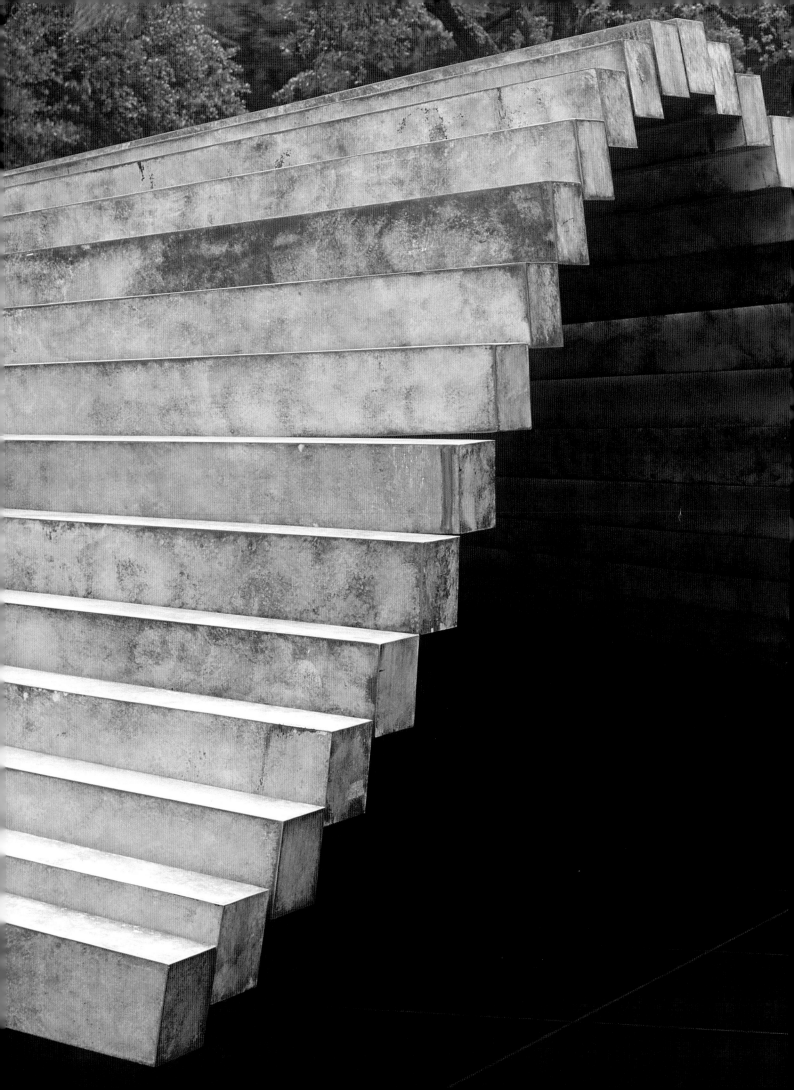

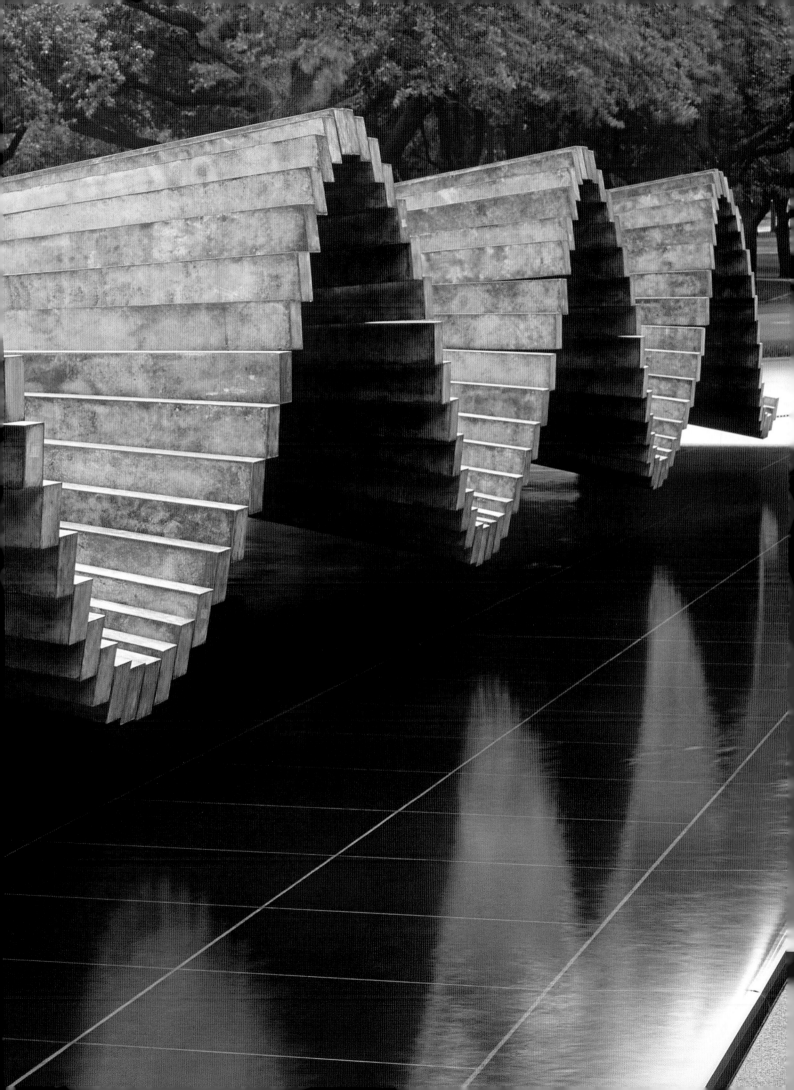

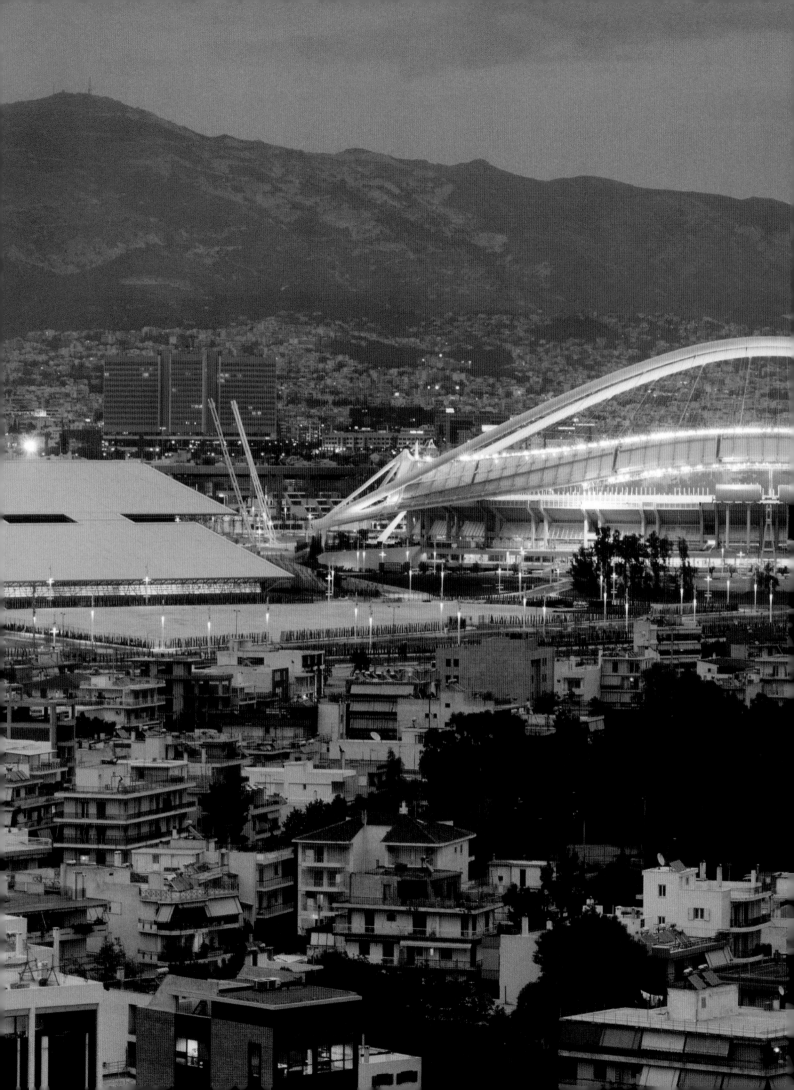

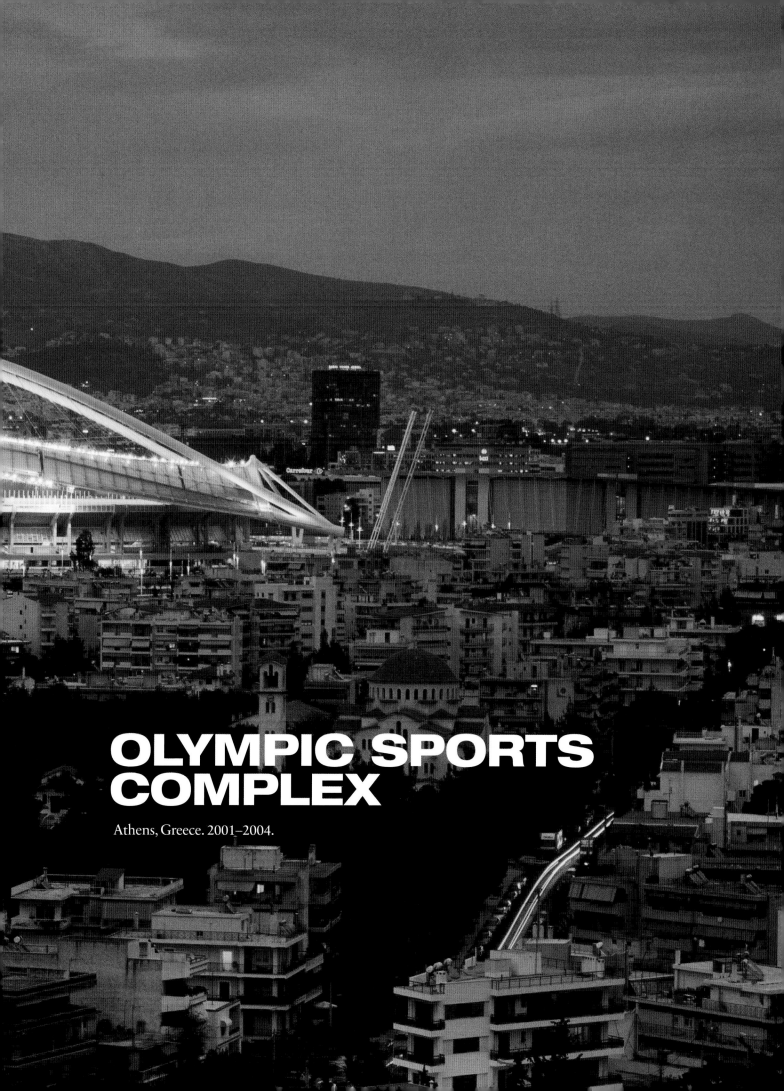

OLYMPIC SPORTS COMPLEX

Athens, Greece. 2001–2004.

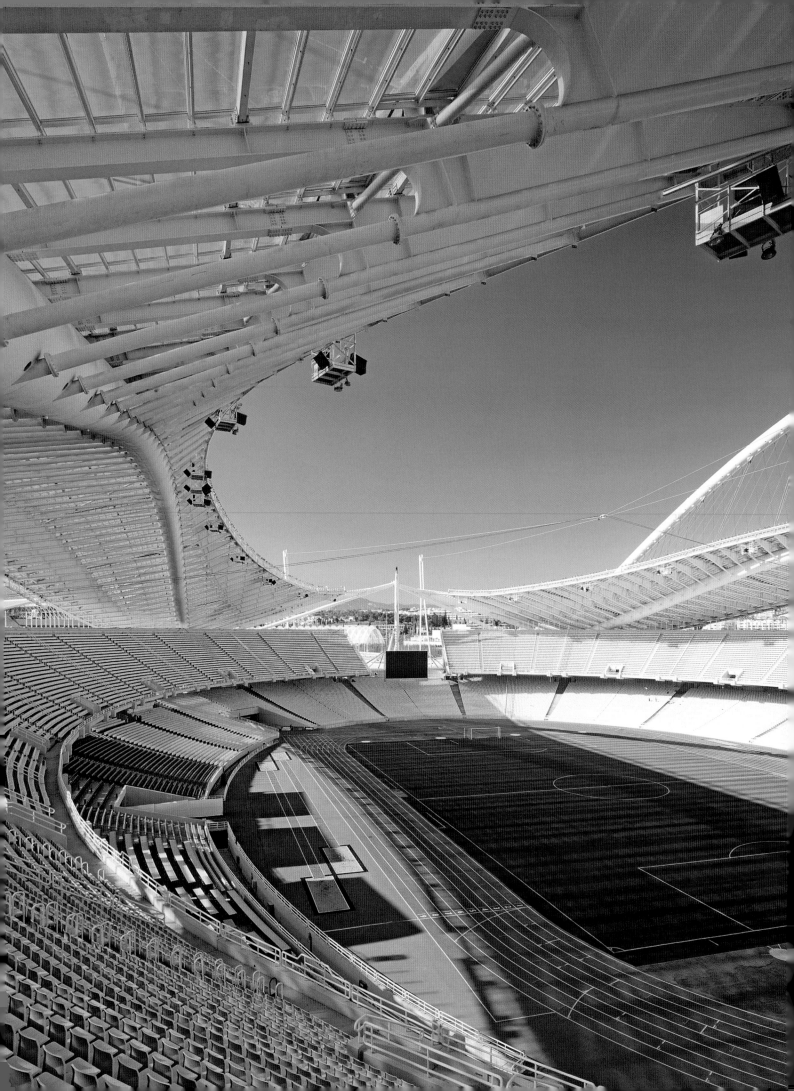

Project
OLYMPIC SPORTS COMPLEX

Location
ATHENS, GREECE

Client
MINISTRY OF CULTURE OF GREECE

Site area
199 000 m² OF PLAZAS; 94 000 m² OF PATHWAYS; 61 000 m² OF GREEN AREAS; 29 000 m² OF WATER ELEMENTS; 130 000 m² OF SERVICE FACILITIES; AND 178 000 m² OF PARKING LOTS AND ROADS

Calatrava's design was intended to deal with the facilities of the existing Athens Olympic Sports Complex (OAKA, located in Marousi, a suburb north of Athens) as well as their infrastructure and access network (subway, commuter rail, highways). As he explains, "The design aimed to meet all the functional requirements of the Olympic and Paralympics Games; to integrate the OAKA's elements aesthetically by providing a common identity through a combination of built and natural elements; to accommodate people with special needs; and to respect the environment through the use of autochthonous plantings (such as olive trees and cypresses), provision of efficient solutions to waste management, and other elements of ecologically sensitive design." The principal architectural interventions were: a new roof for the Olympic Stadium; a new roof and refurbishing of the Velodrome; the creation of entrance plazas and entrance canopies for the complex as a whole; the creation of a central Olympic Icon (a movable steel sculpture in the form of a 110-meter-high spindle); the design of a sculptural Nations' Wall (a 250-meter-long, 20-meter-high tubular steel sculpture); provision of new warm-up areas for athletes; improvement of pedestrian bridges and connections to public transportation; provision of parking areas and bus terminals; and design of the installations and infrastructure for all elements. The most spectacular element is the roof of the Olympic Stadium, covering a surface of 25 000 square meters, with two "bent leaf" structures made of tubular steel and spanning 304 meters each. The structures were designed so that they could be prefabricated off-site to the greatest extent possible, reducing the need for on-site personnel and equipment and minimizing interference with other construction work on the existing buildings. Though Calatrava's intervention was rendered difficult by local working conditions, and perhaps overshadowed by the Olympic Games themselves, his intervention in Athens will remain as one of the major, symbolic encounters between architecture, engineering, and sports.

Calatravas Konzeption sollte mit den Einrichtungen der vorhandenen Olympischen Sportanlagen (OAKA) in Marousi, einem nördlichen Vorort Athens, arbeiten und sich außerdem mit deren Infrastruktur und Verkehrsanbindung mittels Untergrundbahn, Nahverkehrszügen und Schnellstraßen befassen. Calatrava erläutert: „Die Planung war bestrebt, sämtlichen funktionalen Erfordernissen der Olympischen und Paralympischen Spiele zu entsprechen; es sollten die baulichen Bestandteile des OAKA ästhetisch eingebunden werden, indem ihnen durch das Zusammenspiel baulicher und natürlicher Elemente eine gemeinsame Identität gegeben wurde, es galt den Bedürfnissen von Behinderten Rechnung zu tragen, und es sollten mit Rücksicht auf die Umwelt heimische Gewächse wie Olivenbäume und Zypressen angepflanzt, außerdem tragfähige Lösungen zur Bewältigung des Abfalls konzipiert und andere Elemente umweltgerecht gestaltet werden." Die hauptsächlichen architektonischen Maßnahmen waren: ein neues Dach für das Olympiastadion, ein neues Dach und die Modernisierung des Velodroms, die Schaffung von Vorplätzen und Vordächern für die gesamte Anlage, die Gestaltung eines zentralen olympi-

schen Symbols (eine bewegliche Stahlskulptur in Form einer 110 m hohen Spirale), die Gestaltung einer skulpturalen Wand der Nationen (eine 250 m lange, 20 m hohe Stahlrohrplastik), die Schaffung neuer Aufwärmplätze für Sportler, die Instandsetzung von Fußgängerbrücken und die Anbindung an den öffentlichen Nahverkehr, die Schaffung von Parkplätzen und Busterminals sowie die Planung der Installationen und Infrastruktur für sämtliche Bereiche. Das 25 000 m² große Dach des Olympiastadions mit zwei „gebogenen Blattformen" aus Stahlrohr, die jeweils 304 m überspannen, ist zweifellos das markanteste Element. Die Planung der Bauten sah vor, dass sie zum größtmöglichen Teil aus andernorts vorgefertigten Elementen errichtet werden konnten. Das reduzierte die Zahl der vor Ort Arbeitenden und minimierte die Beeinträchtigung von Bauarbeiten an vorhandenen Gebäuden. Obgleich Calatravas Wirken durch die vor Ort herrschenden Arbeitsbedingungen erschwert und durch die Olympischen Spiele selbst dominiert wurde, werden seine olympischen Sportstätten in Athen als eine der großen, symbolischen Begegnungen von Architektur, Ingenieurwesen und Sport in Erinnerung bleiben.

Le projet de Calatrava pour le Complexe des Sports olympiques d'Athènes, situé à Marousi dans la banlieue Nord de la capitale, portait sur des équipements spécifiques, leurs infrastructures et leur réseau d'accès (métro, trains de banlieue, autoroutes). « Le projet avait pour but de répondre aux besoins fonctionnels de l'organisation des Jeux olympiques et paraolympiques et d'intégrer esthétiquement les éléments de l'OAKA en leur assurant une identité commune par la combinaison d'éléments construits et d'éléments naturels ; de répondre aux besoins des personnes handicapées, de respecter l'environnement par l'utilisation de plantes locales (oliviers et cyprès par exemple), de prévoir des solutions efficaces de gestion des déchets et des eaux usées et autres éléments écologiquement sensibles. » Les principales interventions architecturales furent un nouveau toit pour le stade olympique, un autre pour le vélodrome qui était également à rénover, la création de places et d'auvents devant les entrées, une « icône » olympique (sculpture mobile en acier en forme de navette de 110 mètres de haut), la conception d'un Mur des Nations (sculpture en tube d'acier de 250 mètres de long et 20 mètres de haut), des aires d'entraînement pour les athlètes, l'amélioration des passerelles piétonnières et des connexions avec les transports publics, des parkings et des gares routières et toutes les infrastructures indispensables. La création la plus spectaculaire est le toit du stade olympique dont la structure en « feuilles recourbées » de tubes d'acier de 304 mètres de portée chacun recouvre une surface de 25 000 mètres carrés. Les éléments ont été conçus de façon à être préfabriqués le plus souvent possible, afin de réduire les besoins en personnel et équipements de chantier et de limiter les interférences avec les travaux menés en parallèle sur les constructions. Si l'intervention de Calatrava a été compliquée par les conditions de travail locales et peut-être éclipsée par les Jeux olympiques eux-mêmes, elle restera comme l'une des rencontres symboliques majeures entre l'architecture, l'ingénierie et le sport.

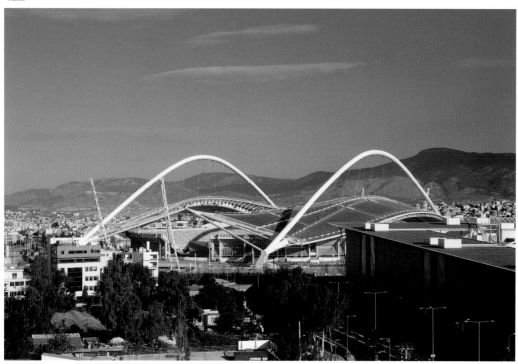

The relation of Calatrava's architectural compositions in studies of the human body in motion, such as the sketches below, seems particularly significant in the context of the curving roof of the Olympic Stadium.

Der Bezug von Calatravas Architektur zu Studien des menschlichen Körpers in Bewegung, wie die untenstehenden Skizzen, erscheint im Kontext der gebogenen Dachform des Olympiastadions besonders bezeichnend.

La relation entre les compositions de Calatrava et ses études sur le corps humain en mouvement (tels les croquis ci-dessous), semble particulièrement claire dans le contexte de la couverture en courbe du stade olympique.

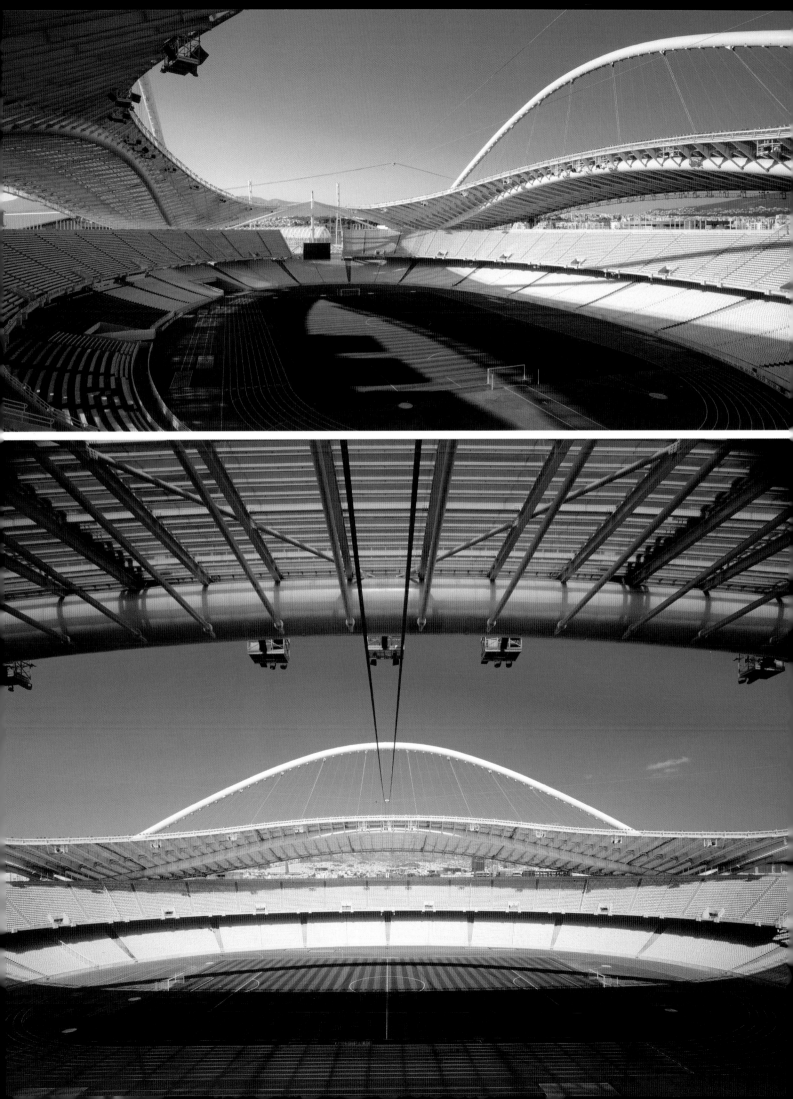

The series of sketches seen on this double page put the human body through unexpected contorsions. It is as though Calatrava's interest focuses not on ordinary movements, but rather on those of dance or certain sports that might entail jumping or falling through space, as in the pole vault, long jump or in diving.

Die Reihe von Skizzen auf dieser Doppelseite zeigt den menschlichen Körper in unvermuteten Verdrehungen. Es ist, als gelte Calatravas Interesse nicht alltäglichen Bewegungen, sondern denen des Tanzes oder bestimmter Sportarten, wie Stabhochsprung, Weitsprung oder Turmspringen, die Sprünge oder das Fallen mit sich bringen.

La série de croquis de cette double page montre le corps humain dans des contorsions inattendues, comme si l'intérêt de Calatrava se concentrait non sur des mouvements ordinaires mais sur ceux de danseurs ou d'athlètes en saut à la perche, saut en longueur, ou plongée.

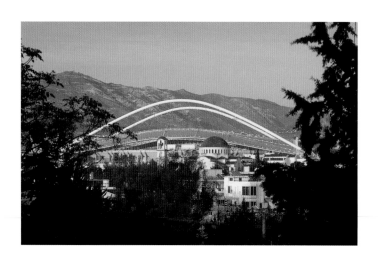

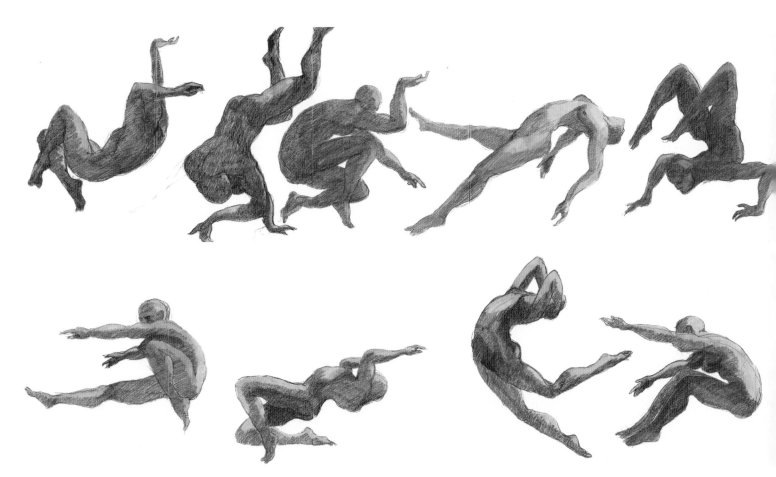

The sketch above of a fallen warrior seems directly related to a pedimental sculpture from the Temple of Aphaia in Aegina (c. 500–480 B.C., Munich, Glyptothek), an appropriate reference for this Olympic Stadium in Athens.

Zwischen der oben stehenden Skizze eines gefallenen Kriegers und einer Skulptur vom Giebel des Aphaia-Tempels in Àgina (ca. 500–480 v. Chr., Glyptothek, München) besteht augenscheinlich ein direkter Zusammenhang, eine passende Geste für das Olympiastadion in Athen.

Le croquis (ci-dessus) d'un guerrier à terre semble être une référence directe à une sculpture du fronton du temple d'Aphaia à Égine (vers 500–480 av. J.-C., Munich, Glyptothèque), référence tout à fait appropriée s'agissant du Stade olympique d'Athènes.

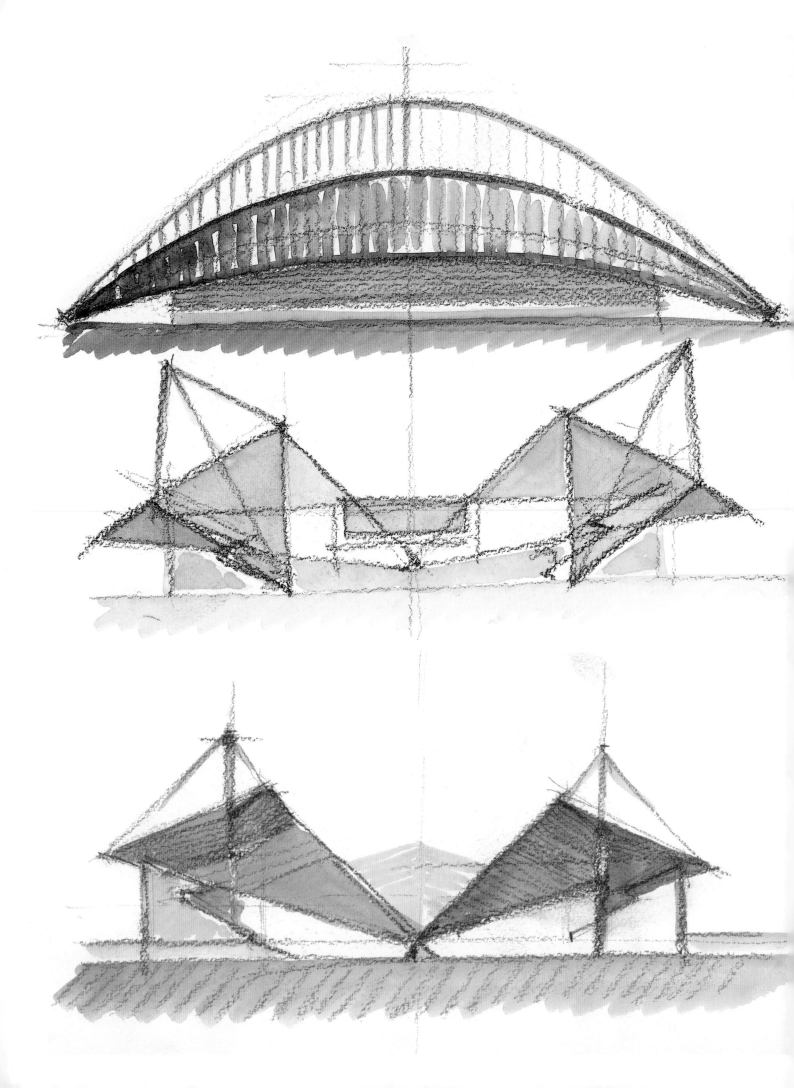

The volumetric expression of Calatrava's drawings tends toward simplicity, the essential play of forces and forms that explain his architecture.

Der volumetrische Ausdruck von Calatravas Zeichnungen strebt nach Einfachheit und zeigt das seiner Architektur zugrunde liegende essentielle Spiel der Kräfte und Formen.

L'expression volumétrique des dessins de Calatrava tend à la simplicité, mettant en valeur le jeu essentiel des forces et des formes qui nourrissent son architecture.

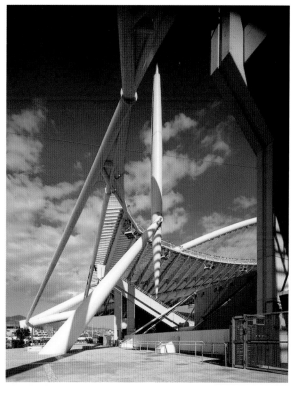

The actual structures tend to be more complex than Calatrava's drawings. Numerous devices seen in other contexts—the suspended spire present in the upper part of the Montjuic Tower (above) or the angled arches visible below and seen in many Calatrava bridges—here serve other functions.

Die realisierten Bauten sind in der Regel komplexer als Calatravas Zeichnungen. Viele Einfälle aus anderen Zusammenhängen – die hängende Spitze vom oberen Teil des Torre de Montjuic (oben) oder die geneigten Bögen (unten), wie bei vielen Brücken Calatravas –, übernehmen hier andere Funktionen.

Les projets réalisés sont en général plus complexes que les dessins. De nombreux procédés vus dans d'autres contextes – l'antenne suspendue de la partie supérieure de la tour de Montjuic (en haut) ou les arcs inclinés (en bas) et présents dans de nombreux ponts de l'architecte –, servent ici d'autres desseins.

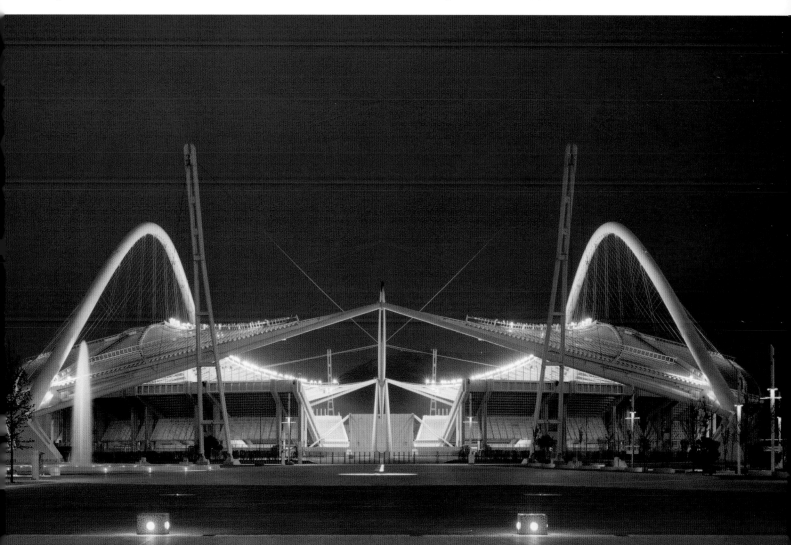

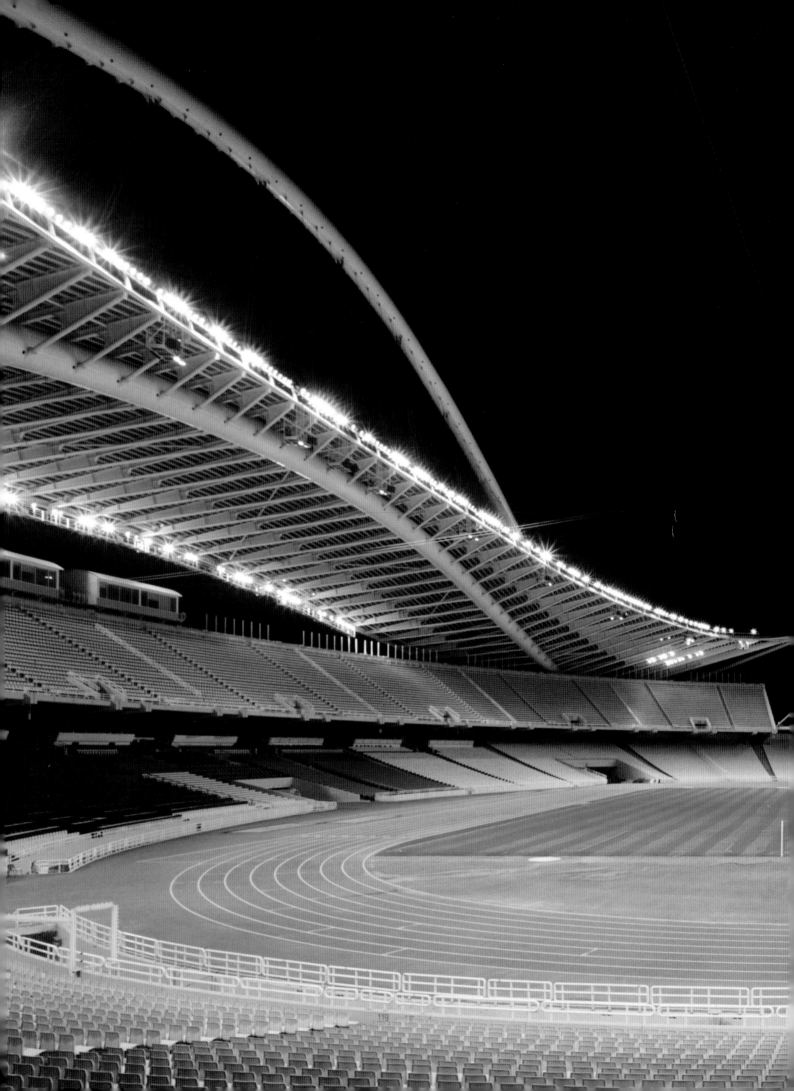

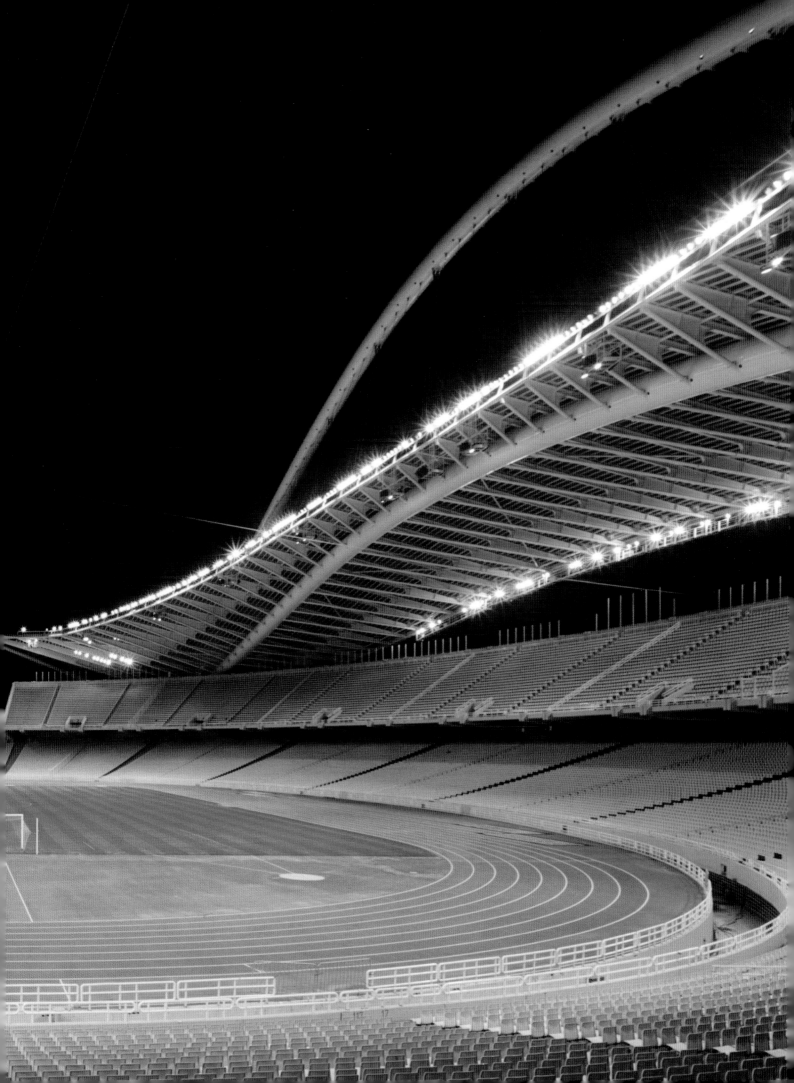

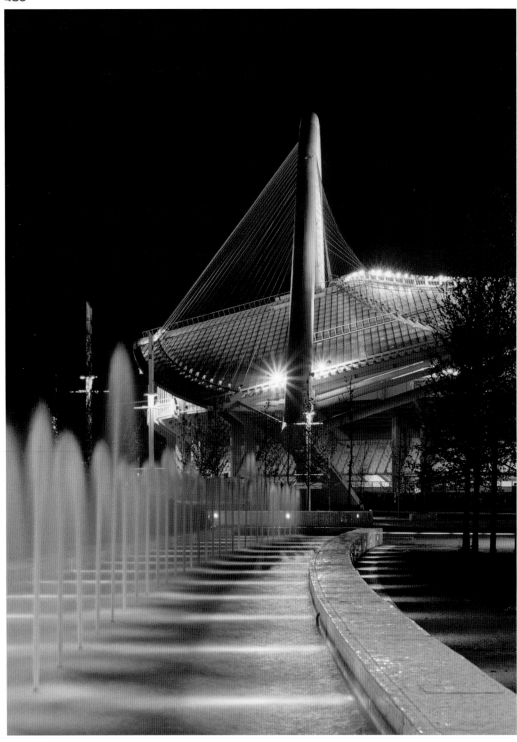

The spectacular empty space of the Athens Olympic Stadium seen to the right or the array of fountains leading to one of the arches (above) speak with the eloquence of forms designed by an engineer, and yet they are also imbued with an aesthetic sense, one that sets Calatrava apart from his contemporaries.

Der bezwingende leere Innenraum des Athener Olympiastadions (rechts) oder die Phalanx der zu einem der Bögen hinführenden Brunnen (oben) sprechen mit der Eloquenz der von einem Ingenieur erdachten Formen und sind doch darüber hinaus von einem ästhetischen Empfinden erfüllt, das Calatrava von seinen Zeitgenossen abhebt.

Le spectaculaire espace vide du Stade olympique d'Athènes (à droite) ou le majestueux ensemble de fontaines menant à l'une des arches (ci-dessus) expriment avec éloquence les idées d'un ingénieur et dégagent, dans le même temps, ce « plus » esthétique qui place Calatrava à part dans l'univers de ses contemporains.

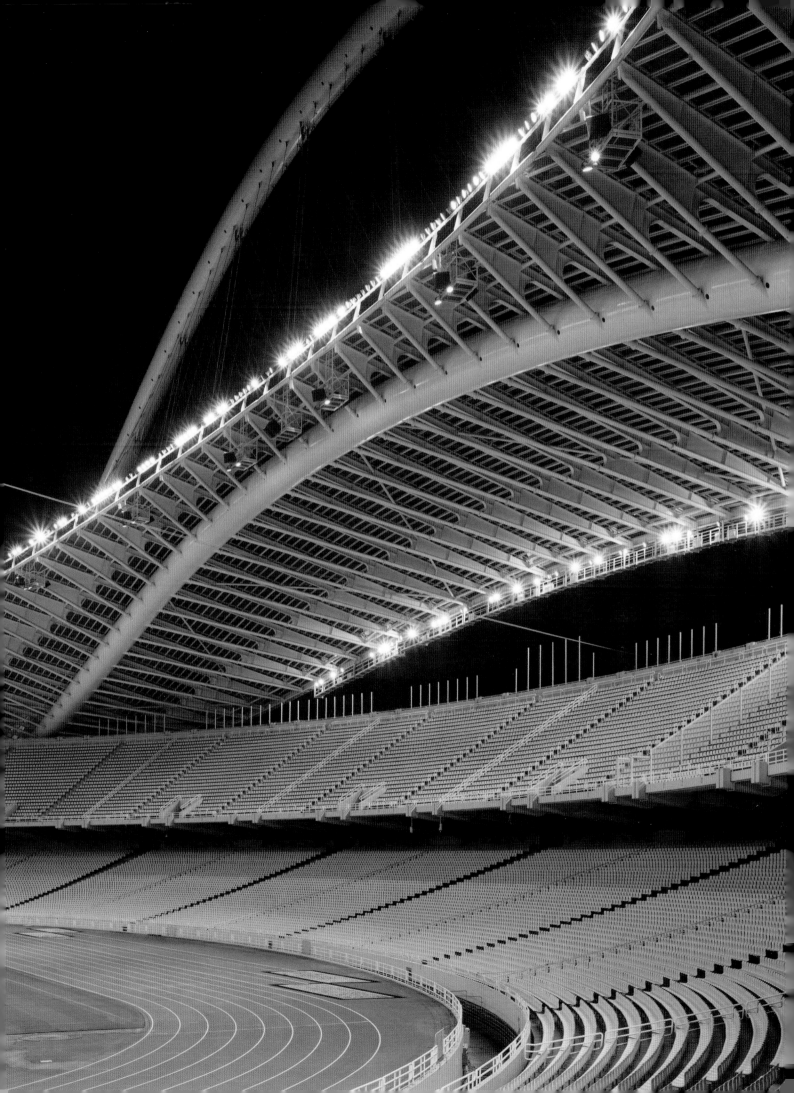

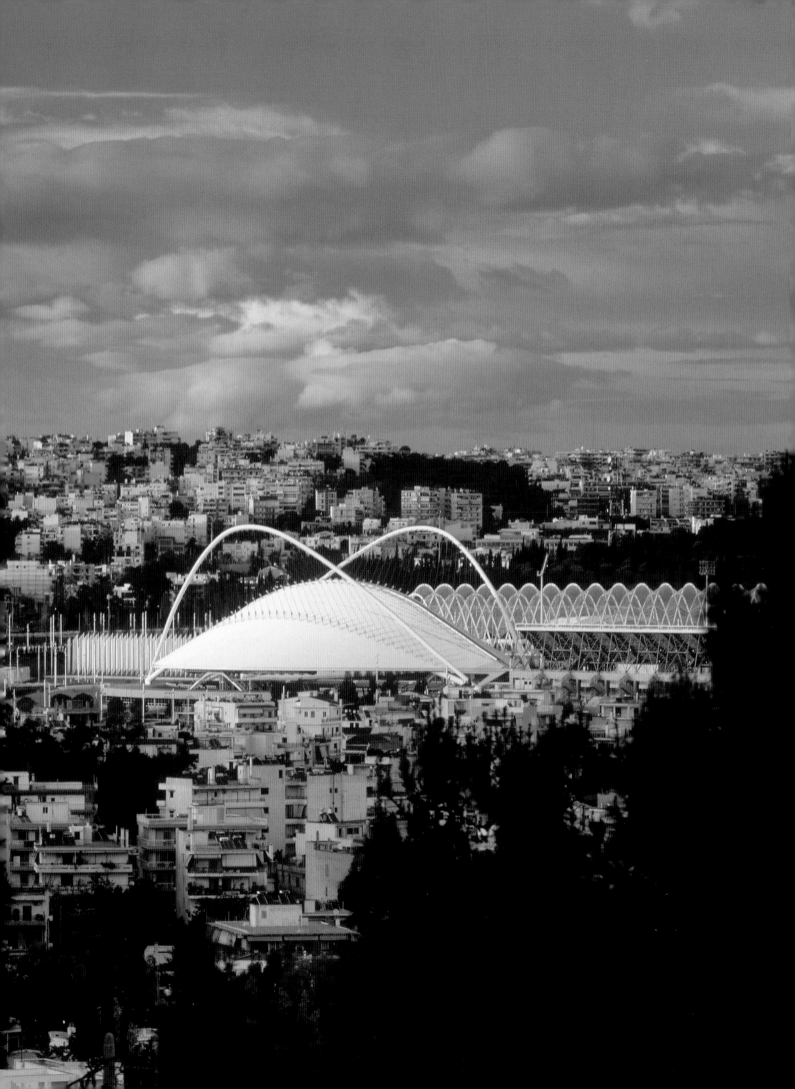

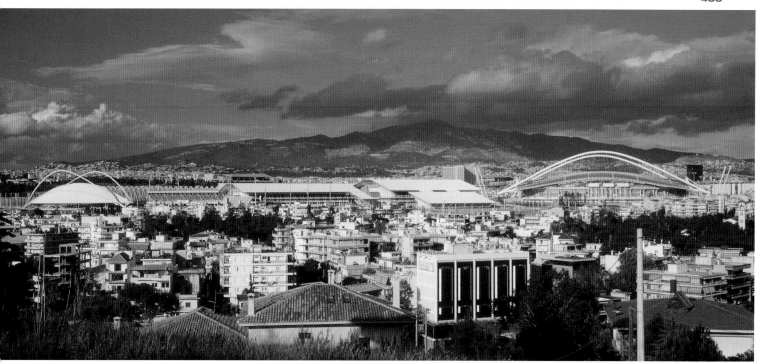

Calatrava's actual work in Athens relates to public spaces and the creation of new roofs for the main stadium and the Velodrome (seen left and in the drawing below), and yet the power of his forms gives the impression that he conceived the whole from scratch.

Der tatsächliche Beitrag Calatravas in Athen beschränkt sich auf öffentliche Platzanlagen und die neuen Dächer des Hauptstadions und des Velodroms (links und Zeichnung unten), und doch erweckt die Wirkungsmächtigkeit seiner Formen den Eindruck, er sei von Anfang an für die gesamte Anlage verantwortlich.

Les interventions de Calatrava à Athènes ne concernaient que les espaces publics et la création de nouvelles couvertures pour le stade principal et le vélodrome (à gauche, et dessin ci-dessous), et, cependant, la puissance de ces formes donne l'impression qu'il a conçu tout l'ensemble dès le départ.

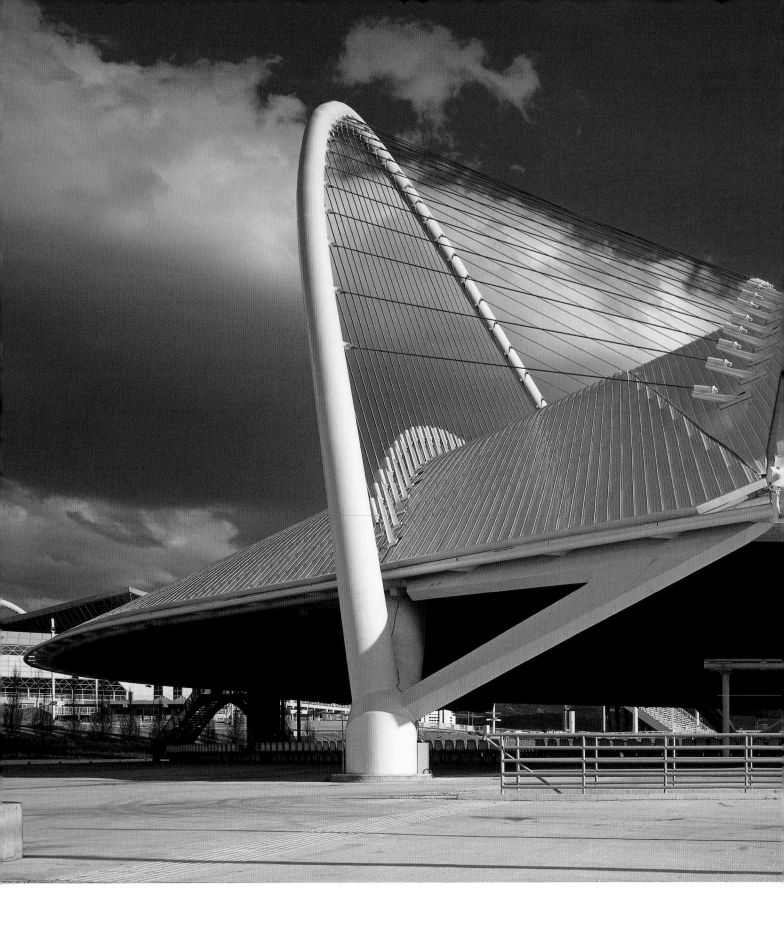

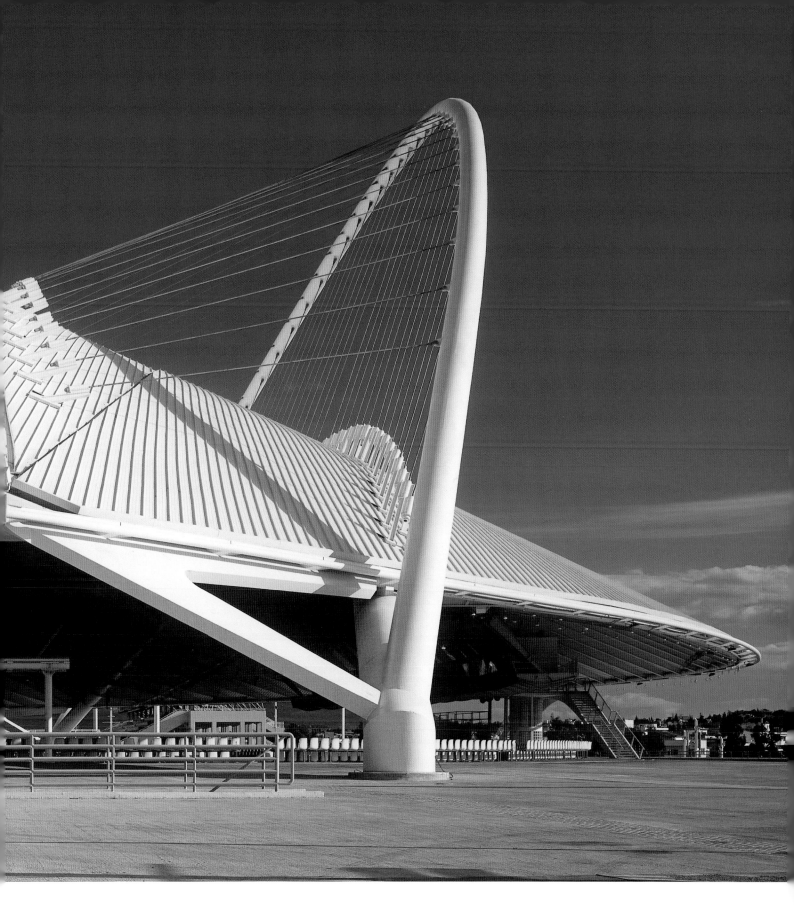

Even Calatrava's critics cannot deny that images such as the one above give an impression of dynamism and modernity, even if it is difficult to classify the architect in any movement in particular. He started in the footsteps of engineers like Nervi, and he has gone on to trace his own path.

Selbst Calatravas Kritiker können nicht abstreiten, dass Bilder wie das oben den Eindruck von Dynamik und Modernität erwecken, selbst wenn es schwer fällt, den Architekten in eine bestimmte Bewegung einzuordnen. Er begann in den Fußstapfen von Ingenieuren wie Nervi und verfolgte dann seinen eigenen Weg.

Même les critiques de Calatrava ne peuvent nier que des images comme celle du haut donnent une impression de dynamisme et de modernité, même s'il est difficile de classifier l'architecte dans un mouvement particulier. Après avoir mis ses pas dans ceux d'ingénieurs comme Nervi, il a su se tracer sa propre voie.

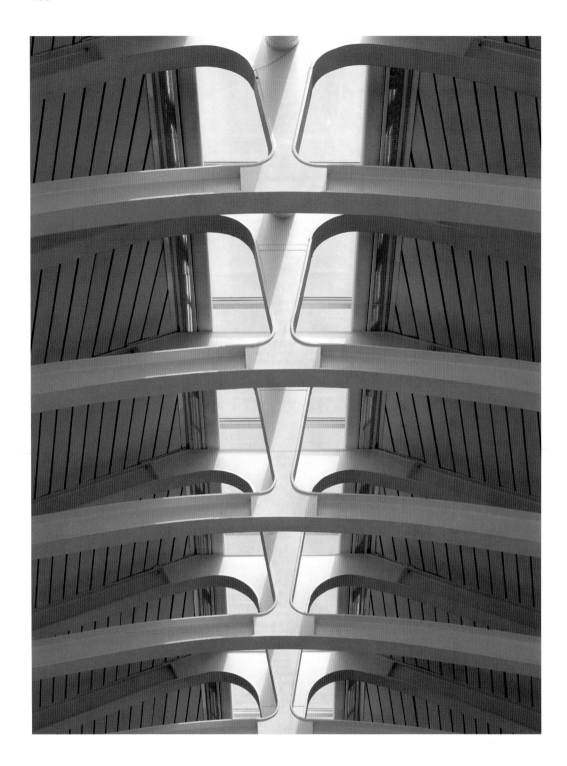

The elegance and simplicity of the Velodrome, seen in the detail above and in the overall, covered volume is an indication of the efficiency of the architect's intervention. He brings daylight into the space and renews it.

Eleganz und Einfachheit des Velodroms, das oben im Detail und in der Gesamtansicht des überbauten Raumes zu sehen ist, lässt auf die Effizienz der baulichen Maßnahmen schließen. Der Architekt bringt Tageslicht in den Raum und erneuert ihn.

L'élégance et la simplicité du volume couvert du vélodrome, visibles dans le détail ci-dessus et dans la vue d'ensemble, illustrent l'efficacité des interventions de l'architecte. En apportant la lumière naturelle dans ce volume, il le renouvelle.

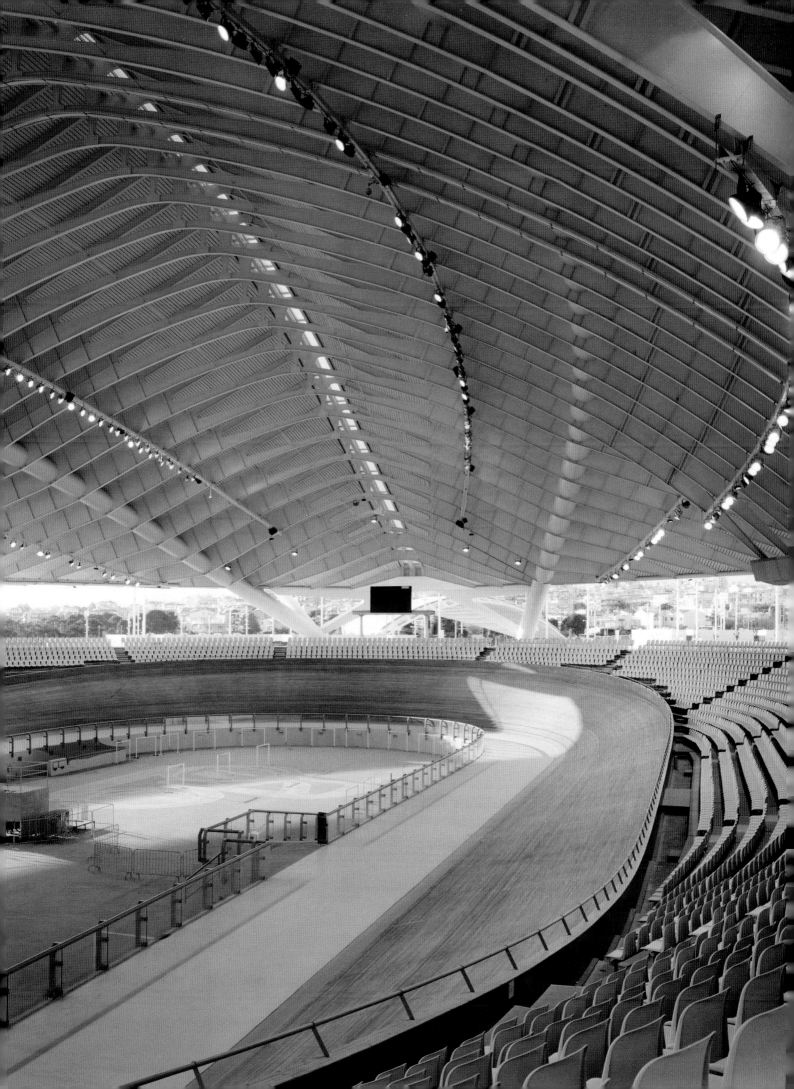

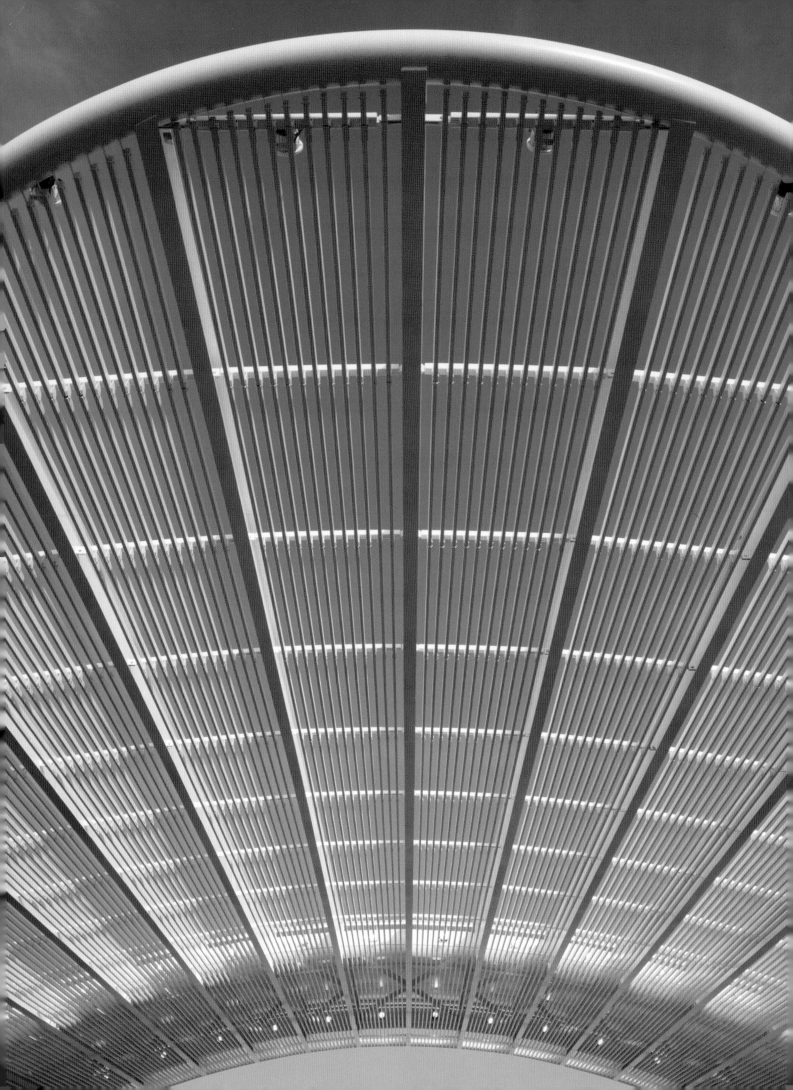

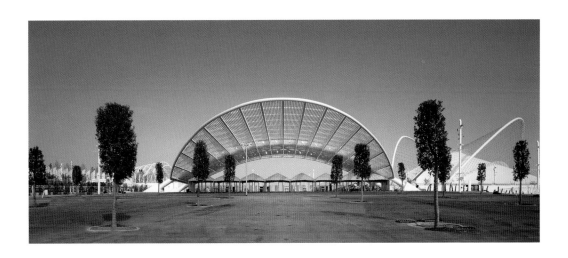

Like the soaring canopies of the Oriente Station in Lisbon, the arched entrance seen left and above sets the tone for the Olympic facilities—great open spans associated with fundamental lightness, and not the slightest hint of pomposity.

Wie die sich erhebenden Überdachungen des Bahnhofs Oriente in Lissabon, ist der von einem Bogen überfangene Eingang (links und oben) tonangebend für die olympischen Anlagen – mit elementarer Leichtigkeit assoziierte, große, stützenfreie Räume und nicht ein Hauch von Bombast.

Comme dans le cas des auvents suspendus de la gare de l'Orient à Lisbonne, l'entrée en arc (photos de gauche et ci-dessus) donne le ton de cet équipement olympique : de grandes portées ouvertes associées à une légèreté de construction sans la moindre trace de pompe.

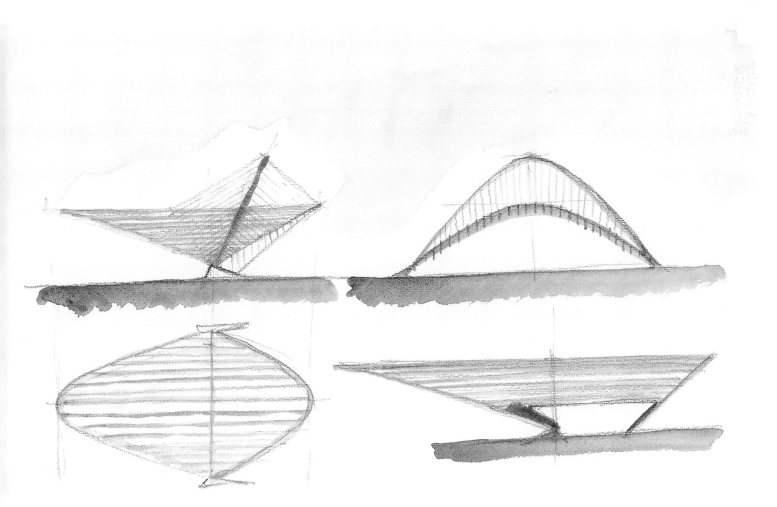

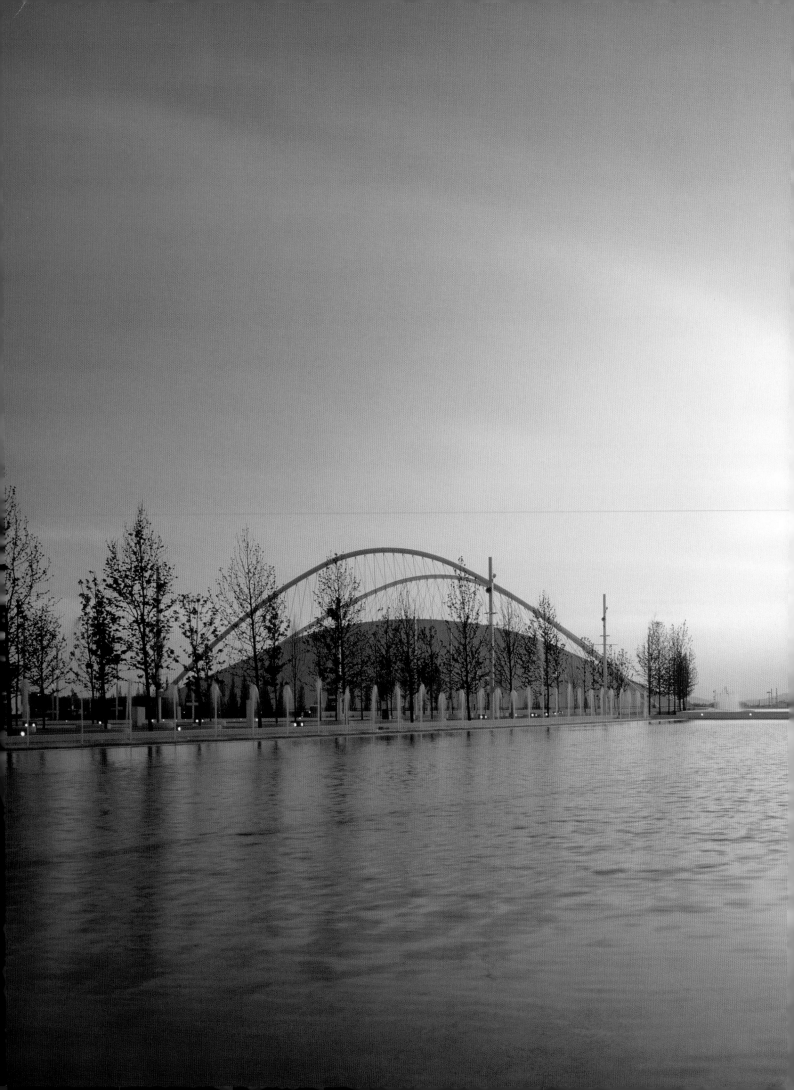

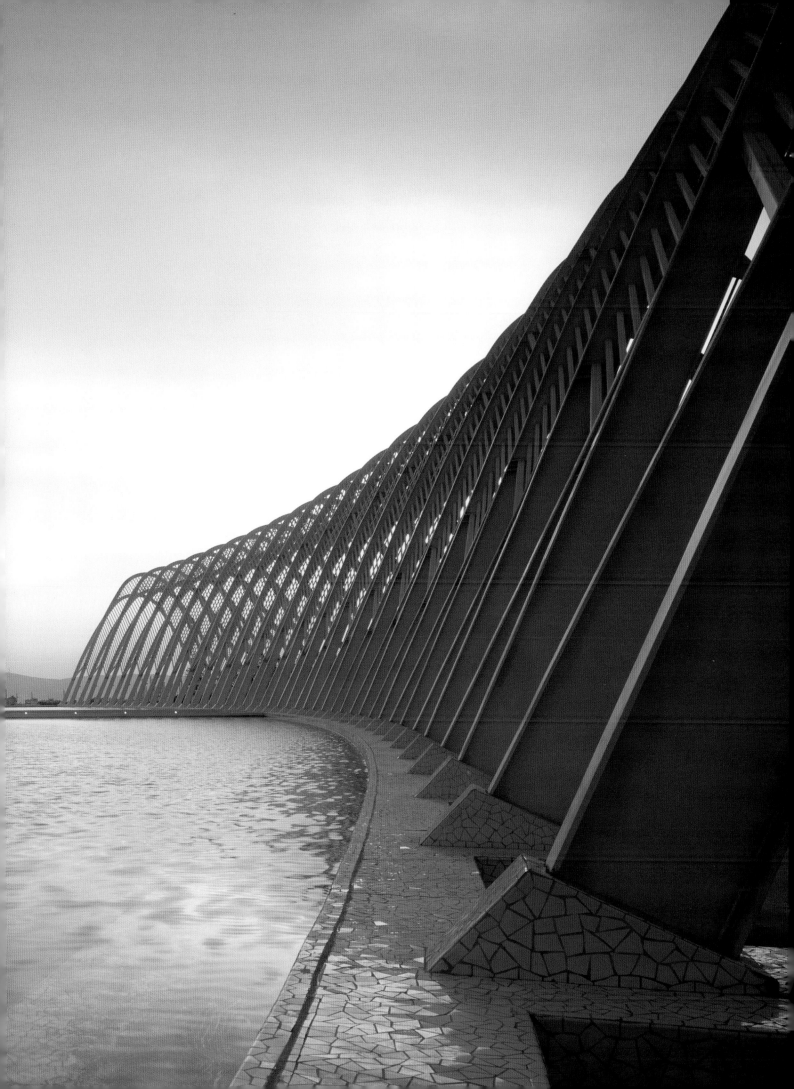

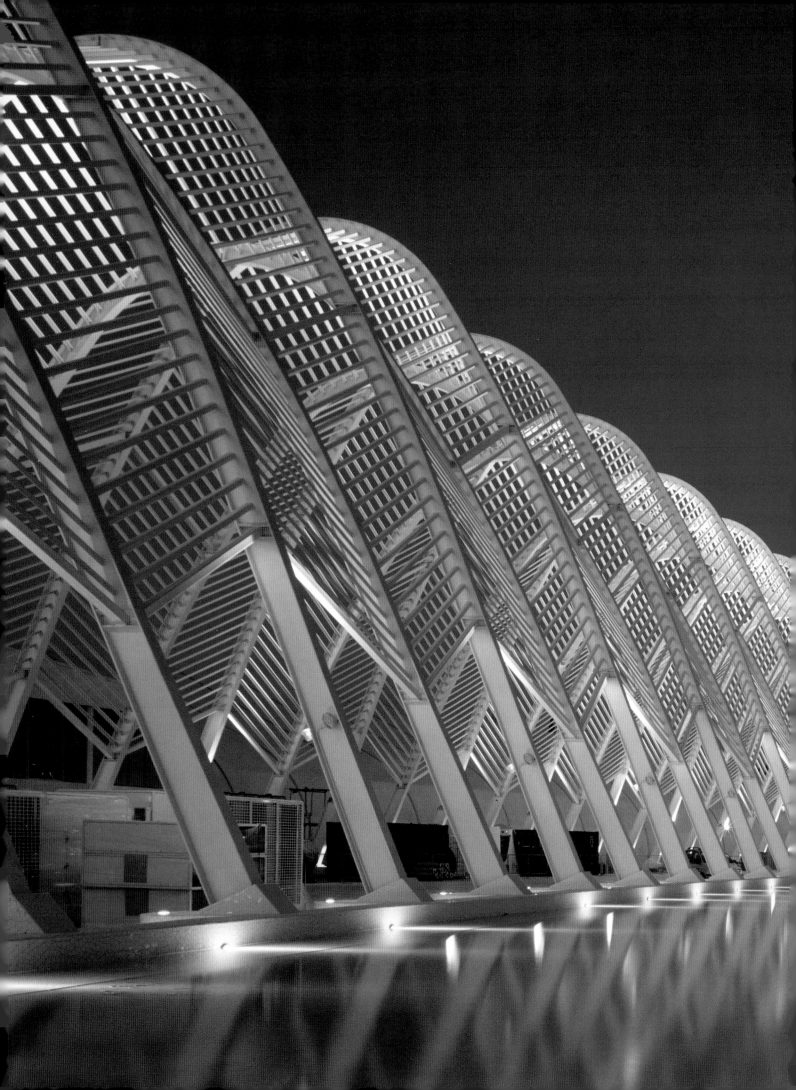

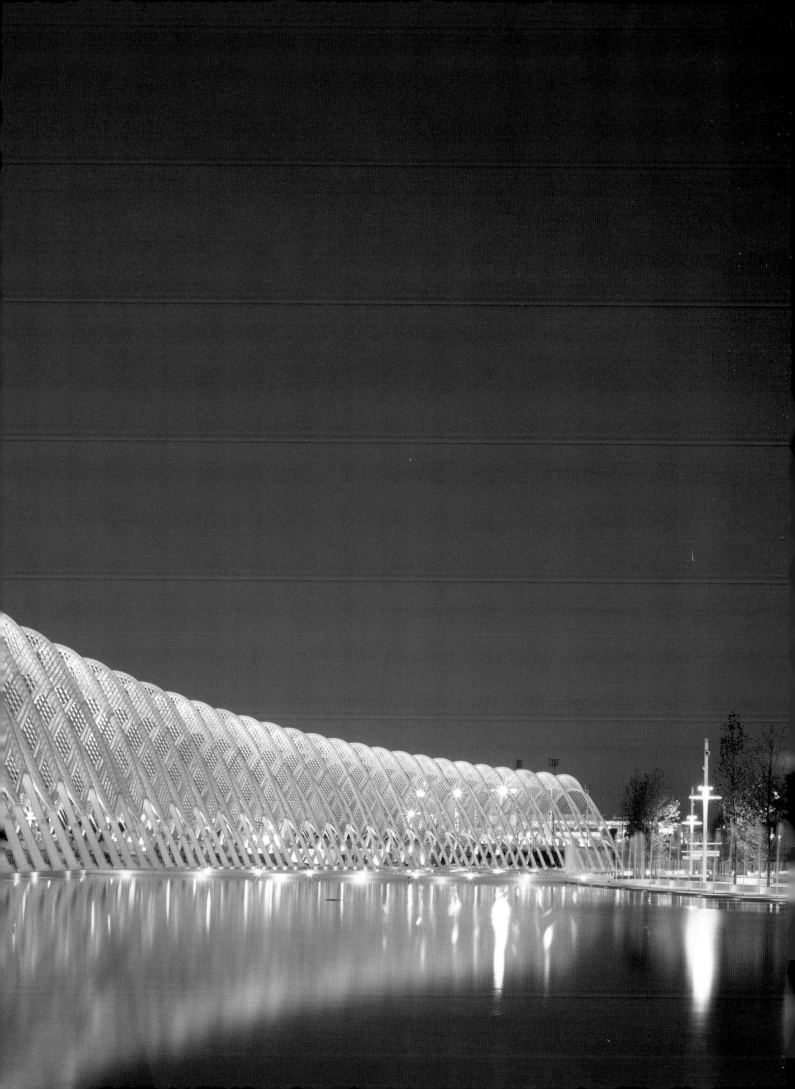

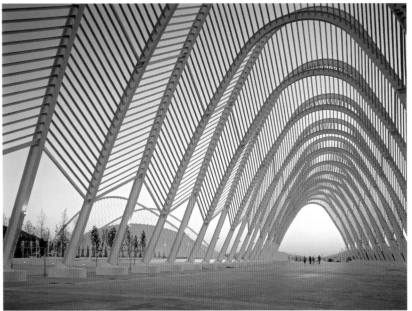

Designs like the architect's broken tile doves above blend with the airy lightness of the entrance sequence seen to the left.

Details wie die aus Fliesenscherben zusammengesetzten Tauben passen zur luftigen Schwerelosigkeit der Eingangssequenz links.

Des motifs comme les colombes en tesselles de faïence (en haut) s'allient à la légèreté aérienne des arches de l'entrée (à gauche).

Despite being located in the congested Greek capital, the Olympic facilities allow for bucolic views with olive trees such as the one below—a kind of reminiscence of the shining city that was ancient Athens.

Wenngleich die olympischen Anlagen in der dichtbevölkerten griechischen Kapitale liegen, gibt es bukolische Ansichten mit Olivenbäumen (unten) – eine Art Reminiszenz an das strahlende antike Athen.

Bien que situées dans la capitale grecque congestionnée, les installations olympiques peuvent offrir des vues bucoliques avec par exemple des oliviers, comme ci-dessous, façon de rappeler quelle brillante cité fut l'Athènes antique.

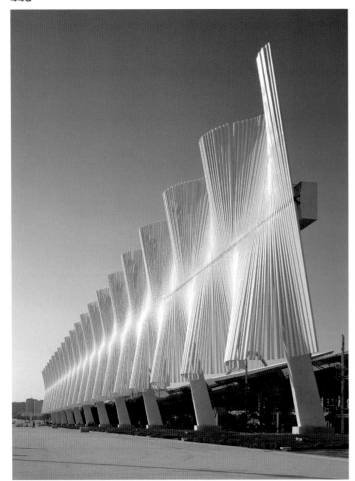

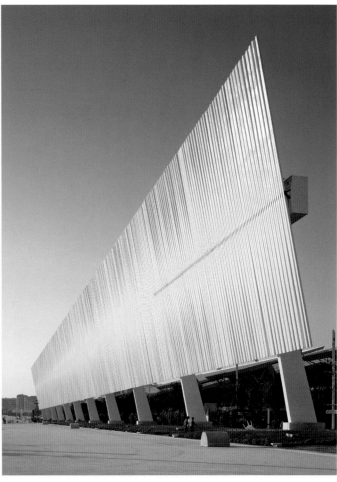

The 250-meter-long Nation's Wall takes up again with Calatrava's idea of moveable sculpture, producing an undulating wave pattern in white metal.

Mit ihrer fließenden Welle aus weißen Metallstäben greift die 250 m lange *Nation's Wall* Calatravas Idee einer beweglichen Skulptur auf.

Le Mur de la Nation de 250 mètres de long reprend l'idée de sculpture mobile de Calatrava et génère un motif de vague ondulante en métal blanc.

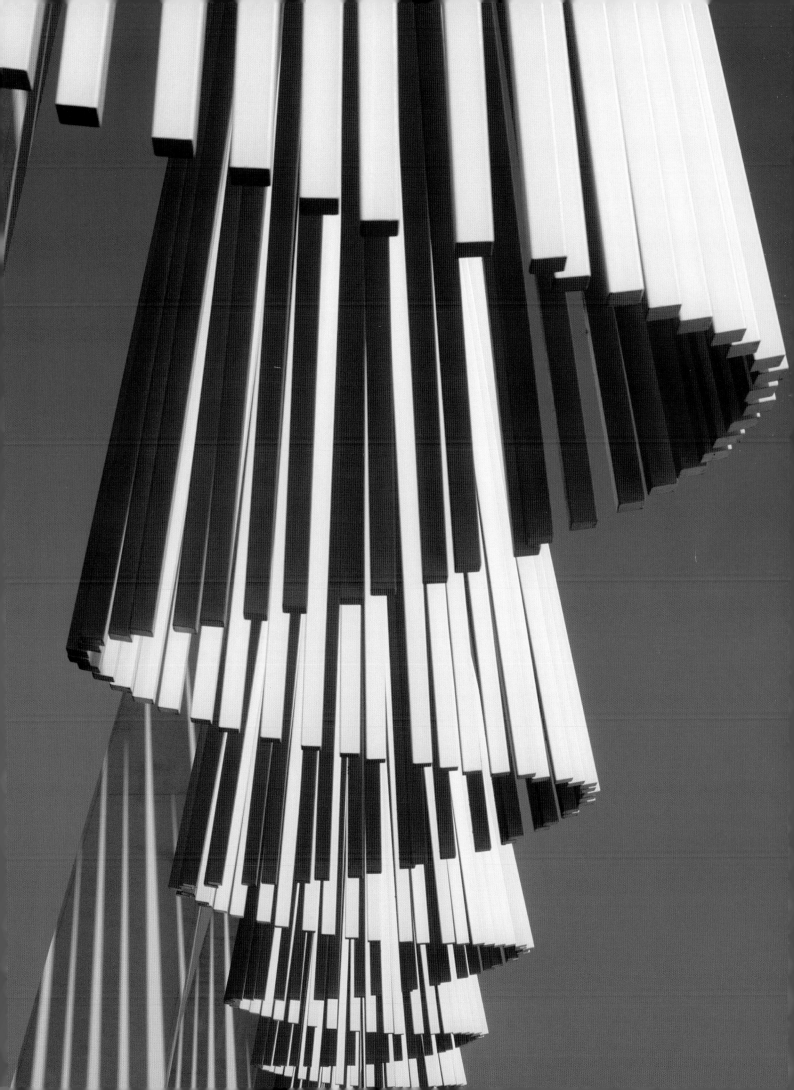

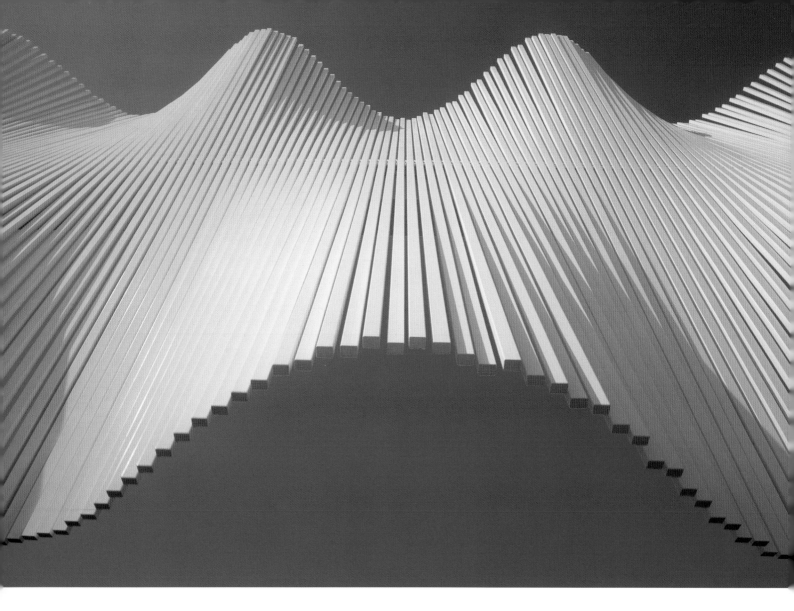

Three views of the Nation's Wall show its movement and a lightness that seems to defy gravity. As he did in Valencia, Calatrava shows a talent for composing architectural elements in a unified whole, leading to the Olympic Stadium.

Die drei Ansichten der *Nation's Wall* zeigen ihre Schwingung und ihre sich über die Schwerkraft anscheinend hinwegsetzende Leichtigkeit. Wie bereits in Valencia stellt Calatrava seine Begabung zur Komposition architektonischer Elemente zu einem organischen Ganzen unter Beweis mit dem Olympiastadion als Höhepunkt.

Ces trois vues du Mur de la Nation montrent à la fois son mouvement et une légèreté qui semble défier la pesanteur. Comme à Valence, Calatrava démontre ici son talent à réunir des éléments architecturaux divers en un tout harmonieux, aboutissant au Stade Olympique.

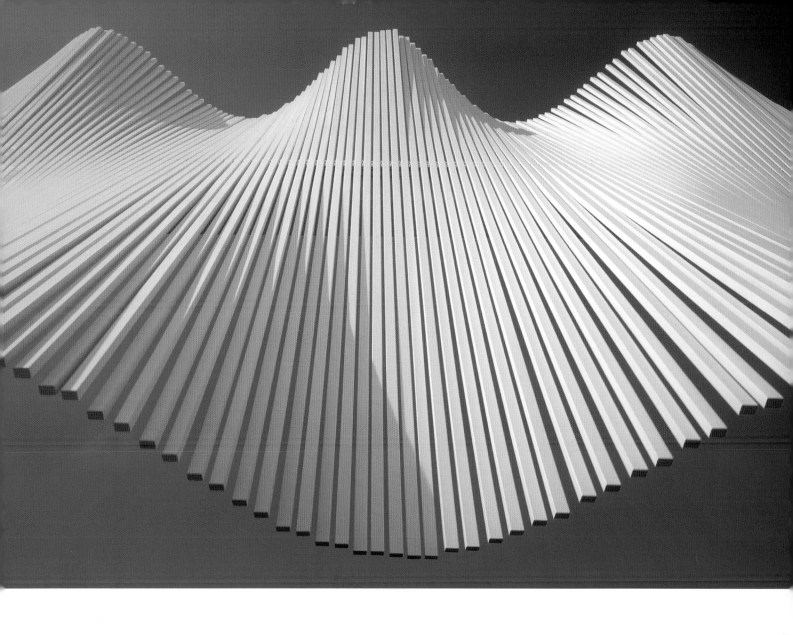

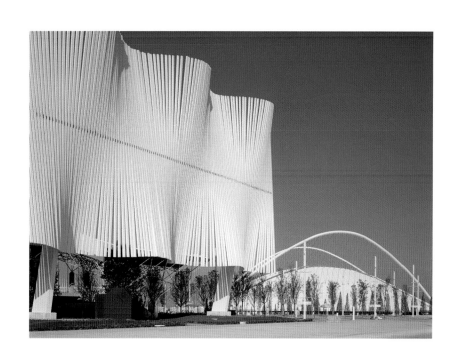

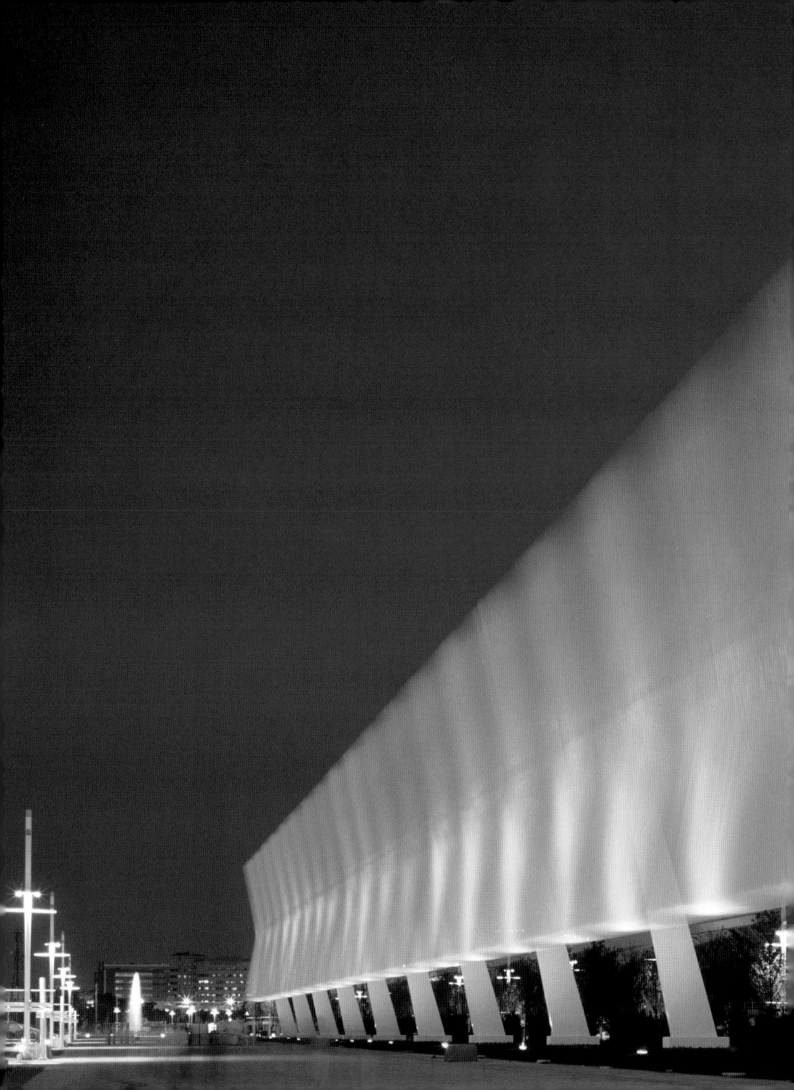

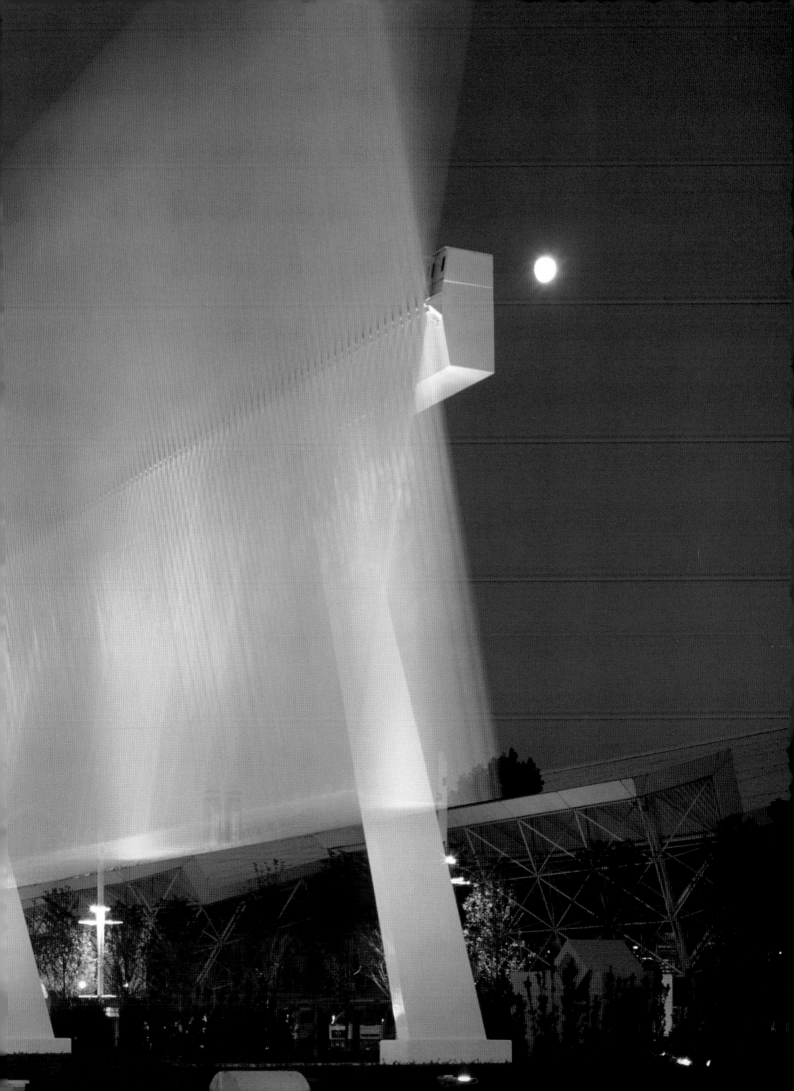

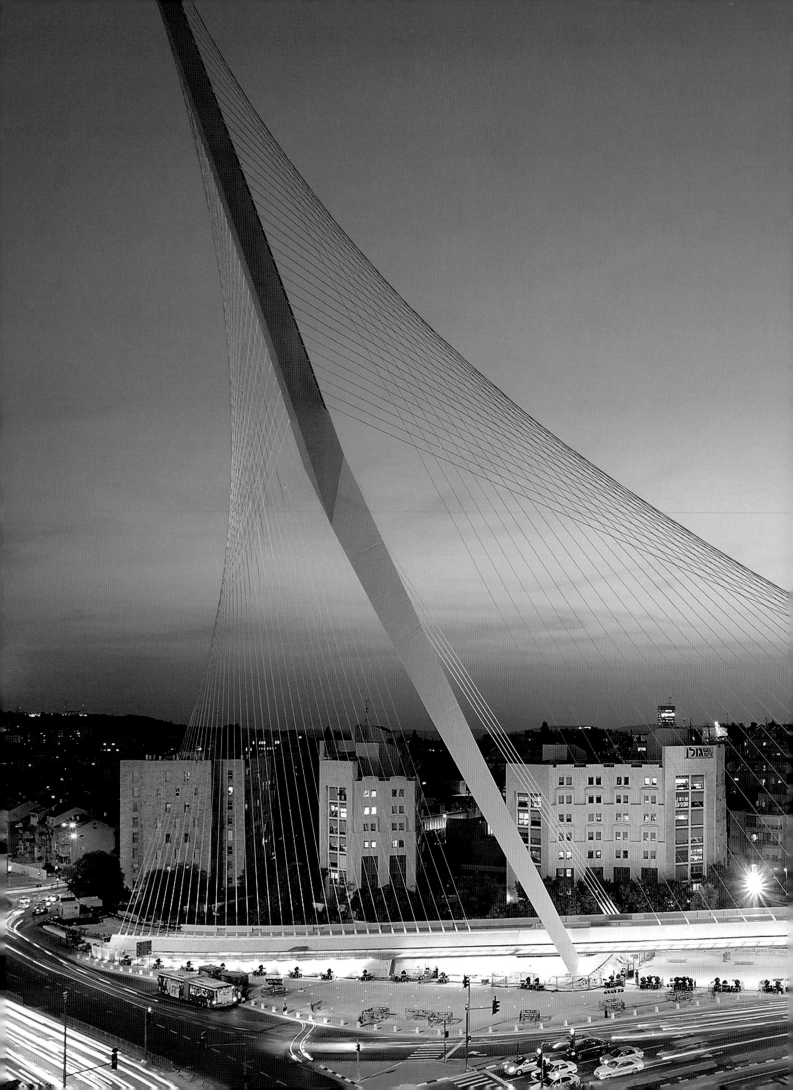

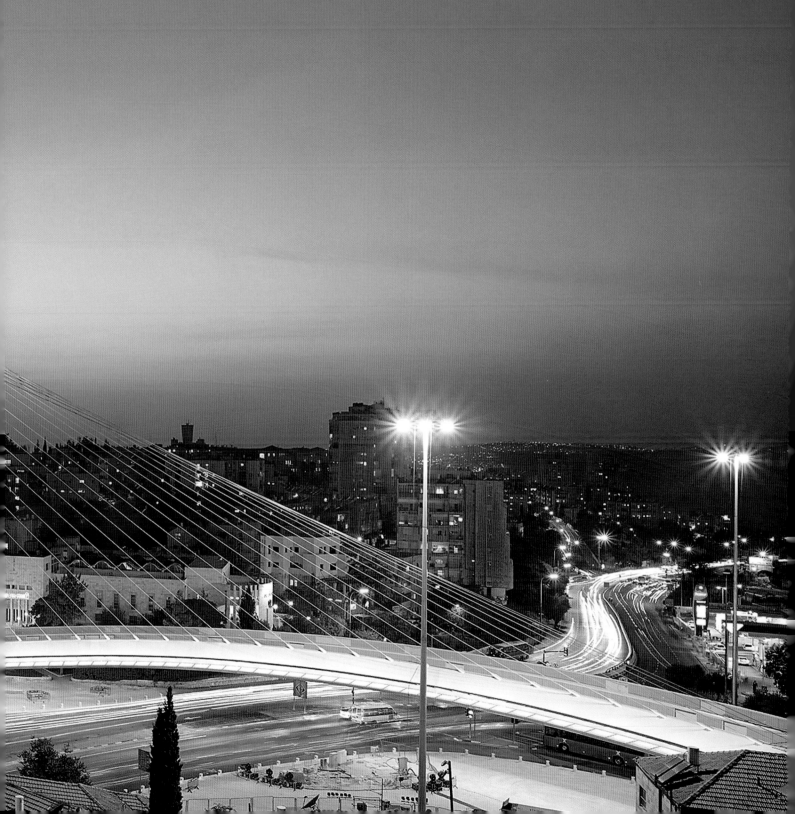

LIGHT RAIL TRAIN BRIDGE

Jerusalem, Israel. 2002–2008.

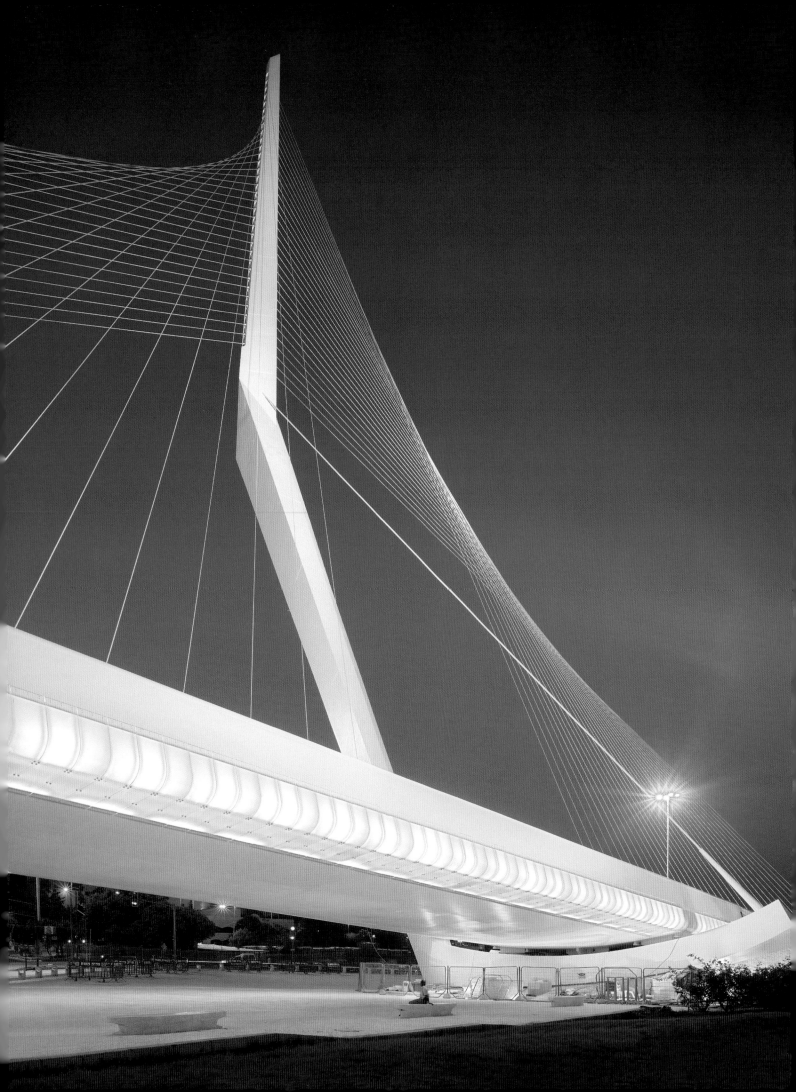

Project
LIGHT RAIL TRAIN BRIDGE

Location
JERUSALEM, ISRAEL

Client
MORIAH – THE JERUSALEM DEVELOPMENT CO.

The dramatic forms of the LRT Bridge in Jerusalem are visible in this photo taken at nightfall. The single pylon appears to hover above the bridge itself.

Die bei Einbruch der Nacht entstandene Aufnahme zeigt deutlich die dramatischen Formen der LRT-Brücke in Jerusalem. Der einsame Pylon scheint über der Brücke zu schweben.

Les formes spectaculaires du pont LRT à Jérusalem, photographiées à la tombée de la nuit. Le pylône unique semble en suspension au-dessus du pont.

This bridge is located near the Eastern Gate to the old City of Jerusalem, near the Central Bus Station. It is on the first line of the light rail mass transit system for Jerusalem that was planned beginning in 1999. It crosses a dense urban area and addresses traffic and pedestrian issues while creating a new landmark for this entrance to the city. Inaugurated on June 25, 2008, it is a cable-stayed bridge with a span of 160 meters and a 118-meter-high pylon. Santiago Calatrava explains, "The Jerusalem light rail train bridge project started with the idea that we had to create a very light and very transparent bridge, which would span a major new plaza at the entry to Jerusalem. These were the elements I got from the client. Ehud Olmert, who was the Mayor of Jerusalem at that time, challenged me in this way. He said, 'Jerusalem is one of the oldest cities in the world.' So I had to make one of the most beautiful bridges." The architect compares the final result with the form of a musical instrument such as a harp with its cables as strings, an apt metaphor in the City of David. S-shaped for reasons related to the technical requirements of the light rail system, this very light bridge carries with it a good deal of symbolic intention as Santiago Calatrava explains: "Bridges are instruments of peace. They join places that were separated. They permit people to meet. They even are meeting points. They are built for the sake of progress and for the average citizen. They even have a religious dimension. The word *religious* comes from the Latin, meaning 'creating a link.' This particular understanding has a very deep meaning, especially in Jerusalem, which contains in its name the words shalom, salaam, peace. A bridge makes a lot of sense in a city like Jerusalem."

Die Brücke liegt in der Nähe des Goldenen Tores an der Grenze zur Jerusalemer Altstadt, unweit des Zentralen Busbahnhofs. Sie befindet sich auf der Linie 1 der Stadtbahn, die seit 1999 in Planung ist. Der Bau überspannt eine dicht besiedelte Stadtgegend, ist auf die Bedürfnisse von Verkehr und Fußgängern zugeschnitten und zugleich ein Wahrzeichen am Eingang zur Stadt. Die am 25. Juni 2008 eingeweihte Schrägseilbrücke hat eine Spannweite von 160 m und einen 118 m hohen Pylon. Calatrava führt aus: „Das Projekt der Jerusalemer Stadtbahnbrücke begann mit der Idee, eine sehr leichte und sehr transparente Brücke zu schaffen, die einen bedeutenden neuen Platz am Tor in die Stadt überspannen sollte. Das waren die Vorgaben, die ich vom Auftraggeber erhielt. Ehud Olmert, damals Bürgermeister von Jerusalem, forderte mich heraus. Er sagte: „Jerusalem ist eine der ältesten Städte der Welt.' Und so musste ich eine der schönsten Brücken der Welt bauen."

Das Endergebnis vergleicht der Architekt mit einem Instrument, einer Harfe, bei der die Kabel den Saiten entsprechen – eine treffende Metapher in der Stadt Davids. Die ausgesprochen leichte Brücke, aufgrund technischer Anforderungen der Stadtbahn S-förmig angelegt, ist durchaus symbolisch befrachtet, wie Santiago Calatrava erklärt: „Brücken sind Friedensbringer. Sie verbinden Orte, die getrennt waren. Sie ermöglichen die Begegnung von Menschen. Sind sogar Orte der Begegnung. Sie werden im Namen des Fortschritts gebaut und für den einfachen Bürger. Sie haben sogar eine religiöse Dimension. Das Wort *Religion* kommt aus dem Lateinischen und bedeutet ‚verbinden'. Besonders dieser Aspekt hat eine tiefe Bedeutung, gerade in Jerusalem, einer Stadt, in deren Namen die Wörter *shalom*, *salaam*, Frieden enthalten sind. In einer Stadt wie Jerusalem macht eine Brücke besonders viel Sinn."

Ce pont se trouve près de la porte orientale de la Vieille Ville de Jérusalem, à proximité de la gare centrale des bus. Il est au départ du système de transport léger sur rail de ville qui a été planifié début 1999. Il franchit une zone urbaine très peuplée et répond aux besoins du réseau et des piétons, tout en créant un nouvel élément monumental pour cette entrée de la cité. Inauguré le 25 juin 2008, c'est un pont à haubans de 160 mètres de portée, dont le pylône s'élève à 118 mètres. Pour Santiago Calatrava : « Ce projet de pont est parti de l'idée que nous devions dessiner un pont très léger et très transparent qui allait franchir une grande place nouvelle à l'entrée de Jérusalem. Tels étaient les éléments de la demande du client. Ehud Olmert, qui était alors maire de la ville, me stimula en me disant que 'Jérusalem est une de plus anciennes villes du monde.' Je devais donc faire l'un des plus beaux ouvrages possible. » L'architecte compare le résultat final à la forme d'un instrument de musique comme une harpe dont les cordes seraient les haubans, métaphore adaptée pour la cité de David. En forme de S pour des raisons techniques liées au système de train choisi, ce pont très léger est chargé d'intentions symboliques qu'explique l'architecte : « Les ponts sont des instruments de paix. Ils réunissent des lieux qui étaient séparés. Ils permettent aux gens de se réunir. Ce sont même des points de rencontre. Ils sont construits pour des raisons qui tiennent au progrès et au développement, mais aussi pour tout le monde. Ils possèdent même une dimension religieuse. Le mot *religieux* vient du latin et signifie 'créer un lien'. Ce sens précis a des résonances particulièrement fortes, ici à Jérusalem, ville qui contient en son nom les mots de *shalom*, *salaam*, la paix. Un pont prend tout son sens dans une ville comme Jérusalem. »

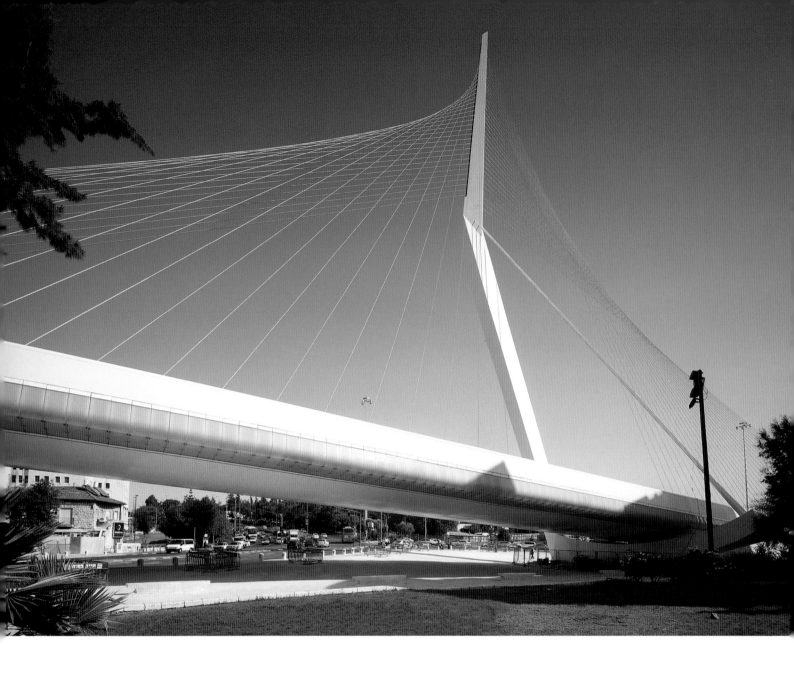

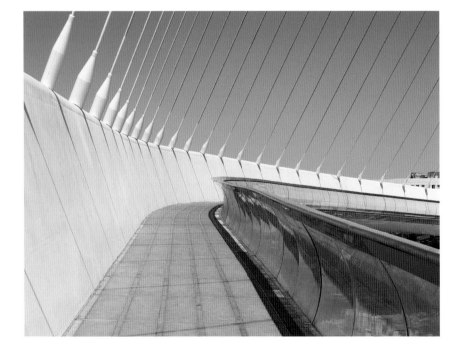

The bridge leaves room for pedestrians to pass beneath its span (above), while its curvature is visible in the image to the left. The leaning pylon (right) resembles a very large-scale sculpture in a state of suspended animation.

Unter dem gespannten Bogen der Brücke ist Platz für Fußgänger (oben), links im Bild wird ihre Krümmung deutlich. Der geneigte Pylon (rechts) wirkt wie eine monumentale Skulptur in atemloser Spannung.

Le pont permet aux piétons de passer sous son tablier (ci-dessus). Sa forte incurvation est visible à gauche. Page de droite : le pylône incliné évoque une énorme sculpture de balance en état de suspension.

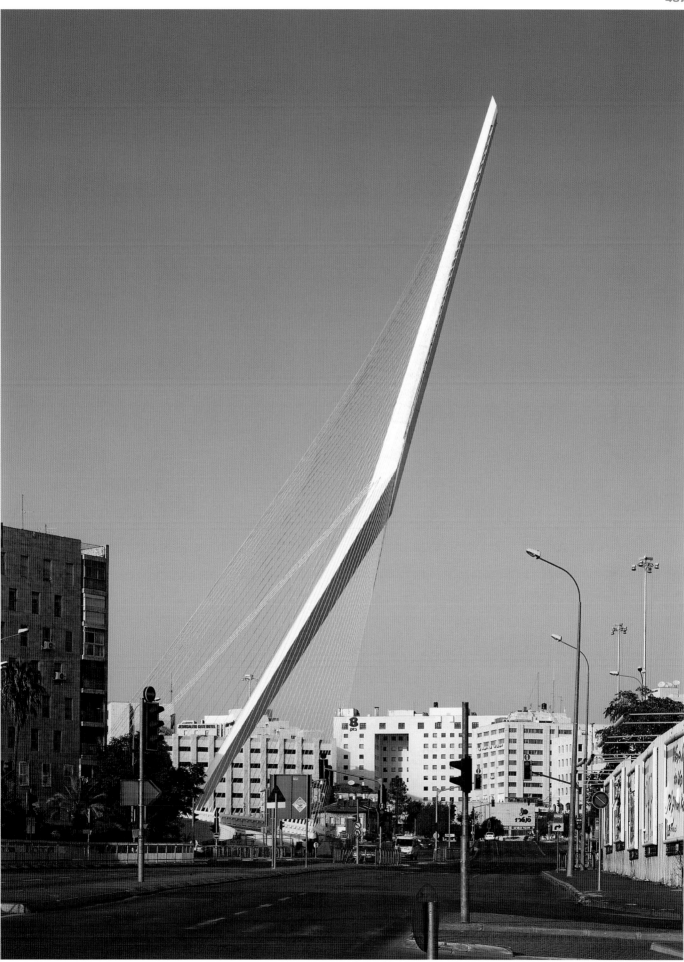

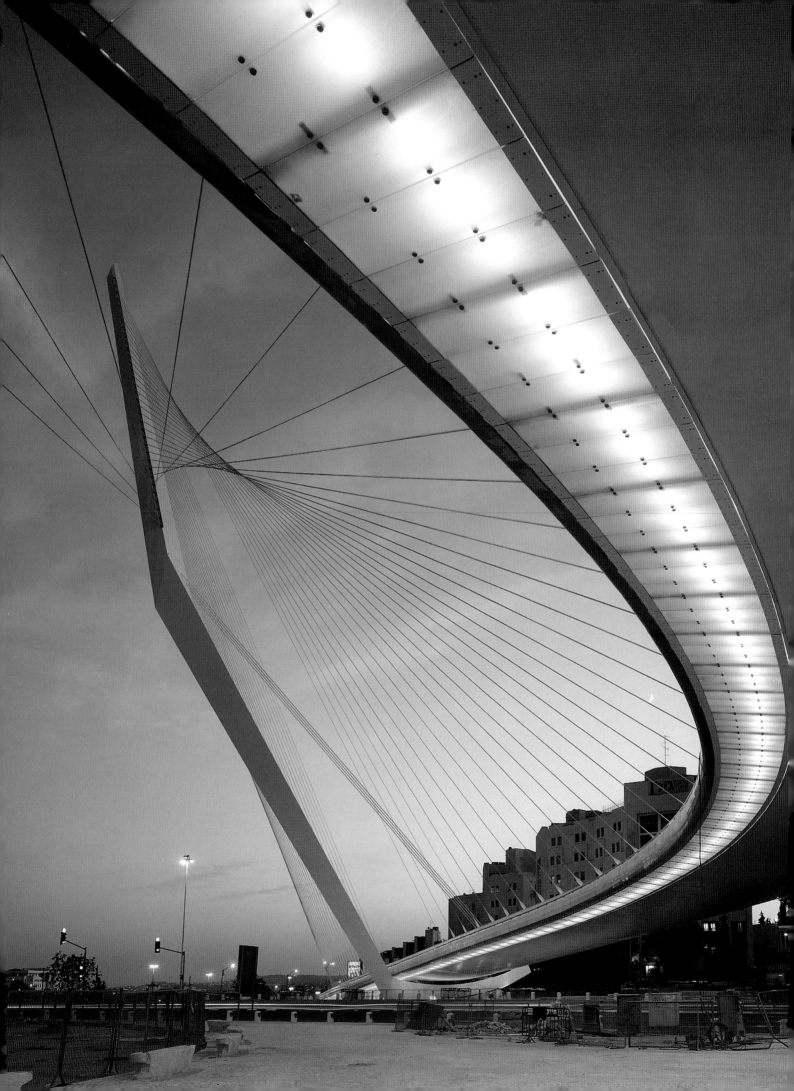

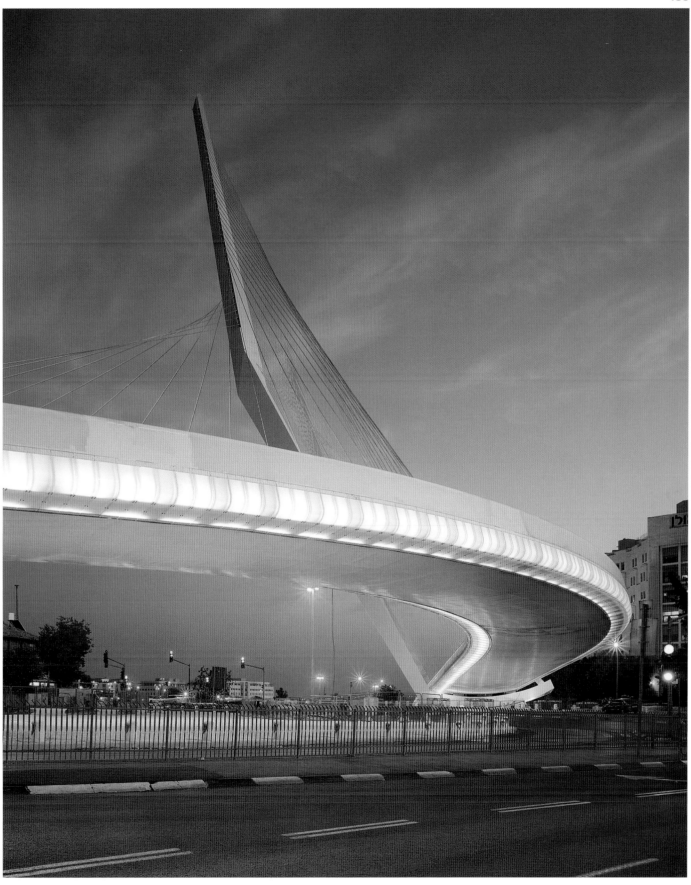

Santiago Calatrava has always been interested in the relation between movement and architecture. Though the bridge is ultimately a study in static forces, these pictures fully express its dynamic design.

Santiago Calatrava hat sich schon immer für die Beziehung von Bewegung und Architektur interessiert. Obwohl die Brücke in letzter Konsequenz eine Studie statischer Kräfte ist, vermitteln diese Bilder dennoch ihr dynamisches Design.

Santiago Calatrava s'est toujours intéressé à la relation entre le mouvement et l'architecture. Si le pont est à la base l'aboutissement d'une recherche sur les forces statiques, ces images expriment pleinement sa dynamique.

REGGIO EMILIA BRIDGES

Reggio Emilia, Italy. 2002–2007.

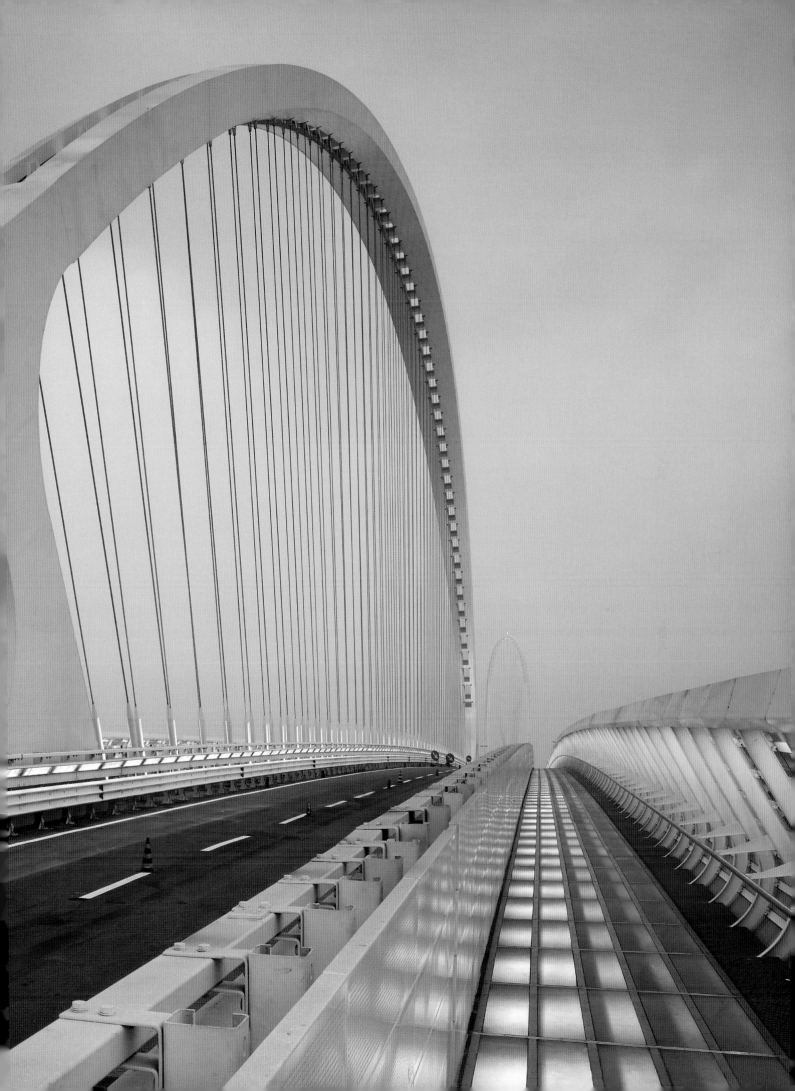

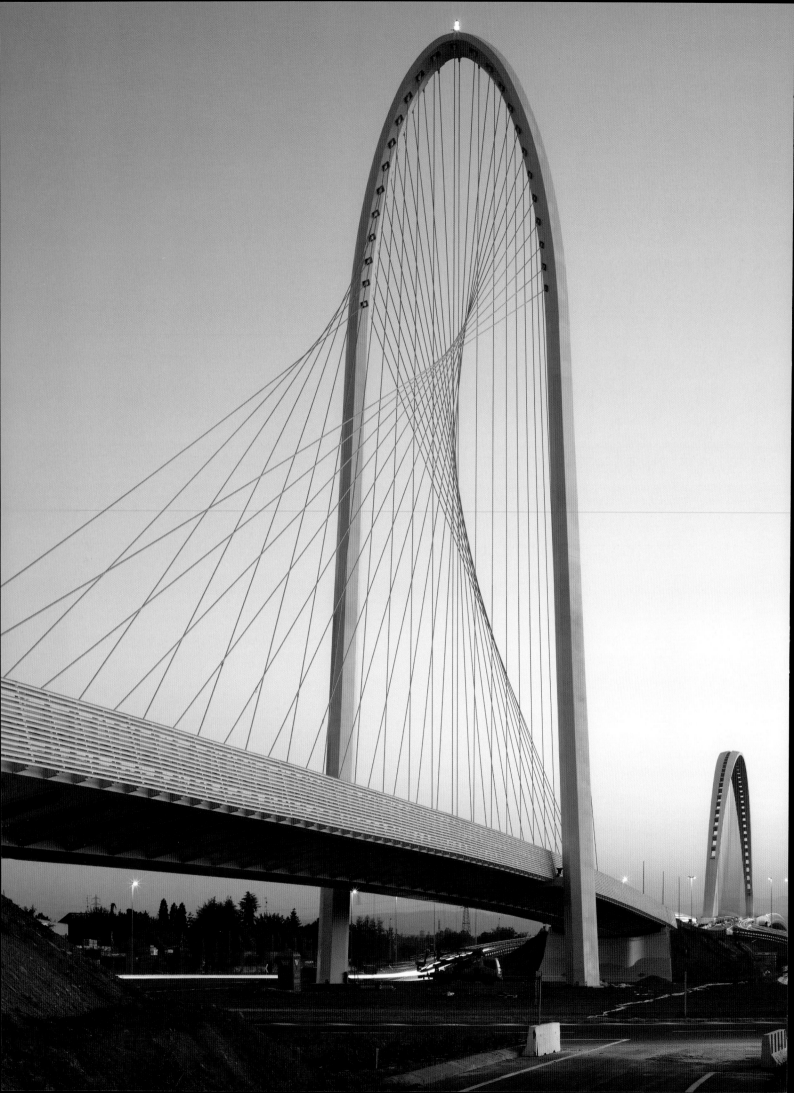

Project
REGGIO EMILIA BRIDGES

Location
REGGIO EMILIA, ITALY

Client
COMMUNE DE REGGIO NELL'EMILIA (CITY OF REGGIO EMILIA)

With their rotated arching supports, the bridges stand out against the flat landscape and impose their presence like great light gateways.

Mit ihren verdrehten, bogenförmigen Stützen zeichnen sich die Brücken vor dem Hintergrund der flachen Landschaft ab und behaupten ihre Präsenz als monumentale und doch zugleich fragile Tore.

Par leurs arcs spectaculaires en rotation, les ponts se détachent du paysage de la plaine et imposent leur présence à la manière d'immenses portes aériennes.

This project concerns the design of a group of three bridges over the high-speed railway and A1 motorway (Autostrada del Sole) in Reggio nell'Emilia, the capital of the northern province of Reggio Emilia. The city was chosen as the site of a new station on the line linking Milan and Naples (Treno ad Alta Velocità or TAV). Santiago Calatrava was asked to design the new railway station (Stazione Mediopadana), as well as a comprehensive plan including bridges, a highway toll station, and other infrastructure intended to facilitate automobile, bicycle and pedestrian access to the city, and to create a "dramatic new gateway to Reggio Emilia from the north." Santiago Calatrava felt that Reggio nell'Emilia, located in the flat plain called the Padana, needed vertical landmarks, and he decided to design three bridges made of white-painted steel and reinforced concrete, the first phase of the larger project, as part of an ensemble meant to be viewed as a whole. The central four-lane bridge, with a single symmetrical, longitudinally placed arch, crosses over both the motorway and the high-speed rail line. Forty-six meters high, it spans a total of 221 meters and is 25.6 meters wide. Twin lateral bridges set at right angles to the flow of traffic are placed to the south and north of the central structure. They are 68.8 meters high, and thus visible from a great distance. Cable-stayed and 179 meters long, they are 13.6 meters wide. A steel and glass toll station is set near the northernmost bridge. The three bridges were inaugurated on October 20, 2007, by the Prime Minister of Italy. The architect stated, "I try to create bridges with a straightforward appearance that clearly belongs to the present. They use modern materials—concrete and steel—and are built with modern construction techniques. A modern bridge can also be a work of art, helping to shape not only the landscape but also the daily lives of the people who use it."

Bei diesem Projekt ging es um den Entwurf von drei Brücken über die Bahntrasse und die Autobahn A1 (Autostrada del Sole) in Reggio nell'Emilia, der Hauptstadt der norditalienischen Provinz Reggio Emilia. Die Stadt hatte den Zuschlag als Haltebahnhof auf der Hochgeschwindigkeitsstrecke (Treno ad Alta Velocità oder TAV) zwischen Mailand und Neapel erhalten. Santiago Calatrava wurde beauftragt, den neuen Bahnhof (Stazione Mediopadana) zu gestalten, ebenso wie ein größeres Planungsprojekt, zu dem Brücken, eine Autobahnmautstelle und weitere Infrastruktur zählten, die den Zugang für Autoverkehr, Fahrräder und Fußgänger in die Stadt erleichtern sollten. Entstehen sollte ein „dramatisches neues Tor in die Reggio Emilia von Norden her". Calatrava war der Meinung, dass die in der Ebene Padana gelegene Stadt vertikale Wahrzeichen brauchte und entschied sich, drei Brücken aus weiß gestrichenem Stahl und Stahlbeton zu entwerfen. Sie waren als erste Phase des Großprojekts und als Ensemble konzipiert, das als Einheit wahrgenommen werden sollte. Die zentrale, vierspurige Brücke besteht aus einem einzel-

nen, symmetrischen, längs verlaufenden Bogen, der sowohl die Autobahn als auch die Bahntrasse überspannt. Die 46 m hohe Konstruktion hat eine Spannweite von insgesamt 221 m und ist 25,6 m breit. Die zwei seitlichen, quer zum Verkehrsfluss orientierten Brücken wurden am Nord- und Südende des zentralen Baus platziert. Sie sind 68,8 m hoch und selbst aus großer Entfernung sichtbar. Die Schrägseilbrücken sind 179 m lang und 13,6 m breit; an der nördlichsten Brücke liegt eine Mautstelle aus Glas und Stahl. Am 20. Oktober 2007 konnten die Bauten vom italienischen Ministerpräsidenten eingeweiht werden. Der Architekt erklärt: „Ich versuche Brücken mit einem klaren Erscheinungsbild zu gestalten, das eindeutig zeitgenössisch ist. Sie nutzen moderne Materialien – Beton und Stahl – und werden mithilfe moderner Konstruktionstechniken errichtet. Eine moderne Brücke kann zugleich ein Kunstwerk sein und dazu beitragen, nicht nur die Landschaft zu gestalten, sondern auch den Alltag der Menschen zu prägen, die sie nutzen."

Ce projet se compose d'un ensemble de trois ponts franchissant les voies du train à grande vitesse (Treno ad Alta Velocità) et l'autoroute A1 (Autostrada del Sole) à Reggio nell'Emilia, capitale de la province septentrionale de l'Émilie-Romagne, choisie pour l'implantation d'une nouvelle gare de TAV sur la ligne Milan-Naples. Santiago Calatrava a été chargé de concevoir la nouvelle gare (Stazione Mediopadana) et un programme d'ensemble comprenant des ponts, un péage d'autoroute et diverses infrastructures pour faciliter l'accès des voitures, vélos et piétons à la ville et créer une « spectaculaire nouvelle entrée Nord pour Reggio nell'Emilia ». Pour l'architecte, la ville, implantée dans une vaste plaine appelée Padana, avait besoin de signes monumentaux verticaux. Il a décidé de faire de ses trois ponts en acier laqué blanc et béton armé, première phase du projet, les composants d'un ensemble destiné à être perçu comme un tout. Le pont central à quatre voies et arc unique longitudinal symétrique, franchit à la fois l'autoroute et la voie ferrée. De 46 mètres de haut, il présente une portée totale de 221 mètres pour 25,6 mètres de largeur. Deux ponts latéraux jumeaux, perpendiculaires au flux du trafic, sont positionnés au sud et au nord de cette structure centrale. De 68,8 mètres de haut, ils sont ainsi visibles de très loin. Haubanés et longs de 179 mètres, ils sont larges de 13,6 mètres. La gare de péage en verre et acier se trouve près du pont le plus au nord. Les trois ouvrages ont été inaugurés le 20 octobre 2007 par le Premier ministre italien. L'architecte a déclaré : « J'ai essayé de créer trois ponts d'aspect simple qui appartiennent clairement à notre époque. Ils font appel à des matériaux modernes – béton et acier – et sont construits selon des techniques modernes. Un pont moderne peut aussi être une œuvre d'art et contribuer à donner une forme non seulement au paysage, mais aussi à la vie quotidienne de ceux qui l'utilisent. »

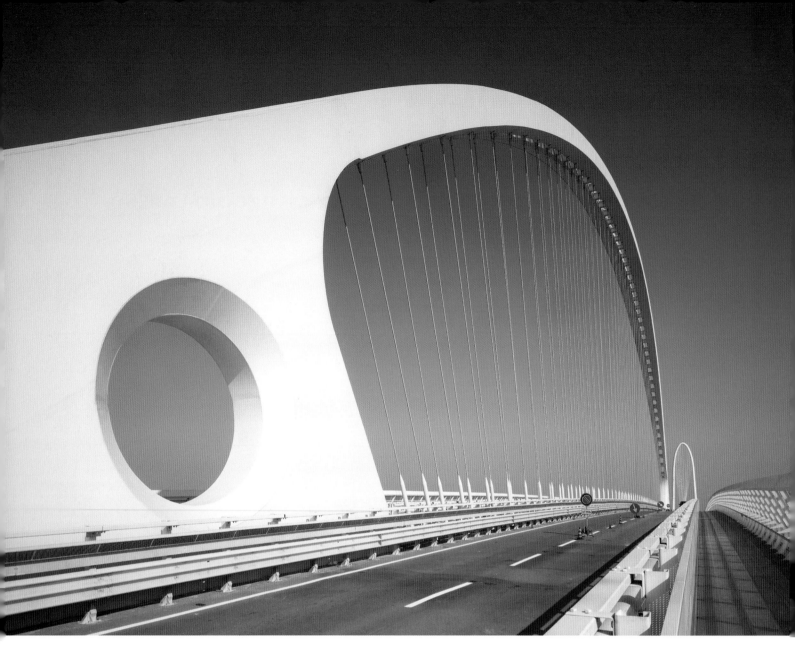

With arches and round openings, the architect-engineer demonstrates that bridges need not look alike, here adding drama to an otherwise flat landscape (below).

Mit Bögen und runden Öffnungen beweist der Architekt/Ingenieur, dass Brücken nicht immer gleich aussehen müssen. Hier verleihen sie der ansonsten flachen Landschaft Dramatik (unten).

Par ces arcs et ces ouvertures circulaires, l'architecte-ingénieur montre que les ponts peuvent faire preuve d'originalité et enrichir un paysage particulièrement plat d'un élément spectaculaire (ci-dessous).

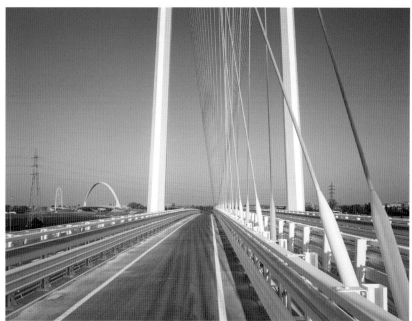

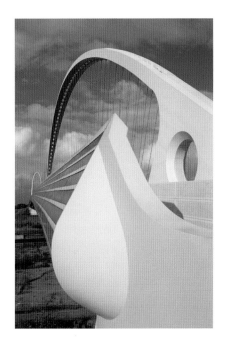

Although he has been designing and building bridges throughout his career, it would seem that Santiago Calatrava has reached a level of mastery in this area that permits him to create even more surprising and vibrant forms.

Obwohl Santiago Calatrava bereits seit Beginn seiner Laufbahn Brücken entwirft und baut, hat er inzwischen eine solche Meisterschaft auf diesem Gebiet erlangt, dass es ihm gelingt, immer überraschendere und dynamischere Formen zu gestalten.

Santiago Calatrava, qui a conçu et construit des ponts tout au long de sa carrière, montre ici qu'il a atteint un niveau de maîtrise lui permettant de créer des formes toujours plus étonnantes et vibrantes.

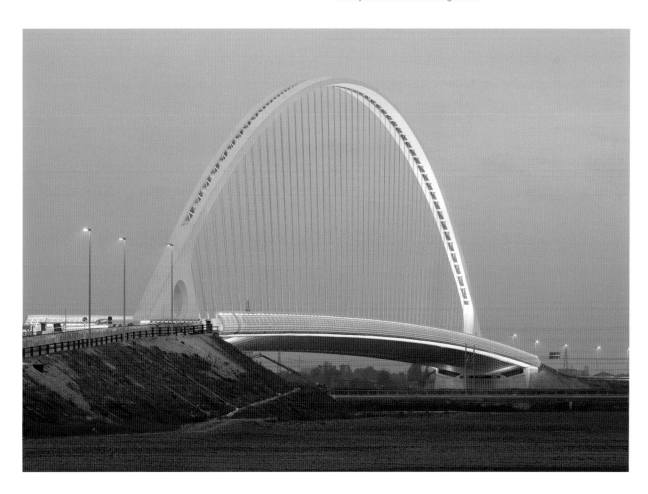

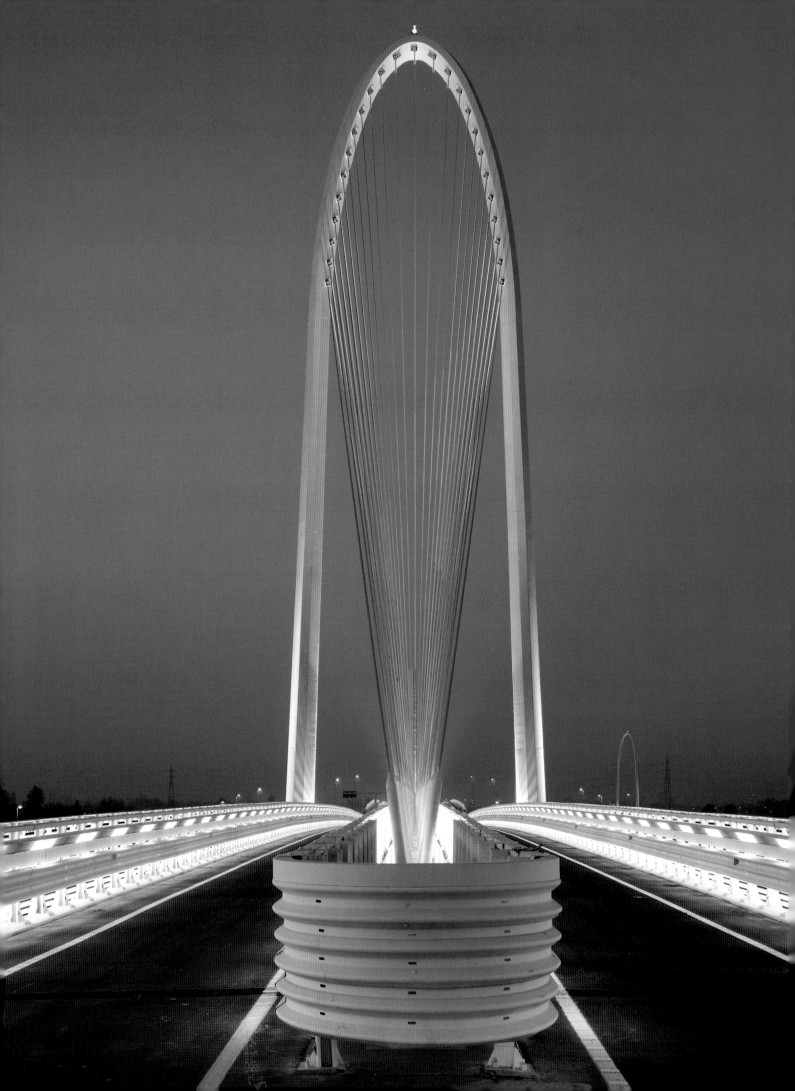

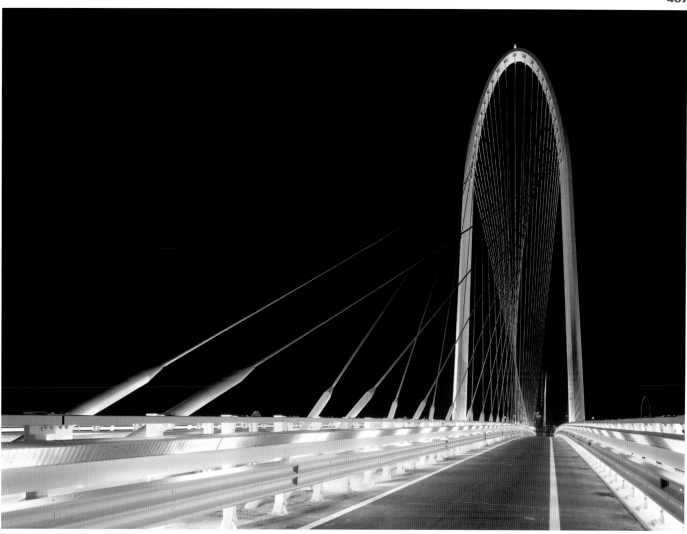

Viewed from certain angles, the arching supports take on a sculptural presence that goes far beyond the staid image that most people have of the bridge, and yet Calatrava uses a minimum amount of materials to express the forces at play.

Aus bestimmten Blickwinkeln gewinnen die Stützen eine skulpturale Präsenz, die weit von der biederen Vorstellung entfernt ist, die viele von Brücken haben. Dennoch arbeitet Calatrava nur mit einem Minimum an Material, um das hier vorhandene Kräftespiel zu illustrieren.

Vus sous certains angles, les supports prennent une présence sculpturale qui va bien au-delà de l'image figée que l'on peut avoir d'un pont, et pourtant, Calatrava utilise le minimum de matériaux pour exprimer les forces en jeu.

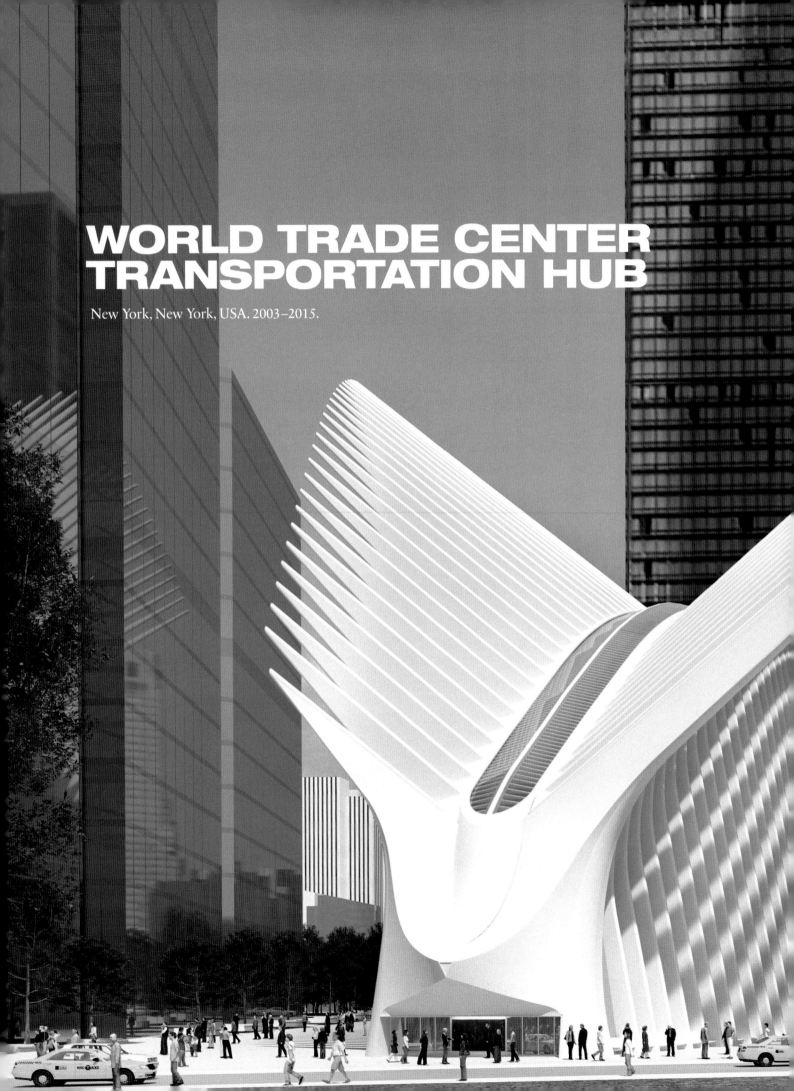

WORLD TRADE CENTER TRANSPORTATION HUB

New York, New York, USA. 2003–2015.

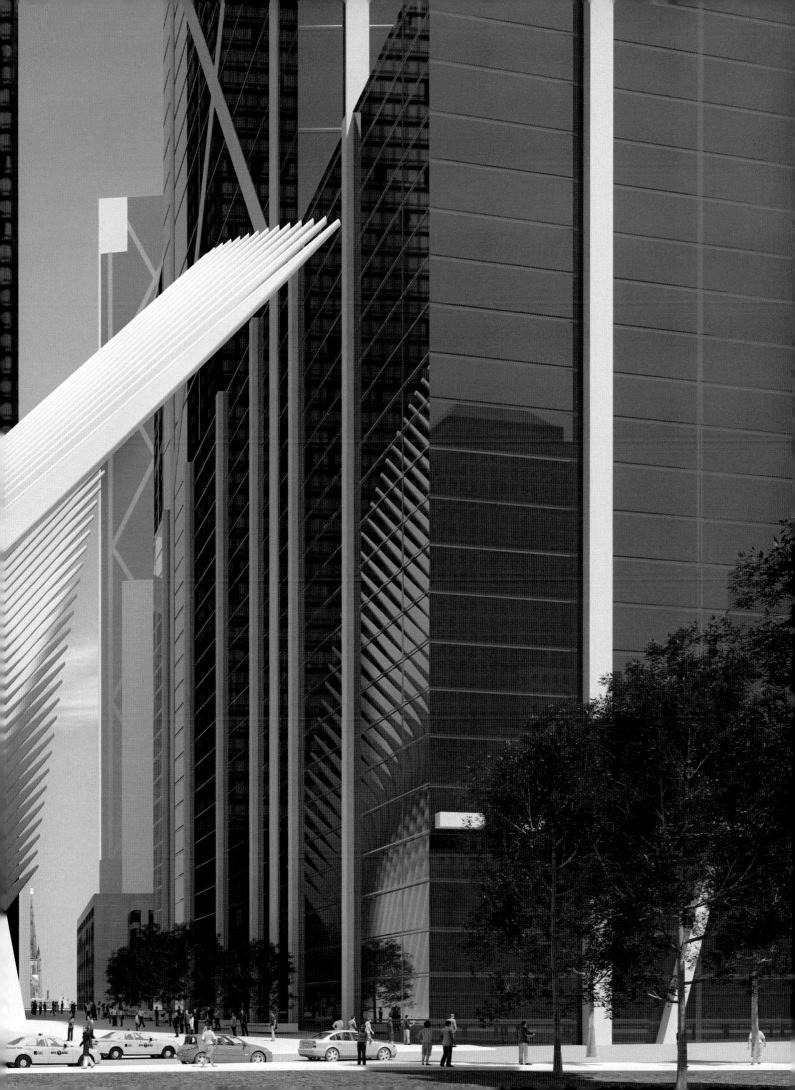

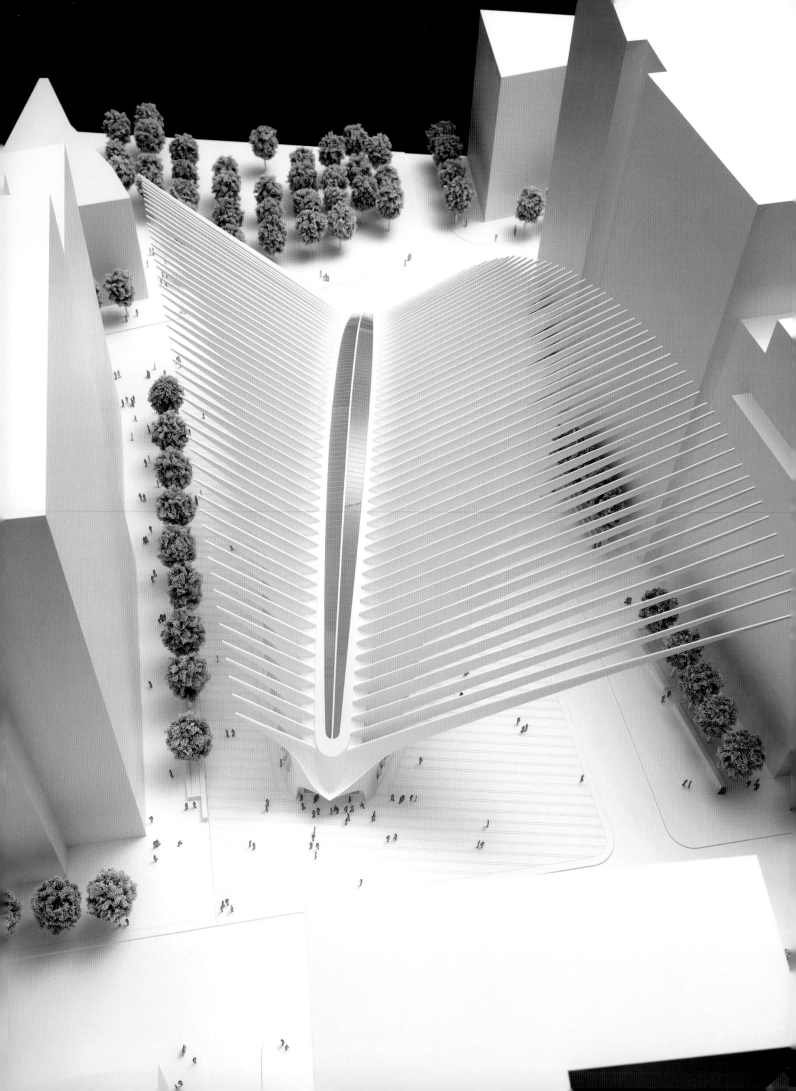

Project
WORLD TRADE CENTER TRANSPORTATION HUB
Location
NEW YORK, NEW YORK, USA
Client
PORT AUTHORITY OF NEW YORK AND NEW JERSEY

Models of the emerging part of the WTC Terminal may bring to mind the Lyon-Saint Exupéry Airport Railway Station, but in this instance scale and location differentiate the projects and it is clear that the architect has matured considerably since the work in Lyon.

Modelle des oberirdischen Teils des WTC Terminals mögen an den Bahnhof Saint Exupéry in Lyon erinnern, aber im Hinblick auf Maßstäblichkeit und Standort unterscheiden sich die Projekte und es fällt auf, wie sehr der Architekt seit der Arbeit in Lyon gereift ist.

Les maquettes des parties apparentes de WTC Terminal peuvent sembler rappeler la gare de Lyon-Saint Exupéry, mais l'échelle et la situation différencient les deux projets et il est clair que l'architecte a considérablement mûri depuis l'intervention lyonnaise.

As might be expected given the circumstances, the plans to rebuild the area around the former World Trade Center in New York have been wracked by disagreements and changes of course. One of the few projects that appears to be advancing as originally planned is that of Santiago Calatrava for a new, permanent transportation hub, designed to serve riders of the Port Authority Trans-Hudson (PATH) commuter trains, New York city subway trains (1/9, E and N/R lines) and a potential rail link to John F. Kennedy International Airport. Set directly to the east of the footprint of the Twin Towers, the work is going forward in collaboration with DMJM + Harris as well as the STV Group. As is almost always the case in Calatrava's work, the Transportation Hub will have a spectacular element—a freestanding structure made of glass and steel bringing forth the image of "a bird released from a child's hands" at the southern edge of Daniel Libeskind's *Wedge of Light* plaza. An arched oval of glass and steel, about 107 meters long, 35 meters across at its widest point, and 29 meters high at its apex. As the architect explains, "The steel ribs that support this structure extend upward into a pair of canopies, which resemble outspread wings and rise to a maximum height of 51 meters." The main concourse of the hub is located about 10 meters below street level, and the PATH train platforms eight meters lower. In good weather and each September 11, the roof can be opened to the sky. Both the birdlike form and the possibility to open the roof are typical gestures of Calatrava, and yet, in this instance, both take on a particularly poignant and appropriate meaning. Calatrava's ability to deal with the substantial local, state, city, and business bureaucracies involved in each step of the design is a testimony to his emergence as one of the major international architects of the 21st century.

Wie angesichts der Umstände zu erwarten, haben sich die Pläne zur Wiederbebauung des Areals des ehemaligen World Trade Centers in New York aufgrund von Meinungsverschiedenheiten und geänderten Prioritäten zerschlagen. Eines der wenigen Projekte, mit dem es wie geplant vorangeht, ist der von Santiago Calatrava konzipierte neue Verkehrsknotenpunkt, der von den Pendlerzügen der Port Authority Trans-Hudson (PATH), bestimmten Zügen der New Yorker Untergrundbahn (1/9, E und N/R Linien) sowie einer geplanten Bahnverbindung zum John F. Kennedy Airport angefahren werden soll. Das unmittelbar östlich der Fundamente der beiden zerstörten Türme des World Trade Centers geplante Bauwerk entsteht in Zusammenarbeit mit DMJM + Harris sowie der STV Group. Wie fast alle Projekte Calatravas wird auch dieses die Blicke auf sich ziehen: ein frei stehender Baukörper aus Glas und Stahl, der wirkt wie „ein Vogel, den ein Kind aus seiner Hand freigibt", am Südrand von Daniel Libeskinds Wedge of Light Plaza. Der Bau hat die Gestalt

eines überwölbten Ovals aus Glas und Stahl, das 107 m lang, an seiner weitesten Stelle 35 m breit und an seiner Spitze 29 m hoch ist. Den Worten des Architekten zufolge „verlängern sich die stählernen Rippen, die das Gebäude tragen, nach oben zu zwei Kragdächern, die ausgebreiteten Schwingen ähneln und sich bis zu einer Höhe von 51 m erheben". Der Hauptgleiskörper des Zentrums liegt etwa 10 m unterhalb des Straßenniveaus und die Bahnsteige der PATH noch weitere 8 m tiefer. Bei gutem Wetter und an jedem 11. September kann das Dach geöffnet werden. Sowohl die vogelgleiche Form als auch die Möglichkeit, das Dach zu öffnen, sind typische gestalterische Einfälle Calatravas, die jedoch in diesem Fall eine ganz besondere Bedeutung annehmen. Die Fähigkeit Calatravas, mit den an jedem Schritt des Entwurfs beteiligten örtlichen, staatlichen, städtischen und geschäftlichen Bürokratien umzugehen, zeugt von seinem Aufstieg zu einem der bedeutendsten, international tätigen Architekten des 21. Jahrhunderts.

Comme on pouvait s'y attendre dans un contexte délicat, la reconstruction des abords immédiats de l'ancien World Trade Center à New York a été paralysée par des désaccords et des réorientations. L'un des rares projets qui semblent avancer comme prévu est celui de Santiago Calatrava pour une nouvelle gare de transit pour les trains de banlieue du PATH (Port Authority Trans-Hudson), le métro de New York (lignes 1/9, E et N/R) et une future liaison avec l'aéroport international John F. Kennedy. Jouxtant, à l'est, le terrain des tours disparues, le chantier se poursuit en collaboration avec DMJM + Harris et le Groupe STV. Comme presque toujours dans les réalisations de Calatrava, cette gare présentera un élément spectaculaire : une structure autoporteuse en verre et acier (un ovale de 107 mètres de long environ, 35 de large et 29 de haut) qui exprime l'image « d'un oiseau s'échappant des mains d'un enfant » en bordure sud de la place du *Wedge of Light* de Daniel Libeskind. Comme l'explique l'architecte : « Les nervures d'acier qui soutiennent la structure se déploient vers le haut pour former une paire d'auvents qui ressemblent à des ailes et s'élèvent à une hauteur maximale de 51 mètres ». Le hall principal de la gare se trouve à dix mètres sous terre et les trains PATH huit mètres plus bas encore. Quand la météo le permet et chaque 11 septembre, le toit peut s'ouvrir complètement. La silhouette d'oiseau et ce principe d'ouverture sont des gestes typiques de Calatrava, et cependant, ils prennent ici une signification particulièrement poignante. Le talent de l'architecte pour prendre en compte le contexte local et s'adapter aux méandres bureaucratiques de la municipalité, de l'État et des promoteurs impliqués dans chaque étape du projet confirme son accession au rang d'architecte international majeur du XXIe siècle.

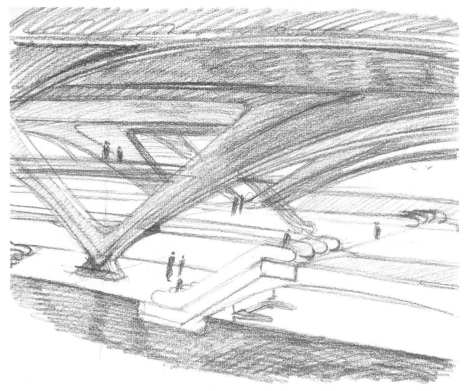

The architect made a large sketchbook full of his own impressions of the forms of the future building. The sketch below emphasizes the lightness and soaring forms of the terminal.

Der Architekt fertigte ein umfangreiches Skizzenbuch mit seinen Eindrücken von den Formen des künftigen Gebäudes an. Die Skizze unten unterstreicht Schwerelosigkeit und aufragende Formen des Terminals.

L'architecte a rempli un grand cahier de croquis avec ses impressions personnelles sur les formes possibles du nouveau projet. Le croquis en dessous souligne la légèreté et les lignes élancées du terminal.

Below a computer view of the part of the station that emerges from the underground tracks near Ground Zero.

Unten eine Computeransicht vom oberirdischen Teil des Bahnhofs, der sich über den unterirdisch verlaufenden Schienen am Ground Zero erhebt.

Ci-dessous, une vue en image de synthèse de la partie de la gare qui semble jaillir des voies du métro, près de Ground Zero.

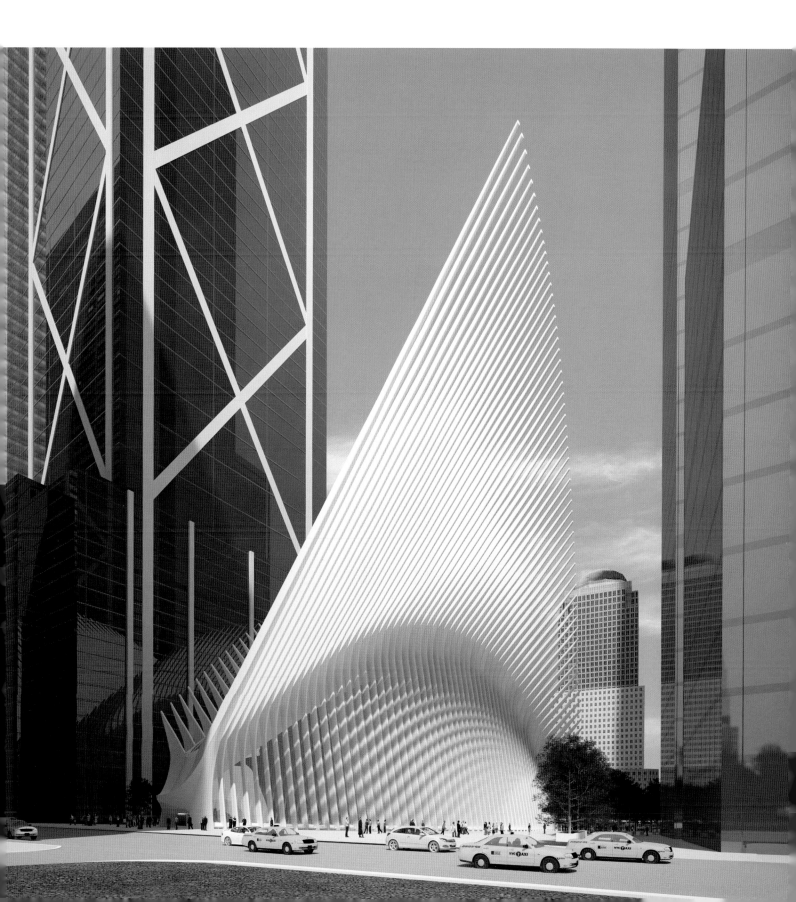

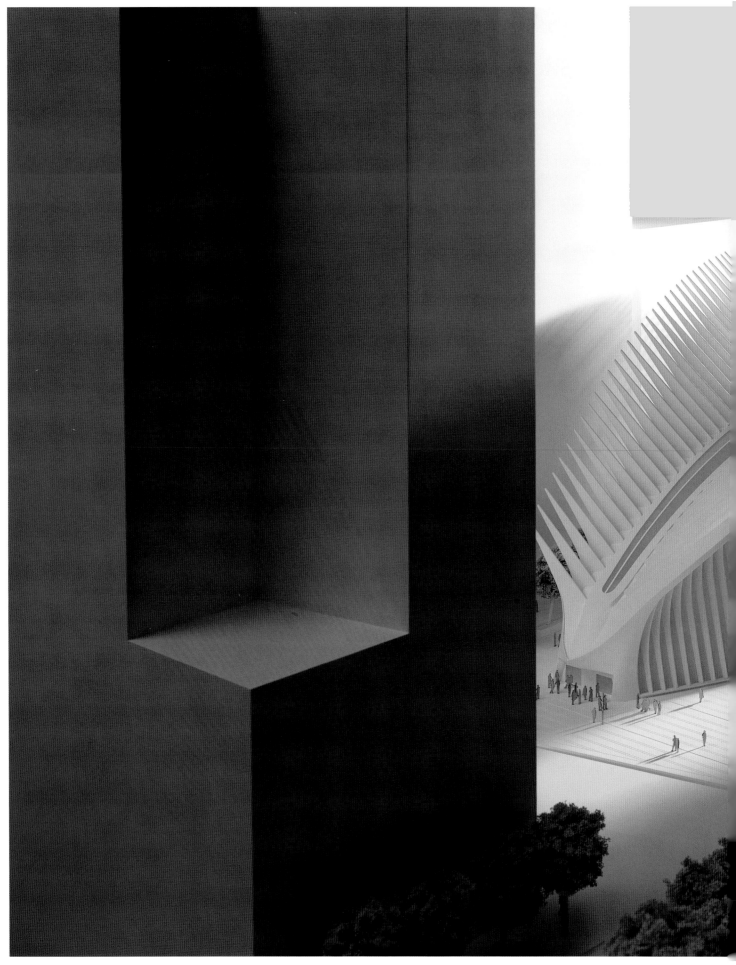

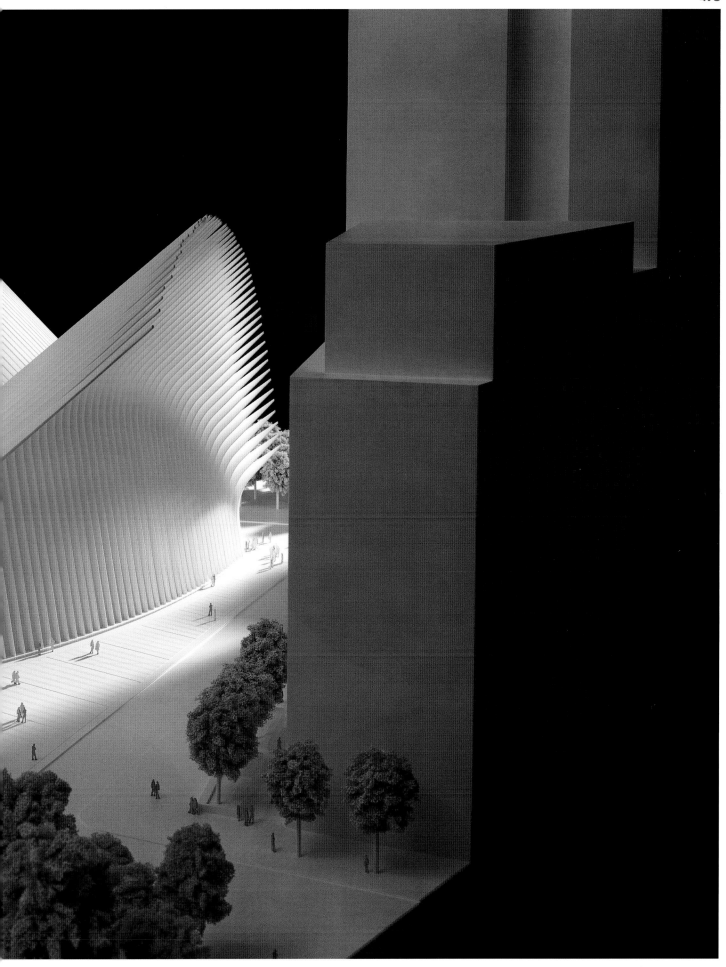

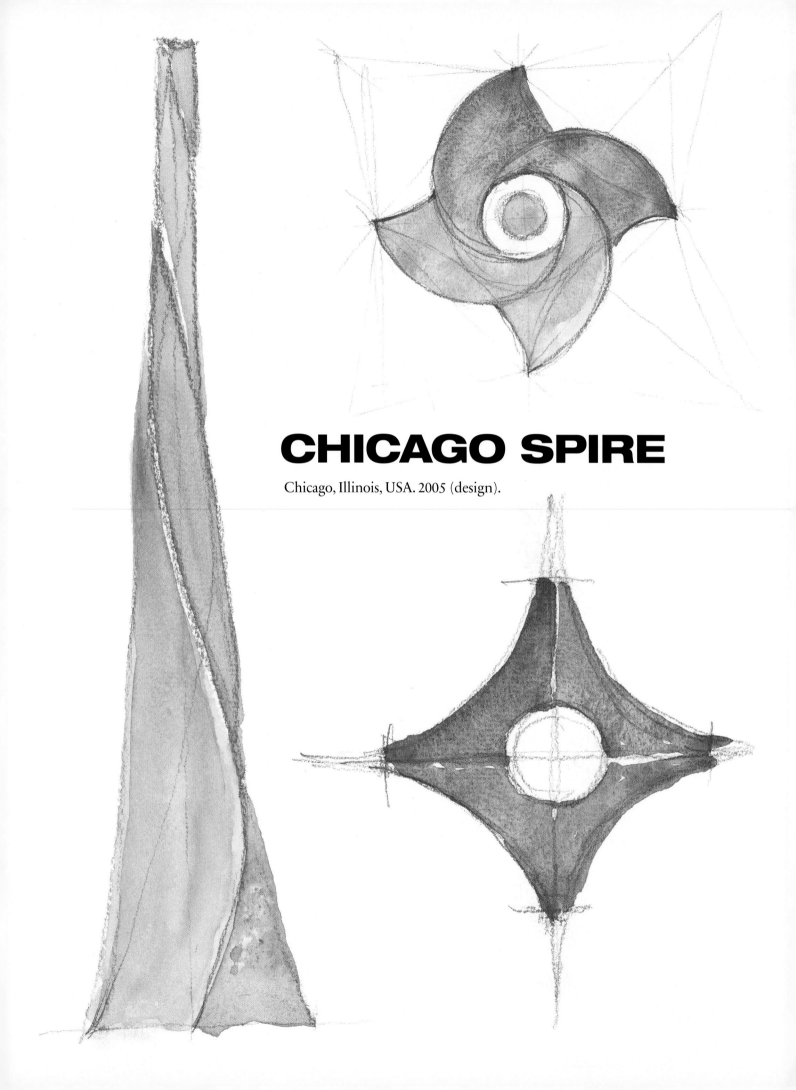

CHICAGO SPIRE

Chicago, Illinois, USA. 2005 (design).

Project
CHICAGO SPIRE

Location
CHICAGO, ILLINOIS, USA

Client
SHELBOURNE DEVELOPMENT

Height
610 METERS

Floor area
278 700 m²

Calatrava's drawings cannot always be specifically related to a project or a detail of a project, and yet the movement of the human body, or of animals, appears to constantly inform his research into new forms.

Calatravas Zeichnungen lassen sich nicht immer bestimmten Projekten oder Details von Projekten zuordnen und doch scheinen seine Versuche mit neuen Formen beständig inspiriert von Körpern in Bewegung, ob menschlicher oder tierischer Natur.

Les dessins de Calatrava ne peuvent pas être systématiquement reliés à un projet précis ou au détail d'un projet et cependant le mouvement du corps humain, ou celui des animaux, réapparaît constamment dans sa recherche de formes nouvelles.

Located on North Water Street at Lake Shore Drive, this 150-story condominium structure will be the tallest building in the United States, as well might seem appropriate in a city that long held the record for the tallest building in the world. Located on a one-hectare site, the tower was originally to have a footprint of just 1300 square meters and a gross floor area of 85 500 square meters. Enlarged to include as many as 1300 condominiums, the new design is broader than the original and has a much higher floor area as well. As the architect's office describes the design, "Based on a sculpture by Santiago Calatrava, the building is a tall, slender elegant form whose glass façade seems to ripple downward in waves, like the folds of a cloak swirling around a figure. This effect is achieved by means of a structural innovation. Each floor unit of the tower is built out from the central core like a separate box, with gently curving, concave sides. As these boxes are stacked up, each is rotated by a little more than two degrees from the one below. In this way, the floors turn 270 degrees around the core as they rise, giving the façade an impression of movement." Floor to ceiling windows and column-free floor plans will allow both hotel and condominium residents to have breathtaking views. Calatrava specifically links his design proposal, in its rippling aspect, to his sculptures such as the MoMA *Shadow Machine* or the SMU *Wave*, as well as architectural works like the Brise Soleil at the Milwaukee Art Museum or the curving roof of the Bodegas Ysios. The idea of cantilevered geometric modules suspended from a central core is of course explored both in the Turning Torso and South Street Towers. In his capacity as an engineer, Calatrava has also carefully examined the strength of the structural core of the tower and its ample emergency exits. He further advances that its twisting form will reduce the lateral force of wind gusts on the structure.

Das in der North Water Street am Lake Michigan geplante, 150-geschossige Hochhaus mit Eigentumswohnungen wird das höchste Gebäude der Vereinigten Staaten sein durchaus passend für eine Stadt, die lange den Rekord für das höchste Bauwerk der Welt innehatte. Der Turm, der auf einem 1 ha großen Baugelände errichtet wird, sollte sich auf einer Grundfläche von nur 1300 m² erheben mit einer Bruttogeschossfläche von 85 500 m². Das neue Design ist nun breiter als ursprünglich geplant und bietet Raum für ganze 1300 Appartments. Das Büro des Architekten beschreibt den Entwurf wie folgt: „Das auf einer Skulptur von Santiago Calatrava fußende Gebäude zeichnet sich durch eine hochaufragende, schlanke, elegante Form aus, deren Glasfassade sich wellenförmig nach unten kräuselt, wie die Falten eines Umhangs, der um eine Figur schwingt. Dieser Effekt entsteht durch konstruktive Neuerungen. Jede Geschosseinheit wird vom zentralen Kern aus nach außen gebaut wie ein autarker Kasten, mit sanft gebogenen, konkaven Seiten. Beim Stapeln dieser Kästen wird jeder etwas weiter als 2 Grad über den darunterliegen-

den hinaus gedreht. Auf diese Art vollziehen die Geschosse mit zunehmender Höhe um den Kern herum eine Drehung von 270 Grad und lassen die Fassade bewegt erscheinen." Deckenhohe Fenster und stützenfreie Grundrisse ermöglichen Hotelgästen wie Bewohnern überwältigende Ausblicke. Calatrava setzt seinen Entwurf wegen des Welleneffekts in Bezug zu seinen Skulpturen „Shadow Machine" im MoMA oder „Wave" im Meadows Museum und zu architektonischen Werken wie der Sonnenblende am Kunstmuseum in Milwaukee oder dem gewellten Dach der Bodegas Ysios. Die Idee, einen zentralen Kern mit vorkragenden, geometrischen Modulen zu bestücken, wurde auch beim „Turning Torso" und dem South Street Tower verwirklicht. In seiner Eigenschaft als Bauingenieur hat Calatrava die Stärke des tragenden Turmkerns wie auch die zahlreichen Notausgänge einer sorgfältigen Prüfung unterzogen. Darüber hinaus macht er geltend, dass die Spiralform des Gebäudes die seitliche Kraft von Windlasten verringern wird.

Située North Water Street près de Lake Shore Drive, cette tour de 150 étages prévue pour des appartements sera l'immeuble la plus haute des États-Unis, ce qui convient à une ville qui a longtemps détenu le record du plus haut immeuble du monde. Édifiée sur un terrain d'un hectare, elle devait n'occuper à l'origine qu'une emprise au sol de 1300 mètres carrés pour une surface utile totale de 85 500 mètres carrés. Agrandi pour offrir 1300 appartements, le nouveau design est plus vaste. Selon la description de l'agence : « Inspiré d'une sculpture de Santiago Calatrava, l'immeuble présente une forme élégante et élancée dont la façade de verre semble ondoyer en vagues descendantes, comme les plis d'un manteau. Cet effet est dû à une innovation structurelle. Chaque appartement est construit à partir du noyau central comme une boîte indépendante à faces délicatement incurvées. En s'emplant les unes sur les autres, ces boîtes pivotent chacune d'un peu plus de deux degrés par rapport à la boîte inférieure. De cette façon, les niveaux tournent de 270 degrés autour de l'axe central, ce qui crée une impression de mouvement. » Des baies du sol au plafond et des espaces ouverts dénués de piliers permettront aux clients de l'hôtel comme aux résidents de bénéficier de vues à couper le souffle. Calatrava relie spécifiquement cet aspect ondoyant à certaines de ses sculptures, comme la *Shadow Machine* du MoMA, la *Wave* du Meadows Museum des réalistions architecturales comme le brise-soleil du Milwaukee Art Museum ou le toit ondulé des Bodegas Ysios. L'idée de modules géométriques en porte-à-faux accrochés à un noyau central est par ailleurs explorée dans les tours du *Turning Torso* et de South Street. En tant qu'ingénieur, Calatrava a également étudié avec soin la résistance du noyau structurel de la tour et les questions de sécurité ; il pense que cette forme en torsion réduira les forces latérales du vent sur la tour.

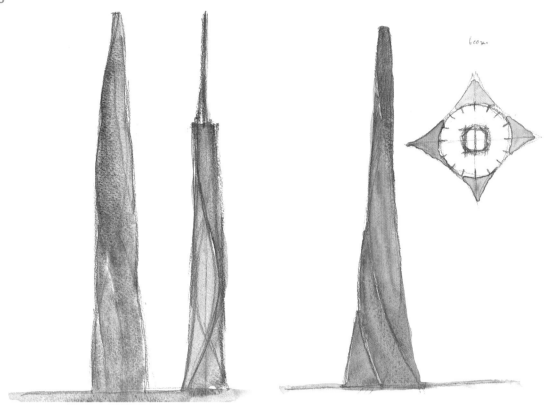

As his sketches show, Calatrava wishes to impart a dynamic twisting movement to this very high tower—a structure that will be subjected to the high winds typical of Chicago. Below, a photomontage showing the building in its future location.

Wie seine Skizzen zeigen, möchte Calatrava diesem sehr hohen Turm eine dynamische Drehbewegung verleihen – ein Bauwerk, das dem für Chicago typischen starken Wind ausgesetzt sein wird. Die Fotomontage zeigt das Gebäude am künftigen Standort.

Comme le montrent ses croquis, Calatrava souhaite insuffler un mouvement de torsion dynamique à cette très haute tour, structure qui sera soumise aux vents violents caractéristiques de Chicago. En bas, photomontage de l'immeuble sur son futur site.

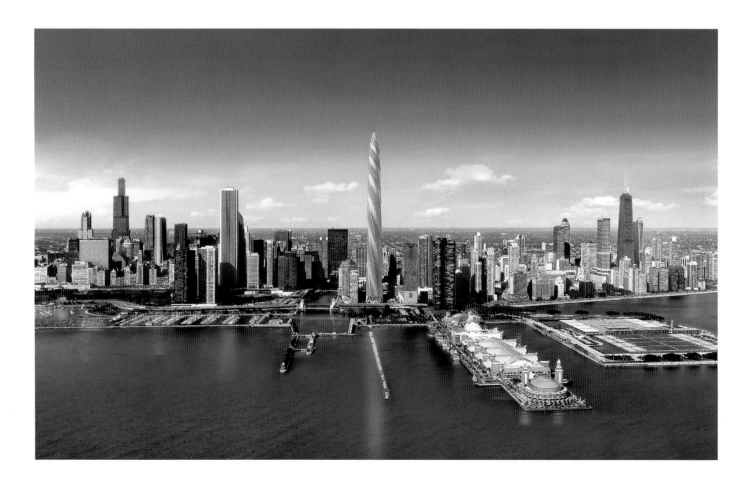

Even when compared with such very large towers as the Sears or John Hancock buildings, the tower soars higher still while retaining the lightness that is one of Calatrava's trademarks.

Der Turm übertrifft mit seiner Höhe selbst den berühmten Sears Tower oder das John Hancock Building und bewahrt doch die für Calatrava kennzeichnende Leichtigkeit.

Comparée à des tours aussi importantes que la Sears Tower ou le John Hancock Center, la « Chicago Spire » s'élève encore plus haut, tout en conservant la légèreté qui caractérise les œuvres de Calatrava.

SAMUEL BECKETT BRIDGE

Dublin, Ireland. 1998–2009.

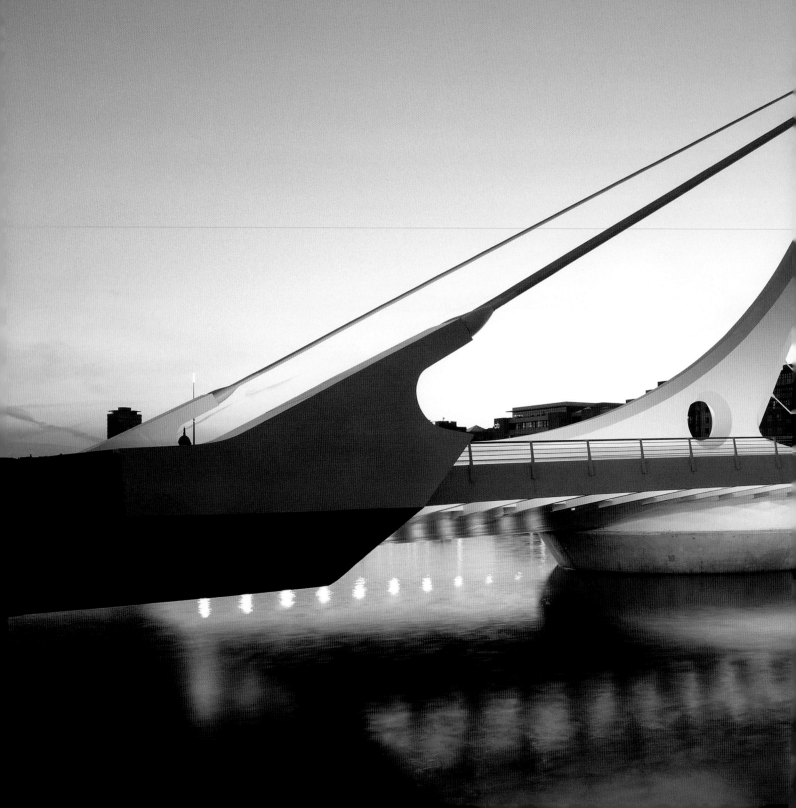

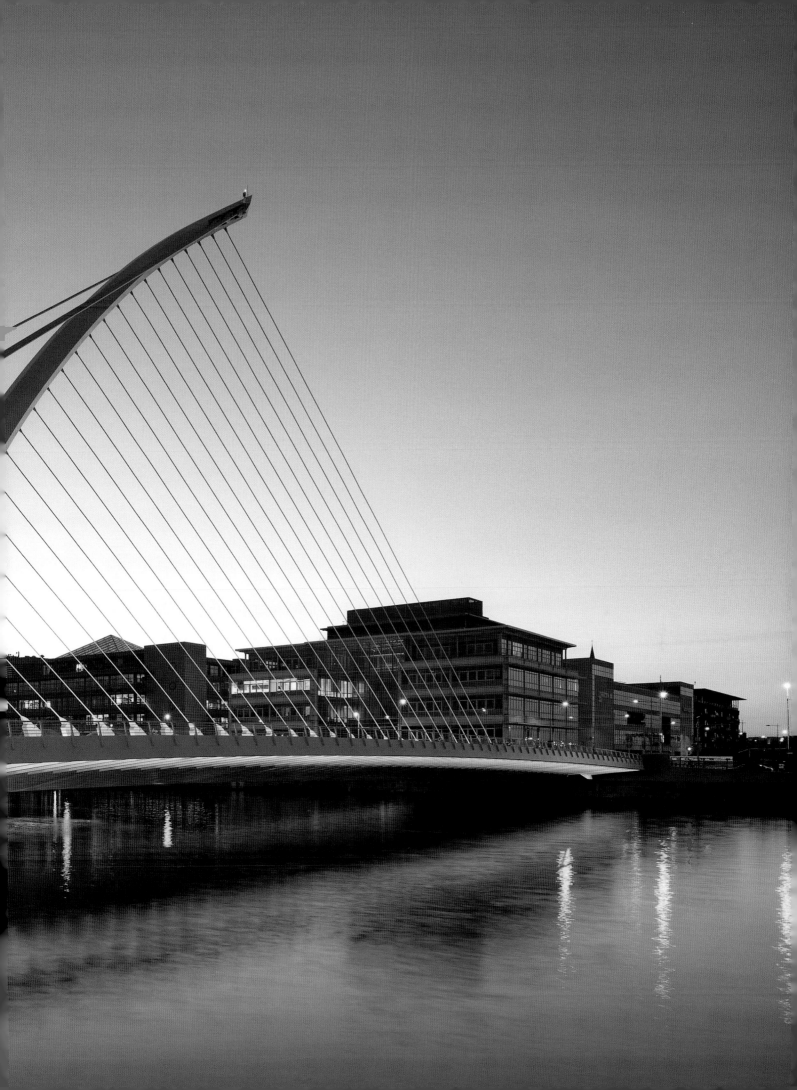

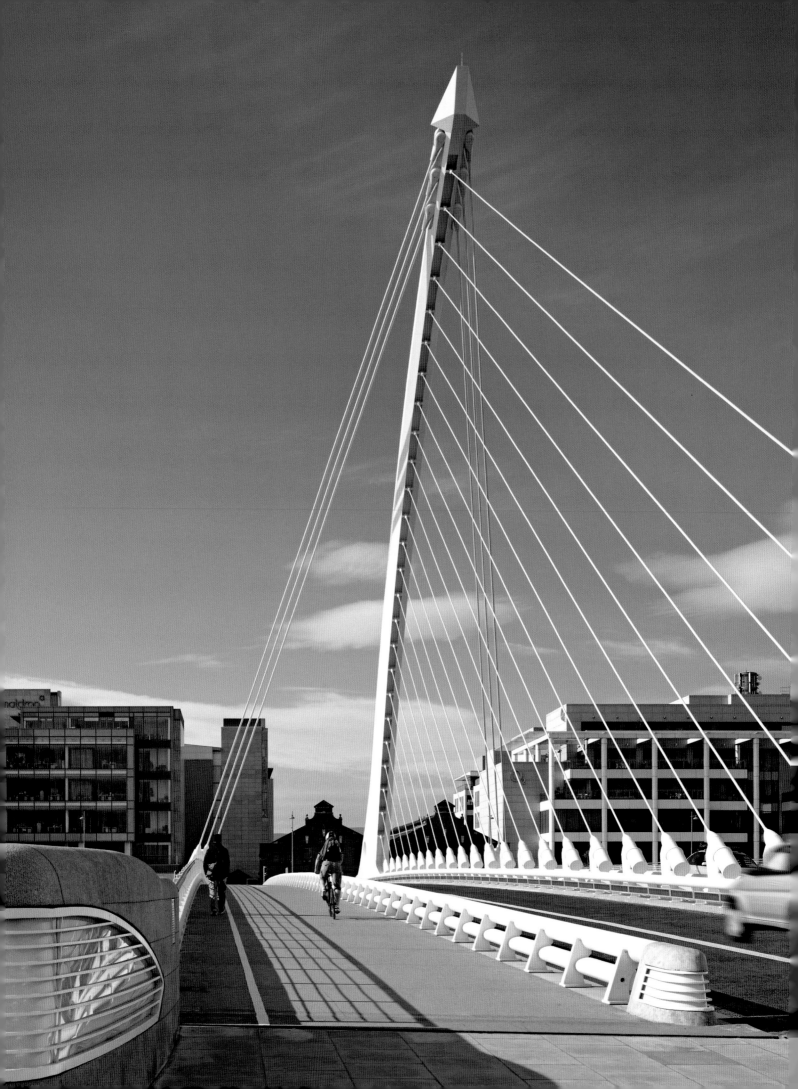

Project
SAMUEL BECKETT BRIDGE
Location
DUBLIN, IRELAND
Client
DUBLIN CITY COUNCIL
Height / length / width
46 x 124 x 27 METERS
Cost
€ 60 MILLION

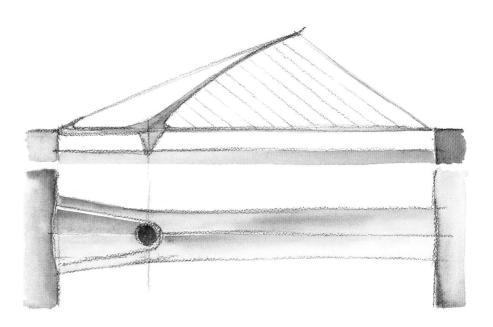

A picture of the completed bridge and two sketches by the architect highlight the simplicity and elegance of the design—seen in plan and elevation.

Eine Abbildung der fertiggestellten Brücke und zwei Zeichnungen des Architekten zeugen von der Schlichtheit und Eleganz der Gestaltung – wie auch in Grundriss und Ansicht erkennbar.

L'image du pont achevé et deux croquis de l'architecte font ressortir la simplicité et l'élégance du projet, vu en plan et en élévation.

This cable-stayed balanced swing bridge is one of two new bridges designed by Calatrava in Dublin, along with the James Joyce Bridge. It has two unequal spans that allow both pedestrians and vehicular traffic to cross the River Liffey. It is designed to allow horizontal rotation, freeing the river channel for boats. It is 124 meters long and 27 meters wide, with a single inclined and curved pylon that rises to a height of 46 meters. There are four vehicular traffic lanes, two bicycle tracks, and two pedestrian paths. Two of the car lanes can be converted in the future to tram use. The architect explains that the "bridge's cross section is a box with a bottom shaped like a circular arc. Cross girders cantilever out on both sides of the box including the parapet, where the stays are anchored, creating the bicycle and pedestrian area." The bridge opened in December 2009.

Diese Schrägseil-Drehbrücke ist, neben der James-Joyce-Brücke, einer von den zwei neuen Brückenbauten, die Calatrava für Dublin geplant hat. Sie hat zwei ungleiche Spannweiten, damit Fußgänger wie auch der Autoverkehr den Fluss Liffey überqueren können. Sie lässt sich horizontal drehen, so dass der Kanal für Boote freigegeben werden kann. Die Brücke ist 124 m lang und 27 m breit und hat nur einen schrägen und gekrümmten Pylon, der 46 m hoch ist. Es gibt vier Fahr-

spuren, zwei Fahrrad- und zwei Fußgängerwege. Zwei der Fahrspuren können in Zukunft für die Straßenbahn umgenutzt werden. Der Architekt erläutert: „Der Querschnitt der Brücke ist ein Kasten mit einer Unterseite in Form eines kreisförmigen Bogens. Seitliche Ausleger mit dem Brückengeländer, in dem die Seile verankert sind, kragen beidseitig aus dem Kasten aus und tragen den Fahrrad- und Fußgängerbereich." Die Brücke wurde im Dezember 2009 eröffnet.

Ce pont tournant à haubans est, avec le pont James Joyce, l'un des deux ouvrages conçus par Calatrava pour Dublin. De deux travées de longueurs inégales, il offre quatre voies à la circulation automobile, deux pistes cyclables et deux passages pour les piétons. Il pivote horizontalement pour laisser le passage aux bateaux naviguant sur la Liffey. De 124 mètres de long et 27 de large, il est suspendu à un pylône unique, incliné et incurvé de 46 mètres de haut. Ultérieurement, deux des voies pourront être affectées à une ligne de tramway. L'architecte explique que « en coupe, le pont est une boîte à fond en arc de cercle. Les traverses de cette boîte qui ressortent des deux côtés intègrent le garde-corps auquel sont ancrés les haubans, dégageant l'espace nécessaire à la circulation des piétons et des vélos. » Le pont a été ouvert en décembre 2009.

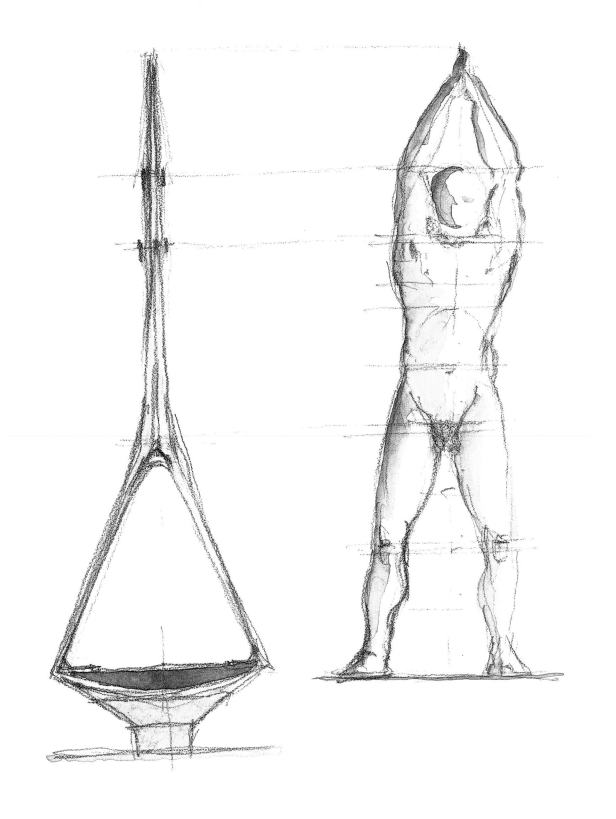

As is often the case, Calatrava here renders explicit the relation between his bridge design and the human body. The body and the bridge serve different functions but share a natural origin.

Wie so oft, betont Calatrava auch hier explizit den Zusammenhang zwischen dem Brücken-entwurf und dem menschlichen Körper. Dieser und die Brücke erfüllen unterschiedliche Funktionen, beiden gemeinsam ist aber ihr natürlicher Ursprung.

Comme souvent, Calatrava aime rendre explicite la relation entre le dessin de son projet et le corps humain. Le corps et le pont répondent à des fonctions différentes, mais partagent une même origine naturelle.

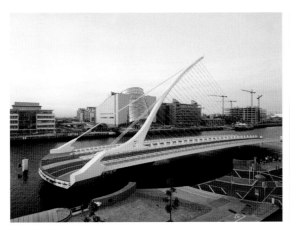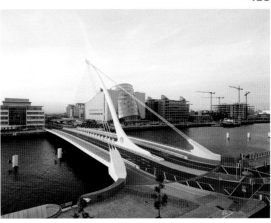

From the time of his doctoral thesis Cala-
trava has been fascinated by architecture
that moves. In the images here, the bridge
can be seen open, closed and in time-lapse
movement.

Seit seiner Doktorarbeit fasziniert Calatrava
die Architektur der Bewegung. Die hier abge-
bildeten Fotos zeigen die Brücke in offenem
und geschlossenem Zustand sowie die
Bewegung im Zeitraffer.

Depuis l'époque de sa thèse de doctorat,
Santiago Calatrava est fasciné par l'architec-
ture en mouvement. Dans ces photos, le
pont est vu ouvert, fermé et en mouvement
décomposé.

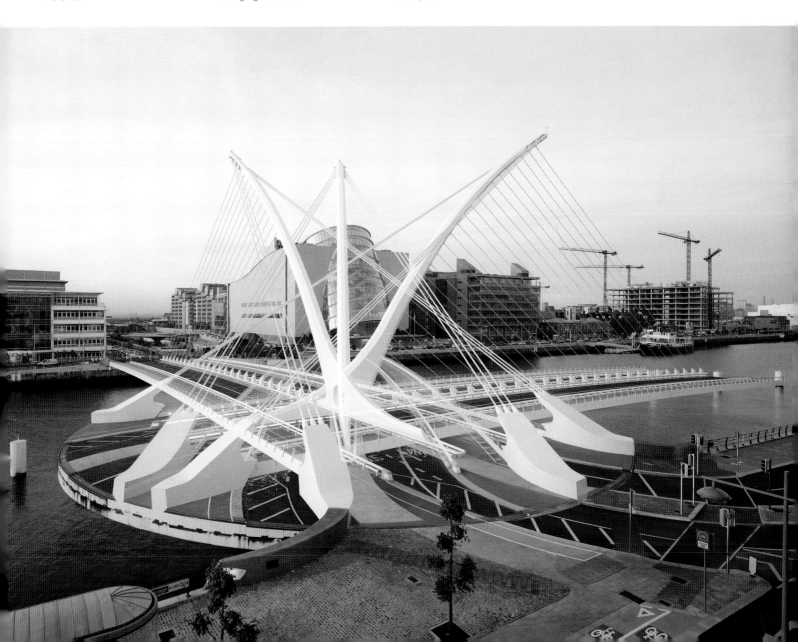

JAMES JOYCE
BRIDGE

Dublin, Ireland. 1998–2003.

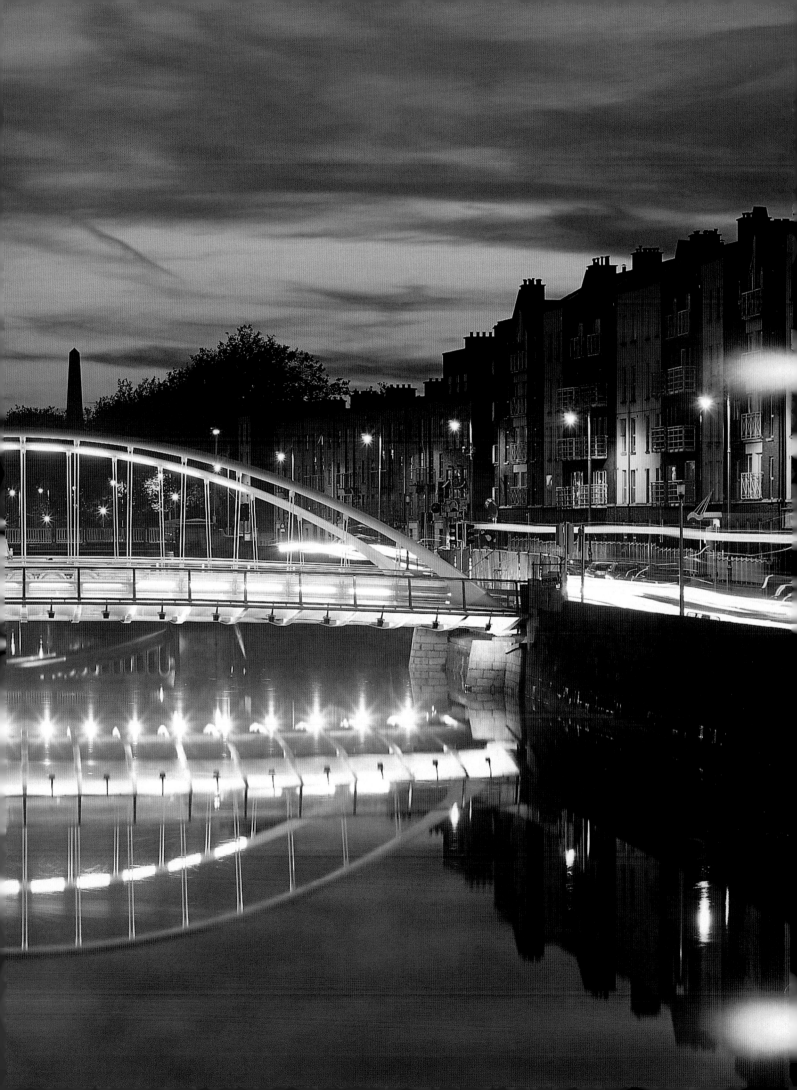

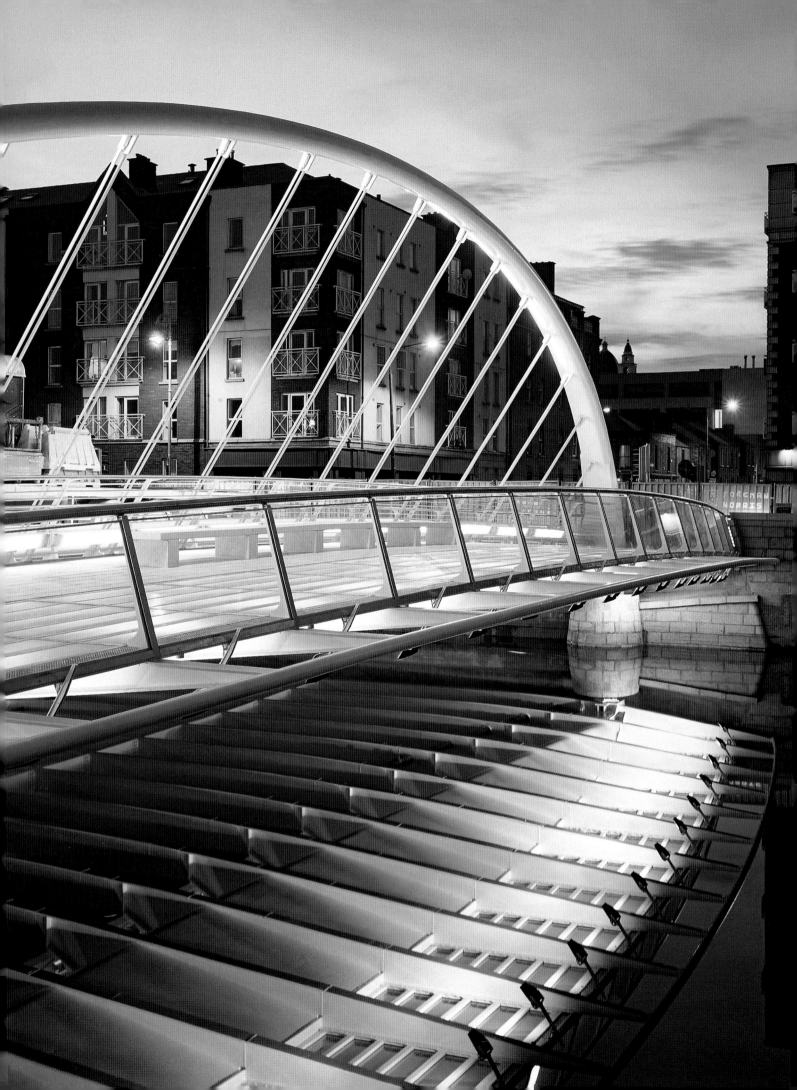

Project
JAMES JOYCE BRIDGE

Location
DUBLIN, IRELAND
Client
DUBLIN CITY COUNCIL
Height
6.5 METERS
Span
42 METERS
Cost
€ 12 MILLION

Santiago Calatrava brings an artistic elegance both to his work as an engineer (the completed bridge to the left) and in his watercolors, which often combine human forms with technical ones.

Santiago Calatrava verleiht sowohl seinen Ingenieurbauten (links die fertiggestellte Brücke) wie auch seinen Aquarellen eine künstlerische Eleganz, die häufig menschliche mit technischen Formen verbindet.

Calatrava sait insuffler une élégance artistique aussi bien dans son travail d'ingénieur (à gauche, vue du pont terminé) que dans ses aquarelles combinant souvent formes humaines et constructions techniques.

This tied-arch pedestrian and road bridge is part of the Dublin Corporation's Historic Area Renewal Project (HARP). It runs between Ellis Quay and Usher's Island. The setting for James Joyce's short story "The Dead," part of the 1914 collection *Dubliners*, is at 15 Usher's Island. The architect explains that the "deck structure is suspended by high tensile steel hangers from a pair of 6.5-meter-high tilted arches, which are inclined outward." Four traffic lanes cross the 42-meter length of the bridge. Balustrades formed mostly of glass line pedestrian walkways that are paved with translucent glass. The architect points out that the James Joyce Bridge was designed in harmony with other arched bridges that span the River Liffey.

Diese Stabbogenbrücke für Fußgänger und Fahrzeuge ist Teil der Stadterneuerungsmaßnahmen Dublin Corporation's Historic Area Renewal Project (HARP). Sie führt vom Ellis Quay nach Usher's Island. James Joyces Kurzgeschichte „Die Toten" aus dem Zyklus „Dubliner" (1914) spielt in Usher's Island 15. Der Architekt erklärt: „Die Brückenkonstruktion ist mit hochfest vorgespannten, stähler-

nen Hängern an zwei 6,5 m hohen, nach außen geneigten Bogen aufgehängt." Vier Fahrspuren führen über die 42 m lange Brücke. Die überwiegend aus Glas bestehenden Brüstungen begrenzen die Fußgängerwege, die mit durchscheinendem Glas gepflastert sind. Der Architekt betont, dass diese Brücke im Einklang mit anderen Bogenbrücken geplant wurde, die über die Liffey führen.

Ce pont en arc pour véhicules et piétons fait partie du Projet de rénovation du centre historique de Dublin (HARP). Il relie le quai Ellis à l'île d'Usher, cadre de la nouvelle de James Joyce intitulée « Les morts » dans son recueil *Dubliners* (1914). « La structure du tablier, explique l'architecte, est suspendue par des haubans en acier haute résistance à une paire d'arcs inclinés vers l'extérieur de 6,5 mètres de haut. Mesurant 42 mètres de long, l'ouvrage comporte quatre voies de circulation. Des garde-corps, essentiellement en verre, bordent les voies pavées de verre translucide réservées aux piétons. L'architecte souligne que cet ouvrage a été conçu en harmonie avec les autres ponts en arc qui franchissent la Liffey.

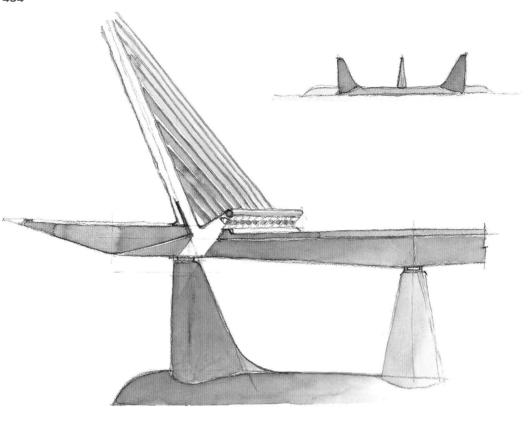

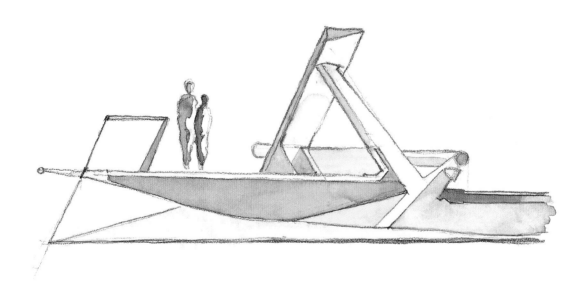

Engineers often refer only to the forces at play, ignoring the more poetic, or "human" side of their own work. Calatrava's drawings and completed work, as seen here, bring the analysis of forces and movement into a comprehensible, natural combination.

Ingenieure nehmen oft nur Bezug auf die wirkenden Kräfte und ignorieren die poetische oder „menschliche" Seite ihrer eigenen Arbeit. Wie hier zu sehen, führen Calatravas Zeichnungen und sein ausgeführtes Werk die Analyse der Kräfte und der Bewegung in verständlicher, natürlicher Verbindung zusammen.

Souvent, les ingénieurs ne se réfèrent qu'aux forces en jeu, ignorant l'aspect plus poétique ou « humain » de leur travail. Les dessins et les œuvres de Calatrava expriment son analyse des forces et du mouvement dans une combinaison naturelle et compréhensible.

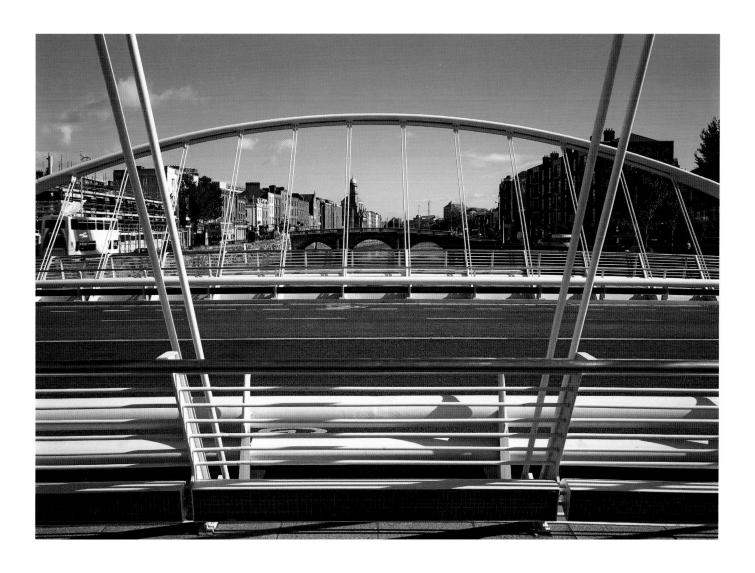

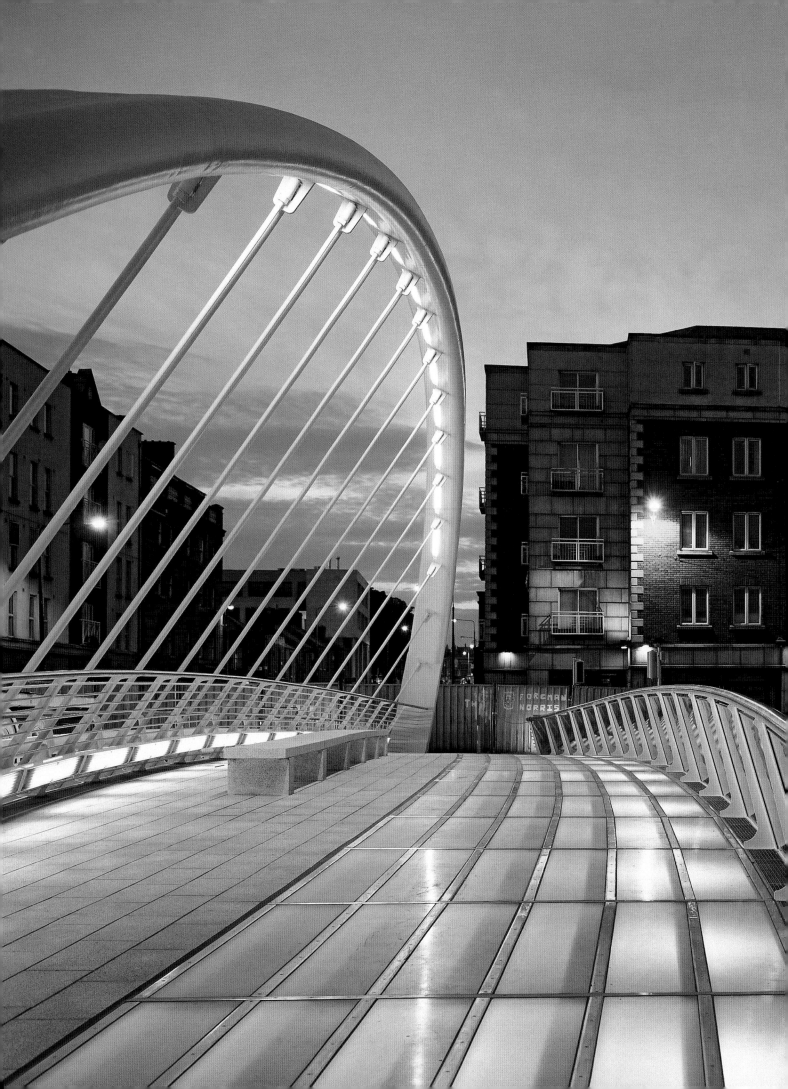

The architect respects the generally low forms of Dublin's architecture with his broad, arching span, with angles and slopes that nonetheless bring the bridge to life.

Der Architekt respektiert die im allgemeinen niedrigen Formen der Dubliner Bebauung durch die weite Bogenüberspannung mit Winkeln und Schrägen, die der Brücke dadurch Lebendigkeit verleihen.

L'architecte a respecté les formes limitées en hauteur du paysage urbain dublinois dans cette travée en arc dont les pentes et les inclinaisons animent néanmoins l'ouvrage.

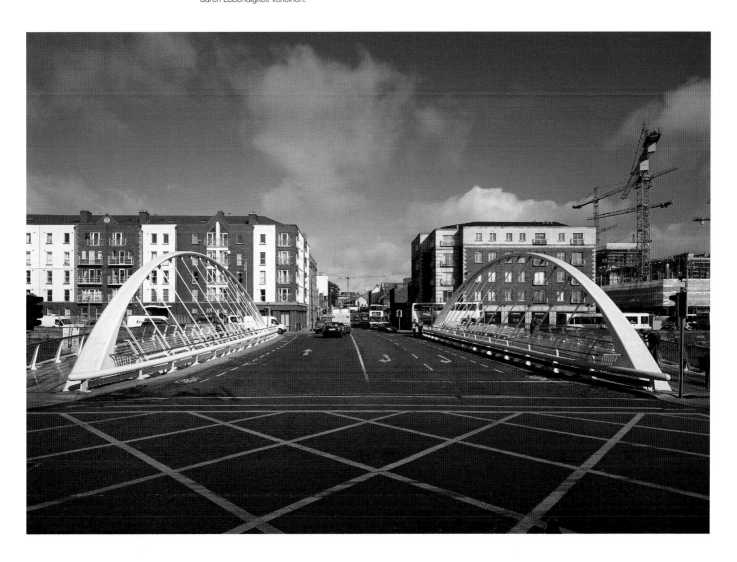

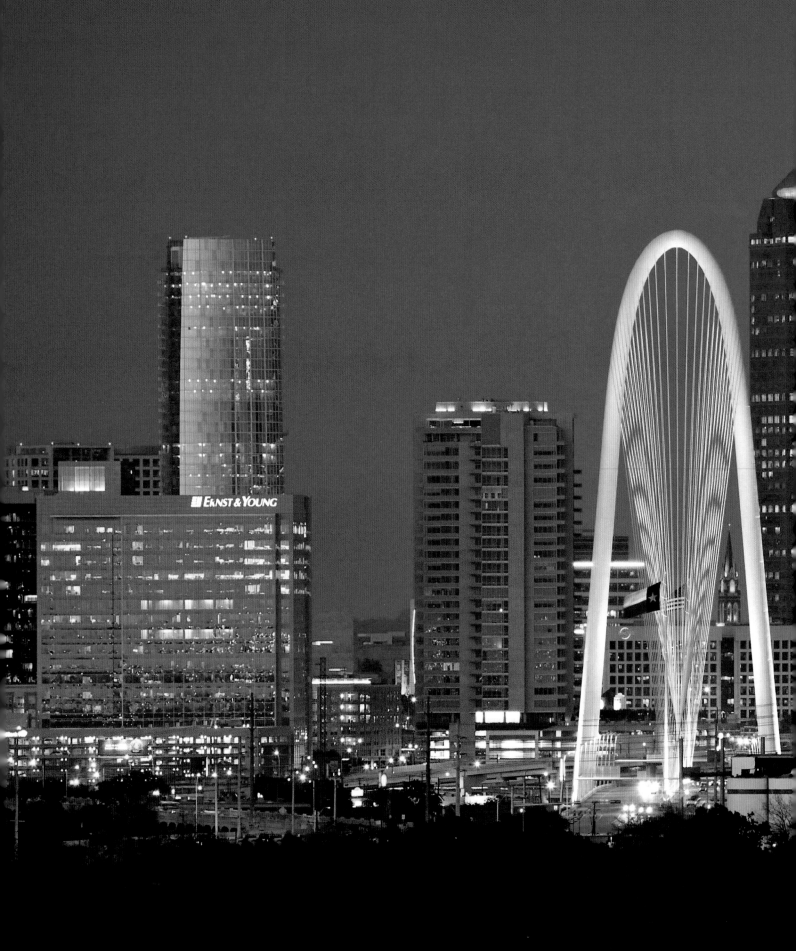

MARGARET HUNT HILL BRIDGE

Dallas, Texas, USA. 2010–2012.

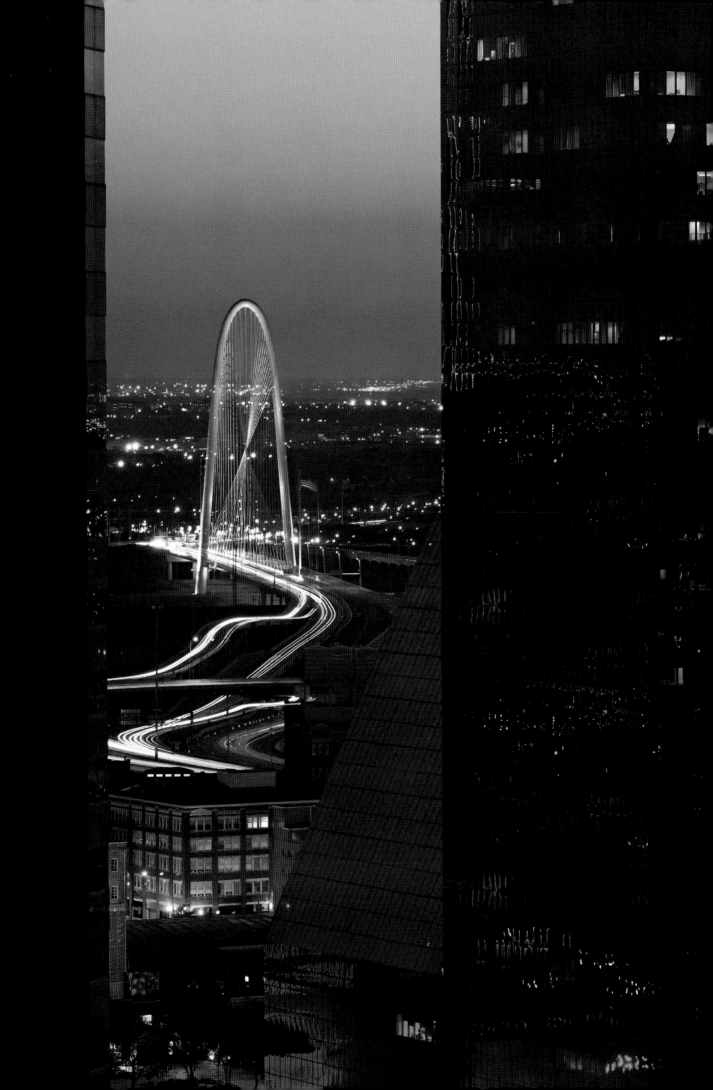

Project
MARGARET HUNT HILL BRIDGE

Location
DALLAS, TEXAS, USA

Client
CITY OF DALLAS

Height / length / width
136 x 418.5 x 36.7 METERS

Maximum span
209.25 METERS

Cost
$ 44 MILLION

The high arch of this bridge and its night lighting, as seen to the left, make it appear like a great sculpture. The relatively simple drawing to the right and the completed work are very similar.

La grande arche du pont et son éclairage nocturne (à gauche) en font une sorte de sculpture. Le croquis relativement simple (à droite) et le pont achevé sont très similaires.

Der hohe Bogen dieser Brücke und ihre nächtliche Beleuchtung (wie links zu sehen) lassen sie wie eine große Skulptur erscheinen. Die relativ einfache Zeichnung rechts und das ausgeführte Bauwerk sind weitgehend deckungsgleich.

This cable-stayed steel bridge with a white parabolic pylon located in Dallas is seen as a major step in revitalizing the city, connecting the downtown area to West Dallas. The bridge carries six lanes of traffic across the Trinity River and is 418.5 meters long, 36.7 meters wide, and spans 209.25 meters. The central support pylon is 136 meters high, giving the bridge a considerable presence in the city. The 58 cables, with diameters ranging from 165 to 127 millimeters and lengths ranging from 196 to 119 meters, distribute the loads of the structure through the slender and spectacular arched pylon. The actual pylon is a closed steel tube with internal diaphragms, stiffeners, and anchors for the cables. The Margaret Hunt Hill Bridge was the first of a series of bridges designed by Santiago Calatrava to span the Trinity River and also Calatrava's first vehicular bridge in the United States.

Diese stählerne Schrägseilbrücke mit einem weißen, parabolisch gekrümmten Pfeiler in Dallas, die die Innenstadt mit dem westlichen Stadtbereich verbindet, gilt als wichtige Maßnahme zur Stadterneuerung. Sie führt mit sechs Verkehrsspuren über den Trinity River und ist 418.5 m lang, 36,7 m breit und hat eine Spannweite von 209,25 m. Der zentrale Stützpfeiler ist 136 m hoch und macht die Brücke zu einem beachtlichen Wahrzeichen in der Stadt. Die 58 Stahlseile mit

Durchmessern von 127 bis 165 mm und Längen von 119 bis 196 m verteilen die Lasten der Konstruktion über den schlanken und spektakulär gebogenen Pylon. Dieser besteht aus einem geschlossenen Stahlrohr und enthält Zwischenwände, Aussteifungen und Verankerungen für die Stahlseile. Diese Brücke war die erste von mehreren, die Santiago Calatrava über den Trinity River geplant hat, und auch seine erste Fahrzeugbrücke in den Vereinigten Staaten.

Ce pont en acier à haubans et pylône parabolique blanc est considéré comme une avancée majeure de la revitalisation urbaine de Dallas dont il relie le centre aux quartiers ouest. Son tablier à six voies de 36,7 mètres de large et de 418,5 mètres de portée surplombe la Trinity River. Le pylône central de 136 mètres de haut lui assure une présence monumentale. Les 58 câbles, de diamètres de 127 à 165 mm et de longueurs allant de 119 à 196 mètres, distribuent les charges structurelles vers ce fin et spectaculaire pylône en forme d'arc. Il est constitué d'un tube d'acier fermé à diaphragmes, raidisseurs et système d'ancrage des câbles intégrés. Ce pont est le premier d'une série d'ouvrages conçus par Santiago Calatrava sur la Trinity River, et aussi le premier destiné à la circulation automobile conçu par l'architecte aux États-Unis.

In this instance, Calatrava's drawing of a man seems almost more earthbound than the forms he sketches for the bridge, which is willfully conceived according to the rules of nature.

In diesem Fall wirkt Calatravas Zeichnung eines Mannes fast erdgebundener als seine Skizzen für die Brücke, die er bewusst nach den Gesetzen der Natur konzipierte.

Dans ce cas précis, le dessin de l'homme semble d'esprit descriptif plus réaliste que les formes du pont vues dans le croquis, conçues délibérément selon les règles de la nature.

A web of cable stays marks the horizon of the bridge as seen in the sketch below, but also in the photo of the main arch.

Ein Netz aus Schrägseilen bestimmt das Erscheinungsbild der Brücke, wie die Zeichnung unten, aber auch das Foto des großen Bogens zeigen.

Le réseau de câbles semble fuir du pont vers l'horizon, comme le montrent le croquis ci-dessous et la vue de la grande arche.

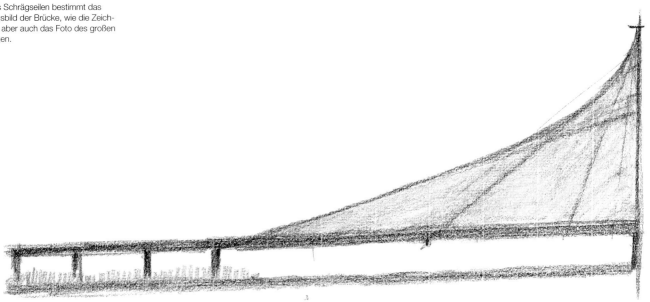

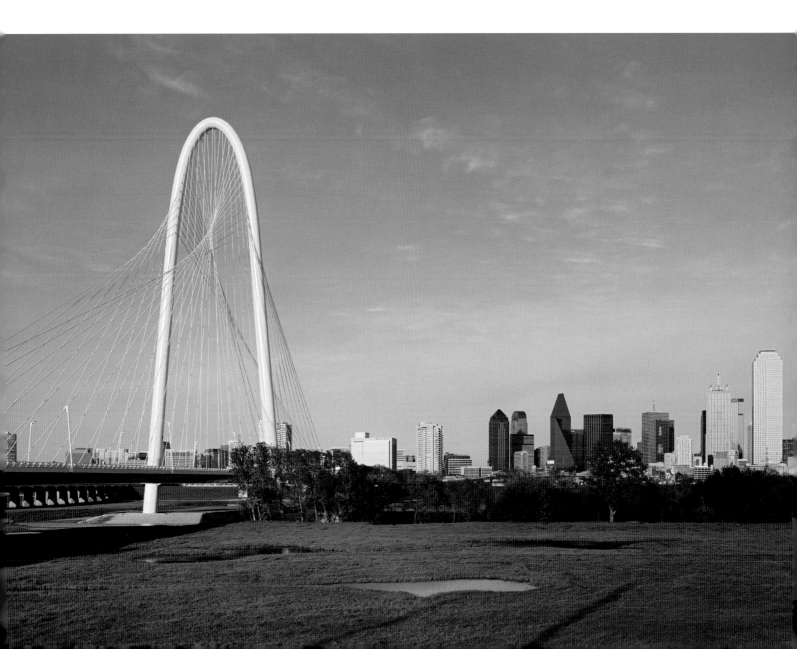

Right page, another sketch by Santiago Calatrava emphasizes the movement of several figures, tracing lines of force in space. Again, the bridge seems airy in comparison.

Rechte Seite: Eine weitere Zeichnung von Santiago Calatrava zeigt die Bewegung einiger Figuren, die dem Verlauf der Kräfte im Raum folgt. Im Vergleich wirkt die Brücke wieder leicht.

Page de droite : un autre croquis de l'architecte met scène plusieurs figures traçant des lignes de force dans l'espace. Par comparaison, le pont semble d'une légèreté aérienne.

The light structure of the bridge stands out against the heavier architectural environment of the city, while emphasizing an upward movement shared by the skyscrapers.

Die leichte Konstruktion der Brücke bildet einen Kontrast zu der massiveren Bebauung in der Stadt, während ihre betonte Aufwärtsbewegung derjenigen der Hochhäuser entspricht.

Légère, la structure se détache de l'environnement des tours du centre-ville, tout en reprenant le mouvement vers le haut partagé par les gratte-ciel.

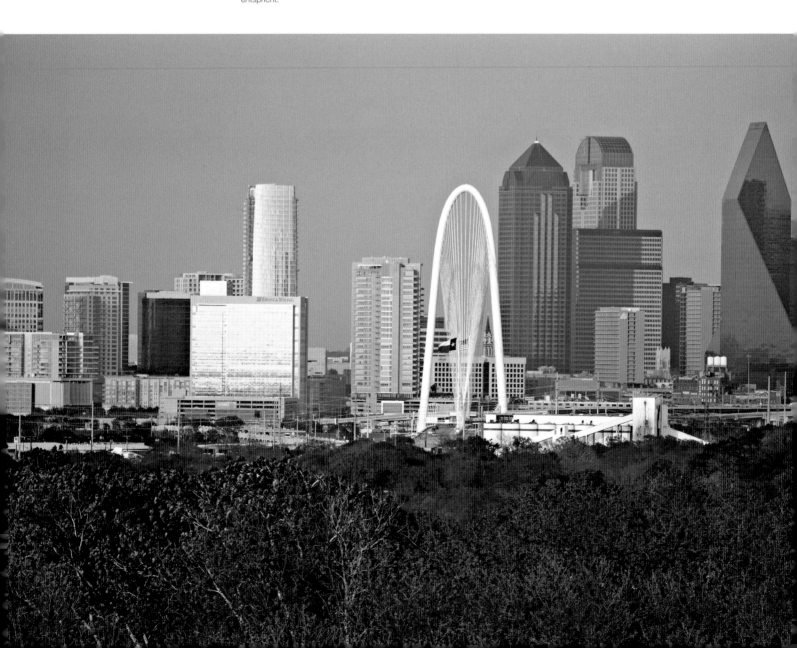

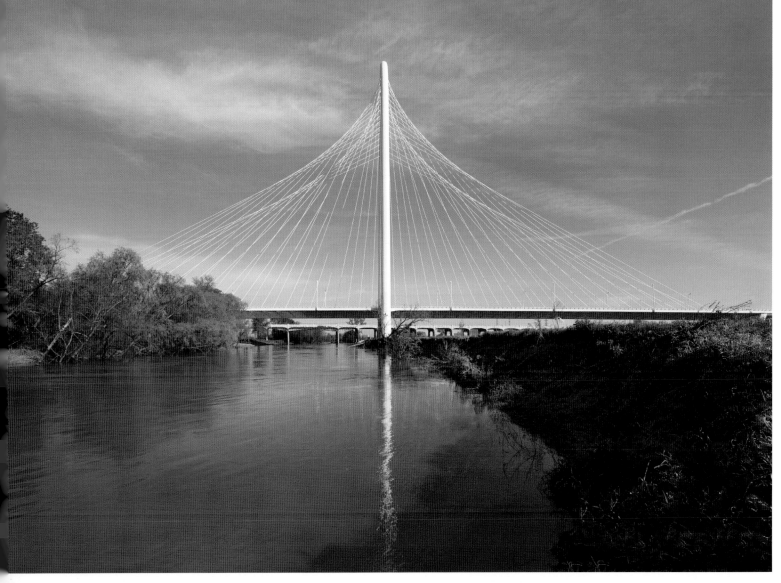

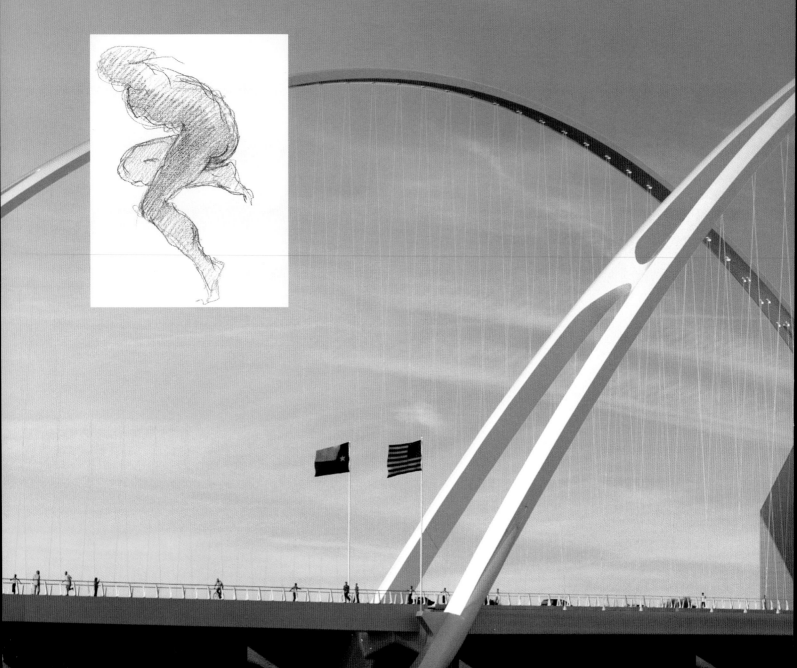

MARGARET MCDERMOTT BRIDGES

Dallas, Texas, USA. 2011–.

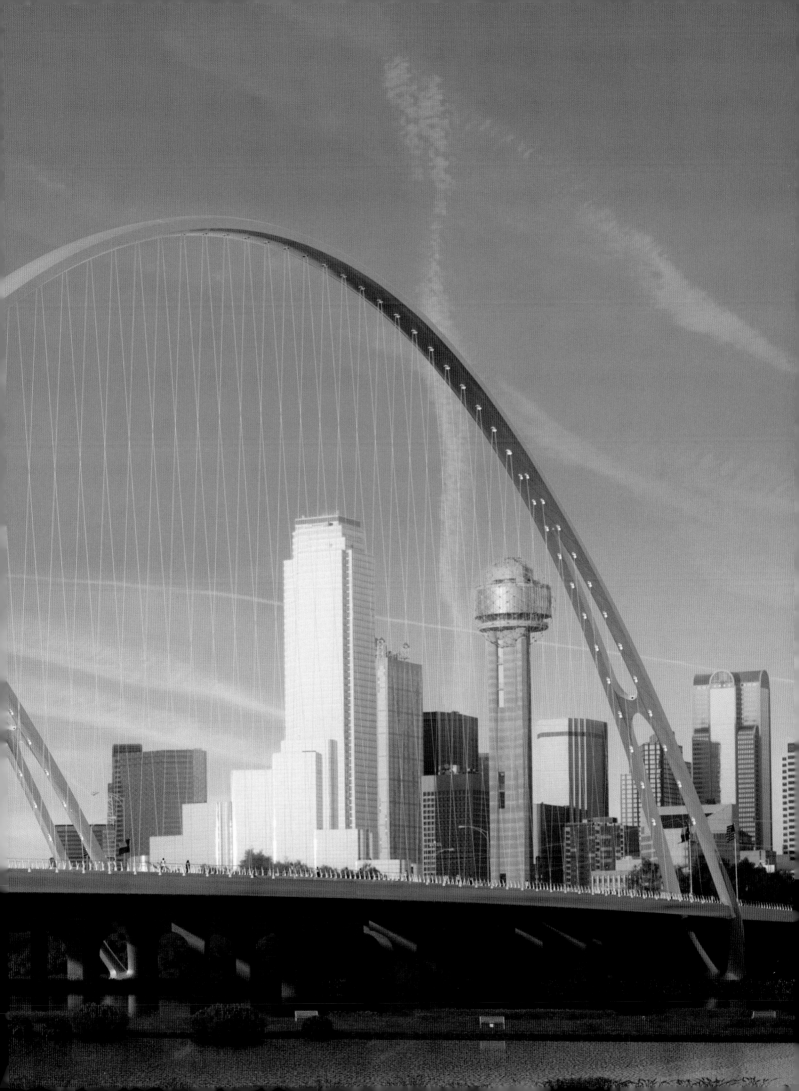

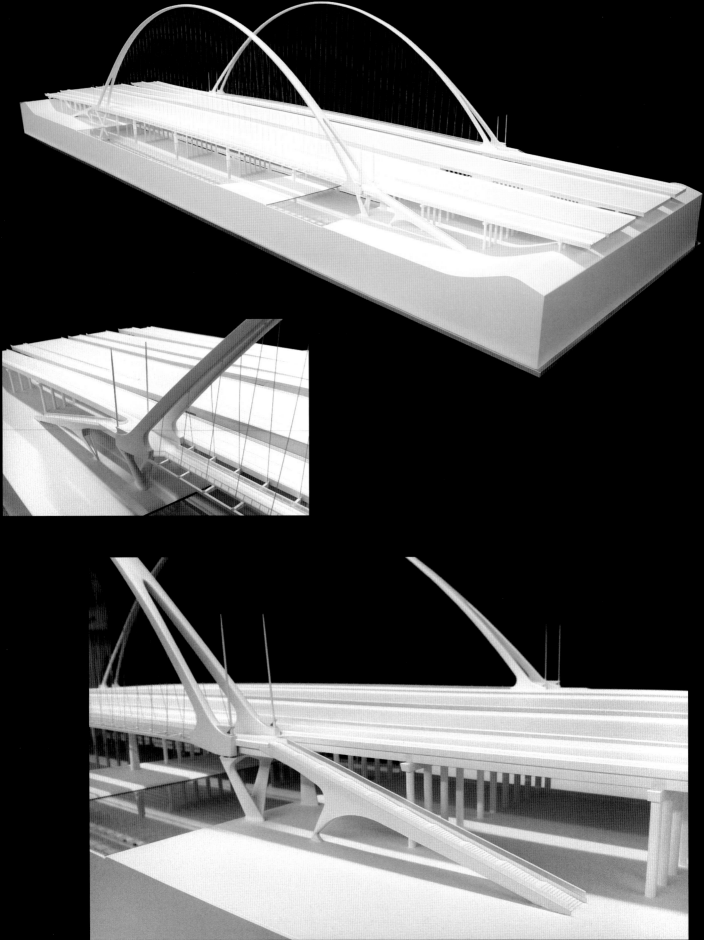

Project
MARGARET MCDERMOTT BRIDGES

Location
DALLAS, TEXAS, USA

Client
CITY OF DALLAS

Height / length / width
83.5 x 343 x 6.2 METERS

Span
343 METERS (MAIN ARCH)

Cost
$ 80 MILLION

Splitting and arching over the void, this bridge provides a lesson in elegance that few engineers or architects have been able to equal in recent years. The beauty of the bridges of Maillart comes to mind.

Diese den Luftraum teilende und überwölbende Brücke bietet ein Lehrstück an Eleganz, wie es nur wenigen Ingenieuren und Architekten in den letzten Jahren gelungen ist. Dabei denkt man an die Schönheit der Brücken von Robert Maillart.

Se divisant et se courbant au-dessus du vide, ce pont est une leçon d'élégance que peu d'ingénieurs ou d'architectes ont su récemment égaler. On pense cependant à la beauté des ponts de Robert Maillart.

"It is our intention," states Santiago Calatrava, "to provide this freedom of access by creating an additional bridge of equal architectural merit to the symbolic Margaret Hunt Hill Bridge that is contextually relevant in scale, position, and function but compliments and maintains the special relationship with the main city gateway bridge." Part of an ongoing scheme to give new life to the riverfront area in Dallas, this pedestrian and bicycle bridge connects to a trail system at four points. Rest areas are provided along the periphery of the bridge, allowing users to enjoy views of a newly formed park as well as sailboats below. The architect explains, "It is envisioned to strategically illuminate the underside of the bridge and the connecting approach ramps in order to create a 'curtain of light' draped below the edge of the structure. It casts a wonderfully fluid reflection on the lake's surface and provides a reassuring sense of safety and clarity on the journey home from a long summer's day at the lake."

„Es ist unser Ziel", erklärt Santiago Calatrava, „mit einer zusätzlichen Brücke von gleicher architektonischer Qualität, die dem Kontext in Maßstab, Lage und Funktion entspricht, aber den besonderen Bezug zur symbolischen Haupterschließungsbrücke Margaret Hunt Hill respektiert und bewahrt, freien Zugang zu dieser zu schaffen." Diese Fußgänger- und Fahrradbrücke ist Bestandteil einer aktuellen Planung, die das Hafenviertel in Dallas lebendiger gestalten und an vier Punkten mit einem Wegesystem verbinden soll. Am Rande der Brücke sind Ruhebe-

reiche geplant, um Ausblicke auf einen neu gestalteten Park sowie die Segelboote auf dem Fluss zu gewähren. Der Architekt erläutert: „Es ist vorgesehen, die Unterseite der Brücke sowie die Zugangsrampen eindrucksvoll zu beleuchten, damit unter der Konstruktion ein ‚Vorhang aus Licht' entsteht, der zu einer wunderbaren Spiegelung auf der Wasseroberfläche führt sowie Sicherheit und Helligkeit auf dem Heimweg nach einem langen Sommertag am See bietet."

« Notre intention, explique Santiago Calatrava, est d'apporter une nouvelle liberté d'accès en créant un ouvrage supplémentaire de valeur architecturale équivalente au pont Margaret Hunt Hill, c'est-à-dire contextuellement pertinent en termes d'échelle, de position et de fonction, mais complétant et maintenant une relation spéciale avec le principal pont d'accès à la ville. » Dans le cadre d'un projet en cours de rénovation des quartiers bordant la Trinity River, ce pont pour piétons et cyclistes donne accès, en quatre points, à un réseau de promenades. Des aires de repos sont prévues en périphérie de l'ouvrage pour permettre aux usagers de profiter des vues sur le nouveau parc en cours de création et sur les voiliers du fleuve. « Nous envisageons un éclairage stratégique du dessous du tablier et des rampes d'accès afin de créer un 'rideau de lumière' drapé sous la structure. Il projettera un reflet merveilleusement fluide à la surface du lac et offrira un sentiment rassurant de sécurité et de clarté lorsqu'on rentre d'une longue journée d'été passée au bord du lac. »

CONFERENCE AND EXHIBITION CENTER

Oviedo, Spain. 2000–2011.

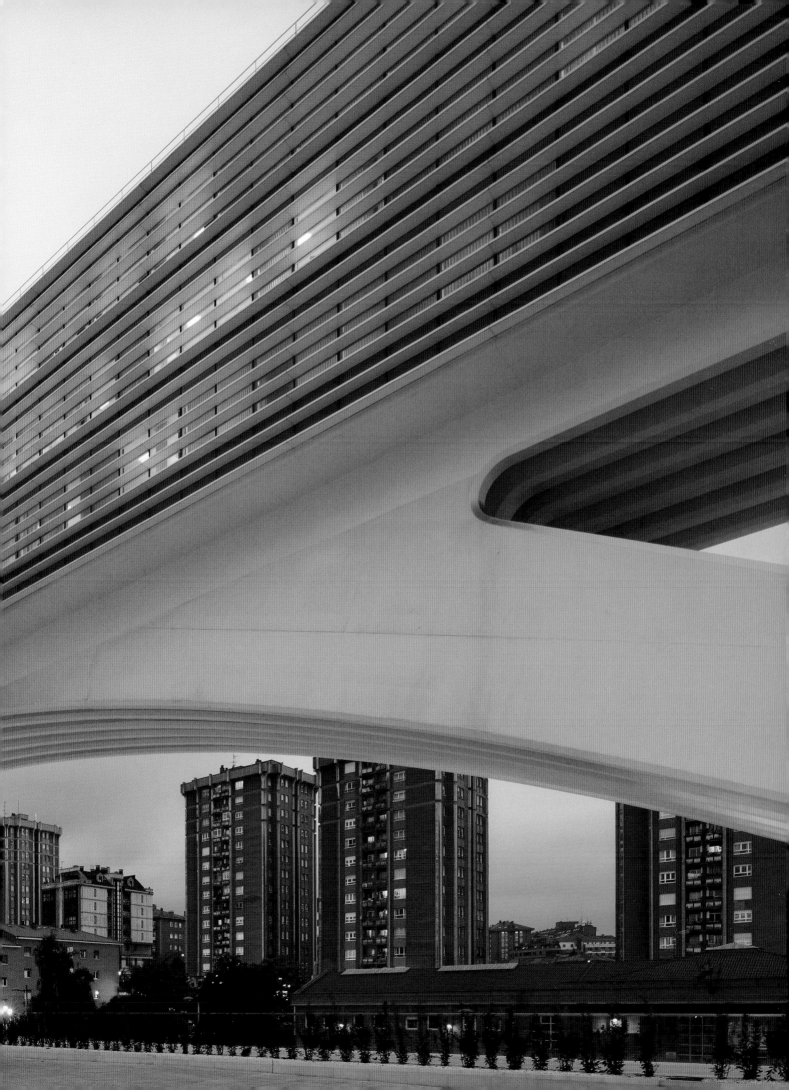

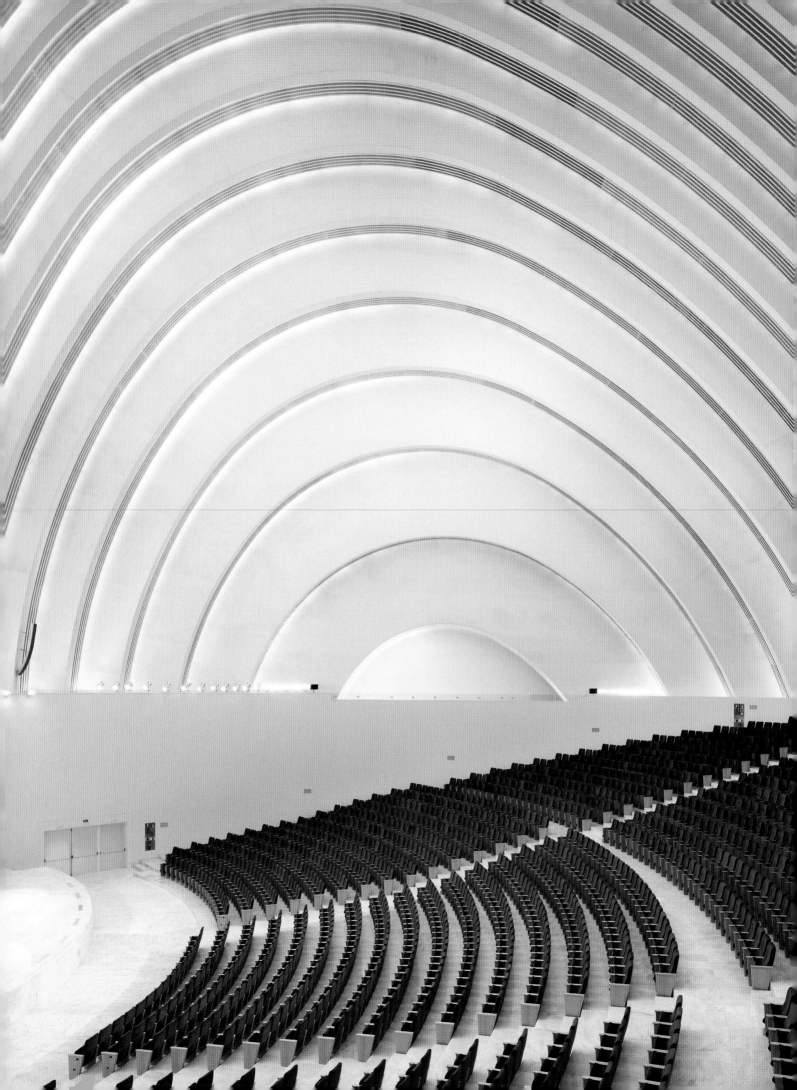

Project

CONFERENCE AND EXHIBITION CENTER

Location
OVIEDO, SPAIN

Client
CITY COUNCIL OF OVIEDO AND JOVELLANOS XXI

Site area
184 510 m²

Floor area
16 512 m² (PALACIO DE CONGRESOS); ca. 3200 m² (HALL AND EXHIBITION SPACE)

Capacity
3600 PEOPLE

The architect literally orchestrates the space, with the successive arches of the ceiling and the rows of seats.

Im wahren Sinn des Wortes orchestriert der Architekt den Raum mit den aufgereihten Bogen der Decke und der Sitzreihen.

L'architecte a littéralement orchestré l'espace à travers la succession d'arcs du plafond auxquels répondent les rangées de sièges.

Oviedo, in northern Spain, is the capital of the province of Asturias. This project is made up of a conference and exhibition center, two office buildings, a five-star hotel, an underground shopping center, and a three-story parking garage that is also below grade. The hotel and office buildings are raised 20 meters above ground level and are covered with parallel horizontal strips of white steel and glass. These structures, lifted up on steel beams, form a U shape that partially surrounds the conference and exhibition area, leaving the ground level accessible to the public. Aside from its main auditorium, the conference and exhibition center has sixteen further rooms for seminars, press conferences, as well as 3200 square meters of event and exhibition space. According to the architect, "The new conference and exhibition center was conceived as a singular sculptural element located over a great concourse. Its elliptical shape, which is covered by a layer of glass and steel, was designed to aid in the building's acoustics and provides maximum sound quality during concerts and other musical events." A cantilevered steel ribbed brisesoleil with operable elements marks the main entrance to the north.

Oviedo im Norden Spaniens ist die Hauptstadt der Provinz Asturien. Dieses Projekt besteht aus einem Kongress- und Ausstellungszentrum, zwei Bürogebäuden, einem Fünf-Sterne-Hotel, einem unterirdischen Einkaufszentrum und einer dreigeschossigen Tiefgarage. Das Hotel und die Bürobauten sind 20 m über Geländeniveau angelegt und mit parallel angeordneten Horizontalstreifen aus weißem Stahl und Glas überzogen. Diese auf Stahlträgern angehobenen Gebäude bilden eine U-Form, die den Kongress- und Ausstellungsbereich teilweise umgibt und die Erdgeschossfläche für das Publikum zugänglich macht. Das Kongress- und Ausstellungszentrum enthält außer dem großen Zuschauersaal 16 weitere Räume für

Seminare, Pressekonferenzen sowie 3200 m² Fläche für Veranstaltungen und Ausstellungen. Der Architekt erläutert: „Das neue Kongress- und Ausstellungszentrum wurde als frei stehendes, skulpturales Element über einer großen Freifläche geplant. Seine elliptische Form, die mit einer Schicht aus Glas und Stahl umgeben ist, trägt zur Verbesserung der Akustik und der Klangqualität bei Konzerten und anderen Musikveranstaltungen bei." Vorkragende, gerippte und verstellbare Sonnenschutzelemente aus Stahl kennzeichnen den Haupteingang an der Nordseite.

Oviedo est la capitale de la province espagnole septentrionale des Asturies. Ce projet comprend un centre de conférences et d'expositions, deux immeubles de bureaux, un hôtel cinq-étoiles, ainsi qu'un centre commercial et un parking de trois niveaux souterrains. L'hôtel et les immeubles sont suspendus à 20 mètres au-dessus du niveau du sol et habillés de bandes horizontales de verre et d'acier laqué blanc. Ils reposent sur un ensemble de poutres d'acier et forment un U qui entoure le centre de conférences et d'expositions en laissant le sol à la circulation des piétons. En dehors de l'auditorium principal, le Centre possède seize salles de séminaires et de conférences de presse et 3200 mètres carrés d'espaces pour expositions et manifestations diverses. Pour l'architecte : « Le nouveau Centre de conférences et d'expositions est un élément sculptural singulier implanté sur un vaste espace libre. Sa forme elliptique, habillée d'une strate de verre et d'acier, a été conçue pour contribuer à la performance acoustique du bâtiment et offrir le maximum de protection sonore pendant les concerts et autres événements musicaux. » Un brise-soleil à nervures d'acier en porte-à-faux doté d'éléments mobiles signale l'entrée principale située au nord.

514

The bold forms of the architecture almost
surpass what is suggested in the watercolor
drawing by Calatrava to the right.

Die kühnen Formen der Architektur wirken
noch stärker, als Calatravas kolorierte Zeich-
nung (rechts) es vermuten lässt.

Les formes audacieuses de l'architecture
surpassent ce que le dessin à l'aquarelle de
Calatrava suggérait (à droite).

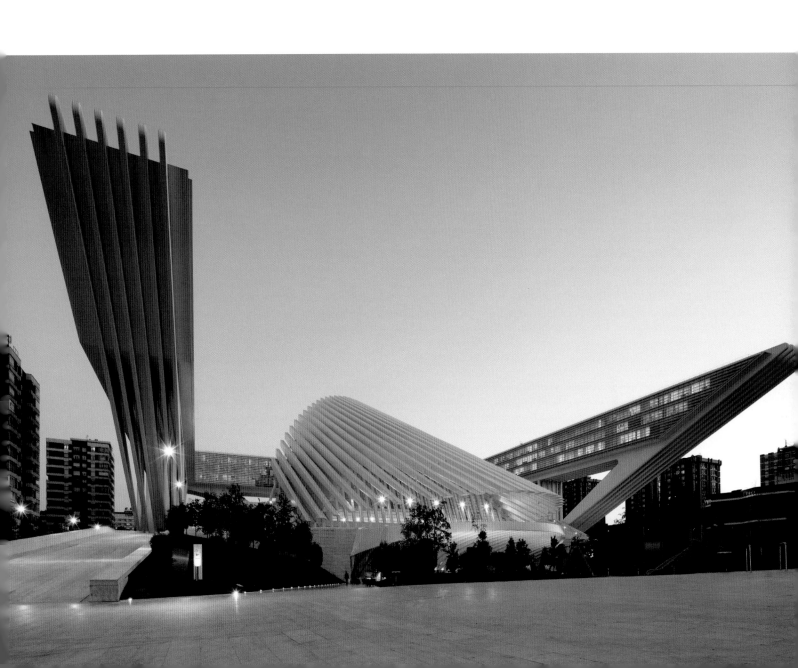

Concepts related to bridge design are at work in this project, where usable space is lifted so high that it seems not to have any weight.

In diesem Projekt wurden Konzepte der Brückengestaltung realisiert, bei denen der funktionale Bereich derart angehoben ist, dass er völlig gewichtslos erscheint.

Des concepts techniques soutenant l'esthétique du pont ont été appliqués ici. L'espace utile est suspendu à une telle hauteur qu'il semble impondérable.

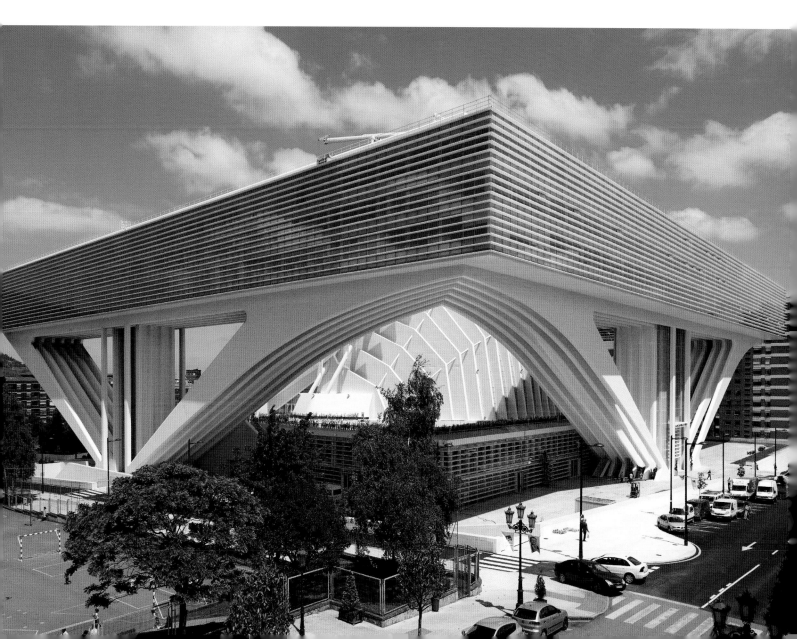

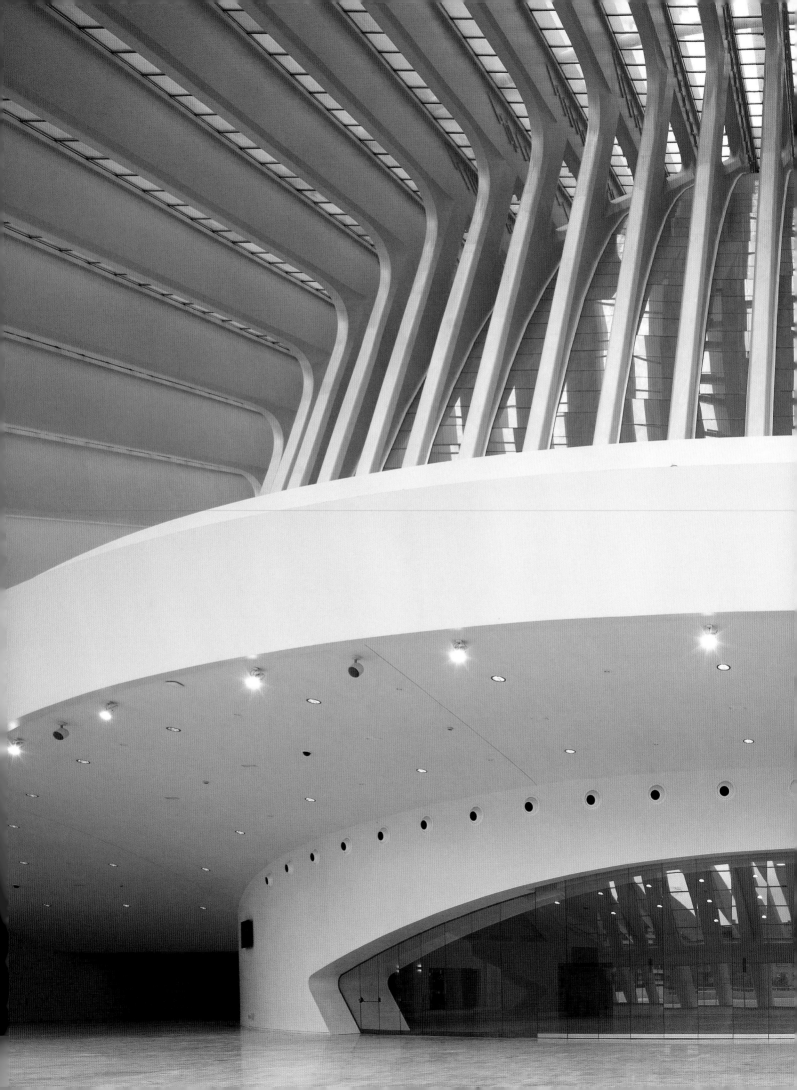

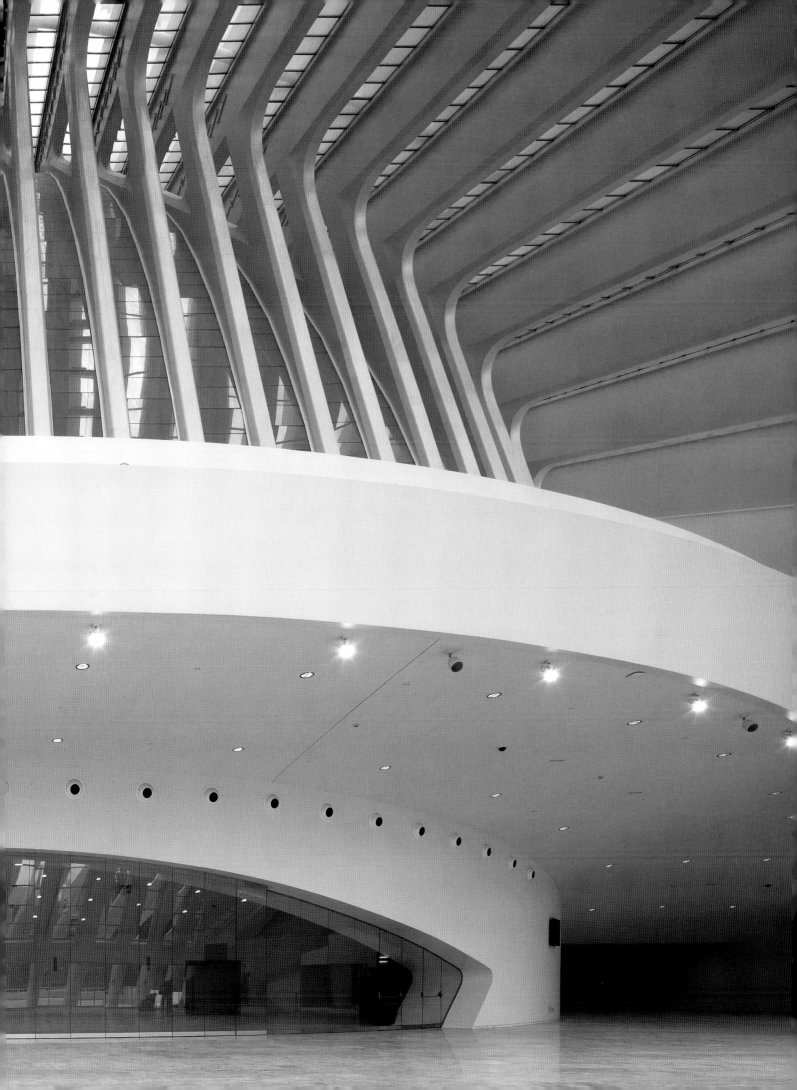

MEDIOPADANA STATION

Reggio Emilia, Italy. 2002–2014.

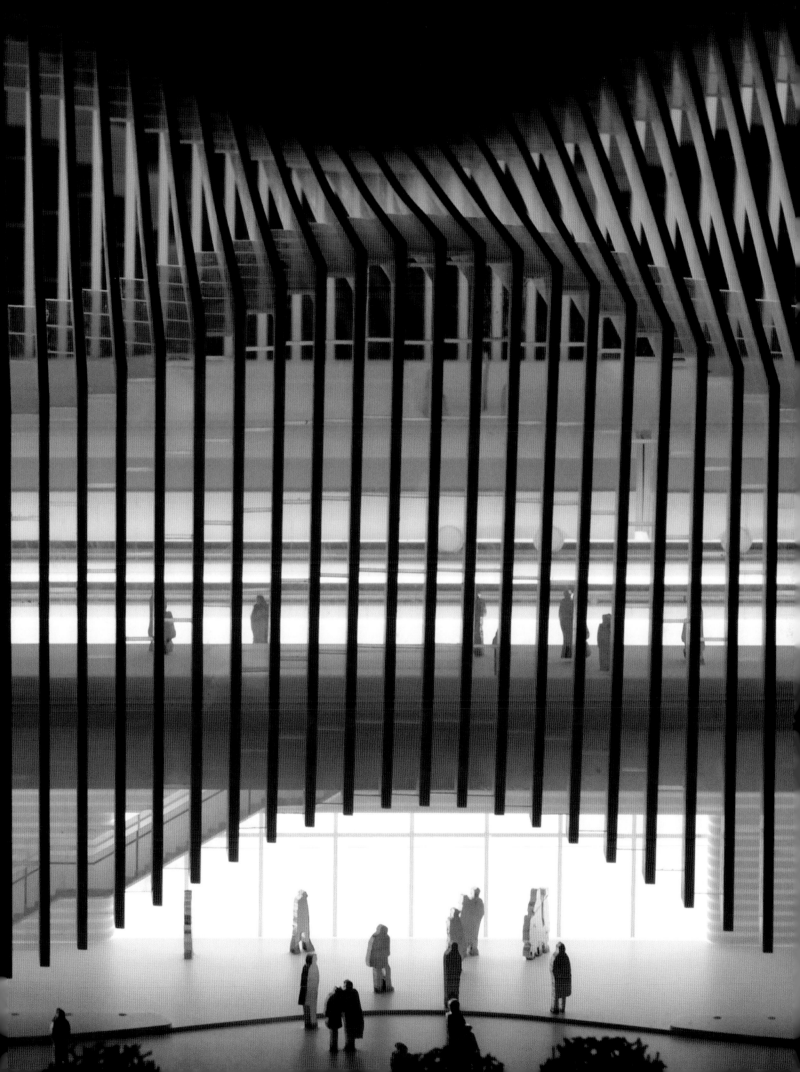

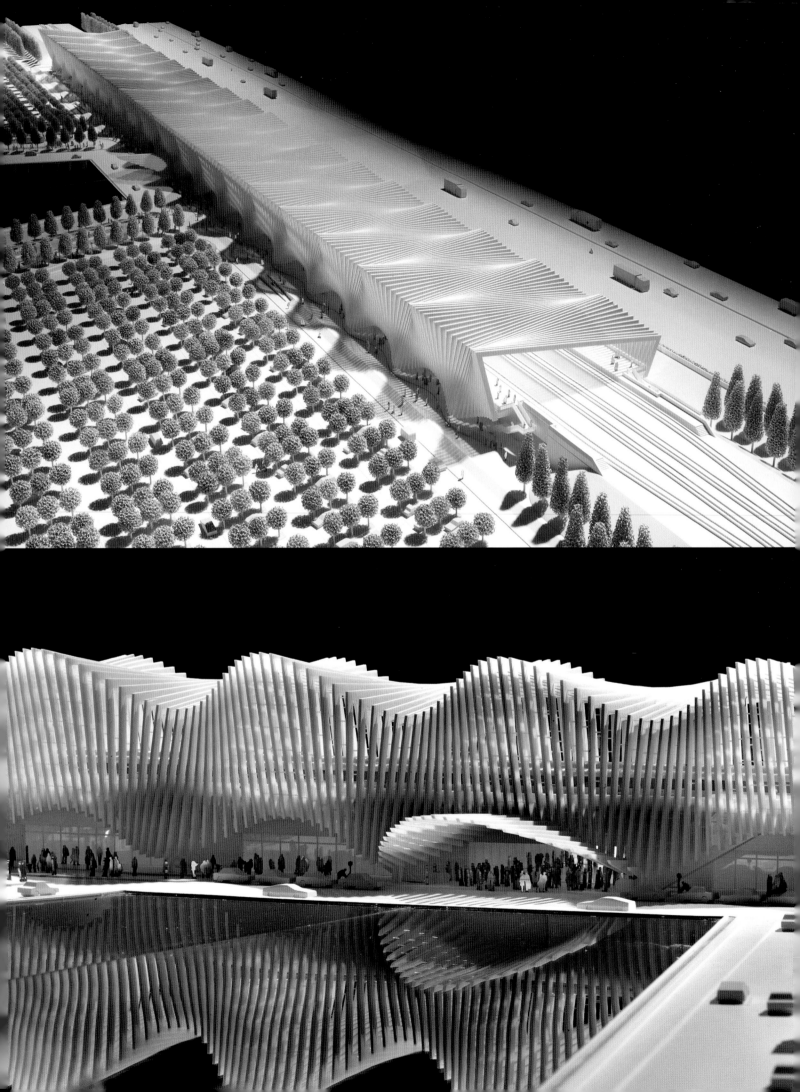

Project
MEDIOPADANA STATION

Location
REGGIO EMILIA, ITALY

Client
COMUNE DI REGGIO EMILIA E TRENO AD ALTA VELOCITÀ SPA (TAV)

Site area
150 000 m²

Floor area
30 000 m²

Total length
495 METERS

Cost
€ 70 MILLION ESTIMATED

Made up of successive tilted shed-like forms and an undulating surface, the station appears to fully accept the movement to which it is dedicated, rather than posing as an immovable mass.

Dieser Bahnhof mit einer Folge geneigter, sheddachähnlicher Formen und einer wellenförmigen Fläche scheint die Bewegung vollkommen aufzunehmen, für die er vorgesehen ist, anstatt eine unbewegliche Masse zu bilden.

Composée d'une succession d'arches protectrices au profil ondulé, la gare semble anticiper le mouvement à laquelle elle est dédiée, plutôt que de se présenter sous la forme d'une masse inamovible.

This station was conceived for Reggio Emilia as a new northern gateway to the city. The program includes not only the high-speed train station, but also a comprehensive master plan with bridges, a highway toll station, and other infrastructure intended to facilitate access to the city. The three new bridges were inaugurated in 2007. Located four kilometers north of the city center, the Mediopadana Station is the only local stop on the Milan–Bologna high-speed railway line. Visible from the nearby A1 highway, the station is recognizable as a new landmark. The design brief called for the canopy of the station and the platforms to be built independently from an existing viaduct. The architect explains, "The repetition of a 25.4-meter-long module consists of a succession of 25 steel portals spaced approximately one meter apart. The repetition of the sequence reaches the total length of 483 meters, which creates a dynamic wave effect. The wave lines on both the floor plan and elevation give rise to a three-dimensional sinusoidal volume. The glass canopy and façade, realized by placing the laminated glass between the portals by means of an aluminum frame, covers the entire length of the platforms." As has been the case in earlier Calatrava projects, such as the one in Lisbon, the main entrance in Reggio Emilia is marked by a projecting canopy, opening onto a landscaped piazza and 300 parking spaces.

Dieser Bahnhof für Reggio Emilia wurde als nördlicher Zugang zur Stadt geplant. Der Auftrag umfasste nicht nur einen Bahnhof für Hochgeschwindigkeitszüge, sondern auch einen weiterführenden Masterplan mit Brücken, einer Mautstation an der Autobahn sowie weitere Infrastruktur, die den Zugang zur Stadt erleichtern soll. Die drei neuen Brücken wurden 2007 eröffnet. Der vier Kilometer nördlich vom Stadtzentrum gelegene Bahnhof Mediopadana ist der einzige Halt an der Hochgeschwindigkeitsstrecke von Mailand nach Bologna und von der nahen Autobahn A1 als neues Wahrzeichen erkennbar. Die Ausschreibung forderte, dass die Überdachung des Bahnhofsgebäudes und der Bahnsteige unabhängig von einem bestehenden Viadukt errichtet werden sollte. Der Architekt erläutert: „Die

Wiederholung eines 25,4 m langen Moduls führt zu einer Abfolge von 25 Stahlportalen in einem Abstand von jeweils einem Meter. Diese Sequenz erreicht eine Gesamtlänge von 483 m und erzeugt eine dynamische Wellenwirkung. Die Wellenlinien sowohl im Grundriss als auch in der Ansicht lassen ein dreidimensionales, sinusförmiges Volumen entstehen. Schutzdach und Fassade bestehen aus Verbundglas, das in einem Aluminiumrahmen zwischen die Portale gesetzt wurde und die gesamte Länge der Bahnsteige abdeckt." Wie auch bei anderen Projekten Calatravas, zum Beispiel dem Bahnhofsgebäude in Lissabon, markiert ein vorkragendes Schutzdach den Haupteingang des Bahnhofs in Reggio Emilia, der sich zu einer gärtnerisch gestalteten Piazza und 300 Parkplätzen öffnet.

Cette gare située à Reggio Emilia a été conçue comme une nouvelle porte d'entrée de la ville. Le programme couvrait à la fois une gare pour les trains à grande vitesse et un plan directeur comprenant des ponts, une station de péage autoroutier et diverses infrastructures pour faciliter l'accès à la ville. Les trois nouveaux ponts ont été inaugurés en 2007. Située à quatre kilomètres au nord du centre-ville, la gare est le seul arrêt sur la ligne à grande vitesse Milan-Bologne. Visible de l'autoroute A1 qui la longe, elle présente une dimension monumentale. L'appel à candidature prévoyait que la verrière de couverture de la gare et des quais soit indépendante du viaduct existant. « La répétition d'un module de 25,4 mètres de long, explique Calatrava, forme une succession de 25 portails en acier espacés d'environ un mètre chacun. Cette séquence répétitive atteint une longueur totale de 483 mètres, et crée un effet de vague dynamique. Ce mouvement de vague visible, tant à proximité du sol qu'en partie haute, délimite un volume sinusoïdal en trois dimensions. La verrière et la façade, réalisée en panneaux de verre feuilleté posés dans un cadre en aluminium entre les portiques, protègent les quais sur toute leur longueur. » Comme dans certains projets antérieurs de l'architecte, dont celui de la gare de Lisbonne, l'entrée principale est signalée par un auvent en projection, qui se déploie vers une place paysagée et un parking de 300 places.

Again, arching bridge-like forms become the leitmotif of the station, whose waves imply and accompany the movement of the trains.

Auch hier werden die gebogenen, brücken-ähnlichen Formen zum Leitmotiv des Bahn-hofs, dessen Wellen die Bewegung der Züge aufnehmen und begleiten.

Ces éléments en forme de pont sont le leitmotiv de cette gare dont le mouvement en vague continue accompagne le déplacement des trains.

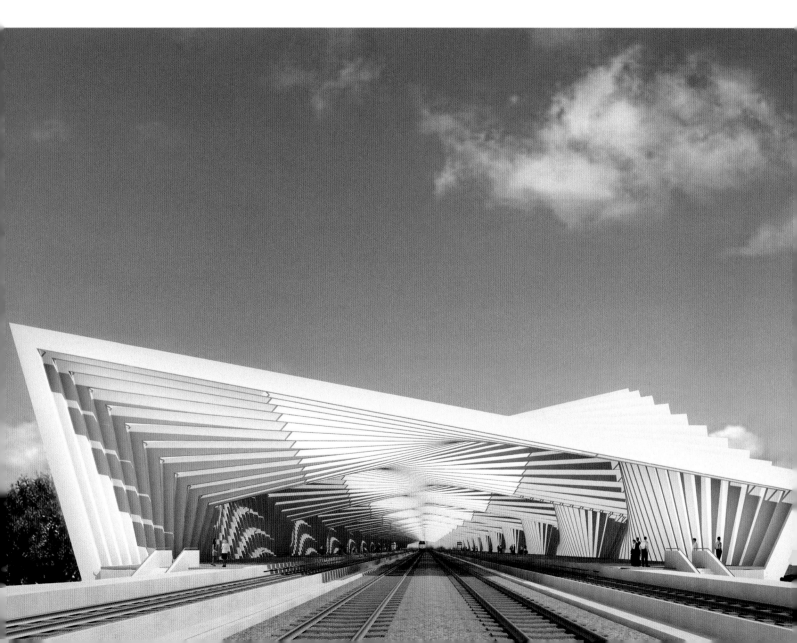

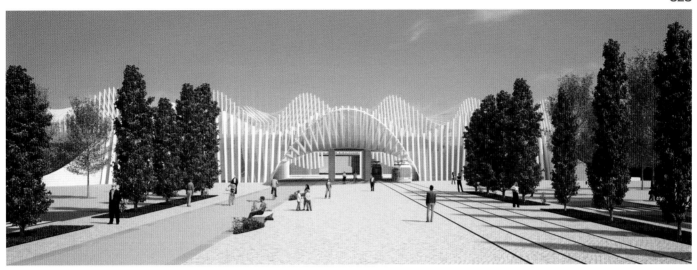

The architect makes his basic forms accommodate their purpose, as in the cantilevered canopy seen below, and from ground level in the computer-generated image above.

Der Architekt passt seine Grundformen ihrer Funktion an, wie das Bild des auskragenden Vordachs (unten) und die Sicht von der Erdgeschossebene aus auf der computererzeugten Abbildung (oben) zeigen.

Ces formes basiques sont adaptées à leur objectif, comme dans l'auvent ci-dessous, et dans l'image de synthèse d'une vue au niveau du sol, ci-dessus.

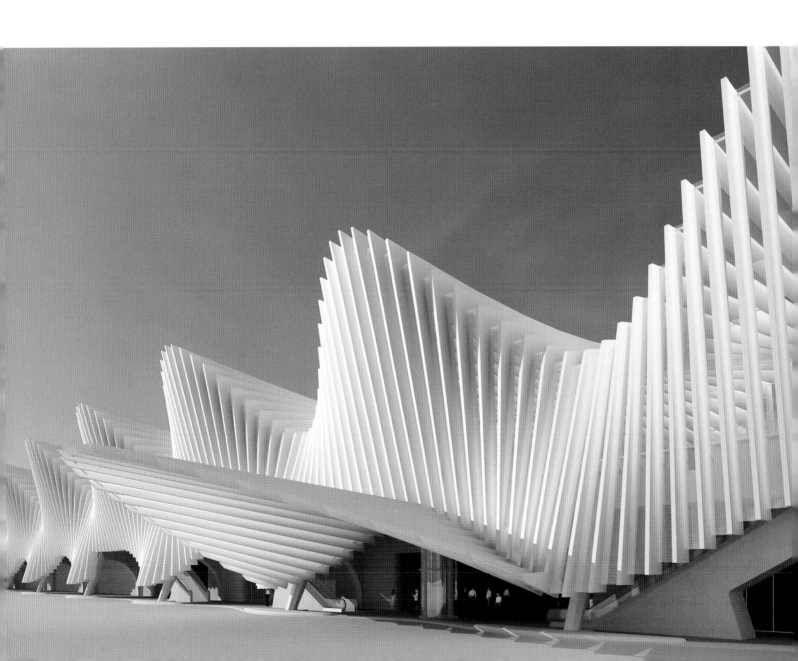

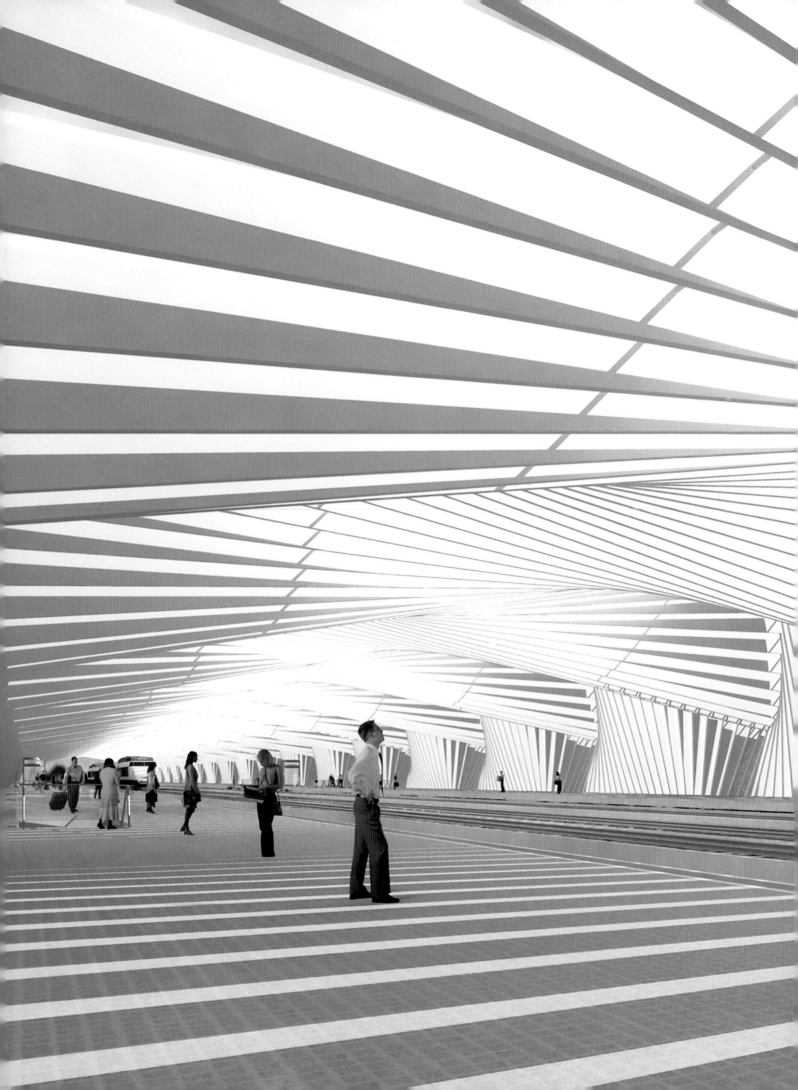

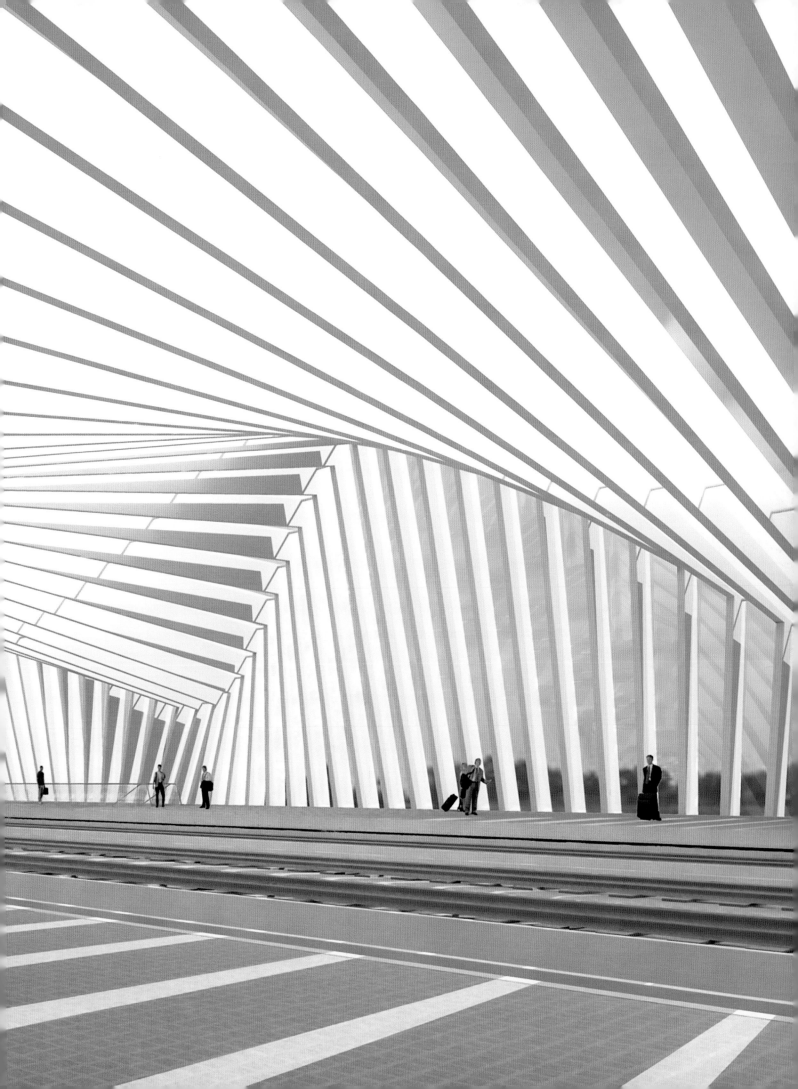

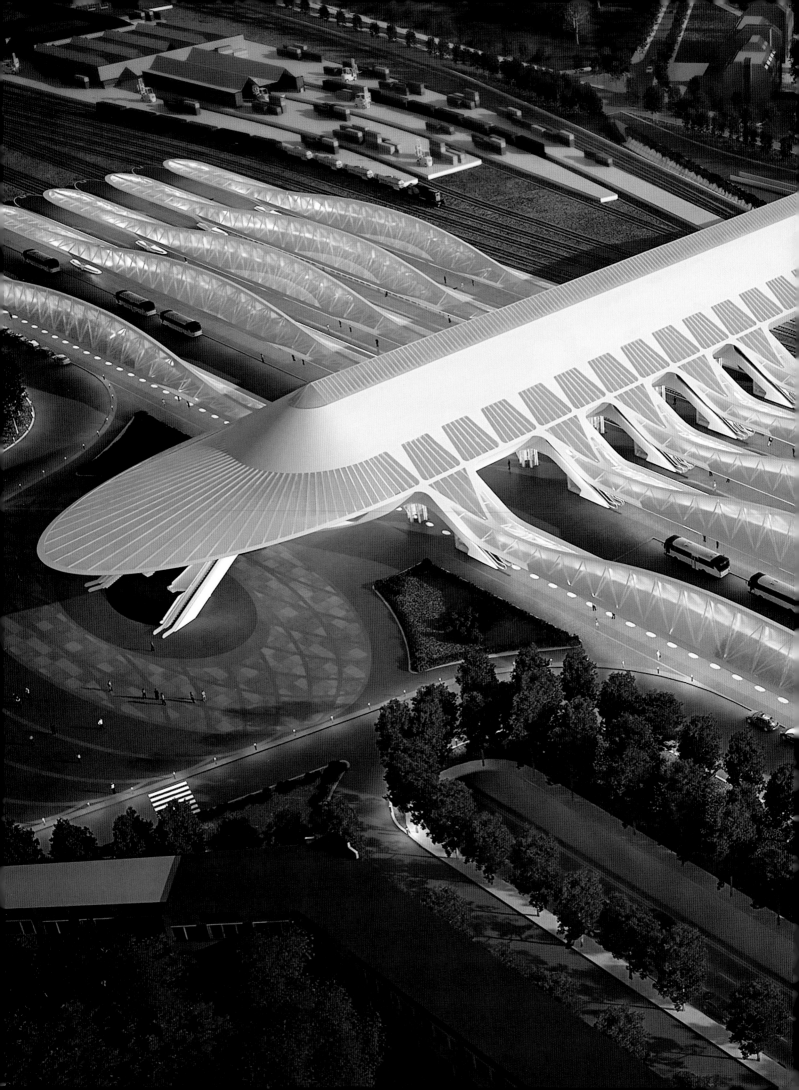

MONS STATION

Mons, Belgium. 2006–.

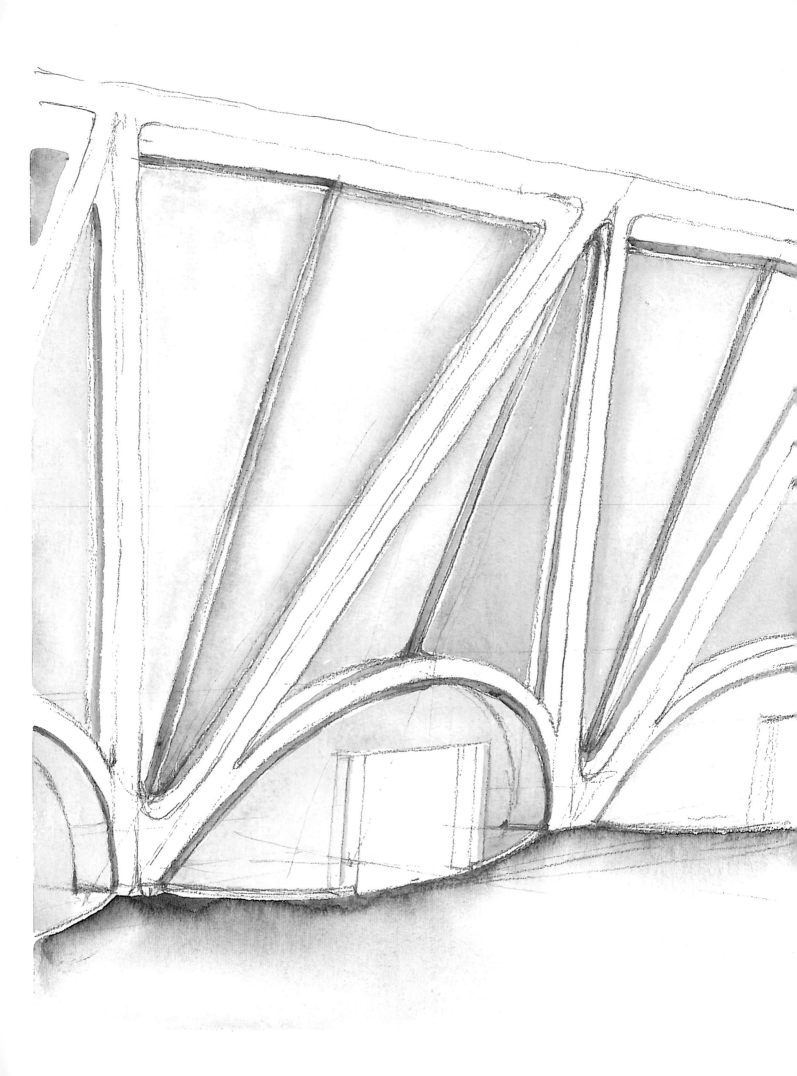

Project
MONS STATION

Location
MONS, BELGIUM

Client
SOCIÉTÉ NATIONALE DES CHEMINS DE FER BELGES (SNCB)

Length
200 METERS (GALLERY); 350 METERS (PLATFORM ROOFS)

Site area / Construction area
37 850 m² / 42 500 m²

Cost
€ 125 MILLION ESTIMATED

Calatrava's vocabulary of forms frees interior space to a point where the great railway architecture of the past is evoked in terms of grandeur.

Calatravas Formenvokabular stellt den Innenraum in einem Maße frei, das die großartige Eisenbahnarchitektur der Vergangenheit wachruft.

Le vocabulaire des formes de Calatrava lui permet de libérer l'espace intérieur au point d'évoquer la grandeur de l'architecture des gares du passé.

Calatrava was commissioned to design a new multi-modal railway station and its surrounding infrastructure after winning a design competition in 2006. The station's gallery forms a bridge over the tracks and platforms, linking two formerly disconnected and distinct areas of the city: a residential area to the north and the historic city to the south. Five hundred underground parking spaces are to be located at the station's south entrance. To the north of the station, an underground structure with utility rooms and 350 parking spots is being created beneath the new Place de Congrès. Santiago Calatrava explains, "Mons is due to be the European Capital of Culture in 2015 and one might compare the station we are designing there to a 'library' as opposed to the cathedral-like volume of the Liège station. In the case of the University Library in Zurich (Law Faculty, Zurich, 1989–2004), I used wood and steel, an idea applied here to create a much more intimate atmosphere than in a larger station. The exterior of the station is in glass, but the interior is made with a steel frame and a great deal of wood, in consideration of the ecological concerns of the city. The skylight of the central gallery will be moveable to allow natural ventilation."

Nachdem Calatrava 2006 einen Wettbewerb gewonnen hatte, wurde er mit der Planung eines neuen, multimodalen Bahnhofs einschließlich dazugehöriger Infrastruktur beauftragt. Die Galerie des Bahnhofsgebäudes bildet eine Brücke über den Bahnsteigen und Gleisen, die zwei bisher getrennte Stadtviertel miteinander verbindet: ein Wohngebiet im Norden und die historische Altstadt im Süden. Unter dem Südausgang soll eine Tiefgarage mit 500 Parkplätzen angelegt werden. Nördlich vom Bahnhof entsteht unter der neuen Place de Congrès unterirdisch ein Bau mit Versorgungseinrichtungen und 350 Parkplätzen. Calatrava erklärt: „Mons soll 2015 europäische Kulturhauptstadt werden, und man kann den von uns dort geplanten Bahnhof mit einer ‚Bibliothek' vergleichen, im Gegensatz zu der einer Kathedrale gleichenden Baumasse des Bahnhofs in Lüttich. Für die Universitätsbibliothek in Zürich (Juristische Fakultät, Zürich, 1989–2004) verwendete ich Holz und Stahl – hier hatte ich die gleiche Idee, um eine intimere Atmosphäre als auf einem größeren Bahnhof zu erzeugen. Das Äußere des Gebäudes ist mit Glas verkleidet, aber das Innere besteht aus einem Stahlskelett und viel Holz in Bezug auf das ökologische Engagement der Stadt. Die Oberlichter der zentralen Galerie ermöglichen eine natürliche Belüftung."

Calatrava a reçu commande de cette nouvelle gare multimodale et de diverses installations d'accompagnement à l'issue d'un concours organisé en 2006. Une galerie en forme de pont, qui franchit les voies et les quais, relie deux quartiers de la ville jusque là séparés : une zone résidentielle au nord et la ville historique au sud. Les 500 places du parking souterrain sont accessibles de l'entrée sud. Au nord, une structure également en sous-sol regroupant diverses installations techniques et 350 places de parking est en cours de construction sous la nouvelle place de Congrès. Pour Santiago Calatrava : « Mons sera la capitale européenne de la culture en 2015 et l'on peut rapprocher la gare que nous concevons ici de l'esprit d'une bibliothèque, comparativement au volume de cathédrale de celle de Liège. Dans le cas de la bibliothèque universitaire de Zurich (Faculté de droit, Zurich, 1989–2004), j'ai utilisé le bois et l'acier, idée retenue ici pour créer une atmosphère nettement plus intime que dans une gare plus importante. L'extérieur est en verre, mais l'intérieur à ossature d'acier utilise beaucoup de bois, pour prendre en considération les préoccupations écologiques de la ville. Les puits de lumière de la galerie centrale sont conçus pour permettre une ventilation naturelle. »

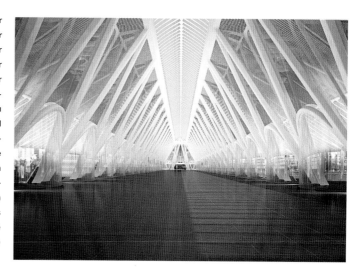

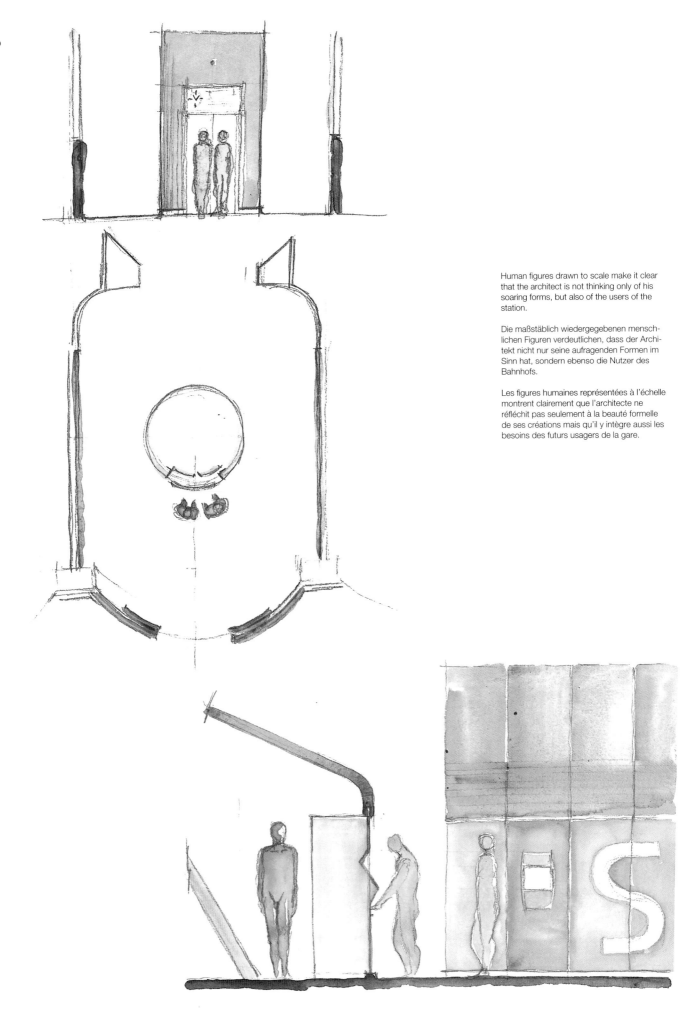

Human figures drawn to scale make it clear that the architect is not thinking only of his soaring forms, but also of the users of the station.

Die maßstäblich wiedergegebenen menschlichen Figuren verdeutlichen, dass der Architekt nicht nur seine aufragenden Formen im Sinn hat, sondern ebenso die Nutzer des Bahnhofs.

Les figures humaines représentées à l'échelle montrent clairement que l'architecte ne réfléchit pas seulement à la beauté formelle de ses créations mais qu'il y intègre aussi les besoins des futurs usagers de la gare.

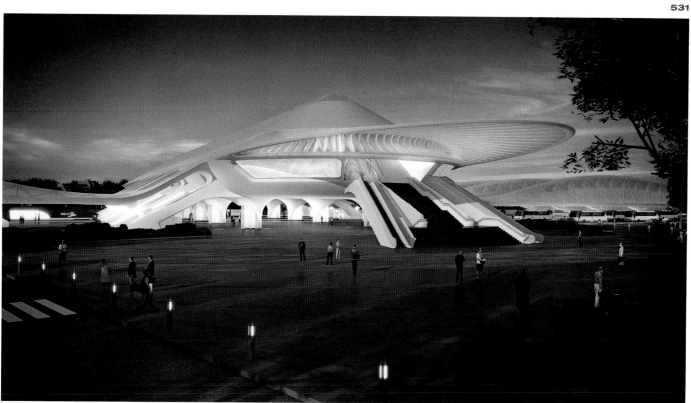

Angles and curves dominate the design, which has a decidedly futuristic aspect in the image above. Diagonals, like the one seen in the sketch below, give a dynamic aspect to the spaces.

Schrägen und Kurven beherrschen den Entwurf, der in der Abbildung oben entschieden futuristische Aspekte aufweist. Die Diagonalen, wie sie die Skizze unten zeigt, verleihen den Räumen einen dynamischen Charakter.

Dans l'illustration ci-dessus, courbes et inclinaisons dominent ce projet d'aspect résolument futuriste. L'utilisation d'éléments en diagonale dans le dessin ci-dessous confère à ces espaces un aspect dynamique.

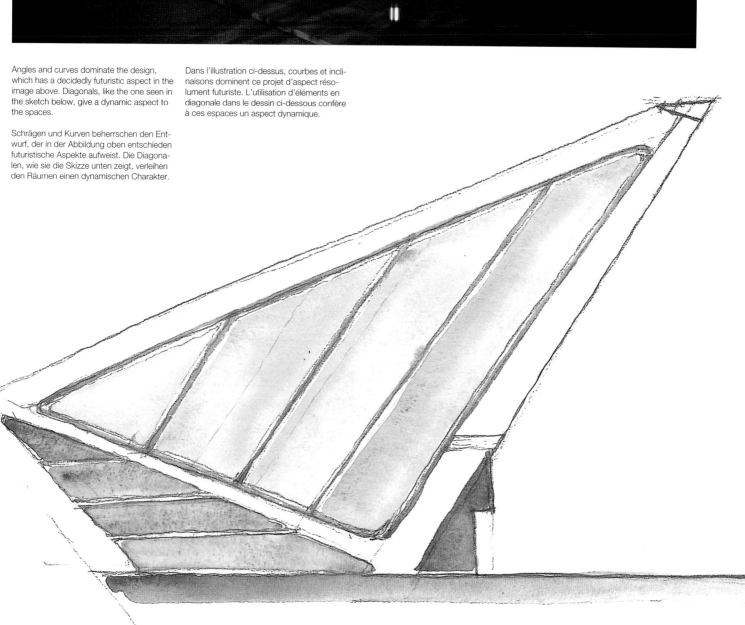

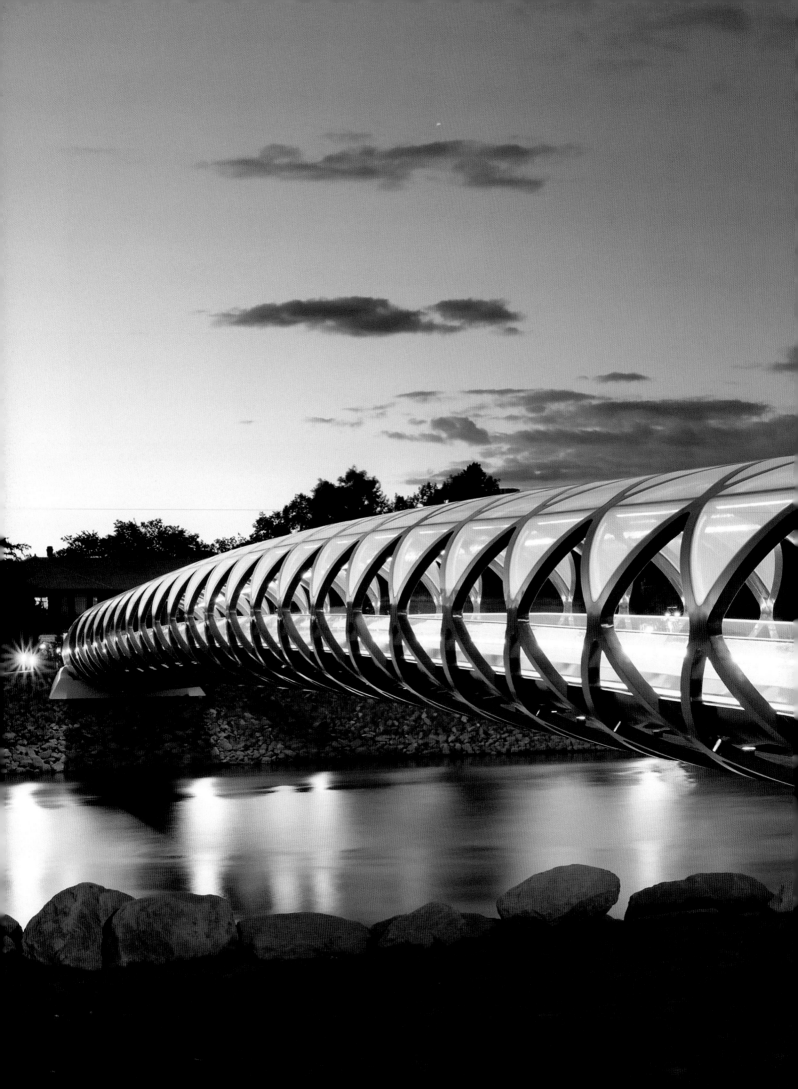

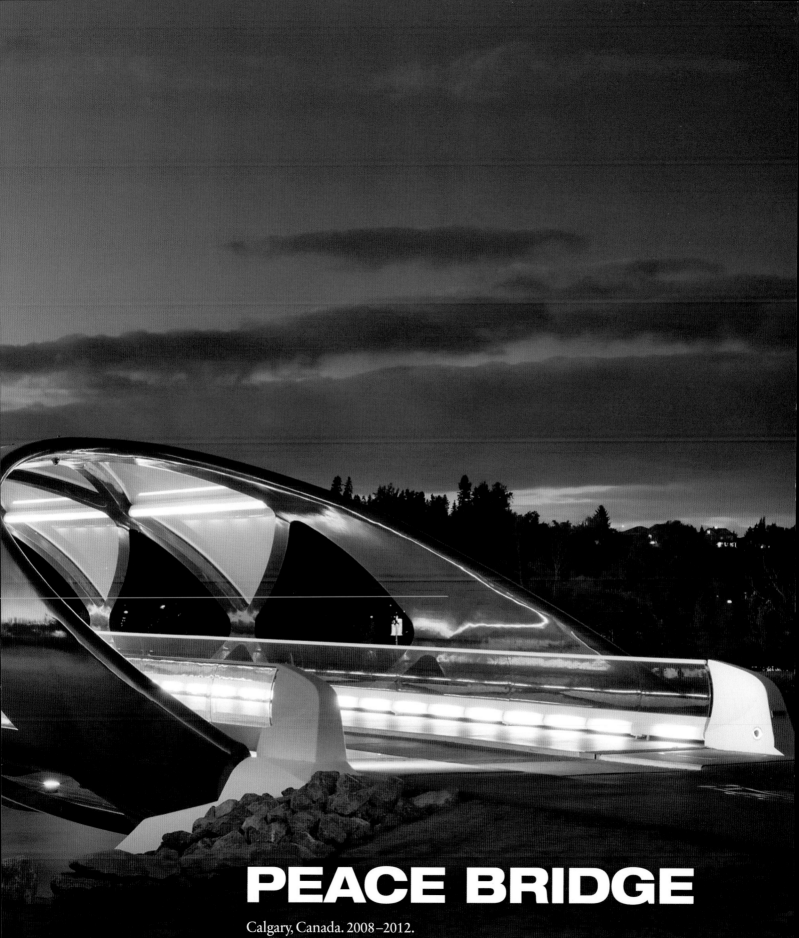

PEACE BRIDGE

Calgary, Canada. 2008–2012.

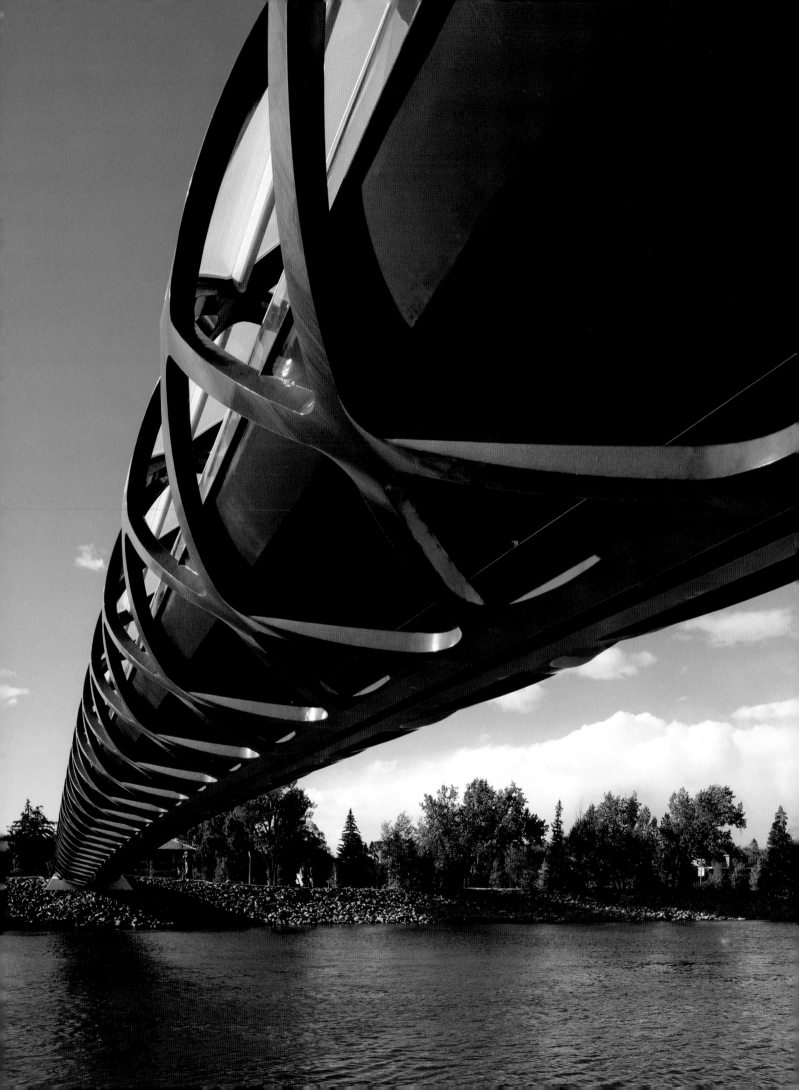

Project
PEACE BRIDGE

Location
CALGARY, CANADA

Client
CITY OF CALGARY

Height / length / width
5.85 x 126 x 8 METERS

Span
130 METERS

Cost
$ 18 MILLION

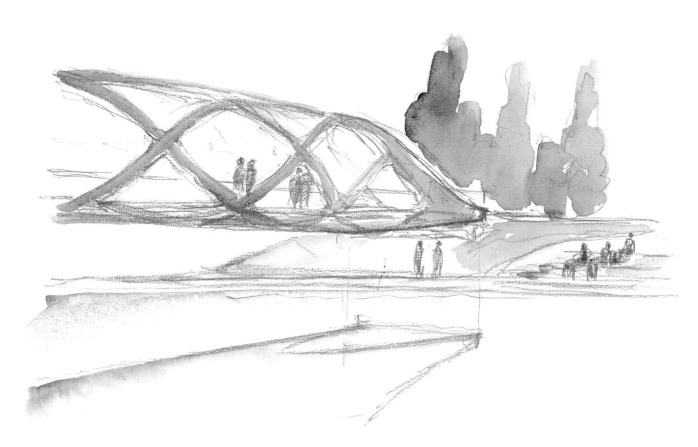

This new pedestrian and bicycle bridge connects Sunnyside on the north side of the Bow River with the modern downtown area of Eau Claire on the south. With a length measuring 126 meters, the bridge structure is 8 meters wide and 5.85 meters high. The architect explains that the sculptural shape "is defined by a helix developed over an oval cross section with two clearly defined tangential radii creating an architectural space within." Glazed panels are bent in the shape of the exterior of the upper part of the helical form and serve to protect users from rain and winter weather. The 2.5-meter-wide bicycle lanes are located in the center of the bridge with two 1.85-meter-wide pedestrian lanes on either side. Lighting is integrated into the structure of the bridge and the handrail, with linear illumination at floor level. Lights below the deck emphasize the underside of the bridge at night, creating reflections in the water.

Diese neue Fußgänger- und Fahrradbrücke verbindet Sunnyside auf der Nordseite des Bow River mit dem modernen Innenstadtbereich Eau Claire im Süden. Die 126 m lange Brückenkonstruktion ist 8 m breit und 5,85 m hoch. Der Architekt erläutert, dass ihre plastische Form aus einer Helix über einem ovalen Querschnitt mit zwei klar begrenzten tangentialen Radien gebildet sei, wodurch im Innern ein architektonischer Bereich entsteht. Im oberen Teil der Helix sind außen in ihrer Form gebogene Glastafeln angebracht, die die Nutzer vor Regen und Kälte schützen. Die 2,5 m breiten Fahrradspuren liegen in der Mitte der Brücke mit je 1,85 m breiten Fußgängerwegen zu beiden Seiten. In die Brückenkonstruktion eingefügt sind die Beleuchtung und das Geländer mit linearer Illumination auf Bodenniveau. Unter der Brückenplatte angebrachte Leuchten betonen die Brückenuntersicht bei Nacht und spiegeln sie im Wasser.

Ce nouveau pont pour piétons et cyclistes relie la rive nord de la Bow River au quartier moderne du centre d'Eau Claire, au sud. D'une longueur de 126 mètres, l'ouvrage mesure 8 mètres de large et 5,85 mètres de haut. L'architecte explique que sa forme sculpturale « est définie par un mouvement hélicoïdal, de coupe ovale, à deux rayons tangentiels clairement matérialisés créant un volume architectural interne. » Les panneaux de verre incurvés suivant le profil de la partie haute protègent les usagers de la pluie et du froid hivernal. Les deux voies centrales pour vélos de 2,5 mètres de large sont encadrées de chaque côté par une voie de 1,85 mètres de large pour piétons. L'éclairage, intégré à la structure et au garde-corps, illumine le sol. Sous le tablier, des éclairages mettent en valeur la sous-face du pont qui se reflète dans l'eau.

The woven helicoidal form of this bridge is unusual in the structural vocabulary of Santiago Calatrava. It does bring to mind natural forms, particularly in his sketches.

Die verflochtene, spiralförmige Gestalt dieser Brücke ist ungewöhnlich im konstruktiven Vokabular Santiago Calatravas. Sie erinnert, vor allem in seinen Zeichnungen, an Formen aus der Natur.

La forme hélicoïdale, comme tissée, de cet ouvrage est inhabituelle dans le vocabulaire structurel de Santiago Calatrava. Elle rappelle certaines formes naturelles, en particulier dans les croquis.

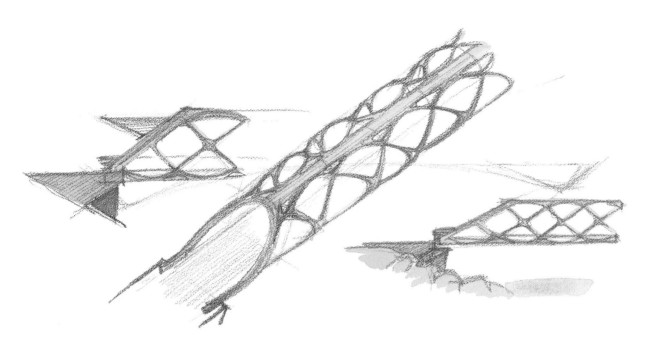

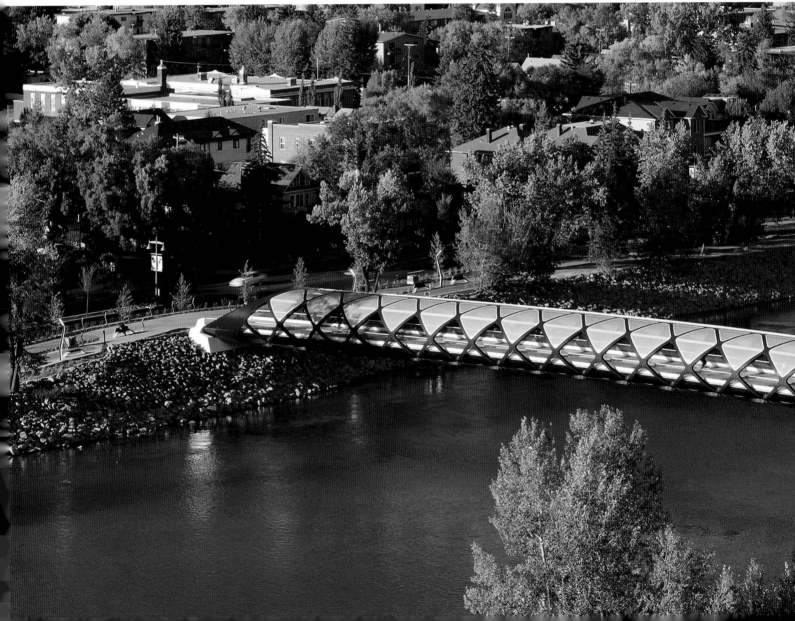

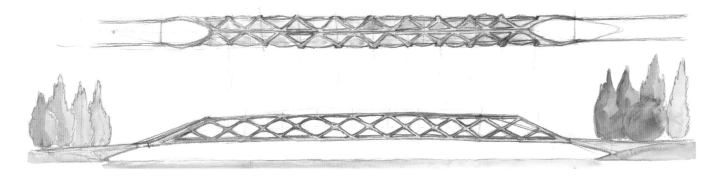

Low like the surrounding landscape and architectural environment, the bridge may bring to mind vegetal or biological forms (veins).

Flach wie die Landschaft und die umgebende Bebauung, zeigt diese Brücke einen Anklang an vegetative oder biologische Formen (Adern).

Surbaissé, à l'image de son environnement paysager et architectural, le pont pourrait évoquer des formes végétales ou biologiques (veines).

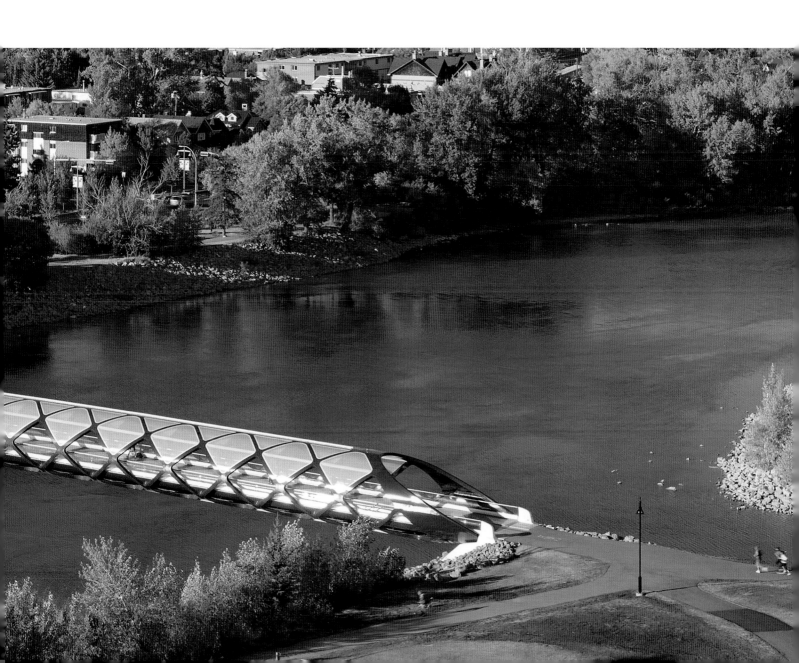

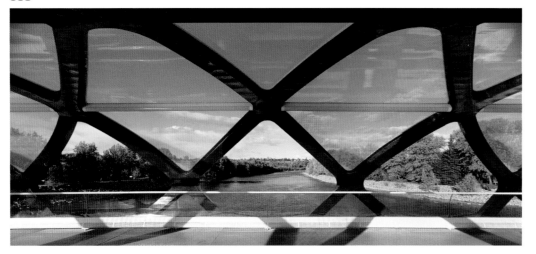

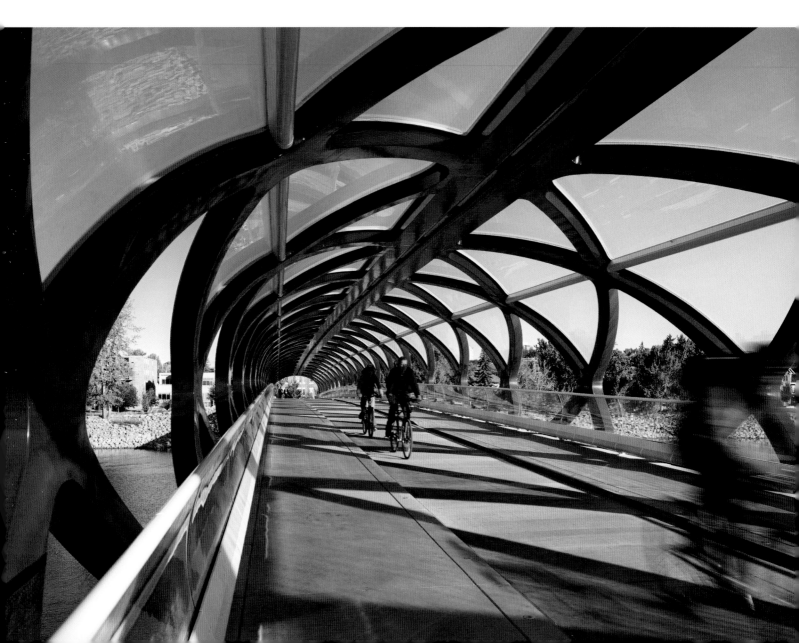

The oval form of the outer structure is designed, as usual with Calatrava, in conjunction with the human scale, as seen in the two sketches on this page.

Die ovale Form der Außenkonstruktion wurde, wie bei Calatrava üblich, im Verbund mit dem menschlichen Maßstab gestaltet, wie die beiden Zeichnungen auf dieser Seite zeigen.

La forme ovale de la structure est conçue, comme d'habitude chez Calatrava, par rapport à l'échelle humaine, comme le montrent les deux croquis de cette page.

The completed bridge emphasizes the flow of movement, almost evoking a kind of natural movement of blood.

Die ausgeführte Brücke unterstreicht den Verkehrsfluss und erinnert entfernt an den natürlichen Kreislauf des Blutes.

L'ouvrage achevé met en valeur le flux des déplacements, évoquant presque une sorte de circulation sanguine.

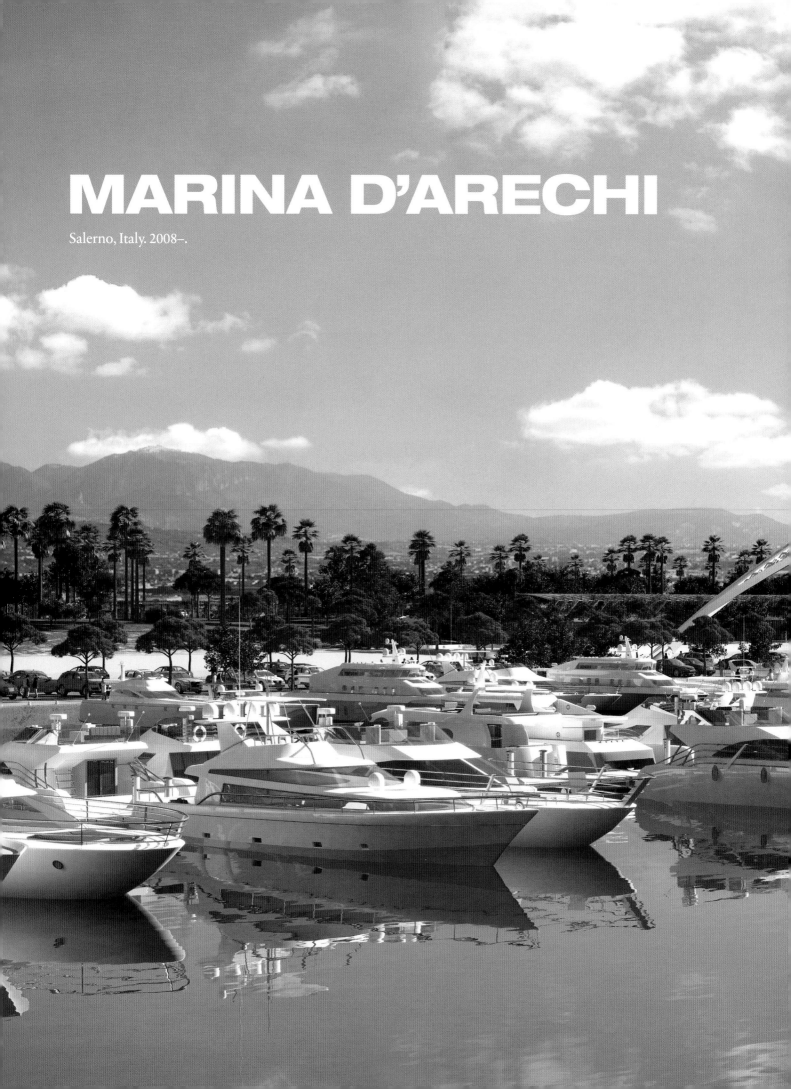

MARINA D'ARECHI

Salerno, Italy. 2008–.

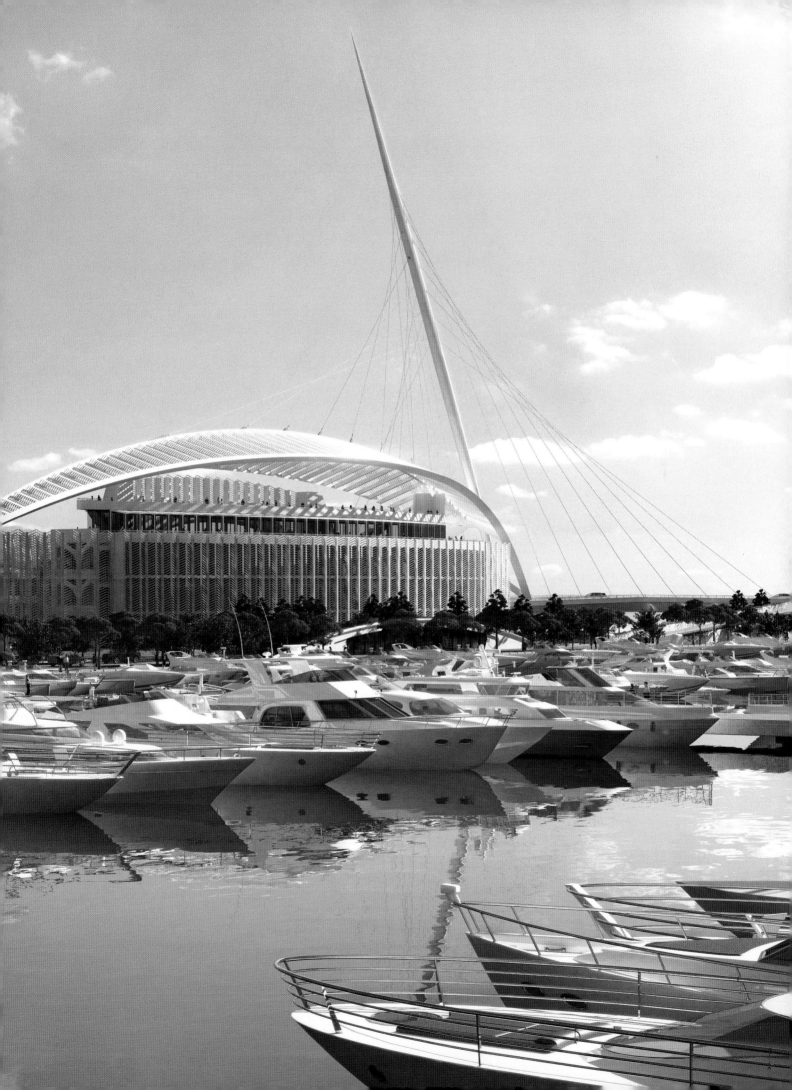

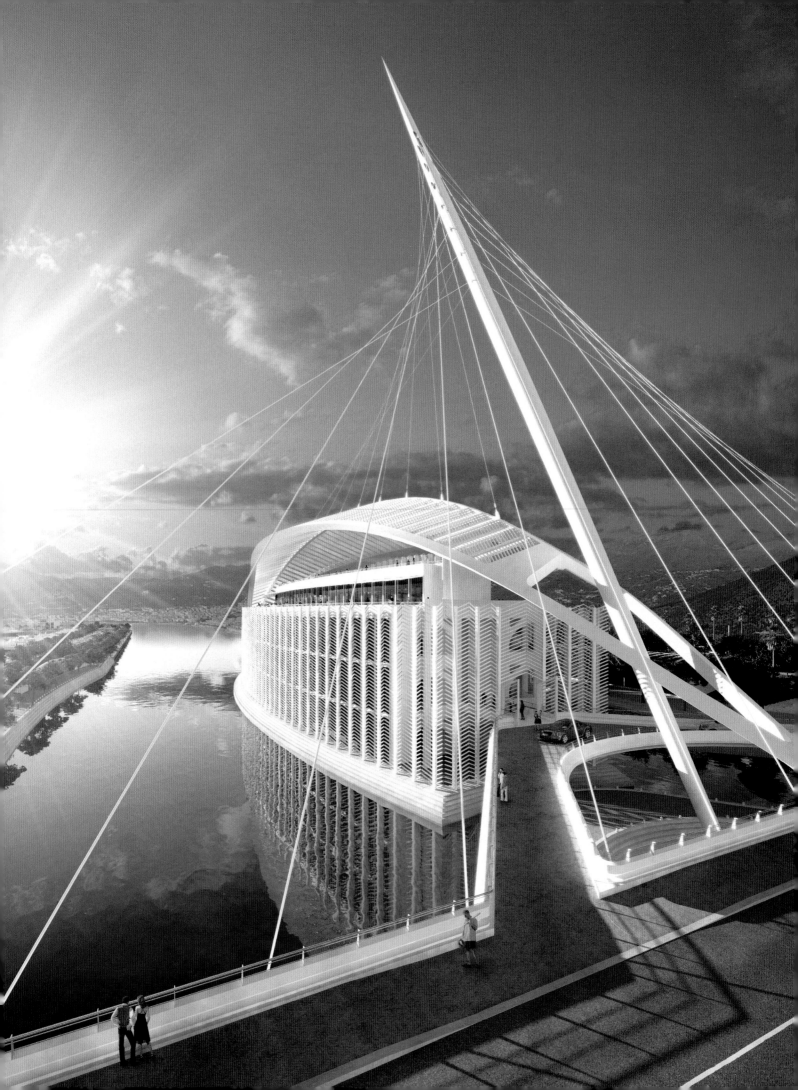

Project
MARINA D'ARECHI

Location
SALERNO, ITALY

Client
GALLOZZI GROUP SPA/SALERNO CONTAINER TERMINAL SPA

Height / length
100 x 105 METERS

Site area
8700 m²

The architect combines bridge and nautical images in this design for a marina. An unusual cable-stayed, overarching roof also evokes the shape of some stadiums.

Der Architekt verbindet in diesem Entwurf die Brücke mit nautischen Bildern zu einer Marina. Das ungewöhnliche seilverankerte, überwölbende Dach erinnert auch an die Form eines Stadions.

Dans ce projet de marina, l'architecte combine le pont et les imageries nautiques. La curieuse toiture en arc suspendue évoque la forme de certains stades.

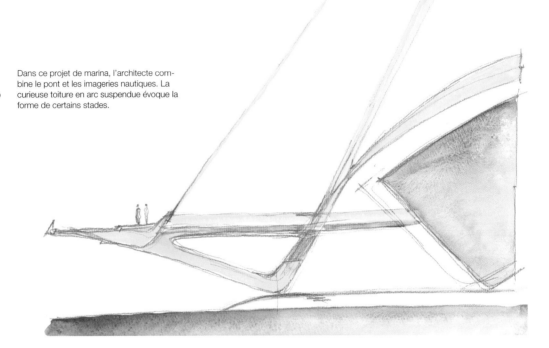

In 2008, the Gallozzi Group commissioned Santiago Calatrava to design a sailing club and a connecting bridge as a centerpiece for the new Marina d'Arechi, located 30 meters off the coast of Salerno. The main element of the project is the Club Nautico Building containing commercial units, restaurants, bars, and a sailing club. A suspension cable bridge provides access from the mainland to the marina while also serving as the primary connection and entrance to first level of the Club Nautico building. The pylon that holds the suspension cables is 100 meters high and is balanced by a 200-meter-long steel roof structure in the form of a leaf which hovers over Club Nautico and its terraces. The club itself is 20 meters high and is shaped like a yacht in plan. The 7000-square-meter structure has four floors, with sun decks on level three and on the roof. Retail and restaurant spaces are located on the two lower levels, and the sailing club is housed in the upper section. An arched exterior gallery runs the length of the building. The façade has a movable lamella system that protects the building from the sun. The suspension cable bridge is 105 meters long, 10.9 meters wide, and serves as the gateway to the marina. Two smaller 30-meter-long pedestrian bridges act as the main entrances to the Club Nautico Building at level one. Small bars, kiosks, and an amphitheater as well as utility spaces are arrayed along a seaside promenade.

Im Jahr 2008 beauftragte die Gallozzi-Gruppe Santiago Calatrava mit der Planung eines Segelklubs und einer Verbindungsbrücke als zentrale Elemente der neuen, 30 m vor der Küste Salernos liegenden Marina d'Arechi. Das Hauptelement des Projekts ist das Gebäude Club Nautico, das kommerzielle Einrichtungen, Restaurants, Bars und einen Segelklub aufnehmen soll. Eine Schrägseil-Hängebrücke führt vom Festland zur Marina und dient auch als Haupterschließung und Eingang zur ersten Ebene des Gebäudes Club Nautico. Der Pylon, welcher die Tragseile hält, ist 100 m hoch und wird von einer 200 m langen Dachkonstruktion in Form eines Blattes entlastet, die über dem Gebäude Club Nautico und seinen Terrassen schwebt. Der eigentliche Bereich des Klubs ist 20 m hoch und hat den Grundriss einer Yacht. Der 7000 m² große Bau hat vier Geschosse mit Sonnenterrassen auf Ebene drei und auf dem Dach. Laden- und Restaurantbereiche befinden sich auf den beiden unteren Ebenen; der Segelklub liegt im oberen Teil. Eine mit Bogen versehene Galerie führt über die gesamte Länge des Gebäudes. Die Fassade ist mit einem verstellbaren Lamellensystem ausgestattet, das den erforderlichen Sonnenschutz bietet. Die Tragseilbrücke ist 105 m lang, 10,9 m breit und dient als Haupterschließung der Marina. Zwei kleinere, 30 m lange Fußgängerbrücken dienen als Zugänge zum Club Nautico auf Ebene eins. Kleine Bars, Kioske und ein Amphitheater sowie Versorgungsräume sind entlang der Uferpromenade angeordnet.

En 2008, le Gallozzi Group a demandé à Santiago Calatrava de concevoir un club de voile et une passerelle d'accès au centre de la nouvelle Marina d'Arechi, à 30 mètres de la côte devant Salerne. L'élement principal du projet est le bâtiment du club nautique regroupant des boutiques, des restaurants, des bars et un club de voile. Un pont suspendu permet l'accès à la marina du rivage, en desservant l'entrée au premier niveau du bâtiment du club nautique. Le pylône de 100 mètres de haut qui soutient les câbles de suspension vient en contrepoint d'une toiture en acier de 200 mètres de long en forme de feuille, suspendue au-dessus du club et de ses terrasses. Le plan du club lui-même, haut de 20 mètres, évoque celui d'un yacht. Le bâtiment de 7000 mètres carrés sur quatre niveaux possède des terrasses sur trois étages et une en toiture. Les locaux commerciaux et les restaurants sont aux deux premiers niveaux et le club lui-même occupe la partie supérieure. Une galerie extérieure en forme d'arc court tout au long du bâtiment. La façade est dotée d'un système de protection solaire à volets mobiles. La passerelle suspendue mesure 105 mètres de long et 10,9 mètres de large. Deux petites passerelles piétonnières de 30 mètres de long constituent les accès principaux au premier niveau du club nautique. Des bars, des kiosques, un amphithéâtre et des bâtiments de service sont aménagés le long de la promenade en bord de mer.

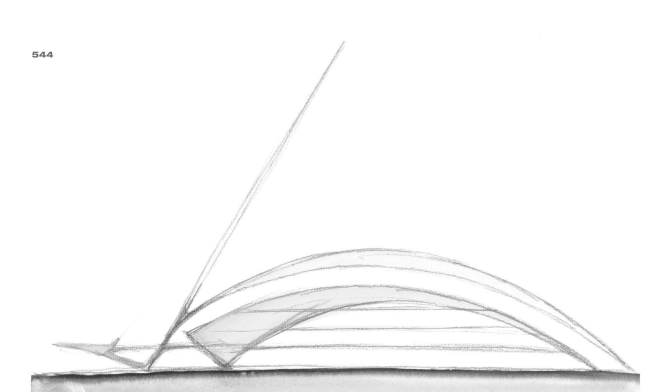

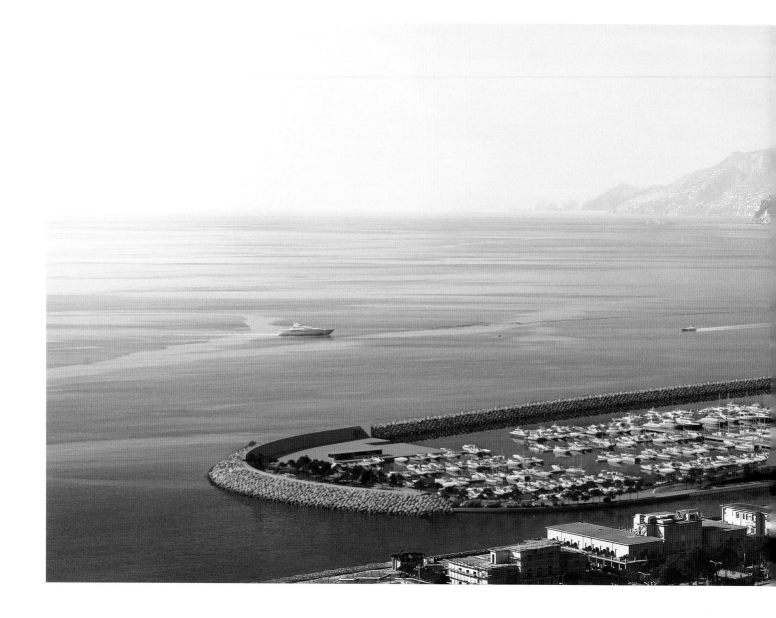

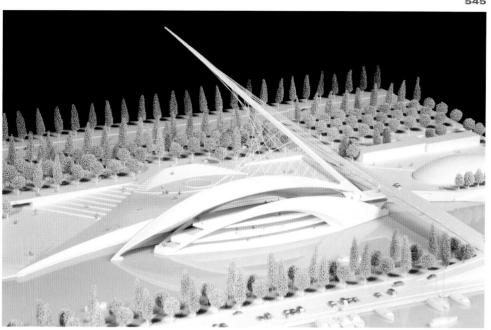

Seen in a sketch (left) a model (right) and a computer-generated image (below) the structure definitely incarnates the image of a very modern boat, with a single inclined mast.

Das Bauwerk verkörpert mit Sicherheit auch das Bild eines sehr modernen Schiffes mit nur einem schrägen Mast, wie auf der Zeichnung (links), einem Modell (rechts) und einer computererzeugten Abbildung (unten) zu sehen.

Vue en croquis (à gauche), sous forme de maquette (à droite) et d'image de synthèse (ci-dessous), la structure évoque un navire un peu futuriste doté d'un unique mât, mais incliné.

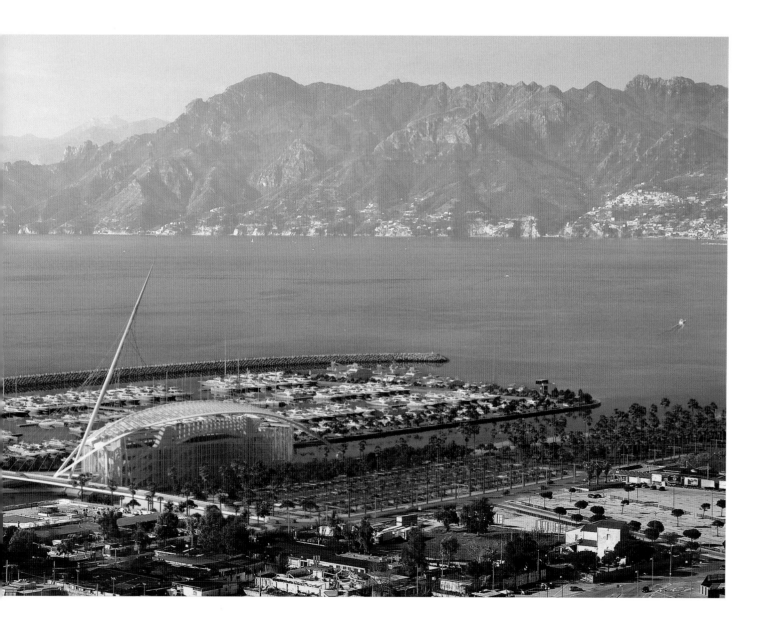

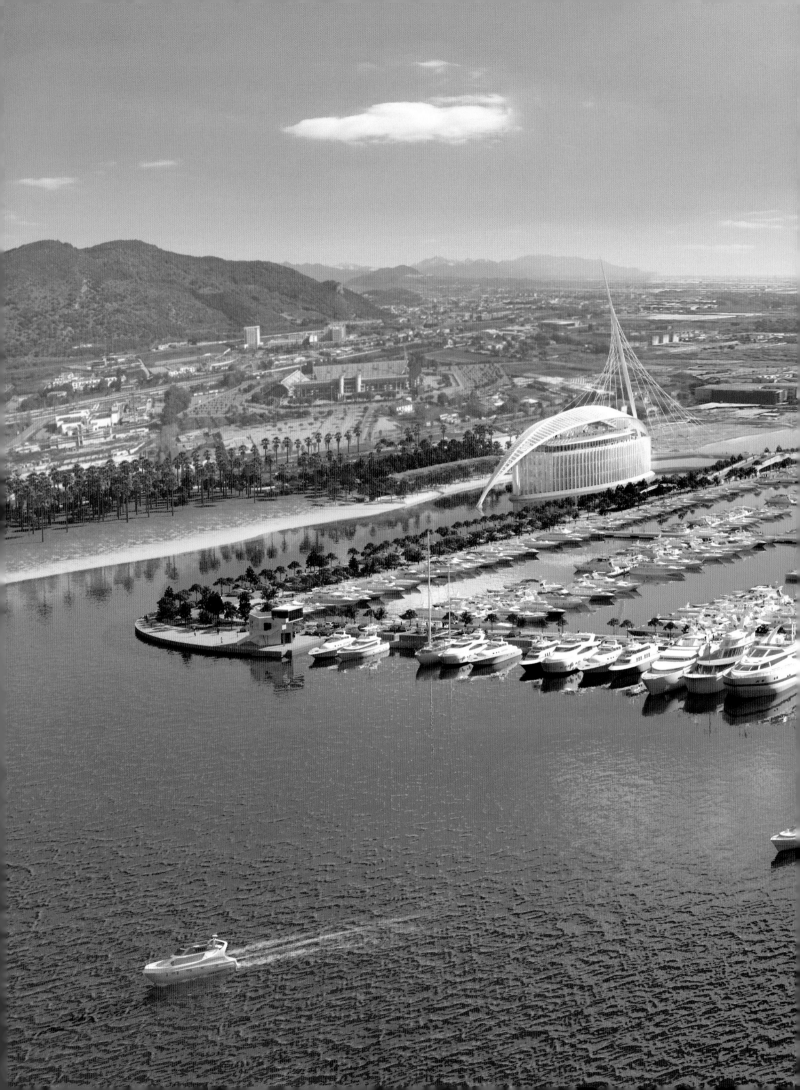

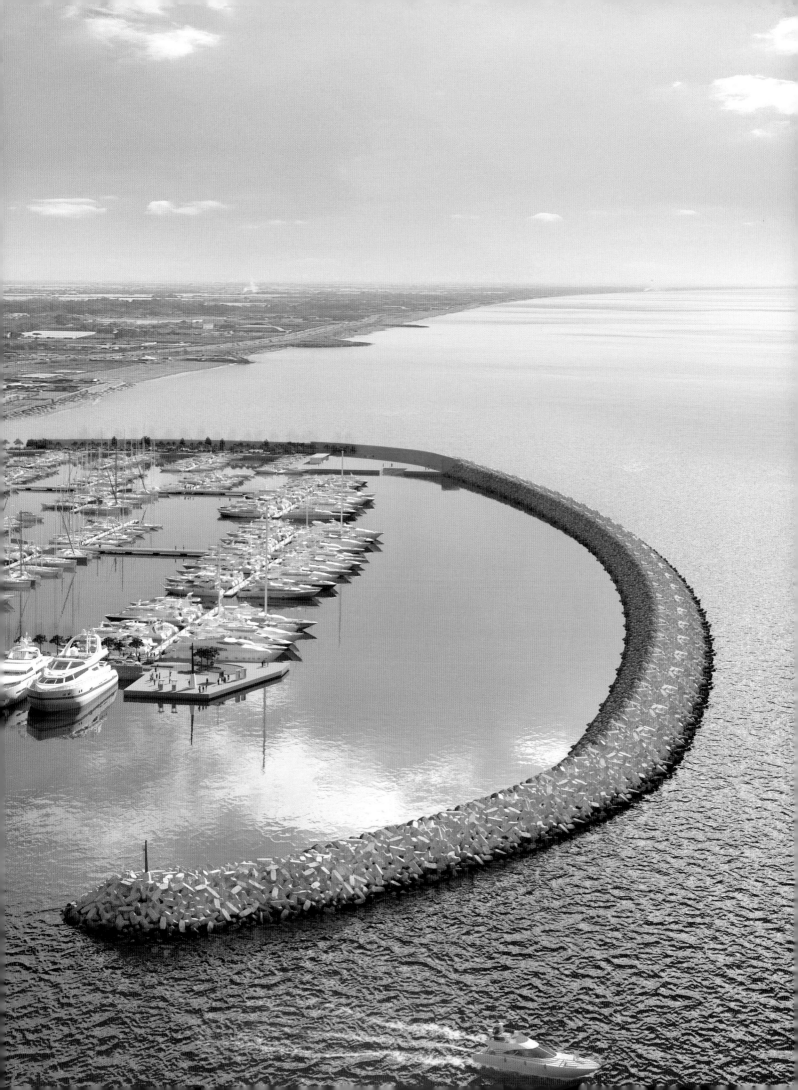

YUAN ZE UNIVERSITY CAMPUS NEW BUILDING COMPLEX

Yuan Ze University, Taoyuan County, Taipei, Taiwan. 2008–.

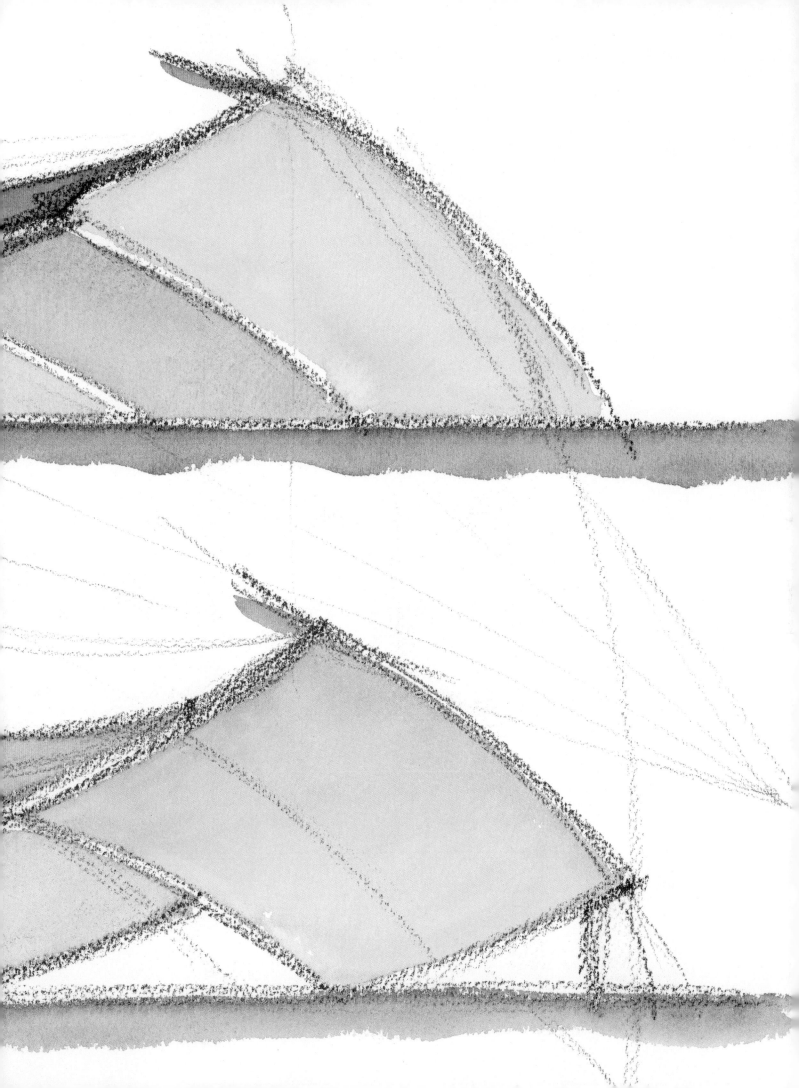

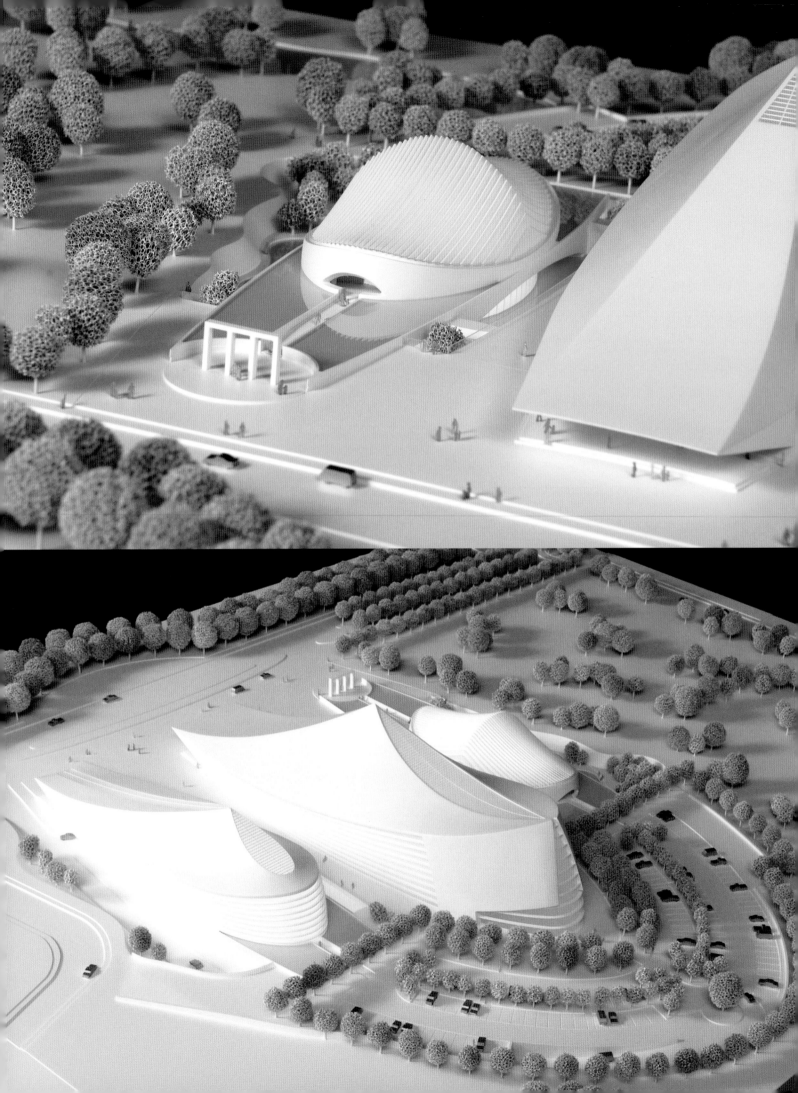

Project

YUAN ZE UNIVERSITY CAMPUS NEW BUILDING COMPLEX

Location

YUAN ZE UNIVERSITY, TAOYUAN COUNTY, TAIPEI, TAIWAN

Client

YUAN ZE UNIVERSITY / FAR EASTERN Y. Z. HSU SCIENCE AND TECHNOLOGY MEMORIAL FOUNDATION

Site area

116 400 m²

Total building area

58 000 m² (5300 m² MEMORIAL HALL; 10 000 m² ARTS & DESIGN SCHOOL; 17 500 m² PERFORMING ARTS BUILDING)

Capacity

1150 SEATS (CONCERT HALL); MAX. 700 SEATS (THEATER)

The architect evokes "traditional" architecture, and has clearly taken some inspiration from the design of temples, in this case dedicated to art.

Der Architekt deutet „traditionelle" Architektur an und hat sich eindeutig von der Gestaltung von Tempeln inspirieren lassen, die in diesem Fall der Kunst gewidmet ist.

L'architecte, qui évoque ici une architecture « traditionnelle », a clairement puisé une partie de son inspiration de la conception des temples, dans ce cas consacré à l'art.

Located 40 kilometers southwest of Taipei, the first phase of the program includes the Performing Arts Center, a new building for the university's art and design programs, and a memorial dedicated to the founder of Yuan Ze University. Scientific research labs are slated for a second phase of the development. The Performing Arts Building has a curved roof "that evokes traditional Taiwanese architecture." A concert hall seating 1150 people is located to the north of the building, and a theater to the south. The concert hall has a moveable ceiling that "can expand or contract the volume of the hall to meet the acoustic requirements of any performance." The theater, which can seat between 400 and 700 people, has a trumpet-shaped ceiling culminating in an illuminated ovoid. The Y. Z. Hsu Memorial Hall has a roof made of curving steel ribs on top of a concrete base clad in stone. Located to the east of the Performing Arts Building, the Art and Design School is similar in scale to the memorial. An exhibition space, as well as art and design studios located here receive natural light. The three buildings are connected below a public plaza. Forming the gate to the main public entrance of the university is a sculptural arch.

Die erste Baustufe umfasst das 40 km südwestlich von Taipei gelegene Performing Arts Center, einen Neubau für das Studium von Kunst und Design sowie eine Gedenkstätte für den Gründer der Yuan Ze University. Wissenschaftliche Forschungsinstitute sind für eine zweite Baustufe vorgesehen. Das Theatergebäude hat ein gekrümmtes Dach, „das an die traditionelle taiwanesische Architektur erinnert". Ein Konzertsaal mit 1150 Plätzen ist im Norden des Gebäudes angeordnet, ein Theater im Süden. Die Konzerthalle hat eine bewegliche Decke, die „den Rauminhalt des Saales ausdehnen oder reduzieren kann, entsprechend den akustischen Bedingungen der jeweiligen Aufführung". Das Theater kann 400 bis 700 Zuschauer aufnehmen; es hat eine trichterförmige Decke, die in einer beleuchteten Eiform gipfelt. Die Gedenkstätte für Y. Z. Hsu hat ein Dach aus gekrümmten Stahlrippen auf einer mit Naturstein verkleideten Betonbasis. Die östlich vom Theater gelegene Hochschule für Kunst und Design entspricht im Maßstab der Gedenkstätte. Im Hochschulgebäude sind der Ausstellungsbereich sowie die Ateliers für Kunst und Design natürlich belichtet. Alle drei Bauten sind unter einer öffentlichen Plaza miteinander verbunden. Das Tor zum Haupteingang der Universität bildet ein skulptural geformter Bogen.

Située à 40 kilomètres au sud-ouest de Taipei, l'Université Yuan Ze a lancé, en 2008, un nouveau programme de développement dont la première phase comportait la construction d'un bâtiment pour les arts du spectacle, d'un autre pour les arts et le design et d'un mémorial dédié à son fondateur. Des laboratoires de recherche scientifique sont prévus dans une seconde phase. Le bâtiment des arts du spectacle présente un toit incurvé « qui évoque l'architecture traditionnelle taïwanaise. » L'auditorium de 1150 places est implanté au nord et la salle de théâtre au sud. La salle de concert est équipée d'un plafond mobile « qui peut accroître ou contracter le volume pour l'adapter aux contraintes acoustiques des différents types de spectacles. » Le théâtre, de 400 à 700 places, est logé sous un plafond en forme de trompette culminant en une forme ovoïde illuminée. Le mémorial Y. Z. Hsu est couvert par une toiture en acier à nervures incurvées reposant sur une base en béton habillée de pierre. Situé à l'est du bâtiment des arts du spectacle, l'école d'art et de design est d'échelle similaire à celle du mémorial. Le lieu prévu pour les expositions et les studios d'art et de design bénéficie de l'éclairage naturel. Les trois bâtiments sont reliés en souterrain sous une place. Un arc sculptural constitue la principale porte d'entrée à l'université.

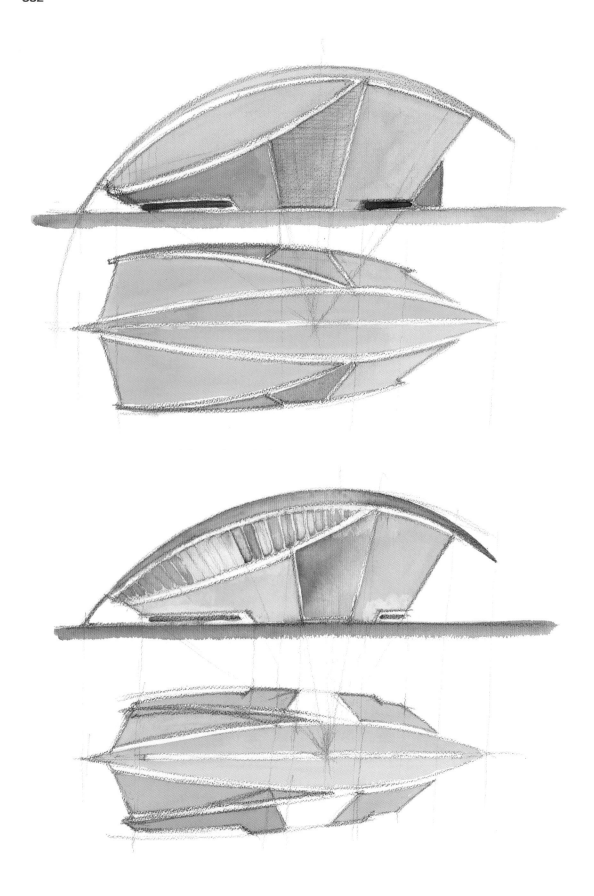

The watercolor drawings of Calatrava clearly show the form of the building, in plan and elevation. The emphasis in the drawings is indeed on form rather than function.

Diese Aquarellzeichnungen von Calatrava zeigen deutlich die Form des Gebäudes in Grundriss und Ansicht. Die Betonung wird eher auf die Form als auf die Funktion gelegt.

Les dessins en couleurs de Calatrava illustrent clairement la forme du bâtiment en plan et en élévation. L'accent est davantage mis sur la forme que sur la fonction.

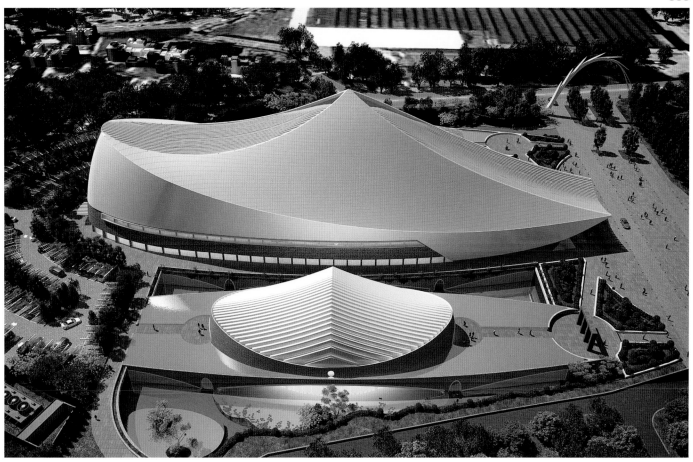

Above, a model of the complex with its curving forms. The shapes, as drawn by Calatrava (below), have no specific reference, but nonetheless seem to somehow be related to the natural world.

Oben: Ein Modell der Anlage mit ihren gekrümmten Formen. Auf den Zeichnungen von Calatrava (unten) haben sie keine spezifischen Bezüge, wirken aber dennoch irgendwie mit der natürlichen Welt verbunden.

Ci-dessous, maquette du complexe au profil en courbes. Les formes dessinées par Calatrava (ci-dessous) ne se réfèrent à rien en particulier, mais semblent cependant liées au monde naturel.

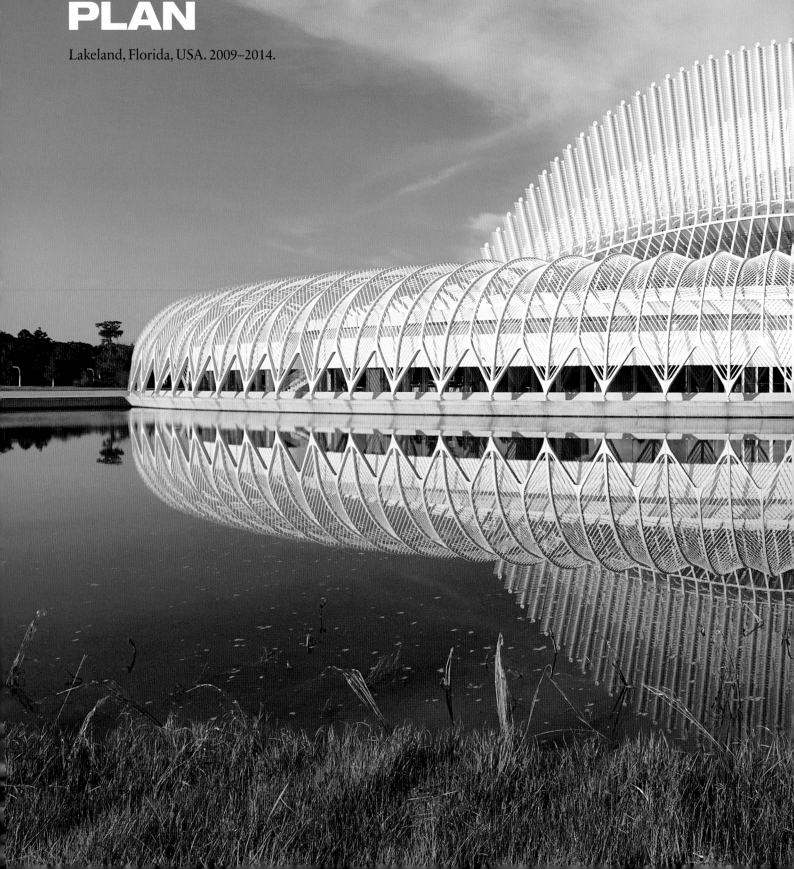

UNIVERSITY OF SOUTH FLORIDA POLYTECHNIC CAMPUS MASTER PLAN

Lakeland, Florida, USA. 2009–2014.

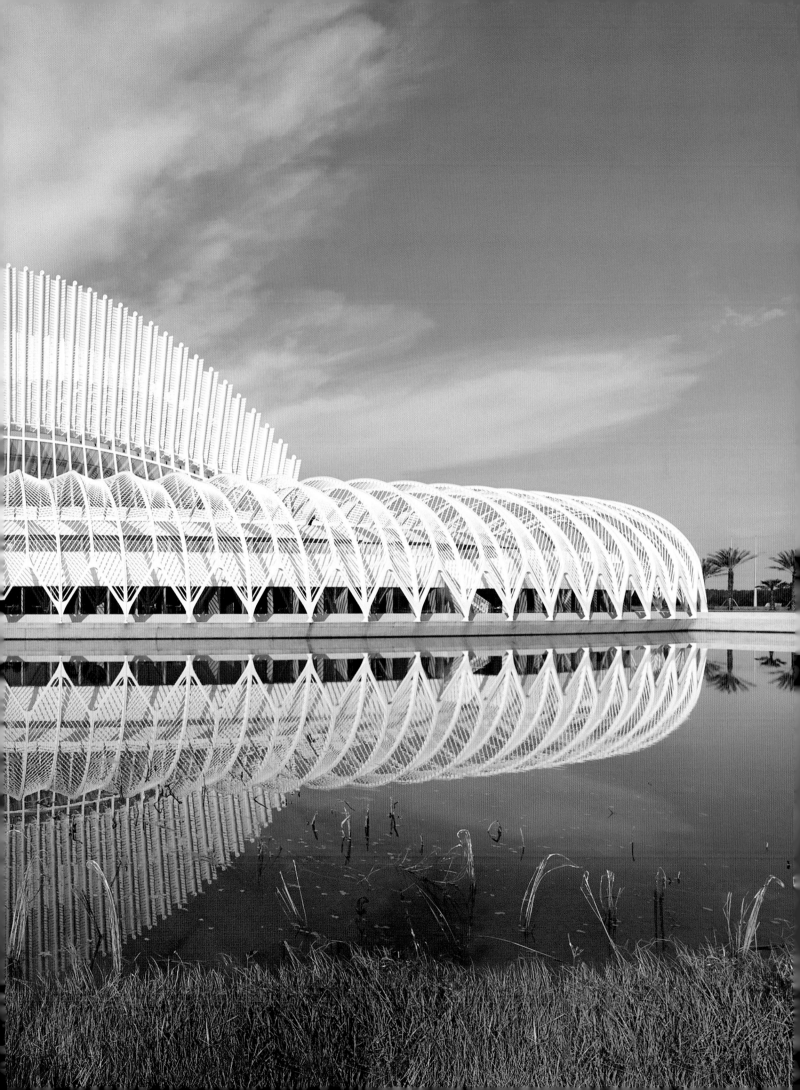

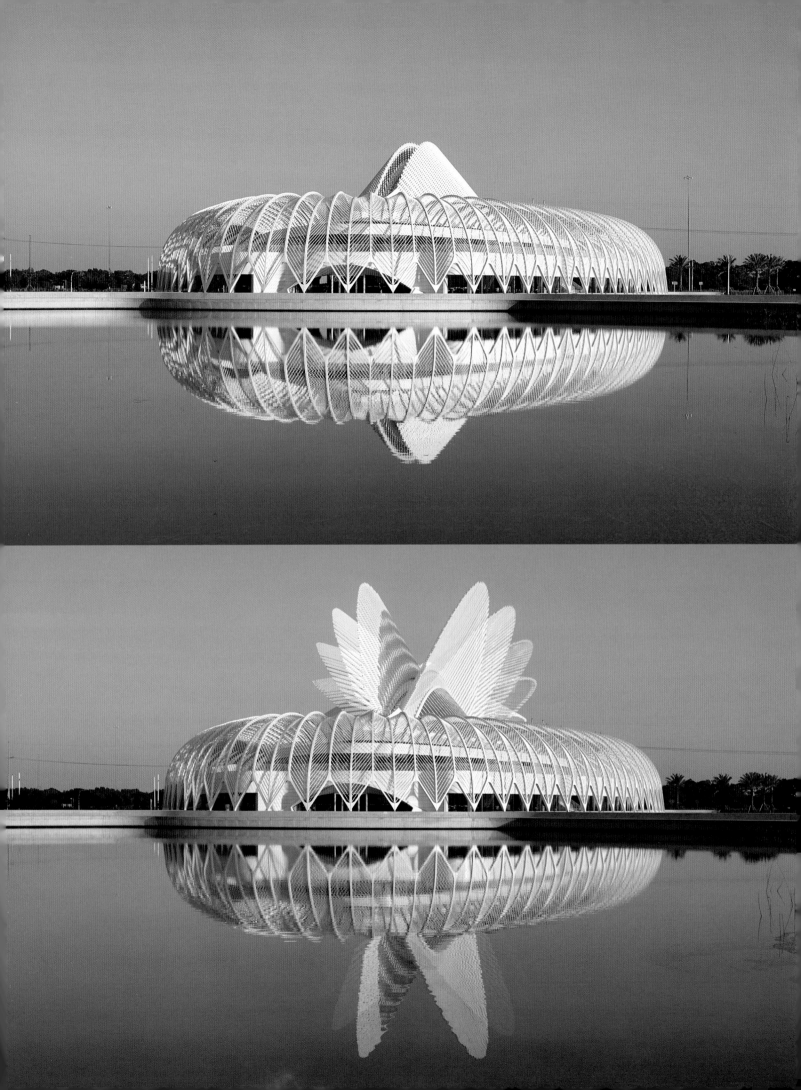

Project

UNIVERSITY OF SOUTH FLORIDA POLYTECHNIC CAMPUS MASTER PLAN

Location
LAKELAND, FLORIDA, USA

Client
FLORIDA POLYTECHNIC UNIVERSITY (FPU)

Gross / net building area
18 580 m²/ 11 148 m²

Height
25 METERS (LOUVERS CLOSED)
39 METERS (LOUVERS OPEN)

Cost
$ 60 MILLION

Left, images in time-lapse of the operable brise-soleils on top of the Innovation, Science and Technology Building, which change the outline of the structure completely.

Links: Zeitraffer-Aufnahmen der verstellbaren Brise-soleils oben auf dem Innovation, Science and Technology Building, die das Erscheinungsbild des Gebäudes total verändern.

À gauche, images prises à intervalle régulier montrant le déploiement des brise-soleil mobiles de la toiture du Bâtiment de l'innovation, de la science et de la technologie, qui modifie complètement ses contours.

In 2009, Santiago Calatrava was selected to create the master plan for the new campus of Florida Polytechnic, and to design the first building. The master plan placed a good deal of importance on landscaping, vehicular and pedestrian traffic, and the creation of "an iconic structure marking the campus within the larger local and regional context." Calatrava designed the Innovation, Science and Technology Building (2009–13) as the "centerpiece and anchor of the University." It is located to the north of a lake and at the end of the central axis of the campus. Science and research labs are located in the interior of the building with non-technical teaching labs around the periphery. The two-story corridors have clerestory glazing, while faculty offices are on the second floor, surrounding a large multiuse hall lit by a central skylight. Given its role as the first building, the structure was conceived as a "miniature campus." A light steel trellis or pergola surrounds the building, reducing solar gain by as much as 30%. The architect explains, "The operable roof consists of a series of hydraulically activated brise-soleils that provide shading to the commons' skylight. The louvers are individually controlled and can be programmed to follow the course of the sun throughout the day. In the next stage of development, the brise-soleils will be outfitted with solar panels creating a 1860 square meter solar array."

2009 wurde Santiago Calatrava mit der Erarbeitung des Masterplans und der Planung des ersten Gebäudes für den neuen Campus der technischen Hochschule Florida Polytechnic beauftragt. Der Masterplan sollte besonderen Wert auf die Landschaftsgestaltung legen, auf den Fahrzeug- und Fußgängerverkehr sowie auf die Errichtung „eines ikonischen Bauwerks, das den Campus aus dem größeren lokalen und regionalen Kontext hervorhebt". Calatrava entwarf den Neubau, das Innovation, Science and Technology Building (2009–13), als „Herzstück und Anker der Universität". Es liegt nördlich vom See und am Ende der zentralen Achse, die über den Campus führt. Wissenschaftliche Arbeitsräume und Forschungslaboratorien befinden sich im Innern des Gebäudes, die nichttechnischen Lehrsäle sind an der Peripherie angeordnet. Die zweigeschossigen Korridore sind von oben natürlich belichtet; die Fakultätsbüros liegen im zweiten Geschoss rund um einen großen

Mehrzwecksaal, der durch ein zentrales Oberlicht Tageslicht erhält. Als erstes Gebäude auf dem Gelände wurde der Bau als „Miniaturcampus" konzipiert. Umgeben ist er von einem leichten Stahlgitter, einer Art Pergola, die den Sonneneinfall um bis zu 30 % reduziert. Der Architekt erklärt: „Das verstellbare Dach besteht aus einer Reihe hydraulisch angetriebener Sonnenschutzelemente, die das Oberlicht beschatten. Diese Brises-soleil können einzeln kontrolliert und nach dem jeweiligen Sonnenstand programmiert werden. In der nächsten Entwicklungsstufe sollen sie mit Solarzellen ausgestattet werden, die eine 1860 m² große Fläche bilden."

C'est en 2009 que Santiago Calatrava a été choisi pour concevoir le plan directeur du nouveau campus de Florida Polytechnic et en dessiner le premier bâtiment. Le plan directeur accordait beaucoup d'importance au traitement du paysage, à la circulation des piétons et des véhicules et à la création d'une « structure iconique identifiant le campus dans son contexte local et régional ». Calatrava a conçu le Bâtiment de l'innovation, de la science et de la technologie (2009–13) comme « l'élément central, le point d'ancrage de l'université ». Il est implanté au bord d'un lac, à l'extrémité de l'axe central du campus. Les laboratoires des sciences et de la recherche sont installés à l'intérieur du bâtiment, ceux des enseignements non techniques étant répartis en périphérie. Les corridors à deux niveaux sont éclairés par des ouvertures hautes, et les bureaux des enseignants sont situés au second niveau autour d'un vaste hall multifonctions, éclairé par une verrière zénithale centrale. Étant donné qu'elle est le premier bâtiment construit, cette structure a été conçue comme un « campus miniature ». Un treillis léger en acier — sorte de pergola —, entoure l'immeuble et permet de réduire le gain solaire de près de 30 pour cent. « Le toit transformable, explique l'architecte, consiste en une série de brise-soleil à commande hydraulique qui assurent la protection nécessaire des verrières. Chaque volet est contrôlé individuellement et l'ensemble programmé pour suivre la courbe du soleil. Dans une prochaine étape de développement, ces brise-soleil seront dotés de panneaux solaires ce qui créera une petite installation photovoltaïque de 1860 mètres carrés. »

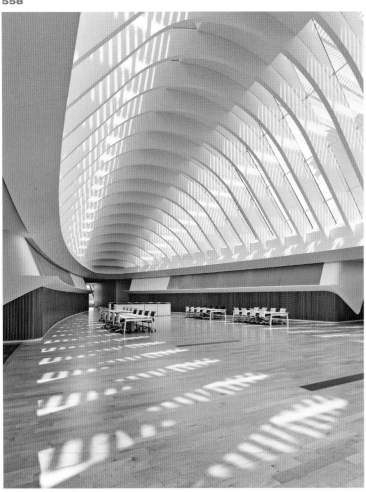

To the left, interior space that has all the hallmarks of a Calatrava design—the arched ribs and curving, generous forms that he is known for. Below, a view of the campus.

Links: Der Innenbereich zeigt alle Merkmale eines Calatrava-Entwurfs – die gebogenen Rippen und die gekrümmten, großzügigen Formen, für die der Architekt bekannt ist. Unten: Blick auf den Campus.

À gauche, l'espace intérieur est caractéristique du style Calatrava : arcs, courbes et générosité des volumes. Ci-dessous, vue du campus.

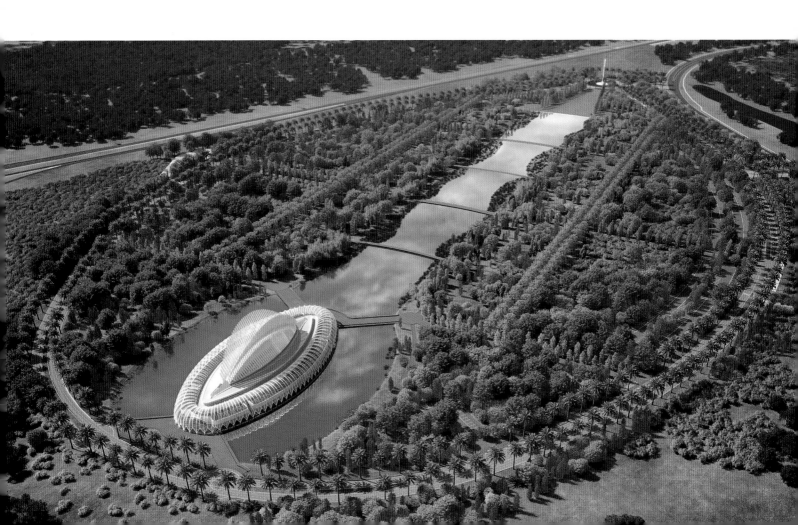

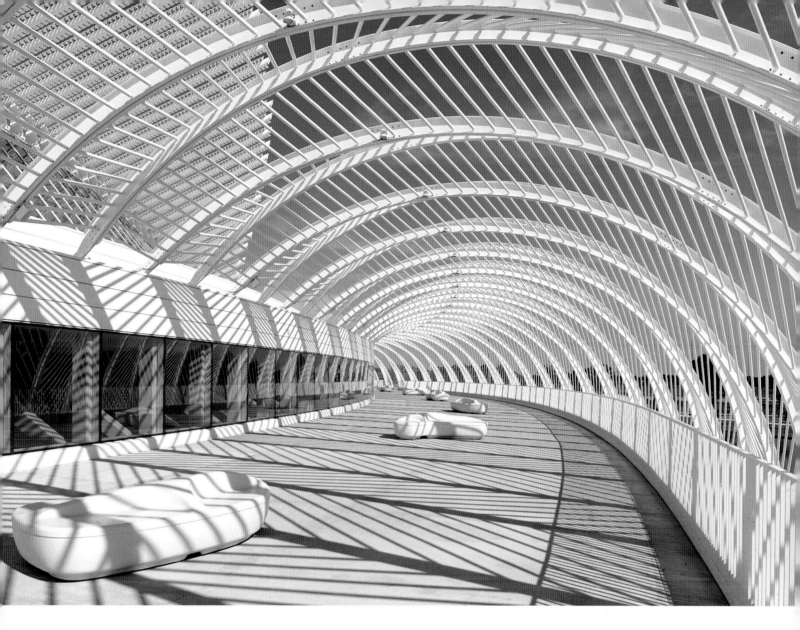

The successive ribs seen in these interior spaces are evocative of the natural world (skeletons) but cannot be specifically related to any living organism.

Die aufeinanderfolgenden Rippen in diesen Innenräumen erinnern an die Welt der Natur (Skelette), lassen sich aber keinem spezifischen lebenden Organismus zuschreiben.

Les arcs successifs de ces volumes intérieurs évoquent le monde naturel (squelettes), mais ne se rattachent à aucun organisme vivant en particulier.

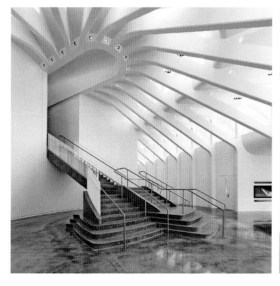

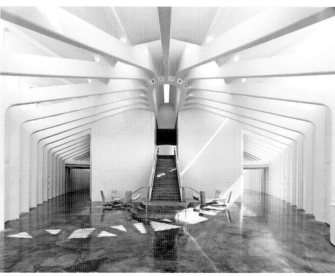

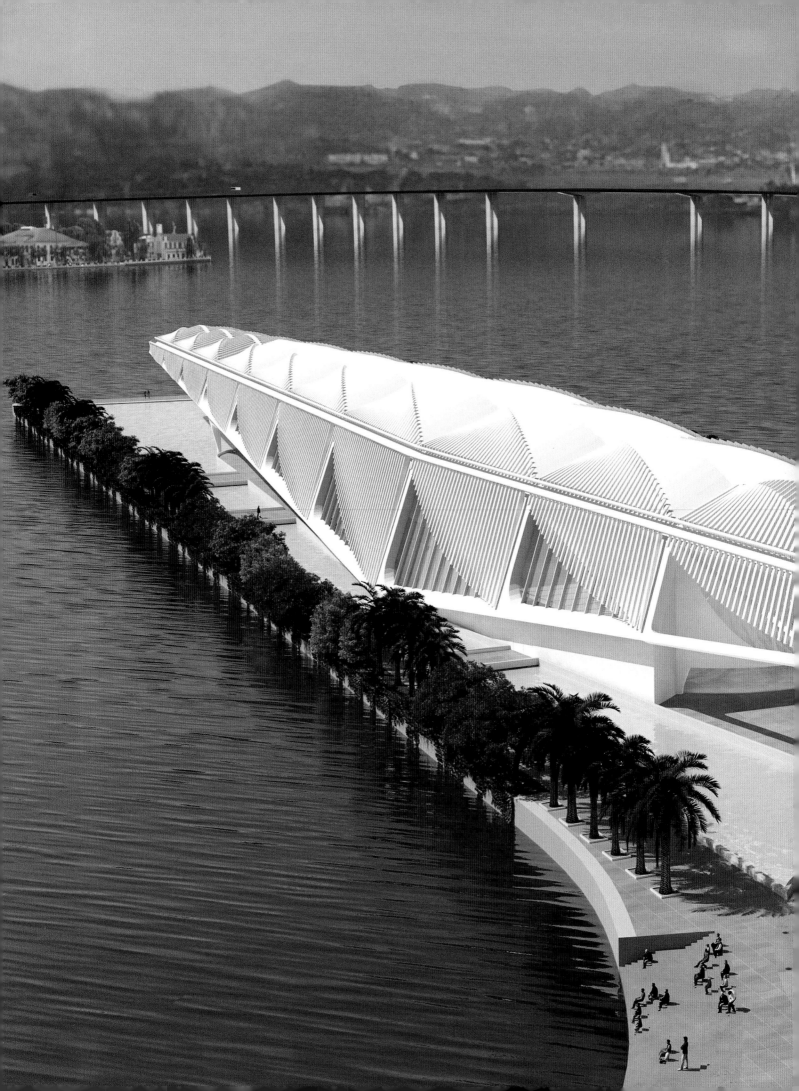

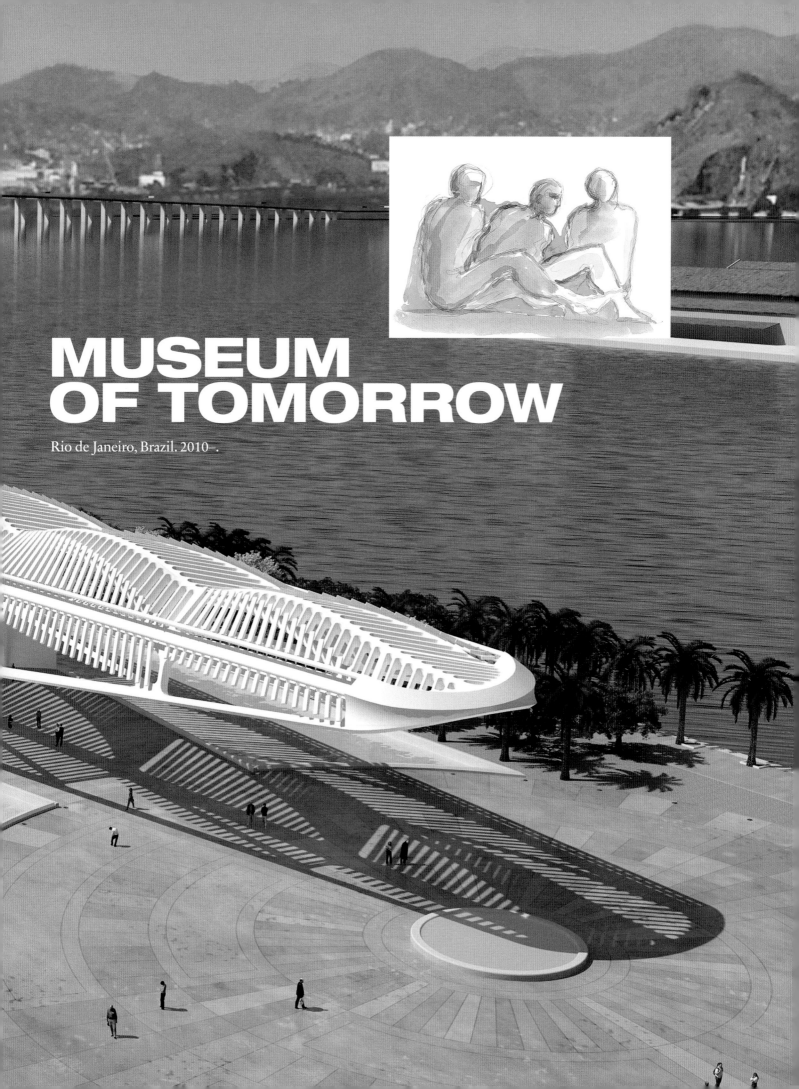

MUSEUM
OF TOMORROW

Rio de Janeiro, Brazil. 2010–.

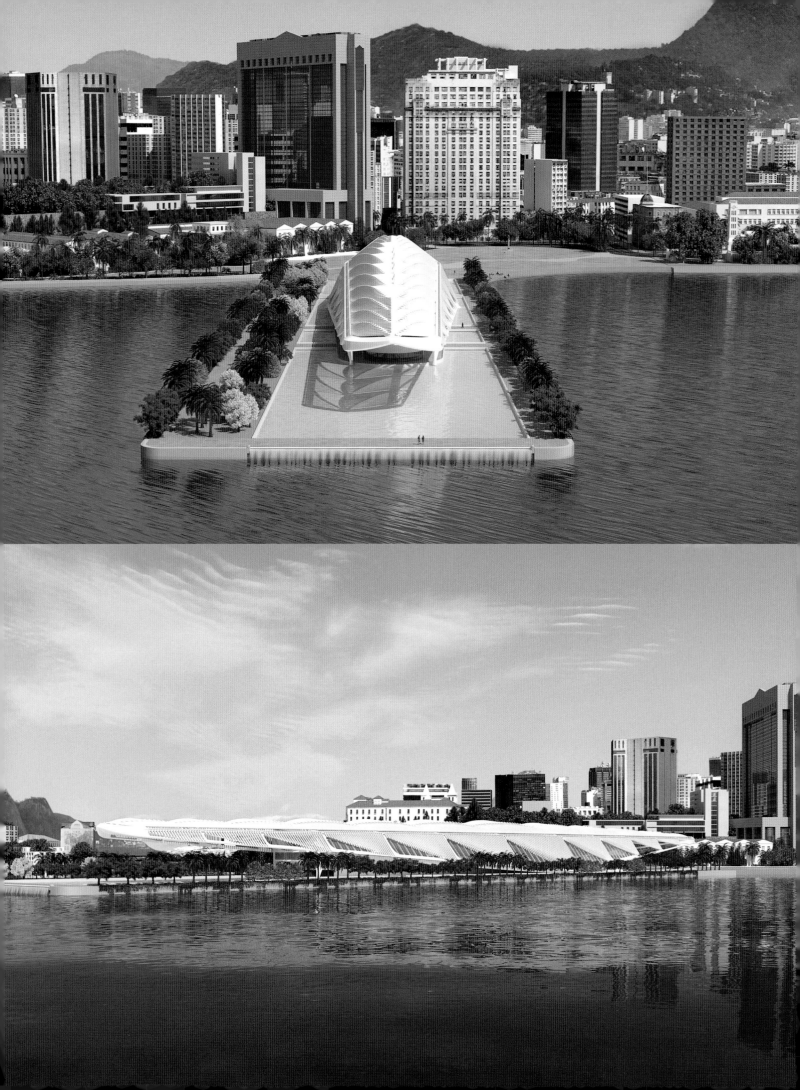

Project
MUSEUM OF TOMORROW

Location
RIO DE JANEIRO, BRAZIL

Client
FUNDAÇÃO ROBERTO MARINHO, RIO DE JANEIRO, BRAZIL

Floor area
12 600 m²

Length
340 METERS

Cost
$ 90 MILLION

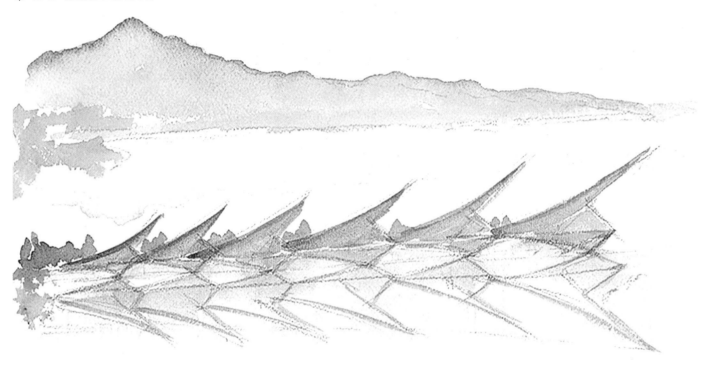

Rio has evoked a number of schemes in relation to events such as the Olympics, without always carrying through on their announced intentions. This built project is located in the Porto Maravilha cultural area.

Rio hat eine Reihe von Projekten für Events wie die Olympischen Spiele vorgelegt, ohne jedoch immer die angekündigten Absichten zu realisieren. Dieser ausgeführte Entwurf liegt im Kulturbezirk Porto Maravilha.

Rio de Janeiro a annoncé un certain nombre de projets en vue de grands événements comme les Jeux olympiques, sans que les intentions se soient, pour l'instant, concrétisées. Ce projet, s'il est réalisé, sera implanté dans la zone culturelle de Porto Maravilha.

Located at Rio de Janeiro's Mauá Harbor Pier, the Museum of Tomorrow plays a central role in Rio de Janeiro's urban revitalization plans for the 2016 Olympic and Paralympic Games. The program called for 5000 square meters of exhibition space as well as an auditorium, observatory, administrative offices, archives, and technical areas for a total of nearly 12 500 square meters. The two-story structure is 18 meters high, allowing for 10-meter ceilings on the upper exhibition floor. Below the exhibition area are offices, educational and commercial facilities, research rooms, a cafe, a theater, the lobby, the archive, and the storage and delivery zones. The cantilevered roof and façade structure with operable elements stretch almost the entire length of the pier. A landscaped strip occupies the southern length of the pier, and a large reflecting pool marks the northern side.

Das am Pier von Rio de Janeiros Hafen Mauá gelegene Museum von Morgen spielt eine zentrale Rolle in den Stadterneuerungsplänen für die Olympischen und Paralympischen Spiele von 2016. Die Ausschreibung forderte 5000 m² Ausstellungsfläche sowie ein Auditorium, ein Observatorium, Verwaltungsräume, Archivräume und Technikbereiche für eine Gesamtnutzfläche von 12 500 m². Das zweigeschossige Gebäude hat eine Höhe von 18 m und im oberen Ausstellungsgeschoss eine Deckenhöhe von 10 m. Unter diesem liegen Büro-, Unterrichts- und kommerziell nutzbare Bereiche, Forschungsräume, ein Café, ein Theater, die Eingangshalle, Archivräume sowie Lagerflächen und Lieferzonen. Das auskragende Dach und die Fassadenkonstruktion mit verstellbaren Elementen erstrecken sich fast über die gesamte Länge des Piers. Ein landschaftlich gestalteter Streifen nimmt die ganze Südseite des Piers ein, und ein großer, reflektierender Pool betont die Nordseite.

Implanté sur la jetée du port de Mauà à Rio de Janeiro, le Musée de Demain joue un rôle central dans les plans de revitalisation de la ville pour les Jeux olympiques et paralympiques de 2016. Le programme comprend un auditorium, un observatoire, 5000 mètres carrés d'espaces d'expositions, des bureaux administratifs, des archives et des équipements techniques pour un total d'environ 12 500 mètres carrés. La structure sur deux niveaux mesure 18 mètres de haut, ce qui a permis la création de salles dotées de plafonds de 10 mètres de haut à l'étage réservé aux expositions. Au rez-de-chaussée se trouvent des bureaux, des installations éducatives, des boutiques, des salles destinées à la recherche, un café, un théâtre et le hall d'accueil, les archives et les installations de stockage et de livraison. La toiture en porte-à-faux et la structure de la façade à éléments mobiles recouvrent la quasi totalité de la jetée. Une bande de jardin paysager occupent la partie sud de la jetée qui se termine, au nord, par un grand bassin réfléchissant.

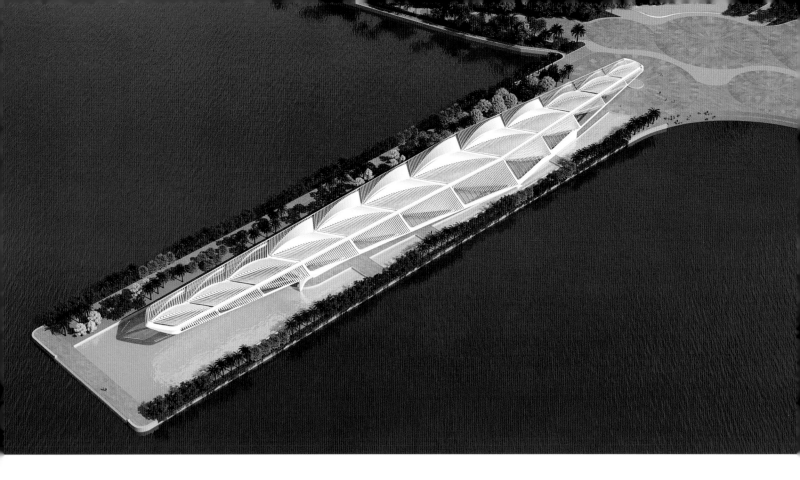

Calatrava's design, seen in a computer rendering (above) and in drawings by the architect (below), relies on a modulated repetition of forms that increase in width towards the middle of the building.

Calatravas Entwurf in einer Computeransicht (oben) und in Zeichnungen des Architekten (unten) beruht auf einer Wiederholung modularer Formen, die zur Mitte des Gebäudes an Breite zunehmen.

Le projet de Calatrava, en image de synthèse (ci-dessous) et en croquis (ci-dessous) s'appuie sur la répétition modulaire de formes qui vont en s'élargissant en partie centrale du bâtiment.

The ribbed, open structure allows for the considerable cantilever seen in the computer image below. Above, a watercolor by the architect of the design.

Die offene Rippenkonstruktion ermöglicht weite Auskragungen, wie auf der Computerdarstellung unten zu sehen ist. Oben: Ein Aquarell des Architekten von seinem Entwurf.

La structure ouverte et nervurée permet l'extension considérable de l'auvent en porte-à-faux visible sur l'image de synthèse ci-dessous. Ci-dessus, une aquarelle du projet par Calatrava.

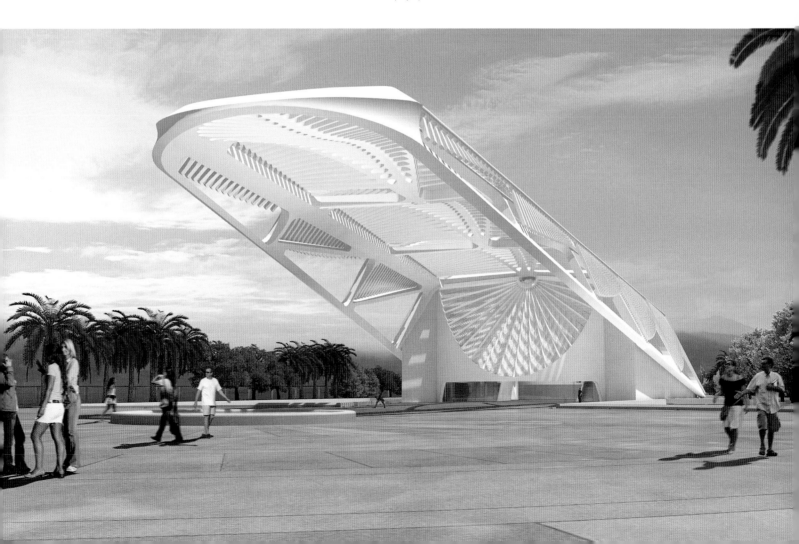

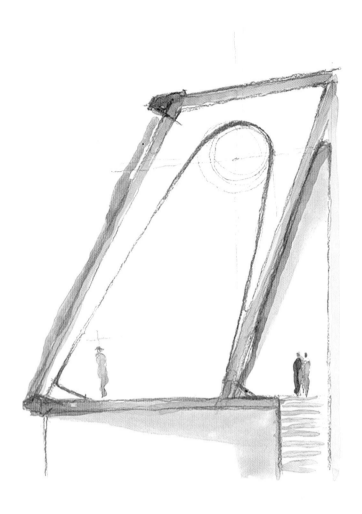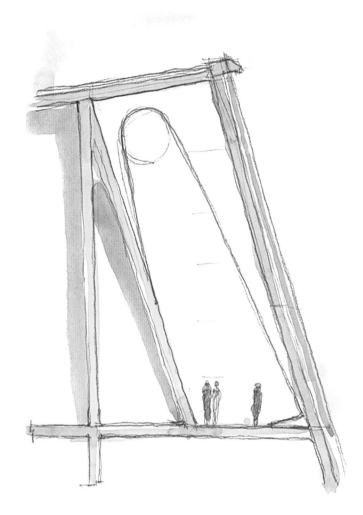

Here, as in other buildings, Calatrava evokes the human form in terms of scale but also with respect to masses and movement.

Hier, wie auch in seinen anderen Bauten, bezieht sich Calatrava auf die menschliche Gestalt, sowohl im Maßstab als auch im Hinblick auf Baumasse und Bewegung.

Ici, comme dans d'autres projets, Calatrava évoque la forme humaine en termes d'échelle, mais aussi par rapport aux masses et au mouvement.

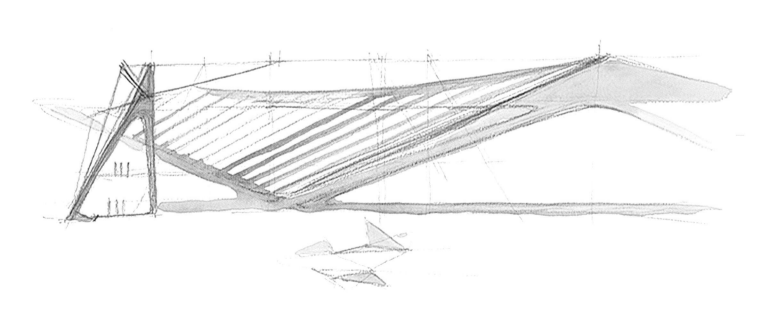

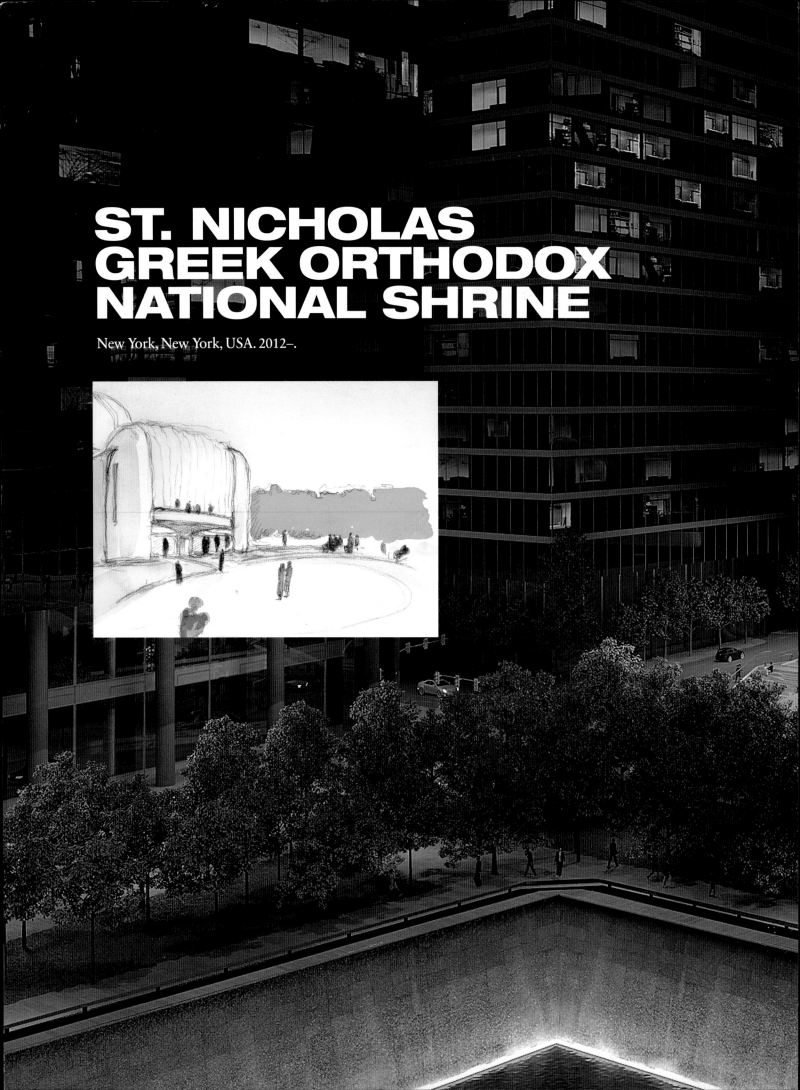

ST. NICHOLAS
GREEK ORTHODOX
NATIONAL SHRINE

New York, New York, USA. 2012–.

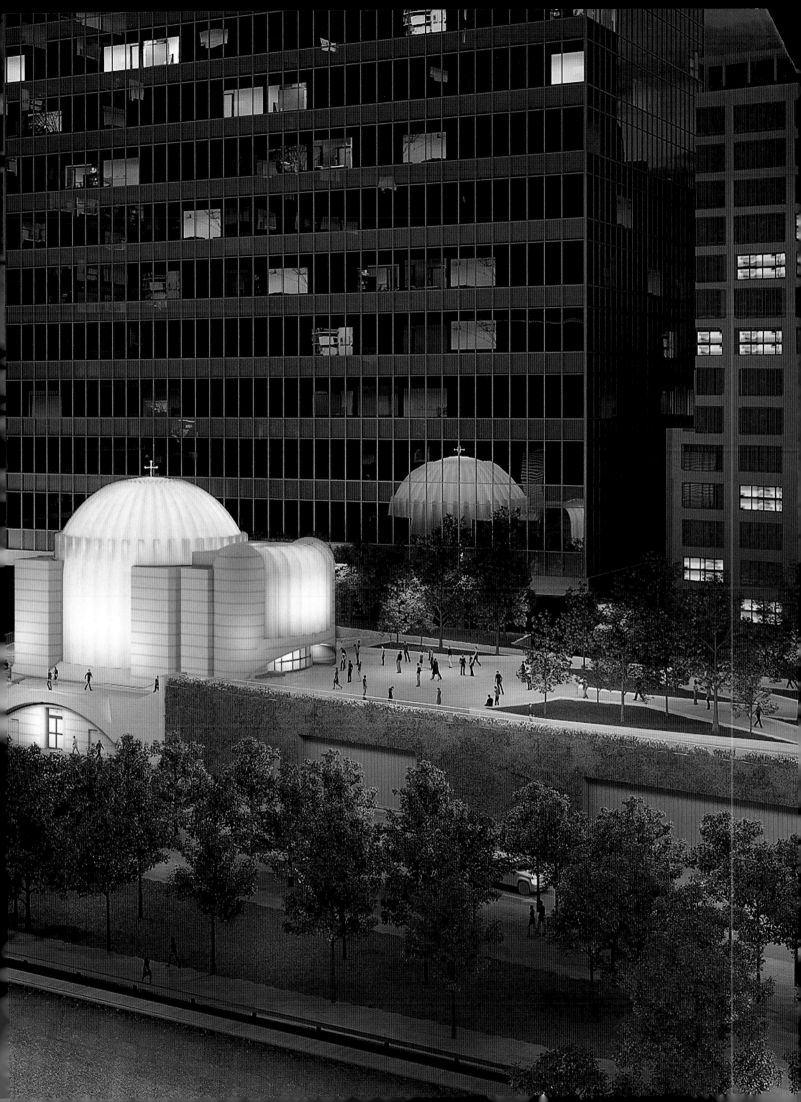

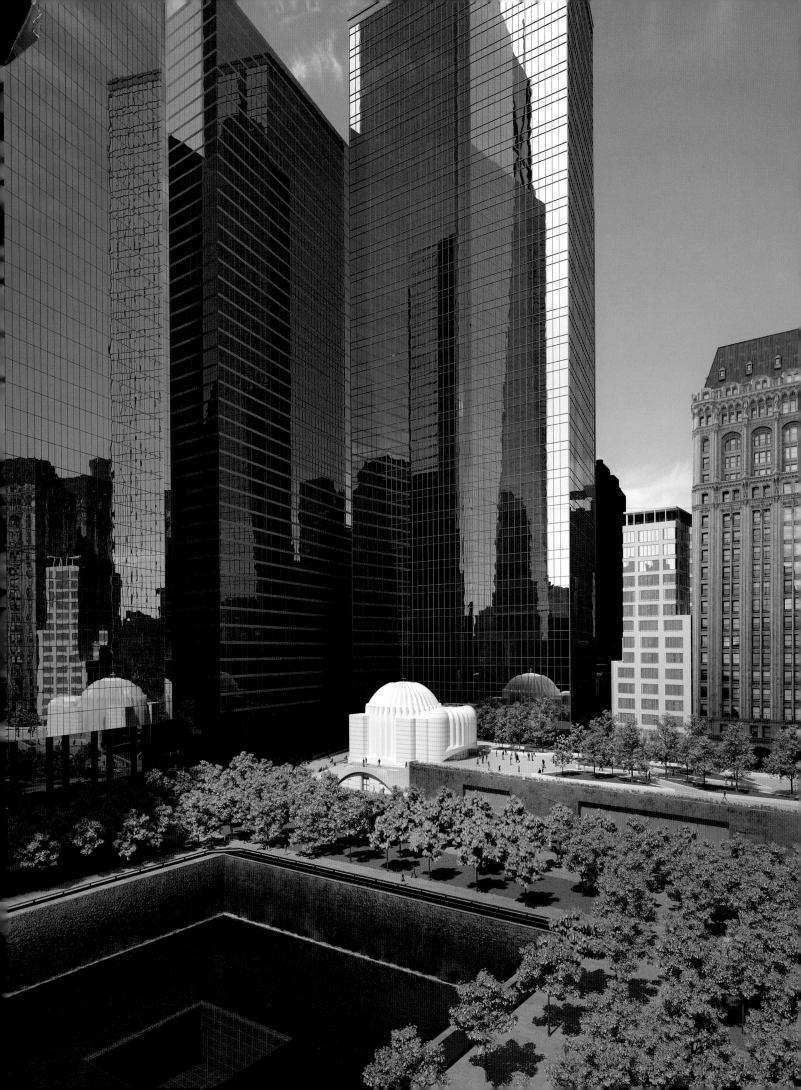

Project
ST. NICHOLAS GREEK ORTHODOX NATIONAL SHRINE

Location
NEW YORK, NEW YORK, USA

Client
GREEK ORTHODOX ARCHDIOCESE OF AMERICA

Height
15.96 METERS

Building area
1068 m² (ABOVE PLAZA LEVEL)

Calatrava's design was chosen over a dozen other schemes and was influenced in its form by Hagia Sofia and the Church of the Holy Savior in Chora, both in Istanbul.

Calatravas Entwurf wurde aus über einem Dutzend anderer Projekte ausgewählt und zeigt Einflüsse von der Hagia Sophia und der Erlöserkirche in Chora, beide in Istanbul.

Le projet de Calatrava a été choisi parmi plus de douze autres. Sa forme est influencée par la basilique Sainte-Sophie et l'église du Saint-Sauveur-in-Chora, toutes deux à Istanbul.

Subsequent to the destruction of the original St. Nicholas Greek Orthodox Church on September 11, 2001, the Greek Orthodox Archdiocese of America received permission to build a new church at the eastern end of Liberty Park, the only religious structure on the periphery of the new complex. Located above the World Trade Center's vehicle security center, the new building had to comply with considerable constraints, including its precise location, footprint, and volume. The Greek Archbishop Demetrios stated "The design for the church must respect the traditions and liturgy of the Greek Orthodox Church, but at the same time it must reflect the fact that we are living in the 21st century." Calatrava's design will have an exterior clad in stone and glass-laminated panels that are illuminated from behind "so that the entire stone curtain-wall system glows in counterpoint to the solid mass of the towers."

Nach der Zerstörung der früheren griechisch-orthodoxen Kirche St. Nicholas am 11. September 2001 erhielt die griechisch-orthodoxe Erzdiözese die Erlaubnis, am östlichen Rand des Liberty Park eine neue Kirche zu errichten – als einziges religiöses Bauwerk an der Peripherie des neuen Komplexes. Der oberhalb vom Fahrzeug-Sicherheitsbereich des World Trade Center gelegene Neubau muss beträchtliche Einschränkungen in Kauf nehmen, die unter anderem den genauen Standort, den Grundriss und den Umfang des Gebäudes betreffen. Der griechische

Erzbischof Demetrios erklärte: „Die Gestaltung dieses Kirchenbaus muss die Tradition und die Liturgie der griechisch-orthodoxen Kirche respektieren, zugleich aber auch der Tatsache gerecht werden, dass wir im 21. Jahrhundert leben." Calatravas Entwurf sieht eine Außenverkleidung aus Naturstein mit Verbundglastafeln vor, die von hinten beleuchtet werden, „damit das gesamte steinerne Curtain-Wall-System leuchtet und einen Gegensatz zu der geschlossenen Masse der Türme bildet."

À la suite de la destruction de l'église orthodoxe grecque Saint-Nicolas lors des attentats du 11 septembre 2001, l'archidiocèse grec d'Amérique a reçu l'autorisation d'édifier un nouveau lieu de culte à l'extrémité orientale de Liberty Park, qui sera le seul bâtiment religieux dans la périphérie du nouveau complexe. Située au-dessus du centre de sécurité des véhicules du World Trade Center, la nouvelle construction devra se plier à des contraintes considérables tant en termes d'implantation que d'emprise au sol ou de volume. L'archevêque Demetrios a déclaré : « La conception de cette église doit respecter les traditions et la liturgie de l'église orthodoxe grecque, mais en même temps refléter le fait que nous vivons au XXIe siècle. » À l'extérieur, l'église sera habillée de panneaux de pierre et de verre feuilleté rétro-éclairés la nuit « pour que le mur rideau tout entier scintille en contrepoint de la masse sombre des tours. »

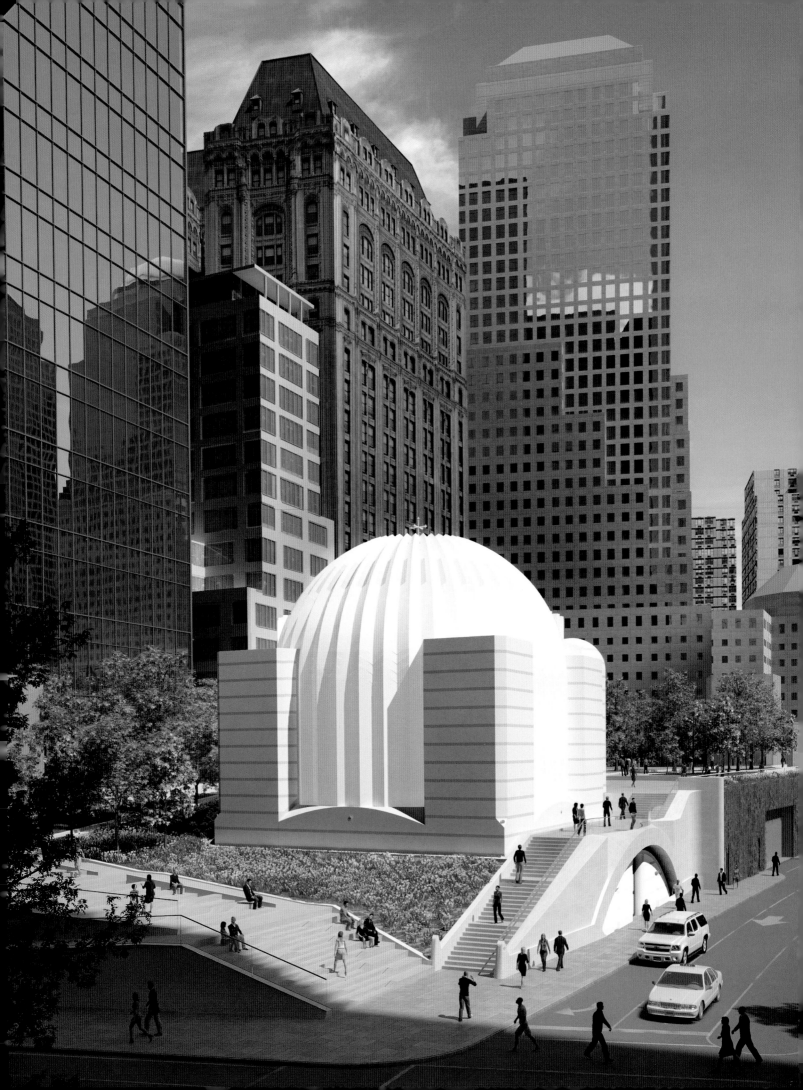

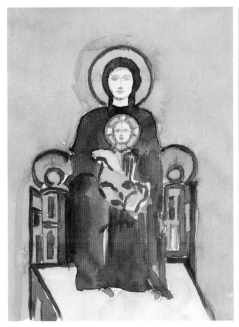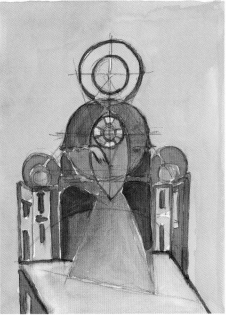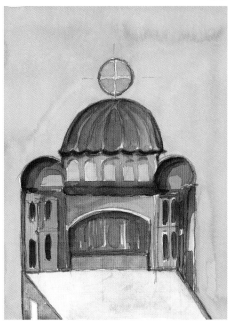

Calatrava's drawings of the Virgin and Child show the influence of this form on the new church, seen in a computer view (left page) and in an another drawing by the architect (below).

Calatravas Zeichnungen von der Heiligen Jungfrau mit Kind zeigen den Einfluss dieser Form auf die neue Kirche, wie auf der Computeransicht (linke Seite) und auf einer anderen Zeichnung des Architekten (unten) zu sehen ist.

Ces dessins par Calatrava d'une Vierge à l'Enfant montrent l'influence de cette forme sur la nouvelle église, vue en image de synthèse (en page gauche) et dans un autre dessin de l'architecte ci-dessous.

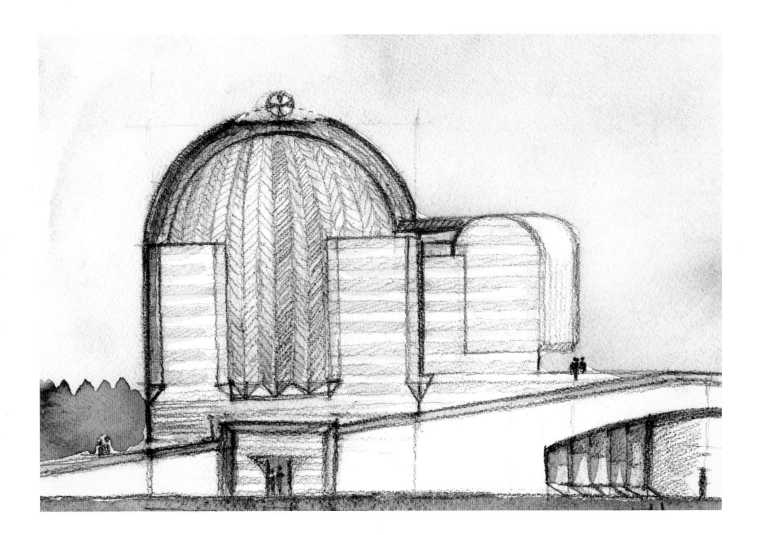

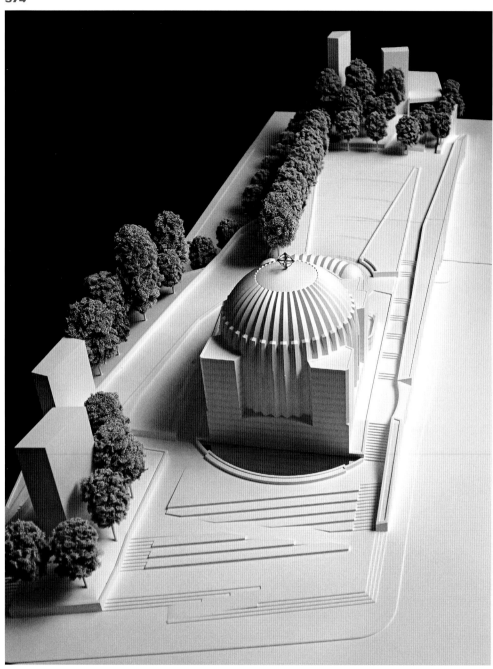

The site of the church posed considerable constraints of size and orientation. A model (left) shows the church and its immediate environment.

Der Bauplatz der Kirche forderte erhebliche Einschränkungen im Hinblick auf Größe und Orientierung. Ein Modell (links) zeigt die Kirche in ihrer unmittelbaren Umgebung.

Le site de l'église était soumis à de lourdes contraintes de dimensionnement et d'orientation. Une maquette (à gauche) montre l'église dans son environnement immédiat.

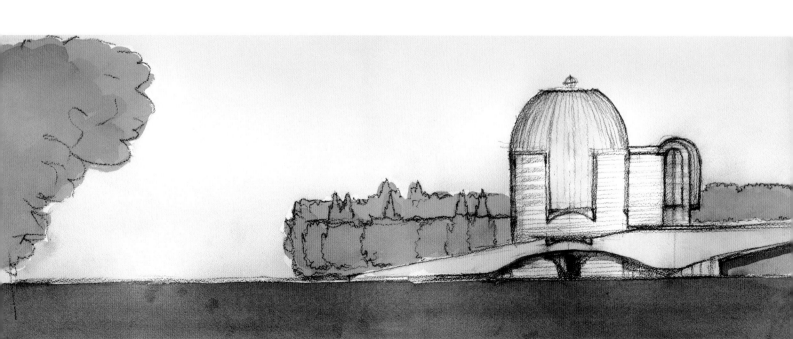

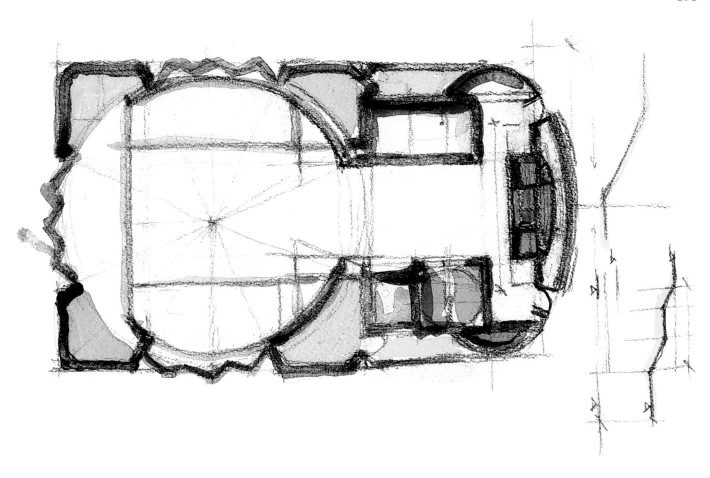

Eine Zeichnung des Architekten zeigt den Grundriss der Kirche, der sowohl an die traditionelle griechisch-orthodoxe Kirchenarchitektur wie auch an andere typische Bezüge des Architekten, etwa die Form des menschlichen Auges, erinnert.

A sketch by the architect shows the plan of the church, which seems to recall both traditional Greek Orthodox church design and other preoccupations of the architect, such as the shape of the human eye.

Un croquis de l'architecte montre le plan au sol de l'église, qui semble rappeler à la fois ceux des églises orthodoxes grecques et d'autres préoccupations de l'architecte comme la forme de l'œil humain.

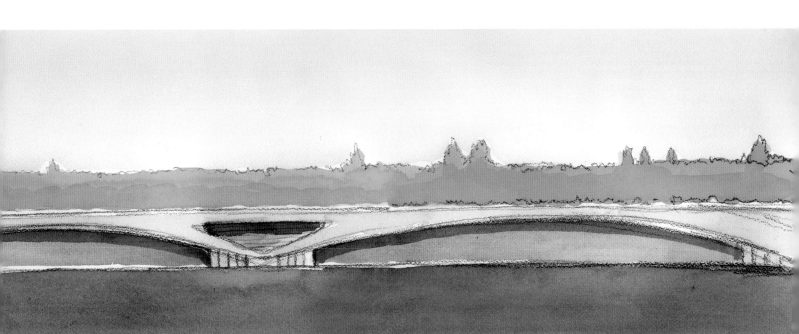

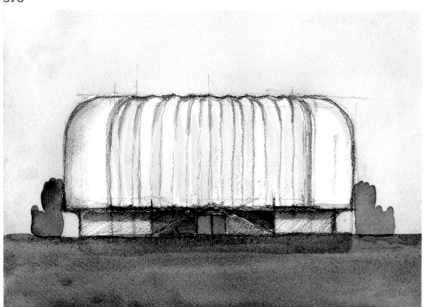

Calatrava's watercolor sketches give an idea of his interest in light and space as it is expressed in this religious structure.

Calatravas Aquarelle geben eine Vorstellung von seinem Interesse für Licht und Raum, das auch dieses religiöse Bauwerk prägt.

Les croquis à l'aquarelle de Calatrava donnent une idée de son intérêt pour la lumière et l'espace, comme exprimé dans cet édifice religieux.

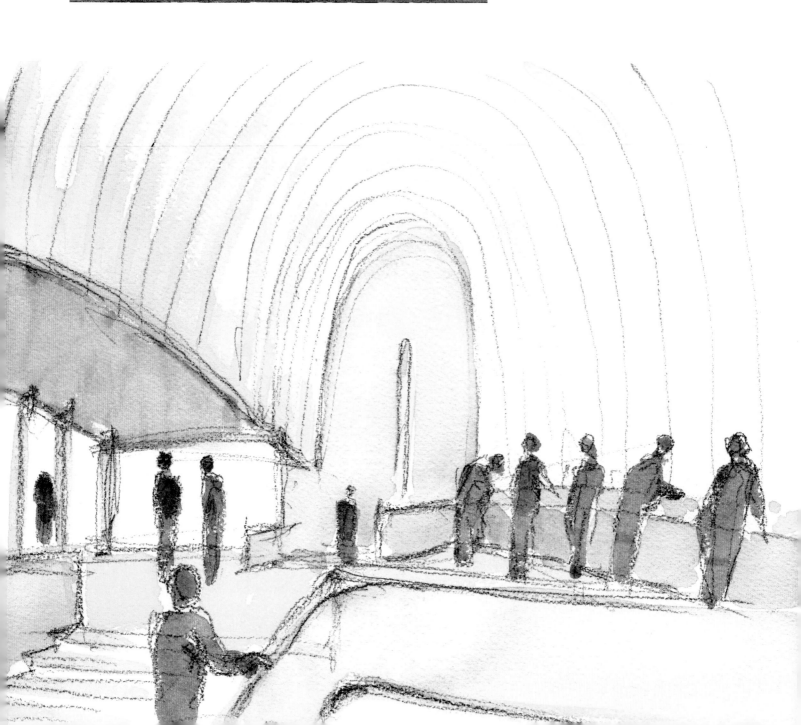

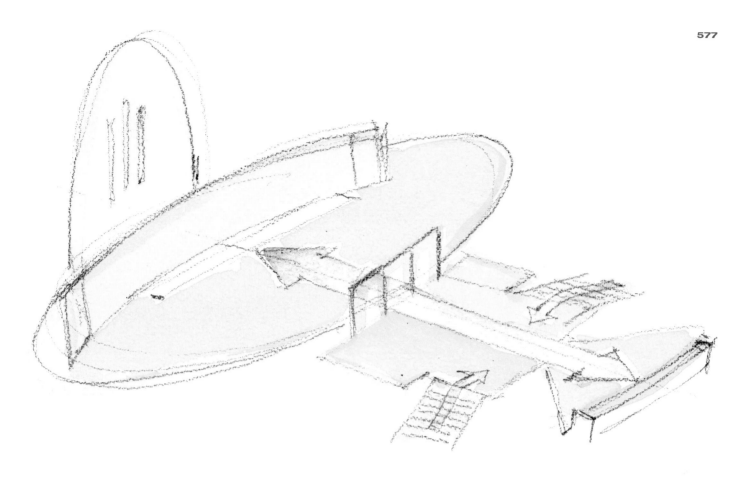

A sketch above shows the patterns of movement within the church and the elongated oval shape.

Die Zeichnung oben zeigt das System der Bewegung innerhalb der Kirche und ihre länglich ovale Form.

Le croquis, ci-dessus, montre les axes de circulation dans l'église et sa forme ovale allongée.

The new church is being built in steel and concrete but the exterior will be clad in stone.

Die neue Kirche wird aus Stahl und Beton errichtet, aber außen mit Naturstein verkleidet.

Si la nouvelle église est prévue en béton et acier, son extérieur sera habillé de pierre.

SHARQ CROSSING

Doha, Qatar. 2011–.

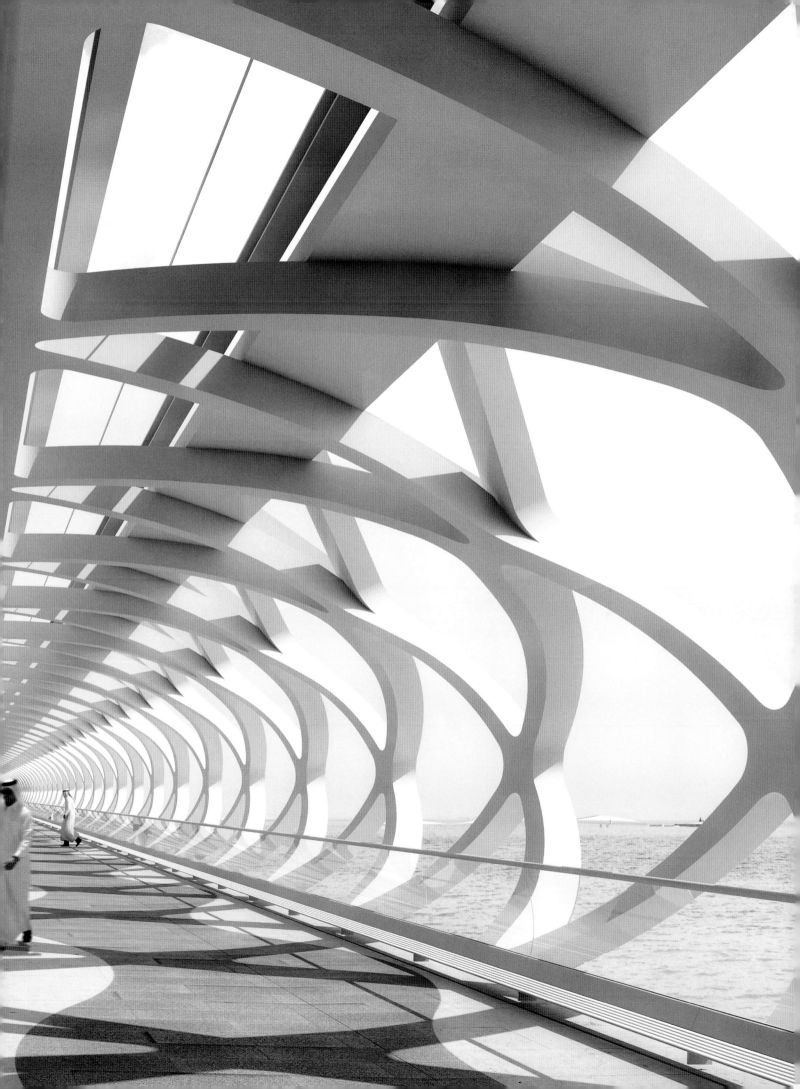

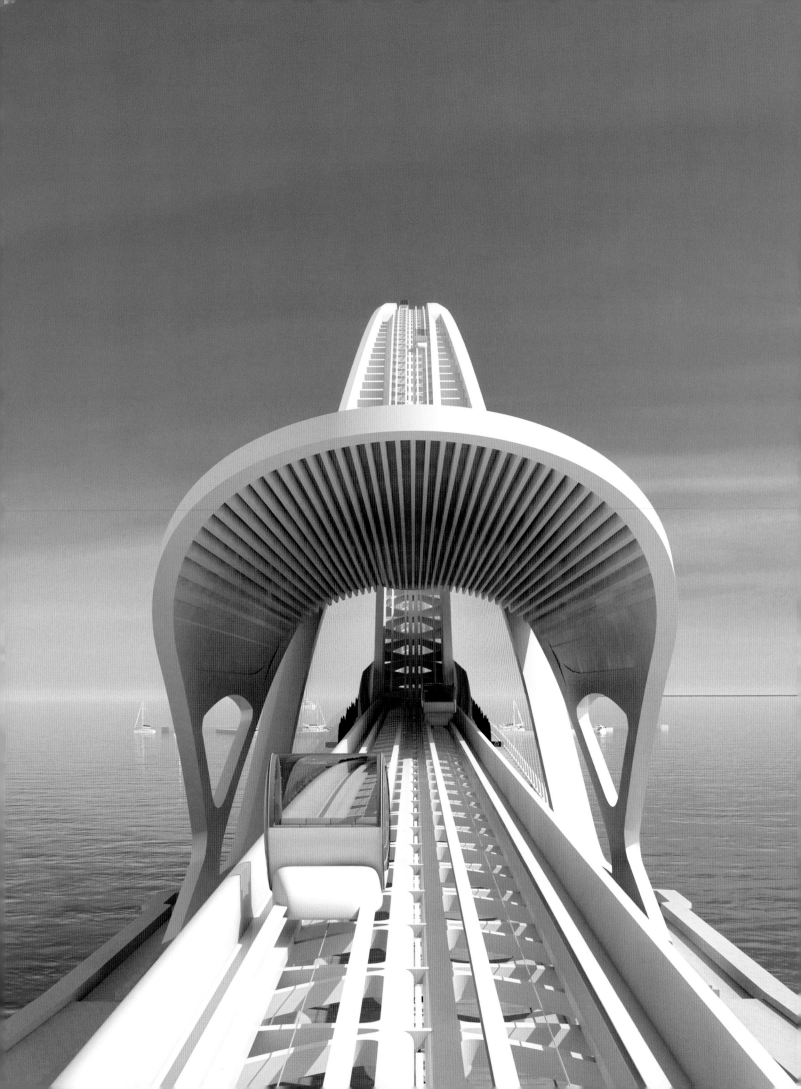

Project
SHARQ CROSSING

Location
DOHA, QATAR

Client
MINISTRY OF MUNICIPALITY AND URBAN PLANNING (MMUP)

Total fixed link length
12 KILOMETERS

Immersed Tube Tunnels
5.1 KILOMETERS IN TOTAL

To the right, the form of Doha is clearly visible, with I. M. Pei's Museum of Islamic Art at the lower, central part of the image with West Bay opposite. Left, the futuristic form of one of the bridges.

Rechts: Die Form von Doha ist deutlich erkennbar, mit I. M. Peis Museum für islamische Kunst im unteren zentralen Bereich des Bildes und der gegenüberliegenden West Bay. Links: Die futuristische Form einer der Brücken.

À droite, le plan de Doha est clairement visible, le Musée de l'art islamique de I. M. Pei en partie basse centrale de l'image, face à West Bay (baie de l'Ouest). À gauche, la forme futuriste de l'un des ponts.

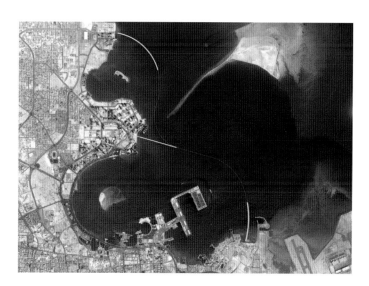

The Sharq Crossing was designed by Santiago Calatrava at the request of the Ministry of Municipal Affairs and Urban Planning (MMUP) of Qatar. Rather than a simple tunnel, which was the originally planned solution, Calatrava proposed bridges at each of the three ends of the crossing. The Sharq area of Doha, not far from Jean Nouvel's National Museum of Qatar now under construction, is also relatively close to the Hamad International Airport. The main business area of Doha, at West Bay, is across the water, hence the need for this crossing, intended to relieve the Corniche Road of some of its heavy traffic, and to reduce transit times to the city center. West Bay is also near to the Lusail development zone, a substantial urban project that is part of Doha's current rapid development. In the style of Santiago Calatrava, each of the bridge segments is "iconic" and different in design. The West Bay Bridge is an arched structure incorporating a "longitudinal park" extending from the proposed Corniche Park along the bridge's length on an elevated walkway. The Cultural City Bridge is in fact formed by a series of cable-stayed bridges that "skims across the bay in a pattern of descending scales creating a long bridge dramatically reducing the lengths of the submerged tunnel links." The Sharq Bridge is a tubular structure located close to Hamad International Airport. In a city where such architects as I. M. Pei and Jean Nouvel have marked the horizon, Santiago Calatrava will thus take a substantial role in forming the city as it prepares for the 2022 World Cup.

Sharq Crossing wurde von Calatrava auf Wunsch des Ministeriums für städtische Angelegenheiten und Stadtplanung (MMUP) von Qatar geplant. Anstelle des ursprünglich vorgesehenen einfachen Tunnels schlug Calatrava Brücken für alle drei Überquerungen vor. Der Bezirk Sharq in Doha, nicht weit von Jean Nouvels gegenwärtig im Bau befindlichen National Museum of Qatar entfernt, liegt auch relativ nahe am Hamad International Airport. Das Hauptgeschäftszentrum Dohas, West Bay, befindet sich am jenseitigen Ufer. Deshalb bestand der Bedarf für diese Überquerungen, die der Entlastung der Corniche Road vom Schwerverkehr dienen und die Fahrzeiten verkürzen sollen. West Bay liegt auch hinter dem Bebauungsgebiet Lusail, einem wichtigen städtischen Bauprojekt, das zu Dohas schneller Entwicklung beitragen wird. Im Stil Calatravas ist jeder Brückenabschnitt „ikonisch"

und unterschiedlich gestaltet. Die West Bay Bridge ist eine Bogenkonstruktion, die auch einen „Längspark" aufnimmt, der sich vom geplanten Corniche Park auf einer erhöhten Fußgängerebene über die ganze Länge der Brücke erstreckt. Die Cultural City Bridge besteht eigentlich aus mehreren Schrägseilbrücken, die „in einem System abnehmender Maßstäbe über die Bay führen und eine lange Brücke bilden, die die Länge der unterirdischen Tunnelverbindungen entscheidend verkürzt". Die Sharq Bridge ist eine Stahlrohrkonstruktion nahe dem Hamad International Airport. In dieser Metropole, in der Architekten wie I. M. Pei und Jean Nouvel die Silhouette geprägt haben, wird Santiago Calatrava eine wichtige Rolle in der Gestaltung der Stadt spielen, die sich auf den World Cup 2022 vorbereitet.

Sharq Crossing est un projet conçu par Santiago Calatrava à la demande du Ministère des affaires municipales et de l'urbanisme (MMUP) du Qatar. Au lieu du simple tunnel – solution prévue à l'origine – Calatrava a proposé des ponts à chacune de ses trois extrémités. Le quartier Sharq de Doha, non loin du Musée national du Qatar (en cours de construction) par Jean Nouvel, est proche de l'aéroport international d'Hamad. La principale zone d'affaires de Doha, West Bay, est située de l'autre côté de la baie, d'où la nécessité de ces ouvrages qui doivent soulager la route de la Corniche d'une partie de sa circulation et réduire les temps de transit vers le centre-ville. West Bay est également située non loin de la zone de développement de Lusail, vaste projet urbain prévu dans le cadre du développement rapide de la capitale. Dans le style caractéristique de Calatrava, chacun de ces ouvrages de qualité fortement iconique est de conception différente. Le West Bay Bridge est un pont en arc intégrant un « parc longitudinal » s'étendant tout au long de l'ouvrage et accessible par une passerelle surélevée à partir du parc de la Corniche. Le Cultural City Bridge est en fait constitué d'une série de ponts suspendus qui « glisse sur la baie vers une succession d'écailles de dimensions décroissantes pour créer un pont allongé réduisant spectaculairement la longueur des segments de tunnel ». Le Sharq Bridge est une structure tubulaire proche de l'aéroport international. Dans cette cité dont des architectes tel que I. M. Pei et Jean Nouvel ont marqué l'horizon, Santiago Calatrava joue ainsi un rôle d'importance, investi dans la composition de celle qui se prépare à accueillir la Coupe du monde de 2022.

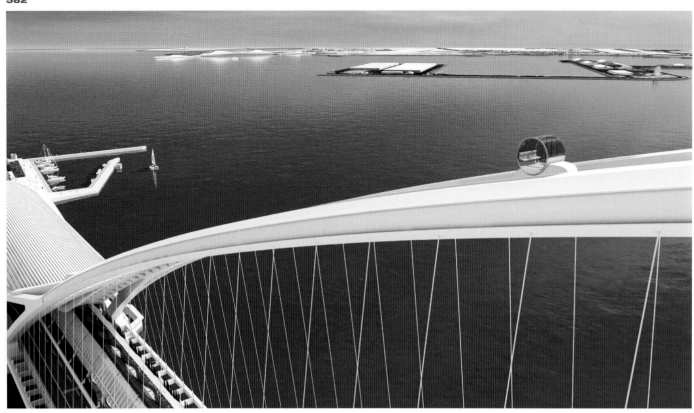

A sketch by Calatrava likens a bridge to a curving, jumping fish. Above, a computer view of one of the arches.

Auf einer Zeichnung Calatravas ähnelt eine Brücke einem gekrümmten, springenden Fisch. Oben: Computerdarstellung eines Bogens.

Un croquis de Calatrava rapproche le pont de l'image d'un poisson volant. Ci-dessus image de synthèse de l'une des arches.

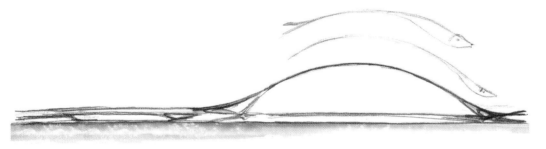

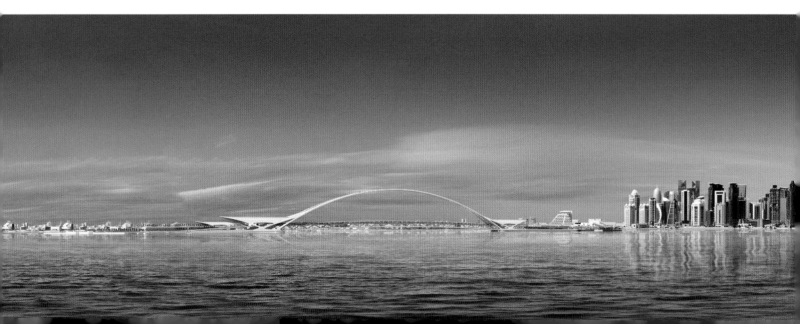

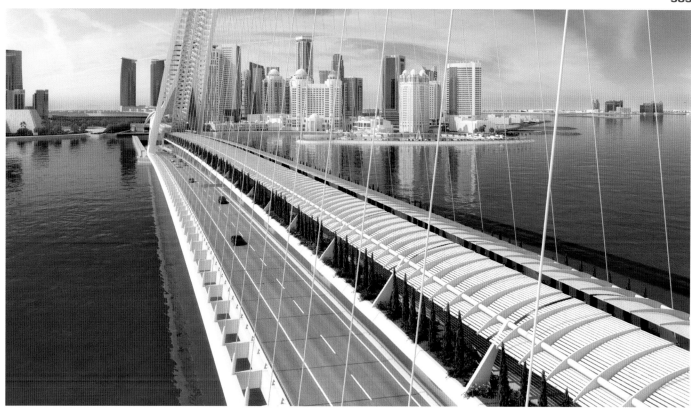

West Bay, visible in the background of the image above, is presently reachable only by following the long Corniche around the edge of the Bay. Below, a watercolor with the successive angled towers of the bridges.

Die im Hintergrund der Abbildung oben sichtbare West Bay ist gegenwärtig nur über die lange, am Rande der Bucht entlangführende Corniche erreichbar. Unten: Ein Aquarell mit der Reihe schräger Brückentürme.

West Bay, visible dans le fond de l'image ci-dessus, n'est aujourd'hui joignable qu'en empruntant la longue route de la Corniche en bordure de la baie. Ci-dessous, une aquarelle montrant les piliers inclinés des ouvrages.

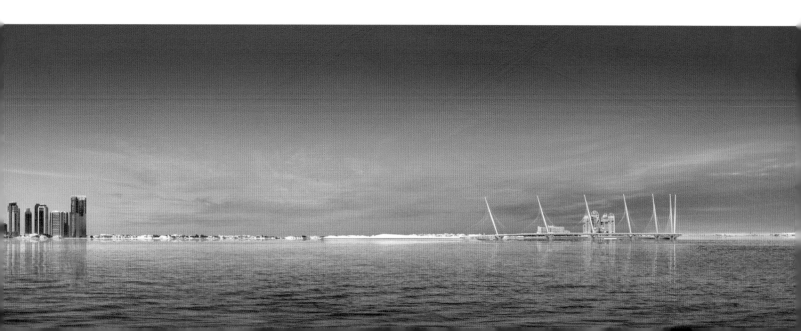

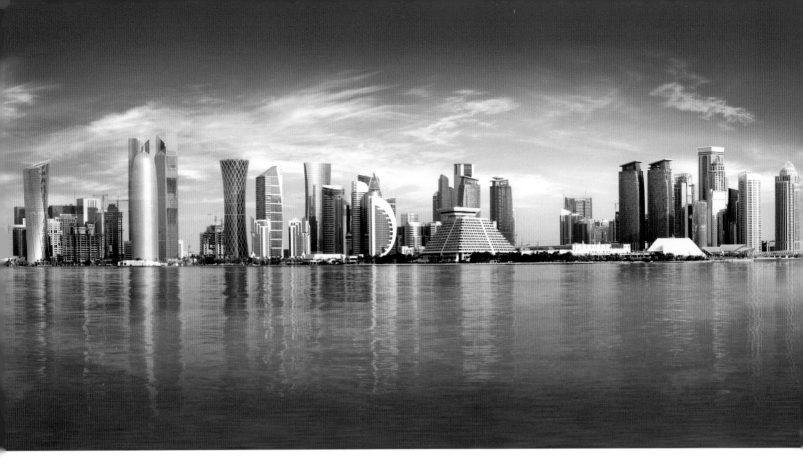

Above, a view of West Bay with Jean Nouvel's Doha Tower to the left, the Sheraton Doha Hotel (William Pereira, 1982) in the center and Calatrava's dramatic bridge on the right.

Oben: Ansicht der West Bay mit Jean Nouvels Doha Tower links, dem Sheraton Doha Hotel (William Pereira, 1982) in der Mitte und Calatravas eindrucksvoller Brücke rechts.

Ci-dessus, une vue de West Bay avec la tour de Doha par Jean Nouvel, à gauche, le Sheraton Doha Hotel de William Perreira (1982), au centre, et le spectaculaire ouvrage de Calatrava à droite.

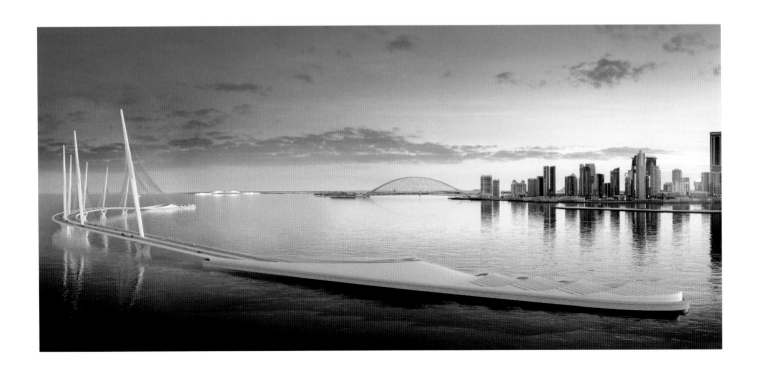

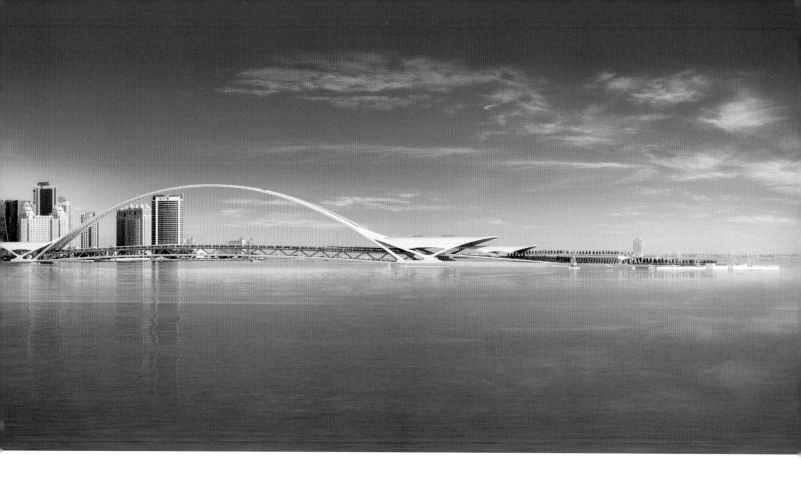

Calatrava's drawings and the images below emphasize the almost dunelike nature of the design, inspired by local topography.

Calatravas Aquarelle und die Abbildungen unten betonen die dünenähnliche, von der örtlichen Topographie inspirierte Wirkung seines Entwurfs.

Les dessins de Calatrava et les images ci-dessous mettent en valeur le profil de dune du projet, inspiré de la topographie locale.

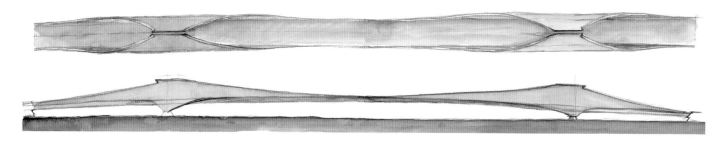

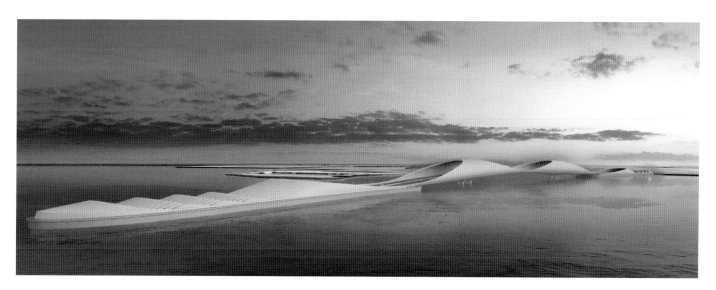

APPENDIX

MAIN PROJECTS
BIOGRAPHY
PRIZES AND AWARDS
BIBLIOGRAPHY
CREDITS & ACKNOWLEDGMENTS

MAIN PROJECTS

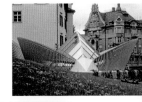

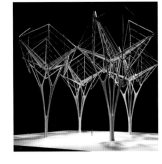

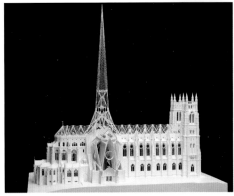

From left to right:
Bauschänzli Restaurant, Zurich, Switzerland;
Cathedral of St. John the Divine, New York,
New York, USA; *Emergency Service Center*,
St. Gallen, Switzerland; *Trinity Footbridge*,
Salfort-Manchester, U.K.; *L'Assut de l'Or
Bridge*, Valencia, Spain; *Margaret McDermott
Bridges*, Dallas, Texas, USA; *Christ the
Light Cathedral*, Oakland, California, USA.

ALPINE BRIDGES
Switzerland, 1973–79

**CABLE-STAYED
BRIDGE STUDIES**
1979

**IBA SQUASH
COMPLEX**
Berlin, Germany, 1979

**SWIMMING POOL
ETH ZURICH**
Zurich, 1980

**ZÜSPA EXHIBITION
HALL**
Zurich, Switzerland, 1981

**LETTEN MOTORWAY
BRIDGE**
Zurich, Switzerland, 1982

**MÜHLENAREAL
LIBRARY**
Thun, Switzerland, 1982

RHINE BRIDGE
Diepoldsau, Switzerland, 1982

**SCHWARZHAUPT
FACTORY**
Dielsdorf, Switzerland, 1982

**BAUMWOLLHOF
BALCONY**
Zurich, Switzerland, 1983

**THALBERG HOUSE
BALCONY EXTENSION**
Zurich, Switzerland, 1983

JAKEM WAREHOUSE
Münchwilen, Switzerland,
1983–84

**ERNSTING'S
WAREHOUSE**
Coesfeld-Lette, Germany,
1983–85

**PTT POSTAL CENTRE
CANOPY**
Lucerne, Switzerland, 1983–85

**ST. FIDEN
BUS SHELTER**
St. Gallen, Switzerland,
1983–85

**OHLEN HIGH SCHOOL
ROOFS AND HALL**
Wohlen, Switzerland, 1983–88

**LUCERNE STATION
HALL**
Lucerne, Switzerland, 1983–89

**STADELHOFEN
STATION**
Zurich, Switzerland, 1983–90

**CABALLEROS
FOOTBRIDGE**
Lérida, Spain, 1984

**DE SEDE COLLAPSIBLE
EXHIBITION PAVILION**
Zurich, Switzerland, 1984

DOBI OFFICE BUILDING
Suhr, Switzerland, 1984–85

**BACH DE RODA-
FELIPE II BRIDGE**
Barcelona, Spain, 1984–87

**BÄRENMATTE
COMMUNITY CENTRE**
Suhr, Switzerland, 1984–88

**FELDENMOOS PARK
& RIDE FOOTBRIDGE**
Feldenmoos, Switzerland,
1985

**STATION SQUARE
BUS TERMINAL**
Lucerne, Switzerland, 1985

**AVENIDA DIAGONAL
TRAFFIC SIGNAL
GANTRY**
Barcelona, Spain, 1986

RAITENAU OVERPASS
Salzburg, Austria, 1986

**ST. GALLEN
MUSIC SCHOOL
CONCERT ROOM**
St. Gallen, Switzerland, 1986

**BLACKBOX
TELEVISION STUDIO**
Zurich, Switzerland, 1986–87

TABOURETTLI THEATRE
Basel, Switzerland, 1986–87

9 D'OCTUBRE BRIDGE
Valencia, Spain, 1986–88

BANCO EXTERIOR
Zurich, Switzerland, 1987

**BASARRATE
METRO STATION**
Bilbao, Spain, 1987

CASCINE FOOTBRIDGE
Florence, Italy, 1987

PONTEVEDRA BRIDGE
Pontevedra, Spain, 1987

**THIERS PEDESTRIAN
BRIDGE**
Thiers, France, 1987

**OUDRY-MESLY
FOOTBRIDGE**
Créteil-Paris, France, 1987–88

**ALAMILLO BRIDGE &
LA CARTUJA VIADUCT**
Seville, Spain, 1987–92

**BCE PLACE:
GALLERIA & HERITAGE
SQUARE**
Toronto, Canada, 1987–92

**BUCHEN HOUSING
ESTATE**
Würenlingen, Switzerland,
1987–96

**BAUSCHÄNZLI
RESTAURANT**
Zurich, Switzerland, 1988

**COLLSEROLA
COMMUNICATIONS
TOWER**
Barcelona, Spain, 1988

GENTIL BRIDGE
Paris, France, 1988

**LEIMBACH
FOOTBRIDGE AND
STATION**
Zurich, Switzerland, 1988

**PRÉ BABEL SPORTS
CENTRE**
Geneva, Switzerland, 1988

**WETTSTEIN
BRIDGE**
Basel, Switzerland, 1988

LUSITANIA BRIDGE
Mérida, Spain, 1988–91

**EMERGENCY
SERVICE CENTER**
St. Gallen, Switzerland,
1988–99

**BAHNHOFQUAI
TRAM STOP**
Zurich, Switzerland, 1989

**CH-91 FLOATING
CONCRETE
PAVILION LAKE**
Lucerne, Switzerland, 1989

GRAN VIA BRIDGE
Barcelona, Spain, 1989

MIRAFLORES BRIDGE
Cordoba, Spain, 1989

**MURI CLOISTER OLD
AGE HOME**
Muri, Switzerland, 1989

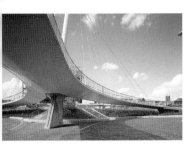
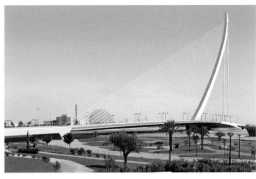

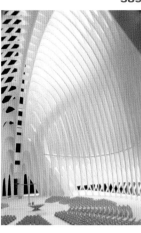

PORT DE LA LUNE SWINGBRIDGE
Bordeaux, France, 1989

REUSS FOOTBRIDGE
Flüelen, Switzerland, 1989

SWISSBAU CONCRETE PAVILION
Basel, Switzerland, 1989

LA DEVESA FOOTBRIDGE
Ripoll, Spain, 1989–91

MONTJUIC COMMUNICATIONS TOWER
Barcelona, Spain, 1989–92

LYON-SAINT EXUPÉRY AIRPORT RAILWAY STATION
Satolas, France, 1989–94

PUERTO BRIDGE
Ondarroa, Spain, 1989–95

BOHL BUS AND TRAM STOP
St. Gallen, Switzerland, 1989–96

ZURICH UNIVERSITY, LAW FACULTY LIBRARY
Zurich, Switzerland, 1989–2004

BELLUARD CASTLE THEATRE
Fribourg, Switzerland, 1990

EAST LONDON RIVER CROSSING
London, UK, 1990

NEW BRIDGE OVER THE VECCHIO
Corsica, France, 1990

SPITALFIELDS GALLERY
London, UK, 1990

CAMPO VOLANTÍN FOOTBRIDGE
Bilbao, Spain, 1990–97

SONDICA AIRPORT
Bilbao, Spain, 1990–2000

BETON FORUM STANDARD BRIDGE
Stockholm, Sweden, 1991

CALABRIA FOOTBALL STADIUM
Reggio Calabria, Italy, 1991

CATHEDRAL OF ST. JOHN THE DIVINE
New York, NY, USA, 1991

GRAND PONT
Lille, France, 1991

KLOSTERSTRASSE RAILWAY VIADUCT
Berlin, Germany, 1991

MÉDOC SWINGBRIDGE
Bordeaux, France, 1991

SALOU FOOTBALL STADIUM
Salou, Spain, 1991

SPANDAU RAILWAY STATION
Berlin, Germany, 1991

VALENCIA COMMUNICATIONS TOWER
Valencia, Spain, 1991

KUWAIT PAVILION
Seville, Spain, 1991–92

ALAMEDA BRIDGE AND SUBWAY STATION
Valencia, Spain, 1991–95

KRONPRINZEN BRIDGE
Berlin, Germany, 1991–96

OBERBAUM BRIDGE
Berlin, Germany, 1991–96

CITY OF ARTS AND SCIENCES
Valencia, Spain, 1991–2000/ 1996–2005/2005–

TENERIFE AUDITORIUM
Santa Cruz de Tenerife, Spain, 1991–2003

JAHN OLYMPIC SPORTS COMPLEX
Berlin, Germany, 1992

LAKE BRIDGE
Lucerne, Switzerland, 1992

MODULAR STATION
London, UK, 1992

REICHSTAG CONVERSION
Berlin, Germany, 1992

SERPIS BRIDGE
Alcoy, Spain, 1992

SHADOW MACHINE
New York, NY, USA, 1992

SOLFERINO FOOTBRIDGE
Paris, France, 1992

RECINTO FERIAL DE TENERIFE
Santa Cruz de Tenerife, Spain, 1992–95

REMODELLING OF PLAZA DE ESPAÑA
Alcoy, Spain, 1992–95

L'ASSUT DE L'OR BRIDGE
Valencia, Spain, 1992–2008

ALICANTE COMMUNICATIONS TOWER
Alicante, Spain, 1993

DE LA RADE BRIDGE
Geneva, Switzerland, 1993

GRANADILLA BRIDGE
Tenerife, Spain, 1993

HERNE HILL STADIUM
London, UK, 1993

ILE FALCON VIADUCT
Sierre, Switzerland, 1993

ÖRESUND LINK
Copenhagen, Denmark, 1993

ROOSEVELT ISLAND SOUTHPOINT PAVILION
New York, NY, USA, 1993

TRINITY FOOTBRIDGE
Salford, Manchester, UK, 1993–95

SONDICA CONTROL TOWER
Bilbao, Spain, 1993–96

ORIENTE STATION
Lisbon, Portugal, 1993–98

HOSPITAL BRIDGES
Murcia, Spain, 1993–99

MICHELANGELO TRADE FAIR AND CONVENTION CENTRE
Fiuggi, Italy, 1994

QUAYPOINT PEDESTRIAN BRIDGE
Bristol, UK, 1994

ST. PAUL'S FOOTBRIDGE
London, UK, 1994

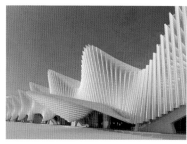
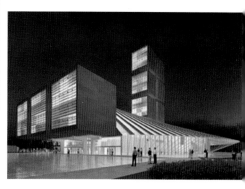

**MANRIQUE
FOOTBRIDGE**
Murcia, Spain, 1994–99

**MILWAUKEE ART
MUSEUM**
Milwaukee, WI, USA,
1994–2001

**BILBAO FOOTBALL
STADIUM**
Bilbao, Spain, 1995

**EMBANKMENT
RENAISSANCE
FOOTBRIDGE**
Bedford, UK, 1995

KL LINEAR CITY
Kuala Lumpur, Malaysia, 1995

SUNDSVALL BRIDGE
Sundsvall, Sweden, 1995

**VELODROME
FOOTBALL STADIUM**
Marseille, France, 1995

ZURICH STATION ROOF
Zurich, Switzerland, 1995

CATHEDRAL SQUARE
Los Angeles, CA, USA, 1996

**CHURCH OF
THE YEAR 2000**
Rome, Italy, 1996

CITY POINT
London, UK, 1996

OLYMPIC STADIUM
Stockholm, Sweden, 1996

**POOLE HARBOUR
BRIDGE**
Poole, UK, 1996

**PORTE DE LA
SUISSE MOTORWAY
SERVICE AREA**
Geneva, Switzerland, 1996

**MIMICO CREEK
PEDESTRIAN BRIDGE**
Toronto, Canada, 1996–98

BRIDGE OF EUROPE
Orléans, France, 1996–2000

OPERA HOUSE
Valencia, Spain, 1996–2006

**LIÈGE-GUILLEMINS
RAILWAY STATION**
Liège, Belgium, 1996–2009

BARAJAS AIRPORT
Madrid, Spain, 1997

PORT DE BARCELONA
Barcelona, Spain, 1997

**PFALZKELLER
GALLERY**
St. Gallen, Switzerland,
1997–99

SUNDIAL FOOTBRIDGE
Redding, CA, USA, 1997–2004

**PENNSYLVANIA
RAILWAY STATION**
New York, NY, USA, 1998

**TORONTO ISLAND
AIRPORT BRIDGE**
Toronto, Canada, 1998

PONT DES GUILLEMINS
Liège, Belgium, 1998–2000

BODEGAS YSIOS
Laguardia, Spain, 1998–2001

MUJER BRIDGE
Buenos Aires, Argentina,
1998–2001

JAMES JOYCE BRIDGE
Dublin, Ireland, 1998–2003

**PETAH-TIKVA
FOOTBRIDGE**
Tel Aviv, Israel, 1998–2006

**SAMUEL BECKETT
BRIDGE**
Dublin, Ireland, 1998–2009

CRUZ Y LUZ
Monterrey, Mexico, 1999

LEUVEN STATION
Sint–Niklaas, Belgium, 1999

**NOVA PONTE SOBRE
O RIO CAVADO**
Barcelos, Portugal, 1999

PEDESTRIAN BRIDGE
Pistoia, Italy, 1999

**REINA SOFIA NATIONAL
MUSEUM OF ART**
Madrid, Spain, 1999

RESIDENTIAL HOUSE
Phoenix, AZ, USA, 1999

ROUEN BRIDGE
Rouen, France, 1999

**THE CORCORAN
GALLERY OF ART**
Washington D.C., USA, 1999

WILDBACHSTRASSE
Zurich, Switzerland, 1999

ZARAGOZA STATION
Zaragoza, Spain, 1999

**THE NEW YORK TIMES
CAPSULE**
New York, NY, USA, 1999–2001

**BRIDGES OVER
THE HOOFDVAART**
Hoofddorp, the Netherlands,
1999–2004

TURNING TORSO
Malmö, Sweden, 1999–2004

**FOURTH BRIDGE ON
THE CANAL GRANDE**
Venice, Italy, 1999–2008

**CHRIST THE LIGHT
CATHEDRAL**
Oakland, CA, USA, 2000

**CIUDAD DE LA
PORCELANA**
Valencia, Spain, 2000

**DALLAS FORT WORTH
AIRPORT**
Dallas, TX, USA, 2000

**DARSENA DEL PUERTO,
CENTRO MUNICIPAL**
Torrevieja, Spain, 2000

KORNHAUS
Rorschach, Switzerland, 2000

**OPERA HOUSE
PARKING**
Zurich, Switzerland, 2000

**RYERSON
POLYTECHNIC
UNIVERSITY**
Toronto, Canada, 2000

STADIUM ZURICH
Zurich, Switzerland, 2000

PONTE SUL CRATI
Cosenza, Italy, 2000

**UNIVERSITY
CAMPUS BUILDINGS
AND SPORTS CENTER**
Maastricht, the Netherlands,
2000

**SMU'S MEADOWS
MUSEUM WAVE
SCULPTURE**
Dallas, TX, USA, 2000–02

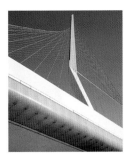
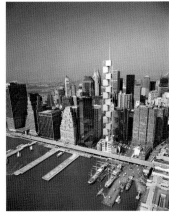
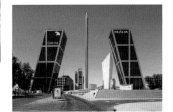
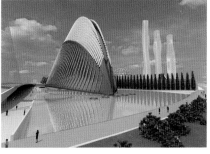
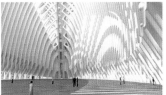

From left to right:
Conference and Exhibition Center, Oviedo, Spain; *Reggio Emilia Bridges*, Reggio Emilia, Italy; *Mediopadana Station*, Reggio Emilia, Italy; *University Campus Buildings and Sports Center*, Maastricht, the Netherlands; *Light Rail Train Bridge*, Jerusalem, Israel; *80 South Street Tower*, New York, New York, USA; *Obelisk Plaza Castilla*, Madrid, Spain; *City of Arts and Sciences, Towers and Agora* (above) / *Agora* (below), Valencia, Spain.

CONFERENCE AND EXHIBITION CENTER
Oviedo, Spain, 2000–11

LAKE PROMENADE
Rorschach, Switzerland, 2001

NERATZIOTISSA METRO AND RAILWAY STATION
Athens, Greece, 2001

PRIVATE RESIDENCE QATAR
Qatar, 2001

QUEENS LANDING PEDESTRIAN ACCESS IMPROVEMENT
Chicago, IL, USA, 2001

STAGE SETTING LAS TROYANAS
Valencia, Spain, 2001

THE AMERICAN MUSEUM OF NATURAL HISTORY
New York, NY, USA, 2001

KATEHAKI PEDESTRIAN BRIDGE
Athens, Greece, 2001–04

OLYMPIC SPORTS COMPLEX
Athens, Greece, 2001–04

BRIDGE OF VITTORIA
Florence, Italy, 2002

RECONSTRUCTION OF THE MUSEUM OF THE OPERA DI S. MARIA DEL FIORE
Florence, Italy, 2002

80 SOUTH STREET TOWER
New York, NY, USA, 2002

ATLANTA SYMPHONY ORCHESTRA
Atlanta, GA, USA, 2002

GREENPOINT LANDING
New York, NY, USA, 2002

PHOTOGRAPHY MUSEUM DOHA
Doha, Qatar, 2002

STAGE SETTING ECUBA
Rome, Italy, 2002–03

REGGIO EMILIA BRIDGES
Reggio Emilia, Italy, 2002–07

LIGHT RAIL TRAIN BRIDGE
Jerusalem, Israel, 2002–08

NUOVA STAZIONE AV DI FIRENZE
Florence, Italy, 2002–13

MEDIOPADANA STATION
Reggio Emilia, Italy, 2002–14

LAKE SHORE DRIVE
Chicago, IL, USA, 2003

WORLD TRADE CENTER TRANSPORTATION HUB
New York, NY, USA, 2003–15

RAILWAY AND AUTOMOBILE BRIDGE
Kiev, Russia, 2004

TOWERS
Valencia, Spain, 2004

OBELISK PLAZA CASTILLA
Madrid, Spain, 2004–09

MONS STATION
Mons, Belgium, 2006–

INTERNATIONAL FAIR WORLD EXPO
Thessaloniki, Greece, 2005

CHICAGO SPIRE
Chicago, IL, USA, 2005 (design)

AGORA
Valencia, Spain, 2005–09

CITY OF SPORTS TOR VERGATA
Rome, Italy, 2005–

UNIVERSITÀ DEGLI STUDI DI ROMA
Tor Vergata, Rome, Italy, 2005–

GOVERNORS ISLAND GONDOLA CARS
New York, NY, USA, 2006

SCIENCE HOUSE
Zurich, Switzerland, 2006–08

THE NEW YORK CITY BALLET COLLABORATION
New York, NY, USA, 2008–10

PEACE BRIDGE
Calgary, Canada, 2008–12

MARINA D'ARECHI
Salerno, Italy, 2008–

YUAN ZE UNIVERSITY CAMPUS NEW BUILDING COMPLEX
Taipei, Taiwan, 2008–

UNIVERSITY OF SOUTH FLORIDA POLYTECHNIC
Lakeland, FL, USA, 2009–14

MARGARET HUNT HILL BRIDGE
Dallas, TX, USA, 2010–12

MUSEUM OF TOMORROW
Rio de Janeiro, Brazil, 2010–

MARGARET MCDERMOTT BRIDGES
Dallas, TX, USA, 2011–

SHARQ CROSSING
Doha, Qatar, 2011–

RIO BARRA BRIDGE
Rio de Janeiro, Brazil, 2012 (design)

ST. NICHOLAS GREEK ORTHODOX NATIONAL SHRINE
New York, NY, USA, 2012–

HUASHAN BRIDGES
Wuhan, Hubei, China, 2015–

BIOGRAPHY

Santiago Calatrava by Suzanne DeChillo.

Architect, artist, and engineer, Santiago Calatrava was born on July 28, 1951, in Valencia, Spain. He attended primary and secondary school in Valencia. From the age of eight, he also attended the Arts and Crafts School, where he began his formal instruction in drawing and painting. Upon completing high school in Valencia, and following a period spent in Paris he enrolled in the Escuela Técnica Superior de Arquitectura where he earned a degree in architecture and took a postgraduate course in urbanism. Attracted by the mathematical rigor of certain great works of historic architecture, Calatrava decided to pursue postgraduate studies in civil engineering and enrolled in 1975 at the ETH in Zurich. He received his Ph.D. in 1981 presenting the thesis "Concerning the Foldability of Space Frames."

After completing his studies, he opened his first office in Zurich in 1981 and began to enter competitions with his first winning proposal, in 1983, for the design and construction of Stadelhofen Station in Zurich. In 1984, Calatrava designed the Bach de Roda Bridge in Barcelona, the first of the bridge projects that established his international reputation. Among his following notable bridges were the Alamillo Bridge and La Cartuja Viaduct in Seville (1987–92); Campo Volantín Footbridge in Bilbao (1990–97); and Alameda Bridge and Subway Station in Valencia (1991–95). Other large-scale public projects from the late 1980s through the 1990s include the BCE Place Hall in Toronto (1987–92) and the Oriente Station in Lisbon (1993–98).

Calatrava established his second office in Paris in 1989, when he was working on the Lyon-Saint Exupéry Airport Station (1989–94). In 1991, he won the competition in Valencia for the City of Arts and Sciences and started working in Spain.

In 2004, following Calatrava's first building in the United States (the expansion of the Milwaukee Art Museum, in 1994), he opened an office in New York

City. Further projects in the United States include the Sundial Bridge, Redding, California (his first bridge in the United States); the bridges over the Trinity River in Dallas, Texas; and the World Trade Center Transportation Hub in New York City. Later commissions in the USA include the first building for the Florida Polytechnic University's new campus and St. Nicholas Greek Orthodox National Shrine at the World Trade Center in New York City.

Selected projects completed since 2000 include Sondica Airport, Bilbao, Spain (2000); the Bridge of Europe, Orléans, France (2000); Bodegas Ysios winery in Laguardia, Spain (2001); Mujer Bridge in Buenos Aires (2001); James Joyce Bridge, Dublin, Ireland (2003); Tenerife Auditorium, Santa Cruz, Canary Islands, Spain (2003); Three Bridges over the Hoofdvaart, Hoofddorp, the Netherlands (2004); Olympic Sports Complex, Athens, Greece (2004); Zurich University Law Faculty, Zurich, Switzerland (2004); Turning Torso, Malmö, Sweden (2004); Petah-Tikva Bridge, Tel Aviv, Israel (2006); the Opera House, City of Arts and Sciences, Valencia, Spain (2006); Three Bridges in Reggio Emilia, Italy (2007); Light Rail Train (LRT) Bridge, Jerusalem, Israel (2008); Fourth Bridge on the Canal Grande, Venice, Italy (2008); l'Assut de l'Or Bridge in Valencia (2008); the Liège-Guillemins TGV Railway Station (2009); the Samuel Beckett Bridge, Dublin, Ireland (2009); the New York City Ballet Collaboration (2010), Conference and Exhibition Center, Oviedo, Spain (2011); Calgary's Peace Bridge (2012); the Margaret Hunt Hill Bridge in Dallas, Texas (2012) and the Mediopadana Station in Reggio Emilia (2013).

Other projects currently being designed or under construction include the Margaret McDermott Bridges, Dallas; Yuan Ze University Performing Arts Center, Arts and Design School and Y. Z. Hsu Memorial Hall, Taipei; the Museum of Tomorrow, Rio de Janeiro; Mons Station, Mons; and the Sharq Crossing masterplan in Doha, Qatar.

Exhibitions of Calatrava's work were first mounted in 1985, with a showing of nine sculptures in an art gallery in Zurich. A new stage in recognition was marked by two solo exhibitions: a retrospective at the Royal Institute of British Architects, London, in 1992, and the exhibition "Structure and Expression" at the Museum of Modern Art, New York, in 1993 while in the same year "Santiago Calatrava: Bridges" was exhibited at the Deutsches Museum in Munich. In 1994, "Santiago Calatrava: The Dynamics of Equilibrium" was exhibited in Tokyo's MA Gallery. "Santiago Calatrava: Artist, Architect, Engineer," an exhibition of architectural models, sculpture and drawings, was presented at Palazzo Strozzi in Florence in 2000. "Santiago Calatrava: Wie ein Vogel" (Like a Bird) was exhibited at Vienna's Kunsthistorisches Museum in 2003. In 2005, an exhibition of his artistic body of work was mounted at the Metropolitan Museum of Art titled "Santiago Calatrava: Sculpture into Architecture." In 2010, "Santiago Calatrava: Sculptectures" was exhibited at the Museum Le Grand Curtius in Liège. Together with Frank Stella he exhibited their joint work "The Michael Kohlhaas Curtain" at the Neue Nationalgalerie in Berlin in 2011. In 2012, Calatrava's "The Quest for Movement" was exhibited at the State Hermitage Museum in St. Petersburg. "Santiago Calatrava. Le metamorfosi dello spazio" was mounted at the Vatican Museum, Vatican City in 2013. Most recently his sculptures, ceramics and paintings were exhibited at the Marlborough Gallery in New York in 2014.

Calatrava is a permanent guest lecturer in universities such as the ETH Zurich, MIT School of Architecture and Design, Yale University, Azrieli School of Architecture in Tel Aviv and Columbia University in New York. Throughout his career, he has received over 20 honorary doctorates (Doctor Honoris Causa) from universities around the world: Heriot-Watt, Salford, Strathclyde and Oxford Universities in the UK, the European Universities of Delft, Liège, Cassino, Ferrara, Lund, Valencia, Seville, Madrid and the Aristotle University of Thessaloniki alongside Israel's Technion Institute in Haifa and Tel Aviv University. Honorary Doctorates have also been forthcoming from the United States from the Milwaukee School of Engineering, Columbia University and Rensselaer Polytechnic Institute of New York, Southern Methodist University of Dallas, Pratt Institute in New York City and the Georgia Institute of Technology.

PRIZES AND AWARDS
BIBLIOGRAPHY

PRIZES AND AWARDS

Calatrava has received numerous prizes and awards from renowned institutions and organizations such as the UIA Auguste Perret Prize in 1987, the Gold Medal of the Institution of Structural Engineers, the Royal College of Art "Sir Misha Black Medal" (2002), the Principe de Asturias Art Prize, Oviedo, SEFI's Leonardo da Vinci medal, and the MIT "Eugene McDermott Award in the Arts" (2005), for his artistic achievements. He also received the Fritz Schumacher Prize for Urbanism, Architecture and Engineering (1998), Médaille d'Argent de la Recherche et de la Technique from the Fondation Académie d'Architecture (1990), the AIA Gold Medal (2005), the Premio Nacional de Arquitectura (2005), the Grande Médaille d'Or d'Architecture, Académie d'Architecture (2003) and the AIA National Medal (2012).

Calatrava's buildings such as the Milwaukee Art Museum received the SEAOI 2002 Excellence in Design Award for Best Large Structure, the 2004 IABSE Outstanding Structure Award, the 2004 Outstanding Project Award from the NCSEA; the Turning Torso in Malmö received the MIPIM Award (2005) and the fib 2006 Award for Outstanding Concrete Structures. The Stadelhofen Station and the Oriente Station received the Brunel Award in 1992 and 1998 respectively and the Liège-Guillemins Railway Station received the ESCN 2006 European Award for Excellence in Concrete. He also received numerous ECCS European Steel Design Awards for his projects such as the reconstruction of Berlin's Kronprinzenbrücke, the Bridge of Europe in Orléans, the Zurich University Law Faculty, Three Bridges over the Hoofdvaart, Athens Olympic Sports Complex, Three Bridges in Reggio Emilia and most recently the Margaret Hunt Hill Bridge in Dallas in 2012.

He received the CISC-ICCA 2013 Steel Design Award of Excellence and the 2014 National Steel Design Award of Excellence for the Peace Bridge in Calgary, Canada. The Florida Polytechnic University project (2014), received the Award of Merit for Quality Concrete and was the winner of the ENR's National Best of the Best Project in the Higher Education/Research and Specialty Construction categories. The same project won the American Institute of Steel Construction IDEAS Award of 2015. In 2015, the WTC Transportation Hub in New York City, was awarded the SARA Special Award for Excellence in Urban Infrastructure. In the past 35 years, Santiago Calatrava has participated in over 80 design competitions.

Calatrava's personal contribution has been recognized by many renowned institutions and organizations. He was named a "Global Leader for Tomorrow" by the World Economic Forum in 1993 and was named as one of the 100 most influential people by *Time* magazine in 2005.

Santiago Calatrava in the garden of his Zurich office, 2005.

BIBLIOGRAPHY

Galerie Jamileh Weber
SANTIAGO CALATRAVA
Exhibition catalogue, Wolfau-Druck, Weinfelden 1986

Generalitat Valenciana
SANTIAGO CALATRAVA
Exhibition catalogue, Valencia 1986

Pierluigi Nicolin
**SANTIAGO CALATRAVA
IL FOLLE VOLO / THE DARING FLIGHT**
Electa, Milan 1987

Werner Blaser
**SANTIAGO CALATRAVA
INGENIEUR-ARCHITEKTUR**
Birkhäuser, Basel 1989

Richard C. Levene, Fernando Márquez Cecilia
**SANTIAGO CALATRAVA
1983 / 1989**
El Croquis, Madrid 1989

Bernhard Klein, Kenneth Frampton, Lukas Schmutz, Peter Rice
EIN BAHNHOF / UNE GARE
Archithese, Arthur Niggli, Heiden 1990

Santiago Calatrava
**DYNAMISCHE GLEICHGEWICHTE:
NEUE PROJEKTE /
DYNAMIC EQUILIBRIUM:
RECENT PROJECTS**
Artemis, Zurich 1991

Anthony C. Webster, Kenneth Frampton
SANTIAGO CALATRAVA
Exhibition catalogue, Museum für Gestaltung, Zurich 1992

Robert Harrison
**CREATURES FROM THE MIND OF THE ENGINEER.
THE ARCHITECTURE OF SANTIAGO CALATRAVA**
Artemis, Zurich 1992

Dennis Sharp
SANTIAGO CALATRAVA
Exhibition catalogue, Book Art, London 1992

Matilda McQuaid
**SANTIAGO CALATRAVA
STRUCTURE AND EXPRESSION**
Exhibition catalogue, Museum of Modern Art, New York 1993

Kenneth Frampton, Anthony C. Webster, Anthony Tischhauser
**SANTIAGO CALATRAVA
BRIDGES**
Artemis, Zurich 1993

El Croquis
**SANTIAGO CALATRAVA
1983–1993**
Exhibition catalogue, El Croquis, Madrid 1993

Bernhard Klein
**SANTIAGO CALATRAVA
BAHNHOF STADELHOFEN, ZÜRICH**
Ernst Wasmuth, Tübingen / Berlin 1993

Michael S. Cullen, Martin Kieren
CALATRAVA. BERLIN: FIVE PROJECTS / FÜNF PROJEKTE
Birkhäuser, Basel 1994

Marianne Le Roux, Michel Rivoire
**CALATRAVA
ESCALE SATOLAS**
Glénat, Grenoble 1994

Gallery MA
**SANTIAGO CALATRAVA
THE DYNAMICS OF EQUILIBRIUM**
Exhibition catalogue, Tokyo 1994

Europa Akademie
**SANTIAGO CALATRAVA
BUILDINGS AND BRIDGES**
Exhibition catalogue, Moscow 1994

Mirko Zardini
**SANTIAGO CALATRAVA
SECRET SKETCHBOOK**
Monacelli Press, New York 1996

Alexander Tzonis, Liane Lefaivre
MOVEMENT, STRUCTURE AND THE WORK OF SANTIAGO CALATRAVA
Birkhäuser, Basel 1995

Gobierno de Navarra
SANTIAGO CALATRAVA
Exhibition catalogue, Museo de
Navarra, Pamplona 1995

Sergio Polano
SANTIAGO CALATRAVA
COMPLETE WORKS
Exhibition catalogue, Electa,
Milan 1996

Dennis Sharp
SANTIAGO CALATRAVA
Architectural Monographs 46,
Academy Editions, London 1996

Luis Fernández-Galiano
SANTIAGO CALATRAVA
1983–1996
AV Monografías / Monographs 61,
Madrid 1996

Mario Pisani, Enrico Sicignano,
Domizia Mandolesi
SANTIAGO CALATRAVA
PROGETTI E OPERE
Rome 1997

Rifca Hashimshony
SANTIAGO CALATRAVA
STRUCTURES AND
MOVEMENT
Exhibition catalogue, Haifa 1997

Philip Jodidio
SANTIAGO CALATRAVA
TASCHEN, Cologne 1998

Anthony Tischhauser,
Stanislaus von Moos
SANTIAGO CALATRAVA –
PUBLIC BUILDINGS
Birkhäuser, Basel 1998

Philip Jodidio
ORIENTE STATION
Livros e Livros, Lisbon 1998

Luca Molinari
SANTIAGO CALATRAVA
Exhibition catalogue, Skira, Milan 1998

Alexander Tzonis
SANTIAGO CALATRAVA
THE POETICS OF MOVEMENT
Universe Publishing, New York 1999

Manuel Blanco
SANTIAGO CALATRAVA
Exhibition catalogue, Generalitat
Valenciana, Valencia 1999

Kosme de Barañano
SANTIAGO CALATRAVA:
AEROPUERTO DE BILBAO
Fundación Aena, Madrid 2000

Michael Levin
CALATRAVA. DRAWINGS
AND SCULPTURES
Exhibition catalogue, Wolfau-Druck,
Weinfelden 2000

James A. Ledbetter
SANTIAGO CALATRAVA
STRUCTURES IN MOVEMENT
Exhibition catalogue, South China
Printing Company, Hong Kong 2001

IVAM Centre Julio Gonzales
SANTIAGO CALATRAVA:
SCULPTURES AND
DRAWINGS / ESCULTURES
Y DIBUIXOS
Exhibition catalogue, Aldeasa – IVAM,
Madrid / Valencia 2001

Ralph Herrmanns
SANTIAGO CALATRAVA
FÖRVERKLIGAR DET
OVERKLIGA
Bokförlag Läseleket, Stockholm 2001

Alexander Tzonis, Liane Lefaivre
SANTIAGO CALATRAVA'S
CREATIVE PROCESS
PART I: FUNDAMENTALS
PART II: SKETCHBOOKS
Birkhäuser, Basel 2001

Umberto Trame
OP/O OPERA PROGETTO:
SANTIAGO CALATRAVA –
QUADRACCI PAVILION
MILWAUKEE ART MUSEUM
Editrice Compositori, Bologna 2001

Cecilia Lewis Kausel,
Ann Pendleton-Jullian
SANTIAGO CALATRAVA:
CONVERSATIONS WITH
STUDENTS
Princeton Architectural Press,
New York 2002

Michael Levin
SANTIAGO CALATRAVA –
THE ARTWORKS
Birkhäuser, Basel 2002

Wilfried Seipel
SANTIAGO CALATRAVA
WIE EIN VOGEL / LIKE A BIRD
Exhibition catalogue, Kunsthistorisches
Museum, Wien / Skira, Milan 2003

Philip Jodidio
SANTIAGO CALATRAVA
TASCHEN, Cologne 2003

Auditorio de Tenerife
AUDITORIO DE TENERIFE
VISIONES VISION
Tenerife 2003

Kirsten Kiser
SANTIAGO CALATRAVA
Exhibition catalogue, Arvinius Förlag,
Stockholm 2004

Santiago Calatrava
CALATRAVA
ALPINE BRIDGES
Wolfau-Druck, Weinfelden 2004

Alexander Tzonis
SANTIAGO CALATRAVA:
THE COMPLETE WORKS
Rizzoli, New York 2004

Cheryl Kent
SANTIAGO CALATRAVA:
MILWAUKEE ART MUSEUM
QUADRACCI PAVILION
Rizzoli, New York 2005

Alexander Tzonis,
Rebecca Caso Dondei
SANTIAGO CALATRAVA
THE BRIDGES
Universe, New York 2005

Alexander Tzonis
SANTIAGO CALATRAVA
THE ATHENS OLYMPICS
Rizzoli, New York 2005

Santiago Calatrava
L'AMÉNAGEMENT DU SITE
DE LA GARE DE MONS
Santiago Calatrava LLC, Zurich 2006

Philip Jodidio
SANTIAGO CALATRAVA
ARCHITECT, ENGINEER,
ARTIST
TASCHEN, Cologne 2007

Alexander Tzonis
SANTIAGO CALATRAVA
THE COMPLETE WORKS
Expanded Edition, Rizzoli, New York
2007

Boye Llorens Peters, Tomàs Llorens
SANTIAGO CALATRAVA
ESCULTURES, DIBUIXOS I
CERAMIQUES
Exhibition catalogue, Es Baluard
Museu d'Art Modern i Contemporani
de Palma / Bancaja 2007

Boye Llorens Peters, Tomàs Llorens
SANTIAGO CALATRAVA
DALLE FORME
ALL'ARCHITETTURA
Exhibition catalogue, Scuderie del
Quirinale, Rome 2007

Juan Garcia Rosell (Photographer)
SANTIAGO CALATRAVA
CERAMICAS
Santiago Calatrava LLC, Zurich 2009

Manuel de la Fuente
EL MONUMENTO DE
CAJA MADRID
Fundación Caja Madrid, Madrid 2010

Santiago Calatrava
THE QUEST FOR MOVEMENT
Exhibition catalogue, The State Hermitage
Publishers, St. Petersburg 2012

Cristina Carrillo de Albornoz Fisac
SANTIAGO CALATRAVA
Assouline, New York 2013

Micol Forti (Ed.)
SANTIAGO CALATRAVA
THE METAMORPHOSES OF
THE SPACE
Exhibition Catalogue, Edizioni Musei
Vaticani, Vatican City 2013

Stanislao Farri
BONJOUR, MONSIEUR
CALATRAVA
Corsiero Editore, Reggio Emilia 2014

CREDITS
ACKNOWLEDGMENTS

CREDITS

All drawings by Santiago Calatrava.
All photographs, renderings and plans by Archiv Calatrava unless otherwise noted.

© **Architekturphoto** 114/115, 120/121; © **Nathan Beck** 586, 593; © **Sergio Belinchon** 209 top; © **Leonardo Bezzola** 44 top, 46, 49, 50/51; © **Robert Burley** 92, 95; © **Collection Tom F. Peters/Courtesy of Lehigh University Art Galleries (LUAG)** 41, 42 top, 42 bottom; © **Courtesy of Gallozzi Group SA** 540/541, 542, 544/545 bottom, 546/547; © **Suzanne DeChillo/*The New York Times*** 592; © **Christophe Demonfaucon** 352/353, 354, 357 bottom, 358 bottom, 361; © **Hans Ege** 233, 588 top right; © **Roland Halbe** 363 top, 366/367, 368; © **James Ewing** 342/343, 346, 347 bottom, 348 top, 349 bottom, 351; © **Heinrich Helfenstein** 34 top, 40 top, 40 middle, 40 bottom, 43, 96/97, 116, 118 top, 119, 258/259, 261 top, 261 bottom, 270, 588 a, 588 b, 589 c, 589 d; © **Alain Janssens** 350 top; © **Alan Karchmer** 184 top, 189, 190/191, 193 bottom, 194 left, 194 right, 195, 196, 197 left, 197 right, 199, 200/201, 202, 203, 204, 205, 206/207, 308/309, 310, 315 top, 315 bottom left, 315 bottom right, 316, 318, 319 top, 321 top, 325, 328/329, 330, 332 top, 333, 335, 374/375, 376, 379 top left, 379 top right, 379 bottom, 396 bottom, 398 top left, 402 bottom, 403 top, 404/405, 406, 408, 410/411, 412, 413, 414 bottom, 414/415 top, 416/417, 418/419, 420, 422 top, 423 top, 423 bottom, 424 top, 427 top, 427 bottom, 428/429, 430, 431, 432, 433 top, 434/435, 437, 439 top, 440/441, 486, 498/499, 500, 503 bottom, 504 bottom, 505 bottom, 532/533, 534, 536/537 bottom, 538 top, 538 bottom, 554/555, 556 top, 556 bottom, 558 top, 559 top, 559 bottom left, 559 bottom right; © **Palladium Photodesign/ Oliver Schuh** 58, 59 top, 59 middle, 59 bottom, 60/61, 63 top, 63 bottom, 74, 75, 78/79, 84, 87, 111, 128, 129, 130 top, 131, 132/133, 135, 136/137, 140, 143, 144 bottom, 151, 155, 156 bottom, 160 bottom, 161 bottom, 162 top, 163 top, 164 bottom, 165 bottom, 167, 168 top left, 168 top right, 170/171, 172 top, 172 bottom, 173 bottom, 174/175, 215 top, 215 bottom, 216 top, 216 bottom, 221, 226/227, 228, 229, 230/231, 232, 234, 235 bottom, 236, 237, 239, 240, 242 top, 242 bottom, 243, 244/245, 246, 247 top, 247 bottom, 248 top, 248 bottom, 249, 250, 251 top, 251 bottom, 252 top, 252 bottom, 253, 255 bottom, 267 bottom, 290/291, 298/299, 301, 348 bottom, 350 bottom, 381 middle, 386, 389, 390, 392/393, 394, 397 top, 398 top right, 398 bottom left, 398 bottom right, 400 top, 401, 436, 438, 442/443, 444 top, 444 bottom, 445 top, 445 bottom, 446 left, 446 right, 447, 448, 449 top, 449 bottom, 450/451, 452/453, 454, 456 top, 456 bottom, 457, 458, 459, 484/485, 489 top left, 489 top right, 489 bottom, 495 bottom, 497 bottom, 510/511, 512, 514 bottom, 515, 516/517; © **Paolo Rosselli** 68 top, 72, 77, 80 bottom left, 80 bottom right, 81, 83, 86 bottom, 89 bottom, 108 bottom, 123 bottom, 138/139, 142 top, 142 bottom, 148 bottom, 149, 152/153, 154 bottom, 266 top left, 266 top right, 267 top left, 267 top right, 269, 272/273, 274, 277, 278, 279 top left, 279 top right, 279 bottom, 280 bottom, 289, 292 bottom, 293 bottom, 294 top, 295 top, 297, 303, 304, 306 top, 306 bottom, 307 top, 320 bottom, 323 bottom, 324 top, 324 bottom left, 324 bottom right, 327, 371, 372, 373, 589 a; © **Frank Schwarzbach for Santiago Calatrava LLC** 470, 474/475; © **Morley von Sternberg** 490/491, 492, 496; © **Hisao Suzuki** 88, 98, 102, 104/105, 106, 108 top left, 108 top right, 109, 178, 180 top left, 180 top right, 181, 182, 183, 260.

ACKNOWLEDGMENTS

The author would like to thank Santiago and Tina Calatrava for their patience and kindness, and for the efforts they made for this book.

IMPRINT

EACH AND EVERY TASCHEN BOOK PLANTS A SEED!
TASCHEN is a carbon neutral publisher. Each year, we offset our annual carbon emissions with carbon credits at the Instituto Terra, a reforestation program in Minas Gerais, Brazil, founded by Lélia and Sebastião Salgado. To find out more about this ecological partnership, please check: www.taschen.com/zerocarbon
Inspiration: unlimited. Carbon footprint: zero.

To stay informed about TASCHEN and our upcoming titles, please subscribe to our free magazine at www.taschen.com/magazine, follow us on Twitter, Instagram, and Facebook, or e-mail your questions to contact@taschen.com.

© 2015 TASCHEN GmbH
Hohenzollernring 53, D–50672 Köln
www.taschen.com

Design: Sense/Net, Andy Disl and Birgit Eichwede, Cologne
Project management: Florian Kobler, Berlin
Collaboration: Sonja Altmeppen and Inga Hallsson, Berlin
Production: Thomas Grell, Cologne
German translation: Christiane Court, Frankfurt/Main; Nora von Mühlendahl, Ludwigsburg
French translation: Jacques Bosser, Montesquiou

Printed in Slovakia
ISBN 978-3-8365-4964-6